THE COLLECTION OF ALFRED STIEGLITZ

FROM THE LIBRARY OF
GARY METZ

A 1972 GRADUATE OF VISUAL STUDIES WORKSHOP, GARY METZ WAS
AN ACCOMPLISHED PHOTOGRAPHER AND NOTABLE SCHOLAR.

OCTOBER 14, 1941 – SEPTEMBER 28, 2010

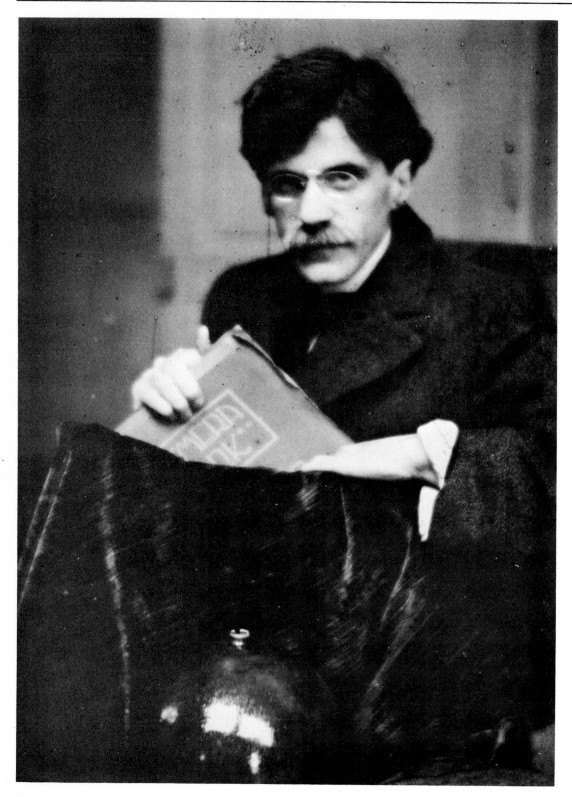

FRONTISPIECE » Edward J. Steichen. *Alfred Stieglitz*, 1907. Cat. 514.

THE COLLECTION OF ALFRED STIEGLITZ

FIFTY PIONEERS OF MODERN PHOTOGRAPHY

WESTON J. NAEF

A STUDIO BOOK
THE METROPOLITAN MUSEUM OF ART / THE VIKING PRESS
NEW YORK

In memory of my father,
whose temperament helped me better understand Stieglitz.

The Metropolitan Museum of Art is grateful to the Vivitar Corporation, Santa Monica, California, for its grant in support of the exhibition of the Alfred Stieglitz Collection.

First published in 1978 by The Viking Press
625 Madison Avenue, New York, N.Y. 10022
Published simultaneously in Canada by
Penguin Books Canada Limited

Library of Congress Cataloging in Publication Data
New York (City). Metropolitan Museum of Art.
 The collection of Alfred Stieglitz.
 (A Studio book)
 Includes bibliographies and index.
 .1. Stieglitz, Alfred, 1864-1946—Photograph
collections. 2. Photographers. I. Naef, Weston J.,
1942– II. Title.
TR646.U6N484 770′.92′2 78-6850
ISBN 0-670-67051-0

Printed in the United States of America

CONTENTS

ACKNOWLEDGMENTS

Cataloging and introducing five hundred eighty photographs by fifty photographers could not have been accomplished in the time permitted by anyone working singlehandedly. Less than a dozen of the photographers have been treated monographically since the death of Stieglitz in 1946. The absence of an organized body of standard references necessitated reliance on information compiled from a variety of sources that include published works, unpublished letters, and recollections by persons associated with the events. We were fortunate to have the cooperation of Georgia O'Keeffe, whose vivid memories of Stieglitz and his associates after 1917 (many sparked by her assistant, Juan Hamilton) added a dimension to my understanding that would otherwise be missing. I am enormously grateful to Miss O'Keeffe for permission to quote many passages from the letters of Stieglitz that appear in print here for the first time.

Ansel Adams and Eliot Porter both contributed extensive recollections of their days in the Stieglitz circle which greatly enrich that portion of the book. Karl Struss, although not represented in the Stieglitz collection, opened his files of exhibition catalogs. The descendants of Photo-Secession generation photographers were particularly helpful, including Stephen Keiley, Harriet Dyer Adams, Mr. and Mrs. J. Cameron Bradley, Mr. Montgomery C. Bradley, Mrs. Hugh Brooks, H. C. Rubicam, Jr., Frau Lotte Schönitzer-Kühn, Mrs. John Franklin Weston, Miss Laura Seeley, and Mrs. Thomas C. Byron.

Delving into the published and unpublished record required substantial legwork supplied in large part by graduate students of Dr. William I. Homer, Chairman, Department of Art History, University of Delaware. I wish to thank particularly the following students enrolled in his 1976 Photo-Secession seminar who contributed important research to, and prepared drafts of, chronologies and bibliographies, and also collected useful information on the individual photographs: Steven E. Bronson, Kristi Eisenberg, Betsy Fahlman, Gale Harris, Ellen G. Landau, Lisa Lyons, Melinda Parsons, Elizabeth Pollock, and Dorothy Satterfield. In addition to participating in the seminar, Mss. Fahlman, Parsons, and Pollock were engaged in specific projects. Ms.

Fahlman investigated sources of illustrations and bibliography in major peri-
odicals, Ms. Parsons studied the holdings of the International Museum of
Photography at George Eastman House, and Ms. Pollock became a full-time
general Research Assistant. As an example of collaboration between university
and museum, each with somewhat different educational goals, the project has
been a model of its kind, and without the dedicated efforts of these nine stu-
dents the catalog would have taken a much different form. William Homer
unstintingly opened his own files and gave us the benefit of his rich expertise in
American art and photography in conversations and in a thorough reading of
the text and catalog, an effort that deserves special thanks.

Substantial original research was contributed by Elizabeth Pollock working
independently of the Homer seminar, as Vivitar Corporation Research Intern,
and by Sarah E. Greenough, a doctoral candidate at the University of New
Mexico, now Kress Fellow at the National Gallery of Art. During the summer
of 1976 Ms. Pollock read and digested relevant parts of the Stieglitz Archive,
Collection of American Literature, Beinecke Rare Book and Manuscript Li-
brary, Yale University (YCAL). Simultaneously Ms. Greenough worked in
the Department of Prints and Photographs of The Metropolitan Museum of
Art preparing notes from firsthand examination of the photographs. In addition
to these basic contributions both women undertook numerous related tasks
attendant to publication including careful reading of the manuscript in its
first draft form.

Mss. Pollock and Greenough contributed to the research and production of
the book in ways that defy specific itemization. Ms. Pollock verified all the
quotations from Stieglitz correspondence, became general editor of the un-
published documents, took responsibility for organizing the portraits of the
photographers, arranged the picture index, and performed ancillary adminis-
trative duties. Ms. Greenough verified the published Stieglitz quotes and edited
the bibliography as it was accumulated from various sources, and corrected the
galleys. The author, however, takes responsibility for the general arrangement
of the bibliography, which in its organization cannot satisfy the needs of every
reader.

Donna Landau spent countless hours leafing through periodicals searching
for reproductions of our photographs and in verifying their location in exhibi-
tion catalogs. Judith Steinhof took responsibility for verifying illustrations
reproduced in *Camera Notes,* and in verifying numerous bibliography entries.
Louis H. Hollister verified the measurements of the photographs and assisted
in other ways whenever called upon to do so. Olga Marx translated several
texts from German to English and Lucy Bowditch digested introductions to the
Paris salon catalogs. Nancy Olsen, Mary Smith, and Robert Chambers pitched
in when asked above and beyond the call of other duties.

Among the most essential tools for completing the catalog was the file of
copy negatives and prints of the entire collection made in the Museum's Pho-

tography Studio by Allen Rodney under the direction of William Pons. The set of photomicrographs of selected images used for identifying ambiguous processes was the work of Steven Weintraub, Assistant Conservator in the Museum Object Conservation Department.

Professional colleagues in America and Europe responded to queries during the research phase of the project and others unhesitatingly accepted the responsibility of reading the typescript, making corrections and adding new information from their personal files. Peter C. Bunnell, David Hunter McAlpin Professor of the History of Photography, Princeton University, read the first draft in its entirety, clarifying many troublesome points. He contributed numerous additions to the White chronology and to the collaboration between White and Stieglitz which materially strengthened those sections. Brian Coe, Curator, Kodak Museum, Harrow, England, supplied information about Davison. Colin Ford, Keeper of Film and Photography, National Portrait Gallery, London, made addenda to the Hill & Adamson and Cameron chronologies. Donald Gallup, Curator, Collection of American Literature, Yale University Library, read the introductory text and gave us the benefit of his perceptive editorial eye in correcting the galleys. Margaret Harker, Pro Rector, Polytechnic of Central London, enriched us with unpublished research on The Linked Ring and gave access to the collection of the Royal Photographic Society. Therese Heyman and her assistant, Ann Harlow, read the Brigman chronology and searched their collection for prints duplicated in the Stieglitz collection. The staff of the International Museum of Photography at George Eastman House, Robert J. Doherty, Director, made available that collection for study, and we wish particularly to acknowledge the assistance of Martha Jenks, Director of the Archives, and William Jenkins, Assistant Curator.

Grace M. Mayer, Curator Emeritus, Steichen Archive, The Museum of Modern Art, gave many hours to refining the Steichen chronology and generously opened the Archive for study. John Szarkowski, Director, Department of Photography, The Museum of Modern Art, and Dennis Longwell, Assistant Curator, permitted access to that collection and made possible the direct comparison of their Steichens to ours. Barbara L. Michaels read the Käsebier chronology, offering important suggestions. Beaumont Newhall, Visiting Professor of Art History, University of New Mexico, opened his files, which included much elusive bibliography. Prof. Dr. Wilhelm Mutschlechner, Director, Höhere Graphische Bundes-lehr-und Versuchsanstalt, Vienna, supplied the Henneberg portrait and read the chronologies of Henneberg, Kuehn, and Watzek. Ann Percy, Associate Curator for Drawings, Philadelphia Museum of Art, compared our list of photographs to theirs. Naomi Rosenblum, who is at work on a Strand dissertation, drafted his chronology as printed and satisfied numerous queries. David Travis, Curator of the Photography Collection, The Art Institute of Chicago, and his associates, Miles Barth and Nancy Thrall, expended much effort checking our holdings against their Stieglitz collection.

Andrea Turnage, assistant to Ansel Adams, searched his files for relevant correspondence and assisted in compiling the Adams recollection.

Dorothy Norman, a close friend and associate of Stieglitz, transcribed his conversations and stories beginning in 1928. We are indebted to her for permission to quote extensively from those texts. Jonathan Green's indices and concordances to *Camera Work* articles and illustrations were indispensable tools since many of Stieglitz's prints were reproduced there.

The search for portraits of the fifty photographers collected by Stieglitz, and the verifying of elusive facts required us to call on the good nature of many archivists, collectors, curators, and librarians: Andrew Birrell, Public Archives of Canada, Ottawa; Robert Brandau, New York; Walter S. Dunn, Director, Buffalo and Erie County Public Library, and his associates Ruth Willett and Gemma De Vinney; Wynn Byard Fooshee, Archivist, The Cosmopolitan Club, New York; David Haberstich, Division of Photographic History, Smithsonian Institution, Washington, D.C.; Mrs. C. E. Helfter, Jr., Curator of Iconography, Buffalo and Erie County Historical Society; Michael E. Hoffman, Estate of Paul Strand, Millerton, New York; Ann Horton, Sotheby Parke-Bernet, Inc., New York; Joyce Kasman, Franklin Institute, Philadelphia; Alfred Lowenherz, The Camera Club, New York; Harry L. Lunn, President, Graphics International, Washington, D.C., and his associate, Peter Galassi; Fritz Kempe, Hamburg, West Germany; Mary Jean Madigan, The Hudson River Museum, Yonkers, New York; Judith Schub, Paris; Benjamin Sonnenberg, New York; Kristen Spangenberg, Curator of Prints, Cincinnati Art Museum; Paul Walter, New York; Kenneth Wall, Secretary, The Royal Photographic Society, London; Ben Wolf, Philadelphia; and Nancy Zembala, Archives of American Art, Washington, D.C. The foregoing all assisted in material ways for which I am grateful.

The support and encouragement of many colleagues at The Metropolitan Museum of Art deserves greater acknowledgment than can be given in these lines. Colta F. Ives, Curator-in-Charge, Department of Prints and Photographs, lent influential support to the project in all its phases and supplied a sympathetic ear when obstacles seemed insurmountable. Brad Kelleher, Publisher, and Townsend Blodget, Publications Associate, gave sound advice on the business of book publishing. Kay Bearman, Special Assistant to the Acting Director, showed estimable patience when the logistics of planning became complicated. Merritt Safford, Conservator of Paper, and his associates, Helen Otis, Marjorie Shelley, and Peggy Holben, assisted in preparing the photographs for exhibition. Edward Stack and Max Berman, Senior Departmental Assistants, shouldered numerous extra responsibilities during the course of the project.

Translating a thoroughly emended manuscript to finished typescript required of the typists near-oracular powers. Wendy Belser prepared the catalog entries; Lisa K. Medina, the chronologies; Susannah Cuyler, the first draft of

the text; and Craig Steadman typed the final draft of the introduction, bibliography, and exhibition lists. For their careful attention I am deeply beholden.

The step from dream to reality in publishing comes when the typescript is given to an editor. That campaign was led by Yong-Hee Last, whose intelligent treatment of the text and catalog buttressed its structure. David Beams prepared the index and contributed good suggestions as to its organization. The staff of Studio Books, Viking Penguin, Inc., undertook the production and design: particular thanks are due to Bryan Holme, Consulting Editor, Chris Holme, Art Director, and Gage Cogswell, Administrative Editor, whose professional handling of all details attendant to the production earns them my respect. Clint Anglin is to be commended for his thoughtful design which reconciles the sometimes separate goals of beauty and usefulness.

This book would not have been possible without the support of John C. Best, Chairman of the Board, Ponder & Best, Inc., and of Jay S. Katz, President, Vivitar Corporation, whose generous financial support was entirely responsible for the funds to employ research assistants, and for mounting a special exhibition. Their response to our call, engineered by William Osmun, is a tribute to enlightened corporate responsibility.

The most intangible obligation I have is to Mary Meanor Naef, my wife, who through the twenty-four months when intense work on this book took place, gracefully permitted my work to interrupt many hours we would otherwise have shared. To all the above, and the others whose names have been inadvertently overlooked, may I give thanks that are justly deserved.

Weston Naef
New York
February 14, 1978

THE COLLECTION OF ALFRED STIEGLITZ

. . . . The only advice is to study the best pictures in all media—from painting to photography—and to study them again and again, analyze them, steep yourself in them until they become a part of your esthetic being. Then, if there be any trace of originality within you, you will intuitively adapt what you have thus made a part of yourself, and tinctured by your personality you will evolve that which is called style.

Alfred Stieglitz,
"Simplicity in Composition."
From *The Modern Way of Picture Making,* 1905 (Biblio. 927)

INTRODUCTION

DE CESNOLA

In the winter of 1902, General Luigi Palma de Cesnola, Director of The Metropolitan Museum of Art, was asked by Duke Abruzzi, a director of Turin's Esposizione Internazionale di Arte Decorativa Moderna, to arrange for an exhibit of important American photographs. General de Cesnola learned that the best person to advise him was Alfred Stieglitz, who was not only a talented photographer but also the most serious collector of photographs in the United States and possibly the world.

Stieglitz met with the General at the Museum and later recalled, "I told the General what my fight for photography had been [and] still was, and that I would let him have the collection needed for Turin if he guaranteed that when it came back it would be accepted by The Metropolitan Museum of Art *in toto* and hung there." Stieglitz recollected that de Cesnola gasped, "Why, Mr. Stieglitz, you won't insist that a photograph can possibly be a work of art . . . you are a fanatic." Stieglitz replied that he was indeed a fanatic, "but that time will show that my fanaticism is not completely ill founded." (Biblio. 918)

TURIN EXHIBITION

Stieglitz arranged for sixty prints by thirty-one persons to go to Turin, where they were awarded the King's Prize. In appreciation, Stieglitz wrote to the Duke that "after an eighteen years struggle I am glad to have accomplished my life's dream, to see American photography—sneered at not more than six years ago—now leading all the world." (Biblio. 871) Stieglitz was not to see the complete realization of his agreement with de Cesnola for the General's unexpected death early in 1903 prevented the collection from being shown at the Museum as had been promised.

KING'S PRIZE
CONTROVERSY

A controversy erupted when the King's prize was mistakenly awarded to The Camera Club of New York rather than Stieglitz's brainchild, the Photo-Secession. The ensuing correspondence revealed that forty-three of the sixty prints sent to Turin were from the personal collection of Stieglitz, which subsequently came to The Metropolitan Museum of Art as a gift in 1933 and as a bequest in 1949. Thus his desire to see the collection of photographs repose with master engravings, woodcuts, and lithographs, as he had contended they deserved to be, was fulfilled.

Even before 1902, the date of the controversial Turin prize, Stieglitz had begun to consider himself as much a collector as a creative artist, and the Museum as the final home for the collection. In an unsigned interview attributed to Theodore Dreiser, Steiglitz was asked, "Have you a very large collection?" To which he responded, "Some very interesting things which I hope some day to give to the Metropolitan Museum." (Biblio. 965) By 1911 Stieglitz had already begun to think about the disposition of his collection of photographs and The Metropolitan Museum of Art was first on his list as a home. Just before Christmas of 1911, Thomas W. Smillie, Honorary Custodian of the Section of Photographs, Smithsonian Institution, one of the first curators of photography in America, wrote to Stieglitz asking if he could be of assistance in assembling a collection of pictorial photography. Stieglitz

<div style="float:left; width:30%;">COLLECTION INTENDED FOR THE METROPOLITAN MUSEUM</div>

responded, "My collection is intended for the Metropolitan Art Museum [sic] some day," adding in his typically brusque manner, "I shall keep in mind your request." (Biblio. 1602) The collection which came to the Museum was the result of Stieglitz's activity as a collector between 1894 and 1911, when his acquisitions of photographs began to abate and his collecting of paintings commenced. Stieglitz's most active collecting of photographs coincided with his editorship of first *Camera Notes* (1897–1902) and later *Camera Work* (1902–1917). Stieglitz's growing interest in other art forms after 1910 caused the roster of photographers' names to be closed and the private controversies into which he seemed continuously embroiled paralyzed his activity as a collector of photographs.

Between 1907, the year of his own remarkable photograph, *The Steerage,* and 1917, when he met Georgia O'Keeffe, Stieglitz entered a new phase in his own artistic life that was in many ways reflected among the photographs he had so resolutely assembled. The Collection of Alfred Stieglitz had, in the words of Georgia O'Keeffe, begun to collect him. More significantly, the photographs proved to represent a visual mode that he came to resent enormously, and against which he would produce in his own photographs of the 1920s what amounted to nothing less than a visual manifesto in repudiation of what many of the pre-war photographs he collected represented esthetically.

Georgia O'Keeffe sagely perceived the discrepancy between Stieglitz's own esthetic and the he expressed in work by others. She wrote that "the collection does not really represent Stieglitz's taste; I know that he did not want [by 1917] many things that were there, but he did not do anything about it [until his gifts to the Museum of 1922, 1928, and 1933]." (Biblio. 1041, p. 24)

<div style="float:left; width:30%;">SCOPE OF THE COLLECTION</div>

The scope and content of the Stieglitz collection is remarkable for it represents certain figures such as Kuehn, Puyo, and Demachy, who, if one were to judge from the appearance of Stieglitz's own photographs of the 1920s and 1930s, would not have had any appeal whatsoever because of their

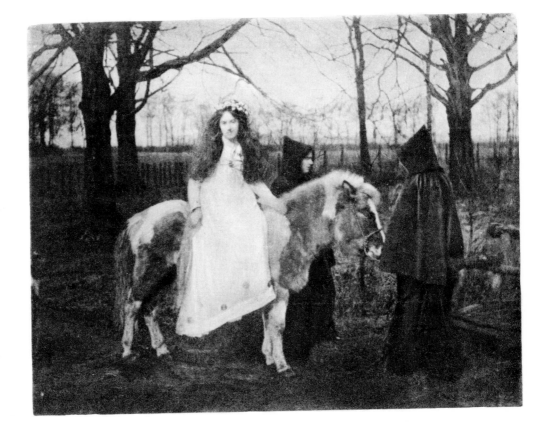

PLATE 1 » J. Craig Annan. *The Church or the World,* 1893. Cat. 13. Actual size.

opposite visual premises. As could be expected, there are numerous works by photographers such as CLARENCE H. WHITE and EDWARD STEICHEN, the co-founders of modernism in American photography, who today seem natural in such a collection. Stieglitz's collection was not, however, assembled with great rationality, but rather exhibits a recurring pattern of accidental, often spontaneous acquisition. Only in the case of the ten photographers represented in great depth was there a methodical attempt to be representative and historical. Seventeen photographers are represented by only a single print and any chronicle of Stieglitz's life as a collector must account for them as well as for the others to whom he committed himself more substantially.

In 1912 Stieglitz wrote to HEINRICH KUEHN asking, "Isn't my work for the cause about finished? Useless to sacrifice time and money simply to repeat oneself—I don't believe in that and therefore I feel far too much the need for my own photography." (Biblio. 1565) By 1919, after the demise of *Camera Work* and the vigorous new interest in modern art, Stieglitz wrote his old friend R. Child Bayley of London regarding his collection of photographs. "It would make interesting history to write up how I came by all these famous masterpieces. They cost a fortune in actual direct cash outlay. My collection is undoubtedly unique." (Biblio. 1437) He went on to describe nostalgically the process of putting in order his "long neglected and messy personal affairs" particularly the five hundred to six hundred photographs, including "the collection of Steichens, Whites, Eugenes, Days, Puyos, Demachys, Kuehns, Hennebergs, Watzeks, Le Bègues, Brigmans, Käsebiers, Coburns, Seeleys, Hofmeisters, Keileys, Evans, etc., etc." (Biblio. 1437) The collection was cataloged on blue parcel post labels affixed to many of the prints and put into storage not long after these words were written. In 1922, Stieglitz again began thinking of the Museum, which resulted in gifts to the Museum of books and photographs in 1922, 1928, and 1933. In 1933 at the time of the gift of 418 photographs by others he had collected, Stieglitz wrote that "the collection represents the very best that was done in international pictorial photography upwards of seventy odd years. Over two hundred and fifty of the prints were exhibited at some time or other in the art galleries of Europe and in some of the American galleries. There are many priceless prints not existing in duplicate. The collection as it stands cost me about fifteen thousand dollars." (Biblio. 871)

Stieglitz had a variety of personal relationships with photographers whose work he collected. Some work was acquired primarily because there had been an early friendship, such as with F. HOLLAND DAY, JOSEPH KEILEY, Edward Steichen and J. CRAIG ANNAN. In many instances photographers sent work to him regularly as it was made and it formed simply the visual counterpart of a longstanding correspondence. This was particularly the case when the persons resided far from New York, as with ANNE W. BRIGMAN.

SEQUENCE OF
DONATIONS

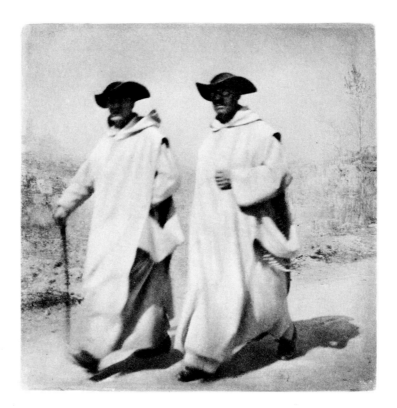

PLATE 2 » J. Craig Annan. *The White Friars*, 1894. Cat. 17. Actual size.

Stieglitz apparently sometimes acquired photographs for reasons other than their esthetic appeal to him. Käsebier's "first photograph" (Cat. 341) was a piece of memorabilia; other works demonstrated new processes or techniques being used by artistically oriented photographers, such as J. Craig Annan's photogravures.

Works of this kind were one of Stieglitz's first interests since they demonstrated the important interplay between processes of photography and the resulting image. Stieglitz also acquired works sent to him for reproduction in the various periodicals of which he was editor, including *American Amateur Photographer* (1893–1897), *Camera Notes* (1897–1902), and *Camera Work* (1902–1917). Stieglitz never accepted work for reproduction that he did not admire, but this does not necessarily mean he assumed the same emotional and philosophical commitment to every photographer or to every single work that was reproduced.

ROLE AS EDITOR

Then there was the core collection by a roster of names that first took public shape in 1899, changing gradually until 1902. By the time of the Photo-Secession, the roster had become crystallized and in 1919 Stieglitz could recite it from memory in a letter to Bayley. However, it should be noted that Stieglitz's collection does not include every Fellow or Associate of the Photo-Secession. After 1902 only a few new names were added to the roster, and one or two were even dropped.

Not every photograph Stieglitz acquired was on the same level of visual or historic strength, nor has every photographer come to be regarded as having realized the same consistency of accomplishment. In this regard Stieglitz's collection presents a spectrum of the range of work produced during the formative decades of artistic photography in Europe and America, without, however, including every photographer whose work might today be included in a survey of the period. Notably lacking are Peter Henry Emerson and Henry Peach Robinson. Many interesting figures such as Frank Sutcliffe in England; Achille Darnis in Paris; Robert R. von Stockert and Ludwig David of Vienna; Franz Erhardt, Berlin; and Emma Farnsworth of the United States, famous then but little known today, are not included in Stieglitz's

SELECTIVITY

collection. Such a roster constitutes a coherent body of quality work that Stieglitz never collected even though he was certainly familiar with their photographs through the unavoidable reproductions in lavishly illustrated anthologies (Biblio. 1264–1273) that included reproductions of his own work and which themselves established a collegial context that itself could have supplied sufficient reason for Stieglitz to have acquired the work. Whether consciously or unconsciously, Stieglitz decided not to collect photographs by many workers who were held in very high regard then, and whose photographs look very strong today. It is evident that Stieglitz did not attempt to collect the photographs of every one of his talented contemporaries, but exercised his power to acquire in a discreet and highly personal manner. What then did

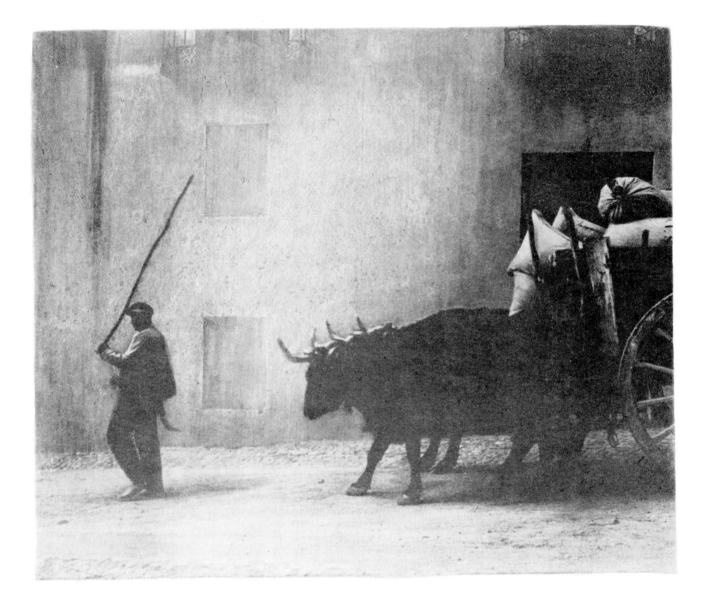

PLATE 3 » J. Craig Annan. *A Burgos Bullock Wagon*, 1914. Cat. 40. Actual size.

LESSONS OF A
COLLECTION

the collection contribute to Stieglitz's understanding of photography in general
or to his own creative work? Some of the more general answers are self-evident
because collections of pictures by their nature teach certain lessons. Stieglitz
was deeply influenced in his photographs before World War I by the work
he collected. From the collection Stieglitz learned how to look at pictures,
how to talk about them, how to exhibit them, and how to care for them.
Between 1902 and 1910 Stieglitz traded his role as artist for one as curator and
publisher. The collection was an incubative experience through which a part
of his love and understanding of the medium of photography came to be, and
through which a great portion of his influence on the emergence of American
photography took material form outside of his own creative image-making.

STUDENT AND
BIBLIOPHILE

Despite its omissions, Stieglitz's collection is a touchstone for the history of
the formative years of modern photography. It is one of the very few collections
of photographs formed by an artist of great stature to have survived intact and
stands as important tangible evidence of a great artist's eye judging the work
of his contemporaries. The division of the collection in unequal portions
between The Art Institute of Chicago and The Metropolitan Museum of Art
has not compromised the representativeness of the portion that came to
the Metropolitan as the master set of work Stieglitz collected by his associates.
With few exceptions, the most notable of which is Steichen's *Rodin—Le
Penseur,* the Metropolitan was given the key prints and the Art Institute
duplicate subjects.

Perhaps the most revealing introduction to the collection is provided by
Stieglitz himself in a letter of transmittal, written in 1933, when he turned
over to the Museum four hundred eighteen photographs. The letter, addressed
to Olivia Paine, an associate of William M. Ivins, Jr., Curator of Prints, shows
his growing ambivalence toward the collection and, in fact, how close he came
to actually destroying it (Biblio. 871):

New York City
May 9, 1933

My dear Miss Paine

When you came to An American Place and asked me whether I'd be willing
to send my collection of photographs to the Metropolitan Museum of Art instead of
destroying it as I had decided to do even though I knew there was no such col-
lection in the whole world and that it was a priceless one, I told you that the mu-
seum could have it without restrictions of any kind provided it would be called for
within twenty-four hours. You called me up on the phone within an hour and told
me that the museum wagon would be down the next day to get it. This happened.
I herewith tell you that the collection is given to the museum if it should decide to
accept it without any restriction whatever.

The collection represents the very best that was done in international pictorial
photography upwards of seventy odd years. Over two hundred and fifty of the prints

PLATE 4 » A. Horsley Hinton. *Fleeting Shadows,* 1897 or before. Cat. 339.

were exhibited at some time or other in the art galleries of Europe and in some of the American art galleries. There are many priceless prints not existing in duplicate. The collection as it stands cost me approximately fifteen thousand dollars. This includes the cost of storage for years. In the collection sent you there are what might be termed some duplicates. In reality there are but few of such. What might seem duplicates to you are in reality different methods of printing from one and the same negative and as such become significant prints each with its own individuality. Frequently similar differences exist in photographic prints from one negative as appear in different pulls from one etching plate—differences in paper, differences in impression, etc. etc., giving particular value to each pull.

In case the museum accepts the collection I shall be only too glad at a future date to come to the museum when Mr. Ivins returns and go through the same with him and you and select what I think should go into the museum's files and which prints might be discarded. Still Mr. Ivins may decide to discard none, for all the prints sent were at one time or another of importance or I should not have incorporated them in the collection.

I might add here that a year or so ago Mr. Ivins expressed the wish that I should present the collection to the museum but at that time I did not know whether I could afford such a gift. To-day it is not a question of being able to afford to make such a gift but the question of how I can continue to physically take care of it for I am a poor man as far as finances are concerned and therefore I decided to destroy the collection so as to get rid of storage charges rather than to go out and try to place the prints piecemeal or in toto. I am telling you this so that you and your museum trustees can understand the facts as they exist. I might add that the collection contains about fifty Steichens and fifty Clarence Whites and fifty Frank Eugenes, all very rare examples of these internationally famous American artists in photography. There are furthermore the very rare French prints and Austrian prints, German prints and English prints together with other famous American prints.

The collection naturally does not include any of my own work since it is a collection I have made of the work of others. The museum has a collection of my own work.

Sincerely yours,
Alfred Stieglitz

CHAPTER ONE

SETTING THE STAGE

STIEGLITZ THE STUDENT AND BIBLIOPHILE

Of German-Jewish ancestry, Stieglitz's father was a successful merchant in the wool business, whose prosperity allowed him to move the family in 1871 from Hoboken to a brownstone residence on East Sixtieth Street in New York, and ultimately bequeath to Stieglitz an inheritance that made possible his collection. Stieglitz was educated at P.S. 55, Townsend Harris School, and the College of the City of New York (from which he never graduated) before further schooling in Munich and Berlin. His years as a student in Germany served initially to undermine his identity as an American, and were still on his mind in 1921, when he began the introduction to his Anderson Galleries exhibition with the statement: "I was born in Hoboken. I am an American. Photography is my passion. The search for Truth my obsession." (Biblio. 1057, p. 142)

The Stieglitz family had a strong orientation towards visual art. His father, Edward (Cat. 468), was an amateur painter who enjoyed socializing with artists, the most prominent among whom was Fedor Encke (1851–1926). The Stieglitz homes in New York and Lake George were decorated with prints and decorative objects by artists active in New York in the 1860s and 1870s, such as sculptor Moses Ezekiel (1844–1917), who was Edward Stieglitz's favorite artist. (Biblio. 1205, p. 270, n. 3) Stieglitz was curiously silent in his reminiscences about the formative influence exerted by the artists and art works that surrounded him at home. While Stieglitz might not have had enthusiasm for these specific artists or their work, his close firsthand experience with original art must have contributed, at least in part, to the deeply ingrained picture consciousness that was among the only consistently predictable aspects of his personality. Stieglitz loved pictures with a passion shared by few of his contemporaries, and it was this compulsion to make, see, and ultimately own pictures that made him a successful collector. Stieglitz shared with his father an attraction for work by living contemporaries whose reputations had yet to be canonized either by museums or the marketplace.

FATHER'S COLLECTING

Georgia O'Keeffe, whom Stieglitz married in 1924, noticed that he showed the compulsive instincts of a collector while very young. O'Keeffe commented, "Maybe his collecting was started when, as a boy with a toy racing stable, he collected lead and wooden models of horses and jockeys, stabled the horses and ran the great races of racing history again and again." (Biblio. 1041, p. 235) The first stage of Stieglitz's life as a collector was his university education in Germany and an early love of books that surfaced during his studies there. In 1882 at the age of eighteen Stieglitz went with his family from New York to study at the Realgymnasium in Karlsruhe, Germany. He was enrolled to study mechanical engineering but soon diverted into the making of photographs and into studying the chemical and technical underpinnings of photography. We are told that one day he passed a shopwindow and spontaneously purchased a small camera, an incident about which Stieglitz later wrote, "I bought [the camera] and carried it to my room and began to fool around with it. It fascinated me, first as a passion, then as an obsession." (Biblio. 1049, p. 91; 1057, p. 25) For Stieglitz the purchase of this small camera and the making of his first prints (about 1883) were not only the first steps toward his future role as one of the most important artist-photographers the medium has ever produced, but also to becoming the most important collector of photographs of his generation.

It was during this German period between 1885 and 1889 that Stieglitz began to acquire books and assembled an impressive library (Biblio. 1206–1400) that played a significant role in formulating his thinking on photography. The library formed a portable gallery of photographs that he could study at his leisure and amounted to a museum-without-walls by virtue of the fact that many of the publications which he so voraciously obtained were illustrated either with original pasted-in photographs, or with high quality photomechanical reproductions. These books contain facsimiles of photographs by many camera workers who would later enter the Stieglitz collection, as well as a group of photographs by those who had already earned their reputations by the time Stieglitz came along, but who for one reason or another never entered Stieglitz's personal collection. (Biblio. 1060) Stieglitz did not collect the photographs of every person whose work was admired by others; he did not have all the prizewinners from the various exhibitions; he did not focus on one school, one continent, one nation, one city, or even one style. The remarkable fact of the collection is its geographic and stylistic diversity. The library of Alfred Stieglitz reveals the broad range of personalities about whom he was informed, and the boldness with which he chose to disregard many photographers with considerable reputations between 1883 and 1895. The library provides ample evidence that no matter what Stieglitz failed to acquire, his final decisions were based on a very informed opinion long before his own name came to be a household word in American photography.

Books were the primary vehicle through which the influence of Stieglitz's

LIBRARY OF
ILLUSTRATED BOOKS

PROMINENT
CONTEMPORARIES NOT
COLLECTED

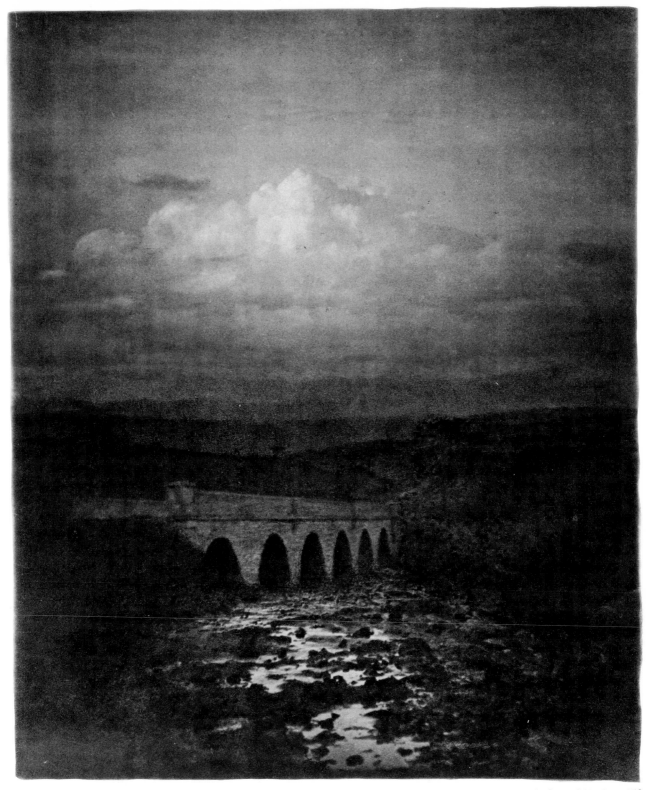

PLATE 5 » Archibald Cochrane. *The Viaduct,* before 1910. Cat. 153

teachers was transmitted. Hermann W. Vogel, his most illustrious mentor, edited the *Photographische Mitteilungen* and authored numerous treatises and handbooks on photography (Biblio. 1206, 1217, 1225), including *The Chemistry of Light and Photography* that had been translated into English as early as 1875. (Biblio. 1062) The treatise says little about the history of the medium or its potential as a means of creative expression, but a great deal about practical applications ranging from portraits to microfilms for carrier pigeons. What Vogel taught, however, did not have direct influence on Stieglitz as an artist or as a collector.

The other books and journals in the Stieglitz library were the first donations he made to the Museum in 1922. The books were not only a physical burden to Stieglitz, but they also appear to have had the least meaning for him of all that was in his collection. The library contains many finely made illustrations, carefully selected in consideration of the great expense good illustrations cost then. Among the few names from the 1885–1890 period that have since entered the history of photography and whose works are admired and collected today, is Frank Sutcliffe who would have been natural for Stieglitz to have collected. He failed to do so, despite their mutual concern for genre subjects. Readers' eyes at the time were not bombarded with photographic images in any form, much less in facsimiles, and thus the chances of these images having a strong impact were much greater then than now. Despite the attention which the featured plate illustrations inevitably commanded from the readers, they left a somewhat passive imprint on Stieglitz's style. Stieglitz did not base his acquisitions upon seeing a photograph reproduced, nor did he focus attention on a single photographer whose work was illustrated before 1889. This is partly suggested by the extraordinary fact that (excluding JULIA MARGARET CAMERON and HILL & ADAMSON) only two of Stieglitz's contemporaries whom he collected—A. HORSLEY HINTON (Pl. 4) and GEORGE DAVISON—were even mentioned before 1891 in the massive literature contained in Stieglitz's library. Stieglitz followed his father's instinct for discovering new talent.

Between 1885 and 1889 Stieglitz silently witnessed the birth of an entirely new attitude about photography. He waited by the sidelines, absorbed everything he could, and then about 1890 began to emerge as a force. He watched the evolving institutionalization of amateur photography, and the highly organized campaign of public-awareness through which amateurs, in a classic instance of reverse snobbism, came to see themselves as superior picture-makers to studio-bound professionals whose work had been reduced to pat formula.

Charles Caffin, the most historically minded critic of Stieglitz's generation, observed the shift in attitude of the 1840s and 1850s toward the battle of Stieglitz's contemporaries to revive the reputation of artistic photography:

PLATE 6 » Frederick H. Evans. *In Deerleap Woods—A Haunt of George Meredith,* about 1909. Cat. 300. Actual size.

ARTISTIC PHOTOGRAPHY:
1885

"... [around 1885] photography as an art fell upon evil times; it was seized and exploited for moneyed ends, and its artistic possibilities became obscured by commercialism. With the usual interacting of cause and effect, the photographers aimed to please the public, and the latter accepted their work as representative of the art at its best." (Biblio. 1282, p. 3) Caffin also noted that the period around 1880, in his opinion, was "one of banality in all the arts. A few names of painters and sculptors stand out as eminences, but for the most part the two arts showed a dead level of mediocrity. This is as true of Europe, with its uninterrupted traditions, as of America, which was just commencing its art consciousness." Stieglitz and others of his generation strove to rectify the "evil times" that photography had fallen upon, and this quest soon became the "cause."

The amateur photography movement was seen by its founders as a means of reinstating the creative integrity of photography as a medium of expression. "Amateur" was a word equal to "artistic." One of the most important forces in this new movement was *The Amateur Photographer* (Biblio. 1243), first issued in 1884, called by a name that had never before been used for a journal. The title was chosen specifically to distinguish it from other photography journals aimed at professionals which concentrated more on technique and equipment than on the picture esthetics. *The Amateur Photographer,* edited by A. Horsley Hinton, on the other hand, was deeply interested in photographs for their own sake, and had an influence around the world, including Germany, where Stieglitz, then a student, received his copies.

The first issue of *The Amateur Photographer* appeared on London newsstands the week of October 10, 1884, with a motto from Shakespeare prominently on the masthead, "to hold as t'were the mirror up to nature." The editors (who go unnamed on the masthead) declared unequivocally, "No dry, scientific details will here be set down, but our pages will ever brim over with information put in the clearest and most readable form."

STIEGLITZ AS AUTHOR

Stieglitz began his prolific career as an author (Biblio. 1059) on photography topics with his first article in *The Amateur Photographer,* "A Word or Two About Amateur Photography In Germany" (Biblio. 874), where he expressed his commitment to amateurism. The equation of amateur equals artistic soon appeared in other publications around the world. *The Amateur Photographer* spawned *Der Amateur Photograph* (Biblio. 1242) in Düsseldorf, which published Stieglitz's early German photographs, and *American Amateur Photographer* (Biblio. 1245) out of Brunswick, Maine, and New York.

The *American Amateur Photographer* (where Stieglitz had his first real job beginning in 1892) commenced publication in 1889, a year that was generally considered to mark the beginning of modern photography. An editorial note on the 1884 Royal Photographic Society Exhibition in the first number declares that "the best pictures taken this year by amateurs—which is almost tantamount to saying the best photographs which have yet been pro-

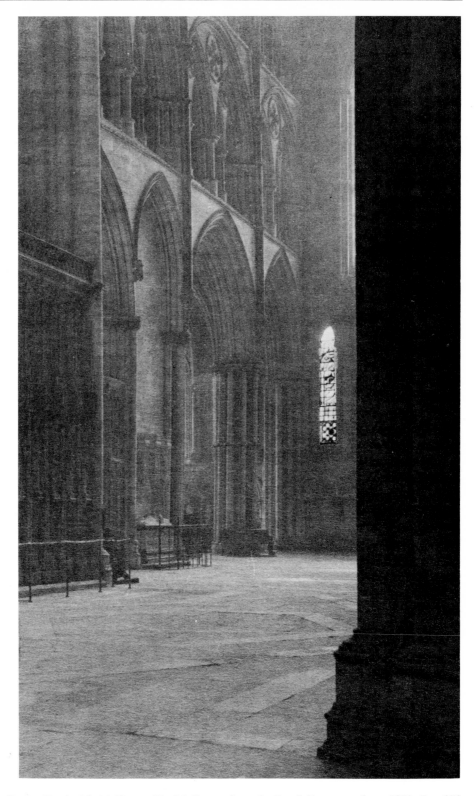

PLATE 7 » Frederick H. Evans. *York Minster, Into the South Transept,* about 1900. Cat. 292

duced—are not there." The word "amateur" was an accolade and the journal printed the revisionist notion that "photography is an art—perhaps the only one in which the amateur soon equals, and frequently excels, the professional in proficiency." (Biblio. 1243, v. 1, p. 3).

Among the primary functions of amateur photography periodicals was to instill in the readers an element of self-confidence and pride in their own work through firsthand accounts like Stieglitz's and published photographs by amateurs. In the late 1880s the absence of cheap, accurate methods of reproduction precluded more than three or four facsimile quality reproductions in each issue of a typical publication. Soon less expensive halftone reproductive

processes multiplied the number of illustrations possible in the amateur periodicals, although the very coarse halftone dots did little justice to the beauty of the images. Stieglitz's earliest German photographs were reproduced in the context of amateur photography periodicals at the very moment of the transition from photoglyptic (Woodburytype) and photo-lithographic (collotype, heliogravure) processes to halftone and photogravure processes, a state of affairs that left Stieglitz with strong opinions about the technical manner by which most photographs were reproduced on the printed page.

The Amateur Photographer became an important forum for discussing the exhibitions. It placed continued emphasis on the photographs rather than on the encrusted structure which had come to stand for photography, but which had ceased to be deeply concerned about the end results—the pictures themselves. The editors remarked, "There is one pervading feature among amateur photographs—the strong evidence of their having been done for love." The key phrase is "their having been done for love," implying that photographs made for money were somehow inferior. A significant distinction was introduced between work made from highly personal motivations, and a broad category which was done to satisfy external, usually commercial needs. For the first time it became a generally accepted principle that the best pictures were made for personal reasons, and the converse of this also came to be admitted: when money was accepted for work, it was probably inferior. This theme would recur between 1898 and 1917 in Stieglitz's milieu.

Stieglitz the collector grew to be deeply influenced by the precept that highly personal photographs were more akin to traditional art works than the generally unexpressive, often formularized work of professionals. Stieglitz harbored such a resentment towards professionals that later, when certain of his clique turned coat and began to earn their livings from photography— most notably GERTRUDE KÄSEBIER, Clarence White, and finally even Edward Steichen—they soon found themselves no longer on speaking terms with him. Doubtless Stieglitz came to believe strongly in the principle of amateurism— his earliest writing was on the subject (Biblio. 871, 1059)—not because it was espoused by *The Amateur Photographer,* but because his personal experience corroborated the idea.

PLATE 8 » Frederick H. Evans. *Across the Transepts of Westminster Abbey,* 1911. Cat. 301

Stieglitz did not express a full understanding of the importance of amateurism for the esthetics of photography until after he returned to the United States to work for the *American Amateur Photographer*. In 1887 he still held the notion that professionals were better and wrote a short article asking that in future exhibitions the genre and portrait classes be divided into "for amateur" and "for professional" categories. He reasoned, "How can an amateur whose supply of apparatus is generally more or less limited, no studio at his command, ever hope to compete with professionals, who are so favorably handicapped." (Biblio. 874). Over the next five years Stieglitz would come to share the radical notion held by *The Amateur Photographer* that amateurs were more likely to realize artistic results because of their freedom from external artistic requirements. Among those who came to hold similar admiration for amateurs' strengths was Richard Stettiner, who wrote in the preface to *Nach der Natur:* "Is amateur photography really an amateur art in the accepted sense of the word? As far as the scope of their activity is concerned, part of the men who are first and foremost in the field differ from the professional only in that they do what they do for money. Most of them are even superior to the professional in technical experience and technical ability." (Biblio. 1272)

THE LINKED RING

The spirit of amateurism was manifest not only in periodicals but in social clubs. In 1892 The Linked Ring was formed in London through the efforts of George Davison, A. Horsley Hinton, H. P. Robinson, and H. H. H. Cameron, son of Julia Margaret Cameron, and Andrew Maskell, along with several other founding members of less relevance to Stieglitz's future. (Biblio. 1181) The purpose of The Linked Ring was to sift from the rank and file amateurs an elite group comprised of what were deemed to be the most serious photographers then working. It was the most important amateur society as far as Stieglitz's future was concerned. Peter Henry Emerson's absence from this group, and the reinstatement of Robinson's credibility came about by a bizarre turn of events. In January of 1891 the editors of many photographic journals unexpectedly received a letter from Emerson begging them to print his notice "To All Photographers" (issued later as *The Death of Naturalistic Photography,* 1890), apologizing to all those who had followed his teaching, for he now realized that photography was *not* art; he said, "the medium must rank the lowest of all arts, *lower than* any graphic art." (Biblio. 1066) Thus, Robinson, who sanctioned the use of any manipulations which were at the photographers' disposal and who was respected by the French, Germans, and Austrians, replaced Emerson as chief spokesman for the modern movement. Emerson, whose philosophy of naturalistic photography had been so influential on Hinton, Davison, and many other contemporaries, including J. Craig Annan, and Stieglitz, was temporarily *persona non grata* among photographers.

One hundred twenty-two American societies were listed in the *Blue Book*

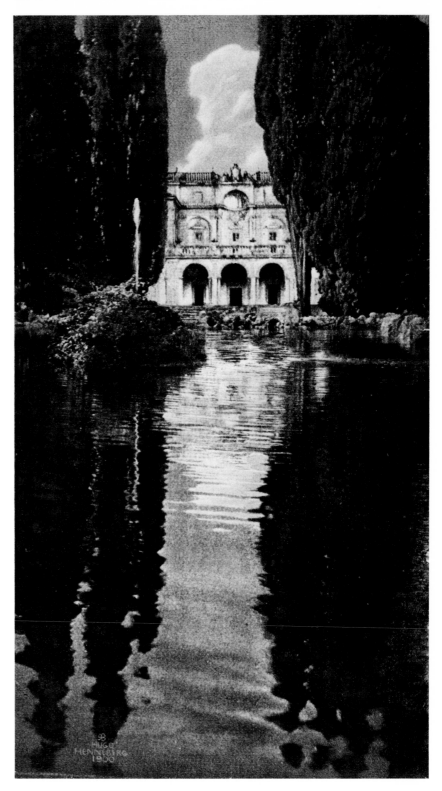

PLATE 9 » Hugo Henneberg. *Villa Falconieri, Frascati,* 1900. Cat. 314

(of Photography) for 1894. (Biblio 1226) The camera clubs of the major cities enjoyed special prestige because of their important locations and the general affluence of their members. Members were required to pass the same strict admission requirements that prevailed in other types of eating and social clubs such as the Century Club and the National Arts Club (Biblio. 1342), two societies with many members in the visual arts. New York was the home of two clubs united by their consolidation in 1896. The Society of Amateur Photographers and the New York Camera Club were joined to form The Camera Club, an amalgamation which Stieglitz was influential in bringing about. The Camera Club had among the goals listed in its By Laws, "frequent exhibitions of the best members' work," and in 1897 established a regular one-man exhibition program that was very influential on Stieglitz's style of presenting exhibitions as it was to emerge about 1905.

The *Photo-Club de Paris* (Biblio. 1302, 1306, etc.) was formed to counterbalance the professionally oriented *Société Française de Photographie*. The Vienna camera clubs (Biblio. 1298, 1300) were the artistic counterpart to the technically oriented *Photographische Gesellschaft* in Vienna. Societies of artistic photographers sprouted up in many other cities of Europe, including Brussels and Hamburg (Biblio. 1303, 1307). It was through these societies that Stieglitz encountered the personalities who would come to play such an important role in the publications he edited and in his collection of photographs.

PHOTOGRAPHIC EXHIBITIONS, 1891–1893

After his library the next greatest early influence on Stieglitz were photographic exhibitions which focused his attention on the special experience only obtained by viewing original prints, where qualities that were inevitably lost even in the finest book reproductions could be seen. Six or seven years had elapsed from the time the first amateurs were admitted to the Pall Mall exhibition of the Photographic Society of Great Britain in 1884 until the first rigorously juried international exhibition was held in Vienna in 1891. (Biblio. 1300) Stieglitz did not see either of these two early exhibitions, but he was familiar with them through printed reports, and they whetted his appetite for a more direct exposure to the images.

The *Ausstellung Kunstlerischer Photographien* was held in Vienna from May 4 to July 1, 1891, sponsored by the *Club der Amateur-Photographien* under the direction of Carl Srna, Dr. F. Mallmann, and Carl Ulrich. It was juried by a panel of eleven painters and draughtsmen who selected for display six hundred photographs by one hundred seventy-six persons. The significance of the exhibition was that it was the first international collection aimed at assembling the very best work from around the world without the prizes and awards that

PLATE 10 » Heinrich Kuehn. *Venezianische Brücke,* 1903. Cat. 391

had come to be thought of as so undesirable at the Pall Mall Salon. The organizers did much homework before advertising the competition and making their final choices. They exercised considerable foresight in being the first to include the younger generation who would actually make a mark on the esthetic development of photography. Alfred Stieglitz, John E. Dumont and five other New Yorkers were selected, along with one of Philadelphia's most promising young photographers, JOHN G. BULLOCK. Bullock was among the first Americans besides Stieglitz to be noticed in a European exhibition. He would not only come to be represented in the Stieglitz collection, but also would be among the founding members of the Photo-Secession and one of the very few of Stieglitz's early associates (pre-1897) to be illustrated in *Camera Work*. (Biblio. 1247) Although the exhibition was not Stieglitz's first, its importance doubtlessly created a bond of friendship between them.

The prominent British names were naturally given strong representation at Vienna in 1891. In fact George Davison was the star with eighteen pictures, followed closely by H. P. Robinson with fourteen works, suggesting that the eleven jurors were able to expose the key esthetic currents and give them nearly equal weight. A few Germanic names that have not survived the test of time are to be expected among those with fifteen or more photographs: Moritz Hahr, A. and N. von Rothschild. Also among those given prominence was the Countess Loredana da Porto Bonin, typical of the numerous photographers who were then prominent but were not collected by Stieglitz and were ultimately omitted from the standard histories. Frank M. Sutcliffe, a seasoned professional, was exhibited beside the vast majority consisting of amateurs. He demoted himself to the rank of "amateur" and thus earned his due as an "artistic" worker.

HUGO HENNEBERG (Pl. 9) was included at Vienna in 1891 along with A. Horsley Hinton, Davison and Bullock, thus marking the first occasion at which several photographers who would one day be represented in the Stieglitz collection were shown together. Those who began showing before 1898 constitute the founding generation of pictorial photography.

The Vienna Salon was a catalyst vital to upgrading the standards that would be applied to local exhibitions. The following year, in 1892, The Linked Ring was formed. The founders decided to hold an exhibition in 1893 and to call it the "Photographic Salon," (Biblio. 1301, etc.) to distinguish it from the annual exhibition of the Photographic Society of Great Britain held in galleries on Pall Mall. (Biblio. 1305, etc.)

The Photographic Salon was established upon the principle that the only honor bestowed was acceptance into the exclusive circle of the exhibitors. There were no prizes or medals, no commercial sponsorship by manufacturers of photographic equipment; and it was not a forum for professionals to drum up business for their studios. Its goal was the propagation of fine art in photography. Because of its consistency, longevity, and international scope, the

AMERICAN CONTINGENT

EUROPEAN CONTINGENT

PLATE 11 » Heinrich Kuehn. *Ein Sommertag*, 1898. Cat. 386

Salon was perhaps the most successful and influential force before Stieglitz began his independent activities as an exhibition director in 1903.

PHILADELPHIA
EXHIBITION

In 1893, the year the London Salon made its debut, the Boston Camera Club, the Photographic Society of Philadelphia, and the Society of Amateur Photographers of New York held their Sixth Annual Joint Exhibition in Philadelphia (Biblio. 879) to which foreign photographers, who had occasionally been represented in earlier American exhibitions, were invited. Modestly international in scope, the Philadelphia exhibition was greatly expanded from previous years and included eighteen hundred pictures by two hundred exhibitors including several Englishmen and an *hors concours* selection by George Davison. Directed by Robert S. Redfield who a decade later, along with Bullock, would represent Philadelphia as a charter member of the Photo-Secession, the sixth joint exhibition was judged by a panel of painters and photographers.

Stieglitz was awarded a silver medal for his three photographs, *The Card Player, A Nook in Pallanza,* and *At The Brook,* none of which would later be ranked among the most memorable of his early photographs.

STIEGLITZ THE CRITIC

Stieglitz wrote a review of the show in which his expressed thoughts are as significant as the photographs he exhibited. His first codified thinking on the esthetics of photography, these thoughts were to influence Stieglitz both as a creative photographer and as a collector. (Biblio. 879) Having become editor of the *American Amateur Photographer* in 1893, Stieglitz's mind was already being shaped as a writer on photography. In 1892 he had begun to lay out a set of principles by which a picture could be judged: simplicity, originality, tone and atmosphere. Simplicity was for Stieglitz "the key to all Art." He

ESTHETIC PREMISES

was vague as to the meaning of originality and tone, but atmosphere was defined as "the medium through which we see all things . . . what atmosphere is to Nature tone is to a picture." (Biblio. 877) Such thinking emerged directly from Emerson, whose absence from the 1894 Philadelphia exhibition Stieglitz greatly lamented. "Call him by whatever name you may, criticize him from any point of view, and still the fact remains: his teachings formed the basis of what we saw in this exhibition." Stieglitz also regretted the omission of H. P. Robinson, who he claimed was "missing for the first time since the establishment of these exhibitions." In the absence of Emerson or Robinson, Stieglitz focused on George Davison as the model of the modern artistic photographer. In discussing *The Onion Field, Oyster Boats,* and *Wind Blown,* Stieglitz noted that the work "stands in a class by itself . . . here we are dealing with a genuine artist." Stieglitz was particularly impressed with Davison's soft focus, details of which Stieglitz apparently did not learn until a much later correspondence with Davison. Stieglitz viewed Davison as the antithesis of such older generation Americans of the albumen and collodion era as John Carbutt and William A. Rau who, then nearing the end of their careers, represented at Philadelphia the American documentary tradition in photography.

Eustace Calland, represented in the Stieglitz collection only by Cat. 107, was not singled out for praise but grouped among the many foreign exhibitors "all represented by first class examples of their work." Stieglitz was not a serious collector of photographs at this time and did not return to either Davison or Calland until years later.

Three years' residence back in New York was a very short time for experiences like the Philadelphia Salon to crack Stieglitz's snobbishness about Europe acquired during his eight student years there. He returned to this country convinced that the best work in the world was being done abroad and in an outspoken article made "A Plea for Art Photography in America." (Biblio. 877) He lamented, "When we go through an exhibition of American photographs, we are struck by the conventionality of the subjects chosen: we see the same types of country roads, of wood interiors; the everlasting waterfall, village scenes; we see the same unfortunate attempts to illustrate popular poetry." He called out for Americans to exercise the visual imagination that he saw lacking, fully confident that the talent was here to make that possible.

PIONEER PICTORIALISTS

Stieglitz was generally neutral about the American medalists he spoke of at Philadelphia in 1893, names that are mostly unfamiliar even to specialists today: Clarence S. Moore, Charles R. Pancoast, Mr. Clow, F. B. Warner—all Philadelphians; George Morgan and Francis Blake of Boston. But two of the medalists went on to exhibit internationally, Emma Justine Farnsworth of Albany and John E. Dumont of Rochester, who had shown at Vienna in 1891. Only Rudolph Eickemeyer (Pl. 26) would come to have an extensive international reputation, and would be nominated along with Stieglitz as the first two Americans elected to The Linked Ring in 1894. Stieglitz gave Eickemeyer but slight notice describing the two prize winners as "clever little pictures with good posing and harmonious composition on the style of Mr. Gill [of England]." (Biblio. 879, p. 32) This was faint praise, indeed, for a person who would enter the Stieglitz collection in 1903, the year after the founding of the Photo-Secession.

Typical of Stieglitz's adversary posture toward the Americans was his criticism of John G. Bullock (Pl. 22) and William B. Post (Cat. 420), both of whom would later enter his collection, each represented by a single print. Post had the distinction of being the first to receive Stieglitz's soon-to-be-legendary quip "photographically good, artistically poor" (Biblio. 879, p. 33) which he later rephrased in his memoirs as "technically perfect, pictorially rotten." (Biblio. 1057, p. 42) Post was, however, complimented for the distinction gained at home and abroad for "his hand camera work [which] is of high artistic merit," a style of candid photography with which Stieglitz greatly sympathized. As for Bullock, Stieglitz noted he "has shown to better advantage in previous exhibitions." (Biblio. 879, p. 33)

Stieglitz's most enthusiastic praise went to Emma Justine Farnsworth, a fact worth noting because of her absence from his collection, and the interna-

tional fame into which she was soon catapulted. Stieglitz was writing from his new rostrum as Editor of *American Amateur Photographer* at a time when his role as a tastemaker was just beginning. "Full of life and artistic quality, bold in conception and execution," wrote Stieglitz. He continued, "Miss Farnsworth is one of the strongest lady amateurs in the United States; taking all qualities into consideration probably the strongest." (*Ibid.*) Farnsworth posed children and women in landscape settings to realize a faintly arcadian air that anticipated F. Holland Day (Pls. 28–33). Farnsworth appealed to the German taste for historicizing and arcadian subjects, and by 1897 she was being featured in the lavish publications of *Der Deutschen Gesellschaft von Freunden der Photographie, Berlin*. (Biblio. 1272) The exact influence of Stieglitz's recommendation remains unrecorded but assuredly contributed to her rise. Farnsworth was the first photographer whom Stieglitz helped to go from obscurity to fame, and it remains a mystery why Stieglitz never owned an example of her work.

The season of 1892–1893 brought Stieglitz's own creative energies to their mature stride, and he began to work, as he later recollected, in "large format and full strength." His first widely exhibited photograph, *Fifth Avenue, Winter,* was made in a raging snowstorm on February 22, 1893. Although his friends scorned it at the time for being out of focus, Stieglitz recollected, "I knew [it] was a piece of work quite out of the ordinary." (Biblio. 892) Stieglitz thus earned his stripes as a judge not only of the works of others but of his own work as well. More significantly, it was perhaps the first moment when his role as an artist began to come into conflict with his role as an author, promoter, and in the near future, even a collector of photographs.

STIEGLITZ THE ARTIST

RETURN TO EUROPE: PRELUDE

HONEYMOON

In the summer of 1894, flushed with his success as a photographer, editor, intrepid student of pictures made by others, and a recently married man, Stieglitz honeymooned in Europe with his new wife, Emmeline. Emmeline (née Obermeyer) was the sister of his Berlin roommate, Joseph Obermeyer, with whom Stieglitz had gone into business partnership along with another Berlin friend, Louis Schubart, in The Photochrome Engraving Company (Biblio. 880) The firm was first named Heliochrome but soon changed to Photochrome and utilized Klíč's photogravure process (Biblio. 1156), or one of its generic derivatives. The business was not prosperous, but Emmy Stieglitz had a moderate income and he received an allowance from his father of three thousand dollars a year, which gave them sufficient funds for a Grand Tour honeymoon. Most of Stieglitz's own photographs at this time were printed in platinum and in the photogravure process, of which he had an intimate knowledge through his business.

PLATE 12 » Heinrich Kuehn. *Der Malschirm*, 1910. Cat. 402

STREET PHOTOGRAPHS

Stieglitz was a street photographer constantly prospecting for good motifs, the search for which he recollected as a colorful adventure:

From 1893 to 1895 I often walked the streets of New York downtown, near the East River, taking my hand camera with me. I wandered around the Tombs, the old Post Office, Five Points. I loathed the dirty streets, yet I was fascinated. I wanted to photograph everything I saw. Wherever I looked there was a picture that moved me—the derelicts, the second hand clothing shops, the rag pickers, the tattered and the torn. (Biblio. 1057, p. 39)

Stieglitz was restrained in his appreciation of other styles of photographs. Candid street scenes caught under difficult circumstances yet composed with natural elegance excited him most, and of the photographers working in Europe he shared with J. Craig Annan (Pls. 1–3) the closest kinship. Conversely, Stieglitz had a very difficult time appreciating posed and artificial photographs, of the kind being shown in Paris, perhaps because he had struggled to purge these from his own style.

HAMBURG EXHIBITION

The season before Alfred and Emmeline embarked on their honeymoon the European photographic pulse had begun to beat at an accelerating pace measured by the increasing numbers of publications and exhibitions. In Hamburg alone for the first annual International Exhibition of Amateur Photography modeled on that in Vienna in 1891, five hundred photographers exhibited six thousand prints that were seen by twenty thousand visitors. (Biblio. 1152, p. 151)

Stieglitz was well informed of the first half-year's events through his compulsive acquisition of books and journals that whetted his appetite for the June trip and sent him off with certain preconceived ideas. In January the first issue of the *Wiener Photographische Blätter* (Biblio. 1256) appeared, edited by F. Schiffner and published by the *Camera-Klub in Wien* with seventeen original photogravures by Hugo Henneberg, HANS WATZEK, F. Mallman, J. S. Bergheim, and Adolf Meyer. Each gravure was printed with an ink of a different tone, and some like Meyer's were mounted on colored paper, making this among the most carefully produced photography periodicals published anywhere in the world.

PARIS EXHIBITION

The most stunning event, outdoing anything yet seen in the world of photography, was the 1894 *Première Exposition d'Art Photographique* (Biblio. 1302) held by the *Photo-Club de Paris*. Stieglitz was able to vicariously experience the exhibit through the lavishly produced folio volume (Biblio. 1265) of photogravures issued in a limited edition of thirty copies printed on Imperial Japan paper and four hundred seventy copies on white Marais hand made paper. Each copy of the deluxe edition was imprinted with the recipient's name on the colophon (Stieglitz receiving copy number 169, doubtless a courtesy in return for his allowing them to print one of his gravures). The finely printed gravures, each with a subtly different tone of ink, gave

PLATE 13 » Heinrich Kuehn. *Teestilleben*, 1908/1909. Cat. 400

Stieglitz the opportunity to see reproductions of René Le Bègue (Pls. 17, 18), C. Puyo (Pls. 19, 20) and Robert Demachy (Pls. 14–16), whose work he perhaps saw here for the first time. By 1906 the trio had come to represent the mainstream of French artistic photography in the Stieglitz collection. Stieglitz could already have seen the work of Henneberg and Watzek represented by gravures in two issues of the *Wiener Photographische Blätter,* and he was doubtless familiar with Hinton, Annan, and Calland through coarse halftones in *The Amateur Photographer.* The one American represented here with a gravure besides himself was Eickemeyer.

PARIS JURY

The 1894 Paris exhibition was selected by a blue ribbon jury of ten headed by Armand Dayot, *Inspecteur des Beaux-Arts,* under the general direction of Maurice Bucquet, President, and P. Bourgeois, Secretary of the *Photo-Club.* The jury consisted of five painters, a sculptor, an art critic, and two photographers who collectively admitted 505 works by 154 persons. The selection process was not as highly selective as that of the Photographic Salon in London, nor did it reflect the direction Stieglitz would take in organizing American exhibitions.

Winner of the sweepstakes for most works exhibited at Paris was J. Craig Annan with fifteen photographs, followed closely by René Le Bègue, with fourteen pictures. Surprisingly high in the running was Emma Justine Farnsworth, whose nine images considerably outdistanced Eickemeyer's seven and Stieglitz's three. The exhibition reflected the tastes of a jury half of which consisted of painters and sculptors, while the selection in the deluxe catalog was made by the photographers. Whether the jury should be weighted in favor of painters and sculptors rather than photographers was a hotly debated issue. Stieglitz was initially in favor of painters as the juries of photographic salons, but in 1902 reversed himself (Biblio. 913) in a landmark turnabout that was the beginning of a streak of photographic purism which would profoundly affect his judgment of works by other photographers.

PHOTOGRAPHY AS FINE ART

Frederick Dillaye's introduction to the catalog entitled "L'Art Photographique?" (Biblio. 1068) attempted to demonstrate that photography was art, arguing that it involved many of the same principles of picture making as painting, a theme which continued to be of importance to Stieglitz.

SUMMER OF 1894: STIEGLITZ ON THE CONTINENT

MILAN EXHIBITION

Stieglitz's 1894 European itinerary began with Milan, where he saw the photographic section of the Milan International Exhibition, then traveled by carriage through Switzerland across the Tyrol to Austria, then through Germany, Holland, Belgium, France, and England. (Biblio. 883) Stieglitz made a point of seeing the Milan exhibition because he was personally represented by four of his own photographs, of which he noted that his " 'Washerwomen

PLATE 14 » Robert Demachy. *Dans les coulisses,* about 1897. Cat. 201

at Lake Como' looks especially good in the light in which it is hung." (Biblio. 884) The only other American in this exhibition was W. B. Post. Stieglitz disliked Post's frames and black mats but concluded, "His pictures are good and full of atmosphere." Despite the praise, he assessed Post as subordinate to three Europeans: Giuseppe Belhami of Milan, Countess Loredana da Porto Bonin, and Heinrich Kuehn (Pls. 10–13) of Innsbruck, listed in that order of preference. Belhami was thought to be the best of the three and was represented by twenty-four genre pictures, subjects that paralleled Stieglitz's own photographs of that time. Countess Loredana da Porto Bonin was one of the stars of the 1891 Vienna exhibition, represented there by sixteen manipulated enlargements, running second only to George Davison's eighteen frames. The quality of her enlargements, up to thirty by forty inches, stunned Stieglitz. (Biblio. 884)

Stieglitz was sparing in his praise of Heinrich Kuehn, whose work had not come to his attention before and which he considered subordinate to that of Countess Loredana and Belhami. Unlike Kuehn neither of the two entered Stieglitz's collection nor did they play any future role in his publications. Kuehn would assume a role of considerable importance in the collection, exhibitions at the Little Galleries of the Photo-Secession, (Biblio. 1381) and in *Camera Work,* a fact that Stieglitz did not anticipate at this time. This exposure to original Kuehn prints came three or four years before Stieglitz commenced collecting, exhibiting, or publishing them. Nor is it even likely that Stieglitz and Kuehn met when Stieglitz was in Austria in 1894; at this time Kuehn was not yet a member of the camera clubs in Vienna, which would have been their point of contact. The surviving correspondence (Biblio. 570) between the two dates from 1898, but it did not reflect a tone of friendship until 1904. In 1894 Kuehn was primarily a landscape photographer (Pl. 11), while Stieglitz's own predilection was toward genre and portrait photographs, a fact which may explain why Stieglitz had not taken prior notice of him.

CAMERA CLUBS

In Vienna Stieglitz apparently visited Hugo Henneberg (Pl. 9), who was on the board of directors of the *Camera-Klub* there, as well as on its picture committee. Stieglitz had corresponded with Henneberg since 1890, and it was doubtless through Henneberg's friendship that Stieglitz became a member of the *Camera-Klub,* where he is listed in their membership roster of October 1, 1894. (Biblio. 1071) Henneberg's *Im Hochsommer* and *November* were issued as delicately printed photogravures in the *Wiener Photographische Blätter* in 1894. Their moody interpretation of nature and thick atmosphere resembled the work of George Davison who, not so coincidentally, was then the only British member of the *Camera-Klub* in Vienna. Henneberg, likewise, was the only popular Austrian in London's Photographic Salon (The Linked Ring) for 1894.

Stieglitz apparently was not nearly as friendly with Hans Watzek at this time as he was with Henneberg, Stieglitz's main contact in Vienna who later

PLATE 15 » Robert Demachy. *Panel,* 1898. Cat. 200. Actual size.

"THE TRIFOLIUM"

arranged for Stieglitz to have prints by the Viennese Trifolium, as Henneberg, Watzek and Kuehn called themselves. (Biblio. 1073) Their association, sufficiently cohesive, often led them to draw a cloverleaf near their signatures on a print to symbolize the Trifolium. (Cats. 314, 315, 318, 530, etc.) Intrigued by the group identity, Stieglitz focused all his attention on the three when he arranged to present the Austrians in America. (Biblio. 1381) The trio thus came to stand for all that most Americans would know of Austrian Secessionist photography—an injustice, perhaps, to the many others who had helped make Vienna a center of art photography.

Despite his later depression over the other exhibitions he saw, Stieglitz was exhilarated by what he experienced that summer in Europe, if his frame of mind is to be judged by the photographs he made there. In 1899 he described *Mending Nets,* made at Katwyk, Holland, as his "favorite picture," feeling that it expressed "the life of a young Dutch woman, every stitch in the fishing net, the very rudiment of her existence. . . ." (Biblio. 899) In this and other pictures—*Gossip at Katwyk* and *Scurrying Home,* among others—Stieglitz was deeply involved in an anthropological naturalism (Biblio. 886) that owed a great deal to P. H. Emerson's approach as expressed in *Life and Landscape of the Norfolk Broads.* The artificiality of H. P. Robinson that had been Stieglitz's first style as represented in *The Dice Players* (Biblio. 1242, I, p. 112) now left Stieglitz unable to appreciate any but those photographers who shared his vision of the world. "Photographs I have seen here [in Paris] are rather mediocre, nothing worth speaking of," reported Stieglitz, adding, "It is rather odd that no better work is done here, as the city is simply 'chock' full of motives of all descriptions." (Biblio. 883) The style of French photographs, especially as represented in the deluxe book (Biblio. 1265) accompanying the first Salon, showed a strong preference for artifice and manipulated printing methods. Stieglitz was not at the time ready for most of the French stylizations, but he was sufficiently open-minded to carefully preserve the folio volume of gravure plates sent to him by the Paris salon committee. (*Ibid.*)

ANTWERP EXHIBITION

The photographers of Paris were not the only ones who left Stieglitz cold. When he arrived in Antwerp in late August of 1894, he was disappointed at what he saw and wrote home, "The photographic section of the Antwerp Exhibition does not amount to much." (Biblio. 885) Such frank assessments became Stieglitz's trademark and were to eventually cause both the love and the hatred that would be directed at him by his friends and detractors. More importantly, we see that Stieglitz at this point had as yet little appreciation of German (Pls. 9–13) and French (Pls. 14–21) work that would by 1897 play an important role in *Camera Notes,* of which he would become the founding editor.

SUMMER OF 1894: STIEGLITZ IN LONDON

FIRST ACQUISITIONS?

England was the last stop on the 1894 tour where Stieglitz and Emmeline arrived in late August, and it was here that Stieglitz may have acquired the first photographs in his collection. One of his main contacts there was George Davison, his counterpart at *The Amateur Photographer* and one-time supporter of Emersonian naturalism. Moreover, Davison was Stieglitz's supporter when his first public recognition came in *The Amateur Photographer* competitions of 1888 and 1889.

The question as to which was the first photograph to enter the Stieglitz collection cannot be answered with certainty. Once such obvious names as Emerson and Robinson who are not represented in the collection have been eliminated, the candidates can be narrowed down to a handful of possibilities. The reasons for which Stieglitz should have owned Emerson's work are similar to those for which he did collect George Davison (Cat. 155), who was highly praised by Emerson in his review of the 1889 London exhibition at Pall Mall. (Biblio. 1065, p. 139) It remains a mystery why Stieglitz failed to collect work by the eminent proponents of naturalism, the dominant style of his own pre-1898 photographs.

PHOTOGRAVURE

Another candidate for early acquisition by Stieglitz was J. Craig Annan, who, along with his father Thomas Annan, played a key role in the practice of commercial photogravure. Stieglitz himself entered this business and presented much of his work between 1890–1900 in the form of commercially printed photogravure. Moreover, he relied heavily on photogravure for the illustrations in *American Amateur Photographer* and later *Camera Notes* and *Camera Work*. Annan's father, a noted Glasgow photographer of the 1860s and 1870s, had acquired the British rights to Karl Klíč's process of photo-engraving. (Biblio.1240) In 1883 Annan traveled with his father to Vienna, where Klíč resided, for a demonstration of the process by which a photographic image was transferred to a copper plate that was etched with acid, steel faced, then printed on a press to yield a fine facsimile of a photograph in printer's ink, with a very high degree of uniformity among impressions. Thomas Annan and his son returned to Glasgow, where they built a reputation between 1883–1887 for making facsimiles of art works by the process, presumably its most lucrative application. About 1888 photogravure, or "gravure" as it came to be commonly called, became the favored medium for making facsimiles of photographs for a small but influential group of photographers that included Emerson, whose praise of gravure was widely published. By 1895 any book or periodical that expected to command the respect of the *cogniscenti* was illustrated with a few gravures (see Biblio. 1264–1267, 1269, 1270, 1277, etc.) in place of the formerly popular Woodburytypes, heliotypes, and even tipped-in silver prints.

As early as 1888, Stieglitz believed that genre photographs were intrinsi-

GENRE SUBJECTS VERSUS LANDSCAPE

cally more demanding than landscapes. He felt that "the difficulties of arranging a group of figures are as difficult, if not greater than for landscape; those who favour landscape work have rather an undue advantage over those who make a specialty of genre." (Biblio.937) Annan's first love was village life, and he shared with Stieglitz the love of prospecting for picturesque genre subjects in the small hamlets and towns of the Continent (Pl. 2). Annan had another side to his style that was distinctly Robinsonian, expressed in such works as *The Church or the World* (Pl. 1) and *A Venetian Requiem* (Cat. 16), both of which depend on overtly staged artifice for their impact. Stieglitz and Annan shared moments when the esthetics of Robinson assumed equal importance to Emersonian naturalism. In contrast to Davison's single print in the collection, Stieglitz owned approximately sixty by Annan (including those now at The Art Institute, Chicago)—a number surpassed only by Steichen.

THE SECOND LINKED RING EXHIBITION

GENERAL COMMITTEE

Emmeline and Alfred Stieglitz returned to New York from London in September 15, 1894 and missed the October opening of the second annual Photographic Salon. (Biblio. 1301) Organized by The Linked Ring, the Salon was held annually at the Dudley Gallery on London's Piccadilly. At the time Stieglitz was not a member of either The Linked Ring or its competitor, the Royal Photographic Society, which also held an annual salon on London's Pall Mall. He had not been selected for the first Photographic Salon the year before and felt a great sense of accomplishment when *A Wet Day in Paris* was included in the 1894 Salon. The exhibition was selected by a General Committee of The Linked Ring that included J. Craig Annan, Eustace Calland, George Davison, and Alfred Horsley Hinton, all of whom would one day be represented in the Stieglitz collection. Also on this committee but not in the collection were Valentine Blanchard, who had been an active wet-collodion photographer in the 1870s; Frank M. Sutcliffe, one of the most widely exhibited professionals who self-consciously aligned himself with the amateurs; and H. P. Robinson, who had regained his laureate stature since the abdication in 1899 of Peter Henry Emerson from the world of photography. The Committee selected for exhibition three hundred nineteen photographs by ninety-nine persons.

The Photographic Salon, on view from October 1 to November 4, was the most important exhibition Stieglitz could have seen by extending his stay a few extra days. The fact that Stieglitz did not see this second London Salon where he was himself represented suggests that exhibitions were not yet as important to him as they would one day be. Photographs by the core of the European segment of his incipient collection came together here for the first time. Thirteen out of the twenty Europeans his collection represented were exhibited in the London Salon. For the first time came an indication of the initial reasons for which Stieglitz collected photographs by others.

PLATE 16 » Robert Demachy. *The Crowd*, 1910. Cat. 211

Stieglitz did not have a deep esthetic kinship with either Eustace Calland or A. Horsley Hinton, but both are in his collection represented by a single token photograph. Hinton's print (Pl. 4) represents a variant on the theme of moody landscape established in Day's *Decline,* reproduced in *Camera Notes* (July 1899), a major work absent from Stieglitz's collection. The fact that Hinton and Calland were on the General Committee of London's Photographic Salon, and that they were powerful figures in the small world of photography in London, suggests that Stieglitz was occasionally motivated in his collecting for reasons other than the purely artistic; put another way, his artistic judgment was sometimes bent to fit photo-world politics. Stieglitz's main goals at this particular moment were to be accepted in London's Photographic Salon, become a member of The Linked Ring, and sit on the General Committee that selected the exhibition. In 1893 Davison had written a polite note informing Stieglitz that his work was not quite up to expectations and therefore would not be included in the first London Salon, but by 1894 he was accepted. He and Eickemeyer were both proposed for membership in The Linked Ring, Davison wrote Stieglitz on October 30, 1894, just after Stieglitz and Emmeline had departed London for New York. The 1894 trip gained for Stieglitz the support of an important group of his London colleagues, especially Calland, Davison, and Hinton. Also exhibited at London were Cadby, de Meyer, and Post, all of whom were exhibited together for the first time in the Photographic Salon of 1894. Ironically, de Meyer did not come to be represented in the Stieglitz collection until 1905 or 1906, by which time the others had the best part of their careers behind them.

If Stieglitz was tempted to play art world politics, he doubtless also expressed convictions of taste that would prove to last far into the future. J. Craig Annan, represented by the second largest number of images in Stieglitz's collection, was also the star of London's second Photographic Salon, exhibiting fourteen photographs, four more than Davison. (Biblio. 1301) Most of the other personalities who were represented both in the Salon and the Stieglitz collection exhibited three or four pictures, with the exception of Hinton, who had six. Le Bègue, Evans, and Henneberg each had four: Watzek and Eickemeyer three each; Cadby, Calland, and de Meyer two each; Stieglitz and his New York friend, W. B. Post, each had but one photograph, indicating their relatively low status as compared to the Europeans.

Only Annan's *The White Friars* (Cat. 17) and *A Franciscan* (Cat. 22) can be specifically identified to have hung in London's 1894 Photographic Salon and to have also entered Stieglitz's collection. Works by Davison (Cat. 155) and Henneberg (Cats. 312–318) generally fit several of the titles listed but resist specific identification. The titles of works by Cadby, Calland, de Meyer, Post, and Watzek bear no relation to the titles of those exhibited, suggesting that Stieglitz was not actively collecting on the 1894 European trip.

Plate 17 » René Le Bègue. [*Étude en orange*], 1903. Cat. 415

PRICES

Most of the photographs in the London Salon were for sale at prices that ranged from a few shillings to a few pounds. The most expensive item was George Davison's *The Salting,* at six guineas, followed by his *Wivenhoe,* for five guineas. Annan's platinum prints were priced at three guineas. His gravures, including *The White Friars* and *A Franciscan,* were not even priced but doubtless could not have cost much more than the work of FREDERICK H. EVANS, who exhibited here for the first time. Evans's *Woodland Study, New Forest* (related to Pl. 6) sold for ten shillings and *Portrait of Aubrey Beardsley* sold for seven shillings. René Le Bègue asked ten to fifteen shillings for his photographs, with the exception of *Le Boquet* at one pound. Stieglitz at this time had a relatively high opinion of his own work but in asking two pounds for *A Wet Day in Paris* placed himself below Davison, Hinton, and Annan, yet above the great majority of other exhibitors. Many, including Henneberg, Watzek, and Eickemeyer, set no prices on their work, a modest reflection of the reality that few works actually sold, for in 1894 there were very few collectors of photographs, a situation that began to change by 1897 or 1898.

LINKED RING LECTURES

London's 1894 Photographic Salon was also an important forum for airing some esthetic issues that had been brewing over the previous half-decade in a series of lectures sponsored by The Linked Ring at the Dudley Gallery while the Salon was hung. H. P. Robinson, primogenitor of pictorial photography in its theoretical aspects, spoke on "Our Aims and Ends," (Biblio. 1301) laying out an historical framework for what he called "modern" photography and establishing 1880 as the year in which all the esthetic and technical elements were in place for artistic photography. Another lecture by A. Horsley Hinton questioned the legitimacy of hand-work to negatives or prints, manipulations he called "photo-faking." There was evident hostility from the staunch Emersonian segment of The Linked Ring against pure practices, while another less powerful segment supported Robinsonian manipulations. Alfred Maskell, the most informed spokesman of the manipulative segment, gave a short history of the non-silver printing process, focusing on the gum-bichromate method of Rouillé-Ladevèze and the sawdust process utilizing Artigue *Papier Velours* that had yet to be introduced in the United States. (Biblio. 254, Ch. V) Stieglitz took it upon himself to introduce the manipulative processes to America and he appears to have come away from London with a perspective he did not have during his first month on the Continent. By 1898 Stieglitz was the main American exponent of manipulated printing, and his own 1899 retrospective at The Camera Club (which he would be responsible for founding shortly after this trip) consisted in large part of manipulated prints.

ROYAL PHOTOGRAPHIC
SOCIETY EXHIBITION

On view simultaneously with the 1894 Photographic Salon of The Linked Ring held annually at the Dudley Gallery, was the thirty-ninth annual show organized by the Royal Photographic Society at Pall Mall, where, in 1889, Davison had been the most popular figure. The star of the 1894 Pall Mall Salon was Karl Gregor, whose rough surface enlargements of backlighted subjects

such as *Shipping on the Thames* caused his work to be the most popular. Stieglitz was represented by his *Winter—Fifth Avenue,* and Eickemeyer by *A Grey Day in the Meadow,* that Hinton described as "one of the best and most remarkable things in the room." (Biblio. 469) Stieglitz also noticed the remarkable changes from technical orientation to a concern for beautiful images. Eleven medals were given, of which nine were for "artistic" (his word) photography, and the remaining two for technical work.

The polarization of The Linked Ring's Photographic Salons and the Royal Photographic Society's Annual Exhibition began to dissolve, and many of the key figures were represented in both exhibitions. Hinton concluded that a new time had finally arrived for the Royal Photographic Society: "If this is to be as indicating the general tendency of photography today, it means an enormously greater interest and sympathy for the artistic than the scientific side." (*Ibid.*) Except for Davison and Eickemeyer, none from the Royal Photographic Society exhibition came to be included in the Stieglitz collection. Despite the narrowing gap between the two societies, Stieglitz was deeply committed to the Photographic Salon of The Linked Ring, and his collection was to be solidly influenced by the Salon's taste.

MODERN MOVEMENT IN
THE UNITED STATES

CHAPTER TWO

AMERICA CATCHES UP

THE EXHIBITIONS IN EUROPE AND AMERICA, 1894–1896

NEW YORK EXHIBITION

Upon his return to New York, Stieglitz pursued his role as critic and editor with increased vigor and decisiveness. Stieglitz's anglophilia is evident in his writing on the Seventh Annual Joint Exhibition held in New York. He characterized H. P. Robinson, whose reputation had been rehabilitated by The Linked Ring, as "the old veteran [whose] new work is a decided improvement over the old." (Biblio. 882) In his 1893 review of the Sixth Annual Joint Exhibition, Stieglitz had focused his attention on the legacy of Emerson. This modest reinstatement of Robinson reveals how Stieglitz was influenced by the 1894 European trip, an impact that would not become evident in his collecting activities until 1896 or 1897 when he acquired the first work of Demachy. Stieglitz's appreciation of Annan reaches a crescendo in his description of *Labor-Evening:* "The picture breathes atmosphere, it is a piece of nature itself; we can give no higher praise." (*Ibid.*) Cadby and de Meyer received qualified praise; he felt both were commendable but their work suffered from bad matting and framing. Stieglitz was evidently becoming greatly concerned with the appearance of pictures on the walls, in addition to their look on the printed page with which he had hitherto been mainly concerned. Mounting, framing, and hanging had begun to interest the organizers of the London Salon because bad framing and hanging was one of the biggest complaints of The Linked Ring against the salons of the Photographic Society of Great Britain (whose name had just been changed to the Royal Photographic Society). Evidently Stieglitz came to share this concern expressed in London.

AMERICANS IMPROVE

The most surprising change of heart expressed by Stieglitz concerned the role of Americans in photography. In 1892 he had been vociferous about America's artistic inferiority (Biblio. 874), but in his 1894 review of the Seventh Annual Joint Exhibition in New York, he stated, "Americans show decided improvement." (Biblio. 882) The work of James Breese was highly praised, but

next in order of praise came Eickemeyer, whom he described as having "feeling and brainwork." His *Sweet Home* was called "unquestionably the finest landscape in the exhibition." Eickemeyer was also one of the stars of the 1894 show, being represented by twenty-one frames compared to the five or six by others.

Post and Bullock were the only two others in the Seventh Joint exhibition who would be represented in the Stieglitz collection. Post was described as one of "the very few progressive workers we have here in the States," but whose work in general was "not up to his artistic standard." Post's reputation stagnated perhaps because of his ill health, and in 1895 he was not selected for London's Photographic Salon.

STIEGLITZ CURATOR

About this time Stieglitz began to expand his curatorial interests, for not only had Alfred Maskell invited him and Eickemeyer to select the American participants in the 1895 London Salon, but he began to express concern for the care and handling of his own work. He accused the Philadelphia Society of mishandling five of his prints sent for the 1893 Joint Exhibition and began to assume the role of caretaker for the works of others, as issues of conservation and handling became a regular theme with increasingly valuable photographs.

PARIS AND LONDON EXHIBITIONS

The *Photo-Club de Paris* held its second salon in 1895 (Biblio. 1306) and issued a deluxe companion to the catalog (Biblio. 1266), in which eight members of the collection plus Stieglitz are represented in finely printed gravures—Annan, Cadby, Demachy, Eickemeyer, Henneberg, Le Bègue, Puyo, and Watzek. It was, however, the Photographic Salon in London that continued to capture Stieglitz's personal interest. In 1895 the General Committee had been expanded to include Stieglitz and six new names from the collection—Cadby, Demachy, Eickemeyer, Henneberg, and Watzek. (Biblio. 1301) Along with incumbents Annan, Calland, Davison, and Hinton, who were also represented in the Stieglitz collection, these new members comprised three-quarters of the General Committee. In his copy of the exhibition catalog, Stieglitz exuberantly wrote, "7 pictures *out of* 7 accepted," referring to his seven photographs on display in contrast to one in 1894. (Biblio. 1301) With this declaration, Stieglitz knew he had been fully accepted by The Linked Ring, which had been his aspiration since 1894.

Each year brought changes that heightened public consciousness about photographs. In the brief foreword to the 1895 London Salon catalog, an unidentified member of The Linked Ring wrote:

It is too early to foresee clearly what the effect will be of the *new photography,* with its fresh aims and modern methods. But with a craft of almost unlimited adaptability, used by those who have that particular combination of taste and imagination which we call artistic feeling, the influence can scarcely be less, and will probably be greater, than that of the *older system which it now supplants.* (Biblio. 1304) [my italics]

A spirit of experiment, progress, and rapidly evolving events characterized what was described as "the new photography." Hinton had noted elsewhere that pictures that "would a few years ago have been accounted as triumphs" are now taken for granted.

BRUSSELS EXHIBITION

The close of the Photographic Salon was followed by the debut of the Brussels Salon. (Biblio. 1303) A print by Stieglitz was hung along with thirteen photographers represented in his collection—Annan, Cadby, Calland, Davison, Demachy, Eickemeyer, Henneberg, Hinton, Le Bègue, de Meyer—as well as Heinrich Kuehn, who had not yet shown in London. Also included was Julia Margaret Cameron, whose work was shown as a historical digression for the first time in the context of the salons of artistic photography. Her presence was doubtless due to her son, H. H. H. Cameron, also a photographer in The Linked Ring. This was not the first posthumous exhibition of her work. The Camera Gallery in London had already exhibited it in April of 1889, before she had become a heroine to the modern movement. Emerson reviewed the exhibition for the *American Amateur Photographer,* in which he invoked a comparison between Cameron and Claude Monet. (Biblio. 1065, p. 123) Stieglitz, however, did not publicly declare the merits of her work until 1913, when he introduced her to the American public through the gravure photographs in *Camera Work*. (No. 41, plates 1–40)

It was evident to those involved with modern photography that a similar golden age of creative output and ambitious exhibitions that flourished in Europe between 1890 and 1895 was now gestating in America and elsewhere. The seasoned first generation of pictorialists were gratified, to quote Hinton, that "quite a number of younger and newer workers" were coming along to take their places in the galleries beside the pioneers. In order to insure that the most talented new men and women were given opportunity to exhibit and publish an informal network was established by The Linked Ring to supply information about promising newcomers. Accordingly, Davison invited Stieglitz to act as agent for The Linked Ring in America. The Linked Ring, he explained, had "a sort of agent-friend in most of the countries who looks after the talent for us." (Biblio. 1479) Stieglitz would soon learn that the same role had been offered to Eickemeyer who wrote to Stieglitz that "as members of The Linked Ring it is our duty to put together a representative lot for the coming (1896) Salon." (Biblio. 1511)

AMERICANS ATTRACT
EUROPEANS

At this point Davison was doing very well on his own by discovering before Stieglitz F. Holland Day, who had promised to send work for the 1896 London Salon. Day's name was apparently unknown to Stieglitz at this time and familiar to but a few in Boston. Day was typical of the *Wunderkinder* of the younger generation, so talented that their quality was recognized immediately by the seasoned exhibitors. Before commencing to photograph around 1887, Day had been a bibliophile and had spent the summer of 1885 in Europe with Louise I. Guiney searching for literary artifacts of the poet Keats. In 1895

PLATE 18 » René Le Bègue. *Académie*, 1902. Cat. 413

Day became the third American to be elected to The Linked Ring and the same year was included in the London Salon. He was spared the slow process of earning a reputation by diligently sending prints year after year as most of the first generation had done. In his rapid success, Day was different from Stieglitz and Eickemeyer, who had slowly attained reputations. He immediately eclipsed the second-tier participants such as Post, Bullock, Farnsworth, and a handful of other Americans who had participated early in international exhibitions but were to fall into artistic lethargy not long after the turn of the century.

The new generation of photographers typified by Day was not unanimously accepted. The old guard resisted acknowledging the special talents that were emerging and some even thought the golden age was about to fade. "Where are the [replacements for] Post, Clarkson, Farnsworth, etc.; is artistic photography in its decadence here?" wrote Eickemeyer to Stieglitz, suggesting that the first heroes were not about to be replaced. (Biblio. 1512) Stieglitz would not have agreed with Eickemeyer, and the first American prints Stieglitz collected, those by Day, are a testimony to his belief that a talented younger generation was on its way.

There were at least two newcomers of great talent besides F. Holland Day whose careers had just begun, waiting to be discovered by Stieglitz and Eickemeyer: Gertrude Käsebier (Pls. 38–43) in New York, and Clarence H. White (Pls. 44–53) in Newark, Ohio. White had only begun photographing in 1894 but by 1896 had succeeded in producing work that displayed to his first critic, Ema Spencer, "a severity of definition and a brilliancy of burnish considered inseparable from photographic art." (Biblio. 1905) Stieglitz had no way of seeing White's photographs as yet, but it would have been a great coup to have made that discovery.

Gertrude Käsebier had been awarded a fifty-dollar prize by the *Quarterly Illustrator* photographic competition of 1892. But she was not yet affiliated with either of New York's photographic societies that were about to merge in 1896, so she too escaped Stieglitz's notice when he was scouting for new talent for London. Both Käsebier and White were to remain known only to their close friends for a short while longer.

Stieglitz did not take his job as an American eye for The Linked Ring seriously. He was busy making his own images, spending the rest of his time writing and editing. Stieglitz was a good writer although he had neither the mind trained in art criticism nor the mastery of critical vocabulary and philosophical issues. He did, however, have an enormous capacity for using words to express his own feelings, a talent that later got him into trouble because his ideas often flowed counter-current. Up to this time Stieglitz had not published any writing that reflected negatively on a person or on a group of people to generate hostility. (Biblio. 1069, pp. 32–35)

Stieglitz's first public skirmish was to come in 1895 when he published "A Plea for a Photographic Art Exhibition." (Biblio. 887) He proposed to abolish

PLATE 19 » C. Puyo. *The White Horse*, 1906. Cat. 426

the annual joint exhibitions and establish an *"art exhibition"* based on the European examples of the London, Paris, Brussels, and Vienna salons. Stieglitz cited recent American exhibitions, particularly the Washington Salon (Biblio. 1311), sponsored by the Capital Bicycle Club, as examples of the mediocre standard for exhibitions. "An exhibition like [Washington] is very apt to disgust the serious workers," he exclaimed. (Biblio. 891) The reaction in Boston was to cancel the Joint Exhibition that was to be held there in 1895. Stieglitz had to bear at least part of the responsibility for destroying the only existing framework for exhibiting photographs in America that was comparable with the elaborately evolved exhibitions in Europe.

THE CAMERA CLUB FORMED

The most immediate repercussion for Stieglitz was his resignation from the editorial board of the *American Amateur Photographer* in January of 1896, a position he had held since 1893. In his characteristic vacillation between acts of social destructiveness (many unintentional) and of inspired artistic creativity, Stieglitz moved on from his resignation to work on the amalgamation of the Society of Amateur Photographers and the New York Camera Club. The merger was implemented in May of 1896, thereby creating *The* Camera Club. Stieglitz later recollected that he had helped bring "the dying and the dead into a newly consolidated organization so that it might become a living entity." (Biblio. 1057, p. 43) When it came time to choose officers, Stieglitz was invited to become president but declined in favor of William D. Murphy. According to Stieglitz, Murphy's qualifications were his wealth, even-handedness, and after-dinner speaking talent which Stieglitz self-effacingly denied having. In 1897 Stieglitz became Vice-President and Chairman of its Publications Committee, with the mandate to expand the newsletter to a national publication, *Camera Notes,* which led to the famous *Camera Work*. He thus found himself back to where he had been at the *American Amateur Photographer*.

AMERICAN LINKED RING

Meanwhile, Stieglitz felt some personal responsibility for the absence of an invitational exhibition and lamented, "a whole year has passed without a single first-class photographic exhibition having been held in this country." (Biblio. 899) He proposed that "New York is the natural centre [sic] for American art" and where the exhibit should be held. He laid down six principles for a good exhibition, similar to those Emerson had expressed in 1889 (Biblio. 1063): the exhibition should be purely pictorial admitting only work of artistic value; it must be international in character; there must be an initial fund of one thousand dollars to cover the organizational expenses; there must be a committee to oversee framing; hanging the exhibition must be treated carefully; and it should be run as an art exhibition not as a cheap fair. The idea was unabashedly modeled on the London Salon, which had already fought battles to purge commercialism and vanity from the annual exhibitions. Many interpreted Stieglitz's statement as a wish to implement an American Linked Ring, and Hinton offered to do whatever he could in his capacity as a leader of the European counterpart. (Biblio. 1523) Stieglitz's growing interest in exhibitions during

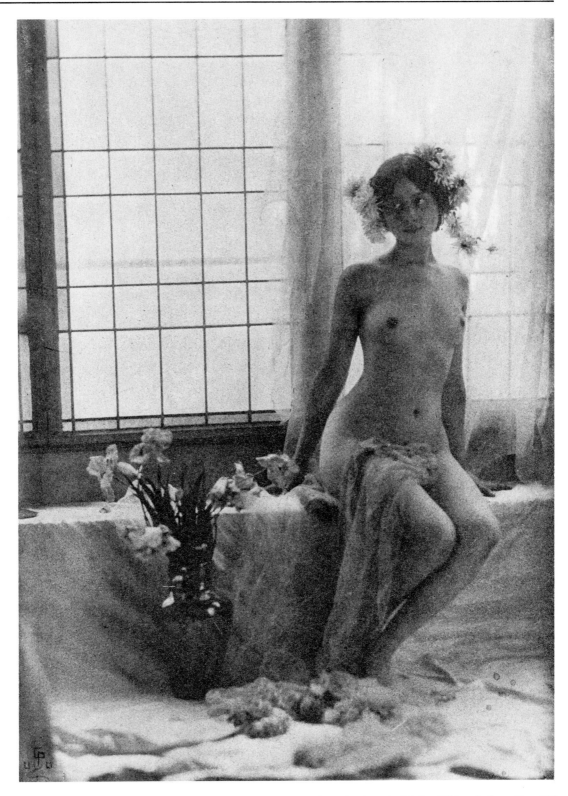

PLATE 20 » C. Puyo. *Nude—Against the Light,* 1906 or before. Cat. 429

this period created an increased awareness of original prints, which helped sow the seeds of his role as a collector.

The exhibition activities in London and the other European centers, particularly Vienna, continued to be emulated in the United States. In 1898, The Camera Club initiated a program of one-man exhibitions, modeled on the Vienna *Camera-Klub.* Clarence B. Moore of Philadelphia, with his studies of Negro life, was the first to be given a one-man exhibit at The Camera Club. Next came Emma Justine Farnsworth of Albany, who had captured the fancy of the Germans at the Berlin Salon in 1898. (Biblio 1272) Stieglitz was supportive of Farnsworth but did not collect her work. Henry Troth of Philadelphia, the third exhibitor, showed his photographs which had also been hung at the London Salon in 1896.

Stieglitz evidently had little influence on the first season's exhibition calendar at The Camera Club although he was a strong supporter of Day, who was unanimously acclaimed that year. An anonymous American, in his article in London's *Photograms of the Year 1898,* noted that "the most important display of the year [in New York] was that by F. Holland Day, whose work shows imagination and occasional weird mysticism that are entirely his own." The writer further noted that Day's three hundred prints were "mounted, framed, arranged, and hung by himself on walls draped with his own hands," concluding that Day is "one of the most masterly figure-photographers the world has yet known." (Biblio. 1077, p. 46)

AMERICAN INSTITUTE
EXHIBITION

In an adventuresome gesture to fill the lack of an invitational group show, The American Institute, a society of arts and letters, unexpectedly included a section of photographs in its annual art exhibition held at the galleries of the National Academy of Design in New York. (Biblio. 1319) Although Stieglitz was not on the organizing committee of the American Institute show, he was well represented in the exhibition with twelve photographs. The six-member jury included A. T. Bricher, the painter; the printer Edward Bierstadt; and Charles I. Berg, a photographer who had exhibited in Europe and whom Stieglitz had once characterized as the most advanced photographer in New York. ZAIDA BEN-YUSUF (Fig. 3) was responsible for the hanging and the decorations, thus emerging as an important figure after her London exhibit of the year before. Ben-Yusuf was represented by the only finely printed gravure in the catalog and by ten works in the show. Joseph T. Keiley (Pls. 33–36), who would soon become Stieglitz's assistant at *Camera Notes,* made his debut with twelve photographs. W. B. Post showed four pictures and F. Holland Day three.

The American Institute show was not as representative of the group collected by Stieglitz as was the Photographic Salon in London, but it provides important evidence that Stieglitz was not alone in promoting exhibitions in the United States. The American Institute show was an important step towards a salon based on artistic merit modeled on the European examples. It also coincided with a growing international interest in collecting photographs.

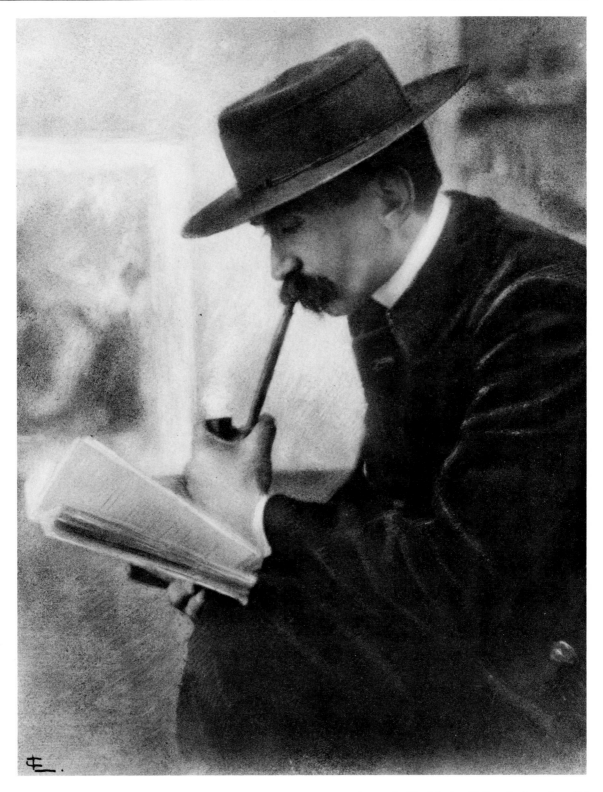

PLATE 21 » Céline Laguarde. *Un Bibliothécaire,* 1909 or before. Cat. 410

International exhibitions (Biblio. 1298–1321) generated interest in acquisition and helped raise collectors' consciousness of the value of photographs. The American Institute show of 1898 (Biblio. 1319) listed numerous prices and offered a yardstick for progress on this front. Stieglitz's high estimation of his work was reflected in his prices that far outdistanced others in the show. *Winter—Fifth Avenue* was his dearest print, priced at seventy-five dollars, followed by *Scurrying Home* (Gold Medal) and *Mending Nets* at sixty dollars, and *A Wet Day on the Boulevard* at fifty dollars. By contrast, Ben-Yusuf asked from two-fifty to five dollars; Troth, one dollar twenty-five; even a relative newcomer like F. Holland Day set his price at twenty-five dollars per print. The newly emerging amateurs were divided between those who knew the value of their work and those who lacked this self-awareness. Interestingly, the record shows that those who had a high opinion of their work, as expressed in the asking price, often went on to have long careers, but those who set low prices often remained in obscurity. There were such exceptions as Elias Goldensky, who set a price of fifty dollars per print, the nearest competition price to Stieglitz, whose name goes unrecorded in modern histories. He nevertheless went on to have a long and fruitful career as a professional portrait photographer and stylist of artful nudes.

Sadakichi Hartmann, in writing of Stieglitz, observed, "He is so situated in life as to allow himself a constant devotion to his art, which is fortunate not so much because it lifts him beyond the dangers of mercenariness (since artistic photography is still in that idyllic state where a market value of its productions is an unheard of thing)." (Biblio. 953) Since few photographs actually sold at these prices, an outside income was essential to one's survival. One of Stieglitz's most determined convictions was to see the day when photographs would fetch the same prices as fine prints and drawings so that photographers could live by their work. As photographs began to be actively collected this dream would shortly become a reality.

Painters and printmakers were traditionally collectors of work by their contemporaries, and it was natural that photographers would have the same inclination. The first methodical collecting of modern photographs began in England where Harold Holcroft, Stieglitz's counterpart, began buying photographs at London's 1894 Photographic Salon. By 1910 he had formed a collection of some two hundred pictures by dozens of names, each represented by one or two images. (Biblio. 1131, pp. 22–26) Unlike the Stieglitz collection, the great majority of these names failed to enter the history books despite the recognition they received then. In 1894 the Stieglitz collection had just begun to take shape but by 1910 numbered over five hundred photographs compared to Holcroft's two hundred, which Stieglitz surpassed not only in

BRITISH COLLECTIONS

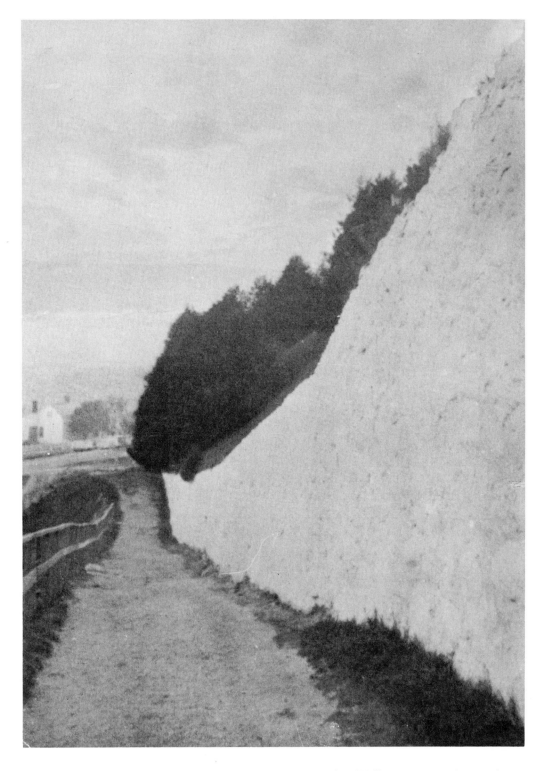

PLATE 22 » John G. Bullock. *The White Wall*, 1901. Cat. 105. Actual size.

quantity but also in quality. The two collections were formed on different premises. Stieglitz concentrated on one dozen photographers held in depth: Annan, Brigman, Coburn, Day, Demachy, Eugene, Evans, Käsebier, Keiley, Kuehn, White, and Steichen.

PRINCIPLES OF
COLLECTING

Holcroft listed three rules of thumb: each accession should "embody some advance or new departure"; the photographer should be "prominent for consistently good work"; and the pictures should be in "the more permanent printing processes." (*Ibid.,* p. 23) Stieglitz would certainly not have disagreed with these guidelines, and it is no surprise that Holcroft acquired work by thirteen photographers who were also collected by Stieglitz (Hill & Adamson, Cameron, Steichen, Hinton, Eickemeyer, Kuehn, Käsebier, Puyo, White, Cochrane, Coburn, Read, and Demachy).

Among the other early European photographer-collectors were Frederick H. Evans, ALVIN LANGDON COBURN, and Robert Demachy. Evans eventually donated to the Royal Photographic Society his collection of photographs by Cadby, Coburn, Day, and Steichen. Coburn likewise donated photographs by Annan, Brigman, Evans, Seeley, and Stieglitz, while Demachy donated work by Day and Steichen. These gifts to the Society were made between 1925 and 1930, a period coinciding with Stieglitz's first gifts to The Metropolitan Museum of Art.

DAY COLLECTION

Following these European examples, the collecting of photographs in the United States became active in 1898. F. Holland Day, whose collection was just being formed, wrote Stieglitz that he had formed a small collection of works by the best photographers he had seen. Among his fifty or sixty choice prints were "two by Stieglitz, six or eight by Käsebier and four or five by Joseph T. Keiley." Day also asked if they could exchange half a dozen pieces since he had "little work by other cameras." (Biblio. 1491)

POST COLLECTION

The most advanced American collector of the period was W. B. Post (Biblio. 619), whose reputed sixty prints exceeded Stieglitz's estimated two dozen. Post, who had been among the earliest Americans to exhibit in the foreign salons including the famous 1891 Vienna exhibition (Biblio. 1300), specialized in winter landscapes. His ambition was to have his be the first work in this genre reproduced in *Camera Notes*. Despite this narrow scope of his own imagemaking, Post had a very informed taste in the work of others. He informed Stieglitz that he had sixty-two framed photographs on his bedroom walls, twenty-five of which he called "masterpieces" and "the nucleus of a fine collection" that included two by Käsebier, one Demachy, and one by Mathilde Weil. (Biblio. 1586)

Late in September, Post wrote Stieglitz from his home in Fryeburg, Maine, asking him specifically to buy Day's work, which he knew from reproductions. His first choices were Day's *Ebony and Ivory* and *An Ethiopian Chief* (Pl. 29), which are also in the Stieglitz collection. (Cat. 178, 181) Two weeks later Post again wrote Stieglitz authorizing him to spend one hundred fifty to two hundred

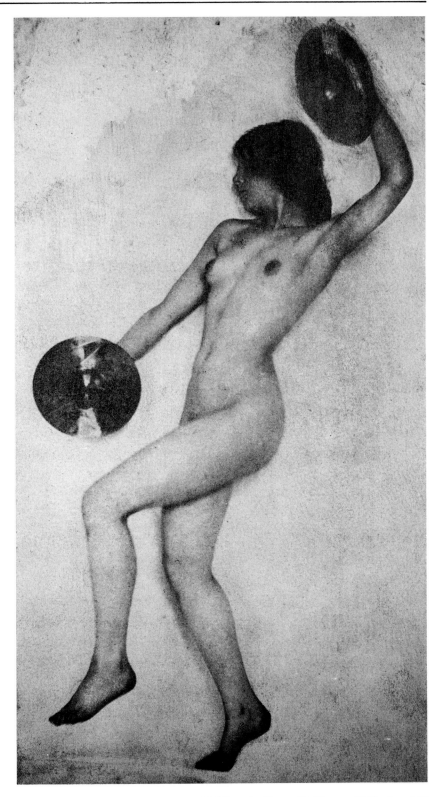

Plate 23 » William B. Dyer. *L'Allegro*, 1902. Cat. 224

dollars to buy examples of the most prominent artists exhibited at the Philadelphia Photographic Salon (Biblio. 1321) representing the best of Viennese and French schools and an Eickemeyer. Stieglitz made a selection, for which there is no list but which apparently satisfied Post, for he wrote Stieglitz, "I admire the collection [sent by Stieglitz] and am most partial to Mary Devens's little Corot landscape." (Biblio. 1586) Post also bought from Stieglitz at this time prints of *Katwyk Dunes* and *Mending Nets* (as Post referred to them) for thirty dollars each.

The price of thirty dollars paid for Stieglitz's prints doubtless reflected what Stieglitz asked of his friends for his photographs at this time. Convinced that the price paid for a work was important as a matter of principle, he noted in 1899 that "it is not an unusual thing to hear of a single photograph having been sold to some collector for upward of one hundred dollars." (Biblio. 903) Later that year, Stieglitz wrote of Käsebier's *The Manger* that it was "generally considered the gem of last year's (1899) Philadelphia Salon [and] was recently bought by a New York lady for one hundred dollars." He added emphatically, "This is the second time within a year that one hundred dollars has been paid for a pictorial photograph in this city." (Biblio. 904) Stieglitz was very pleased that the photograph was not purchased by a photographer but by a person simply interested in pictures regardless of their means of production. The prices fetched by pictures appear to have been a general topic of conversation in 1898, and Hartmann noted that "Mr. Stieglitz has received for a single print as much as eighty dollars." (Biblio. 75)

The closest Stieglitz came to a statement of principle was to say, "In organizing my collection I had set myself the task of including only pictures of outstanding artistic merit." (Biblio. 924) In his writings on the importance of the collector's selective eye, Stieglitz was greatly influenced by traditional principles of connoisseurship based on the collector's capability to recognize and appreciate minute differences between nearly identical examples. "Collectors [of photographs] already display so much understanding in the way they make their selection, that they are willing to pay a price for a single print which, judged superficially, seems to exceed all measure," wrote Stieglitz explaining how subtle physical differences can create great differences in value. He also pointed out that, as with paintings, drawings, etchings, and engravings, photographs required knowledge and understanding for serious appreciation. He added, "The untrained eye and unschooled powers of perception are unable to recognize delicate nuances [in photographs]." (*Ibid.*) From these thoughts Stieglitz immediately moved to the topic of how connoisseurship of photographs helped in establishing their market value. "One hundred ten dollars . . . is probably the highest ever paid for a picture produced by photography. . . . Today it is not unusual to pay from fifty to one hundred dollars for an individual print of an art photograph—at least not in the United States, a country in the vanguard of the tangible appreciation

PLATE 24 » Eva Watson-Schütze. *The Rose,* 1903 or before. Cat. 528

in this field." (*Ibid*) Stieglitz counseled his German colleagues that if taste and judgment were exercised in selecting the best print from a given negative, the price would continue upwards and thus inevitably reward the buyer.

THE FIRST PHILADELPHIA PHOTOGRAPHIC SALON, 1898

JURY

HIGH ASPIRATIONS

On the twenty-fourth of October, 1898, opened the most important modern photographic exhibition in the United States, the first Philadelphia Photographic Salon (Biblio. 1321) held at the Pennsylvania Academy of Fine Arts, where Post had commissioned Stieglitz to buy works for his collection. The jury included William Merritt Chase, an eminent painter, his colleague Robert W. Vonnoh, and the photographer-illustrator Alice Stebbins; the photographers on the jury were Stieglitz and Robert Redfield, a mainstay of the Photographic Society of Philadelphia. The exhibition was held at the prestigious Pennsylvania Academy of Fine Arts, acclaimed as the oldest art institution in the United States. Its purpose was "to show only such pictures produced by photography as may give distinct evidence of individual artistic feeling and execution. For the first time in this country is presented a photographic exhibition confined exclusively to such pictures, rigidly selected by a Jury, whose certificate of acceptance is the only award." (*Ibid*, preface) Proud to be a juror, Stieglitz brought with him the standards of selection and display he had learned from the Photographic Salon in London.

The exhibition was international in but a token way, with individuals to represent France (Henri Breux), Germany (Wilheld Weimer), Austria (Wilhelm Stadler), and even a lone entry from Australia (F. A. Joyner). Great Britain had the largest foreign representation. Evans, Hinton, and Cochrane were members of The Linked Ring. This was ARCHIBALD COCHRANE's (Pl. 5) American debut and very possibly Stieglitz's first experience with his work. The Royal Photographic Society (of which not a single person in this show came to be represented in the Stieglitz collection) was better represented than The Linked Ring. Some of the most prominent foreign names on the international circuit with whom Stieglitz was familiar—Annan, Demachy, Cadby, Davison, Henneberg, de Meyer, and Watzek—all of whom would at different times become important components of the Stieglitz collection, were absent from Philadelphia. The absence of highly acclaimed Eickemeyer from Philadelphia in 1898 was also noteworthy.

As far as the Stieglitz collection was concerned, the Philadelphia Photographic Salon was more important for its inclusions rather than its exclusions. Exhibited together for the first time were three out of the four American photographers (Day was already included) whose works Stieglitz would acquire in depth: Clarence H. White, Gertrude Käsebier, and Joseph T. Keiley

PLATE 25 » Alice Boughton. *Maxime Gorky*, 1907. Cat. 63

(listed in the order of importance to Stieglitz as of 1902). (Biblio. 898) They also turned out to be among the "stars" of the show in terms of the number of photographs exhibited and as such established the Salon exhibition as a vehicle for launching reputations. White and Käsebier joined Mathilde Weil and Stieglitz as the only four exhibitors with ten pictures each. Keiley had nine, Day eight, Watson six, Hinton five, and Evans three, as compared to seventy-eight of the one hundred exhibitors who were represented by one to three pictures each. The European two-tier system of representing one class of photographers in depth and including another class of photographers as a token gesture became a standard practice in the States. The importance of a photographer could now be measured by the number of works included in a show, the common practice being to set a parity (such as ten) reserved for those judged to be most prominent.

The two tiers reflected not only quality of accomplishment but also consistency and productivity. It was possible for many photographers to make a single photograph of exhibition quality, but it was another matter entirely to create a full body of exhibitable work. To the first tier belonged those who produced a sizable number of exhibitable pictures each year, while the second tier included those represented by one or two pictures who doubtless submitted no more than those to the jurors. Exhibitions of artistic photographs in the United States, however earnest their intentions, still did not match in either scope or selectivity the most important European exhibitions of this time.

THE MUNICH SECESSION EXHIBITION, 1898

If importance of an event is to be measured by the breadth of its influence rather than the qualities of its specific parts, the most significant event of 1898 was the Munich Secession Exhibition which opened on November 19, 1898. (Biblio. 1318) The exhibit was sponsored by the *Verlag des Vereines Bildender Künstler Munchens "Sezession."* Stieglitz would later borrow the expression "Secession" in quotation marks when the "Photo-Secession" was formed in 1902. (Biblio. 1342) The novelty of the exhibit rested not so much in the specific photographs shown, but rather the inclusion of photographs with painting, sculpture, and printmaking in the avant-garde *separatism* denoted by "Secessionism."

The first German "Secession" had occurred in Munich with the 1892 Exhibition of the "Eleven," which reflected the arrival of a new non-conformist generation of artists pitted against the conventionalism of the old *Düsseldorf* school. The Vienna Secession of 1897 and the Berlin Secession of 1898 followed. These Secessionist exhibits reflected the belief that mediocrity had settled on the art world, inhibiting new methods and unconventional imagery. The spirit of Secessionism was expressed in various styles including

Symbolism, Jugendstil, German Impressionism, as well as the work of idio-syncratic individualists like Edvard Munch and Félicien Rops.

The Munich "Secession" exhibition catalog carried an essay by F. Matthies-Masuren, photographer and theorist. "In every country there are only a few kindred spirits which stand out in the great field of mediocrity. To have these few represented in the first Munich exhibition of art photography was one of the chief aims of the organizers," wrote Matthies-Masuren, thus placing his selection of photographs within the Secessionist tradition. (Biblio. 1318, p. ix) He pointed out how dramatically these photographs broke with the past and observed, "They have freed themselves from photography and sought their models in nature and in the works of artists. They have done away with photo-graphic precision and the intrusive reproduction of details and thus attained simplicity and greatness." (*Ibid.,* p. xi)

FAMILIAR NAMES

Among the familiar exhibitors were Annan, Henneberg, the Hofmeister brothers, Kuehn, Watzek, and Stieglitz. Annan showed five photographs and Stieglitz nine, a number that was a fair representation in comparison with the many who had only one or two pictures. The star of the Munich "Sezession" was Heinrich Kuehn with thirty-four prints, only surpassed by Felicien Rops who exhibited sixty-one etchings in the drawings and prints section. Kuehn was followed by Henneberg with twenty-four, the Hofmeisters with thirteen, and Watzek and Matthies-Masuren each with thirteen. Kuehn had not been as widely exhibited as either Annan or Henneberg up until this time, and this exhibition catapulted him into international prominence.

PRINTS AND DRAWINGS

In rooms adjacent to the photographic section were displayed a collection of prints and drawings by the diverse group of painters and printmakers who had come to be associated with the Secession concept since its inception: among them, Aubrey Beardsley, Will Bradley, Caran d'Ache, Will Carque-ville, Eugène Carrière, Jean-Louis Forain, Alphonse Mucha, Wm. Nicholson, Puvis de Chavannes, Theo van Rysselberghe, Henri de Toulouse-Lautrec (also collected by Stieglitz), Édouard Vuillard, Adolph-Léon Willette, and lastly Félicien Rops, the Secessionist *extraordinaire*. Stieglitz was so driven by the urge to collect that when he stopped collecting photographs between 1910 and 1917 (when the only photographs he acquired were those of Strand), he refocused his efforts on printmakers such as Toulouse-Lautrec, Rops, and others.

In 1899 Stieglitz acknowledged the German "Secessionists'" influence: "They have broken away from the narrow rules of custom and tradition, have admitted the claims of the pictorial photograph to be judged on its own merits as a work of art independently, and without consideration of the fact that it has been produced through the medium of the camera." (Biblio. 903, p. 534) Stieglitz corresponded frequently with Matthies-Masuren (Biblio. 954, 1089, 1284, 1289, 1318), the chief spokesman for the photographic aspect of "Secessionism," whose cumulative influence did not have its proper avenue of expression until Stieglitz formed the American "Photo-Secession" at the

EXPRESSIVE PRINT
MATERIALS

National Arts Club exhibition of 1902. (Biblio. 1342) Stieglitz absorbed from the Munich Secession exhibition another concern that was more immediately to influence his collecting and creative photographic activities. Matthies-Masuren stressed the importance for creative photographers of shifting attention from the negative to the making of the final positive prints that yielded "simple, painterly effects." (Biblio. 1318, p. x) He observed that "the most recent gains in the field [of expressive photography] climaxed in the resumption of the long forgotten and now marvelously perfected gum-bichromate print." He added further that "the gum-bichromate print . . . brings within reach two long desired goals: decorative effect and a faithful reproduction of tones." (*Ibid.,* p. xii) He proposed that the net result of the new gum-bichromate process was a series of photographs "independent and original in concept" without direct dependence on well-known works of art. Deeply impressed by Matthies-Masuren's argument, Stieglitz soon began to advocate the gum-bichromate process as the means through which American photographers could become artistic equals to their European counterparts. The influence of the new non-purist thinking on photographic processes was nowhere more evident than in Stieglitz's fifteen-year retrospective at The Camera Club of New York.

THE STIEGLITZ RETROSPECTIVE EXHIBITION, AND THE CULT OF MANIPULATED PRINT MAKING

EUROPEAN INFLUENCES

Stieglitz's own creative life came to an important juncture simultaneously with the unfolding of European Secessionism. In 1899 The Camera Club of New York presented a retrospective exhibition (Biblio. 956–959) of his photographs, placing great emphasis on the European phase during which most of his published negatives had been deeply influenced by European painters and photographers, who were at that time also considered artistically more advanced than their American counterparts. The show also coincided with the first years of Stieglitz's activity as a collector of photographs and thus serves as a barometer of how the collection affected his personal style.

SEMINAL ROLE OF
STIEGLITZ

In the preface to the catalog of the 1899 retrospective, Keiley observed that the show represented ". . . the result of upwards of fifteen years of constant and serious labor in the field of pictorial photography [in which] the professional career of one man [is] coextensive with the life of that art . . ." (Biblio. 956), thus placing Stieglitz's work as a benchmark against which the progress of others was to be measured. Keiley was not alone in acknowledging Stieglitz's seminal role. Charles Caffin wrote a few years later that "there are few, if any, who will not concede to Alfred Stieglitz the first place among American exponents of pictorial photography. . . . His influence upon the progress of the art has been so widely diffused that it is difficult to estimate

PLATE 26 » Rudolf Eickemeyer Jr. *A Summer Sea,* 1903 print from negative of 1902 or before. Cat. 225

it accurately." (Biblio. 1282, p. 23) The critical assessment of Stieglitz's show was based on several assumptions shared among the international salon circuit. It was generally thought that during its adolescent years (1860–1880) photography was an offspring of scientists who lacked artistic inspiration, hence artistic photography did not exist before 1885—an assumption that seems fallacious today. There was also a general feeling that those concerned with the fine arts were slow in accepting photography, and Stieglitz later called the pursuit of this recognition his "cause." It was also thought that so much esthetic progress had been made during the course of the fifteen years' evolution of modern photography beginning about 1885 that by 1899 an element of historicism was required to properly appreciate the work of that period. It was in the context of these assumptions that Keiley voiced his critical appreciation of Stieglitz's retrospective.

The Stieglitz prints in the 1899 exhibit were in five processes—platinum, photogravure, carbon, gum-bichromate, and gelatine silver toned with platinum—a surprisingly diverse range of processes, considering that Stieglitz had a strong preference before 1899 for platinum prints and photogravure replications of prints originally conceived in platinum. (Biblio. 878) His enlargements and manipulated prints in various materials were quite out of character with the purism that characterized his style between 1894 and 1897. Stieglitz's enthusiasm for manipulated processes coincided exactly with the beginnings of his career as a collector, a role to which we must look for the seeds of changes in his style of expression as a photographer.

By 1899 the Stieglitz collection was sufficiently advanced for him to be among the handful of lenders to The Camera Club's first loan exhibition of international masters of photography, in which manipulated processes were dominant. (Biblio. 540) The exhibition consisted of one hundred ten works lent by J. Wesley Allison, Chas. I. Berg, John Beeby, Joseph Keiley, Joseph Obermeyer, Eva L. Watson, and Mathilde Weil, in addition to Stieglitz. Photographs by A. Horsley Hinton were lent by Allison; Frank Eugene by Keiley; Annan and Demachy by Stieglitz. At least two items in the loan show ultimately entered the Stieglitz collection: Annan's *The White Friars* (Cat. 17) and Demachy's *Coin de rue à Mentone* (Cat. 199), the latter having been issued as a gravure in *Camera Notes* in 1898, while the Annan was later reproduced in 1901.

Stieglitz emerged as a collector of photographs between 1894 and 1899, a period during which two thirds of the negatives and prints in the retrospective were made, and peaked his personal interests in the manipulated print. Evidently there was a symbiotic relationship between Stieglitz's life as a collector and his own creative work at this time: the photographs of others influenced Stieglitz's imagemaking and conversely Stieglitz's own photographs—both their style and subject—influenced what he acquired from his friends. One of the notable contradictions in Stieglitz's personality was

THE MISSION

MANIPULATED PRINTS

FIRST LOAN EXHIBITION

STIEGLITZ COLLECTOR

PLATE 27 » Rose Clark and Elizabeth Flint Wade. *Out of the Past,* 1898. Cat. 116

that in his outward dealings with other people he was stridently independent, yet his collection of work by his colleagues reveals how receptive at this time he was to the influence of others.

The case of Robert Demachy, Stieglitz's French counterpart, is important in isolating from the fifty photographers Stieglitz collected an instance of outside influence on Stieglitz as an artist and as a collector. Prominent in French photographic circles, Demachy had introduced at the 1894 Paris *Salon Photographique* (Biblio. 1302) a revival and improvement upon the gum bichromate process which had first been published in the 1850s but had never been put to a widespread application as a printmaking method. Stieglitz is believed to have seen examples of Demachy's work in Paris in 1894, the year of his marriage and the honeymoon trip to Europe, where thirty-eight of the eighty-seven negatives in his 1899 solo exhibition were made. (Biblio. 956) After acquiring examples of Demachy's work and having exhibited five prints in that medium in his retrospective, Stieglitz wrote of gum-bichromate in 1899, "A new field of possibilities has been opened up [to the artistic photographer], and the prospects for the future of pictorial photography have become much brighter with its advent." (Biblio. 900) It was at this time that Stieglitz also claimed that the most progressive (by this he presumably meant important) photographers in the world were Henneberg, Watzek, Kuehn, Demachy, Puyo, and Le Bègue, all of whom actively worked in the gum-bichromate process.

Stieglitz had already begun to enthusiastically embrace expressive printing methods by 1898. (Biblio. 897) In issue Number Three of *Camera Notes,* he juxtaposed Eickemeyer's *Vesper Bells,* a sharp-focus studio set up, against Demachy's *Coin de rue à Mentone* (Cat. 199) in an understated editorial attempt to visually demonstrate how American photographers were artistically inferior to Europeans. (Biblio. 894, v. 3, p. 24) *Vesper Bells* stood for what Stieglitz was attempting to purge from his own creative work—artificiality of setting and sentimentality. Hartmann had called Eickemeyer's style "scientific realism," a phrase that summarizes how his photographs were absolutely contrary to what Stieglitz admired at this time. Demachy's print stood for expressive, non-literal treatment of the subject.

Stieglitz, however, did not openly criticize Eickemeyer, who was a member in good standing of The Camera Club. Rather, he let Eickemeyer speak for himself in a text accompanying *Vesper Bells* entitled "How a Picture Was Made." (Biblio. 323) The suggestion of Eickemeyer's inferiority came indirectly through Stieglitz's editorial on Demachy in which rather than praising the accomplishments of internationally exhibited Eickemeyer, he dwelled on the perfection of the French work. "In America but few attempts have been made to use the 'gum' printing process [popularized by Demachy]. The French and the Viennese are using it most extensively. It is the printing method *par excellence* for all those who are engaged in photographic picture-

GUM-BICHROMATE PRINTING

SCIENTIFIC REALISM VERSUS EXPRESSIVE PRINTING

PLATE 28 » F. Holland Day. *The Seven Words,* 1898. Cat. 196

making." (Biblio. 897) It was not difficult to read between these lines Stieglitz's oblique criticism of Eickemeyer, who at this time was among the few Americans in competition with Stieglitz for leadership of the American school. All concerned readily interpreted Stieglitz's message that American work was inferior, and it is no surprise that in July 1898 the relationship between Eickemeyer and Stieglitz, initiated by their brotherhood in The Linked Ring, began to cool, as Stieglitz prepared his exhibition of manipulated prints.

UNFULFILLED PROMISE
OF GUM PRINTING

The favoritism Stieglitz expressed for the manipulated print processes in 1898 was reinforced by his own retrospective exhibition at The Camera Club in 1899 where many gum-bichromate and hand-manipulated glycerine-developed platinum prints were exhibited, all of which have since disappeared. The disappearance of Stieglitz's original series of manipulated prints, perhaps destroyed by him at a later time after his style had changed dramatically, dictates that Stieglitz's understanding of what constituted an acceptable manipulated print must be inferred either from unsatisfactory reproductions of his work (for example, Biblio. 543, pp. 230–239) or from the study of prints collected by Stieglitz. The question of his specific appreciation of gum prints is more than academic, for the full weight and authority Stieglitz put behind his position on the gum bichromate process proved unfulfilling for his own creative life. His position would also prove to be ultimately damaging to his reputation as a seer of future directions since gum printing did not become as widely practiced in America as it was in Europe. The damage resulted from his being considered by many photographers as prejudiced in favor of gum printing, which was evident in his own collection of works in this medium (for example, Cats. 199–206, 389–391, 411–416, etc.). When the Photo-Secession was formed in 1902, Stieglitz found it necessary to state expressly that there would be no bias whatsoever for any particular method of printing.

OTHER PRINT
MANIPULATIONS

PROLIFERATION OF
PRINTING METHODS

Stieglitz was not the only photographer to be tempted into enthusiastic experimentation with a variety of new photographic materials and processes that first became commercially available for home use between 1896 and 1902. It is in the context of the international proliferation of processes that Stieglitz's retrospective must be viewed.

George Davison became deeply involved with making enlargements and raved to Stieglitz in 1897 about the new "Royal Bromide Paper" with an antique-colored surface, of which Stieglitz acquired an example by A. Horsley Hinton (Cat. 339). Davison offered to make enlargements from Stieglitz's negatives for the retrospective, pointing out that he had made enlargements for exhibition from negatives by "H. P. Robinson, (J.) Craig Annan, Calland, Horsley Hinton, Sutcliffe & all our best friends on this side." (Biblio. 1480) In a surprising gesture for a former staunch Emersonian naturalist, Davison wrote an article in 1898 on "Faking and Control in Principle and Practice" (Biblio. 219) in which he asked, "With a ray of precious sunlight thus handled as a brush, do we not more nearly approach the act of painting, and so fulfill the literal meaning of the word photography—to draw or paint by

light? And yet there are many who ridicule the idea, and say contemptuously, 'I don't call that photography; that is only "faking"!' "

By 1897 it became necessary to provide a long alphabetical table of processes in the *Exposition d'Art Photographique* catalog (Biblio. 1314) listing nineteen different methods, including enlargements on gelatine silver bromide, carbon prints, gravures of various types, gum-bichromate, Artigue, gelatine silver, platinum, sepia platinum, salted paper, toning with copper, platinum, gold, and uranium, as well as the traditional albumen paper and its modern counterpart Artistotype.

EUROPEAN MALAISE

Dramatic differences in attitude between Europe and America came to be evident in 1898–1899. Stieglitz's correspondence of this period with Demachy reveals the deterioration of morale that was sweeping through Europe by 1898, against which Stieglitz single-handedly was to act as a revitalizing force in America. The *Photo-Club de Paris,* of which Demachy was a leading influence, had three hundred members who met weekly. Rather cynically, Demachy had begun to see these meetings as fulfilling the purposes of "educating little by little our rather backward members." (Biblio. 1500) The *Galerie des Champs-Elysées,* where the *Exposition d'Art Photographique* had been held since 1894, was no longer available, thus contributing to the demise of the Paris Salon. The last year for a deluxe edition of the annual catalog was 1898. The emerging friction between the various esthetic factions led Demachy and Puyo to mount their own private exhibitions in Demachy's studio. Depressed by the unfolding events, Demachy became skeptical of his own works which Stieglitz was about to acquire: "the faults of my work become too apparent to make it pleasing . . . *le malheur* is that I see clearly now what I want to do and can't do it." (Biblio. 1501) Demachy was very concerned that the best visual talents in France were not turning to photography. "Here every man who has an artistic turn of mind [turns] to painting and we [photographers] have the dregs—just the refuse," lamented Demachy to Stieglitz. (Biblio. 1502)

Stieglitz's own temperament and his energetic effort to enhance the standards of photography appealed to Demachy. "We have been trying to do the same thing as you in France and find it rather discouraging," (*Ibid.*) wrote Demachy, who was among the first Europeans to express in writing Post and Keiley's view that Stieglitz was alone in creating a climate for photographs in America that looked to the future, not the past. It was the very pessimism of many Europeans as expressed by Demachy that made the new generation in America so refreshing to the international circuit. While Stieglitz did not continue to work extensively in the manipulated process after this period, his brief experimentation encouraged by seeing Demachy's work did build the foundation for his personal appreciation of the genre long after he had reverted to straight printing.

CHAPTER THREE

THE GENERATION OF 1898 IN AMERICA

By 1898 a very receptive environment for photographs had been created in America through the concerted energies expended by Stieglitz (Biblio. 887–903) through The Camera Club and its publication, *Camera Notes,* and by other Americans such as Juan C. Abel (Biblio. 563), editor of *The Photographic Times* (Biblio. 1251), and dozens of people working at the local level. The newly emerging mood of optimism in America coincided almost exactly with the growing ennui in Europe where photographic exhibitions and societies lost spirit they had once possessed at founding in the early 1890s. By 1902 public complaints (Biblio. 265) were being issued as factionalization over esthetics, art world politics, and even social rivalry began to eat away at the former strength. Thus it was to America that the most serious foreign photographers looked for guidance, and it was Stieglitz in his role as a collector and as a publisher who supplied the strongest and most consistent leadership.

A handful of American photographers were initiated at this time into public life. Among them, the most important were Day, Keiley, Käsebier, White, Eugene, and Steichen—whose photographs account for half of the Stieglitz collection. It was no coincidence that all of them had their work reproduced in *Camera Notes.* This generation—we might call it the generation of 1898—deeply influenced the future course of American photography, each member with an individual contribution and a unique relationship to Stieglitz. They were united by the enthusiastic support Stieglitz gave them early in their careers—support that was not long-lived in every case, but of sufficient intensity that Stieglitz formed major collections of their photographs.

F. HOLLAND DAY

F. Holland Day and Stieglitz were apparently unacquainted even by name until just before Day was shown at the 1896 Photographic Salon in London. Shortly thereafter he became the third American to be invited into The

Linked Ring. Day's name was drawn to Stieglitz's attention evidently for the first time by Davison, who wrote in June of 1895, "I have happened on one excellent artist [in the U.S.A.]. Mr. Day (a publisher) of Boston. We are promised a selection of his work this next time [London Photographic Salon, 1896], the first show he has participated in." (Biblio. 1478) Day's success in London led to his being invited by Stieglitz to be represented in *Camera Notes* in 1897. He soon became a regular editorial contributor of both text and pictures. His articles under the general heading "Art and the Camera" were antecedents of similar attempts by photographers to verbalize the esthetics of the medium that would be published under the editorial imprimatur of Stieglitz at *Camera Notes* and after 1903 at *Camera Work*. (Biblio. 229, 231)

Day was a charismatic personality whose photographs were as attractive to Stieglitz as they were to many others. Returning from a visit to Day's exhibition, Eickemeyer wrote to Stieglitz, "I haven't recovered my equilibrium yet." He continued the account using such descriptive phrases as "unique and original, he recalls no other worker to mind," "he stands alone," "a revelation," and "he has hewn his own way through a virgin forest." (Biblio. 1513) An opposite reaction to Day's eccentricity was that of Keiley who wrote Stieglitz with an undertone of contempt, "[I] understand F. Holland Day arrived with a trunk full of costumes and paraded around in the full moonlight." (Biblio. 1539) Day was among the very few Americans whose outspoken standards were higher than Stieglitz's when it came to matting, framing, and reproducing his work. They commanded Stieglitz's respect and contributed to the general high standard of presentation that came to be called the American style. Also associated with the American style was a mounting that Day devised using layers of colored paper to create a nesting effect as sheets of successively smaller dimensions were laid one on top of another with borders of various sizes.

Day refused to send unmounted prints anywhere and insisted that if he was not allowed to mount and frame his own work, he would rather not participate in an exhibition. "More than half the battle is in the manner in which such things are put forth, and my pictures mounted by others would be no longer mine," wrote Day to Stieglitz around 1898. (Biblio. 1488) This tenet became fundamental for Stieglitz when he became responsible after 1902 for selecting and organizing the American contingent of many international exhibitions.

A fastidious printmaker and one of the first to write about the special qualities of individual prints, Day sent exact specifications for shape, color, value, and texture of the paper for his *Camera Notes* gravures. He did not hesitate to find fault with the reproductions and carefully scrutinized each proof to be certain the corrections requested were actually made in the press runs. (Biblio. 1485) When *An Ethiopian Chief* (Pl. 29) was finally reproduced in *Camera Notes* (October, 1897), he complained to Stieglitz that "it looked muddy" and did not have the right contrast. (*Ibid.*)

For the time being Day and Stieglitz remained on good terms despite minor disagreements. Day acquired by purchase or trade *The Net Menders* from Stieglitz and soon became sufficiently intimate to act as his conscience. He chided Stieglitz for not actively making photographs due to the pressures of editing *Camera Notes* and managing The Camera Club, where he was vice-president: "Do get back to the camera." (Biblio. 1487) Their friendship was soon to be tested, for Day's fertile visual imagination brought him into a rivalry with Stieglitz for the admiration of European photographers. Day began to compete with Stieglitz in organizing exhibitions, recommending Americans for the foreign salons (he endorsed Devens, Sears, and Käsebier), and promoting the appreciation of pictorial photography.

RIVALRY FOR LEADERSHIP

The crisis occurred during 1898–1899 when Day began lobbying for the establishment of an American association of artistic photography that was national in scope and comparable to London's Linked Ring. He wrote to Stieglitz in 1899 that "an American Association of Artistic Photography should be formed at once." (Biblio. 1495) SARAH C. SEARS was considered as a possible financial sponsor who could use her influence at the Boston Museum of Fine Arts, where they hoped to schedule the exhibition. Day attempted to involve Stieglitz, protesting that he would not start a photography movement which Stieglitz would refuse to head; but Stieglitz declined to participate. The Association was to be formed with a Salon of Photographic Arts, an exhibition that Stieglitz was asked to direct but which he somewhat abruptly declined. (*Ibid.*) Day evidently planned to organize a society of artistic photographers whose membership extended beyond a single metropolitan area, an ambition that was to materialize under Stieglitz's leadership in 1902 with the founding of the Photo-Secession.

A similar concept of a national society of artistic photographers in America had by this time also occurred to Stieglitz. But as an officer in The Camera Club, he could not readily abandon his responsibility, especially since he had been such a motivating force in the consolidation of the two New York camera clubs in 1896. Before their final breach in 1900, Day and Stieglitz had already begun to cross swords on this issue, but as collectors they were mutually supportive. Whatever their feelings of competition, however, Stieglitz had already acquired Day's two masterpieces of 1898, *An Ethiopian Chief* (Pl. 29) and *Ebony and Ivory* (Cat. 178), both of which had been illustrated as gravures in *Camera Notes*.

STIEGLITZ COLLECTS DAY

Day and Stieglitz had similar traits on several counts, including the instinct to organize a group (Biblio. 1402, 1403), the social pressures of which cut into both of their creative lives. Suffering in this regard to a greater extent than Stieglitz, Day only had a brilliantly productive artistic life of a decade (1898–1908). Like Stieglitz, but for slightly different reasons, Day was impeded artistically by the politics of the art world. Between 1895 and 1898 Day was a portraitist of his fashionable Boston acquaintances (Cats. 158–162) for which

PLATE 29 » F. Holland Day. *An Ethiopian Chief,* about 1896. Cat. 180

SACRED WORK

his first recognition in London came, but soon he was catapulted into controversy over a series of photographs based on New Testament episodes (Cats. 194–197). In 1898 Day began this series of sacred subjects, including a representation of the Crucifixion called *The Seven Words* (Pl. 28), the originality of which stunned most of the photographic community. Many people were repelled by the series and Keiley's response was typical. He described the work as "crude representations of the crucifixion stamped on the cheapest grade of German mortuary cards." (Biblio. 542) Stieglitz, apparently, was not offended and acquired selected examples from the series.

Day's defense of his sacred work was recorded in an interview. "At this period of the world's history, it seems rather late for any serious objection to be raised to the portrayal of sacred subjects in art. If the painter and the sculptor are permitted to portray such subjects there is no reason why the etcher and the serious lithographer, or the wood engraver, should not have the same privilege. And it immediately comes to a question as to the seriousness of photography." (Biblio. 251, pp. 15–16, quoted in extenso) Ironically, Day's own opinion of the intellectual content of his work was very different

PORTRAITS

from that of Sadakichi Hartmann, who in speaking of Day's portraits perceived that he "has the peculiar gift to render everything decorative. Sensitive to a high degree . . . he can only satisfy his individual code of beauty by arranging and rearranging his subject with all sorts of accessories." (Biblio. 1078)

Day retired in 1899 from the publishing firm of Copeland and Day, where he was a partner. He wrote Stieglitz that he would use his free time to advance the cause of photography. "I may even go to England, in which case I am urged by friends there to fetch over a small collection of American work and exhibit it in London and Paris." (Biblio. 1494) Day took twenty-five or thirty prints from his collection to an evening with the Harvard Camera Club before he departed. He showed prints by White, Keiley, Käsebier, Watson, Devens, and Sears, who were among those represented in his collection and who also came to be in the Stieglitz collection. Day sailed for Europe on April 31, 1900, with his collection of photographs, breaking an appointment to see Stieglitz in New York. Stieglitz was baffled, judging from the letter he wrote Day lamenting the important business they failed to accomplish. (Biblio. 1497)

NEW SCHOOL OF
AMERICAN
PHOTOGRAPHY

The storm brewing between them was not unilateral. Upon arrival in London, Day began seeing people who were in a position to provide space for the exhibition that he desired to present, members of *The New School of American Photography* (Biblio. 1402), a title that deliberately excluded old-timers like Eickemeyer and Stieglitz. Early in June, Day lunched with Hinton, who wrote to Stieglitz of his skeptical impression of Day as "an eccentric prompted largely by selfishness," noting also that Day was distrusted by several British Links. (Biblio. 1525) Day's first choice was for the exhibition to be sponsored by The Linked Ring, of which he had been a member

PLATE 30 » F. Holland Day. *The Vigil*, 1900 or before. Cat. 176. Actual size.

since 1895. Just as they were about to consent, Stieglitz fired off a stormy cable followed by a letter to Hinton urging that Day's proposal be vetoed. (Biblio. 1529) The consent was withheld, and Day finally arranged for the show to be sponsored by the Royal Photographic Society in their Russell Square exhibition rooms. (Biblio. 251) The New School of American Photography opened in London on October 10, 1900, with three hundred seventy-five photographs including over one hundred and two by Day, thirty-three by White, thirty by Käsebier, twenty-one by Steichen, twenty by Eva Lawrence Watson, and over a dozen each by Devens and Eugene. Yet to make his debut in the Stieglitz circle was Coburn who showed six photographs. An abridged version of the show opened in Paris on February 22, 1901. The primary changes were a reduction to seventy-four prints by Day and an increase to thirty-five for Steichen. Up to this point Stieglitz was primarily an editor presenting his picture selections through the medium of the printed page; his career as an organizer of exhibitions was yet to come. Stieglitz undeniably preceded Day in identifying those American photographers whom time would most favor, despite the fact that Day first brought them together in an exhibition.

Despite Day's activities, Stieglitz's position of leadership in modern photography was well established. When Day attempted to solicit from J. Craig Annan the exhibition of his collection as the American contingent at the 1901 Glasgow exhibition, the offer was refused. Annan, who was in charge of arrangements, turned instead to Stieglitz, addressing him as "my dear fellow Link" and invited him to select and send the best American work for the show. Stieglitz thus maintained his position as the international agent for American photographs and effectively blocked Day's rise as a director of exhibitions. In his tastemaker's capacity, Stieglitz continued to pursue the combined roles of collector and entrepreneur to the detriment of his own creative life, a pattern of personal conflict that Day was also soon to experience.

JOSEPH T. KEILEY

It is not certain how Stieglitz came to know Joseph Keiley since he had not exhibited internationally before 1898, nor was he yet a member of The Camera Club. Stieglitz proposed Keiley for membership in 1898 and installed him as an editorial associate for *Camera Notes*. By 1899 Keiley was writing extensive critical pieces (Biblio. 539–541) and conducting experiments that would be published under joint authorship with Stieglitz on the process of developing platinum prints in glycerine. (Cats. 361–377; Biblio. 543) Keiley was a Wall Street lawyer with a passion for photographs and a gift for prose who would soon become Stieglitz's closest photographic colleague.

PLATE 31 » F. Holland Day. [*Study for The Crucifixion*], about 1898. Cat. 195. Actual size.

INDIAN SUBJECTS

Keiley's photographs were diminutive cityscapes (Pl. 36), lyrical landscapes (Cat. 377) and poignant Indian portraits (Cats. 361–368) that were greatly admired for their delicate sensibility. In 1899 Stieglitz described the Indian portraits as "characterized by a strong originality in style, as well as a rare appreciation of the value of delicate gradations in the rendering of the human face. As a study in artistic tonalities his pictures stood in a class by themselves." Stieglitz acquired two of the 1898 studies of Indian heads, proving his words more than fatuous praise. (Biblio. 562)

Well liked, Keiley kept in touch with the comings and goings of the photographic community. A typical letter to Stieglitz reads, "Saw Murray [at Club] . . . he told me that he had been quite unwell—because of overwork. Saw Reed also . . . On the way up to the Club, I met Dr. Bartlett . . . He incidentally attacked my views of a salon . . . and it seemed . . . that he thought you and I were working against him. He spoke of 'Camera Notes' and of Hartmann's article and was fiercely bitter. . . ." (Biblio. 1538)

CAMERA NOTES

As an editorial associate, one of Keiley's jobs was to thoroughly check *Camera Notes* for production mistakes, which he found too often for comfort. In the October of 1899 issue, for example, he found some plates missing, a few duplicates of the same plate, typographical errors, and "many defective in the white print." (Biblio. 1540) Keiley's performance of such tasks left Stieglitz free to be concerned about other matters, and perhaps as a result the period of 1897–1898 was one of the healthiest in Stieglitz's life. By September of 1900 the situation was to change drastically, not for lack of Keiley's assistance, but from art-world pressures that would bring on the first of many fits of chronic illness that would beset Stieglitz during his subsequent career as an editor and a publisher.

THE LINKED RING

Keiley did not require the support of Stieglitz for his success as an artist, but it certainly did not hurt. Stieglitz sponsored his membership to The Linked Ring in 1899 (Biblio. 1524) and in June of 1900 Keiley had a one-man show at The Camera Club. (Biblio. 563, 564) Keiley was subtly supportive of Stieglitz at every opportunity. When Stieglitz was not reinvited to be on the jury of the second Philadelphia Photographic Salon after having served the year before, Keiley grumbled, "I found that among the entire 350 pictures there were not half-a-dozen really great pictures [and] it was clearly evident that the standard of this year's jury was not so high as that of the previous year." (Biblio. 542)

JAPONISME

Keiley's show of 1900 was a financial and critical success. Hartmann, in his article on the exhibit, noted that Keiley "represents the Japanese phase in photography, which for certain reasons is very sympathetic to me. His blurred effects, his losing detail here and discarding it entirely there, and yet suggesting it frequently by an entirely empty place—you see a line and yet it is not there—are truly Japanese." (Biblio. 565) Keiley was evidently very self-deprecating. When at the Philadelphia Salon of 1900 a certain Mr. Busten of Boston bought his *A Decorative Landscape* (which Keiley called *Rustling Leaves*) for thirty

PLATE 32 » F. Holland Day. [*The Entombment*], 1898. Cat. 194

dollars, Keiley wrote Stieglitz that White's *"Ring Toss* [Cat. 551] cost less money than my picture and I think that Busten would have used his money to better advantage had he purchased that, or one of White's other things." (Biblio. 1541) For such qualities Keiley commanded the respect of Stieglitz and many others. Despite his profession as a Wall Street lawyer that made him a classic example of the well-heeled amateur, his love of picturemaking was deep-rooted. Keiley wrote Stieglitz from Cuba, "there is not a professional or amateur photographer in this town—Fancy! . . . it's odd to be out of things as completely as I am." (Biblio. 1542)

GERTRUDE KÄSEBIER

Gertrude Käsebier, Edward Steichen, and Frank Eugene all made their debuts at approximately the same time and had successful careers as professional portrait photographers. By early in the century, all had established professional studios from which they earned livable incomes.

Käsebier first received public notice in February of 1897, when she exhibited a selection of one-hundred-fifty works at the Camera Club in Boston and Pratt Institute in Brooklyn. She had not exhibited abroad and was among the first modern American photographers whose reputation was first achieved at home. The same year, after a short business internship in the Brooklyn portrait studio of Samuel Lifshey, Käsebier established her own studio on Fifth Avenue near Thirty-second Street over her husband's objections. (Biblio. 534) At the Philadelphia Photographic Salon of October of 1898, Käsebier and White were among the four exhibitors to share the honors of being represented by ten photographs each, in comparison to three or four entries by the rest.

APPRENTICESHIP

Käsebier had already won the sympathy of Philadelphian photographers by an informal autobiographical talk she had given the previous spring before the Photographic Society. (Biblio. 514) She began her narrative with a description of how she had begun photographing several years before (early 1890s) only to put it aside after being ridiculed by a man for her inexperience. "Foolish woman to think I could arrive at knowledge without the drudgery of attainment," Käsebier recalled saying to herself. As a student at Pratt Institute, she had been made by her instructors to think of her "camera in a 'get thee behind me, Satan' sort of way." Undiscouraged, she continued making photographs casually. One day in 1892, she submitted entries to the *Monthly Illustrator* competition and won the fifty-dollar prize. But the subsequent response of her teachers who opened "their vials of wrath and [labored] with me as with one fallen from grace," caused her camera to again go into retirement.

SELF-ASSESSMENT

She continued her story to describe how she returned to photographing in the summer of 1893 on a European painting trip. The resulting photographs were so much more satisfying than her sketches that she set about supplement-

ing her self-taught methods with formal training. She found she had little tolerance, however, for such mechanical procedures as retouching shadows and the use of painted backgrounds, *"papier-maché* accessories, high-backed chair(s), the potted palm, the artificial flowers, turkish cushion(s), the same muslin rose, and . . . soft lighting that gives neither an indoor or out-of-door effect." (*Ibid.,* p. 270) She asked the audience rhetorically, "Who has educated the public to a false standard in photography?"—a question Stieglitz had asked many times and which gave the two a common starting point for friendship.

DISLIKE OF COMMERCIAL APPARATUS

Having come to photography from an art school background, Käsebier asked, "Why should it not be required of the photographer, desiring to be known as an artist, that he serve an apprenticeship in an art school?" She continued to reason that "an artist must walk in a field where there is something more than chemical formulae, theatrical effects, affected and monotonous posing. He must see nature through the medium of his own intellectual emotions, and must guard that they not be led into artificial channels." (*Ibid.,* p. 270)

In her discourse, Käsebier addressed herself to the contemporary question of whether works created for reasons other than the artist's inspiration can be considered art. Asking whether it was possible for a professional photographer also to be an artist, Käsebier went on to propose: "Photographers sometimes put forward the claim that they would rather produce artistic work; but as they must live, and our great artless public will not buy, they cannot. There is truth in that too; but it does not excuse a man for selling his soul to the Philistines. He can make a commercial article for their money and still another to justify himself." (*Ibid.,* p. 271)

She also broadmindedly acknowledged the importance of the amateur in photography. "The art in photography . . . will come through the amateurs. They are not hampered by the traditions of the trade, and are not forced to produce quantity at the expense of quality. They go at their work in a more natural, simple and direct way, and they get corresponding results." (*Ibid.,* p. 272) Käsebier concluded her talk with the advice: "The key to artistic photography is to work out your own thoughts by yourself. Imitation leads to certain disaster!" (*Ibid.,* p. 272)

The sources of Käsebier's philosophy of photography so articulately expressed before the members of the Photographic Society in Philadelphia in 1898 are unknown. Whatever the sources, her thoughts earned her an instant acceptance that could have assured her success in photographic circles regardless of the quality of her own photographs. Indeed, what has survived of Käsebier's work before 1898 does not suggest a talent as great as her oratory. In 1899 *The Manger,* the most popular picture exhibited at the Second Philadelphia Salon, sold for one hundred dollars. It was the highest price yet paid for a pictorial photograph, as Stieglitz himself acknowledged proudly. (Biblio. 904) Stieglitz published the picture as the frontispiece to *Camera Notes* (July, 1900) along with *Blessed Art Thou Among Women,* a work more

RECORD PRICE: $100

FIRST FEMALE IN THE
LINKED RING

compelling by modern standards which was made shortly after *The Manger*. In his review of the 1899 Philadelphia exhibition, Keiley remarked that only a year before the name Käsebier was unknown. By 1899 she had exhibited at The Camera Club and in 1900 became a member of both The Camera Club and The Linked Ring, to which she was the first woman to be elected.

Coincidentally with his retrospective at The Camera Club, Stieglitz wrote a memoir of the preceding fifteen years titled "Pictorial Photography." (Biblio. 903) It was illustrated with his own photographs, but in it Stieglitz presented for the first time a modest roster of names to watch and touched on many different philosophical issues of importance to photographers. In both substance and organization Stieglitz shared much in common with Käsebier, thus reflecting the common current of ideas at that time. However, Stieglitz treated parallel topics in greater detail and with an element of historicism that firmly established his role as the most articulate American spokesman of the theory and evolution of modern photography.

CLARENCE H. WHITE

THE BOOKKEEPER
GENIUS

The success of Clarence White's photographs at the Philadelphia Photographic Salon of 1898 was reported in his hometown newspaper in Newark, Ohio: "Mr. White is a bookkeeper, but he has a soul which soars far above ledgers and daybooks." (Biblio. 867, p. 16 cites The Newark (Ohio) *Advocate,* November 19, 1898) By background and artistic temperament White was the opposite of Gertrude Käsebier, with whom he shared the limelight as the year's most promising newcomer to the national scene. Käsebier's *The Manger* was essentially a Robinsonian artifice echoing the painterly theme of the madonna and child. White's photographs, on the other hand, were intimate studies of his family, submitting to his gentle direction but engaged in their daily activities. (Pls. 49, 50) Käsebier was an urbane professional in New York, while White was a small-town boy from the Midwest. Having set a course for her future in photography, Käsebier was well on her way by 1898 to accomplishing her goals, whereas White was still a bookkeeper (he would remain so until 1904) with the wholesale grocery firm of Fleek & Neal who was known to roust out his models before dawn (Pl. 45) to make a few exposures before going to work. He recollected that as a young married man with two children he could initially afford only two film plates per week and had to carefully plot out what his two exposures would be. F. Holland Day, one of White's first admirers, who by this time had just begun corresponding with Stieglitz, wrote admiringly of White, "What a pity he hasn't more time and money to put into it! His work is mostly done during luncheon hour he tells me and some exposures by night and electric light." (Biblio. 1492)

MEAGER INCOME

PLATE 33 » F. Holland Day. *Portrait of a Man with Book* [*Kahlil Gibran*], 1896. Cat. 171. Actual size.

In 1899 White showed one hundred twenty-two photographs at The Camera Club in New York. Emma Spencer, one of his articulate colleagues at whose home the Newark Camera Club met and who had known White's work from the outset, wrote in the exhibit catalog: "White's initial experiments with the camera were undertaken in 1894 and for two years thereafter he made photographs which though marked by a certain individuality were yet characterized by a severity of definition and a brilliancy of burnish considered inseparable from photographic art." (Biblio. 847)

NATIONAL DEBUT

White was first brought into national prominence by Juan C. Abel, the astute editor of *The Photographic Times* where five halftones of White's photographs were published between January and July of 1898, the critical months leading up to the fall exhibition in Philadelphia. (Biblio. 1321)

TRIP EAST

With these events behind him and the first prize at the first annual Pittsburgh Salon, White traveled in November to the East where he met with Stieglitz, Day, and Keiley. Upon his return home, White wrote Stieglitz that he hoped "to keep in touch with the serious workers [I] met on my very short trip East." (Biblio. 1621) The trip was successful on every account, for the following year White became an honorary member of The Camera Club and was invited to show at London's prestigious Photographic Salon organized by The Linked Ring, which elected him to membership in 1900 along with Käsebier. He was also invited to sit on the 1899 Philadelphia jury and modestly wrote Stieglitz, "I have accepted . . . I did so though reluctantly, feeling they had placed too high an estimate on my ability." (Biblio. 1623)

NEWARK CAMERA CLUB

Impressed with the people and the pictures he saw in the East, White conveyed his enthusiasm to his colleagues at the Newark (Ohio) Camera Club and scheduled another invitational exhibition for the following November. (Biblio.1326) The show presented Demachy together with eight Americans whom Stieglitz collected, providing a model for similar exhibitions based upon the principle of great selectivity that came to be organized with increasing frequency in the United States. Although neither the first nor largest of its kind, White's group show anticipated in the selection of names and manner of presentation Stieglitz's style of exhibition when he began regularly organizing them in 1902. One major differing feature was that White used his shows as a vehicle for presenting a large body of his own work. With one hundred thirty-five images, White had the largest single representation. Day followed with sixteen pictures, suggesting that he was at this time the single most important outside artistic influence on White. Käsebier and Watson each exhibited eleven, while Keiley only had five and Stieglitz six. White did make one discovery— WILLIAM DYER (Pl. 23), who was represented by nine works in the exhibit. Through this occasion Stieglitz became familiar with the work of Dyer, which had not been shown elsewhere in a context where Stieglitz would have noticed it. Like many photographers whom Stieglitz collected, Dyer surfaced outside

PLATE 34 » Joseph T. Keiley. *A Sioux Chief*, about 1898. Cat. 367. Actual size.

the mainstream of the international circuit. Peripatetic, he suffered the loss of his entire studio in a fire after moving to Oregon.

When White asked Stieglitz to send pictures for the 1898 loan exhibition, he evidently received gum prints along with platinums and gravures. The manipulated work came as a surprise to White, who knew Stieglitz's photographs through the gravures published in *The Photographic Times of 1898,* the same volume where White's own works were also first extensively published. "They are on entirely different lines than I placed you," wrote White to Stieglitz after seeing his prints sent for exhibition. (Biblio. 1624) White himself had begun to experiment with the gum bichromate process in February of 1899, perhaps as a result of Stieglitz's example.

White organized an even more ambitious invitational show in 1900 including Zaida Ben-Yusuf and Robert Demachy, whose names were already familiar. More importantly two names appeared who would eventually be very important to Stieglitz's collection—Frank Eugene and Edward Steichen. White became familiar with Steichen's work at the 1899 Philadelphia Salon, where he was one of the jurors responsible for selecting the exhibition. White wrote Steichen a letter of encouragement and recommended him to Stieglitz, thus initiating a friendship the effect of which would be felt by all concerned much more than they imagined.

White and Stieglitz soon commenced a lively correspondence revealing of Stieglitz's undisguised admiration for White. *Spring* was published (Pl. 51) as a gravure in *Camera Notes*. Stieglitz once asked why White signed some works at the top of the picture, to which White replied that in one case it was to cover retouching of the print, and in *The Study* it was to "break an abrupt line of the angle of the wall . . . it may be the paintings (of modern artists) influenced me but in placing the signatures I gave no thought to their manner. . . ." (Biblio. 1622) Stieglitz was looking for the influence of modern art, but White claimed to be responding with but a naive sense for pure form.

The establishment of the Studio of Clarence H. White in 1901 signaled his more full-time commitment to photography. It was a location where he also exhibited the work of others. (Biblio. 1626) The following April he wrote Stieglitz, "I have made up my mind that art in photography will be my life work and am preparing to live a very simple life with my little family to carry this out." (Biblio. 1627) About the time White established his public studio in 1901, Stieglitz acquired some of his most important examples of White's photographs. Among those White sent by mail at this time were a portrait of Letitia Felix (Pl. 44, Cats. 536, 537, 541, etc.), *Spring,* and *The Ring Toss* (Cat. 551), the latter being one of White's few attempts at gum printing. (Biblio. 1627) White did not, however, resign from his career as a bookkeeper until 1904, which opened the door for his move to New York, where the Little Galleries of the Photo-Secession were about to open under

PLATE 35 » Joseph T. Keiley. *A Bacchante*, 1899. Cat. 370

Stieglitz's direction. White never had the same commercial success as Käsebier; his calling was that of a teacher, and as such he pioneered the role of photographic educator.

EDWARD J. STEICHEN

FRIENDSHIP WITH WHITE

Eduard Steichen (he later changed the spelling of his first name to Edward) worked as a designer of advertisement posters for a lithographic firm in Milwaukee in 1899 when he and White became acquainted. In 1895 Steichen (Pls. 54–65) bought his first camera, a fifty-exposure flexible film box type, and had begun to photograph as an aid in designing advertisements. (Biblio. 775) Steichen's familiarity with Eastern photographers through periodicals in the public library led him to believe his own work was up to par. He submitted entries to the second Philadelphia Photographic Salon of 1899, where White first saw the work and was much impressed. Steichen also submitted to the first Chicago Photographic Salon at the Art Institute of Chicago in 1900 and was accepted. Filled with confidence, Steichen left Milwaukee for Paris via New York just after his twenty-first birthday. He met Stieglitz, who had already

MEETS STIEGLITZ

received a note from White about Steichen saying, "He is a very interesting fellow judging from his pictures and his letter. He starts for Paris in a couple of weeks and shall write him to call and see you in New York." (Biblio. 1625)

Excited by what he saw, Stieglitz asked whether Steichen had put prices on them. Stieglitz recalled, "He did not know what to answer. Would he accept five dollars a print? I chose three. Steichen, much moved, again did not know what to say. But then he confessed, 'no one has paid me more than

STIEGLITZ COLLECTS

fifty cents for a photograph.' I replied, 'Never mind. I feel I am robbing you in taking your prints at five dollars a piece!'" (Biblio. 1057, p. 24) According to Stieglitz's inscriptions on Cat. 460, in 1902 Stieglitz would pay fifty dollars for a Steichen print and by 1902 as much as one hundred fifty dollars. Steichen himself wrote to Stieglitz of selling prints for one hundred dollars in Paris. Stieglitz got a bargain, but no one could have predicted Steichen's swift rise to international prominence after the first few months in Paris. In the spring of 1900 when Stieglitz paid five dollars for each print, Steichen was virtually unknown in comparison to Eickemeyer, Demachy, Watzek, Kuehn, Keiley, White, or Stieglitz himself, and such a modest price was commensurate with that asked by many seasoned exhibitors.

Among Steichen's unabashed goals was to support himself by just taking photographs. While in New York, he approached editors at *Scribner's* and *Century* magazines, who temporarily rejected his proposal to use photographs for magazine illustrations. (Biblio. 1606) He hoped in Paris to learn skills and meet people who would facilitate his goal. Having established connections

PLATE 36 » Joseph T. Keiley. *A Side Street, New York*, 1902. Cat. 382. Actual size.

at home (White described Steichen as a "brilliant art student" in Biblio. 1333), Steichen remembered vividly his parting words from Stieglitz: "Well, I suppose now that you're going to Paris, you'll forget about photography and devote yourself entirely to painting." As he descended in the elevator, Steichen shouted up to Stieglitz, "I shall always stick to photography!" (Biblio. 751, p. 6)

FIRST PARIS SOJOURN

Steichen had left Milwaukee with his school friend Carl Björncratz, also an art student, with whom he arrived in Le Havre on May 18, 1900, and bicycled to Paris along the Seine. In Paris the two immediately dipped into the cultural events of the city. Among the events Steichen recollected as being of special significance was seeing a plaster cast of one of Balzac's studies of *Rodin* that had been received by Parisians in a whirlwind of controversy. At the Luxembourg Museum he was particularly impressed by Monet, then Degas, Manet, Pissarro, and Sisley. He perceived that "they dealt with something that was still well out of the domain of photography, the magic and color of sunlight." (*Ibid.,* p. 17) Steichen took a studio in Montparnasse and enrolled at the *École Julien* to study drawing and painting. The highlight of this first sojourn in Paris for Steichen was being introduced to Auguste

MEETS RODIN

Rodin by Fritz Thaulow, whose friendship Steichen cultivated through a series of portraits of his children.

Steichen spent the summer of 1900 in Paris, then decided to visit London to show his photographs to receptive members of the Royal Photographic Society and The Linked Ring. Coincidentally, Day was in London at the time with his New School of American Photography show and it could not have been a more propitious moment for them to gain each other's acquaintance. Day liked Steichen's photographs so much that he immediately selected twenty-one prints to be included in the show, a spontaneous decision that placed Steichen with the top three in terms of the numbers of prints represented. Steichen later declared with fond memory, "I was now a member of the New School of American Photography!" (*Ibid.,* p. 18) Steichen felt strongly that Day, rather than Stieglitz, deserved credit as being first "to assemble a collection consisting exclusively of the work of men and women later recognized as leaders in the most important American movement in pictorial photography." (*Ibid.,* p. 18)

PAINTING AND PHOTOGRAPHY

Steichen wrote Stieglitz in January of 1901, "I am doing more painting than photography—possibly because the opportunity is more appropriate." (Biblio. 1607) By August his works had caught the eye of some prominent artists, which led him to say to Stieglitz that he wished he could hear "what some of the big painters and artists say of my things." He concluded philosophically, "I am sure the biggest hindrance to photography has been photography." (Biblio. 1608)

Although Steichen was a man about Paris going to the races at Longchamp (Cats. 491, 492), his most significant works were not views of the city and countryside in the style of Stieglitz's *Picturesque Bits* (Biblio. 1277), but

PLATE 37 » Joseph T. Keiley. *From a New York Ferryboat,* 1904. Cat. 383. Actual size.

rather of fashionable people in their environments. Steichen became a frequent visitor to Rodin's studio where some of his most powerful photographs from the first Paris years were made (Cats. 485–488). Steichen had in fact planned to photograph a series of portraits of many distinguished European artists in which he "hoped to include painters, sculptors, literary men, and musicians." (Biblio. 751, p. 18) He contributed much to the artistic life in Paris, and Demachy reported to Stieglitz that "he acts on me as a stimulant of which I have a great need in the atmosphere of indifference which is peculiar to Paris where there are about three photographers who care about each other's work." (Biblio. 1503) Steichen's rooms became a mecca for such visitors as Day, who came to stay early in 1901 during the run of the American school show in Paris and with whom he shared several sessions of photographing one another. During August of the same year Käsebier was also in Paris, spending a great deal of time in the country with Steichen getting to know the French peasants. It was "the idyll of our lives," wrote Käsebier to Stieglitz. (Biblio. 1533) Steichen also reported this visit to Stieglitz, saying Käsebier gave him "much renewed energy and enthusiasm," along with the friendly advice that she thought Steichen should decide on either *painting* or *photography,* but not both. (Biblio. 1609)

Later that year Steichen was invited to join The Linked Ring. He declined, only to accept a second invitation extended in September of 1903. His reluctance to accept the first invitation reflected not only the declining status of The Linked Ring but also that he was privy to the movement to establish an international society of artistic photographers. (Biblio. 1395)

In his successful new life as an artist-photographer, Steichen did not allow his role as a painter to come into conflict with his photographs. He sagely expostulated *vis à vis* fine art and photography: "Let it not be the medium we question but the man [behind the camera]. Our consideration of lithography was a lowly one 'till Whistler made it art'." (Biblio. 742) Steichen's life in Paris was soon to come to an end when he returned to Wisconsin for rest and recuperation in July of 1902, exhausted from preparing his first one-man show at the *Maison des Artistes,* Paris. By October Steichen was back in New York and took up residence in a studio at 291 Fifth Avenue to pursue a career in portrait photography which had brought him so much success in Europe.

FRANK EUGENE

It is unclear how FRANK EUGENE (for his New York exhibition he had dropped his last name of Smith) achieved his sudden prominence, but it was at least in part through the influence of *Camera Notes.* Joseph Keiley might have been

PLATE 38 » Gertrude Käsebier. *Mother and Child*, 1899. Cat. 346. Actual size.

the first to discover Eugene (Pl. 66–71) since it was he who lent Eugene's work in December of 1899 to the first Loan Exhibition at The Camera Club, where Eugene just a month before had held his first one-man show. His 1899 exhibition of theatrical portraits indicates that by this time Eugene was also an exhibiting portrait painter. Since Eugene was not listed in the foreign or domestic exhibitions where he might have been expected to appear, the particulars of his two bodies of work remain mysterious.

Influenced by his training as a painter, Eugene developed a style based on hand manipulation of the negatives as though they were etching plates. The American illustrator and photographer J. Wells Champney commented in a short review of The Camera Club show that the work was "unphotographic photography." (Biblio. 347) Eugene also captured the attention of Sadakichi Hartmann, who in his third article of the year on a photographer coined the phrase "painter-photographer"—as a parallelism to the traditional usage of "painter-printmaker"—to identify master artists who also practiced the graphic processes. (Biblio. 396) Published sources on Eugene's beginnings are scarce, but we learn from Hartmann that Eugene had practiced photography for several years, accumulating several hundred prints of a uniform and exhibitable style.

Reputations were made overnight in 1899. Eugene was taken up in 1900 first by Day, who showed him in the October New American School of Photography show in London as well as in the London Salon. In November, Clarence White showed him in Newark, Ohio. (Biblio. 1326) The *Wunderkind* of the generation of 1898, Eugene was described by Hartmann as a master of posing, representing the "first time that a truly artistic temperament, a painter of generally recognized accomplishments and ability, asserts itself in American photography." (Biblio. 346) In April Eugene became the seventh American in The Linked Ring.

What made Eugene so attractive not only to his contemporaries but also to Stieglitz was his totally unorthodox method of rubbing oil onto the negatives with his fingers and adding cross hatching with an etching needle (Cat. 226, 227, 244, 254, 265, etc.), thus in many images leaving only small portions of a picture recognizably photographic. Hartmann said in criticism of Eugene's method, "I do not see how any way of retouching is more illegitimate than the gum process." (*Ibid.*) In maintaining that manipulated negatives were more legitimate than manipuated prints, Hartmann clearly opposed Stieglitz's view, as expressed in *Camera Notes* and elsewhere, of gum printing from straight negatives as the most legitimate form of manipulated photography. (Biblio. 897) Some viewed negative retouching as the most practical response to the medium because of the resulting replicability of the alterations. Indeed, the ease of achieving replicability made negative retouching the standard procedure for enhancing the appearance of an original in commercial portrait studios since the mid-1870s. The opposing Emersonian forces viewed

touching negatives as the worst travesty of pure photography. Stieglitz would surely have shared the same viewpoint, yet there are good reasons why he embraced Eugene's maverick method. Eugene's photographs represented an esthetic reconciliation of these two camps by amalgamating an element of practicality with the higher artistic ideal of achieving expressiveness through whatever means possible. The very boldness with which Eugene manipulated the negative by scratching and painting forced even those with strong sympathy for the purist line of thinking like White, Day, and Stieglitz to admire Eugene's particular touch. Distinguishing in Eugene an "expressive" intent contrary to the "rationality" of Day and Käsebier, Hartmann observed, "All the others think to accomplish their results; he feels." (*Ibid.*)

H. P. Robinson was among the very few photographers taken seriously until then who had established an acceptable style of manipulating the negative, although he did not apply marks and gestures. Eugene created a new syntax for the photographic vocabulary, for no one before him had hand-worked negatives with such painterly intentions and a skill unsurpassed by his successors.

PURISM VERSUS
EXPRESSIONISM

CHAPTER FOUR

CONFLICTING GOALS

PORTRAIT STUDIOS

PORTRAITURE

"Photography as a profession should appeal particularly to women," wrote Frances B. Johnston in the *Ladies Home Journal* of 1898. (Biblio. 1075) Realizing that women were assuming a very special role in the history of photography, Johnston felt that women were particularly suited to portrait photography "by the judicious and proper exercise of that quality known as tact; a woman can, without difficulty (in fact, she can readily), manage to please and conciliate the great majority of her customers—even the most exacting ones." (*Ibid.*, p. 84) Few today would agree that the statement encompasses even one of the reasons for the female renaissance in photography around 1900, nor is it true that talent for portraits was possessed only by women. Her theoretical posture evidently did not endear Johnston to Stieglitz. Despite her great affection for him, which Johnston expressed by resigning from The Camera Club after Stieglitz was expelled in 1908, Stieglitz never reciprocated by adding even a single work of hers to his collection even though they had been acquainted from the mid-1890s.

H. Snowdon Ward estimated that in 1911 there were "sixteen hundred women in the United States . . . working for incomes as proprietors of studios. . . ." (Biblio. 1130, for 1911, p. 34) Ward went on to declare the special contribution of women: "The prices secured by the women are better, on the average, than those obtained by men. . . . Women have had a very large share in breaking down forever the old traditions of professional posing and lighting and in introducing freedom, variety, and individuality into professional portraiture." Admiring photographic portraiture in general, Stieglitz also collected numerous portraits by his male colleagues so that his critics accused him of lacking appreciation for landscape. An inevitable chain of events carried many of those who had begun to photograph as amateurs to a point where they desired to pursue their avocation full time and earn income from doing so. Women did play an interesting role in the rise of professional

portraiture at this time, leading to a general revival of portraiture as a vehicle for creative expression for many of the photographers whom Stieglitz collected.

In America, both Stieglitz and Day recognized the accomplishments of women. In singling out five names as the most promising talent to appear at the 1898 Philadelphia Photographic Salon, Stieglitz included Watson and Käsebier together with White, Day, and Keiley. (Biblio. 898) Of the works by these artists collected by Stieglitz, only Keiley is not well represented by portraits, which are an important portion of his work. Day also included Watson, Käsebier, and Johnston in his New School of American Photography show that traveled to London and Paris during the season of 1900–1901. He had taken every opportunity to endorse the accomplishments of Sears, Devens, and Käsebier to Stieglitz, thus becoming partly responsible for the examples of their photographs entering the Stieglitz collection along with Ben-Yusuf, Boughton, and Clark & Wade (Pl. 27).

Ben-Yusuf had been instrumental in organizing the American Institute Show of 1898 (Biblio. 1319), where her prominently reproduced work attracted the attention of Sadakichi Hartmann. "She had the ambition to become the Mrs. Cameron of America," commented Hartmann, sarcastically concluding, "Until now she had not yet accomplished her ambition." (Biblio. 75) Acceptance of women was not a token gesture, and the critics treated them equally with men. Leveling all his guns, Hartmann observed that compared to the "scientific composition of an Eickemeyer, the epigrammatic Japonism of a Keiley, the decorative lyricism of a Day, Miss Yusuf's work looks rather monotonous." (*Ibid.*) Keiley, on the other hand, was enthusiastic of her work exhibited in the 1900 Philadelphia Photographic Salon: "Two of Miss Ben-Yusuf's four pictures were especially striking, and no matter in what part of the room a visitor might be standing, did he chance to turn his face their way they compelled his attention." (Biblio. 542) Keiley was also attracted to MARY DEVENS's work at the 1899 Philadelphia Salon, which he characterized as "reminiscent of certain immortal canvases of painters long since dead," referring to portraits by Van Dyck. (*Ibid.*) This salon had the added distinction of having Johnston and Käsebier on the jury along with White, Day, and Henry Troth.

Hartmann raised the issue of "professionalism" in his discussion of Eva Watson, where selling photographs was equated with selling flesh:

INCOME POSSIBILITIES

A person who keeps a studio for the purpose of photographing people for a monetary remuneration is *professional* [his italics], no matter whether she avoids the ordinary hackneyed ways of advertising her business, or whether she has a show case standing before her door or not. Her methods of securing customers are simply different from others, and for that very reason, perhaps more shrewd. . . . In my opinion only men like Messrs. Stieglitz, Day and Keiley are artistic photographers: like the true artist they only depict what pleases them, and not everybody [sic] who gives

them twenty-five dollars in return. That is the line which divides artistic and professional photography, as it does art and potboiling. Money has nothing to do with it. . . . (Biblio. 75)

Hartmann's writing on the role of women was muddied by his highly traditional notion of the types of activities for which women could properly receive compensation. His spurious line of thinking suggested that making photographs on commission was a very low form of art, but when done by women was close to prostitution. By casting the issue in this light Hartmann failed to identify a general change in the transition of creative photographers, especially among women, from part-time amateurs to full-time practitioners of the medium. The new status quo emerged with the generation of 1898 who, as full-timers by choice, had to earn livelihoods from their photographs unless, as with Stieglitz, they had independent means.

COMMISSIONED WORK

Johnston and Käsebier led the way in making it acceptable for an artist photographer to do commissioned work. Johnston supported herself on architectural photography and still retained the coveted laurel "artist," a title so difficult to earn initially but easily lost. Such examples as hers not only changed the course of amateur photography as an organized movement, but also caused long-established professionals to reconsider the traditional styles. The famous German portraitist Rudolph Duhrkoop (1848–1918) chronicled the emergence of a new style in commercial portraits and analyzed the positive influence of amateur photography: "The amateur has taught us that it is by no means impossible to take portraits in living rooms, or in the open, with natural and individual surroundings, without artificial background, without head support, and without the unnatural way of retouching the face." (Biblio. 1152, pp. 155–156)

FULL TIME
COMMITMENTS

Suddenly a great many talented Americans who had been photographing part-time wanted to make a full-time commitment. Clarence White, who had been working as a bookkeeper for five years and photographing in his spare time, aired his frustrations to Stieglitz in 1902, long after Käsebier and Ben-Yusuf had established themselves in portrait businesses: "My time is still so limited that when I get an interesting quality in a print [I] have not the time to continue experiments, but am compelled to lay the work by, and again in a week or two take it up only to go over it all again; hence the process is very slow." (Biblio. 1628) The previous March Steichen had written Stieglitz from Paris relating his solution to the problem of finances. Having received as much

SITTING FEES

as one hundred dollars for a portrait sitting of a very important person, Steichen could get ten dollars a print for "professional portraits." He also mentioned having sold for fifty dollars each three different prints from the Rodin sittings. (Biblio. 1610) By 1902 Steichen's estimate of his services was comparable to Käsebier's of only two years before. In 1900, the year she was described in the Newark, Ohio exhibition catalog as "the foremost professional

PLATE 39 » Gertrude Käsebier. *Blessed Art Thou Among Women*, 1899. Cat. 345

photographer in the United States" (Biblio. 1333), Käsebier had sent an in-
voice for photographing Mrs. Alfred Stieglitz and her daughter in which she
charged ten dollars for two prints of "mother and baby." She also offered
another view for five dollars, a print of Mrs. Stieglitz (Cat. 358, 359) for five
dollars, plus an additional "expense for going to house, $10." (Biblio. 1531)
This was the year that Stieglitz, after downgrading the general artistic achieve-
ment of American photographers in 1900, recognized that "decided progress
has been made by a certain class of American professional portrait photog-
raphers in the last two years." (Biblio. 900)

Each member of the generation of 1898 dealt with the problem of earning
a living from photographs a little differently and with slightly different motiva-
tions. In 1900 Day sold his share of the Copeland & Day publishing business.
His desire to establish a portrait studio in London when he arrived there in
early summer of 1900 was not financially motivated. Day's primary purpose
in London at this time was to escort the New School of American Photography
show that he had organized. Although his idea of establishing a studio never
transpired, the exhibition does reflect the sudden attraction portraiture began
to offer, which few experienced at the time.

While Day's attempt to establish a portrait business was abortive, such was
not the case for BARON ADOLF DE MEYER, the most important of the first genera-
tion collected by Stieglitz to devote himself almost exclusively to portraits.
Active in Dresden before 1895, then in London between 1896 and 1914, he
applied himself to portraiture from the start. Very little is known about de
Meyer before his years in London except that according to the Buffalo exhibi-
tion catalog of 1910 (Biblio. 1399) he also lived in Dresden, a fact which
escaped de Meyer's most recent biographers. (Biblio. 311) Portraits by one
Adolf Meyer of Dresden are reproduced in early issues of *Photographisches
Centralblatt* and *Wiener Photographisches Blätter,* where he is listed as resid-
ing in Dresden. He is presumably the same person as the Adolph Meyer listed
intermittently in London's Photographic Salon 1894–1908, and whose name
is listed as Adolf *de* Meyer first in the Photographic Salon of 1898. Consider-
ing that Baron de Meyer had a record of changing his name after Stieglitz
knew him, it can be safely inferred that the Meyers of London and Dresden
are one and the same. Despite de Meyer's exhibitions in contexts that would
have made both his name and his work familiar to Stieglitz much before 1906,
de Meyer was not collected until after that date. Not a word of surviving
correspondence predates de Meyer's introduction to Stieglitz in 1906 by Käse-
bier and Steichen, who admired an uncharacteristic series of still lifes by de
Meyer. Stieglitz, too, was taken by their beauty for he exhibited a group of
them at the Little Galleries of the Photo-Secession in 1907, where he doubtless
acquired the example in his collection. (Cat. 216)

De Meyer's case is of interest on several counts, the most relevant being
that his portraits failed to catch Stieglitz's attention even after the rave review

STILL LIFE

PLATE 40　»　Gertrude Käsebier. *The Bat,* 1904 print of 1902 negative. Cat. 356

in *Photograms of the Year 1898.* (Biblio. 293A) It can be suggested that until then landscape, genre, and architectural studies were the three dominant categories to which the most serious amateur photographers addressed themselves. Portraits were the provenance of either the rankest amateurs doing what were hitherto construed as merely family pictures or the rankest studio professionals working just before the new generation proved that portraits could be expressive as well as professional.

The transition from public subjects, as exemplified in landscape, genre, and architecture, to highly personal subjects was led by Day and White. In selecting his family as models, White was working in the hitherto maligned category of family portraiture. The sheer popularity of White's work was perhaps the result of his introduction of subtle psychological elements (Pl. 48) and a certain air of narrative mystery (Pl. 46) which through their novelty immediately attracted a wide public following. White, in turn, was deeply influenced by Day, who had been previously involved in portraiture but whose reputation was particularly based on his symbolic studies of the Negro (Pls. 24, 30) and of classical (Pl. 31) and Christian (Pl. 32) themes. If Day's New School of American Photography had a planned theme, it was the excellence of portraiture in America. Indeed the American use of figure studies and portraits gave the word "New" an appropriate place in the title. It was ironic that de Meyer's pioneering work in portraiture remained unrecognized, especially by Stieglitz, who ultimately valued de Meyer's still lifes (Pl. 82) more than his portraits.

PHOTOGRAPHIC
ILLUSTRATION

The complex mix of sociology and economic events made portraiture a key topic from a philosophical as well as a financial point of view. The same social and economic obstacles did not exist for all part-time photographers who stretched to find full-time occupations. Making photographic illustrations for books and magazines was a job many generations of illustrators had well established even before the application of photography. The limits on the artistic freedom of illustrators, defined by the text to be illustrated, were even more restricted than in portraiture which was but one of several commercial applications. William H. Dyer (Pl. 23), who came to Stieglitz's attention probably through Clarence White, had established himself as a photographic illustrator in Chicago by 1897. Only two years before, Steichen had been discouraged by the editors of *Scribner's* and *Century* magazines on the feasibility of photographic illustration for magazines. Not too long after Keiley had described Dyer as "one of the features of this year's salon [1900]" (Biblio. 542), Dyer proudly reported to Stieglitz that he would charge Lathrop & Co. Publishers five hundred dollars for twelve or fifteen studies so they would realize that "photographs are not make-shifts in illustration and are not 30-cent goods." (Biblio. 1510) Established outside the Stieglitz circle, Dyer's career after the 1912 Montross Gallery exhibition where his works were featured remains a mystery.

In London, WILL and Corrine CADBY had also carved out for themselves

PLATE 41 » Gertrude Käsebier. *The Sketch*, 1899. Cat. 348

their role as photographic illustrators, as had the HOFMEISTER brothers in Hamburg, Germany. (Biblio. 1307) By 1902, almost a dozen of the amateurs who had caught Stieglitz's attention were attempting to make their livelihoods from photographs, thereby narrowing the former distinction between amateur and professional.

STIEGLITZ: EDITOR AND EXHIBITION DIRECTOR

CAMERA NOTES
RESIGNATION

In the spring of 1900 Stieglitz tendered his resignation as Vice-President of The Camera Club, the first of a series of changes that were to affect his life during 1900–1902. The following December, a popular Philadelphia photographer-critic, Dr. Charles Mitchell, wrote a scathing criticism of Stieglitz's photographs at The Third Philadelphia Photographic Salon as works derivative of popular Dutch genre painting. (Biblio. 1334) Perhaps sensing the hostility towards him, Stieglitz resigned from the Photographic Society of Philadelphia. In June of 1902 he resigned as editor of *Camera Notes* after being informed by the president of The Camera Club that the journal lacked relevance to the members. Stieglitz's health had begun to suffer from the pressures, and in September of 1900 an editorial note published the condolence:

ILL HEALTH

"It is particularly to be regretted that Mr. Stieglitz, through his ill health and preoccupation, has been unable to do anything this year to keep up his succession of interesting works which his hand had produced." (Biblio. 961) Stieglitz did not produce another memorable run of photographs until the winter of 1902/1903, when some of his most melancholic New York views were made, among them, *Spring Showers, The Hand of Man,* and *The Flat Iron Building.* In 1901 Stieglitz was very busy putting the pieces into place in preparation for the new direction his career would take with the establishment of a new publication, *Camera Work,* that appeared late in 1902 with a cover date of 1903.

Stieglitz's professional life had also begun to show another facet in addition to his role as publisher. He became increasingly involved with selecting and organizing the American representation in European international exhibitions. Despite Day's New School of American Photography show which had focused attention on the generation of 1898, it was Stieglitz, with his longstanding European contacts, who was asked to make future selections. J. Craig Annan in 1899 had invited Stieglitz to arrange for the American representation at the

GLASGOW EXHIBITION

Glasgow International Art Exhibition that opened in the spring of 1901. Day had wanted to see his New School of American Photography show hang there as well as in London and Paris, but Glasgow was destined to be the scene of Stieglitz's debut as director of the American section of an invitational exhibition. This was also apparently the first instance that a major exhibition of modern American photographs had been selected without the moderating force of

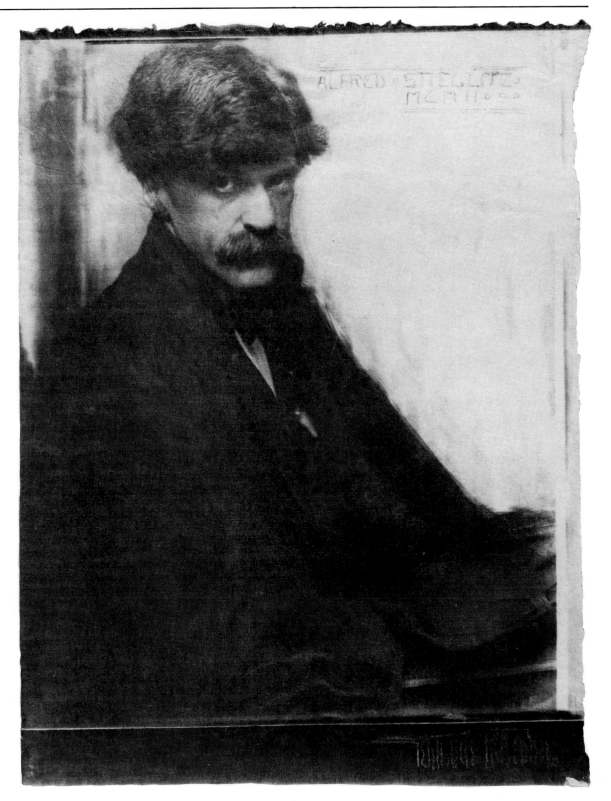

PLATE 42 » Gertrude Käsebier. *Alfred Stieglitz*, 1902. Cat. 354

a committee. Firm in his preferences, Stieglitz in his arrangement of rosters for exhibitions generally listed them in descending order of their importance to him. The Glasgow list, including also his own work, read as follows: Käsebier, White, Eugene, Keiley, Steichen, Eickemeyer, Dyer, Ben-Yusuf, Clark & Wade, Abbott, Watson, Post, Berg, Johnston, Dumont, Clarkson, Adamson, Bullock, Stirling, Edmiston, Troth, and Fergusson. The first half-dozen names came to be well represented in the Stieglitz collection. Conspicuous by absence was Day, whose photographs Stieglitz admired enormously and had wanted to include in the show. Even after blackballing Day's New School of American Photography, proposed to The Linked Ring the year before, Stieglitz had the courage to invite Day, who naturally refused to cooperate. Stieglitz had not yet closed his list of names, but rather he was still looking and thinking. Three-dozen American photographers were shown at Glasgow, of which nine, including Frances B. Johnston, never entered the Stieglitz collection.

The Glasgow photographs comprised the first sizable exhibition of works by others which represented Stieglitz's personal choice. It also was the first sizable number of prints that he, before the group was forwarded to Glasgow for hanging, personally had in his possession to study carefully. The first-hand experience with these works perhaps accounts for the fact that more of the Glasgow group than of any other prior exhibition entered the Stieglitz collection, among the highlights being: Steichen's *Self Portrait* (Cat. 450), *Landscape-Evening* (Cat. 451), *Landscape—Interior of Woods* (Cat. 452); Eugene's *Adam and Eve* (Cat. 226), *La Cigale* (Cat. 228); Käsebier's *Blessed Art Thou Among Women* (Cat. 345); and White's *The Ring Toss* (Cat. 551), *Spring* (Cat. 554), and *Letitia Felix* (Cat. 536, 537, 541). These photographs had all been exhibited before but not collectively in one place.

Stieglitz's resignation from *Camera Notes* only served to emphasize the annoyance he shared with his friends towards The Camera Club, which did not become apparent until after the Glasgow selections had been made. Since a generous sampling of Club members was included (among them, Berg, Johnston, Dumont, and Clarkson), Stieglitz couldn't be accused of disloyalty in looking outside the Club for his selections. The demise of *Camera Notes* turned Stieglitz, at least privately, against the Club, and he made every attempt to circumvent its authority.

At the age of thirty-eight, Stieglitz had come to realize that The Club had outlived its function for him. He discussed with John Aspinwall the feasibility of reorganizing The Camera Club on "broad and progressive principles." (Biblio. 1436) Aspinwall liked the idea and even proposed that within the Club a special group be formed that would elect its own members, a concession made to encourage the continued association of Stieglitz, whose departure seemed imminent. Stieglitz submitted to Aspinwall a proposal to form a new association of photographers that would be very loosely organized with

PLATE 43 » Gertrude Käsebier. *Clarence H. White and Family*, 1908 print of negative from 1902. Cat. 360

SEEDS OF THE
PHOTO-SECESSION

no president, no secretary, no dues, no club rooms, and no regular meetings (to paraphrase Stieglitz's words). The proposal got nowhere at The Camera Club, but it was soon to be implemented by Stieglitz acting independently. The idea of an elite corps of Americans had already occurred to Demachy, who followed events in the United States more closely than most of his colleagues. Shortly after Stieglitz's resignation from *Camera Notes* in June of 1902, Demachy suggested supportively, "You must get all of the same men together over there and start some sort of American Linked Ring." (Biblio. 1505) Keiley had likewise expressed the same thought in October of 1901, just before he resigned from the Print Committee of the Club.

Thinking over the photographic situation I am convinced that the time has come at last in which to form some skeleton organization among the pictorial workers— White, Redfield, Bullock, Stirling, Mrs. Watson-[Schütze], Becker, Maurer, Mullins, James, Lawrence and the others . . . an American Linked Ring so to say that will be more effective and progressive than its prototype over the sea. What do you think? Am I right?

asked Keiley, anticipating events that would lead to the formation of *Camera Work* to replace *Camera Notes,* and the Photo-Secession to replace The Camera Club. (Biblio. 1541)

ABORTED DURAND-RUEL
EXHIBITION

Before moving in the direction Demachy and Keiley suggested, Stieglitz and Charles Caffin, among others, contemplated mounting an exhibition in competition with the Club's exhibition. They explored the possibility of hiring the Durand-Ruel Gallery for a special exhibition but tabled the idea when they learned the space would cost five hundred dollars for two weeks. (Biblio. 1465) That became an unnecessary alternative when Stieglitz was invited the following December to join F. Benedict Herzog (illustrated in *Camera Work,* No. 12, January, 1905) and Chas. I. Berg on a special committee to consider mounting photographs for the first time in the galleries of New York's National Arts Club. Berg had been Chairman of the Print Committee at The Camera Club, where periodic disagreements with Stieglitz would lead him to be among those who pressed for Stieglitz's resignation from the Club in 1908. Herzog, on the other hand, was a good friend. The trio selected a benchmark exhibition which opened on the snowy night of March 5, 1902, where the term "Photo-Secession" was first used for an American movement, in the title "American Pictorial Photography Arranged by The 'Photo Secession.'" A new word, "Photo-Secession" (his quotes),thus entered the English language, and the spirit and partially formed *corpus* of a new movement were presented to the public. The title of the show was pure Stieglitz, who was soon asked by Charles de Kay, Director of the National Arts Club, "What is 'The Photo-Secession?'" Stieglitz replied, "Yours truly for the present, and there will be others when the show opens." (*Ibid.*) The first printed roster

PLATE 44 » Clarence H. White. *Portrait—Letitia Felix*, about 1901. Cat. 536. Actual size.

of the Photo-Secession (Biblio. 915) cited the founding date of February 17, 1902, three weeks before the National Arts Club show opened. The assigned date is misleading since the Secession was not founded but rather came into being through an evolutionary process that began, as Stieglitz himself said, when those represented in the National Arts Club show congealed into a loosely knit group with Stieglitz as spokesman.

NATIONAL ARTS CLUB
EXHIBITION

On the opening night of the National Arts Club show, the photographers and guests arrived unaware that an infant had been born. Stieglitz later recollected his conversation with Käsebier at the opening. "What is this Photo-Secession?" asked Käsebier, "Am I a Photo-Secessionist?" "Do you feel you are?" inquired Stieglitz. "I do," she responded and Stieglitz concluded, "that's all there is to it." (Biblio. 919, p. 117) To most people, including Käsebier, the "Photo-Secession" was for the time being little more than Stieglitz and three editorial associates of the as-yet-unborn publication *Camera Work*. In December of 1902 Stieglitz sent to the photographers on his roster a broadside soliciting their responses to the idea of the "Photo-Secession." By the time the first issue of *Camera Work* was issued late in December of 1902 but dated January of 1903, six photographers had lent their support to the organization: Steichen, Käsebier, White, Dyer, the recently married Watson who now called herself Watson-Schütze, and Frances B. Johnston.

Just as White had dominated his Newark, Ohio invitational of 1900 and Day his New School of American Photography, so Stieglitz himself was the star of the National Arts Club show with seventeen photographs. His close ally Joseph Keiley followed with fifteen. Käsebier and Steichen exhibited fourteen; White and Dyer (close friends) thirteen; Eugene and Day, ten and eleven respectively. Eight of the thirty-one exhibiting photographers contributed one hundred twenty-one of the total one hundred sixty-two works. These most heavily represented eight correspond to the first half-dozen names of Stieglitz's Glasgow group (excepting Dyer) and also to seven of the strongest units of the Stieglitz collection. Despite the committee method of selecting the National Arts Club show, the top tier of the exhibition was very much representative of Stieglitz's taste. The second tier, consisting of the many names unfamiliar to Stieglitz's roster, each with one to three works, typified the result of committee work.

NO PAINTERS ON JURY

The absence of painters on the jury of the National Arts Club show broke precedent. Stieglitz had hitherto felt it was essential to have painters and sculptors on the salon juries. In 1902, he unexpectedly reversed his position, using the National Arts Club show to test the theory that there should be no painters judging photographic exhibitions. Stieglitz argued that "photographers will be called upon to judge photographs, just as the sculptor is called upon to judge statues, the landscapist landscapes, the marine painter marines, the figureman figure work, the etcher etchings, the architect architecture, etc."

Plate 45 » Clarence H. White. *The Bubble*, 1898. Cat. 540

(Biblio. 913) Some of the more conservative members of the American and European camera clubs had initially adopted the same posture to the question of jury composition. Stieglitz's reversal on the issue introduced an element of confusion for those who wished to legitimize artistic photography by attaching it to the coattails of painting.

Stieglitz had his own opinion on the importance of the National Arts Club show. "Not only was the exhibition national in the localities represented, but, strangely enough, all printing media from aristo to 'gum bichromate,' on the one hand, and bromide to 'glycerine-platinotype' on the other, were embraced, thus showing the Photo-Secessionist is committed to no other medium than that which best lends itself to his purpose." (Biblio. 916) At the time of his writing, there were no more than a handful of Photo-Secessionists, and through this statement Stieglitz conveyed a very clear message to potential supporters. He was still struggling to establish that he was not a single-minded advocate of one printing method, as might have been suggested by both his earlier writing on gum and platinum printing and his 1899 retrospective exhibition that had included so many gum prints.

It was while the National Arts Club show was still hanging that Stieglitz received the telephone call described in the introduction from the secretary to General Luigi Palma de Cesnola, director of The Metropolitan Museum of Art, regarding the American representation at the Photographic Section of the Esposizione Internationale di Arte Decorativa Moderna in Turin, Italy. The call from de Cesnola's office came at the very moment when Stieglitz was torn between his role as a member of The Camera Club, where he received his mail at the time, and his emerging role as an independent organizer of exhibitions. Stieglitz was not an officer of The Camera Club at the time, and he accepted the Turin assignment as a personal one, thereby causing some confusion since the rest of the Turin exhibition was arranged by the various European camera clubs. He was shocked when the King's prize was awarded to the Americans under the collective name of The Camera Club of New York. He took great pains in several long letters to remove both the praise and the responsibility from The Camera Club, which had not delegated him to make the selection and where there might not have been unanimous approval of his selections. Stieglitz also undoubtedly wanted the credit given to his role as the "eye," but the incident only served to create new tensions upon those which had already fomented his resignation from *Camera Notes*.

The Turin exhibition was not monographically organized but consisted of sixty photographs by thirty Americans, out of whom only eleven became significant to Stieglitz's future program of publications and exhibitions or to his collection. Eugene, Käsebier, Keiley, and Steichen were there to be sure, but so were such unknowns as McCormac, Cassavant, Stoiber, Fergusson, Edmiston, Stirling, Adamson, Sloane, Ladd, and Becher. Except for Fergusson, they had never before appeared in Stieglitz's rosters and represented a diverse geographical range including Ohio, Delaware, New Jersey, Pennsylvania,

TURIN EXHIBITION

Illinois, and Oregon. The unexpected presence of so many newcomers did not go unnoticed by Stieglitz's old friends. "I feel somewhat hurt as I notice [at Turin] names of people I never saw before," wrote veteran William B. Post to Stieglitz, after seeing the selections. (Biblio. 1589) Stieglitz's choice for Turin evidently was intended to show that as director of the Photo-Secession he would not be riding all the same hobby horses from his old roster. While shaping his thoughts on collecting and exhibiting photographs and generally becoming visible in the world of photography, Stieglitz made new friends but alienated several of his old ones.

STEICHEN

One person—Steichen—was to begin to play an extraordinarily influential role in Stieglitz's life as a friend, counselor, and critic. Many of Stieglitz's key decisions as to who would be published in *Camera Work* and then later exhibited in the Little Galleries of the Photo-Secession were influenced by Steichen.

Steichen was at the time bringing to a triumphant close his brief but stellar residence in Paris. Towards the end of the National Arts Club exhibition, Steichen sent Stieglitz an urgent cablegram from Paris relating how his photographs had been excluded at the last minute from the prestigious *Champs de Mars Salon* due to "jealousies and political intrigue within the Salon itself." (Biblio. 911) Just before the cable arrived, Stieglitz had written that Steichen was to be "the first photographer whose prints were admitted to an art exhibition of any importance," an event that was awaited with great anticipation in New York and elsewhere. Many felt that artistic photography suffered a setback when Steichen's photographs were rejected from the *Champs de Mars Salon,* despite the acceptance of his paintings and drawings. Steichen, however, did not leave Paris without a one-man show at the *Maison des Artistes* of his prints in two styles. "Series A contained straight prints without any manipulation or retouching. Series B consisted of prints obtained by different processes that permitted manipulation in varying degrees. In the exhibition catalog I referred to Section B as *Peinture à la lumière,* Painting with Light," wrote Steichen. (Biblio. 751, p. 21) Despite the apparently equal roles shared by painting and photography in Steichen's life at the time, he consistently showed basic instincts of the photographer. "There are, in my opinion, certain pictorial ideas that can be expressed better by photography than by any other 'art medium,' " Steichen told Stieglitz, who later observed that "[Steichen] has taken up artistic photography as another painter might take up lithography or etching." (Biblio. 757)

Steichen was uncertain whether his future was really as a painter or as a photographer. After his recuperative visit to Wisconsin in 1902 Steichen settled in New York and established a studio at 291 Fifth Avenue. "It is my ambition to produce a photography gallery of great people, present the series of enlargements to a big museum, and publish the same in book form. It will be my life work," declared Steichen in an interview of 1902, publicly committing his life to photography. (Biblio. 759) Ironically, the portraits of *Rodin* (Cat. 460), *von Lenbach* (Cat. 461), *Maeterlinck* (Cat. 464), and

Watts (Cat. 459) did arrive at The Metropolitan Museum of Art via the circuitous route of the Stieglitz collection, and as Steichen hoped, they also were published as a book. (Biblio. 764)

"He will never find elsewhere the special atmosphere of *mon cher* Paris," wrote Demachy to Stieglitz lamenting Steichen's departure from Paris for the States, where Steichen was not bashful about publicizing his European success. (Biblio. 1505) " 'The Black Vase' [(Cat. 490) exhibited in the Brussels Photographic Salon] has been officially recognized as worthy of a place in a national collection and was purchased by the Belgian government, which ordered it hung in the National Gallery, Brussels," said Steichen in his first New York interview. (Biblio. 759)

Stieglitz had just finished his longest and most thorough piece of historical writing, "Modern Pictorial Photography" (Biblio. 914), which, as the title suggests, is a chronicle of the events that culminated in the National Arts Club show. Stieglitz mentioned in the article nineteen of the fifty names that eventually constituted his collection in the following order: Kuehn, Henneberg, Watzek, the Hofmeister brothers, Demachy, Annan, Hinton, Davison, Calland, Steichen, Käsebier, Eugene, White, Watson-Schütze, Dyer, Day, Devens, Clark, and Keiley. Following the precedent set in the Glasgow selection, the list was arranged by nationality in a hieratic order, with Kuehn being the first among Austrians, Demachy the first (and the only in this case) among the French, Annan leading the British, and Steichen temporarily replacing Käsebier, who headed his earlier lists, as the premier American. Stieglitz's "Modern Pictorial Photography" roster established the nucleus of those who would soon be featured in succeeding issues of *Camera Notes,* and to which few names would be added, even in the *Camera Work* epoch.

FOUNDING *CAMERA WORK*

The record is unclear on the exact sequence of events that began with the National Arts Club exhibition, where the Photo-Secession took its first shape, and led to the birth of *Camera Work,* that was so important to the last phase of Stieglitz's role as a collector. There are three parts to the equation, for which documentation is sparse, and meaningful interpretation thus requires a certain amount of inference. The events occurred roughly in the following order: Stieglitz assigned the name "Photo-Secession" (a word usually printed with quotation marks by Stieglitz, following the style set by the 1898 Munich "Sezession," Biblio. 1318) in March of 1902 as the subtitle to the National Arts Club show called American Pictorial Photographs. The title, chosen before there was even an informal organization, was intended by Stieglitz as a direct gesture of separation from The Camera Club, where tensions precipitated his resigna-

PLATE 46 » Clarence H. White. *The Kiss*, 1904. Cat. 553

tion as Editor of *Camera Notes* in 1902. The last number of *Camera Notes* to appear under Stieglitz's direction was the July issue which carried an extensive article on the Photo-Secession. Stieglitz invited reproach by flaunting his new creation in the face of those whose authority he wished to supersede.

EDITORIAL ASSOCIATES

Unemployed for the time being, Stieglitz and Keiley came together with other former editorial associates at *Camera Notes,* Dallett Fuguet and John Francis Strauss, to publish *Camera Work,* which appeared late in 1902, dated January 1903. It served the immediate purpose of reemploying them all. The name "Camera Work" was derivative of the euphemism commonly used by photographers to describe themselves. As early as 1899 White described his associates to Stieglitz as "camera workers," and it was doubtless from such a usage that Stieglitz adopted the phrase which later became a household word in the world of photography. (Biblio. 1247) The funds for *Camera Work* came presumably from Stieglitz, who acted as its sole proprietor in editorial decisions, but the other three parties were financially secure and could equally have afforded to invest in the new enterprise.

FINANCES

The relationship of *Camera Work* to the Photo-Secession is particularly confusing. Issue Number One carried an opening editorial statement signed by the four editors of *Camera Work,* the self-contradictory nature of which suggests there was lack of clarity in the authors' minds. *"Camera Work* owes allegiance to no organization or clique, and though it is the mouthpiece of the 'Photo-Secession' that fact will not be allowed to hamper its independence in the slightest degree." They apparently did not recognize that it was impossible for *Camera Work* to be the mouthpiece of the Photo-Secession and at the same time be completely independent of it. The result was an attempt to create an artificial separation between the two units. The Photo-Secession was initially an amorphous social organ (no president, no regular meetings, no clubhouse), the members of which were intended to give credibility to the infant journal that had little or no constituency at birth. The reputable members, serving as a platform for *Camera Work,* became the sponsoring body of the journal modeled on The Camera Club's *Camera Notes* and *Wiener Photographische Blätter* (Biblio. 1256), the organ of the *Camera-Klub* in Vienna. These publications were clearly distinct from such commercial publications as *Photographic Times* and *The Amateur Photographer* which, through the active solicitation of advertisements, attempted to make a profit for the publishers. Stieglitz created a not-for-profit undertaking, an important philosophical premise if the art-for-art's-sake editorial policy was to be maintained. The non-profit posture was fundamental to Stieglitz's thinking, dominating his personal life and driving him to a near penniless state by the First World War.

EDITORIAL POLICY

HOSTILITY TO SECESSIONISM

It was perhaps Stieglitz's wish to make the Photo-Secession and *Camera Work* more closely parallel than circumstances permitted them to be at the outset. Stieglitz and his associates failed to anticipate the hostility which the

PLATE 47 » Clarence H. White. *Coming Through the Door*, 1898. Cat. 550

radical artistic and social concepts behind the international secessionist movements would generate among the conservative elements of advanced amateurs in America who constituted the audience for his publication. The introductory editorial in Number One appealed to this very audience, those "who have faith in photography as a medium of individual expression, and to make converts of many at present who are ignorant of its possibilities." The desire to make *Camera Work* appealing to as broad a spectrum of subscribers as possible moderated the radical and elitist aspects of the Photo-Secession. Later, between 1910 and 1917, *Camera Work* would function primarily as a mouthpiece for progressive movements in painting and sculpture.

Stieglitz planned to inaugurate *Camera Work* with a portfolio of gravures after photographs of F. Holland Day, who had played such an important role in the early issues of *Camera Notes* and whose photographs were enormously popular in Europe. "The final o.k. will be left in your hands—It may be necessary to have the negatives for a few days in order to obtain the very best results," wrote Stieglitz to Day in a vain hope that he might concede in having his works reproduced. (Biblio. 1498) But Day was still offended by Stieglitz's interference eighteen months before with the New School of American Photography show and did not respond to Stieglitz's request.

DAY UNCOOPERATIVE

Gertrude Käsebier, also popular in Europe, returned to her former place at the top of Stieglitz's list after briefly being replaced by Steichen, who was granted the leading American role at the Glasgow exhibition. She was represented in *Camera Work* Number One by six gravures, two of which had already appeared in *Camera Notes,* the two original prints which Stieglitz had in his collection (Cat. 343, 345). Stieglitz's *The Hand of Man* constituted another gravure, along with one by the hitherto unheard of A. Radclyffe Dugmore.

Camera Work was special in every way. For an extra fifty cents a subscriber received his copy specially packed and registered. The texts, consisting of poetry, satire, and tongue-in-cheek criticism, differed dramatically from the arid prose of *Camera Notes*. In his first editorial Stieglitz expressed gratitude to the photographers to whom he was indebted in the following order: Demachy, Cadby, Steichen, Käsebier, Eugene, Annan, White, Dyer, Watson, Frances B. Johnston, and R. Child Bayley. It is remarkable that Stieglitz, after having spent seventeen years in photography, during which time he had come into contact with scores of photographers and editors with whom he developed reciprocal relationships, cited only eleven photographers' names as being of key importance at this important juncture in his life as a collector and publisher. Stieglitz's admiration for Demachy, Steichen, Käsebier, Eugene, Annan, and White is reflected in his in-depth collection of their work, and their presence in the acknowledgment list could have been predicted by a close study of the collection. The specific importance Stieglitz

CHARTER
PHOTO-SECESSIONISTS

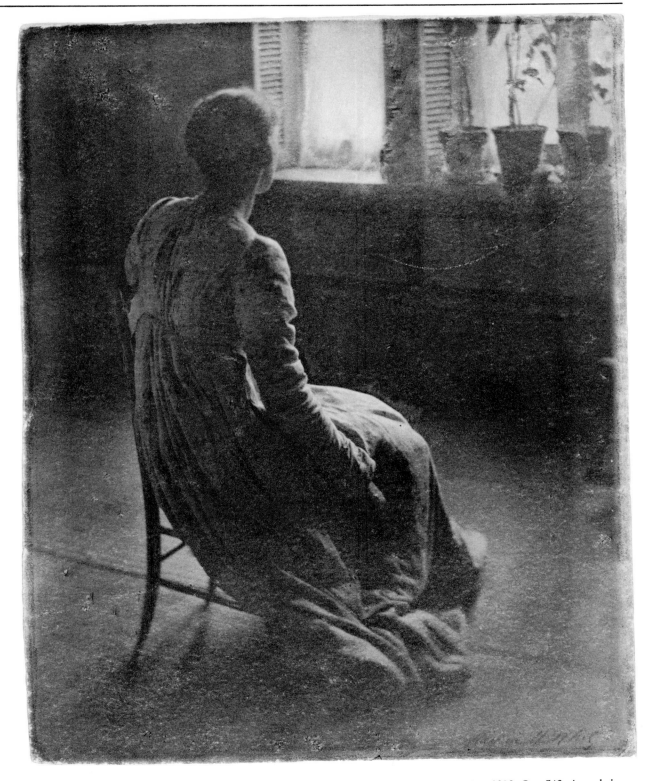

PLATE 48 » Clarence H. White. *Evening—Interior,* 1899. Cat. 542. Actual size.

attached to Cadby, Dyer, and Watson-Schütze, who were each represented by a single work in the Stieglitz collection, remains undefined, but it is probable that they were important to him for reasons other than their roles as artists and photographers. The same can be said for Johnston and Bayley, neither of whom are represented in the Stieglitz collection.

THE BIG FIVE

When Stieglitz's old friend, the wealthy recluse William Post, received his first number, he immediately fired off a tart response. "Are you going to shut out from *Camera Work,* everyone except the big five?—Käsebier, Keiley, White, etc.—You do well, however, to stick by Steichen. His work is the best I have ever seen in photography—Even better than yours, old man, and that is saying a good deal." (Biblio. 1589)

Number Two was devoted exclusively to Steichen, who in succeeding years had more full-page illustrations in *Camera Work* than any other photographer. Twenty-two of Steichen's originals were reproduced in *Camera Work* and collected by Stieglitz, thus comprising the most important body of work by a single photographer in the Stieglitz collection.

The first two numbers of *Camera Work* established patterns that would repeatedly recur in the publication until 1910, when photographs ceased to be important. During the first six to eight years, most of the issues illustrated one photographer prominently (as with Käsebier in Number One), along with a token one or two illustrations by two or three other photographers. Other issues would exclusively feature one photographer, a precedent established with Steichen in Number Two. It ultimately became a great status symbol to have an entire issue of *Camera Work* devoted to one's work, but it was no less significant to be represented by four or five gravures, thus being the featured photographer in a given issue.

Camera Work Number Three showcased Clarence White with three gravures and two halftones, along with a single halftone after Joseph Keiley and a single gravure after Stieglitz's *Design for a Poster*. Also included were three new discoveries, names (as with Dugmore of Number One) that had not yet appeared either on the domestic or international exhibition scene, nor on any of Stieglitz's rosters of names: Ward Muir, John Francis Strauss (an associate editor of *Camera Work*) and Alvin Langdon Coburn, whose reputation would rise meteorically following the pattern established by Day and Käsebier half a decade earlier. Numbers Four and Five featured respectively Frederick H. Evans and Robert Demachy; Number Seven, the Hofmeister brothers of Hamburg; Number Eight, J. Craig Annan; issues Nine and Ten returned to White and Käsebier, starting the cycle over again.

COBURN ENTERS THE CIRCLE

Coburn would star in issue Number Six, as White had in Number Two. After issue Number Five, such unfamiliar names as Muir and Strauss with token representation no longer appeared, and a more conscientious loyalty to Stieglitz's old friends became the rule. When names new to Stieglitz's roster appeared such as Seeley in Number Fifteen (July, 1906), de Meyer in issue

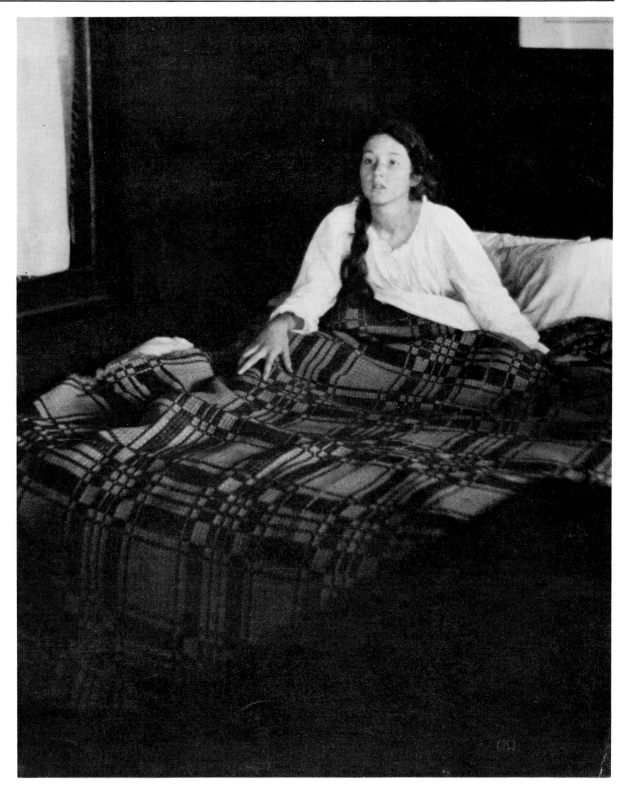

PLATE 49 » Clarence H. White. *Morning—The Coverlet*, 1906. Cat. 549

Number Twenty-four (October, 1908), Brigman in Number Twenty-five (January, 1909) and Strand in Numbers Forty-eight and Forty-nine/Fifty (1916–1917), they were given full-dress treatment from the start. Through issue Number Seven (July, 1904), the policy of every issue having token representation by unknown talent was followed doubtless to appeal to such critics of elitism as Post.

The first two-and-a-half years of *Camera Work* differed little from Post's predictions in his letter to Stieglitz. The sole exception was that an American big five had been replaced with an international quintet, all of whose reputations had been established before 1900. Only Coburn (July, 1903) can be considered to have been an infusion of new blood. The remainder of illustrations in Numbers Seven through Ten form a list straight from the "Modern Pictorial Photography" roster. In addition to those already mentioned were Devens, Watson-Schütze, and Hinton. There was not a single discovery until George Seeley (Herzog in Number Twelve, while not in the Stieglitz collection, was an old friend) in Number Fifteen.

THE PHOTO-SECESSION BEFORE THE LITTLE GALLERIES

AIMS AND GOALS OF
PHOTO-SECESSION

In December 1902, no doubt printed simultaneously with the first issue of *Camera Work* (which also appeared that month although dated January, 1903), Stieglitz published a broadside headlined *The Photo-Secession* with a small banner that read: "Founded February 17, 1902." The February, 1902 date must have commemorated the conversation between Stieglitz and Charles Dé Kay (Biblio. 957), Director of the National Arts Club, on the occasion when Stieglitz proposed calling the exhibition he was organizing a "Photo-Secession." (Biblio. 919) The aims and purposes of the new organization were firm in Stieglitz's mind and were listed by him in an orderly fashion:

THE OBJECT OF THE PHOTO-SECESSION IS:

TO advance photography as applied to pictorial expression;
TO draw together those Americans practicing or otherwise interested in the art, and
TO hold from time to time, at varying places, exhibitions not necessarily limited to the productions of the Photo-Secessionists or to American work.

THE PHOTO-SECESSION CONSISTS OF:

1. A *Council,* composed of a Director and twelve others, to whom is absolutely committed the management of the affairs of the organization. The Council until 1905 shall consist of the Founders of the organization. Thereafter the Council shall

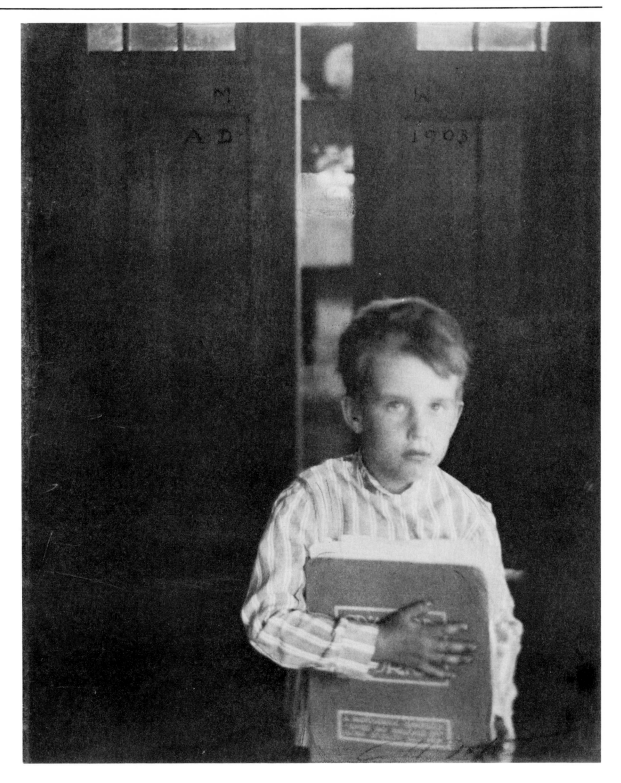

PLATE 50 » Clarence H. White. *MW—A.D. 1903*, 1903. Cat. 544. Actual size.

consist of the Founders and five additional Fellows elected biennially by the Fellows.

2. Of *Fellows,* chosen by the Council.
3. Of *Associates.*

FELLOWS SHALL BE ENTITLED:

1. To elect from their own body the five additional members of the Council.
2. To the admission of two new pictures, without submission to the jury, in all exhibitions devoted solely to the work of the Photo-Secession, but no limit shall be placed upon the number of prints which they may submit to the jury.
3. To vote for the admission of applicants to associateship.

ASSOCIATES SHALL BE ENTITLED:

1. To submit work to the jury at all Photo-Secession exhibitions.
2. To participate in such privileges as may be secured to the organization.

MEMBERSHIP in any class carries with it the right of admission to all private views of exhibitions held by the Photo-Secession and to a general card of admission thereto, as well as a right to participate in any General Meeting called by the Council.

TO be eligible to Fellowship it is necessary to demonstrate to the satisfaction of the Council that the applicant is entitled by reason of his photographic work or labors in behalf of pictorial photography to this rank.

TO be eligible to associateship, interest in the aims of the organization is the sole requirement.

THE discipline of the organization shall be in the hands of the Council.

IN order that the Photo-Secession may exercise a potent influence upon the welfare of pictorial photography, each member will be duly advised by the Council of the attitude which the Photo-Secession will assume toward any important exhibition and whether it is deemed desirable that the members of the Photo-Secession shall exhibit as a body, or individually.

AS sympathy with the ideals of the Photo-Secession and mutual fellowship will actuate all members, it is unnecessary and impracticable to hamper the organization with constitution or by-laws.

ORGANIZATION-DUES of five dollars, payable annually to the Director prior to February first of each year will be assessed to meet incidental current expenses.

MEMBERS will receive intermittent printed communications relating to the activities of the Photo-Secession.

The following were listed as the Council of The Photo-Secession, all but four of whom are represented in the Stieglitz collection: John G. Bullock, Pennsylvania; Wm. B. Dyer, Illinois; Frank Eugene, New York; Dallett Fuguet, New York; Gertrude Käsebier, New York; Joseph T. Keiley, New York; Robert S. Redfield, Pennsylvania; Eva Watson-Schütze, Illinois; Eduard J. Steichen, New York; Alfred Stieglitz, New York; Edmund Stirling, Pennsylvania; John Francis Strauss, New York; and Clarence H. White, Ohio.

PLATE 51 » Clarence H. White. *Spring—Triptych*, 1898. Cat. 554

A MANIFESTO

A brief statement of the aims and goals of the Photo-Secession was published in issue Number Two. It did not equal in intensity Stieglitz's statement in a small pamphlet published by the Bausch & Lomb optical corporation that was the first manifesto of the Photo-Secession. Couched in the rhetoric of European social radicals, it suggested that artistic progress, the key premise of modernism, was at the heart of the Photo-Secession:

> In all phases of human activity the tendency of the masses has been invariably towards ultra conservatism. Progress has been accomplished only by reason of the fanatical enthusiasm of the revolutionist, whose extreme teaching has saved the mass from utter inertia. . . . What is today accepted as conservative was yesterday denounced as revolutionary. It follows then, that it is to the extremist that mankind largely owes its progression. . . . The Secessionist lays no claim to infallibility, nor does he pin his faith to any creed, but he demands the right to work out his own photographic salvations. (Biblio. 920)

The tone of the manifesto was political and dogmatic, in contrast to the actual poetic and literary stylizations that were printed in *Camera Work*. The discrepancy in tone reveals that *Camera Work* was never really a mouthpiece of the Photo-Secession. There was but a single short piece that attempted to define the Photo-Secession in much less strident terms than those quoted above. It was not until the formation of the Little Galleries of the Photo-Secession late in 1905 that the Photo-Secession came to have a corpus. Even then the exhibitions rarely coincided with the publication of an issue of *Camera Work* devoted to the same photographer. Beginning with issue Number Two, a regular column first called "Photo-Secession Notes," and later, "The Photo-Secession," and finally "Exhibition Notes," was the slim thread in print connecting *Camera Work* and the exhibition program at the Photo-Secession Galleries.

RESISTANCE TO STIEGLITZ

There was a certain amount of hostility towards the Photo-Secession from photographers like William B. Post, who had long been a friend of Stieglitz. When he received the "Photo-Secession" circular inviting his participation, Post expressed his discomfort with the structure of the group:

> Am I to understand it as an invitation to join [the Photo-Secession] or is it a notification of election? As I read over the paper it appears to be a clique, who vote to themselves absolute command for all time, but who wish outsiders (like myself) to come in under the name of "Associates"—This class will have to pay $5.00 per annum and also bind themselves to pay pro rata, for all the mistakes of the first class called "Fellows" and "Council."—It seems to me also that a member binds himself to do nothing in the way of showing his work, without first asking permission of the aforesaid clique.—Who is the Director? In what class am I invited to join, and if I accept what are my financial obligations? What has Dallet Fuguet and John Francis Strauss ever done for photography that entitles them to hold down a chair before the Council fire? (Biblio. 1590)

PLATE 52 » Clarence H. White. *The Bubble*, 1905 print [from 1898 negative?], Cat. 558

Stieglitz was concerned that his new publishing venture be financially sound, which required the loyalty of subscribers. They, too, would have been as up in arms as Post had they known their *Camera Work* subscription was floating such a potentially radical organization as the Photo-Secession, as envisioned in the Bausch & Lomb circular.

Stieglitz described the Photo-Secession as a loosely organized group. Indeed it had no president, although in exhibition catalogs Stieglitz was referred to as the director. Meetings occurred in public places like the Holland House or Mouquin's restaurants, where the social-club role of the Photo-Secession became evident. However, in 1903 and 1904 the primary function of the Photo-Secession was to supply loans to various exhibitions in which the borrower was required to keep the collection of photographs together and to catalog it as the "Loan of the Photo-Secession." By August of 1903 Stieglitz claimed loans had

PHOTO-SECESSION LOAN EXHIBITIONS

been made to Turin, St. Petersburg, *Photo-Club de Paris,* Wiesbaden Art Gallery, *L'Effort* (Belgium), Hamburg, Toronto, Denver, Minneapolis, Cleveland, and Rochester. These exhibitions brought the best in current American photography before public eyes for the first time.

The two most important American exhibitions after the National Arts Club show were those held at the Corcoran Art Gallery in Washington, D.C. in January, 1904, where the first roster of Photo-Secession members was published, and at the Art Galleries of the Carnegie Institute the following month. Both exhibits were entitled, "A Collection of American Pictorial Photographs Arranged by the Photo-Secession." They were co-sponsored by local organizations, The Capitol Camera Club, and the Camera Club of Pittsburgh respectively, which meant that neither was a pure expression of the Photo-Secession. (Biblio. 1366, 1368)

Although the two shows opened less than a month apart, they were not identical in their content, nor did they precisely mirror the National Arts Club show of March, 1902. The most notable absences from the Washington and Pittsburgh shows were the names of Day and Berg, suggesting that their association with the National Arts Club "Photo-Secession" was accidental. The inclusion of Eickemeyer's name raises some question, since he never was a member of the Photo-Secession, although Stieglitz had acquired his *Waves— Evening* (Cat. 225) dated 1902.

Washington saw the addition of Coburn (Pl. 72–76) who, although not included at the National Arts Club, made his debut with Stieglitz in *Camera Work* Number Three with a single gravure; in April of 1904 he would be featured with five photogravures. Three new names that had not been listed in any of Stieglitz's lists made their debuts in Pittsburgh: Anne W. Brigman of Oakland, California; SIDNEY CARTER of Toronto, Canada; and HERBERT FRENCH of Cincinnati. All three had been very much outside the mainstream of photography and can be counted among Stieglitz's personal discoveries. Included in all three exhibitions was Robert Redfield of Philadelphia, who, along with Bul-

NEWCOMERS TO THE CIRCLE

PLATE 53 » Clarence H. White. *Portrait—Mrs. C. H. White*, 1905. Cat. 546

lock, Eickemeyer, and Stieglitz, was among the earliest internationally exhibited Americans. His photographs were included in the 1891 Vienna Jubilee exhibition (Biblio. 1300), yet mysteriously never entered the Stieglitz collection.

Although seen in various forms internationally, the Photo-Secession collection had not been exhibited in New York since the National Arts Club show. There were numerous reasons for which it should have been exhibited in New York, in part because of Stieglitz's increasing international prestige. Hinton had agreed to consult with Stieglitz before any new Americans were invited to The Linked Ring. (Biblio. 1528) Stieglitz also became responsible for the final selection of the Americans to be represented in the 1904 London Salon. (Biblio. 1530) Despite the prestige of the Photo-Secession, there was no exhibition in New York until late in 1905, when the Little Galleries of the Photo-Secession were established in a recently vacated studio in the same building at 291 Fifth Avenue occupied by Steichen. The Little Galleries were spurred into being through an interconnected sequence of events, one of which was the disconcerting presence of a new competing society of photographers in New York organized by Curtis Bell. His Salon Club prepared an exhibition ambitiously (but wrongly) titled The First American Salon (Biblio. 1404) held from December 5–17, 1904, in the hired rooms of the Claussen Art Galleries. Many years later Stieglitz reflected on the Bell salon and declared that it was organized "to save photography from Stieglitz and what Stieglitz represented." (Biblio. 919, p. 118; 1205, p. 38) The exhibition was boycotted by the Photo-Secessionists and Bell made a determined effort to enlist the best non-affiliated photographers, perhaps the most important of whom was George Seeley, who made his New York debut there.

In addition to the large number of national and international loan shows organized by the Photo-Secession, there were other distractions that prevented Stieglitz or his associates from establishing a New York gallery for exhibiting photographs prior to late 1905. Among them was the movement toward establishing an International Union of Artistic Photographers. (Biblio. 1395) The idea of an international society was so advanced by 1901 that Steichen declined his invitation to join The Linked Ring in anticipation of membership in the new society (Biblio. 1526), of which Stieglitz was considered by his colleagues as the natural leader. Keiley wanted to call it the "World's Secession," but in 1904 he already perceived that the Europeans did not favor Stieglitz's leadership. (Biblio. 1545) The Germans and Austrians seemed to agree that J. Craig Annan should be the leader. With the absence of the French involvement, the axes of power were clearly drawn between Great Britain, Vienna, and New York. The Austrians wanted to have an announcement ready for the Vienna Salon. When the name "The International Society of The Linked Ring" was proposed by Davison, however, Kuehn recoiled in surprise. "International Society of the Linked Ring? Oh God forbid! Never! As if these English gentle-

COMPETITION: CURTIS BELL

INTERNATIONAL UNION OF ARTISTIC PHOTOGRAPHERS

PLATE 54 » Edward J. Steichen. *Melpomène,* about 1904. Cat. 483

men were the *center*." He added, "If it were the Photo-Secession, then we could talk . . . our new association must stand above all groups." (Biblio. 1552) The materialization of an international society of photographers was impossible at this time due to the obvious disagreements on such basic matters as the choice of its president and its name. Such a group did, however, make a single public appearance at the 1909 Dresden exhibition (Biblio. 1395) where a roster very similar to that represented here was assembled by Kuehn to exhibit under the collective banner of the "International Union of Art Photographers." (*Ibid.*)

The prospect of an international organization of artist-photographers possibly headquartered in New York was yet another impediment to Stieglitz's establishing an independent exhibition space in New York. Stieglitz did not at this point want to act unilaterally when others with whom he was not only in sympathy, but also in active collaboration were embarked on a parallel course.

RADICALISM ABATES

The Photo-Secession very soon lost its radical identity as a broad spectrum of members were enrolled. Membership proceedings could be instituted simply by writing to Stieglitz, as many unknowns did in 1903 and 1904, who paid their five dollars and became associates. Late in December, 1903, H. Stockton Hornor applied for membership. By January 8, 1904, he was an Associate and had sent prints for Stieglitz to view. In June, 1903, Louis Stephany of the Carnegie Steel Co., Pittsburgh, likewise was promptly accepted for membership, and through him the Carnegie exhibition was arranged. Louis A. Lamb, an investment banker in Chicago with Knight, Donnelley & Co., who had just become a member, already sent in his resignation by June, stating his preference for the membership in Curtis Bell's Salon Club which he felt would become more powerful than the Photo-Secession. (Biblio. 1577) Spencer Kellogg, Jr. of Buffalo, New York, Vice-President and Treasurer of a firm bearing his name that manufactured linseed oil, became an associate of the Photo-Secession and wrote to Stieglitz, "I hope in time to become a fellow." (Biblio. 1551) His hopes were not far-fetched for in February of 1904 Sarah Sears was promoted from Associate to Elected Fellow. Although outsiders rarely entered the Stieglitz collection, that these members were accepted about the same time as French, Brigman, Carter, and Coburn is suggestive of Stieglitz's attempt to establish a national relevance for the Photo-Secession.

The Photo-Secession was not every photographer's cup of tea. Stieglitz wanted the participation of a number of important figures who refused, most notably Day, whose polite letter of refusal came soon after Stieglitz's solicitation of December, 1902. (Biblio. 251, p. 219) George Seeley was also invited to become an associate late in 1904, but did not act upon it until late in 1906.

Stieglitz was in Europe the summer of 1904 with Emmeline and their daughter Katherine. Steichen, who had been at the front a short time and

PLATE 55 » Edward J. Steichen. *The Little Round Mirror,* 1902 print from 1901 negative. Cat. 500

EUROPE: SUMMER OF 1904

whose friendship with Stieglitz grew, stayed in New York with his pregnant wife, who gave birth in June to their daughter Mary. The spring had been exasperating for Stieglitz and Keiley, which was reflected in their health and outlook. "Have had a curious gripping sensation around the heart," wrote Keiley to Stieglitz about his failing health that contributed to Keiley's loss of interest in photography. (Biblio. 1544) Thinking his creative career was at an end, Keiley offered Stieglitz all his negatives and prints, threatening to destroy them otherwise.

ILL HEALTH

Stieglitz, in turn, wrote in August, "Here I am in Berlin, in a private hospital, paying the penalty for ten years of incessant strenuousness. I came over here for a rest and pleasure, but on my arrival collapsed completely and am now undergoing a rest-cure which implies absolute quiet all summer." (Biblio. 923) After a month in bed, Stieglitz packed up and went to Dresden to see the Internation Art Exhibition. "Hardly out of the sick bed, and against the express instructions of my physician, the ruling passion asserted itself" (*Ibid.*), wrote Stieglitz. At Dresden he took particular note of the Hofmeister brothers: "It was clear at a glance that Hamburg had followed the Viennese lead, but they could readily be differentiated by the grosser and more brutal technique of the former." (Biblio. 925) Particularly surprised by Käsebier's European status, Stieglitz reported, "throughout Europe I found her influence dominant." (*Ibid.*)

Stieglitz was present for the opening of the Twelfth Annual Exhibition of the Photographic Salon (Biblio. 1364), which astonishingly was the first time he had seen the exhibit first hand. "My first impression was of keen disappointment," wrote Stieglitz, "and yet, to my way of thinking, the artistic average of the American prints were far in advance of that of the English." (*Ibid.*) With such mixed thoughts about foreign exhibitions, Stieglitz returned to New York late in 1904, his daughter Kitty (Cat. 516) having been dangerously weakened by an illness picked up in Europe.

SALE PRICES

Stieglitz was struck by the prices photographs fetched at the European exhibitions. Two Steichens were sold for ten and fifteen guineas each in London, while platinotypes by Käsebier and White brought five each. In Dresden he noted that a Kuehn went for three hundred marks, and two five-by-seven-inch platinotypes by Eugene for two hundred and three hundred marks respectively. (*Ibid.*) Stieglitz concluded that New York should have a permanent gallery where the best photographs could be viewed, framed and displayed in ways that enhanced their appearance rather than the infelicitous presentations he had so recently seen in Europe. He had finally witnessed the European malaise that Demachy had so graphically described in letters since 1900.

FOUNDING THE PHOTO-SECESSION GALLERIES

Steichen and Stieglitz became very close friends as Steichen rose to the top of Stieglitz's list, unsurpassed in the number of photographs shown at exhibitions organized by Stieglitz. Steichen once and for all replaced Käsebier as the number one American photographer at foreign exhibitions as well as in Stieglitz's estimation.

Stieglitz later recalled that the idea for a Photo-Secession exhibition gallery came from Steichen one night in 1905 as they stood together on the corner of Fifth Avenue and Thirty-first Street. Steichen mentioned space availability in the building where his studio was at 291 Fifth Avenue, not far from where they were standing. "I liked the idea, being eager that New York should see both what we were doing and outstanding prints from other countries, hung in suitable manner and surroundings. Since I knew I could rely on Steichen's enthusiasm and ability, I signed a one year lease for the rooms at fifty dollars a month. The cost of installing electric fixtures and having the necessary carpentry done was no more than three hundred dollars," recollected Stieglitz. (Biblio. 919; 1057, p. 68)

The decorations of the new premises, designed by Steichen, were described in *Camera Work*:

One of the larger rooms is kept in dull olive tones, the burlap wallcovering being a warm olive gray; the woodwork and moldings similar in general color, but considerably darker. The hangings are of olive-sepia sateen, and the ceiling and canopy are of a very deep creamy gray. The small room is designed especially to show prints on very light mounts or in white frames. The walls of this room are covered with a bleached natural burlap; the woodwork and molding are pure white; the hangings, a dull *écru*. The third room is decorated in gray-blue, dull salmon, and olive gray. (*Camera Work*, no. 14, April 1906, p. 48. Quoted in full in Biblio. 1057, p. 69)

Already in 1901, F. H. Evans had proposed similar decorations for the Dudley Gallery, where the Photographic Salon sponsored by The Linked Ring was held. He had written Steichen describing the natural color canvas background with very pale grey and white accents, not greatly different from the colors selected for the Photo-Secession Galleries. (Biblio. 1517)

The first exhibition in the Little Galleries of the Photo-Secession (hereafter shortened to Photo-Secession Galleries) opened on November 21, 1905. One hundred photographs by thirty-nine members of the Photo-Secession were exhibited. Steichen, predictably enough, was the star of the show with eleven photographs, including several that constituted the highlights of the Stieglitz collection: among them, *Rodin—Le Penseur* (Pl. 60), *The Pond, Moonrise* (Pl. 63), *The Flatiron* (Pl. 58), and *In Memoriam* (Cat. 503). White followed with nine photographs, one of which was likewise a true chestnut of the Stieglitz collection: *The Kiss* (Pl. 46). Käsebier ranked third with eight

photographs, most of which were new, unfamiliar titles. Neither *The Manger* nor *Blessed Art Thou Among Women* (Pl. 39), her two most famous photographs at this time, were shown. Both Stieglitz and Keiley were represented by seven photographs each, Stieglitz by *The Hand of Man* and *Going to the Post,* and Keiley by two studies of Indians. While they cannot be precisely identified from their titles, Keiley's studies were certainly among Stieglitz's holdings on the subject. (Cat. 361–368).

Eugene, Brigman, and Dyer each exhibited four photographs; at least one photograph by each specifically entered the Stieglitz collection. Eugene's *La Cigale* (Cat. 228) and *Song of the Lilly* (Cat. 227), Brigman's *Incantation* (Cat. 72), and Dyer's *Cymbals* (Cat. 224) are among those that can be specifically identified as those Stieglitz acquired from the exhibition.

Represented by three photographs each was a group including several newcomers to his roster, some of whom Stieglitz never added to his collection: Jeanne E. Bennett and Fred H. Pratt. Among those he finally acquired were Boughton, Watson-Schütze, and Coburn. Both Coburn and ALICE BOUGHTON, represented by *The Bridge—London* (Cat. 152) and *Children* (Cat. 62) respectively, came to be highly regarded by Stieglitz.

Photographers with a token representation of one or two prints included some of Stieglitz's oldest exhibition colleagues. W. B. Post and John G. Bullock each showed two photographs, while Mary Devens, Sidney Carter, HARRY RUBINCAM, Sarah Sears, and J. F. Strauss each had one. Some were friends of friends. Sears, Devens, and Landon Rives were old acquaintances of Day; and the Stanberry sisters were protégées of Clarence White. A few with a single representation were undoubtedly acolytes of the Photo-Secession who had become members by simply writing Stieglitz. Among them were J. M. Elliott, W. F. James, F. D. Jamieson, C. A. Lawrence, Helen Lohman, Wm. J. Mullins, Jeanne E. Peabody, W. P. Stokes, Orson Underwood, Mary Vaux, S. S. Webber, W. E. Wilmerding, and S. L. Willard—all known to Stieglitz only by the initials of their first names.

All the works on exhibit were for sale but sales were few, with Stieglitz himself being the main acquisitor.

THE MAJOR ACQUISITIONS:
EIGHTEEN MONTHS OF PHOTO-SECESSION EXHIBITIONS

The golden age of Stieglitz's activity as a collector of photographs occurred between the first number of *Camera Work* (dated January, 1903) and the third members' exhibition at the Photo-Secession Galleries (December 8–30, 1908). During this period Stieglitz purchased works in considerable numbers from the exhibitions at the Photo-Secession Galleries. He also received for

PLATE 56 » Edward J. Steichen. *Experiment in Multiple Gum*, 1904. Cat. 476

viewing at this time many photographs from photographers who were hopeful that their works would be reproduced in *Camera Work,* exhibited in the Photo-Secession Galleries, or selected for one of the many foreign exhibitions for which Stieglitz arranged the American section. When works were not purchased by Stieglitz, they were frequently left to his care in expectation that they would eventually be of some use.

Up to 1902 Stieglitz had bought selectively from such exhibitions as the first Philadelphia Salon or directly from the photographers after seeing their work on exhibit. He was well aware of the prices photographs brought from the information that was often printed in the exhibition catalogs, of which he had a large collection by this time. (Biblio. 1292–1400) Nowhere is Stieglitz's awareness of value more evident than in his purchases from Steichen which began in 1899 at five dollars (Cats. 451–453) and soon climbed to fifty. By 1920 he was paying one hundred dollars for each Steichen print. (Biblio. 965) In 1902 Stieglitz wrote Hinton and Davison inquiring about prices and the salability of photographs in London. Davison replied that the most he had

PRICES

ever sold at a London Salon were photographs worth eighteen pounds total (then about $100), the highest single price being five guineas ($30). The most anyone ever sold at a London Salon were pictures worth twenty-two pounds ($110) by the veteran H. P. Robinson. (Biblio. 1481) Hinton responded to similar questions from Stieglitz that he generally sold photographs worth twenty-five to thirty pounds ($125–150) at each salon, with individual pictures selling for three, four, or five guineas each. (Biblio. 1527)

Stieglitz was more actively than ever in the market for photography early in 1902. Watzek, who died shortly thereafter, sent him a parcel of eight prints offered for sale between twenty and seventy-five marks. (Biblio. 1620) Many similar offers must have gone unrecorded. Between 1902 and 1906, however, correspondence regarding prices and letters accompanying parcels abated dramatically, most certainly because *Camera Work* absorbed much of his attention.

Beginning in 1906, not long after the Photo-Secession Galleries were founded, Stieglitz resumed correspondence with his colleagues about acquiring photographs. The surviving letters must represent but a fraction of what was actually written, and many acquisitions were surely consummated verbally. In July he made a purchase from Clarence White, who acknowledged a check for an unspecified amount, saying that he trusted Stieglitz would "find the prints . . . to give him the value received." (Biblio. 1629)

FRENCH WORK

The first exhibition of photographs by foreign photographers at the Photo-Secession Galleries, French Work (Biblio. 1376), opened on January 10. At its close, Stieglitz was offered as a gift from Demachy whatever of his in the exhibit remained unsold, thus accounting for the bulk of the prints by Demachy in the Stieglitz collection. (Biblio. 1507) Stieglitz was sufficiently inspired by this work to purchase photographs by Puyo and Le Bègue. Puyo received a check for three hundred seventy-five francs, while Le Bègue wrote

PLATE 57 » Edward J. Steichen. *Figure with Iris*, 1902. Cat. 458

that he would be honored to be representd in the Stieglitz collection and offered the *Blue Académie* (Cat. 412) for half its regular price. (Biblio. 1578) Such correspondence typifies both the deliberate and accidental ways in which Stieglitz collected and partially accounts for the considerable range of taste represented in his collection. Stieglitz did not always select his acquisitions one picture at a time. French Work represented the taste of Demachy as much as Stieglitz since Demachy had selected the pictures for the exhibit from which Stieglitz acquired most of the French photographs in his collection (including among others: Cats. 199, 201, 206, 207, 210, 412, 424, 425, 429).

French Work was soon followed by two other national anthologies: British (Biblio. 1379) and German-Viennese (Biblio. 1381). These were the only three exhibitions Stieglitz mounted at the Photo-Secession Galleries based on national origin. Parts of all three exhibitions were anticipated in *Camera Work:* Issue Number Four (October, 1903) featured Evans (who was also a subscriber), issue Number Five (January, 1904) Demachy, issue Number Seven (July, 1904) Theodor and Oskar Hofmeister, issue Number Eight (October, 1904) Annan, and issue Number Eleven (July, 1905) Hill (and Adamson).

In scheduling the Photo-Secession Galleries, Stieglitz played the illustrations in *Camera Work,* which became a kind of portable gallery, against the politics of exhibitions. Some photographers were represented both in *Camera Work* and exhibitions, while others were granted one honor but not the other. Stieglitz

FIRST PHOTO-SECESSION
ONE MAN SHOW

gave honor of the first solo show (Biblio. 1377) at the Photo-Secession Galleries to Herbert G. French (January 26–February 2, 1906), rather than to one of the "Big Five," as Post had characterized Käsebier, White, Steichen, Keiley, and Stieglitz. French had been in New York in the late spring of 1905 where he was deeply impressed by Stieglitz and what was happening at the Little Galleries. "I feel that photography has done a great deal for me in helping me value things and people properly," wrote French to Stieglitz, sending a check for seventy-five dollars to support the gallery, a sum he could afford as Procter and Gamble executive. (Biblio. 1520)

The choice of H. G. French to inaugurate solo shows at the Photo-Secession Galleries reflects partly White's enthusiasm for his work, partly French's own financial generosity to the Photo-Secession and finally a spillover of the current wave of interest in the history of photography. H. G. French showed forty-five photographs illustrating verses from Tennyson's "Idylls of the Kings," that had been so definitively rendered by Cameron thirty years before. Stieglitz continued to think highly of French's photographs over the years and featured him in *Camera Work* issue Number Twenty-seven of 1909. Typical of many outsiders, French believed that "one must keep in touch with progress in New York City [but] I am rather disposed to feel that the best creative work must be done away from there," a feeling shared by other Secessionists such as Seeley. (Biblio. 1521) Stieglitz doubtless heeded French, for in the coming months Stieglitz often looked away from New York for new talent.

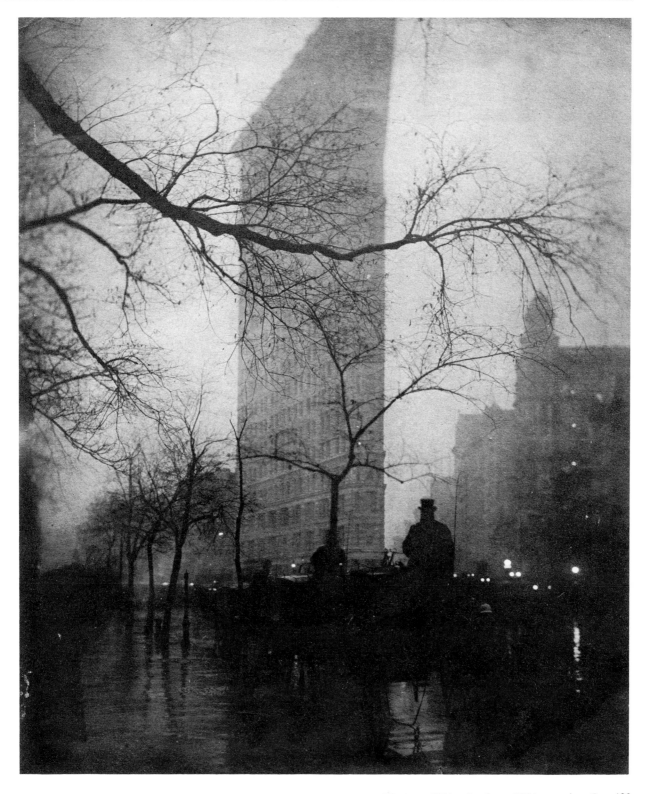

PLATE 58 » Edward J. Steichen. *The Flatiron,* 1909 print from 1904 negative. Cat. 480

PHOTOGRAPHY AS FINE
ART: HOLME

Stieglitz's idea for group shows was perhaps suggested by Charles Holme's *Art in Photography* (Biblio. 1288), the first history of "modern" photography. Written from the British standpoint but international in scope, the book treated photography by national schools, anticipating three important exhibitions at the Photo-Secession. Texts on Great Britain, France, and Belgium were written by Clive Holland, while A. Horsley Hinton wrote on Austria and Germany, and Charles Caffin (See also Biblio. 962, 1076, 1094) on the United States. They argued that photography was art, an idea that was evident to only a few at the time. "Ten years ago or so we remember reading in a leading magazine a statement that photography threatened to become a fashionable hobby. The passage of the years since then has shown that it was destined to become much more. With scores of workers it has long passed out of the hobby stage, and in their hands has become endowed with the semblance of art," wrote Holme. (Biblio. 1288, p. 1) The statement marks an important juncture in the evolution of modern photography because arguments were not marshalled to prove that photography was art; but it was assumed. Following Shaw's model for criticism (Biblio. 697, 699) photographers were treated with the same verbal descriptive tools that were applied by art critics to painters.

Käsebier and White (Biblio. 1288) were the two who perfectly fit Holme's scenario of photographers passing from a phase where their craft was a fashionable hobby to a point where they already had (Käsebier) or began to have (White) independent professional careers that allowed them to photograph full time. Käsebier was described in the first issue of *Camera Work* as being "merely a professional," a tongue-in-cheek reference to the recent past when professionals were scorned. White wrote Stieglitz on Independence Day of 1904 that he resigned from Fleek and Neal's to establish his own career as a portrait photographer.

WHITE AND KÄSEBIER
EXHIBITION

Considering Stieglitz's belief in the special value of the amateur, it was fitting that he should select H. G. French, an archetypal amateur who once wrote that he made photographs simply because they made him at peace with the world, to have the honor of the first one-man show at the Little Galleries. Käsebier and White shared the second exhibition in which twenty-seven works by each were shown, including some of their most striking photographs that entered the Stieglitz collection: Käsebier's *Blessed Art Thou Among Women* (Pl. 39), *Blossom Day* (Cat. 357), *The Picture Book* (Cat. 349) and *The Sketch* (Pl. 41); White's *The Orchard* (Cat. 555) and *Letitia Felix* (Pl. 44 being one of several examples).

Käsebier's career was unfolding with little assistance from Stieglitz. She spent the summer of 1901 in Europe hobnobbing with important figures in the photography world. In July she was in England, meeting with Annan, Hinton, the Cadbys, Evans, and Davison. Their conversations on photography were so heated, she reported to Stieglitz, that she thought she would never "get a word in." (Biblio. 1532) In August she stayed with Steichen in Paris,

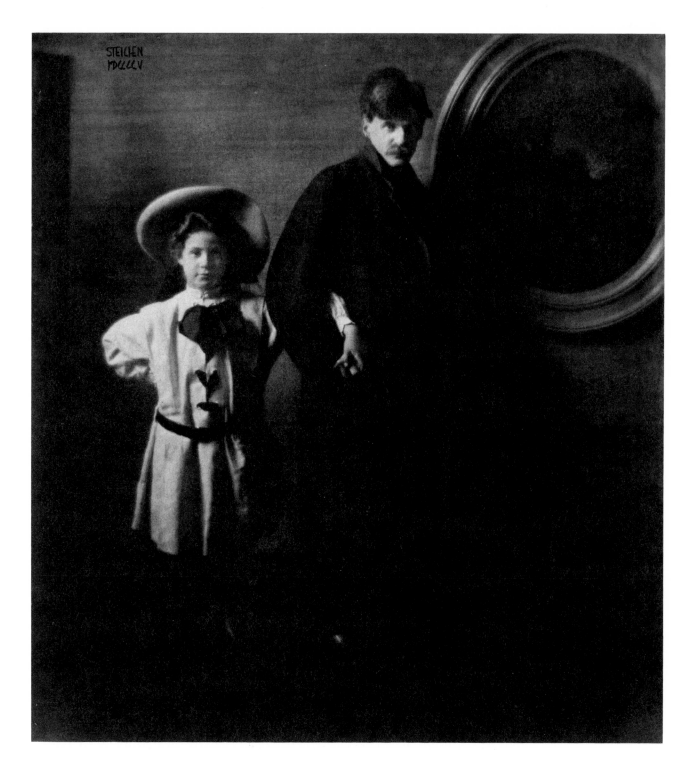

PLATE 59 » Edward J. Steichen. *Alfred Stieglitz and His Daughter Katherine*, 1905 print from 1904 negative. Cat. 509

joining him at the opening of Day's New School of American Photography show (Biblio. 1403) and witnessing him produce some of his finest gum-bichromate prints, some of which she acquired for her own collection. An intimate friendship between Steichen and Käsebier is suggested in Steichen's teasing suggestion that a large picture of an Indian by Käsebier would be called by critics an imitation of Keiley and her *Blessed Art Thou Among Women* an imitation of Day. (Biblio. 1533) Such was the friendly interchange among the photographers, paralleling the animated discourse between painters in Paris and New York that advanced their art.

During 1904–1905 White traveled as a portrait photographer learning the profession from a grass roots level. His exhibit at the Photo-Secession Galleries encouraged him to move to New York in 1906 where his native instincts as a teacher began to emerge, and he mentored, among others, Karl Struss (1908–1912) and PAUL HAVILAND. (Biblio. 1631) By 1907 White and Stieglitz were very friendly, collaborating on a series of nudes that they jointly signed (Pls. 87, 88). Between 1907 and 1910 White lectured at Columbia and at the Brooklyn Institute of Arts and Sciences, and established his own summer school of photography in Sequinland, Maine.

Stieglitz had seen Annan and Hill exhibited together at Dresden in 1904 and commented at the time that "their pictures will always hold their own in the very best of company—sane, honest, temperamental." Stieglitz decided to exhibit them at the Photo-Secession Galleries along with Evans from February 21 to March 7, 1906. (Biblio. 925) Shortly thereafter Stieglitz featured Annan in *Camera Work* issue Number Eight (October 1904) and Hill in issue Number Eleven a year later.

Thirty-one of Evan's architectural studies were exhibited at the Photo-Secession, including the famous *Sea of Steps, Wells*. Evans was characterized by Stieglitz as "an advocate of the so-called straight photography," which meant not only straight negatives but straight prints. It was even found necessary to comment on the fact that in two subjects the overexposed sunlight coming through the windows was masked to allow for printing those areas where details took longer to develop.

By placing Annan, Evans, and Hill on the same walls. Stieglitz forced attention to the various possible results within the parameters of straight photography. The primary stylistic difference between Annan and Evans expressed their differing points of view. Annan's *White Friars* typified his link to British naturalism in his desire to suggest motion while stopping it and in his selection of the subject from the streets. Evans, on the other hand, rarely photographed in the streets, but rather mastered architectural subjects, making their form and the play of light on shapes and surfaces the subjects of his photographs. Evans thus was a formalist, while Annan was a naturalist, although both treated their subjects without manipulation.

The British exhibition expressed a strong element of historicism. Hill was

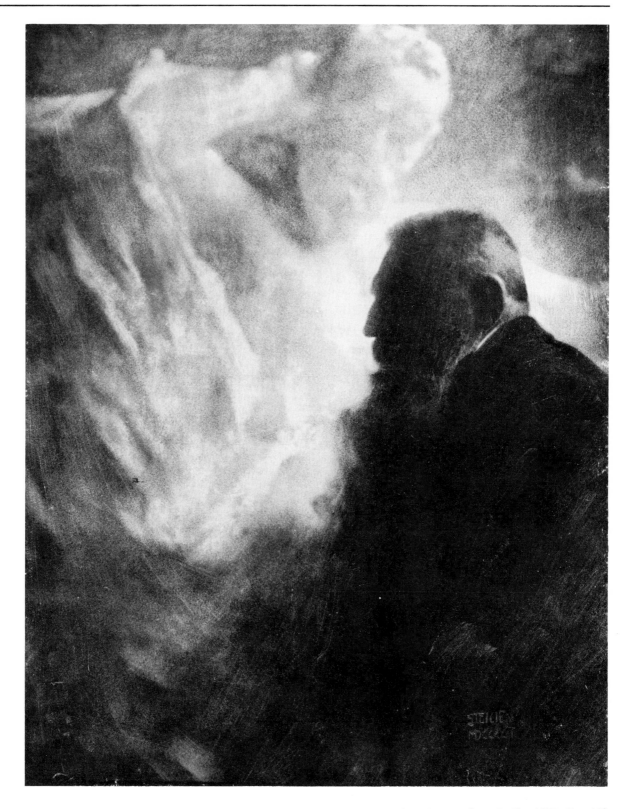

PLATE 60 » Edward J. Steichen. *Rodin*, 1902. Cat. 460

treated not only as the primogenitor of straight photography, but also as the starting point of all artistic photography who, according to Stieglitz's checklist, had "never been surpassed [even though] called into existence over sixty years ago." (Biblio. 1379) Hill's partner, Robert Adamson, was not recognized as a full artistic partner at that time. Next in the British genealogy came Annan, whom Stieglitz described as "one of the first of the living men to attract universal attention by the excellence of his work and by the spirit in the evolution of the photographic movement." (*Ibid.*) The exclusion of Peter Henry Emerson illustrates how personal was Stieglitz's view of history. Annan's work was listed as being in four processes: "plain photogravure," indicating that the plate was machine-printed; "original photogravure," meaning that the plate was hand-printed before steel facing; "mezzotint gravure," meaning that a screen was utilized to give texture to the shadows; and platinum prints. Clearly a master of photographic processes, Annan applied his virtuosity to Hill's paper negatives. All but one of the prints Stieglitz exhibited were actually printed by Annan, who had access to the paper negatives that had survived in the Hill & Adamson studio at Rock House in Calton Hill, Edinburgh. Annan printed the negatives in carbon using original gravure (later machine-printed for *Camera Work*).

Among the other figures from the roots of British photography was Julia Margaret Cameron, brought to Stieglitz's attention during the summer of 1904 by Coburn, who exclaimed after studying her prints, "She is a remarkable woman." (Biblio. 1467) Coburn's enthusiasm stemmed from his role both as a collector and a photographer. Cameron was not exhibited in the Photo-Secession Galleries although reproductions of her work were published in *Camera Work* Number Forty-One (January, 1913). Stieglitz did not collect any of Cameron's original albumen prints but only had modern carbon examples that were copied from copies in the files of the Autotype Company which thirty-five years earlier had produced fine carbon prints from Cameron's original negatives. It was perhaps the absence of fine originals that prevented Stieglitz from ever exhibiting Cameron in the Photo-Secession Galleries. The growing appreciation of the antecedents of the Photo-Secession led Keiley, for example, to exclaim upon first seeing original Camerons, ". . . [they are] better than anything we have seen." (Biblio. 1546)

GEORGE BERNARD SHAW summarized the wave of historicism that crested in 1909 when he said in the context of Coburn that his ideal exhibition would include, "D. O. Hill, Mrs. Cameron, old silver prints, early gums, Evans's platinum prints, modern oil prints, and Coburn's photo-gravures." (Biblio. 703)

British Work was followed by the Germans and Austrians, punctuated by the most important one-man show yet presented at the Photo-Secession Galleries, that of Steichen to which we shall return shortly. The large size of the German and Austrian prints permitted the exhibition of only eighteen gum-

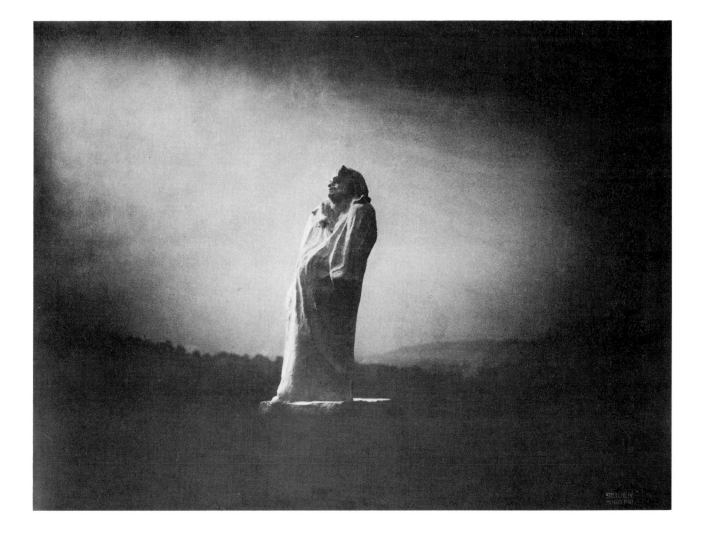

PLATE 61 » Edward J. Steichen. *Balzac, Towards the Light, Midnight,* 1908. Cat. 486

bichromates, thirteen of which were by Kuehn. Watzek and the Hofmeister brothers were each represented by one print, while Henneberg had three. Stieglitz adopted a historicizing tone similar to that of the British show:

Hugo Henneberg, of Vienna, Heinrich Kuehn, of Innsbruck, and Hans Watzek, deceased (1905), known as the "Viennese Trifolium," evolved the multiple gum printing method as is now used extensively by the Austrian and German pictorial photographers. They are the founders of the Austrian school of photography. The two Hofmeisters, of Hamburg, are the pioneers in Germany, having followed in the footsteps of the three Austrians. (Biblio. 1381)

Stieglitz acquired for himself some of the most important German and Viennese works exhibited, including Henneberg's *Villa Falconieri, Frascati* Kuehn's *Roman Villa* (Cat. 388), Watzek's *An der Danau* and *Sheep* (Cat. 529, 530). Stieglitz had owned the *Solitary Horseman* (Cat 340) since July of 1904, when it was reproduced from this print for a gravure in issue Number Seven of *Camera Work* (July, 1904) that featured the Hofmeisters with six illustrations. In issue Number Thirteen that appeared three months before the exhibition of German and Viennese work, Watzek was given five illustrations compared to the single picture hung in the Photo-Secession Galleries.

Stieglitz deliberately avoided having an issue of *Camera Work* coincide exactly with the opening of an exhibition at the Photo-Secession Galleries. It is possible to surmise that an ethical principle was involved and that Stieglitz wanted to avoid being thought of promoting the magazine with exhibitions or vice-versa. He would otherwise have taken the natural course of having the exhibitions and publication coincide.

Henneberg was Stieglitz's first contact in Vienna. His *At the Rushy Pool* appeared as a gravure in *Camera Notes* issue Number Two (October, 1897) in which Day made his debut with *An Ethiopian Chief* (Pl. 29). It was probably Henneberg who proposed Stieglitz for membership in the Vienna Photo-Club before Kuehn was even a member. Having given up photography by 1904 in favor of etching, woodcutting, and painting, Henneberg had little influence on Stieglitz during the *Camera Work* and Photo-Secession years. Kuehn was particularly distressed over Henneberg's retirement from photography and confessed to Stieglitz that he felt his friend was a better photographer than a printmaker. "He will never become a [William] Nicholson," wrote Kuehn to Stieglitz referring to the successful British master of the woodcut. Kuehn was confident that Henneberg's current project of making facsimiles after the etchings of Goya was a waste of talent. (Biblio. 1552)

Kuehn commenced a very active correspondence with Stieglitz in 1904 and was very likely the catalyst that initiated the Photo-Secession Galleries exhibition of Germans and Austrians. The meeting of Stieglitz and Kuehn in

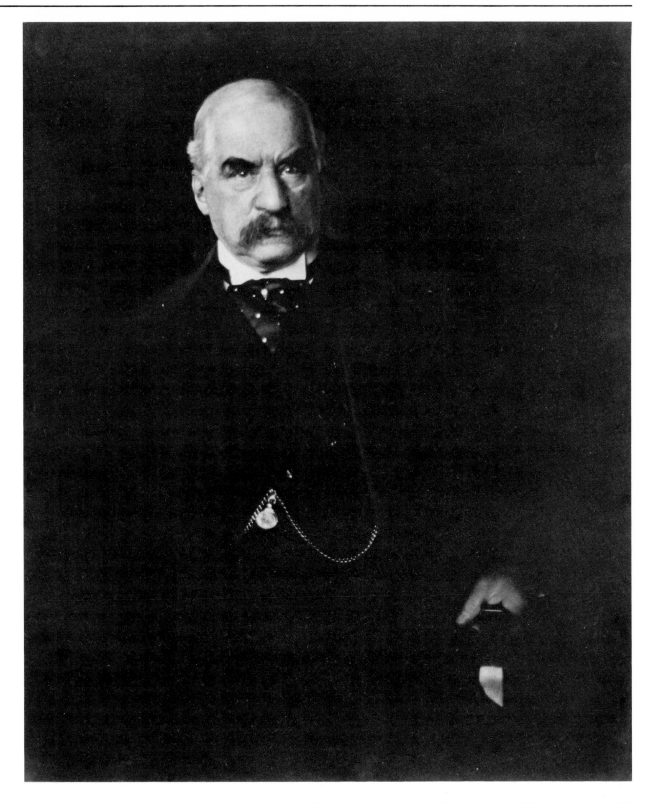

PLATE 62 » Edward J. Steichen. *J. Pierpont Morgan, Esq.*, 1904 print from 1903 negative. Cat. 497

Vienna in 1904 apparently led Kuehn to introduce to his repertory of subjects figure-in-landscape and genre studies. Taking Stieglitz's advice about the merits of Katwyk, Holland, and Chioggia, Italy, where Stieglitz had made an important series in the early 1890s, Kuehn actually photographed in these places. His images pay direct homage to Stieglitz but carry the artistic idea into the dimension of scale, color, and texture. The friendship between Kuehn and Stieglitz was facilitated by Stieglitz's fluent German and by their common interest in collecting as well as making photographs.

KUEHN COLLECTION

Kuehn, like Stieglitz, actively acquired photographs by his contemporaries, and wrote Stieglitz that his collection of Watzek and Henneberg was "so sublime that [now] the Photo-Secession must be represented in larger proportion." Kuehn continued, "I collect only very few names but want a clear picture of the work of these artists." (Biblio. 1556) Stieglitz arranged for him to obtain Steichen's *Small Model, The Big White Cloud* (Pl. 64), and one of the Rodin series; Käsebier's *Happy Days* (Cat. 352) and *The Picture Book* (Cat. 349); and White's *The Orchard* (Cat. 555), works that paralleled Stieglitz's own collection. New Year's, 1906, "is going to be the start of a new life," wrote Kuehn to Stieglitz as he moved into a new house that had been designed for him by the prominent *Wiener Werkstatte* architect, Professor Moser, with decorations by Joseph Hoffman (1870–1956). The interior decoration did not, however, suit his collection of photographs, making it impossible to hang either Stieglitz or White on account of the bright-colored walls that made these particular works look "grey and without force." (Biblio. 1559) Steichen's *Rodin* (Pl. 60) and Kuehn's six Watzeks held the walls of his new house. "Steichen's 'Rodin' is the only one that looks absolutely splendid on the wall," reported Kuehn. (Biblio. 1558)

Stieglitz evidently valued Kuehn's opinion greatly, and Kuehn admitted to having been very much influenced by the American Photo-Secession, reporting that it also had been a generally strong influence on the Germans. (Biblio. 1561) Like every collector, Kuehn had his likes and dislikes. It might have appeared from Stieglitz's presentation of the Austrian and German exhibition that they were a closely-knit group. Kuehn evidently had little regard for the Hamburg school in general and the Hofmeister brothers in particular by the time of the New York show. When the Hamburg contingent boycotted the 1904 Vienna Salon, Kuehn wrote,

We are happy to be rid of the Hamburgers. The big sheets of pictures in many screaming colors would only have spoiled the atmosphere and the mood in the exhibition room. When people were still working in monochrome they did good work and were competent. Since they are all megalomaniacs [now]—everything is over. . . . These Hamburgers are so revolting I would not want to have them in the International [Society of Artistic Photographers]. (Biblio. 1560)

Despite the foreknowledge of these feelings, Stieglitz hung the works together in the Photo-Secession Galleries in April of 1906.

LATENT PURISM

Kuehn had a streak of the purist in him that is not immediately evident in his photographs. Although there might be a seeming contradiction between photographic purism (as exemplified by Evans) and the school of manipulated prints dominated by the Germans and Austrians, there was no contradiction in Kuehn's mind. "It seems to me that the highest achievement of photography must be based on obtaining pictorial effect without messing around. We know there are painters but the photographer is not permitted to paint." (Biblio. 1554) Kuehn condemned the photographs of Le Bègue as hopelessly derivative of painting, while praising the elements of naturalism in Demachy. Kuehn observed, "However interesting Demachy always is, I place the pictures developed naturally above those worked for effect." On another occasion he waxed poetically in his enthusiasm about the medium of photography. "To have the sun in the leaves, just winking through the trees and to suggest the glory of color . . . possibly this is the hardest thing in photography—light, sun! The picture must give you the feeling of the warmth of the light!" (Biblio. 1552) Such verbal elegance about the experience of picturemaking appealed very much to Stieglitz's temperament. Kuehn's enthusiasm for photography and the intrinsic beauty of his pictures won him thirteen frames out of the eighteen photographs in the 1906 Photo-Secession Galleries exhibition. When the Hofmeister brothers began their correspondence with Stieglitz, they had just been featured with five illustrations in *Camera Work,* and it was quite a distinction for Kuehn to have won over from them Stieglitz's confidence.

NATIONAL STYLE AND PERSONAL STYLE

The three national anthologies at the Photo-Secession Galleries were undoubtedly scheduled with the specific purpose of laying a credible groundwork for the proper appreciation of American photography. Another purpose was to establish the idea that style was as inherent to photography as to any other medium of art. The indirect message was that recognizable national styles emerged from the distinct personal styles of photographers. Annan and Evans were presented as the quintessential exponents of naturalism, with Hill as the historical antecedent not only for naturalism but all varieties of pictorial photography. The French were considered the exponents of "artificialism," to use Davison's terms, although Demachy was much influenced by British naturalism. The Germans were offered as representing an esthetic compromise between the British and French Schools, amalgamating the best qualities of British naturalism with the best of French artificiality, a combination best seen in the Hofmeister brothers and to a lesser degree in Kuehn and Watzek.

STEICHEN: 1905–1909

The exhibition to follow British work was a one-man show of Steichen. In contrast to the work-in-progress idea represented in H. G. French's exhibition, Steichen's was a retrospective show of sixty-one photographs. Also included

were experimental pre-Lumière color work accomplished by making three separate black and white negatives through blue, green, and red filters, then printing them with blue, green, and red bichromate. The color experiments were listed in the catalog (Biblio. 1380) "merely as tentative experiments in a direction the author feels is full of promise." None are recorded to have survived, but they attest to the attraction color photographs held in the weeks and months before the first publicly distributed color process became available. The following summer the Lumière process made all former attempts at color seem unsatisfactory.

Steichen's exhibition was the most successful yet to open at the Photo-Secession Galleries from both financial and artistic points of view. Fifteen hundred dollars' worth of prints were sold and twenty-five hundred people visited the gallery. (Biblio. 1598) Stieglitz, an admirer of Steichen since 1902, accounted for a number of the purchases and a long list from the show entered his collection, including *George Frederick Watts* (Cat. 459), *Maurice Maeterlinck* (Cat. 464), *Rodin* (Cat. 460), *Franz von Lenbach* (Cat. 462), *Alfred Stieglitz and His Daughter Katherine* (Cat. 513, 514), *La Cigale* (Cat. 484), *Melpomène* (Cat. 483), *The Big White Cloud—Lake George* (Cat. 489), and *The Flat Iron* (Cat. 477–480). Among the significant photographs not included in the exhibition was the astonishing Morgan portrait of 1904 (Pl. 62).

During the summer of 1906 Steichen and his wife vacationed in the Rockies where he made the negative of *Garden of the Gods* (Cat. 472) which Stieglitz acquired in 1907. It was also on this trip that Rubincam must have portrayed Steichen on horseback (Cat. 432). In the fall Steichen returned to France via England, spending a raucous October evening at dinner with a dozen brothers of The Linked Ring. (Biblio. 1612)

Paris in 1906 turned out to be less kind to Steichen than during his first sojourn between 1900–1902, and he wrote Stieglitz lamenting he had never been "so completely down and out." (Biblio. 1612) In December things turned up briefly when he sold a print of the *Little Round Mirror* (Pl. 55) for two-hundred-fifty dollars (approximately twenty-five-hundred dollars in the purchasing power of modern currency). Struggling to support himself completely from portrait work, he made it a firm policy not to portray friends for free as he had done during his first stay and turned down even some famous sitters. Steichen had the opportunity to photograph Leo Tolstoi, but refused to do the portrait without a commission. (Biblio. 1613) His clients were rich Americans, like the Meyers (Cat. 454) and the Blumenthals, and he worked hard at establishing a vivacious portrait style to support himself.

About this time Steichen became excited over the art of Henri Matisse, to which he introduced Stieglitz on his 1907 European tour. Matisse drawings were lated exhibited in the Little Galleries. Steichen hand-carried them to New York in February of 1908 when he returned with the material for his own second one-man show there that opened on March 12, 1908. Drawings, litho-

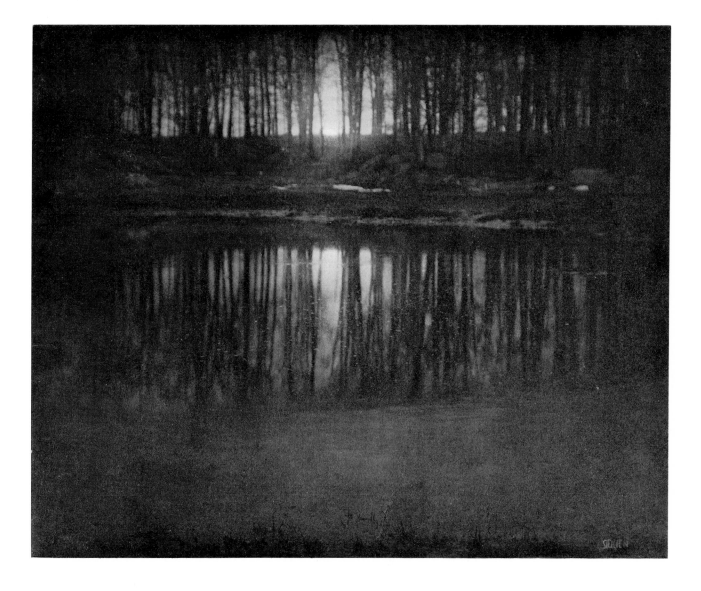

PLATE 63 » Edward J. Steichen. *The Pond—Moonrise*, 1903. Cat. 482

graphs, watercolors, and etchings by Matisse opened on April 6, inaugurating the epoch of the Photo-Secession Galleries as a haven for the avant garde as well as the latest in paintings, drawings, and prints that soon began to crowd out photographs from the exhibition schedule.

CÉZANNE EXHIBITION

By the summer of 1908 Steichen was back in France and had taken a country house, *Villa l'Oiseau* at Voulangis. His enthusiasms had turned toward Maurice Denis and Cézanne, whose exhibition would open the Photo-Secession on March 1, 1911. During the summer of 1909 Steichen learned to pilot an airplane, which improved his mental outlook significantly. He wrote Stieglitz ebulliently, "Flying just beats even color photography. (Biblio. 1615)

EXPRESSIVE PRINTMAKING

By the close of the second Exhibition of Members' Work on December 13, 1906 (Biblio. 1382), Stieglitz found himself in a position where conflicting demands were placed upon him. As Director of the Photo-Secession Galleries, the focus of his attention was on the particular qualities enjoyed by original photographic prints. As editor and publisher of *Camera Work*, Stieglitz desired to create the belief that its reproductions duplicated the original prints.

ORIGINAL PRINTS VERSUS REPRODUCTIONS

Stieglitz was one of those rare persons capable of simultaneously holding two opposite ideas. He genuinely believed that *Camera Work* gravures were facsimiles of the original prints and in some instances claimed them to be superior to the photographers' own originals. (Biblio. 917) On the other hand, even during the early years of *Camera Work,* Stieglitz exhibited his intuitive understanding of the superior value in the dedication with which he acquired for his collection original prints from the Photo-Secession Galleries exhibitions. Stieglitz was as aware as any of his contemporaries that each original photograph had unique physical properties of scale, texture, hue, and tonal subtlety that could never be reproduced by mechanical methods. This issue created a conflict in Stieglitz's mind, if one is to believe the numerous statements in *Camera Work* regarding the fidelity of the reproductions to the originals. When original prints in the Stieglitz collection are compared to the *Camera Work* illustrations from the same negatives, the differences between the two states are inescapable, as also is the conclusion that Stieglitz deceived himself in regard to their fidelity. He had successfully educated the public that photographs were receptive to the same principles of connoisseurship as those of old master prints and drawings, but they were applicable only in the most general way to the appreciation of the mass-produced illustrations in *Camera Work*. Despite the explanatory text in the columns of *Camera Work* called "Our Pictures," dedicated to translating into words the effects of the original prints, fail-

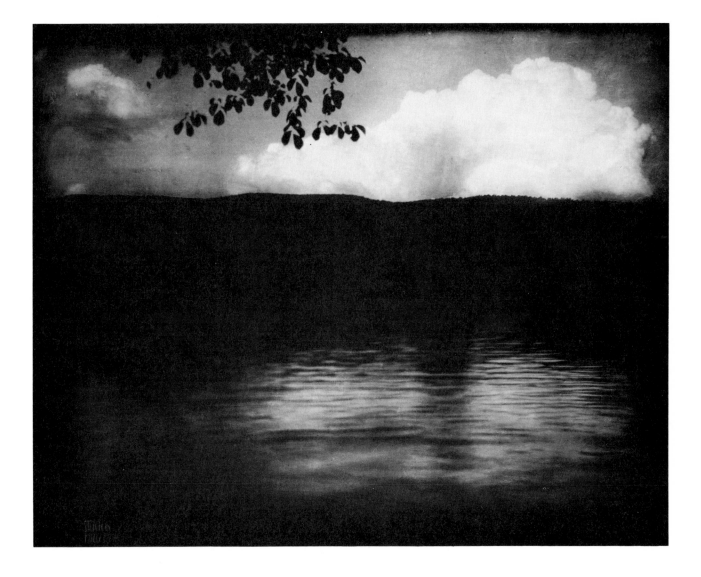

PLATE 64 » Edward J. Steichen. *The Big White Cloud, Lake George,* 1903. Cat. 489

ure to realize absolute facsimiles was inevitable. No matter what printing process was used—gravure, mezzotint-gravure, duogravure, hand-toned photogravure, halftone, three-color halftone, four-color halftone, or collotype, processes all used at one time or another in *Camera Work*—the results were quite distant from original prints made by the photographers themselves. (Biblio. 1173) The German and Austrian prints exhibited at the Photo-Secession Galleries (Biblio. 1381) are typical of those having one life on the walls of the Photo-Secession Galleries and quite another in the pages of *Camera Work* (No. Thirteen, January, 1906). On the gallery walls the prints communicated visually without the interference of words that were ever present in *Camera Work*. Words offered non-visual interpretations of the pictures whose appearance was also necessarily homogenized, while their original sizes and particular surface qualities changed completely in the printed reproductions. When viewed in *Camera Work,* the original processes were inevitably subordinated to the particular surface qualities of the printing method used.

Exhibitions at the Photo-Secession Galleries heralded a golden age of expressively made prints of all kinds, from the most subtle straight prints to the most garishly hand-manipulated ones. Between 1899 and 1906 photographic materials and processes for making prints proliferated, while the materials for negatives changed very little during this time. Photographers began to pay less attention to the making of the negative and redirected their attention to printmaking, exploring the interpretative possibilities open to negatives that earlier might have been considered technically mediocre.

SUBTLE VARIATIONS

Among the most delicate manipulations were those of Annan and Evans, each of whom started from rather separate points. The modest manipulation of Evans in masking his cathedral interior negatives so as to have the windows print uniformly was a minor adjustment that suggests the degree of subtlety involved in the notion of an expressive print versus a straight print. Far more extensive manipulations were manifest in gum prints of the Hofmeister brothers or the imitation pastels of Le Bègue. Even before 1900 Day was experimenting with the differing effects that could be obtained from one print to another. Stieglitz was certainly aware of this aspect of Day, whose work represented one of the rare instances when Stieglitz collected more than one print of the same negative (Cats. 169, 170, 171, 182, 183, 185, 186). Day, too, left no doubt of his own appreciation of the nuance of a print as he wrote Stieglitz at the time of sending his *Ebony and Ivory* (quoted in full Cat. 178).

PLATINUM

Stieglitz had once called platinum the prince of photographic printing materials, and it continued to be very important and far more adaptable than might have been expected. Eugene and Käsebier coated platinum on Japan tissue (Cat. 226, 227; Pl. 42) to realize a medium in which light from the paper surface below was reflected back up through the photograph to give a special luminosity. In 1904 Evans reported to Stieglitz that he had seen some remarkable prints by Coburn. "I am greatly in love with [Coburn's] use of the fasci-

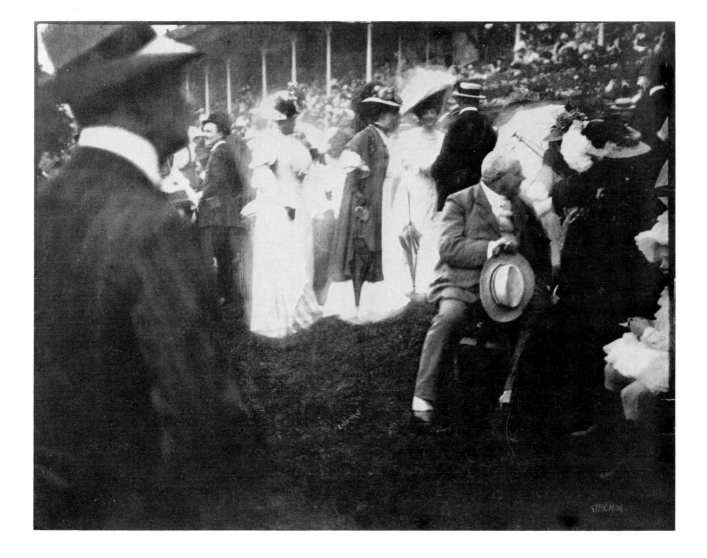

PLATE 65 » Edward J. Steichen. *Steeplechase Day, Paris—The Grandstand*, 1907. Cat. 491

nating gum platinotype" (Pl. 73), he wrote (Biblio. 1514), heralding a material that was in great vogue until about 1910 (Cat. 121, 479).

OZOTYPE

About this time a bastardized gum-bichromate process called by the trade name Ozotype (Pl. 19) was invented by Thomas Manly. It did not require handwork and had a much more photographic appearance than hand-coated gum prints. Steichen used it for his first Paris exhibition. (Biblio. 758) Coburn also experimented with Ozotype and reported to Stieglitz that its great virtue was a beautiful rich black and the fact that the printing took place in full daylight, an advantage that was sure not to be overlooked by photographers with a dislike for the darkroom.

Steichen emerged as having the most inherent feel for the purely photographic aspects of the manipulative processes. Kuehn had expressed a similar appreciation when he stated the goal of achieving pictorial photography without adulteration, suggesting that natural effects were not completely alien to the manipulated printing processes. Steichen treated method and process like notes on a piano, mixing and combining in most unorthodox ways, yet always tenaciously adhering to principles of pure photography in ways that Puyo, Le Bègue, or the Hofmeister brothers did not. The latter did their best to conceal the fact that the camera was used to make their pictures, which could well be mistaken for paintings. Steichen was making painterly photographs (Pl. 56), while others made imitation paintings photographically (Pl. 16–18). Well aware of his instinct for the possibilities of photographic processes, Steichen called his hybrid method *peinture à la lumière*. He abandoned plain platinum

MULTIPLE GUM

during his first stay in Paris (1900–1902) and soon began making gum and other manipulated prints, of which few extant examples are recorded. An album collected by Gertrude Käsebier of prints by Steichen, very likely given to her when she spent late August of 1901 with him, are among his few surviving gum prints. (Sotheby Parke-Bernet Sale, November 9, 1976, no. 248) Steichen began to use a variety of methods to replicate his unique gum and gum-over-platinum prints through copy negatives. These were printed as Ozotype, carbon, and even gelatine-silver prints that rendered the illusion of handwork copied from the original gum prints (Pl. 56). The replications were often given a single printing of gum-bichromate or other tone, or were hand-colored with high-

DECEPTIVE REPLICAS

lights. Steichen's goal was to deceptively replicate unique prints using purely photographic means. His copies were successful, causing much anger from disgruntled colleagues who misinterpreted his intent to be malicious deception.

Steichen's use of gum over platinum, multiple gum, and gelatine-silver enlarging papers was equally inventive, for instead of utilizing them to gain artificial painterly effects he pushed them to realize a dense but highly resolved photographic appearance. None is more typical than *Experiment in Multiple Gum* (Pl. 56), the edges of which betray the fact that the well-resolved image is constituted of layers of pigment brushed on the paper. Robert Demachy

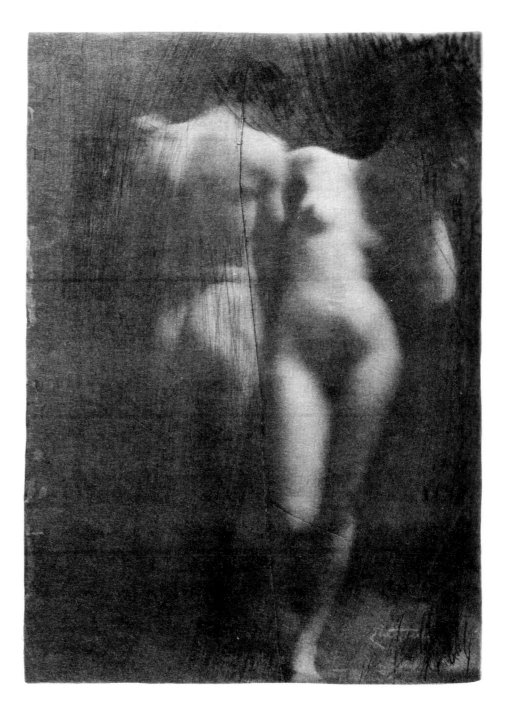

PLATE 66 » Frank Eugene. *Adam und Eva*, 1898. Cat. 226. Actual size.

had already begun experimenting with a highly resolved but densely printed gum-bichromate effect in works like *La Seine* (Cat. 205), where the print might be confused with platinum.

AUTOCHROMES

For those photographers involved with purely photographic issues, no invention was more fortuitously timed than the Lumière Autochrome process in which an approximation of natural color was realized photographically rather than by the artificial pigmentation required in other processes. Auguste and Louise Lumière announced their new process for color photographs in the summer of 1906, but it did not become publicly available until a year later.

Steichen was the first among Stieglitz's circle of photographer friends to report using the new color transparency medium. About the same time, Evans was attracted to the Rawlins color bromoil process that yielded color prints from three black and white negatives exposed through color filters. But his experiments led to nothing, and Evans wrote Stieglitz that his four-hundred-pound income did not permit toying with such an expensive process. (Biblio. 1515)

Steichen attended the first demonstration of the process by the Lumières at the *Photo-Club de Paris* in early June of 1907, an event which fortuitously occurred during Stieglitz's summer holiday in Europe but which illness prevented his attending. (Biblio. 929) Steichen portrayed Stieglitz (frontispiece) and Stieglitz was so impressed with the samples he saw in Paris that he immediately wrote to his friend at London's *Photography* magazine to introduce Steichen's colorwork: "the pictures themselves are so startlingly true that they surpass anyone's keenest expectations. . . ." (*Ibid.*) Stieglitz left Paris for Munich where he met with Eugene who used Stieglitz's plates to make his first autochromes (Cat. 287) that were soon reproduced in *Camera Work* Number Twenty (October, 1907). Steichen went to England in July, taking a supply of plates and producing results that elicited enthusiasm from the ranking British photographers. He made a series of autochromes of G. B. Shaw (MOMA collection) and the same week gave a demonstration to Coburn. By September Eugene had obtained his own plates and had begun experimenting. "A splendid thing turned a very glorious green . . . heartbreaking," he lamented to Stieglitz (Biblio. 1603), attesting that for all its simplicity compared to modern color photography, the method was not foolproof.

The seductive color in Lumière plates was based on individual grains of starch dyed green, red, and blue (the primary colors of light), coated in layers onto a glass plate with a top layer of ordinary gelatine-silver emulsion that acted as the sensitizing agent for the grains of color starch. When the plate was exposed through the camera, the colors in nature caused the starch grains to form a three-color mosaic that resembled a pointillist painting upon close examination. The process was a miraculous gift to those like Steichen who had already begun manually to introduce color into their work.

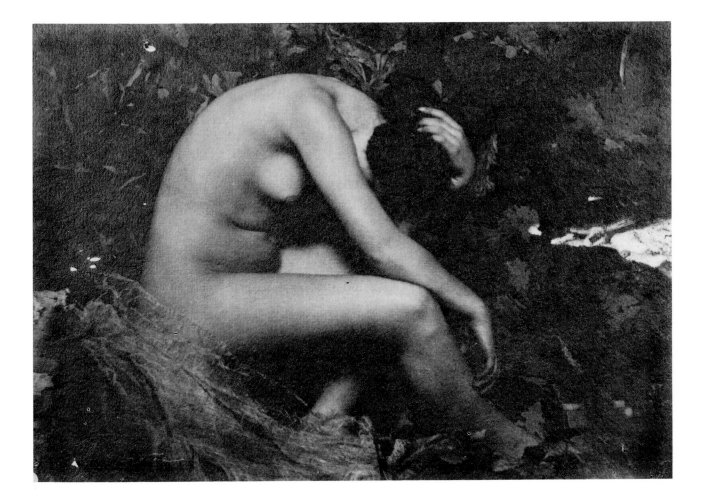

PLATE 67 » Frank Eugene. *Dido,* 1898. Cat. 228

The possibility for nature to record its own colors was greeted with great enthusiasm. Steichen, reported Coburn, felt color would displace black and white and declared he did not want to continue black-and-white work. Coburn himself confessed to Stieglitz that "I [too] have the color fever badly and have a number of things that I am simply in raptures over." (Biblio. 1471) By late October Kuehn had also begun doing color, raving to Stieglitz that his results were "faultless." (Biblio. 1564) Such was the demand for the new Lumière plates that the manufacturers could not satisfy the demand. Coburn described having to reserve a supply to satisfy his wish to do autumn landscapes. He also made autochrome portraits of G. B. Shaw, his mother, and a self-portrait, among others. (Biblio. 1472) Baron de Meyer took up the process that fall and sent an example for Stieglitz's inspection in January, confessing by August of 1908 that he could no longer sustain an interest in black and white. (Biblio. 1508) The results of this feverish activity were to appear in a book edited by Charles Holme (Biblio. 1292) which reproduced the best examples by various photographers to date.

The most expedient way to make prints from the transparencies was on a printing press with halftone dots replacing the starch grains that created the pointillist effects of the original transparencies. *Camera Work* reflected the recent excitement of color in 1905 by publishing its first color halftone, White's gum print, *The Ring Toss* (Cat. 551), in issue Number Three. It was followed by Arthur E. Becher's *Moonlight* in issue Number Four, and one of the masterpieces of pre-Lumière artificial color, Steichen's *The Flatiron—Evening* (Cat. 479), in issue Number Fourteen of April, 1906. Thus by the summer of 1907 the urge for color photographs was quite evident in the pages of *Camera Work*. The first reproduction of Lumière plates based on three Steichens from his London trip in July of 1907 were featured in issue Number Twenty-two, including *G. Bernard Shaw* and *Lady Hamilton*. Stieglitz acquired a black-and-white version (Cat. 473) of *Lady H.* presumably from the same sitting. Ironically the first issue of *Camera Work* devoted to color photographs was also the last. The next color illustrations to appear in *Camera Work* were John Marin's two studies called *In the Tyrol* in issue Number Thirty-nine of July, 1912—a date marking the end of Stieglitz's activity as a collector and publisher of photographs, but the beginning of a rich period of collecting paintings and drawings. (Biblio. 1205)

CHAPTER FIVE

NEWCOMERS TO THE CIRCLE

ANNE W. BRIGMAN

January of 1903 is an important date in Stieglitz's life as a collector of photographs. It marks the publication of *Camera Work* Number One and the end of the period during which Stieglitz was introduced to three-quarters of the photographers published in *Camera Work*, as well as most of those who were exhibited at the Photo-Secession Galleries and represented in the Stieglitz collection. Anne W. Brigman (Pls. 77–79) and Alvin L. Coburn hold special places in the Stieglitz circle of photographers because they were his first post-*Camera Work* discoveries who were featured both in the Stieglitz collection and *Camera Work*.

Every name that enters the Stieglitz collection hereafter misses part of this equation. Many knew him from before the *Camera Work* period and therefore did not qualify as new discoveries. Several new discoveries somehow achieved a token representation in the Stieglitz collection with one to five prints, but failed to be featured in *Camera Work* with many illustrations. A few photographers (Sheeler, Schamberg, Adams, Porter) came to his attention around or after the demise of *Camera Work*, thus precluding their appearance. The most common pattern for a newly-discovered photographer was to have one or two illustrations in *Camera Work* but no representation at the Photo-Secession Galleries or in the Stieglitz collection. Those who fitted all parts of the equation—being illustrated in *Camera Work* (or *Camera Notes*), having an exhibition at the Photo-Secession Galleries, and being represented in the Stieglitz collection—received the ultimate stamp of Stieglitz's approval.

THE EQUATION

Brigman and Coburn represented the last photographers whose prints Stieglitz collected in great numbers. Stieglitz subsequently became more concerned with quality than quantity in the pictures he acquired for his collection, a policy paralleled in *Camera Work* after 1910 when there were more illustrations by fewer photographers.

Brigman was apparently the last photographer to approach Stieglitz first

SAN FRANCISCO
EXHIBITION

ingenuously by mail. She suceeded in catching his attention with her mailed photographs, finally winning his friendship and admiration to such an extent that he published, exhibited, and collected her work in a signfiicant way. Brigman's early contact was established upon seeing the Photo-Secession collection sent by Stieglitz to the third San Francisco Salon of 1903 (Biblio. 1357), at which time she had written Stieglitz how impressed she was with Evans, her stylistic opposite. (Biblio. 1451) She chatted in subsequent correspondence about the contents of *Camera Work* with simple but perceptive observations, as revealed in her note about Demachy's *The Struggle* [*Camera Work*, No. 5 (January 1904)], which she interpreted as an allegory of struggling womankind. (Biblio. 1452) She saw its artistic kinship with her own allegorical style.

FIRST CALIFORNIA
SECESSIONIST

By early 1903 Brigman was a member of the Photo-Secession, the only Secessionist in California, a status of which she was duly proud. She had a high self-esteem that drove her to ask Stieglitz to promote her from Associate to Fellow of the Photo-Secession. Although Stieglitz responded that her work was not up to the mark, he promoted her soon thereafter.

Brigman had made portraits and views of San Francisco, until one day in 1905 she wrote Stieglitz asking if he would like to see "one of my fantastic conceptions . . . dreamy evening landscapes." (Cat. 71, 90; Biblio. 1453) These pleased Stieglitz, and by 1908 he had offered to feature these photographs in *Camera Work* and had agreed to a solo show that apparently never transpired.

EUGENE INFLUENCE

Brigman had a very personal idea not only of how to treat her subjects but also how to deal honestly with the medium. She learned about her own work by seeing reproductions of Eugene's photographs and took note of his manner of scratching or drawing on the negative with a very soft pencil. "I am after an 'illusive thought' and not a method," she wrote Stieglitz. (Biblio. 1457) When her gravures were about to be printed [*Camera Work*, 25 (January 1909)], Brigman asked Stieglitz to try to interpret *Soul of the Blasted Pine* (Cat. 83) as she had. "Nudes must be handled as I have tried to handle them—keeping the features indistinct." (Biblio. 1456) Stieglitz did not hold unswervingly to these instructions. Made from the original negatives, the gravure reproductions were far more detailed and quite different in effect from her original prints in the Stieglitz collection (esp. Cat. 80).

TRIP EAST

Brigman traveled East for the first time in the winter of 1910 and met the stars of a world which until then she had experienced only through *Camera Work* and other publications. When *Dryad* (Cat. 69) was reproduced in *International Studio,* she confessed to Stieglitz that it was "breathtaking to find a print of mine rubbing elbows with a Käsebier and a Steichen and a Stieglitz." (Biblio. 1454) While East, Brigman learned proper use of platinum printing from Clarence White, which remedied her earlier complaint to Stieglitz that she had tried "working in other mediums besides bromide . . . but I can't make the mediums come up to my wishes." (Biblio. 1455)

Through a combination of ingenuousness, imagination, and down-to-earth

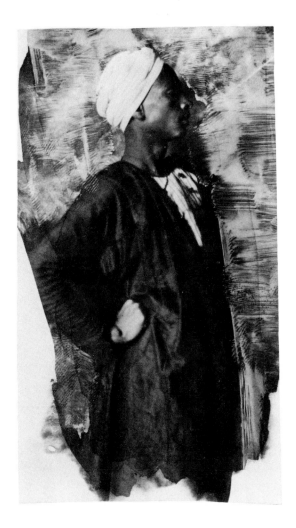

PLATE 68 » Frank Eugene. *Our Dragoman in Cairo*, 1901. Cat. 268. Actual size.

communicativeness, Brigman sustained a friendly relationship with Stieglitz through the First World War, a feat matched by few other photographers. She maintained a successful career as an illustrator for Frank Crowninshield's magazine empire, where Steichen was about to make a hit after his return from the War, and turned to Stieglitz constantly for advice in dealing with the publisher. Theirs was a friendship sustained through the mail that resulted in Stieglitz's acquiring a body of work from a more representative span of time than for any other photographer in his collection. For Brigman, Stieglitz was a kindred spirit in a wilderness of Philistines; she, in turn, was a loyal ear to Stieglitz. In response to the question "what does 291 mean to me," Brigman wrote Stieglitz of her 1910 New York trip and her impressions of the Photo-Secession Galleries.

LOYALTY TO STIEGLITZ

It was one of my gifts of the gods, that I met in those little rooms with their sunny gloom . . . nearly all of the fellows. This little place, the Man in back of it, the Fellows in back of him, and yet, shoulder to shoulder, stand for one of the great storm centres of life. (Biblio. 90)

The last photograph Stieglitz added to his collection was Brigman's *Charybdis* (Cat. 104), dated 1942. His acceptance of this trite composition can be interpreted in no way other than as a gesture of loyalty, for in all respects it fails to match the quality of Adams or Porter's work, which Stieglitz had been collecting most recently.

ALVIN LANGDON COBURN

Alvin Langdon Coburn, like Anne Brigman, came to Stieglitz's circle after the National Arts Club show and was made a Fellow of the Photo-Secession by the time the second number of *Camera Work* was published. He was attracted to Stieglitz by the flamboyant birth of the Photo-Secession in late 1902 and by *Camera Work*. He too promptly sent off his five dollars and became an Associate. In late 1901 Coburn had just returned to the United States from Europe where he had been traveling since the summer of 1899 with his mother and his distant cousin, F. Holland Day, who had taken the New School of American Photography exhibition to London. The experience brought him into personal contact with Steichen, Evans, Eugene, Demachy, and Puyo, all of whom were potent influences on the eighteen-year-old Coburn. In 1902, shortly after returning to New York, he established a studio on Fifth Avenue, an adventuresome step for one so young. But New York was to bring Coburn neither fame nor fortune, which had to wait until after his return to Europe in

RETURNS FROM EUROPE

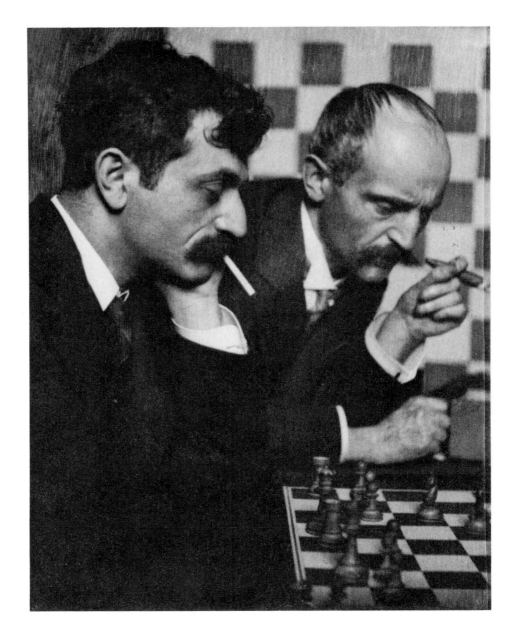

PLATE 69 » Frank Eugene. *Dr. Emanuel Lasker and His Brother*, 1907. Cat. 271. Actual size.

1904, and the making of a portrait collection of European celebrities commissioned by *The Metropolitan Magazine*.

Stieglitz was deeply impressed with the near-teenager and published *Winter Shadows* (Cat. 120) in *Camera Work* Number Three (July, 1903) with a note saying more photographs by Coburn would be forthcoming in the near future. Coburn returned to Europe on the portrait assignment that was to bring his first real fame, and which took him out of Stieglitz's circle until 1904. Their ties were reestablished during Stieglitz's European summer holiday. Coburn soon assumed for Stieglitz the role of first-hand informant on British matters, in a correspondence that abruptly but temporarily ended late in 1904, not to resume until after Coburn's meteoric rise to international prominence. The vehicle for his sudden fame was his 1906 show of celebrity portraits at the Royal Photographic Society that was lavishly praised by G. B. Shaw.

SHAW PRAISE

"At age 23 he is one of the most accomplished and sensitive artists living," wrote Shaw, who took the chance to place one very backhanded compliment: "The photographer is like the cod which produces a million eggs in order that one may reach maturity." (Biblio. 188) The result of Shaw's generous compliment was a run on Coburn's services for portraits. The exhibition broke the attendance record formerly held by Demachy at the Royal Photographic Society's galleries, and Coburn informed Stieglitz, "I have so many sitters I may have to get a studio." (Biblio. 1468) Fame soon lost its fascination, and by the following November he complained to Stieglitz, "I am plugging away at pot-boilers [portraits]—do not find it too agreeable." (Biblio. 1473)

HARTMANN: COBURN VERSUS STEICHEN

Hartmann wrote unabashedly in Coburn's favor. "[Steichen's] portraits of celebrities were always self-explanatory, even melodramatic. Coburn is subtler, more poetic and elegant. One only has to look at the two men. Steichen was proud, eccentric, intolerant. Coburn is genial, cheerful, more temperamental." (Biblio. 189)

NEW ENGLISH ART GALLERIES EXHIBITION

Positioned squarely among older colleagues by the critical acclaim, Coburn organized an invitational exhibition based on his choice of the best recent work. The New English Art Galleries show (Biblio. 1419, 1420) in London was organized in collaboration with Baron de Meyer, who solicited from both Steichen and Stieglitz recommendations on possible exhibitors. The final selections for the show that opened on January 26, 1907, read straight from the roster of the Stieglitz collection. Alice Boughton (Pl. 25) was a newcomer among the now familiar names of Brigman, Coburn, Demachy, Day, Devens, Dyer, Eugene, Henneberg, Käsebier, Keiley, Kuehn, de Meyer, Puyo, Sears, Seeley, Steichen, Stieglitz, and White. There was not a single name from outside the ranks of Stieglitz's international circle of correspondents. The show was divided into two tiers—hypothetical group A was represented by eight pictures apiece, and group B by five, a subtle but important psychological distinction. The majority belonged to the first group; Boughton, Brigman, Keiley, Seeley, and Devens were placed in the second rank.

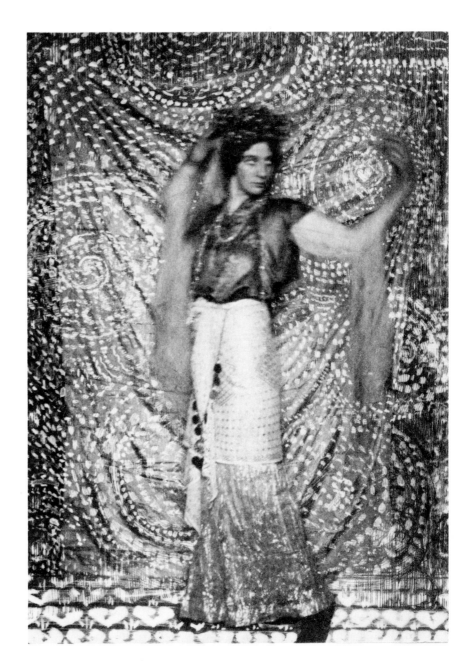

PLATE 70 » Frank Eugene. *Studie* (*Mosaik*), 1908 or before. Cat. 254. Actual size.

Feeling he was ready to show in New York, Coburn archly replied to Stieglitz's proposal for an exhibit, "I presume you consider me of sufficient importance (or at least prolific enough), to give me a show all by myself?" (Biblio. 1469) It was agreed upon, and Coburn returned to New York in mid-winter of 1907 with his mother, who was so delighted with her son's new fame that she began to address him by his surname, "Coburn." Coburn had remounted each picture to harmonize with the gallery, as he customarily did for each exhibition, and had firm ideas about installation. (*Ibid.*)

PHOTO-SECESSION
GALLERIES EXHIBITION

Coburn's show, consisting of gum and gum-platinum prints, opened at the Photo-Secession Galleries on March 11, 1907, preceded seven months earlier by Number Fifteen of *Camera Work* illustrating five of his pictures along with a portrait of Coburn by Shaw. In January of 1908, with the exhibition and *Camera Work* behind him, Coburn was catapulted into the same league as Käsebier, Steichen, White, and Demachy, leaders in the sweepstakes for numbers of photographs reproduced in *Camera Work*. He moved ahead of Brigman, who had established relationship with Stieglitz before, but whose turn in *Camera Work* did not come until issue Number Twenty-five (January, 1906). Frank Eugene patiently waited with only token representation until issue Thirty-one of July 1910 was entirely awarded to him, an honor heretofore bestowed only upon Steichen, who would be so honored by Stieglitz twice again. With the life span of *Camera Work* a little over half expired,

NEWCOMERS TO CIRCLE
LESS FREQUENT

only two other newcomers to Stieglitz's circle—Baron de Meyer in 1909 and Paul Strand in 1917—would have entire issues devoted to their photographs.

GEORGE H. SEELEY

New faces in Stieglitz's circle became increasingly fewer after the winter of 1906. Among those to appear was George Seeley (Pls. 80–81) who made his debut in Stieglitz's roster of photographers with two gravures in Number Fifteen of *Camera Work* (July, 1906) which featured Coburn. Seeley had come to Stieglitz's attention after having been an art student in Boston and having exhibited one print in the 1904 First American Photographic Salon (Biblio. 1404) organized by Stieglitz's *bête noire*, Curtis Bell. At the London Salon of the same year Seeley showed *The Staghound* (Cat. 439), later printed as a gravure in Number Twenty of *Camera Work* (October 1907) that featured his work. Seeley thus joined the race for *Camera Work* gravures, ranking just behind Demachy but ahead of Käsebier. In gratitude for the kindness Seeley offered Stieglitz his choice of one of the three prints sent for reproduction (of which only two were used), and Stieglitz chose *The Staghound*. (Biblio. 1593)

STIEGLITZ COURTS
SEELEY

Stieglitz saw Seeley's work for the first time in 1904 at the First American Salon, and then made the uncharacteristic gesture of inviting him to submit prints for the Council of the Photo-Secession. Stieglitz wanted Seeley in the

circle so badly that he was invited as a Fellow, not just an Associate. Seeley was apparently not too impressed with the invitation and left the matter in abeyance until after his first prints appeared in *Camera Work*.

White immediately recognized the talent of twenty-four-year-old Seeley and struck up a friendship. He paid a visit to Stockbridge, Massachusetts, where Seeley lived, rarely going to New York and thus postponing the opportunity for a similar friendship with Stieglitz. White made an often exhibited portrait of Seeley, and it was doubtless through this friendship that Seeley was persuaded in 1906 to become a Fellow of the Photo-Secession. Seeley's debut at the Photo-Secession Galleries was a tandem show with Baron de Meyer (Biblio. 1387), new to Stieglitz's circle but a seasoned professional nearing age forty whose style had been formed in Dresden and London during the 1890s.

WHITE'S INFLUENCE

It is easy to see why White admired Seeley's work, for they had much in common. Both relied heavily on family for their models, who were transformed by the magic of art into figures from an unwritten story. Seeley's prime model was his sister, Laura, who posed with one of their friends for *The Burning of Rome* (Cat. 440), a print with allegorical connotations. In another print a simple motif of a woman and a dog assumes the character of the fair damsel in a Gothic novel in much the same way as in the dream world of White's early work.

UNTITLED PHOTOGRAPHS

Seeley's photographs were the first in *Camera Work* to be published with the caption *No Title,* although Clarence White garners the palm for being the first to publicly exhibit a *No Title* work at the Photo-Secession Galleries exhibition of Members' Work. (Biblio. 1369) Seeley was among the few photographers of his time to publish and exhibit work as *No Title,* while at the same time assigning imaginative names like *The Burning of Rome* (Cat. 440) to other pictures, presumably in an attempt to manipulate the literary associations of his photographs.

PHOTO-SECESSION
GALLERIES EXHIBITION

Unlike White (who moved to New York), Seeley worked in isolation from the center of the photography world, without the benefit of seeing photographs by others. Apparently Seeley first visited Stieglitz on the occasion of his second show at the Photo-Secession Galleries in 1908, where he saw for the first time original work by the leading figures of modern photography. He wrote Stieglitz how impressed he was with Steichen in particular and vowed to have himself as well represented in the Stieglitz collection as Steichen. (Biblio 1594) The avowal was never fulfilled, for Stieglitz had only a handful of original prints by Seeley. A year later Seeley wrote admiringly of Kuehn, Eugene and Steichen, asking whether he might be able to meet them personally. (Biblio. 1596) In the meantime Seeley's work had come to Steichen's attention; he declared it subordinate only to Stieglitz and White in artistic quality and importance. (Biblio. 1614) Seeley met several of his older colleagues for the first time in 1908. Although he remained slightly aloof from the group, Seeley's work enabled him to be accepted by his peers among the seven strongest Ameri-

can photographers, counted alongside Coburn, who had become sixth in the pantheon informally maintained by members of Stieglitz's circle.

The warm friendship that Steichen and Brigman fostered with Stieglitz never existed for Seeley, who was initially slow to fall in line with Stieglitz and was among the first to step away in 1909 as the Photo-Secession began to disintegrate. When Stieglitz was preparing to organize what would prove to be the last representation of the Photo-Secession in a foreign exhibition, the *Internationale Photographische Ausstellung* in Dresden in 1909 (Biblio. 1395), he requested photographs from Seeley, who had just a few months before had a one-man show at the Photo-Secession Galleries in February of 1908. Seeley replied that it was impossible for him personally to supply photographs for the Dresden show because he had made few fine prints and needed them to study and show clients over the summer season in Stockbridge. He agreed, however, that Stieglitz could send prints from his own collection, which Stieglitz did grudgingly because he preferred photographers to supply their own new work. (Biblio. 1595) Stieglitz decribed to Kuehn, who was organizing the section of artistic photographs, how Seeley's response had demoralized him. This was the very moment when Stieglitz began to lose faith in his American photographer friends and turned to avant-garde painters for personal satisfaction from his life as a collector and director of exhibitions. Stiegglitz acquired Seeley's work very sparingly in relation to its importance, perhaps a result of Seeley's continued unwillingness to release prints.

SLIGHTS STIEGLITZ

BARON DE MEYER

SOCIALLY GIFTED

Baron de Meyer came into Stieglitz's circle of photographers almost simultaneously with Seeley, and they exhibited jointly for the first time in the Photo-Secession Galleries in January of 1907. (Biblio. 1387) Gregarious, international, and socially adept, de Meyer was diametrically opposite to Seeley. While Seeley held himself distant from Stieglitz and resisted being drawn intimately into the circle, de Meyer stretched for the opportunity to be included. It is not coincidental that de Meyer was represented in the Photo-Secession Galleries in 1907, the year he and Coburn had invited Stieglitz to send his own work to the exhibition they had organized at the New English Art Galleries in London. (Biblio. 1419)

De Meyer began showing in the Vienna Salon of 1896 while he was still living in Dresden and by 1898 was exhibiting in London's Photographic Salon. His name must have been familiar to Stieglitz if only because he had been praised as the best exhibitor in the 1898 Salon. (Biblio. 1316) Stieglitz had begun corresponding with de Meyer in 1903, but it was not until 1905 or 1906 on the strength of the high recommendations of Steichen and Käsebier, who

PLATE 71 » Frank Eugene. *Nude—A Study*, 1898. Cat. 231. Actual size.

had become friends and great admirers of de Meyer's work, that direct contact between the two was made. De Meyer met Steichen in Paris and after his introduction to Stieglitz reported that an hour's time with Steichen was inspiration for a year. Steichen, likewise, was equally excited, for he soon wrote Stieglitz of having seen de Meyer's "wonderful still lifes," which he preferred to similar work by White, Coburn and Eugene. (Biblio. 1615) The still lifes also impressed Käsebier, who owned eighteen of them according to de Meyer. Stieglitz was sufficiently impressed with this strong word-of-mouth recommendation, and he arranged to have Frances B. Johnston bring back from London a group of de Meyer prints, one of which must have been acquired for his collection. (Pl. 82)

In 1907 de Meyer wrote Stieglitz, "I think it is detestable to have to be brought into contact with personalities of which the London Salon consists." (Biblio. 1508) The heretofore passive criticism of The Linked Ring was now being expressed with no reluctance. Stieglitz himself had boycotted the London Photographic Salon in 1907 along with several prominent Photo-Secessionists. Considering the esteem in which Stieglitz had held the annual show until then, it is likely this correspondence marks the beginning of Stieglitz's alienation from his old London friends that culminated in his own resignation from The Linked Ring.

De Meyer's debut in *Camera Work* Number Twenty-four (October, 1908) preceded by six months his first show at the Photo-Secession Galleries that opened in February of 1909. He was featured with four still lifes accompanied by three portraits, the work which so impressed Käsebier and Steichen. The portraits were a hybrid of his two colleagues' styles, amalgamating Steichen's love for dramatic single-point lighting with Käsebier's skill at making the artificial seem natural.

De Meyer's show at the Photo-Secession Galleries marked the beginning of a dramatic decline in the number of photographs exhibited there. Between 1908 and 1917 photographs were shown at the Photo-Secession Galleries on just five occasions, one of which was another solo show of de Meyer. Of the remaining shows, two were of Steichen, one of Stieglitz, and the very last featured Paul Strand in 1916. De Meyer also had a full issue of *Camera Work* devoted to his photographs (Number Forty, October, 1912), a doubly significant honor since it immediately followed the Special Number devoted to Matisse and Picasso.

De Meyer offered Stieglitz a gift of friendship that lasted long after other photographers from the founding years of pictorialism had stopped communicating regularly with him. De Meyer respected Stieglitz's own creative efforts enormously. He admired Stieglitz the photographer, not just Stieglitz the collector, Stieglitz the publisher, or Stieglitz the gallery director. In 1921 de Meyer described the influence of Stieglitz's photographs on his own work, a compliment paid by few others in the Stieglitz circle. Most were intrigued by Stieglitz the man, rather than Stieglitz the artist.

DECLINE OF LINKED RING

THE CIRCLE IS CLOSED

CHAPTER SIX

FROM PHOTO-SECESSION TO "291"

SNEAKS AND CADS

PAINTINGS AND
DRAWINGS ATTRACT
STIEGLITZ

The changes in Stieglitz's life that diminished his activity in photography were gradual and complex in their origins. By 1908 he had stopped adding new names of photographers to his roster and began to select just old friends for the *Camera Work* illustrations. He set a policy for the Photo-Secession Galleries of exhibiting primarily paintings and drawings, which by the winter of 1909 had crowded out photographs altogether. The galleries retained their old name, however, despite the change in policy. Stieglitz moved not so much away from photography, but away from the people of the photography world. "Why cannot photographers be more liberal minded and broader? Why are most of them such awful sneaks and cads?" wrote Juan C. Abel to Stieglitz who was in Europe on his summer holiday. He added, "I think you are the only man I have any respect for in the whole photography field." (Biblio. 1423)

Stieglitz was active in too many areas not to become a target in a world that really did seem to be as eccentric as Abel said. No matter how Stieglitz acted, it was inevitable that he would offend more people than he pleased. For every photographer who was deeply grateful for being published in *Camera Work,* for being exhibited in the Photo-Secession Galleries, or for being invited to various exhibits, there were dozens of others who not only questioned Stieglitz's right to make these judgments but in whom an enormous hatred for him was kindled. Sadakichi Hartmann stopped speaking to Stieglitz in 1904, accusing him of dictatorial treatment. (Biblio. 1522) Repeated instances of minor misunderstanding or oversight are recorded between Stieglitz and those he formerly depended upon for both friendship and the fulfillment he experienced from the works of others. Some breaches were easily healed, but others resulted in immediate estrangement as in the case of Hartmann and Seeley.

Sometimes the disagreements were as elementary as that with Brigman, who wrote requesting that the titles of her prints not be changed. *Echo* (Cat.

86) had become *The Cave,* thus destroying the original significance of the print. Brigman indicated her unhappiness with liberties that had been taken, but it was no serious impediment to their relationship. (Biblio. 1458) Post catalogued his grievances in regard to titles: in 1906 his *In December* was hung at the Little Galleries as *The Barn—Winter,* in 1907 *Snow Squall* was perverted to *Snow Flurry,* and in 1908 *Wake of the Snow-Roller* was abbreviated to *Winter Landscape.* (Biblio. 1591) While such issues might today seem of negligible importance, much weight was placed on them by the photographers.

For all the instances of dissatisfaction that were directly expressed, dozens of cases must have gone unrecorded. Käsebier, White reported to Stieglitz in 1907, joined the Professional Photographers Association of New York, an action that was surely construed by Stieglitz as a slap in the face to the Photo-Secession. (Biblio. 1630) De Meyer, one of Käsebier's closest friends, tried unsuccessfully to patch things up between them, referring to her as "poor old mother Käsebier" in his typical diplomatic fashion and shrugging off her behavior as due to advancing age and ill health. (Biblio. 1509) De Meyer was equally tactful in his own dealings with Stieglitz, who he sensed was in need of special treatment. When Stieglitz proposed his own titles for de Meyer's *Camera Work* gravures, de Meyer benignly accepted the suggestion. De Meyer was also an impeccable judge of when he could speak out and refused to pass on the proofs of his *Camera Work* gravures, describing what he was shown as "too gray, lack contrast, weak and not luminous," shortcomings which he felt drained the life from his flower studies (Cats. 215, 216). About gravures de Meyer knew Stieglitz was fastidious and would listen to criticism.

Rumor and gossip played an important role in destroying the fragile structure that Stieglitz had assembled for publishing and exhibiting photographs. When Keiley arrived for a visit with the Coburns in England in 1908, the first question they asked was whether, "[Stieglitz], White and Steichen are on the outs." (Biblio. 1549) Perhaps the Coburns were picking up vibrations that had not yet been articulated directly by White or Steichen, but by 1911 they had stopped speaking entirely over a matter of little importance. The conclusion to be drawn from this evidence is that Stieglitz was a curmudgeon who equally alienated both true and false friends. He was an irascible, self-contradictory, outspoken critical human being to some, but an idealistic genius to others.

Stieglitz's *malaise* was not unique. There was an international discontent pervading the photographic world, suggestive of a general boredom that Demachy had already noticed and articulated as early as 1906, when America still seemed the promised land for photography before the same deterioration of morale set in. "The only Photographic work I am interested in is American," wrote Demachy, adding that he received "little inspiration by intercourse with European Links." (Biblio. 1506)

De Meyer and Demachy were joined by other British members in their dissatisfaction with the state of affairs in The Linked Ring. New rules had been

PLATE 72 » Alvin Langdon Coburn. *Alfred Stieglitz*, 1907. Cat. 144

set for membership and exhibition which de Meyer characterized as "ridiculous," and Keiley, in 1908 after attending a Linked Ring dinner, called "utterly —and absolutely unfit and incompetent." (Biblio. 1549) The Photo-Secession sent no collection to the London Salon that year. Stieglitz's ability to obtain greater publicity for American work in England aggravated the more conservative Links. (Biblio. 1483) By 1909 The Linked Ring was in a state of "voluntary liquidation," as Annan described it to Stieglitz, a demise which coincided exactly with the change in exhibition policy at the Photo-Secession Galleries. (Biblio. 1434) The social illness that caused the movement for artistic photography in Europe to collapse had also infected the United States. Stieglitz's erratic relationship with photographers possibly could have resulted from the same general sickness.

The estrangement Stieglitz witnessed occurring around the world was soon to strike him like a bolt of lightning that comes at the end of a long thunderstorm. Friction between Stieglitz and The Camera Club, quite public since his resignation as editor of *Camera Notes* in 1902, opened a wound that never healed and which was irritated on several succeeding occasions. First there was the misunderstanding that resulted when the commendation for excellence at the Turin exhibition (Biblio. 871, 1345) was granted to The Camera Club rather than the Photo-Secession. Then there were the Photo-Secession Galleries shows that competed with The Camera Club's own exhibitions, and his numerous angry outbursts to Club officials over philosophical issues. The wound finally became a festering sore when Stieglitz was expelled from The Camera Club by vote of its Trustees on February 3, 1908. Two weeks later a headline in *The New York Times* read: "Camera Club ousts Alfred Stieglitz. Trustees expel well-known amateur when he refuses to resign. Say there are charges. He denies that these exist and says row is due to " 'animus and jealousy'." (Biblio. 1055)

The charges by the Club against Stieglitz were listed as follows. He made himself obnoxious to Club members; gave the false idea to the world that the Club was dependent on him for financial and technical assistance; made personal use of the Club's custodian; removed Club property without authorization and lured away Club members to join his own organization, the Photo-Secession. The frantic accusation by The Camera Club was an irrational reflex response of a sick organization that just one month before had met to vote on a resolution of its directors that the Club disband because of insolvency. These were internal problems, symptomatic of a general lack of well-being in the world of photography, for which Stieglitz became the public whipping boy. (*Ibid.*)

Stieglitz was privately shattered by the series of events despite the strong public face he maintained. "If you do have to give up I shall feel as though I have given over ten years of my life for nothing. During those years I have fought for the movement but more particularly for you," pleaded Stieglitz's

CAMERA CLUB EXPELS
STIEGLITZ

TEN YEARS WASTED

PLATE 73 » Alvin Langdon Coburn. *The Rudder, Liverpool,* 1905. Cat. 131

old ally Keiley, urging him not to fold *Camera Work* and close the Photo-Secession Galleries. (Biblio. 1547) Less than a year later Stieglitz openly admitted to his friends that the Photo-Secession Galleries and *Camera Work* were a burden to him. "*Camera Work*," wrote Stieglitz to Davison, "continues to be a big load with its annual deficit, but it has become such a power in the art world here, through its articles and appearance and quality of its reproductions—that I feel it would be a calamity to quit it at present . . ." (Biblio. 1484)

Stieglitz's alienation from his photographer friends may also have been a side effect of the unpleasant altercation with The Camera Club.

ALIENATION FROM PHOTOGRAPHY

To my dismay, jealousies soon became rampant among the [Photo-Secession] photographers around me, an exact repetition of the situation I had rebelled against at The Camera Club. Various Secessionists were in danger of harming not only each other but what I was attempting to build and demonstrate. I found, too, that the very institutionalism, commercialism and self-seeking I most opposed were actually favored by certain members. (Biblio. 1057)

He was referring in the last sentence to the desertion to the ranks of professionals of Käsebier and White, who in Stieglitz's eyes had begun to place portrait businesses before art, a pitfall that years earlier had been articulated by Sadakichi Hartmann in reference to Zaida Ben-Yusuf. (Biblio. 75)

In addition to these self-doubts regarding the value of his activity came blows from other directions. The lease on the Photo-Secession Galleries expired, and early in 1907 the landlord notified Stieglitz that it could be renewed at twice the rent for a minimum of four years. The Photo-Secession Galleries had hitherto been financed by the dues of the Secessionists which despite their irregular timing were sufficient to keep the gallery alive. (Biblio. 1057, p. 77) But by 1908 the stark realities of how very few photographers could expect to be published and exhibited in *Camera Work* and the Photo-Secession Galleries left the rest uninterested. Membership and subscriptions dropped; soon dues failed to cover expenses. The lease was allowed to lapse, and the old space was soon occupied by a tailor shop. (*Ibid.,* p. 70)

FINANCIAL DISTRESS

Every melodrama requires a hero, and in this case one was at hand—Paul Haviland. A son of the French porcelain manufacturer and a recent Harvard graduate, Haviland guaranteed the lease for new quarters directly across the hall from the original gallery, and was responsible for publicly christening it "291." (Biblio. 424) Other funds were solicited to guarantee the annual operating expenses, and the Little Galleries were back in operation. It would have been an opportune time for a new name to designate the changed program of exhibition. But according to the record of events in *Camera Work,* the space continued to be called alternately the Little Galleries or the Photo-Secession Galleries. In 1911 Paul Haviland titled one of his articles "The Exhibitions at '291,'" as distinguished from his ordinary column that even up to Number Thirty-three (January, 1911) had been called "Photo-Secession Notes" in refer-

PLATE 74 » Alvin Langdon Coburn. *The White Bridge—Venice*, 1906. Cat. 132

ence to exhibitions at the galleries. (*Ibid.*) Stieglitz recollected, "I called the gallery '291' (shortly after moving in 1908). Within a week the term was commonplace amongst the frequenters of the place." (Biblio. 1057, p. 79) The statement perhaps expresses his personal nickname that did not become the publicly recognized designation until many years later.

Along with his new space across the hall, Stieglitz acquired new passions. Steichen took Stieglitz to see a Cézanne exhibition in 1907 that Stieglitz later recollected left him thinking, "why there is nothing there but empty paper with a few splashes of color here and there." (Biblio. 873, p. 81) But he soon developed a taste for European modernism and with it came a new collecting interest. Shortly thereafter Stieglitz wrote F. H. Evans of his enthusiasm for Lautrec, to which Evans replied that he should see Odilon Redon. (Biblio. 1516) Stieglitz vividly remembered why he lost interest in exhibiting photographs at the Little Galleries:

In 1908 Steichen was still living in Paris, and I, guardian of what was then known as the Photo-Secession Gallery, tired of the "swelled heads" the photographers had gotten—(that is those who had banded themselves around me, they thinking that they were quite as important as Michelangelo and Leonardo da Vinci and others of that calibre—possibly more important)—decided to open the doors of the Photo-Secession Gallery to the work of Pamela Colman Smith. . . . I had written to Steichen in Paris what I had done and told him that maybe I was making a fool of myself but that I preferred to make a fool of myself than to continue representing a lot of conceited photographers. (Biblio. 873, p. 82)

The Pamela Colman Smith exhibition (February 26–March 11, 1908) signaled an important change in the policy of the Photo-Secession Galleries. She was the first American, who was not also a photographer, to be exhibited by Stieglitz. (Biblio. 1205, pp. 295–298) Soon to follow were numerous exhibitions by living painters, sculptors and graphic artists, to whom photographers took a clearly subordinate role.

BUFFALO, 1910

VITAL CHANGES

Vital changes were becoming manifest among the Stieglitz group at "291." While the attitude of his formerly supportive associates began to deteriorate, there were numerous signs of the inevitable generational transition. Already a few of the older generation had begun to pass: first, Watzek, whose pioneering contribution was eulogized in *Camera Work* (Number Four), died in 1903; then, in 1908, Hinton who had been one of the founding members of The Linked Ring and mainstay on the General Committee of the London Salon. His absence contributed to the subsequent decline in prestige of the

PLATE 75 » Alvin Langdon Coburn. *George Bernard Shaw,* about 1907. Cat. 148

Photographic Salon. White's early supporter and charter Photo-Secessionist, Mary Stanbery (whom Stieglitz did not collect), died in 1906, and F. H. Day's good friend, Mary Devens, began to lose her eyesight in 1904. Such were the vital statistics that chronicled the transition from one generation to the next in Stieglitz's circle. The flow of time was causing him to take an increasingly historical posture toward his role as a collector, publisher and curator.

NATIONAL ARTS CLUB
EXHIBITION

Already in 1909 Stieglitz was in a retrospective frame of mind and consented to organize an exhibition of photographs at the National Arts Club (Biblio. 1406) as a sequel to the first exhibition of the Photo-Secession he had mounted there in 1902. (Biblio. 1342) The exhibition catalog listed some two hundred sixty prints representing twenty-four of the fifty photographers in the Stieglitz collection. Over fifty items were identical to those in the Stieglitz collection: the work of the Germans and Austrians listed as loans from a private collection matched item for item prints that Stieglitz owned. The 1909 National Arts Club exhibition proved to be a curtain riser for Stieglitz's swan song at Buffalo in 1910 (Biblio. 1399), to which he lent his collection. It was there that he also saw for the first time other photographs he later acquired. "The show at Buffalo will knock spots out of anything yet done, if I remain alive until it is up on the walls. Quality will be the keynote and there will be quality in quantities, too," wrote Stieglitz ebulliently to Coburn as he was getting his ideas together for the show in May of 1910 in anticipation of the November opening. (Biblio. 1474) The stated goal of the exhibition was to "sum up the development and progress of photography as a means of pictorial expression." (Biblio. 1399, The Foreword) Eight major galleries on the main floor of the museum were given over to the installation of six hundred photographs, mounted under the artistic direction of Haviland, Stieglitz, White and the painter Max Weber, who also designed the catalog cover with its cryptic numerical cipher "79—1910—12." As with the exhibitions he had organized between 1902 and the opening of the Photo-Secession Galleries in 1905, Stieglitz weighted his selections heavily in favor of a handful of photographers, while a second tier was each represented by a handful of works. "The Open Section was added to this exhibition to give all American photographers an opportunity of being represented . . . ," thus creating one invited group of the names familiar from *Camera Work* and the Photo-Secession Galleries, and another of unknowns. (*Ibid.*)

OPEN SECTION FOR
NEW WORK

The Open Section proved to fulfill a very important function by introducing several newcomers to Stieglitz's circle of photographers who would play varying roles during the last four years of his career as a collector and as publisher of *Camera Work*. Stieglitz saw ARNOLD GENTHE's (Pls. 85–86) work exhibited here for the first time, and of the eight works hung, six entered the Stieglitz collection (Cats. 305–310), suggesting that they were acquired directly from the exhibition. He also saw for the first time the work of a young New York photographer, Karl Struss, who went on to have a long career as a cinema-

ARNOLD GENTHE

PLATE 76 » Alvin Langdon Coburn. [*The Bubble*], 1909. Cat. 151

SIDNEY CARTER

tographer. (Biblio. 1179) Although Stieglitz did not collect Struss, he devoted the major part of *Camera Work* Number Thirty-eight (April, 1912) to him. Sidney Carter, a Toronto portrait photographer, exhibited a portrait of Kipling (Cat. 115) that Stieglitz perhaps saw for the first time and which entered the Stieglitz collection accidentally in an incident that contributed to the breach between Stieglitz and White. The Kipling portrait was lent by White, who was a friend of Carter's, to Stieglitz for the show. After the exhibition Stieglitz misplaced it and several of White's other loans that were soon located and returned. (Biblio. 1634) The Kipling portrait stayed misplaced and never got back to White, thus remaining in the Stieglitz collection, where Carter is represented by this single print that might not otherwise have been acquired. It must be presumed that a few others represented by single photographs entered the Stieglitz collection in similarly accidental ways.

The Open Section included the work of several photographers whose work appeared for the first time in the context of an international exhibition, and who would go on to have productive careers although not singled out by Stieglitz for any special notice. Among them were Paul Anderson (Biblio. 1135), who took up the reins as esthetician and historian when they were dropped by Hartmann and Caffin. Francis Bruguière started as a romantic pictorialist and, along with Coburn, was one of the first to apply to photography the lessons of non-objective painting after the First World War.

THE OPPONENTS OF STIEGLITZ

The most astonishing aspect of the Open Section was that in the final analysis it did not contain even a token representation of well-known, well-published and well-exhibited photographers from outside Stieglitz's circle, who had either excluded themselves or were excluded by Stieglitz from the Photo-Secession and had formed their own counter-Secessionist organization called the Photo-Pictorialists of America. Moreover, Stieglitz committed a mortal offense to their pride in calling the Buffalo show the "International Exhibition of Pictorial Photography." It could have been called more appropriately an international collection of Secessionist photography, as the Invitation Section consisted almost entirely of names actively involved with the International Secessionist movement that never got off the ground. (Biblio. 1395) The American Photo-Secession was well represented, thus clinching the exhibition's general Secessionist bias. Stieglitz attempted to undercut the preferential treatment given Secessionists by having Paul Haviland's work hung in the Open Section instead of the Invitation Section, where as an insider and member of the hanging committee he might have been expected to be found along with Stieglitz. Putting Haviland outside was probably a gesture acknowledging Haviland's status as a relative beginner in photography. His role as a dilettante was soon confirmed in 1915 when his family porcelain business took him back to France, thus truncating his promising start as a photographer. (Biblio. 1205, p. 52)

SECESSIONIST FAVORITISM

"The Invitation Section consists largely of the work of photographers of international reputation, American and foreign, whose work has been the chief

PLATE 77 » Anne W. Brigman. *Incantation*, 1905. Cat. 73

factor in bringing photography to the position to which it has now attained," stated the foreword to the catalog, establishing the exhibiting group as the historical masters of modern photography. (Biblio. 1399)

For anyone familiar with the taste of Stieglitz as expressed in the work reproduced with cyclical frequency in *Camera Work,* the luminaries of the International Invitational Section could easily have been predicted with one exception—the star. Unexpectedly, D. O. HILL (and Robert Adamson) out-distanced everyone else with forty prints, twenty-eight of which were original calotypes lent by Andrew and J. Craig Annan. The remainder consisted of seven platinum prints made by Coburn from the original paper negatives and five gravures from *Camera Work* printed by T. & R. Annan & Sons, Glasgow, under the personal supervision of J. Craig Annan. Appearing first in the ex-hibition catalog (out of alphabetical order), Hill and Adamson served to underscore the academic historical context of the exhibition. "The work of the late David Octavius Hill is worthy of the closest attention and study by every serious photographer of today," the catalog told its readers, failing however to mention the name of Robert Adamson, Hill's partner, who is today generally considered to have been co-author of their portrait series. (*Ibid.,* p. 17) The description continued, "thus at the very threshold of the new art of photog-raphy there was a worker who realized its possibilities—restricted though they were technically—for pictorial and individual expression, and for the producton of results that have yet to be equalled." (*Ibid.*)

Stieglitz had recognized Hill's importance by printing twenty-six gra-vures in three numbers of *Camera Work* and by including him in the Photo-Secession Galleries' second exhibition in 1906, the British show. In 1912 the entire issue Number Thirty-seven was devoted to Hill. Hill had hitherto played a role subordinate to Stieglitz's team that included Steichen, in number one position, followed by White and Coburn, who were way ahead of Demachy, Käsebier, Annan, Seeley, and Eugene, who each had only a total of ten to fifteen gravures in *Camera Work* by 1910.

The Buffalo exhibition reflected the hierarchy of importance Stieglitz established for the work of his associates as indicated by the numbers of repro-ductions allocated to each in *Camera Work* and by the number of photographs in the Stieglitz collection. Steichen followed Hill in the Buffalo pantheon with thirty-one prints, in keeping with his prominent role in the Photo-Secession Galleries and *Camera Work*. White followed Steichen with thirty photographs, Stieglitz followed with twenty-nine. Eugene was placed some-what higher than he had heretofore been with twenty-nine prints. Annan and Coburn tied with twenty-six each. De Meyer and Seeley exhibited twenty-four and twenty-three works respectively; Käsebier and Keiley twenty-two each; Demachy and Kuehn twenty-one and nineteen each, while Brigman and Evans showed fifteen and sixteen photographs respectively. Eleven photographers accounted for three-fifths of the works in the entire exhibition: (Hill & Adam-son, Steichen, White, Stieglitz, Coburn, Eugene, de Meyer, Annan, Seeley,

HILL AND ADAMSON

ELEVEN NAMES
DOMINATE

Käsebier, and Demachy) and also represented at this point three-fifths of the Stieglitz collection.

The exhibition fundamentally represented the taste and membership of the Photo-Secession Galleries, and when its roster is tallied with the Buffalo roster, we find 355 of the 479 photographs in the Invitation Section. More than anything, the Buffalo exhibition mirrored the names and many of the specific pictures that had been exhibited at the Photo-Secession Galleries between late 1905 and late 1908. The Buffalo catalog stated that "something more thorough and definite than ever has been attempted heretofore in any previous exhibition, either in America or Abroad." It was a slightly exaggerated claim since Stieglitz had sent many of these pictures to foreign and domestic exhibitions, as chronicled in "Photo-Secession Notes" columns of *Camera Work*. The catalog introduction also stated that the exhibition "comprises a number of one man 'shows,' and in many instances these exhibits include a number of prints executed quite recently." It was especially true for the eleven key figures who, with twenty to thirty prints each, were offered what amounted to retrospective shows. The new work in some instances reflected points of significant stylistic change. Annan, Demachy, and Kuehn all submitted photographs from 1909/ 1910 that were of much less formalistic composition than work on which their reputations rested at this point. Coburn in his *Bavarian Cloudscape* (Buffalo no. 248) of 1909 embarked on a landscape style that he was soon to follow in California, but a contrast to the portrait series for which he had become well-known in London. Similarly, Seeley's *Winter Landscape* (visible in Coburn's installation view) takes a direction different from his symbolistic works of 1904–1909.

STIEGLITZ CURATOR

The overwhelming importance of Buffalo was its historicism and an appreciation of the art historian's concern for recording the evolution of artists' styles. Stieglitz had undergone a transformation from being essentially entrepreneurial in his instincts at both *Camera Work* and the Photo-Secession Galleries, to having a decidedly curatorial and historical framework that gave the Buffalo exhibition a point of view that had never before been present in an exhibition of modern photographs.

The exhibition catalog carried a brief historical sketch of each key figure, summarizing his or her particular contributions to the modern movement in photography. Lenders were identified; the dates of the print or negative, and sometimes both were cited; and in many instances the process of printing was identified. The combined information established the catalog as the first attempt to clarify the historical record for a large number of American photographers. Since the Stieglitz collection was so heavily represented in Buffalo, the catalog becomes an essential handbook for the study of the collection.

DAY REFUSES TO
COOPERATE

Day was most poorly represented of the personalities for whose work Stieglitz had an enormous appreciation. In May, 1910, Stieglitz had written Day begging him to participate, hoping his boyish enthusiasm would cause him to forgive the decade-old incident over the blackballing by Stieglitz of the

New School of American Photography show at The Linked Ring which had kept them off speaking terms ever since. "As the exhibition is to be partly historical new prints are not necessarily essential," wrote Stieglitz, hoping to tempt Day into sending whatever prints he had on hand from the early period, but Day never even responded. (Biblio. 1499; 1519) Day made very few photographs after a fire had destroyed his studio the night of November 11, 1904. Day's reasons for refusing Stieglitz's invitation were possibly more complex and not entirely attributable to the New School of American Photography incident.

Stieglitz, however, would not accept Day's refusal to participate in the Buffalo exhibition, and lent his own collection of early Day prints, much to Day's annoyance. This necessitated the intermediation of F. H. Evans, a good friend of Day's, in a comical triangular trans-Atlantic exchange of letters. Evans communicated Day's response to Stieglitz, pointing out that the prints had been shown "without Day's approval and against his express wishes." (Biblio. 1518) Day protested that Stieglitz exhibited only his early work, which was not what Day wished to be known for. To be represented only by his early work, felt Day, would be inappropriate in a historically based exhibition. Stieglitz replied to Evans that he had been "morally bound to show [Day's photographs] with or without his permission," and he closed the letter to Evans imperiously, "Who is Mr. Day to me?" (Biblio. 1519) Not wishing to be accused of historical inaccuracy, Stieglitz managed to locate at the last minute a single later work by Day and entered the following note to the catalog entry. "The above collection of prints [by Day] is loaned by the Photo-Secession. It represents, with a single exception, Mr. Day's early period. The *Mother and Child* [Cat. 168; Buffalo "Addenda," no. 281-A] however marks the beginning of his later work, which is not ready for exhibition." (Biblio. 1399, p. 26)

The Buffalo exhibition posed many unresolved conflicts for Stieglitz. He wanted the exhibition to represent at any cost what his judgment caused him to believe was the best in modern photography from 1894 to 1910, and he was prepared to take whatever personal risks in accomplishing the goal. The incident with Day was only the first of what would be a series of catastrophic public denunciations of him emerging from the Buffalo show.

The exhibition seemed jinxed from the very beginning with the untimely death of Dr. Charles M. Kurtz, Director of the Albright Art Gallery, who approached Stieglitz early in 1909 with an idea for a broadly representational international exhibition. Stieglitz replied that he could only organize a Photo-Secession exhibition and declined the invitation. A month later Kurtz died and Cornelia Sage was named acting director. (Biblio 1130) The following November she spent an afternoon with Stieglitz at the Photo-Secession Galleries, after which she wrote him, "I felt I had found a friend and one who was in tune with my innermost thoughts." (Biblio. 1463) Before the visit she had decided

A JINXED EVENT

PLATE 78 » Anne W. Brigman. *The Spider's Web*, 1908. Cat. 85

to abandon the idea of a large international exhibition and to permit Stieglitz to organize the show however he wished. It was evidently Stieglitz's idea to call the show "International Exhibition of Pictorial Photography," omitting any mention of the Photo-Secession in the title to camouflage effectively the Photo-Secession's actual domination of the walls. Why Stieglitz felt the need remains a mystery, for the Open Section adequately served the purpose of admitting worthy neophytes. They merely needed to mail a portfolio of pictures for review by a jury that consisted of Caffin, White, Max Weber (the painter), and Stieglitz, as Bruguière had done. (Biblio. 1461) Evidently many of Stieglitz's opponents simply did not submit work.

<div style="text-align: right">JURY: STIEGLITZ, CAFFIN, WHITE, WEBER</div>

The small group of names in the Open Section failed to be representative of "American Pictorial Photography" according to the highly vocal spokesmen for "Pictorial Photography." In 1910 the anti-Secessionist photographers (Biblio. 1060) had just coalesced into a national organization called the Photo-Pictorialists of America, standing in violent opposition to the Photo-Secession movement. Kurtz had contacted representatives of the Photo-Pictorialists who had a stronghold in Philadelphia, and many followers in Buffalo, about the same time as his first communication with Stieglitz. When Walter Zimmerman of Philadelphia wrote Miss Sage (who had been named director at Buffalo), asking that the Pictorialists also be invited, the request was refused on the grounds that the exhibition had already been decided upon. The anger in Philadelphia quickly spread to Buffalo, where sympathetic pictorialists hastily united to mount opposition. The chapter succeeded in wrenching from the Albright Art Gallery the concession of a single room to hang their own works, an offer that was not accepted. A heated and highly acrimonious debate followed in the national photography journals, especially the *American Amateur Photographer*. Defending himself on the grounds that exhibitions are based upon the principle of quality not quantity, Stieglitz contended that the exhibition was not exclusive, as testified by the Open Section. He added that the opposition was basely motivated by envy of the Photo-Secession's accomplishments. (Biblio. 930)

Stieglitz had invited the trouble he was in by appropriating the name of the opponent organization and failing to give due regard to the semantic liberty he had taken. In titling the exhibition as he did, Stieglitz failed to consider that the new anti-Stieglitz pictorial photography movement was different in fundamental ways from the Photo-Secession, and even from the principles of early pictorialism. The most general characteristic of those who aligned themselves with the Photo-pictorialists was the unabashed acceptance of the stylistic models set by the masters of photography who had emerged through the international Salon circuit over the previous two decades. Independent spirit and visual imagination were alien concepts, artistic progress was actually frowned upon, and any connection to avant-gardism or even

<div style="text-align: right">MISLEADING TITLE</div>

PLATE 79 » Anne W. Brigman. *The Heart of the Storm*, about 1915. Cat. 103

modernism was deliberately avoided. It is baffling that Stieglitz would have even used the term "pictorial" to describe what he stood for at this late date.

In failing to recognize this important distinction between the two rival groups and in titling his exhibition International Exhibition of Pictorial Photography, Stieglitz created an unwitting *faux pas* that associated him and his colleagues with what would be the most despised art movement of the twentieth century, pictorialism in its late phases. Photo-pictorialism grew out of Secessionism in many ways and emphasized all of the worst aspects of the parent style. Had Stieglitz's Buffalo exhibition been titled International Exhibition of Secessionist Photography, not only would it have been a more apt description of what was exhibited, but it would also have been far less offensive to the Photo-Pictorialists. Kuehn had already established such a model in the 1909 Dresden exhibition (Biblio. 1395) but Stieglitz failed to take note of it.

Among the most devastating results of the wide public debate the issue generated was the defection of Gertrude Käsebier and Clarence White to the anti-Stieglitz side. The defection of White was brought about by a series of events only in part connected with the Buffalo exhibition, and had at least as much to do with basic personality differences that fomented a lapse in their friendship. The straw that broke the camel's back was White's claim that Stieglitz failed to return prints by others White had lent to the Buffalo Show, including the print by Sidney Carter (Cat. 115) and a de Meyer lent by Käsebier through White. "It is no longer pleasant for me to visit the gallery of the Photo-Secession," wrote White to Stieglitz.(Biblio. 1632) For the first time Stieglitz was accused in his role as a director of exhibitions of mistreating works that were left in his custody as head of the Photo-Secession. White complained that he could not ask the Photo-Secession for the return of the missing prints "because they never meet and act as a body, but only meets and acts through you." (*Ibid.*) Stieglitz's response to White conveys better than any summary his state of mind in the wake of the intense controversy over the Buffalo show and the bitterness that was in the air. It sums up all the accumulated issues that caused Stieglitz to abandon his collection of photographs and seek out a new circle of friends among painters, writers, and philosophers. (Biblio. 1634)

As for the De Meyer print belonging to Mrs. Kasebier I beg to quote to you your letter and refresh your memory. You say in your letter: "You have also a De Meyer print the loan of which I obtained for you from Mrs. Kasebier." This statement is absolutely incorrect, and I think I shall be able to prove to you that your statements are not always based upon facts. The facts in this case are: You will remember —if you can't I can help you—through proper evidence that Mr. Laurvik was responsible for the International Photographic Exhibition held at the National Arts Club a few years ago, and that at *his* request—I [had] nothing whatever to do with it—you loaned the De Meyer prints from Mrs. Kasebier for the Arts Club Ex-

PICTORIALISM AND SECESSIONISM

DEFECTION OF WHITE

THE PARTING WORDS OF WHITE

PLATE 80 » George Seeley. *The Burning of Rome*, 1906. Cat. 440

hibition. When that show was over you requested Mr. Laurvik, that for your own convenience he should kindly have the De Meyer prints sent to "291" where you could run over from your own place across the street and get them at your own leisure. I remember when you did this, and also remember that one print was not found and that you were in too great a hurry to look for it. Furthermore I remember that I told you that I'd look for it and would put it aside so that you could get it. . . .

As for repudiating responsibility for the care of prints left at the Photo-Secession I am afraid that you are unintentionally the quibbler yourself. You know very well that I have always assumed more than my share of responsibility in all things pertaining to the work done in the name of the Photo-Secession. You also know that if something were lost, I would be the very first one to say so. But I have always assumed that it is generally understood, and especially by those who have been close to me, not even as close as you have been, that whatever is left at "291" is not left in my *personal charge*. As you know "291" has always been open to the public, and often it is without any guardian whatever; the public including your friends, therefore, is trusted. It is self-evident that I could certainly not be held responsible for any misplaced confidence. Your typewritten letter is therefore apt to give a false impression of the spirit of my so-called responsibility.

The prime virtue of the Secession has always been sincerity; and it is that today, and will be that as long as I have anything to do with it. Your aspersions and sneers cannot change that.

What you say about the Albright Exhibition is certainly intensely interesting when analysed. According to you the responsibilities were on my shoulders. And so they were. In spirit I thought all the Secessionists were ready to share them, but you it seems know you were not. But in the matter of success, which according to you was due to yourself and the others who co-operated with me, all share alike. As far as you are concerned and those who think like you and with you I am only too glad to let your statement stand. As for the strained relationship you speak of, I fear it dates further back than the Albright Show. The Albright Show simply hastened a sickly condition on your part.

In regard to the series of experiments in which we collaborated [Pls. 87–88]—The Cramer-Thompson Series—some five years ago, I am astonished and grieved, more than I can tell you, to see that it is your desire to even soil the pleasant memories of a past friendship and those very pleasant days. In view of your poisoned frame of mind, which is reflected throughout your letter, I have decided to turn over to you all those negatives made by us together and which are not already in your possession. You have some of them I know. As for the prints which were in my safe keeping, and which I looked upon as our joint property, I have decided to turn the whole lot over to you, with the exception of fourteen. A few prints you already have. I have gone through the negatives at the "Camera Workers" [sic] where they were in an open locker so that you could get at them whenever you wanted to, as you understood. I found eighty-four (84); these I have just sent over to you by messenger, together with seventy-five (75) prints which I had mounted. Should I, while cleaning house this summer, run across any of the series which may have escaped my attention I shall have them sent to you. All the negatives and the prints, excepting the fourteen I have kept you may consider as your sole property. I waive

PLATE 81 » George Seeley. *The Pines Whisper,* 1904. Cat. 438

all rights thereto. One thing I do demand, and I put you on your honor, and that is that my name be not mentioned by you in connection with either the prints or the negatives. As for those that I am keeping I shall put them away in storage with the collection of prints I have of your own work and which I bought from you. My name will not be connected with them in any way. I shall see to that. Unfortunately I cannot wipe out the past. You will remember that Mr. Mullins bought one or two prints of the series, I do not remember which, and that 50% of the proceeds were turned over to you, and 50% to help pay the rent of the Photo-Secession. I also believe that you made a print from one of the negatives for Mr. George Haviland, and for which 100% of the pay was turned over to you. These prints I believe were signed by both of us. If you care to write the persons yourself to erase my name, or both the names, you have my permission to do so.

As for your opinions and your insinuations about the Secession I take them at their proper valuation. The insinuations you make about no one in particular sound frightfully familiar. They are the same species that have made my life so miserable for the past twenty years. Similar insinuations were made to me by others about yourself when you came from Ohio to establish yourself in New York, and when for months you made your headquarters daily at "291." I met these charges, or rather these insinuations, with the contempt they deserved. As a matter of fact the dastardly unfairness of the insinuations against you caused me many rows. You never were aware of this, for I tried to spare you the nastiness and pettiness of an envious and stupid world. This protection I felt you deserved. I wonder if you remember that about the same time, you were trying to prove to me that Coburn and Seeley, when they wanted exhibitions, etc., were trying to use the Secession solely for their own purposes without really doing anything for the Secession. I don't know whether you remember what I told you, possibly you do. But why start up ancient history?

It might be wise for you to come to "291" some day and make a thorough search of the place. You may have left something there at some time or other about which I know nothing. I wish to forestall any possibility of being asked by you to look for some thing. Of course it is selfunderstood that this search be made at a time when I can be present, not that I do not absolutely trust you, but because I would like to assist you not to overlook anything.

Respectfully,
Alfred Stieglitz

At the close of the Buffalo show and well before the White incident, Stieglitz was in a euphoric mental state, the proverbial calm before the storm. "I feel as though the members of the Secession were all long lost brothers and I am glad to have found them," wrote Cornelia Sage at the close of the Buffalo exhibition. At the same time she informed Stieglitz that the Art Committee had appropriated three-hundred dollars for the purchase of a selection of key works from the exhibition. Stieglitz approached the various photographers selected for purchase in attempts to have them set special prices to maximize the purchase. He wrote Käsebier, "all the men are making a special price," asking if she would cooperate by selling *The Manger* for thirty-five dollars. Her tart response was, "I am an amiable woman as well as

a very busy one. Yes." With these words the remaining threads of friendship between them were severed. (Biblio. 1536)

In November, at the height of the euphoria and before the bitter acrimony had set in, Stieglitz thought his mission as apostle for creative photography had been accomplished. "Even Mrs. Stieglitz . . . *finally realizes something has happened*—it was all a revelation to her!!" (Biblio. 1599) The understanding between them was short-lived, and even the need for such words suggests the distance that was growing between him and Emmeline by 1910.

DEMISE OF *CAMERA WORK* AND "291"

IMOGEN CUNNINGHAM

The entire issue of *Camera Work* Number Thirty-six (October, 1911) was devoted to Stieglitz's photographs as he began increasingly to accommodate his own creative life, putting into the background his role as a collector and publisher. Seven years after its founding, Stieglitz joined Steichen, White, Eugene, and Kuehn, who were the only others in his circle to be honored with a full issue. Stieglitz's introspection caused him temporarily to lose touch with the coming generation of young photographers. Among the responses to the issue Stieglitz received was a letter saying how "alive, human and beautifully photographic" the work was. The author of the letter was twenty-seven-year old Imogen Cunningham, who had met Stieglitz in 1909 on her way to Europe to study photographic chemistry in Dresden, Germany. (Biblio. 1476) Upon her return in 1910, she established herself as a portrait photographer in Seattle, Washington. Cunningham did not correspond with Stieglitz again until 1914 when she confessed that her dream was to one day be represented in *Camera Work*. (Biblio. 1477) She occasionally sent pictures to him during the Teens, but Stieglitz apparently did not acquire any for his collection nor did he publish them.

Stieglitz had two other devoted friends in the West, Brigman, whose work he actively collected and published, and her good friend in San Francisco, Francis Bruguière. Brigman and Bruguière teamed up to organize the photographic section of the 1915 Panama-Pacific Exposition in San Francisco for which they asked Stieglitz to send at their expense a loan of twenty to thirty Photo-Secession prints. (Biblio. 1462) One Bruguière print appeared in *Camera Work* Number Forty-eight, but Stieglitz did not otherwise collect his photographs.

PHOTO-SECESSION
CROWD SCATTERS

At the very moment Stieglitz was receiving supportive input from the West, his Eastern friends were going in different directions, half-way out of touch. Coburn was in California in 1912; Steichen was in Paris designing decorations for "a prominent banker in New York" (Eugene Meyer, Jr.); Eugene had an enormously successful portrait business in Munich. White was busy with pupils and "has not developed intellectually so his work cannot

develop"; and Käsebier had degenerated into a "regular commercial factory," so wrote Stieglitz summarizing the whereabouts of the Photo-Secession gang to F. Child Bayley. (Biblio. 1437) Later that year Stieglitz also wrote Kuehn about White's artistic stalemate, while "Coburn and Seeley are glutted with fame." (Biblio. 1570)

K äsebier had begun to shun Steiglitz two or three years earlier with her refusal to send prints through him to the 1909 Dresden exhibition. She chose to submit directly to the professional photographers' section in the company of her former teacher, Samuel Lifshey, instead of joining the ranks of the special section on international art photography directed by Kuehn with Stieglitz as his American agent. Early in 1912 Käsebier had written Stieglitz canceling her *Camera Work* subscription. Stieglitz chose to interpret her request as an economy move made necessary by slack business, and not wishing to admit the defection, offered to waive her Photo-Secession dues. Stieglitz would not accept her resignation without knowing "that you are no longer in sympathy with the Secession's work, nor believe in its aims and activities," a question he posed to her after suspecting she was driven by motivations more complex than just financial. (Biblio. 1537) "Let [the resignation] go through without bitterness and with dignity," responded Käsebier, making a permanent exit from Stieglitz's circle. (Biblio. 1535)

DEATH OF KEILEY

Perhaps the greatest loss to Stieglitz at this time was Joseph Keiley, who succumbed in 1914 to Bright's disease afflicting the kidney. Stieglitz wrote F. Child Bayley that Keiley was a close personal friend of his family as well as his own most important confidant between 1897 and 1904/1905. Stieglitz frankly admitted that he would never have been able to accomplish what had thus far been done for "the cause" without Keiley's help, a friendship reflected in their prolific correspondence. (Biblio. 1441)

In late 1911 and early 1912 Stieglitz went into a severe depression. "Living in New York is getting to be madder and madder, and try as one will, one becomes half mad oneself," wrote Stieglitz to Coburn. (Biblio. 1475) A year later he wrote Kuehn that "America is going through a period of luxury and unrest bordering nearly on madness. . . ." (Biblio. 1568) Evidently Stieglitz was suffering from the schism in his life, with the photography world offering deteriorating relationships, while the world of painters and sculptors promised new and propitious friendships.

MODERN PAINTING

Stieglitz's attention had first turned to The Metropolitan Museum of Art early in his period of collecting photographs (1902), and then again after his attention focused on paintings, prints and drawings. "I firmly believe that an exhibition [at the Metropolitan] of Cézanne's paintings is, just at present, of more vital importance than would be an exhibition of Rembrandt," wrote Stieglitz in response to an editorial in *The Evening Sun,* which called for an exhibition of Post-Impressionist painting to be held at the Museum. "The study of Van Gogh is nearly equally essential, if not

PLATE 82 » Baron Adolph de Meyer. *Water Lilies,* 1912 print from negative of about 1906. Cat. 216

quite so. If the Metropolitan should desire to extend the scope of the exhibition it might include the work of Matisse and Picasso, two of the big minds of the day expressing themselves in paint." (Biblio. 932) The Museum never mounted the Post-Impressionist exhibition, but Stieglitz proceeded to exhibit some of the most advanced contemporary art of Europe (Cézanne, Matisse, Picasso) and America (John Marin, Max Weber).

THE "291" CIRCLE

TOPICS OF
CONVERSATION

Between 1908 and the First World War Stieglitz saw much less of his old friends from the photography world and cultivated a new circle of creative writers, painters, and intellectuals with various academic interests. The Little Galleries of the Photo-Secession were now called "291" and gradually changed character from simply an exhibition space to a cenacle where issues of pertinence to contemporary cultural life were debated. The topics ranged from esthetics to politics, from the philosophy of patronage to the role of the artist in society, and the syntax of a new critical vocabulary of art. (Biblio. 1205, p. 45) The galleries as renovated in late 1908 provided the meeting place. Among the most important figures in Stieglitz's new circle were Paul Haviland, Marius de Zayas, and Agnes Ernst Meyer. Haviland and Mrs. Meyer were also financial backers, and the core of a group of enlightened dilettantes, whose enthusiasm for culture and philosophy made Stieglitz's not-for-profit activities possible without exhausting his own capital. He had already begun to speak privately of what financial burdens *Camera Work*

HAVILAND

and the galleries were. Haviland had first come to the Little Galleries to see the exhibition of Rodin drawings in January of 1908, and his purchases from the Rodin exhibition put him in a special position with Stieglitz. (Biblio. 1057, p. 78) Haviland began photographing in a style influenced by what he saw in *Camera Work* and became so facile at it that Stieglitz reproduced a small number as gravures in *Camera Work* (Numbers Twenty-eight, Thirty-nine, Forty-six of 1909, 1912 and 1914), and even acquired a single print for his collection (Cat. 311). Writing in an easy journalistic style befitting his liberal-arts education at Harvard, Haviland began in 1910 to author the news columns printed in *Camera Work* variously titled "Exhibitions," "Photo-Secession Notes," and "Notes on the Exhibitions," for which he was listed on the masthead as editor. In one of these notes Haviland was the first to refer publicly to the Photo-Secession Galleries as "291," the name Stieglitz used privately, and which became its new name.

DE ZAYAS

Marius de Zayas (1880–1961) entered Stieglitz's circle shortly after Haviland, and developed a warm friendship with Haviland that resulted in the co-authorship of *A Study of the Modern Evolution of Plastic Expression* (1913), a title suggestive of the content of the philosophical discourses at the

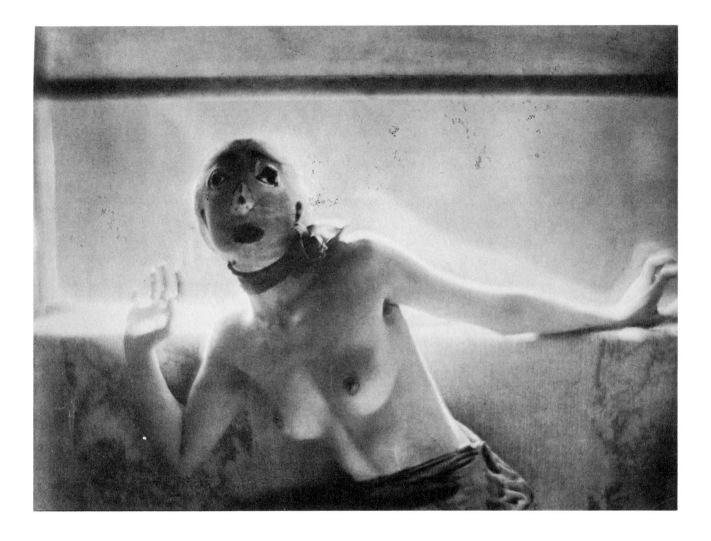

PLATE 83 » Baron Adolph de Meyer. [*Dance Study*], about 1912. Cat. 219

Photo-Secession Galleries. De Zayas was a Mexican of Spanish origin whose family, prominent in Mexican letters, became expatriates in New York during the dictatorship of Porfirio Diaz. A student of the French social caricaturists, especially Gavarni, de Zayas had a quick hand at rendering personalities in society, theatre, dance, and the visual arts, a talent through which he became a minor celebrity soon after establishing himself in New York. (Biblio. 1205, pp. 50–52)

Stieglitz was attracted to de Zayas's two styles, one of which echoed the influence of Picasso, with whom de Zayas was acquainted and to whose work he introduced Stieglitz. Stieglitz exhibited de Zayas's caricatures at the Photo-Secession Galleries early in 1908. The show opened the first full season of implementing the program of non-photographic exhibitions that commenced in earnest that year. Like Haviland, de Zayas was also a writer, contributing such philosophical essays as "Modern Art—Theories and Representations" to *Camera Work* Number Forty-four (March, 1914); his drawings were reproduced in *Camera Work* for January of 1910. Haviland and de Zayas were Stieglitz's liaisons with the School of Paris, taking up whatever slack was left by Steichen. Steichen had no appreciation of Picasso; it was through de Zayas that Stieglitz acquired for his collection Picasso's most important cubist etching (Acc. no. 49.55.315) and one of the most typical of the analytic period drawings (Acc. no. 49.70.34) from the 1911 Photo-Secession Galleries exhibition. (*Ibid.,* p. 52–55)

ERNST

Agnes Ernst (1887–1970), a young Barnard graduate, became the first female reporter on New York's *Morning Sun*. One of her first assignments was to interview Stieglitz after he was expelled from The Camera Club, an event which made front-page news. The interview lasted six hours and was the beginning of a long and mutually supportive friendship. Inspired by Stieglitz, Agnes Ernst made a tour of Europe to round out her education in the visual arts, taking classes at the Sorbonne and the Collège de France, while spending much time at the Louvre and other museums. In Paris she interviewed Matisse and Gertrude and Leo Stein, thus experiencing first hand the roots of modernism. Soon after returning to America, Ernst and her new husband Eugene Meyer, Jr., commenced a regular pattern of purchase and outright financial subsidy to the circle of American painters Stieglitz had begun to support through exhibitions at the Photo-Secession Galleries. About this time Agnes Ernst Meyer sat for a portrait by Steichen (Cat. 454). Among the painters who benefitted from the Meyers' support were Marin, Weber, Hartley and Walkowitz, who became the mainstays of Stieglitz's stable of American artists. (*Ibid.,* pp. 55–57)

PAMELA COLMAN SMITH

The first exhibition of a non-photographer took place in January of 1906 with an exhibition of drawings and watercolors by Pamela Colman Smith. While not a pioneer in the avant-garde spirit of Matisse and Picasso, Smith produced an adventuresome body of work.

MODERN AMERICAN
PAINTING

Through a combination of influences that included Steichen, Haviland, de Zayas, and the firsthand reports of Agnes Meyer, Stieglitz soon commenced a program of exhibiting radically modern European art. The first show of Matisse, recommended by Steichen, created much conversation in New York despite the fact that it included no paintings and omitted his most progressive Fauve work. Following Matisse, lithographs by Toulouse-Lautrec from Stieglitz's recently acquired personal collection opened in December of 1909. The first American exhibition of Paul Cézanne was included in a group show, followed in 1911 by his nearly abstract watercolors of the 1880s and 1890s. Eighty-three works by Picasso were shown during March of 1911, work that even contemporary critics assessed as being the most innovative of their time.

The exhibitions at "291" were of exceptional importance in the cultural history of the United States. They would have a great effect on the art and taste of the first American generation of modern painters, including Marin, Dove, Weber, Hartley and Walkowitz, who were profoundly influenced by work exhibited between 1908 and 1913. (*Ibid.,* p. 66) Stieglitz gradually changed the focus of his attention away from Europe to America, and by the time "291" closed its doors after the War, Stieglitz was only showing American painters. His program of exhibitions anticipated the fabled Armory Show of 1913, which can be credited as the major catalyst in crystallizing the support of enlightened collectors and patrons whose blessing was required for any art movement to grow to its fullest potential. Stieglitz's role in the growth of modern painting in America, however, is beyond the scope of this book.

Stieglitz's new familiarity with painting and drawing began to open new perceptions on photography by 1912. To Kuehn he wrote it was a shame that Kuehn could "not understand what Picasso has to do with photography! Too bad that you can't read the text in *Camera Work* . . . Now I find that contemporary art consists of the abstract [without subject] like Picasso, etc., and the photographic." (Biblio. 1570) Favoring abstraction over representation, Stieglitz continued, "Just as we stand before the door of a new social era, so we stand in art, too, before a new medium of expression—the true medium [abstraction]." (*Ibid.*) Wavering between photography versus abstraction, Stieglitz argued that photography and abstraction could coexist as the modern forms of expression, while backpedaling to reveal his deep sympathies for non-objective art. One of the influences on Stieglitz's thinking on abstraction was Kandinsky's *On the Spiritual in Art,* an excerpt from which had been translated and printed in *Camera Work* Number 39 (July, 1912). It was through such philosophical writings as Kandinsky's, which was one of the seminal defenses of abstract art (Biblio. 1205, p. 75), as well as the content of the paintings that Stieglitz came to espouse abstraction at "291" between 1908 and the *Special Number* of *Camera Work* devoted to Matisse and Picasso (August, 1912).

Stieglitz received considerable publicity for his role in opening the Ameri-

can doors to advanced European art, and suddenly his fame was based on something other than photography. "Mr. Stieglitz is recognized in the world's chief centres as one of the earliest prophets and most active champions of the new and astonishing revolutionary movement in art, which its enemies of the conventional school have scoffingly labeled 'Futurism,' " reported the *New York American* prefatory to the long article by Stieglitz on the Armory show (Biblio. 933) from which he acquired one work by Kandinsky. The Stieglitz collection of paintings would soon grow to eclipse his collection of photographs both in numbers and importance. (Biblio. 1057, p. 117)

The only photographer Stieglitz was seeing at this time was Baron de Meyer, so wrote Stieglitz to Ward Muir, a photographer represented in *Camera Work* Number Three. "As a society man and as a photographer he [de Meyer] has become closely identified with New York life, and his photography has been celebrated in both salons and studios," wrote a reviewer of de Meyer's 1911 show at the Photo-Secession Galleries, the only photographer to be exhibited there during the 1910–1911 season. (Biblio. 303) Despite de Meyer's fame as a society portraitist, he exhibited at least one very uncharacteristic work, *Three Old Women of the Slums*. He was highly praised for bringing "the women out of the slums and back into contact again with the world of light and human society." Stieglitz collected none of de Meyer's work in this style but held his portrait work in considerable awe. He wrote Kuehn reporting enviously that de Meyer could get one hundred dollars a sitting and twelve-fifty per print (prices that formerly only Steichen commanded), while chiding de Meyer and Käsebier for hiring others to make prints for them. Stieglitz concluded, "You couldn't work like that and would want to even less than I." (Biblio. 1569)

Seeds of doubt in the minds of photographers were sprouting all around Stieglitz. Steichen, his most loyal friend after Keiley, advised Stieglitz not to renew the lease on the Photo-Secession Galleries upon expiration of the three-year lease initiated with Paul Haviland's guarantee of the rent in 1908. Finances were Stieglitz's main concern at this time, and he wrote Kuehn that subscribers' interest in *Camera Work* was getting smaller as costs were climbing. Radical painting became the focus of attention in the illustrations of *Camera Work,* which diminished its interest to most photographers. Subscriptions began to shrink annually, and the difference between income and expenses came from the pockets of Stieglitz or his friends. His 1912 European trip was cancelled for financial reasons (making 1911 his last visit there), which permitted Stieglitz to keep things running without dipping into capital. (Biblio. 1568) "How many people today suspect what *Camera Work* means and what it offers? . . . Damned few," grumbled Stieglitz to Kuehn at the very time a complete set was

sold at auction for two thousand francs. (Biblio. 1569) By 1912 subscriptions had dwindled to 304, one hundred of which were outside the United States, compared to the nearly 1,000 subscribers in 1903.

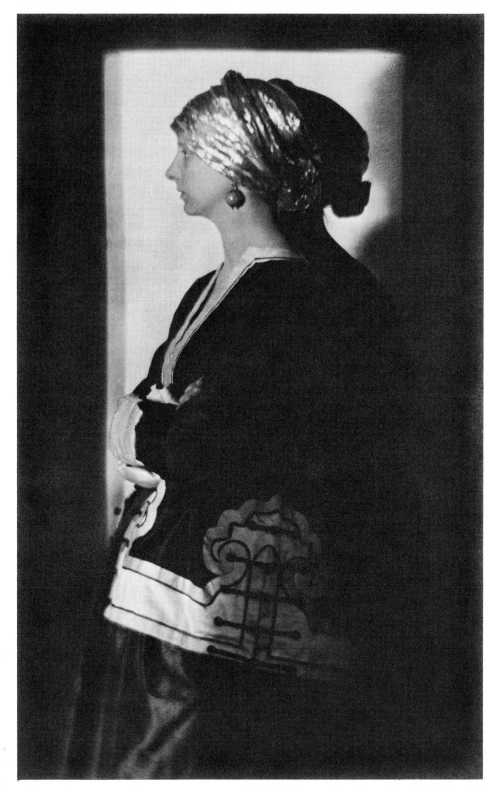

PLATE 84 » Baron Adolph de Meyer. *The Silver Cap*, 1912. Cat. 218

Camera Work, however, was not Stieglitz's only burden. The Photo-Secession Galleries required time and money. Stieglitz reported to F. Child Bayley that in seven years he had only missed two days of presence and during that time 160,000 visitors came. (Biblio. 1437) The malaise that had beset Stieglitz during the winter of 1912 continued through spring. "Isn't my work for the cause about finished?" asked Stieglitz of Kuehn and concluded, "it is useless to sacrifice time and money simply to repeat oneself." (Biblio. 1569)

The idea of whether he could even afford to keep *Camera Work* alive preyed on Stieglitz through the summer of 1912. "I wonder how many more [numbers] there will be. You know that as soon as I feel that there is nothing more to add to the real value of the publication I shall quit, for it would not give me any joy just to publish a picture book," wrote Stieglitz to Eugene.

LAST REGULAR ISSUE OF
CAMERA WORK

(Biblio. 1605) It came as no surprise that the last regular issue of *Camera Work* appeared in January of 1913, devoted to Julia Margaret Cameron and Stieglitz's Paris "snapshots" of 1911, plus two of his earlier photographs. All subsequent issues appeared at irregular intervals, not quarterly, as had been the case. The next issue was a *Special Number* devoted to Cézanne, Van Gogh, Picasso, and Picabia; then came a double issue devoted entirely to Steichen (dated April–July, 1913, but not appearing until November). Subsequent issues appeared irregularly until June of 1917, when the final double issue Number Forty-nine/Fifty was devoted in its entirety to Paul Strand. With the War making publishing difficult, and Stieglitz reassessing his activity as the 1912 correspondence suggests, the stage for *Camera Work*'s demise was set.

"291" remained a great burden to Stieglitz, and events made its closing inevitable despite Stieglitz's resistance. At four in the morning of June 14, 1913, Stieglitz was roused from bed with the telephone message, " '291' on Fire." Although the fire did not cause extensive damage either to his collection or any significant numbers of paintings or photographs, it was a visible omen. A year later the news came that the block from thirtieth to thirty-first streets would be razed for new construction; however, it was not until after Stieglitz voluntarily closed the gallery in June of 1917 that demolition began. Stieglitz's decision was the result of a chain of circumstances that began in 1912 and 1913.

The war in Europe was a strong but not the sole contributing factor. "I believe with you that, like so many others, we are victims of the terribleness of the times," wrote Caffin to Stieglitz in the spring of 1915. (Biblio. 1466) Already that fall Steichen had become a European war refugee. He departed France, reluctantly, thinking that he would really be as well off there as in New York. The war made photographing difficult, and Demachy, along with most others in Europe, came to a complete halt because of the shortages of materials; he took up sketching as an alternative form of expression. The lives of Stieglitz and all those with whom he had associated were changing because of the events.

PLATE 85 » Arnold Genthe. *After the Earthquake—San Francisco*, 1906. Cat. 307

WHAT DOES "291" MEAN?

I sat in my room thinking, weighing, what had been done during the year. Had anything been done? Anything added? Comparing the year to past years, subconsciously visualizing the year in connection with coming year. What work has to be done during the coming year? As I was thinking of these things—without crystalizing any thought—it flashed through my mind that, during the past year, a certain question had been put to me, more and more frequently. The question: "What does '291' mean?" I remember shrugging my shoulders amusedly, smiling as I replied: "291, what *does* it mean?" (Biblio. 934)

The question had become so urgent that Stieglitz decided to devote an entire issue of *Camera Work* to answering it, which resulted in the first number without a single illustration. He sent letters asking "What does '291' mean?" to "twenty or thirty people, men and women, of different ages, of different temperaments, of different walks of life, from different parts of the country, and some in Europe, to put down in as few words as possible, from ten to no more than fifteen hundred, what '291' means to them; what they see in it; what it makes them feel. Not what it is." (*Ibid.*) Sixty-eight responded to the invitation and all sixty-eight essays were printed in *Camera Work*. Among them were only four photographers: Steichen, Haviland, Brigman, and Bruguière. Steichen's baffled response expressed the exasperation felt by many of the photographers:

STEICHEN RESPONDS

Whether it was the discouragement that follows achievement, or a desire to cling to success and permanently establish its value, or merely consequent inertia caused by the absence of new or vital creative forces I am not prepared to discuss here—but "291" was not actively a living issue. I also fail to see any reason other than one or all of those enumerated above that explains to me the attitude leading to the publishing of this number of *Camera Work* unless it is simply the result of nothing better to do.
Again arrives the unforeseen—came the War. (Biblio. 750)

BRIGMAN RESPONDS

Brigman, on the other hand, responded with the vivacious enthusiasm that she always reserved for Stieglitz, while Bruguière, not even a full member of Stieglitz's circle, whose only experience of it was reflected through the pages of *Camera Work,* described "291" as "an oasis in the desert of American ideas." The great majority of replies came from painters, critics, literati, dealers and connoisseurs of radical American painting. The opinion of the photographic circle was best expressed privately to Stieglitz by Charles Caffin, who wrote him, "the old spirit was mutual helpfulness. But during the last winter I felt, rightly or wrongly, that a new spirit, one of bitterness, was creeping in . . ." He further suggested that "What is '291'?" was the obituary for *Camera Work,* the Photo-Secession Galleries, and much of what they had stood for. (Biblio. 1466)
Despite the distance that separated him from most of his old photographer friends, Stieglitz was still very much committed to photography as a

PLATE 86 » Arnold Genthe. *The First Light—San Francisco*. 1906. Cat. 306

medium of personal expression and had not completely closed himself to the photographs of others.

THE TWENTIETH CENTURY GENERATION, THE TEENS

While the first generation of modern photographers had begun to fade, a new generation would supply three new names to Stieglitz's circle: Sheeler (Pls. 89–90), Schamberg (Pl. 91), and Strand (Pls. 92–97). Between 1903 and 1906 CHARLES SHEELER and MORTON SCHAMBERG were classmates at the Pennsylvania Academy of the Fine Arts. They were students of painter William M. Chase, with whom both traveled to Spain in 1903 and 1904 on separate summer excursions that were an informal part of the curriculum. Schamberg began photographing in 1910 and Sheeler not long thereafter, but before 1912.

RELEVANCE TO
STIEGLITZ'S STYLE

Sheeler, Schamberg and Strand did not mature as photographers until the period of 1912–1915; shortly thereafter Stieglitz became aware of their work and immediately recognized the relevance of their respective styles, to which his own photographs between 1915 and 1925 have greater affinities than to most of the pictures he collected between 1896 and 1915.

Sheeler initiated a correspondence with Stieglitz in 1914, with technical inquiries that soon led to their appreciation of each other's work. Sheeler had been photographing for only two or three years, but Stieglitz responded enthusiastically to a series of photographs of Chinese carvings. "If you find the objects as wonderful works of art as I do, I shall hope you will keep the prints as a record of them," offered Sheeler, effacing the creative importance of his photographs of art objects. If Stieglitz did accept these particular prints, they were not in his collection at the time of its dispersal in 1949 by Georgia O'Keeffe.

WANAMAKER EXHIBITION

In the spring of 1916 Stieglitz was invited to sit on the jury of the annual John Wanamaker photography exhibition (Biblio. 1408B) held in Philadelphia. Perhaps the earliest public utterance of a basic change in philosophy appeared in the catalog's brief introduction. "Imitations of paintings and manipulated prints were unanimously condemned by the Judges," wrote Stieglitz as spokesman for the jurors. Stieglitz took a surprising posture for one who had earnestly supported the manipulated print processes between 1898 and 1907. That fall Sheeler wrote Stieglitz: "For the first time I saw a large and comprehensive collection of your photographs which strengthened greatly my belief that they are absolutely unparalleled," thus cementing their friendship. (Biblio. 1600) Sheeler at this time was keeping constant company with Schamberg. They shared a small house in Doylestown, Pennsylvania, where they both photographed, often with a single bright light that created dramatic shadows. Sheeler and Schamberg (but not Stieglitz) were a part of the exclusive Arensberg circle in New York, an enclave of Dadaists and others involved with

PLATE 87 » Clarence White and Alfred Stieglitz. [*Miss Thompson*], 1907. Cat. 572

European modernism. (Biblio. 1205, pp. 179ff.) It was through Sheeler that Schamberg was introduced to Stieglitz, which led to their meeting for viewing prints early in November of 1916 (about the time Stieglitz would have acquired Cat. 433). Schamberg died in the influenza epidemic of 1917, cutting short the career of one of America's most promising artists.

Strand entered Stieglitz's circle at the same time as Sheeler, but he had been a cautious participant as a visitor at the Photo-Secession Galleries. Paul Strand in 1904 had just entered Ethical Culture School, where he later studied photography with Lewis H. Hine, whose attraction to socially conscious subjects influenced him enormously. At Ethical Culture School Strand also studied with Charles Caffin, an art critic with a strong interest in photography. (Biblio. 1282) Strand was taken by Caffin on class outings to the Photo-Secession Galleries, but Strand left no specific record of the exhibitions he saw there. Luckily, Strand was introduced to the Photo-Secession Galleries before photographs had been largely replaced by paintings and sculpture on the exhibition schedule, but he did see the work of Matisse and Picasso before the Armory Show. At the Armory Show he was attracted by Cézanne, Picasso, and Brancusi; Strand again had the opportunity to see Picasso and Brancusi exhibited at "291" in 1914. After exposure to these seminal works of European modernism Strand made a series of abstractions that he recollected were made in the summer of 1916. Plate 96, titled by Stieglitz *Photograph,* and *Abstraction with porch shadows,* reproduced in *Camera Work* Number 49/50, are in their rendering of pure form preceded only by a few paintings by Arthur Dove and Marsden Hartley with the same degree of abstraction. Strand's photographs, like Dove's and Hartley's paintings, reflect the abstract principles at the heart of Picasso and to a lesser extent, Matisse and Cézanne. Strand was not, however, destined to follow through with the first experiments in abstraction; he became famous for photographs endowed with a humane social conscience (Pl. 92).

Stieglitz was a strong personal influence on Strand and was credited by Strand with persuading him to abandon the soft focus lens with which the abstractions and studies of street people were made. (*Ibid.,* p. 13ff.) Stieglitz saw in Strand the hope for the future and described him to Bayley once as "a young man I have been watching for years; without doubt the only important photographer to emerge in the United States since Coburn. His prints are more subtle, . . . and he has actually added some original vision to photography. . . . Straight all the way through in vision, in work, and in feeling. And original." (Biblio. 1443) Stieglitz's confidence in Strand was so great that he devoted the last two numbers (three really, since the last was a double issue) to him. Stieglitz characterized Strand as the first American artist or photographer to have used the exhibitions at "291" as a classroom for learning (Biblio. 1205, p. 15), which truly fulfilled the goals set when Haviland applied for a government tax exemption on the grounds that "291" was an educational enterprise. (Biblio. 1057, p. 79) "He is a protégé of mine. '291' and *Camera*

PLATE 88 » Clarence White and Alfred Stieglitz. [*Miss Thompson*], 1907. Cat. 575

Work were the school," wrote Stieglitz to Kuehn many years later. (Biblio. 1573) With this conviction Stieglitz spent an entire year on the Strand number of *Camera Work* and made it the first to appear in nineteen months since October of 1916. (Biblio. 1444)

THE WAR

America was not embroiled with European hostilities until 1917, and Strand was among the last young artists to be dislocated by the draft, beginning his basic training at Camp Greenleaf, Georgia, in June of 1918. Militarism had first affected Strand long before he was pressed into service. In 1917 Strand wrote Stieglitz, "It seems impossible to get away from the war—it touches everybody now and everywhere one finds the same resentment and lack of enthusiasm." (Biblio. 1617) Strand was not assigned to the Signal Corps branch of the Army as he requested, where he would have been able to continue making photographs, but rather he was billeted as an X-ray technician, and his term of service was partly spent at the Mayo Clinic in Rochester, Minnesota. After being discharged from the Army, Strand immediately purchased on a trial basis an eight-by-ten camera and sixteen-inch rectilinear lens. (Biblio. 1618) He also became enchanted with moving pictures and purchased an Ackeley slow motion camera in 1922 that sold for three thousand dollars. One of the first projects was a film in collaboration with Sheeler called *Mannahatta*. Between 1921 and 1925, Strand undertook commercial assignments, making slow motion films of football games and other newsworthy events for Pathé news. Stieglitz was mildly distressed by Strand's activities as a filmmaker, because he sensed the fundamental difference between moving and still pictures. He responded by sending money to Strand during the late twenties so that he could build a dark room and resume a full-time commitment to still photography.

Typical of Stieglitz's capacity to retain two opposite ideas in his mind simultaneously, he had not forgotten about Sheeler, whose photographs were headed towards a style of concrete abstraction (Cat. 446–449). While Strand was in the Army Sheeler came to be Stieglitz's focus of attention. The last number of *Camera Work* was to have been devoted to Sheeler's Doylestown House series and paintings and watercolors by O'Keeffe. That issue of *Camera Work* would have appeared in the summer of 1917 judging from Stieglitz's request to borrow from Sheeler his negatives to make *Camera Work* gravures. Stieglitz was not the only person to recognize the special qualities of Sheeler's photographs, for he was awarded the first and fourth prizes at the thirteenth annual John Wanamaker Photography Exhibition in 1917 where Strand received the first prize for his *Wall Street.*

A NEW LIFE

"At Lake George nearly 11 weeks physically I have not been so well in 25 yrs. & mentally I have never been quite so well off," wrote Stieglitz euphorically to

PLATE 89 » Charles Sheeler. [*Bucks County House, Interior Detail*], 1917. Cat. 446

GEORGIA O'KEEFFE

Bayley. (Biblio. 1444) The ebullient state of mind was at least partly due to Georgia O'Keeffe, whose drawings had enchanted him in 1915 when they were first brought by Anita Pollitzer. (Biblio. 1057, p. 130) O'Keeffe and Stieglitz established a friendship between 1915 and 1917, during most of which she was outside New York. Stieglitz came to admire O'Keeffe and her work enormously and commemorated the closing of "291" by presenting her first solo exhibition. (Biblio. 1205, p. 239) Not long after, they spent a joyful week together when her show opened. Stieglitz wrote a poem he titled "Portrait—1918" (Biblio. 936), in honor of O'Keeffe, the first stanza of which reads:

> *The Stars are Playing in the Skies*
> *The Earth's Asleep—*
> *One Soul's awake*
> *A Woman*
> The Stars Beckon———

DIVORCE

Stieglitz separated from Emmeline when their daughter Katherine was in her freshman or sophomore year at Smith College. "When I first began to know Stieglitz well in 1918 he was 54, '291' was closed, and this thing called a Collection already existed as some thing to worry about, something there was no place for. He always grumbled about the Collection, not knowing what to do with it, not really wanting it," recollected O'Keeffe shortly after Stieglitz's death in 1946. (Biblio. 1041)

The painting of O'Keeffe, as well as her charm, apparently had an enormous effect on Stieglitz, for it was about this time that he began to articulate the purist theory first made public in the Wanamaker exhibition catalog. (Biblio. 1408B) The non-objective drawings and watercolors by O'Keeffe were rooted in nature, quintessential embodiments of simplicity, originality and atmosphere that Stieglitz had articulated in 1892 as the essential compositional elements in a photograph. (Biblio. 877)

Stieglitz again conscientiously applied himself to photographing after a fallow period between 1910 and 1917. He described the new photographs to Bayley as:

INTENSELY DIRECT PHOTOGRAPHS

Intensely direct—portraits, buildings from my back window at '291,' a few landscapes and interiors all interrelated. I know nothing outside of Hill's work [Cat. 319–338] which I think is so direct, and quite so intensely honest. . . . All 8 × 10 . . . platinum prints. No diffused focus. Just the straight goods. On some things the lens stopped down to f/128. But everything simplified in spite of endless detail. (Biblio. 1444)

Bayley was among the very few to whom Stieglitz spoke candidly of opinions that would have sounded heretical to the Photo-Pictorialists of America, his sworn adversaries after the Buffalo Show. Stieglitz lost all confidence in the artistic merits represented in his collection of photographs.

PLATE 90 » Charles Sheeler. [*Bucks County House, Interior Detail*], 1917. Cat. 448

Gum, diffused lenses, (ultra) glycerining, were of experimental interest once. Steichen, Demachy, Eugene, the Viennese, did honest work for the development of photographic pictorial expression. Most of these are of more value historically than artistically. The prints are neither painting (or its equivalents) nor photographs. (Biblio. 1445)

Stieglitz was personally becoming ever increasingly involved with photographic purism. "Let the photographer make a perfect photograph—if he happens to be a lover of perfection, and a seer, why the resulting photograph will be straight and beautiful—a true photograph." (*Ibid.*)

Among the few consolations left to Stieglitz was the satisfaction of making photographs and of re-experiencing photographs that he had made many years before. Astonishingly, Stieglitz had no one-man show of his photographs between 1899 (at The Camera Club) and 1913 (at "291," simultaneously with the Armory Show). The 1913 show did not have the full weight of a retrospective and was organized to satisfy his own personal curiosity about whether his photographs would hold up against the most progressive painting and sculpture. "I am putting my work to a diabolical test. I wonder whether it will stand it. If it does not it contains nothing vital," wrote Stieglitz to Ward Muir. (Biblio. 1580) Seven years would elapse before Stieglitz's next one-man show in 1921; it was held at the Anderson Galleries, the last major exhibition of his work that marked an important turning point in his creative life. Stieglitz issued a two-paragraph statement that opened on a note of purism, "The exhibition is photographic throughout," and ended with an admonishment:

PLEASE NOTE: In the above STATEMENT the following, fast becoming "obsolete" terms do not appear: ART, SCIENCE, BEAUTY, RELIGION, every ISM, ABSTRACTION, FORM, PLASTICITY, OBJECTIVITY, SUBJECTIVITY, OLD MASTERS, MODERN ART, PSYCHOANALYSIS, AESTHETICS, PICTORIAL PHOTOGRAPHY, DEMOCRACY, CEZANNE, '291' PROHIBITION. The term TRUTH did creep in but may be kicked out by anyone. (Biblio. 935, quoted in full, Biblio. 1057, p. 142)

The design and typography of the catalog were by Stieglitz, whose arrangement of the words demonstrates his love of writing and the spirit of modern literature. Stieglitz was being as much literary as autobiographical for the occasion.

The most direct evidence of Stieglitz's purism was a series of cloud studies begun in 1922, first called *Songs of the Sky* and later titled *Equivalents*. He explained his reasons for having begun such a project.

I wanted to photograph clouds to find out what I had learned in forty years about photography. Through clouds to put down my philosophy of life—to show that (the success of) my photographs (was) not due to subject matter—not to special trees, or faces, or interiors, to special privileges, clouds were there for everyone—." (Biblio. 939)

PLATE 91 » Morton Schamberg. *Portrait Study*, 1917. Cat. 433

In photographing an essential element of nature—the air and the sky—
Stieglitz was committing himself to a kind of non-geometric abstraction in
O'Keeffe's paintings which, despite the abstract appearance, originated from
perceptions of forms in nature. Stieglitz was moving in a considerably different
creative direction from Strand or Sheeler during 1915–1917, who sought out
structural abstractions of angular and curvilinear shapes of man-made objects.
Proud to have reestablished his own creative life, Stieglitz wrote to Brigman,
"I did some pretty fine things during the past few years—odd moments—I
guess they'd impress you.—Sharp and straight—Very direct—Yet different,"
leaving little doubt that his creative life was taking precedence over his life as a
collector and entrepreneur. (Biblio. 1459)

WHITE RAPPROCHEMENT

Stieglitz had come to look upon the years before and during the Photo-
Secession as aberrant; he wanted to abandon the past in anticipation of a new
creative and personal life that was beginning to unfold. Time had mellowed
his once-intractable opinions about the Photo-Secession generation; the passage
of a decade made possible the mending of old fences. He became philosophical
about issues that once had caused serious mental anguish and even occasional
physical disability. Clarence White invited Stieglitz to lecture at his school of
photography in 1923 when Stieglitz was deeply involved in the cloud studies.
"Hear Seeley (is) doing nothing, same with Coburn, Day sick in bed. I don't
know whether I can do anything, but hope someday to try," wrote White to
Stieglitz inviting him to visit, thus mending the longstanding breach. (Biblio.
1633)

SHEELER CRITIQUE

While some fences were mended between Stieglitz and the Photo-Secession
generation, new breaches were opening with the younger generation. Perhaps
the greatest flaw in Stieglitz's personality was his reluctance to allow his ad-
mirers to speak their minds publicly in a spirited way. Sheeler deeply offended
Stieglitz by writing less than one thousand words on his 1923 exhibition at the
Anderson Galleries. He said of Stieglitz: "Having achieved the High Renais-
sance in photography through his earlier platinum prints, conditions outside
his control necessitated experimenting with another medium, the various silver
papers, and adapting them to his need. The necessity has introduced new blood,
the pulse has been quickened." (Biblio. 991) Sheeler's writing elicited an un-
expected response (Biblio. 992, 993), thus revealing the presence of an exposed
nerve. Sheeler made Stieglitz acutely aware how much a part of the
nineteenth century were the platinum, gum-bichromate and other prints that
formed a large part of the Stieglitz collection and of his own work. Surpris-
ingly, Sheeler had little sympathy for the historical antecedents of modernism,
yet in closing he expressed a thought Stieglitz had spent his life attempting to
prove: "Recollections of these photographs serve to arouse the persistent ques-
tion . . . how long before photography shall be accorded an importance not
less worthy than painting and music as a vehicle for the transmission of
ideas?" (Biblio. 991)

PLATE 92 » Paul Strand. *Photograph—New York*, 1916. Cat. 520

DISMANTLING THE COLLECTION

GIFT OF STIEGLITZ
LIBRARY TO THE
METROPOLITAN MUSEUM

Stieglitz's alienation from his formerly close colleagues in the photography world was among the external reasons for which he began giving the collection to The Metropolitan Museum of Art in 1922, starting with his library. (Biblio. 1206–1400) There were also many personal reasons, some emerging from the new direction of his creative life and others relating more to the physical, logistical problems posed by the burden of possessions. Already in 1919 Stieglitz had related to Bayley that he soon had to perform the disagreeable task of leaving Lake George for New York to go through what he then estimated to be the five-hundred to six-hundred photographs he had collected. (Biblio. 1445) His separation from Emmeline necessitated the removal of his possessions from the ample space of their apartment and reducing them to what could be accommodated in the much smaller quarters occupied by him and Georgia O'Keeffe. The Stieglitz collection of photographs went into storage about this time, which probably was to be the last opportunity for him to look at each picture and assess its relevance to him. It is hard to believe that if at this time the collection had no meaning at all for Stieglitz, he would have even bothered to store it. His awareness that the collection had cost him approximately fifteen-thousand dollars caused him to begin to look upon the collection as an investment that could be sold. He was soon to be awakened from this delusion as evidence to the contrary gradually filtered his way from various

FALLEN PRICES

sources. Returning to France after spending the war years in New York, Steichen reported to Stieglitz finding Puyo at one of the first exhibitions he attended selling historic prints from the 1890s for ten francs each (thirty cents at the exchange rate then), a fraction of what Stieglitz had paid years earlier for the Puyos in his collection. (Biblio. 1616) If it were possible to make a case-by-case examination of the value in 1920 accorded the early work of the fifty photographers collected by Stieglitz, the majority would have been considered of little or no commercial value, and some worthless by the new standards of judgment after the advent of modern art.

Among those who died or retired from photography before the war whose work was of negligible commercial value, as typified by Puyo, were Annan, Coburn, Day, Demachy, Henneberg, Hinton, the Hofmeister brothers, Keiley,

ESTABLISHING ECONOMIC
VALUE

Kuehn, Seeley and Watzek. The value of photographs by those who continued to have visible commercial or academic careers was set by commerical price of their services. An appointment could be made with Steichen, de Meyer, Käsebier, White, or Eugene to visit their studios, or in many instances, for them to make house calls, for the purpose of a commissioned portrait. The cost of a sitting might have been as little as twenty-five dollars in the case of Käsebier or White, to as high as a hundred for de Meyer, and more for Steichen. Prints were supplied after the sitting at ten to fifteen dollars each, an economic unit that came to establish the "value" of a photograph. The methodical collecting

PLATE 93 » Paul Strand. [*Photograph, New York*], 1916. Cat. 521

of photographs had changed dramatically since the days when Stieglitz and many of his friends energetically assembled examples of current work. In the 1920s there were fewer collectors of photographs than there had been two decades earlier, the few works collected documenting either the history of photography or historic events. The number of collectors of photographs motivated by creative self-expression that comprised most of the Stieglitz collection diminished considerably. The modern spirit tended to preclude historicism, and even the early work of Stieglitz would have been dismissed as passé. Thus the early photographs of Steichen, White, and Käsebier were looked upon as relics without any great economic value.

RETROSPECTIVE
ASSESSMENT

It was probably during the 1919 perusal of his collection that Stieglitz attached blue parcel-post labels to his photographs, identifying the maker, title, approximate date, and the medium (as best he could remember it after two decades). "My collection is undoubtedly unique. I looked it over last spring and some of the work does look 'queer' these days—prints that *were* famous," wrote Stieglitz to Bayley. (Biblio. 1445) It was becoming clear to Stieglitz that more than thirty years of his life were worthless by the standards of 1920. Already in 1915 there were signs that the physical results of his labor were somehow out of tune with the times. Zaida Ben-Yusuf sent him copies of *Camera Work* late in 1915, asking Stieglitz if he could sell them for her. "Six dollars is all I could get for you," he replied. (Biblio. 1450) In an incident that touched the core of his own creative experience, Stieglitz was further shattered by the results of an expensive and time-consuming project of publishing a folio-size edition of *The Steerage* in conjunction with the journal *291*. One hundred persons subscribed to the regular edition, and eight to the deluxe (thus receiving the large gravure as a part of their subscription); but out of five-hundred extra proofs pulled on Imperial Japan paper for individual sale, not a single example was sold, Stieglitz recollected. (Biblio. 1205, p. 127)

Among Stieglitz's first ideas was that his collection should belong to The Metropolitan Museum of Art. In 1926 he momentarily thought that the collection might also be valuable to George Eastman. "He could certainly open a splendid museum—and show the world what photography has really accomplished," wrote Stieglitz to Kuehn. (Biblio. 1572) In 1927 Stieglitz's attention returned to The Metropolitan and it was evident that, despite the gift of his library, he did not initially intend to donate his collection:

The large museum [Metropolitan] would have liked me to make them a great gift! I laughed. My things, I said, sleep quietly, packed up. Why should they be disturbed—to be transferred from one resting place to another. The Museum has millions upon millions at its disposal. I am fed up with "seeming" to be a millionaire in the eyes of these absolutely unfeeling people. I certainly do not want their damned money. But I know surely that these people have absolutely no understanding for art of any kind—in spite of the fact that they are now collecting Daumier and have

a great love for Dürer. They even whisper of Schongauer. They don't lure me that way. (Biblio. 1573)

Already in 1925 there were signs that Stieglitz was on the downward slope of his life. He wrote Strand, "[I have] no energy—no life—not an idea—." Stieglitz's eyes were troubling him and Paul Rosenfeld was obliging by reading aloud from Goethe. (Bilbio. 1619) Meanwhile, others were beginning to express increased confidence in Stieglitz's creative powers. In 1924 Ananda K. Coomaraswamy and his associate John Lodge, both of the Far Eastern Art Department at the Boston Museum of Fine Arts, made possible the acquisition of a collection of Stieglitz's own photographs for the Museum's Department of Prints and Drawings. William Ivins, Curator of Prints at The Metropolitan, recommended in 1928 that eighteen of Stieglitz's photographs be accessioned, inaugurating the Museum's permanent collection of master photographs. The eighteen photographs were valued on the receipt papers at eighteen-thousand dollars. The recognition given Stieglitz the artist, however, by two eminent museums in the span of four years did not halt the growing irrelevance to him of the approximately seven-hundred photographs (including those at the Art Institute of Chicago) he had collected nor the seeming futility of his early labor. In 1930 Stieglitz wrote Brigman that he burned another thousand copies of *Camera Work:* "I just couldn't take care of them any more." (Biblio. 1460) A similar letter was sent about the same time to Kuehn: "I am almost rid of all of them [*Camera Work*]—also a pity." (Biblio. 1574) By 1933 the Stieglitz collection of photographs had also become too much for him. "Maybe I am like Don Quixote with the difference that I have to furnish my own windmills too," wrote Stieglitz to Peter Henry Emerson the November after he had consigned the collection to The Metropolitan Museum of Art. (Biblio. 1635) Stieglitz wrote to Olivia Paine who acted on the matter in the absence of Ivins:

When you came to An American Place and asked me whether I'd be willing to send my collection of photographs to The Metropolitan Museum of Art instead of destroying it as I had decided to do even though I knew that there was no such other collection in the whole world and that it was a priceless one, I told you that the museum could have it without restrictions of any kind. (Biblio. 871)

Thus was saved the collection from the destruction that Stieglitz had contemplated to relieve himself of the burden of storage charges.

MUSEUM RECOGNITION

STIEGLITZ DISCARDS LAST *CAMERA WORK* COPIES

CHAPTER SEVEN

THE THIRTIES GENERATION

COLD STORAGE

EDWARD WESTON IN
NEW YORK

In the early 1920s Stieglitz found himself alienated from the community of photographers, in self-imposed isolation. There were such occasional exceptions as the speech delivered to an unspecified audience in 1923 or 1924, recorded by Rebecca Strand, where in a moment of candid self-assessment he said, "For many years I have stayed aloof [from the photography world]. Not because I wanted to, but because some good, old friends of mine insisted I was an obstreperous person and it would be good for me to be put into cold storage. Cold storage is good when you have lived in an atmosphere of hot air for many years." (Biblio. 943) Stieglitz's equal doses of candor and bitterness resulted from the significant personal changes he was undergoing: divorce of his wife and separation from his daughter, marriage to Georgia O'Keeffe, and the challenge of a new direction in his own creative life. The decade of 1923–1933 saw Stieglitz in his most unreceptive state to a new generation of photographers who would one day take their places beside the first generation of modern American painters and sculptors. For a period of time Stieglitz was unable to act effectively when confronted by strong examples of work by others. In earlier years, when facing an exceptional new talent, his first instinct was to acquire a picture or two before embarking on further ambitious campaigns of acquisition or promotion. By the early 1920s Stieglitz had suppressed those instincts, as shown in his first meeting with Edward Weston.

Weston traveled by train for his first visit to New York in November of 1922. He planned to immerse himself in the photographic community, to study firsthand paintings and sculpture in The Metropolitan Museum of Art and the Brooklyn Museum, and to meet Stieglitz. In New York Weston kept close company with Joseph Pennell, famous then for his etchings and lithographs. Back in California, one of Weston's closest friends was Johan Hagemeyer, and it was to him that Weston chronicled the events in vivid letters.

The day after arrival, Weston wrote of his great pleasure at being socially accepted and entertained by his older colleagues: "Monday night I go to supper in honor of Gertrude Käsebier—as a guest of Clarence White—too I have hopes of finding Stieglitz." (Biblio. 987) Shortly thereafter Weston's wish to meet Stieglitz materialized, and he shared with Pennell an interview that took place not long after Stieglitz had made the gift of his library to The Metropolitan Museum. "A maximum of detail with a maximum of simplification," Stieglitz advised Weston, according to the correspondence to Hagemeyer that is laced with Weston's direct quotations of his conversations with Stieglitz.

WESTON VISITS STIEGLITZ

I had lugged these pictures of mine around New York and been showered with praise—all the time knowing them to be a part of my past. . . . I seemed to sense just what Stieglitz would say about each print—So instead of destroying or disillusioning me he has given me more confidence and sureness—and finer aesthetic understanding of my medium—Stieglitz is absolutely uncompromising in his idealism—and that I feel has been my weakness . . .

he told Hagemeyer. (*Ibid.*) Stieglitz was also uncompromising in his criticism of Weston.

STIEGLITZ CRITIQUE

Quick as a flash he pounced upon the mother's hands in *Mother and Daughter* (Tina), on irrelevant detail in the pillows of *Ramiel in his Attic*—bad texture in the neck in *Sybil* and the unrelated background in *Japanese Fencing-mask*—Why did you not consider this pipe in *Pipe and Stacks?* [said Stieglitz], it's just as important as those stacks—nothing must be unconsidered—there must be complete release . . .

thus recounted Weston in explicit detail to Hagemeyer the very words of criticism Stieglitz spoke to him. His criticisms notwithstanding, Stieglitz confessed to Weston, "If I were publishing *Camera Work* I would [reproduce] *The Source* (Tina's breast)—these smoke stacks—and these torsos." (*Ibid.*) Weston described to Hagemeyer his impression "that I was well received by Stieglitz—it was obvious that he was interested and the praise he interjected was sufficient to please me." Despite the praise, Stieglitz never acquired Weston's photographs for his collection. The absence of Weston from the Stieglitz collection does not necessarily suggest negative judgment by Stieglitz, but more likely reflects that Stieglitz had stopped collecting photographs and was at this time reducing his possessions, not adding to them. However, others have suggested that Stieglitz felt a sense of artistic rivalry with Weston. Ansel Adams has said Stieglitz often spoke critically of Weston's photographs. (Biblio. 1428)

About this time Stieglitz began to share with Georgia O'Keeffe the responsibility of evaluating work brought for his eyes. When Weston's stay in New York came to an end, he called Stieglitz for a final audience to which Stieglitz replied, "I am glad you called—in fact expected you would—I told

Miss O'Keeffe about your work—please bring it with you to show her." (Biblio. 987) Weston related that O'Keeffe responded favorably to the same pictures as did Stieglitz. When they parted, Stieglitz said,

Weston—I knew from your letters that you were sincere—and felt I had something to offer—and have tried to give to you freely—your work and attitude reassures me— you have shown at least several things which have given Miss O'Keeffe and myself a great deal of joy and this I can seldom say of photographs—goodbye—and let me hear from you. (*Ibid.*)

There is no evidence that Stieglitz collected a single photograph between 1917 and 1928, a period during which Stieglitz was involved with a variety of other activities not the least important of which was his own creative work. During 1922–1923 he was the guiding spirit behind the publication of the periodical *MSS* devoted to arts and letters. In 1923 his one-man show, the first since the 1913 exhibition he personally organized for "291," was held at the Anderson Galleries. In 1924 Stieglitz and O'Keeffe were married, and the Boston Museum of Fine Arts added a collection of Stieglitz's photographs to its permanent collection. About this time Stieglitz again became interested in arranging exhibitions of paintings and drawings by prominent American artists and in 1925 founded The Intimate Gallery at 489 Park Avenue where important exhibitions were held until May of 1929. Between 1929 and the year of his death, 1946, Stieglitz directed approximately seventy-five exhibitions at the now legendary An American Place (Biblio. 1205, pp. 294–298; and Biblio. 1057, pp. 236–238, for complete listing), where the paintings of O'Keeffe, Marin, Dove, Hartley, and Demuth were the mainstays of the exhibition schedule.

THE INTIMATE GALLERY

AN AMERICAN PLACE

After the demise of *Camera Work* and the gallery "291" in 1917, Stieglitz spent eight extremely fertile years, producing the first series of O'Keeffe studies and portraits of artists and literati like Leo Stein, so powerful that Stieglitz was accused of having hypnotic powers over his sitters. (Biblio. 939, quoted in Biblio. 1057, pp. 143–144) As a visual rejoinder to the criticism of his own photographs resulting from qualities inherent in the subject rather than his input as an artist, Stieglitz began to photograph clouds, the most formless motif at his disposal. He had already explored the same motif very tentatively in his Alpine photographs of the 1880s. But the new series, exhibited under the title *Songs of the Skies—Secrets of the Skies as revealed by my Camera* at the Anderson Galleries in 1924, signalled the end of nearly a decade during which Stieglitz, financially troubled, concentrated on his own creative life and that of Georgia O'Keeffe.

SEVEN AMERICANS

After having organized exhibitions of his own photographs and of paintings by O'Keeffe, Stieglitz restated in 1925 his commitment to promoting the careers of other artists by organizing for the Anderson Galleries a show called "Seven Americans." The show featured work by O'Keeffe, Marin, Demuth,

PLATE 94 » Paul Strand. [*Untitled*], 1917. Cat. 523

Dove, and Hartley, as well as his own photographs and those of Paul Strand. With the exception of Strand, they were names whose work would be exhibited repeatedly over the coming fifteen years at the soon-to-be formed An American Place, which opened its first exhibition in December of 1929.

By 1925 such photographers as Weston, who had already produced major bodies of work and had arrived at a certain amount of independent fame, saw themselves excluded from Stieglitz's circle of those honored with exhibitions alongside the greats of modern American painting. Following the same pattern at An American Place as at the Photo-Secession Galleries and at "291," Stieglitz settled on a roster of names that changed very little over time. Until 1933 only

STRAND ACQUISITIONS

photographs by Strand and Stieglitz had been exhibited. Photographs by Paul Strand were exhibited at the "Place" only in a 1932 show jointly with the paintings on glass by Rebecca Strand. Stieglitz at this time apparently acquired the only photographs to enter his collection since the demise of *Camera Work*: Strand's studies of plants (Pl. 97) that were related to his own nature-conscious equivalents of 1922–1927. Shortly after the exhibition Strand went to New Mexico and then to Mexico City, where he was appointed Chief of Photography and Cinematography in the Fine Arts section of the National Bureau of Education. Strand became deeply involved with film, a well-established interest from the days when he and Sheeler collaborated on the film *Mannahatta* and when he had filmed college football games. The Mexican experience brought Strand into close contact with Mexican communists, resulting in his 1935 trip to Moscow. Strand's political activism strained his friendship with Stieglitz, who never offered him another show, thus functionally terminating a friendship that in 1922 Stieglitz had described to Edward Weston as his closest personal relationship after O'Keeffe. (Biblio. 987)

WALKER EVANS IGNORED

In 1929, the year after making his first serious photographs, Walker Evans also visited An American Place. Although Evans was a much less seasoned photographer than Edward Weston, Stieglitz dutifully looked at his prints and bestowed a handshake and a pat on the back. Stieglitz could not have failed to notice, however, that Evans received important solo shows at The Museum of Modern Art in 1933 and 1938. Neither he nor any member of his circle was thus recognized by that Museum until Steichen became director of the Department of Photography in 1947.

ANSEL ADAMS

Such was the life of Stieglitz when ANSEL ADAMS (Pls. 98–100), on his first visit to New York in April of 1933, presented himself and his work to Stieglitz as Weston had a decade earlier. Adams had met Strand the winter of 1929–1930 in New Mexico, where Adams was making the negatives for *Taos Pueblo*. (Biblio.

PLATE 95 » Paul Strand. *From the El*, 1915. Cat. 518

STRAND INFLUENCE

3) Stieglitz was often a topic of conversation, but Adams had not at this point even seen a copy of the now defunct *Camera Work* although he had by word of mouth learned of Stieglitz's seminal importance. Adams was deeply affected by the uncompromising directness of Strand's photographs, an influence evident in the contrast between the lingering influence of pictorialism of Adams's first published work, *Parmelian Prints of the High Sierras,* and the concern for sharp-focus light and form in *Taos Pueblo.* Before his arrival in New York, Adams had through Strand already been exposed to and accepted the indirect influence of Stieglitz the artist. Adams arrived in New York with his pregnant wife, Virginia, on a cold, drizzly morning after three days on the train. They took up residence in a small hotel, with just enough money for about two weeks of room and board. New York was then, much as it is today, the only center of contemporary art in America, including photography, and any artist with serious ambitions sooner or later was bound to spend time there. Like many others of his generation during the depths of the Depression, Adams recollected "I came to make my fortune." (Biblio. 1428) At the very top of Adams's agenda was seeing Stieglitz, to whom he had been given a letter of introduction from Mrs. Sigmund Stearn, a prominent San Franciscan distantly related to Stieglitz.

FIRST MEETING WITH
STIEGLITZ

Immediately after checking into the hotel, Adams departed with the portfolio in hand to An American Place, where he found "rather ferocious, dour looking" (*Ibid*.) Stieglitz seated in the modest gallery, which, except for the paintings, was furnished only with an army cot, a card-table, and a chair, according to Adams's recollection. Like Weston, Adams has vivid memories of his first conversation with Stieglitz, who looked at him and scowled, "And what do you want?" Adams presented his letter, receiving a barrage of uncomplimentary words about Mrs. Stearn. Despite the empty gallery, Stieglitz told Adams he had no time to see him and brusquely admonished him to return at two-thirty that afternoon. Adams remembers leaving the gallery and "pounding up and down Madison Avenue in the rain mad as hell, my sense of courtesy shocked—Mrs. Stearn was a wonderful person." (*Ibid*.) Stieglitz's attitude was so repellent to Adams that he returned to the hotel ready to turn around for California; the calming influence of Virginia caused Adams to keep the two-thirty appointment for that afternoon.

When Adams returned to An American Place, Stieglitz opened the card table, seated himself in front of it, opened the portfolio of about thirty photographs on his lap, and commenced to look carefully at them one at a time. Presumably this was Stieglitz's procedure for viewing work when a young photographer was able to command his attention. "He looked at the prints separately and with great care—every time I would try to say something he would put up his hand so as to shush me up," remembers Adams. Stieglitz closed the portfolio, tied its strings and after letting it rest a moment opened it again and proceeded to look at the prints one at a time all over again.

PLATE 96 » Paul Strand. *Photograph*, 1916. Cat. 522

"YOU ARE ALWAYS
WELCOME HERE"

Meanwhile Adams alternately sat on the windowsill or hot radiator, for lack of a chair. After closing the portfolio the second time, Adams remembers Stieglitz looked him straight in the eye and said, "These are some of the finest photographs I have ever seen. I want to continue to see your work. You are always welcome here." (*Ibid.*) At that point Marsden Hartley entered the room, and Stieglitz introduced them, saying buoyantly, "Hartley, meet Adams—we're going to hear a lot from him." (*Ibid.*) With these words it was evident Adams had replaced Strand as the fairhaired photographer of An American Place. Other than the general compliments paid by Stieglitz at the end of his examination of the portfolio, Adams clearly recalls there was no other conversation about individual photographs. Edward Weston, on the other hand, had had a critique of the specific faults in the composition of individual photographs during his first interview.

Adams returned the next day to see Stieglitz's own prints, and every day after that before returning to California. On one of the subsequent visits, Stieglitz proudly brought out some of the masterpieces of his photography collection that were kept framed in a picture rack along with the paintings and drawings. Adams had heard sketchily about the now legendary Photo-Secession from his older Californian colleague, Imogen Cunningham. Stieglitz lent Adams copies of *Camera Work* and enthusiastically brought out prints from that period, suggesting that Stieglitz had not completely turned his back on the earlier phase of his life. Upon seeing the pioneer works of modern photography, Adams remembers,

ADAMS SEES
PHOTO-SECESSION
COLLECTION

I was impressed with the historic aspect of the Photo-Secession prints, but found it very hard to accept the esthetic of most of what I saw of the earlier photographers; only the photographs of Stieglitz himself and Strand were meaningful to me at that point. The other things had a fuzzy artiness that did not interest me. (*Ibid.*)

Adams's response to the Stieglitz collection doubtless mirrored Stieglitz's own feelings to some extent, and it was no coincidence that only a few months after Adams recollected seeing the gum prints of Kuehn, they were delivered to The Metropolitan Museum of Art as part of the 1933 gift.

Stieglitz was not alone in his appreciation of Adams, whose treatment of the new f/64 school of imagery excited many Easterners. Adams showed his work to other people around New York, including Alma Reed of the Delphic Studios, where he had his first New York exhibition in November of 1933. Dean Everett V. Meeks of the Yale University Art Gallery was sufficiently excited to offer an exhibition the following year, Adams's first solo museum show.

STEICHEN IGNORES
ADAMS

While Adams accomplished all and more than he had expected on his first visit, there were also certain disappointments. He had wanted to show work to Edward Steichen, whose fame from the days of the Photo-Secession was second only to that of Stieglitz. Now a highly-paid fashion photographer,

PLATE 97 » Paul Strand. *Garden Iris—Georgetown, Maine*, 1928. Cat. 524

he was "rude and intolerant. . . . I took an instant dislike to him and we soon became firm enemies," said Adams about his first meeting with Steichen, who like Stieglitz initially had no time to look, but who never extended to Adams the expected receptiveness as had Stieglitz. (Biblio. 1428)

Adams returned to California via New England, happy with the results of that first speculative trip to New York. Annual trips became a habit, and during each stay Adams would spend as much time as possible with Stieglitz. During the 1935 visit, after again viewing Adams's portfolio, Stieglitz declared, "We must show these." (*Ibid.*) With the forty-five photographs that were exhibited to the public on October 27, 1936, Adams became the only photographer since Strand, whom Stieglitz discovered in 1915, to receive the full force of Stieglitz's imprimatur. When the crate of Adams's prints arrived at An American Place, Stieglitz's brief response was, "Pardon my delaying. It is a mad world and I plead increasing old age, which I don't do gracefully. I assure [you] even writing has become an irksome affair." A postscript gave the information Adams most awaited: "The prints are swell and your introduction just right." (Biblio. 1426)

The Adams exhibition represented a virtuoso debut ranging across the motifs available to photographers, including portraits (Cat. 1), landscape (Pl. 98), still life (Pl. 99), and architecture (Cat. 5). Adams had not yet come to be thought of primarily as a chronicler of the Sierra Nevada, although he had made important landscape photographs. The photographs were a manifesto expressing the sensibility of the newly formed f/64. Stieglitz had heard of the group and Adams recollects him teasingly saying at one point, "if you and your friends are f/64 then I am f/128." (Biblio. 1428)

Stieglitz liked Adams's photographs enormously, but the two men were also intellectual soulmates. Both loved to write and did it well, yet both claimed no talent as writers. In sending his personal statement Adams said, "If you can use it—fine. If you don't like it—tear it up. I have a fierce time stating what I feel about anything in words." (Biblio. 1424) In the checklist of the exhibition, Adams wrote, "Perception, visualization, and execution are rigorously interrelated; each in itself has little meaning. A competent technique is essential in photography, and an adequate and precise apparatus also, but without the elements of imaginative vision and taste the most perfect technical photograph is a vacuous shell." (Biblio. 6) The words could well have been Stieglitz's.

Stieglitz saw Adams as being a part of an avant-garde movement of superreality, a phrase Adams used in his checklist to the exhibition. "I will bet that ⅓ of the spectators will like [the photographs], ⅓ will be noncommittal, and the other ⅓ will heartily dislike them. As for the critics—I expect 90 % slams, 9 % milky comment, and 1 % approval," wrote Adams in anticipation of the reception of his work, observing from the standpoint of one on the fringe rather than at the center of acceptability. (Biblio. 1424)

ADAMS EXHIBITS AT
AN AMERICAN PLACE

f/64

PLATE 98 » Ansel Adams. *Winter Yosemite Valley*, 1933/1934. Cat. 6

Adams paid his annual visit to New York near the end of the exhibition's run and ebulliently described to Virginia his response.

The show at Stieglitz is extraordinary—not only are they hung with the utmost style and selection, but the relation of prints to room, and the combination in relation to Stieglitz himself, are things which only happen once in a life-time. He has already sold seven of them—one [*The White Tombstone*] for $100. The others for an average of over $30.00 each. He is more than pleased with the show. I am now definitely part of the Stieglitz Group. You can imagine what that means to me. The numbers of people that have visited the Place and the type of response is gratifying. In other words the show is quite successful! (Biblio. 1425)

Stieglitz knew he had cast his blessing on a future hero of the medium and advised, as though speaking to an heir apparent, "I hope you are as pleased as well as surprised. I am. It's all too wonderful. But Lord you deserve it. I know your head won't be turned. And remember just go your own way. Don't let the Place become a Will O' Wisp. So many have done that. And that's awful all around. Destructive in the worst sense." (Biblio. 1427)

MCALPIN PURCHASES

The importance of the Adams show did not stop with establishing a relationship between the two principals. The buyer of four of Adams's photographs was David Hunter McAlpin, a friend of Georgia O'Keeffe. Introduced in 1919 to the appreciation of etchings and engravings by Clifton R. Hall, a professor of American History at Princeton University, McAlpin soon formed a modest collection as a student at the University. His collecting interests changed after his meeting with Georgia O'Keeffe in December of 1928 at a dinner party in the home of Owen D. Young, a collector of O'Keeffe's paintings. She introduced McAlpin to Stieglitz, and McAlpin bought an O'Keeffe painting himself. She also introduced him to Adams at the screening of a Russian film on Fourteenth Street in 1933, which led to a friendship that resulted in the purchase of Adams's prints from the 1936 exhibit at An American Place. Introduced to collecting photographs by Stieglitz, McAlpin is the most important American to have been influenced by that aspect of Stieglitz's life. (Biblio. 1579)

ELIOT PORTER

YOUNGEST EXHIBITOR
WITH STIEGLITZ

For two years Adams retained a unique position with Stieglitz as the only photographer admitted to an inner circle which, after Strand's departure, had consisted otherwise of painters and writers. In December of 1938 Stieglitz opened an exhibition of photographs by ELIOT PORTER (Pls. 101–102) who, like Adams, was a man of diverse personal interests and was attempting in the early 1930s to discover which of several possible professional directions was best for

PLATE 99 » Ansel Adams. *Political Circus,* 1932/1934. Cat. 7

him. Receiving his M.D. in 1929 from Harvard Medical School, Porter took a job as a researcher and instructor of the laboratory courses at the Harvard Medical School working under Dr. Hans Zinsser. During his years as a bacteriologist, Porter photographed very little and the hobby he started as a boy of thirteen remained dormant. Porter recollects that he began photographing again about 1930 after he was introduced to the Leica camera, an engineering marvel of its time over which he became so enthusiastic that his youthful interest in making pictures was rekindled. His photographs from the period reflect the Leica's portability, his subjects ranging from abstract forms in nature to street life. After about three years of serious work, a dramatic change in his style was precipitated by a meeting with Ansel Adams in 1933 who was returning to California via New Haven and Boston after his first interview with Stieglitz, a name unknown to Porter at this time. (Biblio. 1585)

INFLUENCE OF ADAMS

Porter first saw Adams's photographs at an evening with friends in Cohasset, Massachusetts, where Adams presented many of the same prints he had just shown to Stieglitz. The meeting with Adams, recollected Porter, "had a profound influence on my subsequent work. . . . The photographs he exhibited one by one on an easel took my breath away by their perfection and strength. Never had I seen any photographs like them." (Biblio. 602, p. 80) Adams suggested to Porter that if he wanted to get f/64 effects, he use a camera larger than the Leica with its miniature negative, advice that Porter did not immediately take. The following year Porter's brother Fairfield, an art student in New York, introduced his brother to Stieglitz. "Stieglitz looked at my latest photographs and told me they were all woolly, but that their fault was not a matter of sharpness," recollects Porter of his first visit to An American Place. (*Ibid.*) Not knowing exactly what Stieglitz meant, Porter acquired a view camera which he used to make negatives in Maine and elsewhere, prints from which were taken to Stieglitz periodically between 1935 and 1938. "He was always encouraging, but also noncommittal, cautioning me that photography was very difficult and required much hard work," remembered Porter of the visits leading up to a day in 1938 when, looking through a box of prints Porter had brought, "Stieglitz stopped suddenly and said, 'You have arrived. I want to show these.'" (*Ibid.*) An exhibition was arranged to open on December 29, 1938, two days before Stieglitz's seventy-fifth birthday.

DELPHIC STUDIOS
EXHIBITION

An American Place was not the first New York gallery to show Porter's photographs, for Alma Reed had already, as she had with Adams, exhibited at the Delphic Studios thirty-seven photographs by Porter between February 24 and March 8, 1936. Delphic Studios also showed, among others, Ernest Knee, a photographer of Santa Fe, New Mexico (where Porter had yet to visit but would soon settle), whose work Porter found sufficiently attractive to buy, thus initiating his own collection of photographs by his contemporaries.

PLATE 100 » Ansel Adams. *Americana*, 1933. Cat. 3. Actual size.

The short note Porter composed for the checklist of the Delphic Studios show reveals his sympathetic understanding of Stieglitz and the basic lessons of modernism. "A photograph cannot be a painting or an etching or a lithograph; it can at best only be an imitation of one of these and must of necessity, therefore, be inferior to the genuine article," (Biblio. 596) philosophized Porter on the esthetics of photography. Such thoughts were precisely what had begun to make the Stieglitz collection of photographs meaningless for the new generation who, despite the painterly printmaking methods they used, completely failed to appreciate just how deeply rooted in nature were many of Stieglitz's associates from the *Camera Work* years.

Porter recollects that in 1938 he had heard of *Camera Work* but had not yet seen a copy; nor did Stieglitz even speak to him of the Photo-Secession or its members, events and people that had receded into Stieglitz's private consciousness. Porter did not feast on the monuments of early modernism as had Adams. The bulk of the Stieglitz collection of photographs had already been deposited as a gift to The Metropolitan Museum of Art five years earlier, just after Adams's first visit to Stieglitz. The only names from the *Camera Work* epoch familiar to Porter were Steichen and Strand. Strand's photographs were known to Porter only through reproductions, a testament to the power of the printing press in disseminating visual ideas. Stieglitz did show some of his own photographs to Porter, who remembers being particularly impressed by the dying poplars at Lake George and the New York skyscrapers. "They left an indelible impression on me," said Porter. (Biblio. 1585)

"For four years I have been watching the work of Eliot Porter," wrote Stieglitz in the 1938 checklist. "In the very beginning I felt he had a vision of his own. I sensed potentiality. These photographs now shown I believe should have an audience." (Biblio. 607) Porter's photographs were displayed in conjunction with a small show of Charles Demuth's, including the famous *I Saw the Figure 5 in Gold* (MMA 49.59.1). "Porter compasses [sic] an amazing clarity with very real feeling, even tenderness. In increasing measure much of the best photography seems to me to express very personal viewpoints and to summon up an emotional response as painting does," (Biblio. 609) wrote Howard Devree in the *Times,* much to Stieglitz's pleasure, validating the juxtaposition of Demuth and Porter. The critic of the *Sun* wrote, "Mr. Porter is unquestionably an artist who looks upon nature with the appreciative eye of the painter yet gets his effects through straight photography. He indulges in no tricks and shuns sensational viewpoints. . . . Mr. Porter gains a rank at once among our serious photographers." (Biblio. 595) Thus did Porter take a place not only beside Demuth but also beside Adams, to whom only a few years earlier Porter had presented his photographs with embarrassment.

Stieglitz was to the point when he said Porter's work should have an audience. *Jonathan* (Pl. 102), among the prints exhibited at An American

PLATE 101 » Eliot F. Porter. *Song Sparrow's Nest in Blueberry Bush*, 1938. Cat. 417

GRASSROOTS POPULARITY

Place, was featured in the *U.S. Camera Annual* for 1940, from which it was picked up by many local newspapers as a perfect human interest illustration. It was probably the first photograph collected by Stieglitz that also gained grass-roots popularity. "I wish I could afford to have this picture in my home in a frame. Would you have a [copy] of it [for me]. I adore it. (God bless the baby and also God bless you). With such wonderful work (the most perfect work an artist could do). Words from a mother's heart," wrote Mrs. Edith Marie Bechthold of Versailles, Ohio, to Porter shortly after she lost a 15½ pound infant boy and had seen the photograph reproduced. (Biblio. 595) Porter's photographs combined intimate humanity with the f/64 formalism that, Edward Weston excluded, Stieglitz was at this time finding so attractive.

Stieglitz's correspondence with Porter dealing with the practical details of the exhibition such as matting and framing is salted with personal digressions that reveal a much greater element of introspection than similar correspondence with Adams two or three years earlier. "O'Keeffe and I went thro' your prints yesterday & chose 30 to be passepartouted," began the first sentence of Stieglitz's letter of December 5, 1938, suggesting O'Keeffe's ever-increasing role in the editing and arranging of photographs in the gallery. O'Keeffe had begun to share with Stieglitz an important role in the operating of An American Place, a collaboration that Stieglitz's independent reputation might have suggested he filled with great autonomy. Already in 1922 when Edward Weston brought his photographs to Stieglitz, he invoked the desire for O'Keeffe's opinion.

In 1938 Stieglitz had begun to ruminate on the conflicting needs and interests of his role as a creative artist, a dealer, and an archivist for the medium of photography, and O'Keeffe helped him on both a practical and a philosophical level. The most troubling question of identity for Stieglitz

ART OR COMMERCE?

was whether An American Place was a charity operated for public education or a commercial art gallery run for profit. Stieglitz's correspondence with Porter reveals how little he cared about financial remuneration from the gallery, which he characterized as a not-for-profit operation whose expenses were shared by the family of exhibitors. Stieglitz let Porter set his own prices and reimbursed him fully for the value of prints sold.

"I MAKE NO ATTEMPT TO SELL ANYTHING"

What price do you want to put on [the] prints? There have been inquiries. I make no attempt to sell anything at the Place, but do let people acquire some things if they should want anything—The distinction is not understood by a lot of people. The Place isn't in business nor have I ever received anything in way of remuneration during my 50 years of apprentice life . . .

wrote Stieglitz to make clear that absolutely no service charge was included in the request for $60.90 to cover the cost of passepartouts. (Biblio. 1582) Less than a week later Stieglitz again wrote Porter, "As for 'prices' on your prints I only asked in case inquiries were made as there may be. —No, An American

PLATE 102 » Eliot F. Porter. *Jonathan*, July 1938. Cat. 418

Place is not a business. It makes no attempt directly or indirectly to sell any-thing, but occasionally someone will insist on having something & then I play the role of 'arbiter' if the parties involved so desire. I receive no 'pay' of any kind for this voluntary service. I think you know all this but I repeat it." (Biblio. 1583)

MCALPIN PURCHASES

On January 21, Stieglitz sent Porter a check for four hundred dollars to compensate him for the eight photographs that had been sold at a price of fifty dollars each; nothing was deducted in the way of commission or for the overhead of the gallery. The buyer of seven of the photographs was David Hunter McAlpin, who had also bought seven photographs from the Adams show of 1936. At the close of Porter's show, which was the last exhibition of photographs by another person Stieglitz would mount, and from which he acquired the last photographs that he would solicit for his collection, Stieglitz wrote perhaps the most intimate letter he ever penned to another photogra-pher. It is as though Stieglitz knew that one important phase of his life had finally run its course and felt the need to admit what he had never said to another person, "I learned from your photographs."

"THERE IS MY OWN SPIRIT"

I think I know how you feel about me. *Men* really don't have to thank each other.—Still I must thank you for having given me the opportunity to live with your spirit in the form of those photographs that for 3 weeks were on our walls.— And 'our' includes you.—Some of your photographs are the first I have ever seen which made me feel, 'there is my own spirit,' quite an unbelievable experience for one like myself. I wonder am I clear? Probably not . . .

wrote Stieglitz in the last letter Porter was to receive from him. (Biblio. 1584)

Stieglitz did not articulate his thoughts on each exhibition he arranged or even a fraction of the photographs he acquired for his collection. Had he done so, it is not farfetched to assume that every photographer delivered a message through the pictures that was ultimately Stieglitz's reason for collect-ing them. Nor is it farfetched to suppose that, had Stiegliz focused on the reasons for which he acquired each print in his collection, the response would have been equally sincere.

EPILOGUE

PHYSICAL INFIRMITY

After the Eliot Porter show, Stieglitz did not organize another photography exhibition at An American Place. The gallery continued in operation at 509 Madison Avenue, Room 1710, where he organized painting exhibitions until his death in 1946. The heart attack he suffered in 1928, only four years after he married O'Keeffe, subsequently imposed physical limitations, and weariness was evident in his correspondence of 1939 with Porter. (Biblio. 595) Stieglitz had stopped making negatives in 1937, but continued occasional printing of old work. The early 1940s saw Stieglitz partially disabled, which did not keep him from spending full days in the gallery where a cot enabled him to recline when necessary. Physical infirmity and considerable attrition in the roster of painters who continued to be exclusively represented by Stieglitz prevented him from mounting more than three or four exhibitions per season during the last five years. These exhibitions were uniformly solo presentations of work by O'Keeffe, Marin, and Dove, the painters with whom a reciprocal admiration was shared.

In 1937 Stieglitz said:

LIVE FOR TODAY

I have always been a great believer in *today*. Most people live either in the past or in the future, so that they really never live at all. So many are busy worrying about the future of art or society, they have no time to preserve what *is*. Utopia is in the moment. Not in some future time, some other place, but in the here and now, or else it is nowhere. (Biblio. 1057, p. 225)

Stieglitz's statement reveals the reasons beyond health that caused him to stop collecting. In 1933, the year of Stieglitz's large gift of photographs to The Metropolitan Museum of Art, his collection incontestably represented the past, the antithesis of his quest for "today." Already Stieglitz had lived through a cycle that began with his acquisitions of the Photo-Secession era and before, which by 1933 were not only part of his past but also of history. He had predicted that one day his collection of prints would be rare and valuable, but when that day finally arrived, he was unwilling to accept the ramified implications of collecting. Stieglitz began to appreciate the inde-

pendent life of artworks, favoring their direct passage to museums without the temporary custody of a collector whose psychological involvement was inevitable, as his own case had been previously. This thought was expressed in his discouragement of the collecting spirit in others by making acquisition of work from An American Place very difficult. A client had to prove his worthiness of the artwork purchased. Stieglitz became fanatical in the last years about refusing to sell his own photographs, offering them only as gifts to his closest family and friends, as if to set his own special rules by which others could acquire his work.

If these motivations are presumed, then Stieglitz's failure to acquire Edward Weston in 1928 and Walker Evans in 1929 becomes understandable: he was no longer driven by the desire to capture a place in history through his role as a collector, but rather saw his true role as a photographer whose collecting (and publishing) activities inevitably would be seen as subordinate contributions to culture. The very special role in which Adams and Porter were placed by Stieglitz is underscored by a list of other important photographers who communicated with Stieglitz in the 1930s and 1940s, but were not ultimately represented in his collection. Imogen Cunningham first corresponded with him in 1911 and made portraits of O'Keeffe and Stieglitz in 1934. These were sent to him that year but were not set aside as part of his collection. Likewise, Berenice Abbott corresponded with Stieglitz in 1938 but he never acquired her work for his collection. Others made portraits of Stieglitz in An American Place, among them Arnold Newman, Kay Bell, Dorothy Norman, and even the ubiquitous Weegee (Arthur Felig)—portraits that, with the exception of the latter, were presented to Stieglitz as tokens of admiration, yet he failed to place them with his collection.

Among the last photographers of importance to correspond with Stieglitz was Lazlo Moholy-Nagy, who in the fall of 1945, only months before his death from leukemia in 1946, wrote Stieglitz admiringly of his *Steerage* and a 1936 portrait of *Georgia O'Keeffe*. A friendship had prospered between them by mail after Stieglitz had responded favorably to Moholy's 1941 request for assistance in raising money for his passage from England, where he had fled from Dessau, Germany. Moholy-Nagy finally settled in Chicago at the American Bauhaus at the Illinois Institute of Technology. Regrettably, the two never met personally. A meeting would have allowed Stieglitz to inspect Moholy-Nagy's prints first-hand, as he had with Adams and Porter. Had such a meeting transpired, the philosophical and stylistic parallels between the two men and their work lead us to speculate that, had death not taken them the same year, Stieglitz might once again have felt the hunger to acquire.

REJECTS SOME
PHOTOGRAPHS

MOHOLY-NAGY

THE CATALOG

PREFACE TO THE CATALOG

1. The Catalog is arranged alphabetically by photographer, each having a chronology, catalog of the photographs, selected exhibitions list, selected institutional collections, and selected bibliography. The headline introducing each entry lists how the photographer usually signed photographs, correspondence, or, when a signature was not located, how the person was generally listed in contemporary exhibition catalogs.

2. *Titles* are assigned to photographs according to the following order of preference: A. As titled on the print by the photographer. B. As listed in one or more original exhibition catalogs (Biblio. 1293–1400). C. As titled on contemporary reproductions, with preference to titles published in *Camera Notes* and *Camera Work*. Titles in brackets are inferred by the author from exhibition catalogs, unsupported by other illustrations, or inferred by the author from well-established titles of related prints in the Stieglitz collection or elsewhere.

3. *Dates* are assigned according to the following order of preference: A. As dated on the print by the photographer, establishing the date of the print but not necessarily of the negative. In cases where the date of the negative is known, it has been so indicated. B. As dated in an early exhibition listing (e.g.: Biblio. 1399), which usually establishes the negative date but rarely as explicitly as in Biblio. 1399. C. As dated by Stieglitz on his collection labels (not every print was labeled), signified by his initials following the date. D. When the above sources fail to establish a date, the year be-

fore which a print had to have been made is deduced from the earliest recorded exhibition, a source favored over dates established by the earliest reproduction. E. Dates in brackets are established by modern scholarship or inferred by the author from comparison to other dated photographs in the Stieglitz collection or elsewhere.

4. *Medium* is identified according to the naked-eye assessment of the author or as listed on the Stieglitz collection label affixed to some prints. Occasionally the author's estimation of medium differed from those indicated on the collection label, in which case the discrepancy was resolved by examination under thirty to fifty power binocular magnification, using a set of prints positively identified as to medium. The control set consists of the following: Platinum, Cat. 451; Gravure, Cat. 402; Plain gum-bichromate, Cat. 199; Gum-bichromate over platinum, Cat. 131; Multiple gum-bichromate, Cat. 476; Hand-printed collotype, Cat. 214; Oil print, Cat. 212; Carbon-gelatine, Cat. 459; Gelatine-silver, Cat. 495. Practical application of these comparative examinations is found in the texts accompanying Cat. 131, 198, and pp. 444-467.

5. *Measurements* are of the image dimensions only unless otherwise stated, with height preceding width.

6. *Exhibitions* list selected group and solo shows that were organized during the time Stieglitz was actively collecting photographs (1894–1910, 1935–1940). References are to group shows unless preceded by an asterisk (*) to denote solo exhibition. Preference is given to exhibitions represented by catalogs in the Stieglitz library (Biblio. 1293–1400), which constitute

exhibitions of documented relevance to Stieglitz as a collector. The exhibitions record is listed by city and date, with the particular site indicated only for cities with numerous exhibition locations. When the city is printed in Roman type (e.g., London), a full description is found in the exhibition catalog section of the Bibliography (Nos. 1298–1400). Cities printed in italics (e.g.: *London (NEAG) 1907*) are known to the author only through reviews or other secondary sources and will not necessarily be found in the Exhibition Catalog section of the Bibliography.

7. *Collections* list relevant information about selected institutional holdings: The Art Institute of Chicago (AIC); International Museum of Photography at George Eastman House, Rochester (IMP/GEH); The Museum of Modern Art, New York (MOMA); The Metropolitan Museum of Art, New York (MMA); The Alfred Stieglitz Archive, Collection of American Literature, Yale University (YCAL); and The Royal Photographic Society of Great Britain, London (RPS). The AIC and YCAL collections hold special places for having received portions of the Stieglitz collection and references apply to their Stieglitz holdings only.

8. The photographs are listed in chronological order unless otherwise stated. The small illustrations printed here generally appear sharper than the originals due to loss of surface tone and considerable loss of middle tones in the reduction.

9. The *Bibliographies* are arranged chronologically, beginning anew with writings by the person and about the person.

10. The following *abbreviations* have been used in listing exhibitions and collections:

AI	American Institute
AIC	Art Institute of Chicago (in reference to its portion of the Stieglitz collection)
CC	Camera Club (usually preceded by city)
C-K	Camera-Klub, Vienna
IMP/GEH	International Museum of Photography at George Eastman House, Rochester
MOMA	The Museum of Modern Art, New York
MMA	The Metropolitan Museum of Art, New York
NAC	National Arts Club, New York
NEAG	New English Art Galleries, London
NSAP	New School of American Photography, London, 1901, Paris, 1902, organized by F. Holland Day
PC	Photo Club (sic), Vienna
PSG	Little Galleries of the Photo-Secession (also called in their literature the Photo-Secession Galleries), New York
RPS	Royal Photographic Society of Great Britain, London
TCC	The Camera Club, New York
YCAL	The Alfred Stieglitz Archive, Collection of American Literature, Yale University, New Haven
*	Solo exhibition
Italics	In exhibitions lists denote shows for which no catalog was located

ANSEL ADAMS (American)

Fig. 1 » *Ansel Adams*. Self-portrait, about 1940. Courtesy of Ansel Adams.

CHRONOLOGY

1902: Born Ansel Easton Adams, February 20, in San Francisco, son of Charles Hitchcock Adams and Olive Bray Adams.

About 1914: Studies piano under Marie Butler in San Francisco.

1916: Takes the first of many summer trips to Yosemite Valley where he makes his first photographs using a Kodak Box Brownie camera. Becomes interested in conservation. Returns to San Francisco and is sporadically employed by Frank Dittman, a photofinisher.

1919: Joins the Sierra Club.

1920: Decides to become a pianist and a piano teacher.

1923: Makes his first important photograph, *Banner Peak and Thousand Island Lake.* First of many trips into the High Sierra.

1927: First publication of his photographs *Parmelian Prints of the High Sierras* (sic), a portfolio of eighteen gelatine silver prints sponsored by art patron Albert Bender which includes *Monolith, The Face of Half Dome* from a negative of 1927.

1928: Marries Virginia Best in Yosemite. Becomes assistant manager and photographer for The Sierra Club Outings.

1929: Meets John Marin and Georgia O'Keeffe in Taos, New Mexico, at home of Mabel Dodge Luhan.

1930: Meets Paul Strand in Taos. » Publication of *Taos Pueblo,* with twelve gelatine silver prints and a text by Mary Austin (Biblio. 3).

1932: Forms Group f/64 in collaboration with Edward Weston, Willard Van Dyke, Imogen Cunningham, Sonia Noskowiak, Henry Swift, and others. The group holds its first show at the De Young Museum, San Francisco.

1933: In New York. Meets Alfred Stieglitz at An American Place, 509 Madison Avenue. On return to San Francisco, starts Ansel Adams Gallery. Begins teaching and lecturing on photography.

1934: Gives up Gallery to devote full time to his own commercial and creative photography. Elected to the Board of Directors of the Sierra Club. » Makes first large-size fine prints up to 40 x 72 inches.

1936: Travels in eastern U.S.A. One-man show at An American Place, New York (October 27–November 25, 1936). Adams inscribes a copy of his *Making a Photograph* to Stieglitz in An American Place.

1937: Moves with wife and two children to Yosemite Valley to operate Best's Studio, founded by Harry Cassie Best in 1901. » Exhibits in a group show at the Museum of Modern Art, New York ("Photography, 1839–1937"), organized by Beaumont Newhall, initiating a correspondence that soon becomes a lasting friendship.

1939: In New York. Meets Beaumont and Nancy Newhall. Exhibits in a group show at the Museum of Modern Art ("Seven American Photographers"). One-man show at the San Francisco Museum of Art.

1940: With Beaumont Newhall and David McAlpin,

1

2

4

5

founds the Department of Photography at the Museum of Modern Art.

1946: Founds the first department of photography at the California School of Fine Arts (later the San Francisco Art Institute).

1948: Publishes *Portfolio One* (Biblio. 16), *Dedicated to the Memory of Alfred Stieglitz.*

PHOTOGRAPHS

1 » *Family Portrait* [*The Tressider Family, Yosemite.* 1932/1934. Gelatine silver. 179 × 232 mm. (7¹⁄₁₆ × 9⅛ in) Paper label identical to that on Cat. 7, where it is similarly titled in typescript as above. 49.55.308.

Exhibited: New York (An American Place, 1936), no. 24.

In 1972 Adams recollected the date as 1932, while the 1934 date is given in Biblio. 30, pl. 22. The subjects are the older members of the Tressider family, photographed in Yosemite, California.

2 » *Windmill.* 1932. Gelatine silver. 226 × 183 mm. (8¹⁵⁄₁₆ × 7³⁄₁₆ in.) Signed in pencil "Ansel Adams." 49.55.179.

Exhibited: New York (An American Place, 1936), no. 9. Collections: AIC, Stieglitz Collection.

The windmill, paradoxically located in San Francisco at the horticultural center, is seen from below which would normally result in the bottom of the windmill blades being rendered larger and closer than the top which would look smaller and further away.

The adaptability of a view camera made it possible to tilt the lens and the film plane in opposite directions thus reducing the optical distortions that would otherwise exist if photographed with non-adjustable equipment. Turn-of-the-century photographers generally selected points of view that did not require such extensive correction of the vertical distortions.

3 » *Americana.* 1933. Gelatine silver. 199 × 152 mm. (7¾ × 5 in.) Signed in pencil on mount "Ansel Adams." 49.55.178.

Plate 100.

Exhibited: New York (An American Place, 1936), no. 21.

Reproduced: Biblio. 29, p. 99, titled *Cigar Store.*

The *New Yorker* cover date is October 7, 1933, suggesting the negative was made the first week in October. The shop was on Powell Street, San Francisco. The composition with the out-of-kilter pilaster of the building indicates the view camera was intentionally not perpendicular.

4 » *Latch and Chain.* About 1936 print from 1927 negative. Gelatine silver. 230 × 172 mm. (9¹⁄₁₆ × 6¹³⁄₁₆ in.) Signed in pencil on mount "Ansel Adams." 49.55.176.

Exhibited: New York (An American Place, 1936), no. 1.

The negative was made in Mineral King, California, on Adams's first Sierra Club Outing.

5 » *Barn—Point Reyes, California.* About 1935 (dated through verbal recollection of Adams, 1972). Gelatine silver. 186 × 238 mm. (7⁵⁄₁₆ ×

9⅜ in.) Signed in pencil on mount; dated, titled as above, and dedicated on verso in ink "For Alfred Stieglitz/[illegible]/Ansel Adams/3/40"; below, rubber stamp "Photograph by Ansel Adams." 49.55.307.

6 » *Winter Yosemite Valley.* 1933/1934. Gelatine silver. 234 × 185 mm. (9¼ × 7⁵⁄₁₆ in.) Signed in pencil on mount "Ansel Adams." 49.55.177.
Plate 98.
Exhibited: New York (An American Place, 1936), no. 22.

Reproduced: Biblio. 30, pl. 73, titled *Pine Forest in Snow, Yosemite National Park,* dated about 1933.

The subject is characteristic of Adams's intimate landscapes. The print is remarkably subtle in the detail of the snow and the dark branches, a rendering of the extremes of black and white that is most difficult to realize. Titled as above on verso in typescript on paper label, the print is dated from memory by Adams, June, 1977.

7 » *Political Circus.* 1932/1934. Gelatine silver. 235 × 178 mm. (9¼ × 7 in.) Signed on mount in pencil "Ansel Adams." 49.55.306.
Plate 99.
Exhibited: New York (An American Place, 1936), no. 20; New York (MMA, 1972).

The deliberate phrasing of the title suggests a tongue-in-cheek statement of social consciousness, supported by the humorous juxtaposition of political and circus posters. The rippled metal wall on which the posters are mounted, with deep shadows from raking light, introduces an element of compositional formalism very much in keeping with the f/64 style. Paper label on verso with printed text "A/Photograph/by/Ansel Adams/San Francisco"; titled in typescript as above in space on label left for that purpose.

EXHIBITIONS

Exhibitions are listed only to the death of Stieglitz (1946).

Washington (Smithsonian) 1931 » San Francisco (M. H. de Young Memorial Museum) 1932 »

New York (Delphic Studios) 1933 » Buffalo (Albright Art Gallery) 1934 » New Haven (YU Art Gallery) 1934 » New York (An American Place) 1936 » *Chicago (Kuh Gallery) 1936 » Washington (Arts Club) 1936 » New York (MOMA Group) 1937 » Berkeley (UC) 1938 » New York (MOMA Group) 1939 » New York (MOMA Group) 1944.*

COLLECTIONS

IMP/GEH; MOMA; Center for Creative Photography, Tucson, Arizona.

BIBLIOGRAPHY

Manuscript

1. Ansel Adams Archives, Center for Creative Photography, University of Arizona, Tucson, Arizona. (Correspondence with Stieglitz).

2. Stieglitz Archives, Collection of American Literature, Beinecke Rare Book and Manuscript Library, Yale University, New Haven, Conn.: 123 unpublished letters from Ansel Adams to Alfred Stieglitz and 38 from Alfred Stieglitz to Ansel Adams, between 1933 and 1936.

By Adams

3. Adams, Ansel and Mary Austin. *Taos Pueblo.* San Francisco, 1930. (Reprint 1977.)
4. ———. "An Exposition of My Photographic Technique." *Camera Craft,* 41 (January, 1934), pp. 19–25.
5. ———. "The New Photography." *Modern Photography,* 4 (1934–35), pp. 9–18.
6. ———. [Statement]. *Ansel Adams Exhibition of Photographs.* An American Place, New York, October 27–November 25, 1936.
7. ———. *Making a Photograph.* London, 1936.
8. ———. "The Expanding Photographic Universe." In Willard D. Morgan and Henry M. Lester, *Miniature Camera Work,* New York, 1938, pp. 69–75.
9. ———. *Sierra Nevada. The John Muir Trail.* Berkeley, 1938.

10. ———. "Personal Credo, 1943." *American Annual of Photography for 1944,* pp. 7–16.

11. ———. *Born Free and Equal: The Story of Loyal Japanese-Americans at Manzanar Relocation Center.* New York, 1944.

12. ———. "Letters to Dorothy Norman Received Shortly After Stieglitz's Death." *Stieglitz Memorial Portfolio.* New York, 1947, pp. 14–15.

13. ———. "A Decade of Photographic Art." *Popular Photography,* 22 (June, 1948), pp. 44–46, 153–154.

14. ———. *Camera and Lens.* New York, 1948, revised ed., 1970.

15. ———. *The Negative.* New York, 1948.

16. ———. *Portfolio One: In Memory of Alfred Stieglitz.* San Francisco, 1948. Twelve gelatine silver photographs, edition of 75.

17. ———. *My Camera in Yosemite Valley.* Boston, 1949.

18. ———. *The Print.* New York, 1950.

19. ———. *Natural Light Photography.* New York, 1952.

20. ———. *Artificial Light Photography.* New York, 1956.

21. ——— and Nancy Newhall. *This Is the American Earth.* San Francisco, 1960.

22. ———. *Images, 1923–1974.* Greenwich, Conn., 1974.

23. ———. *Photographs of the Southwest.* Boston, 1976.

24. ———. *The Portfolios.* Boston, 1977.

About Adams

25. Newhall, Beaumont. "The Vignettists—Review of 'The New Photography.'" *American Magazine of Art,* 28 (January, 1935), pp. 31–35.

26. Page, Christina. "The Man from Yosemite: Ansel Adams." *Minicam Photography,* 10 (September–October, 1946), pp. 30–42.

27. White, Minor. "Ansel Adams—Musician to Photographer." *Image,* 6 (February, 1957), pp. 29–35.

28. Weiss, Margot. "What Ansel Adams Teaches." *Popular Photography,* 49 (November, 1961), pp. 62–64, 86–91.

29. Newhall, Nancy. *Ansel Adams—The Eloquent Light.* San Francisco, 1963.

30. DeCock, Liliane, ed. *Ansel Adams.* Foreword by Minor White. New York, 1972.

31. *Ansel Adams: Singular Images.* Essays by Edwin Land, David H. McAlpin, Jon Holmes, and Ansel Adams. Boston, 1974.

32. Cooper, Tom and Paul Hill. "Ansel Adams." *Camera,* 55 (January, 1976), pp. 15, 21, 27, 37–40.

J. CRAIG ANNAN (Scottish)

Fig. 2 » *J. Craig Annan*. Etching by William Strang, 1916. Courtesy of The Royal Photographic Society, London.

CHRONOLOGY

1864: Born James Craig Annan in Hamilton, Scotland, son of Thomas Annan, a professional photographer in Glasgow.

Late 1870s: Joins his father's business (T. R. Annan and Sons) as a photographer.

1883: Travels to Vienna with his father to learn the process of Heliogravure (later known as photogravure) from its inventor Karl Klíč (Biblio. 1156).

About 1890: Begins to re-photograph and make photogravures of the Hill-Adamson calotypes (Biblio. 454, Schwarz, p. 47).

1892: Exhibits photographs of North Holland (alongside D. Y. Cameron's etchings of the same country) at Number 230 Sauchiehill Street, Glasgow—premises of his father's firm (October).

1893–1909: Exhibits at the London Photographic Salon.

1894: Elected a member of The Linked Ring; Stieglitz acquires first gravures. » Stieglitz reviews New York (1894) Joint exhibition: "Here we deal with a true artist, and a decidedly poetical one at that. We have seen but few pictures to equal that called 'Labor–Evening' (called erroneously 'Toil' in the last number of *American Amateur Photographer*). The picture breathes of atmosphere, it is a piece of nature itself. We can give it no higher praise" (Biblio. 882, p. 213).

1896: Stieglitz comments extensively on Annan in "The Hand Camera" (Biblio. 892).

1898: Publishes a photographic portfolio entitled *Venice and Lombardy: A Series of Original Photogravures* (limited edition of seventy-five). Represented in an exhibition of the Edinburgh Photographic Society. » Invites Stieglitz to select American work for 1901 Glasgow exhibition (Annan to A. S. 27 December 1898, YCAL).

1900: Retrospective one-man show at the Royal Photographic Society. Exhibits at the Paris International Exhibition. Praised by Keiley in *Camera Notes* (January, 1901), p. 15. » Demachy enthusiastically praises *The Church or the World* (Cat. 13). » Invited to head the proposed International Society of Pictorial Photographers by Stieglitz, Kuehn and Masuren.

1901: Represented at the Glasgow International Exhibition.

1904: Six gravures published in *Camera Work*, No. 8 (October); Annan visits U.S.A.

1905–09: Exhibits at the Scottish National Salon, Glasgow.

1906: Exhibits at the Photo-Secession Galleries at 291 (February 21–March 7) and at the Salon of the Paris *Photo-Club*.

8

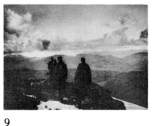

9

11

1907: Five gravures published in *Camera Work*, No. 19 (July).

1909: One gravure published in *Camera Work*, No. 26 (April). Disenchantment with The Linked Ring.

1910: Five gravures published in *Camera Work*, No. 32 (October). » Exhibits twenty-four prints at the International Exhibition of Pictorial Photography at the Albright Art Gallery, Buffalo, where he is described in the catalog as "one of the chief forces in the development of pictorial photography." » Writes: "as soon as the hand is permitted to interfere in any way with the photograph, the automatic perfection is destroyed" (Biblio. 38, p. 24).

1911: Dissatisfied with The Linked Ring's London Salon, he joins a group of photographers to sponsor the formation of a London Secession and participates in its exhibition (Biblio. 1422).

1912: One-man show at Arbuthnot's Kodak, Ltd., Liverpool.

1913: One-man show at The A. P. Little Gallery (gallery of *The Amateur Photographer,* London).

1914: Eight gravures published in *Camera Work*, No. 45 (June), devoted entirely to work by Annan.

1924: Awarded Honorary Fellowship of the Royal Photographic Society.

1936: Elected to the Fellowship of the Royal Society of Arts.

1946: Dies in Lenzie, near Glasgow.

PHOTOGRAPHS

Early Works

8 » *Portrait of D. O. Hill.* (J. Craig Annan after negative attributed to Thomas Annan.) About 1867. Brown-toned gelatine silver copy after albumen original. 230 × 175 mm. (9¹⁄₁₆ × 6⅞ in.) 49.55.310.

Thomas Annan, father of J. Craig, collaborated with Hill on a project in 1867, and it is likely that the original dates from that period, shortly before Hill's death in 1870.

9 » *The Dark Mountains.* 1890. Hand printed photogravure on tissue. 150 × 201 mm. (5¹⁵⁄₁₆ × 7¹⁵⁄₁₆ in.). Signed in margin in pencil "J. Craig Annan." 49.55.276.

Exhibited: London (1895), no. 170; London (RPS, 1900), per review; Dresden (1900), no. 186, dated as above; Philadelphia (1900), no. 11; Dresden (1904), no. 2, lent by Ernst Juhl, titled as above; Philadelphia (1906), no. 10, titled *The Darker Mountains.*

Reproduced: *Photographisches Centralblatt,* 5 (February, 1899), p. 81; *The Amateur Photographer,* 37 (January–June, 1903), p. 514; *Camera Work*, No. 8 (October, 1904), pl. VI, with signs of age on the plate when compared to above.

Same at Cat. 10. The earliest dated print Stieglitz collected by one of his contemporaries, but probably not acquired until 1894 or after.

10 » *The Dark Mountains.* Before 1899. Machine

12

14

printed photogravure. 150 × 202 mm. (5¹⁵⁄₁₆ × 7¹⁵⁄₁₆ in.) 49.55.304.
Not illustrated.
Printed from the same negative as Cat. 9 except for a horizontal hair-line mark on plate and a subtly differing range of tones most evident in the added texture of the sky. The same plate was evidently used to print both impressions, and the differences could be accounted for by steel facing added to this plate to increase the output of impressions.

11 » *The Sand Dunes.* 1892 (A. S.) Platinum. 167 × 226 mm. (6⁹⁄₁₆ × 8¹⁵⁄₁₆ in.) 33.43.242.
Reproduced: *Photographisches Centralblatt,* 5 (February, 1899), p. 83; Caffin (Biblio. 1282), pl. 13, titled as above.

The most important artistic decision was that the men and cart were caught mid-step, making this a fine example of photographic naturalism. Such works were very influential on the emergence of Stieglitz's style between 1894 and 1900.

12 » *The Beach at Zandvoort.* 1892. Hand printed photogravure on heavy paper. 46 × 233 mm. (1¹³⁄₁₆ × 9³⁄₁₆ in.) Titled in pencil on mount as above. 49.55.262.
Exhibited: London (1893) per review; Hamburg (1899), no. 6; Philadelphia (1906), no. 12, *A Dutch Shore,* suggesting related or identical subject.

Reproduced: *Photographic Times,* 27 (March, 1895), p. 85; *Wiener Photographische Blätter,* 2 (February, 1895), p. 23; *Photographisches Centralblatt,* 5 (February, 1899), p. 92.

Annan's trip to Holland in 1892 is briefly described in Biblio. 46, (pp. 1–5).
The dimensions suggest the use of a panoramic camera (also Cat. 24), but the effect could also have been achieved by printing only a portion of the full negative, in which case the decision to crop the sail of the boat would have been out of keeping with the prevailing practice.

13 » *The Church or the World.* 1893 (A. S.) Hand printed photogravure on heavy paper. 105 × 130 mm. (4⅛ × 5⅛ in.) 33.43.243.
Plate 1.
Exhibited: London (1896), no. 249; Philadelphia (1899), no. 13; London (1896), no. 249.

In style and content this image is diametrically opposite Cat. 11 and represents Annan's flirtation with the anti-naturalistic mode of photography, an aspect that made him appealing to the Munich Secession of 1898 (Biblio. 1318). The posed quality reappears in Annan's portraits, suggesting the possibility of retaining two styles simultaneously, which duplicated Stieglitz's vacillation between posed and natural subjects during 1887–1899.

14 » *[Evening Work].* 1893. Hand printed photogravure on heavy wove paper. Plate, 191 × 158 mm.; image, 142 × 118 mm. (7½ × 6¼ in.; 5⅝ × 4⅝ in.) 33.43.371.
Exhibited: Paris (1894), no. 160, pl. 42, deluxe ed. catalog (Biblio. 1302), titled *Travail du Soir.*
The Buffalo catalog suggests Annan was in Holland in 1893, but reproductions of Dutch subjects do not

15 16

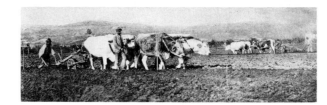

18

appear until 1895 (*Photographic Times,* pp. 89, 335, 342). Stylistically similar to P. H. Emerson's *The Haysel,* published as a large photogravure in 1888, the photograph is a direct homage to his philosophy of naturalistic photography (Biblio. 1213).

15 » *Eleanore.* 1893/1894. Mechanically printed photogravure on heavy paper. 121 × 95 mm. (4¾ × 3¾ in.) Titled on margin in pencil as above; printed from plate is credit to Annan & Sons, printers, and J. Craig Annan, photographer. 49.55.302.
Exhibited: London (1894), no. 253; Hamburg (1899), no. 10; Bradford (1904), no. 91.
 Reproduced: *Photograms of the Year 1896,* p. 25.
 Printed from plate is the verse: "As tho' a star in inmost heaven set/So full, so deep, so slow,/Thought seems to come and go/In thy large eyes, imperial Eleänore." The verse and the mysterious presence of the woman in gown in a forest suggest a work related to Cat. 13 of 1893. Stylistically the image contrasts with Annan's naturalistic Italian studies of the same time and reveals symbolist influence.

Italian Series

16 » *A Venetian Requiem.* 1894. Hand printed photogravure on tissue, mounted on heavy cream wove paper. 117 × 90 mm. (4⅝ × 3⁹⁄₁₆ in.) Signed and titled in pencil on margin "J. Craig Annan." 33.43.373.
Exhibited: London (1894), no. 82; Buffalo (1910), no. 46, titled and dated as above.
 Collections: AIC, Stieglitz Collection.

17 » *The White Friars.* 1894. Hand printed photogravure on heavy paper. 110 × 108 mm. (4⁵⁄₁₆ × 4¼ in.) Titled as above in pencil on margin. 49.55.301.
Plate 2.
Exhibited: London (1894), no. 79; Paris (1896), no. 184 (reproduced as gravure in Biblio. 1269), pl. 14; Philadelphia (1906), no. 11, titled *Walking Friars;* Buffalo (1910), no. 49, titled and dated as above.
 Reproduced: *Camera Notes,* 4 (January, 1901), facing p. 129, titled *Whitefriar Monks* and printed on tissue in a brown tone with more yellow pigment than the above; *American Amateur Photographer,* 15 (October, 1904), p. 431, titled *Two Friars.*
 Influenced by Annan's snap-shot photography, Stieglitz used him as an example to be followed in his article "The Hand Camera" (Biblio. 892), where he describes the athletic quickness required to compose a subject on the move with an unwieldy camera that exposed glass plates the size of this print.

18 » *Plowing on the Campagnetta.* 1894. Hand printed photogravure. 48 × 148 mm. (1¹⁵⁄₁₆ × 5¹³⁄₁₆ in.) Signed on margin in pencil "J. Craig Annan." 49.55.281.
Exhibited: London (1894), no. 80.
 Collections: AIC, Stieglitz Collection.

19 » *The Riva Schiavoni, Venice.* 1894. Hand printed photogravure on tissue. 143 × 199 mm. (5⅝ × 7⅞ in.) Signed on margin in pencil "J. Craig Annan." 49.55.274.
Exhibited: London (1894), no. 81.

19

23

20 22

Reproduced: *Camera Work,* No. 8 (October, 1904), pl. V, with signs of age on the plate.

20 » *Campo San Margherita [Venice].* 1894. Hand printed photogravure on tissue, mounted on heavy cream wove paper. 149 × 50 mm. (5¹³⁄₁₆ × 2 in.) Signed and titled in pencil on margin "J. Craig Annan." 33.43.374.
Exhibited: London (1894), no. 87 .
Reproduced: Caffin (Biblio. 1282), pl. X, titled as above.

21 » *Campo San Margherita [Venice].* 1894. Hand printed photogravure on tissue. 149 × 50 mm. (5¹³⁄₁₆ × 2 in.) Signed on margin in pencil "J. Craig Annan" and titled from plate as above. 49.55.278.
Not illustrated.
Cat. 20 is printed from the same original.

22 » *A Franciscan, Venice.* 1894. Hand printed photogravure, proof before *CameraWork* state. 197 × 139 mm. (7¾ × 5½ in.) Signed in pencil on margin "J. Craig Annan." 49.55.275.
Exhibited: London (1894), no. 78; Philadelphia (1906), no. 13, titled *Franciscan Monk, Venice,* where a gravure was also exhibited; Buffalo (1910), no. 45, titled *The Franciscan of Il Redentore,* a gravure also dated 1894.
Reproduced: *Wiener Photographische Blätter,* 3 (September, 1896), p. 172, titled *Der Franciscaner; Photographisches Centralblatt,* 5 (February, 1899), p. 82; *Camera Work,* No. 8 (October, 1904), pl. I, with

the statement that Annan printed the gravures himself. The *Camera Work* state shows signs of age on the plate in comparison to the early proof that was printed possibly about the time the negative was made. *The Bookman,* 27 (March, 1908), n. p., titled *The Monk of Il Redentore.*

23 » *A Black Canal [Venice?].* 1894. Hand printed photogravure on tissue. 92 × 126 mm. (3⅝ × 5 in.) Signed and titled on margin in pencil "J. Craig Annan/ A Black Canal." 49.55.261.
Reproduced: Caffin (Biblio. 1282), p. 11, titled as above.

24 » *A Lombardy Pastoral.* 1894. Hand printed photogravure on tissue. 47 × 140 mm. (1⅞ × 5½ in.) Signed and titled on mount in pencil "J. Craig Annan/ A Lombardy Pastoral." 49.55.264.
Exhibited: London (1894), no. 93; Philadelphia (1899), no. 14; Buffalo (1910), no. 47.
Reproduced: *Camera Notes,* I (April, 1898), p. 108; *Photographisches Centralblatt,* 5 (February, 1899), p. 84.
Collections: AIC, Stieglitz Collection.

25 » *[Italian Study].* 1894. Hand printed photogravure on tissue. 115 × 69 mm. (4⁹⁄₁₆ × 2¾ in.) 49.55.279.

26 » *Venice from the Lido.* 1894. Hand printed photogravure on tissue. 95 × 150 mm. (3¾ × 5¹⁵⁄₁₆ in.) Signed on margin in pencil "J. Craig Annan." 49.55.280.
Exhibited: London (1896), no. 252; Philadelphia

24

25

26

27

28

29

30

(1899), no. 8; London (RPS, 1900), per review; Buffalo (1910), no. 43.

Reproduced: *Academy Notes* (Biblio. 1399a.), p. 8. Collections: AIC, Stieglitz Collection.

27 » [*Italian Study*]. 1894. Hand printed photogravure on tissue. 123 × 88 mm. (4⅞ × 3½ in.) Signed on margin in pencil "J. Craig Annan." 49.55.282.

28 » *The Harbor—Genoa.* 1894. Hand printed photogravure on textured Japanese paper. 211 × 288 mm. (8⁵⁄₁₆ × 11⅜ in.) Signed on margin in pencil "J. Craig Annan" and titled as above. 49.55.298.

Exhibited: London (1894), no. 97; London (RPS, 1900), per review; Buffalo (1910), no. 42.

Reproduced: *The Amateur Photographer,* 50 (July–December, 1909), p. 286.

1902–1911

29 » *Professor John Young of Glasgow University.* 1901 or before. Hand printed photogravure on tissue. 199 × 155 mm. (7⅞ × 6⅛ in.) Signed on border in pencil "J. Craig Annan." 49.55.277.

Exhibited: Glasgow (1901), no. 58.

Reproduced: *Camera Work,* No. 8 (October, 1904), pl. IV; Holme (Biblio. 1288), pl. G. B., 27.

Posed portraiture must have formed a fairly substantial portion of Annan's work, judging by the command of studio lighting evident in this print. Stieglitz, however, collected few of Annan's portraits.

30 » *The Etching Printer* [*William Strang*]. 1902. Hand printed photogravure on tissue. 197 × 151 mm. (7¾ × 5¹⁵⁄₁₆ in.) 49.55.303.

Exhibited: Leeds (1902), no. 500; Philadelphia (1906), no. 5; Buffalo (1910), no. 52, a gravure dated as above.

31

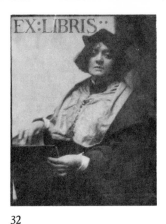

32

33

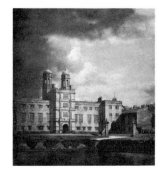

34

Reproduced: *Camera Work*, No. 19 (July, 1907), pl.
III; *The Amateur Photographer*, 57 (January–June,
1913), p. 182.

The photogravure process Annan used for much of
his work utilized many of the same materials as tradi-
tional etching, including the same press and a copper-
plate that was etched differently, but inked and printed
in the same way. The friendship between Annan and
Stieglitz was sparked by this common interest.

William Strang, A.R.A. (1859–1921), at this time
Vice-President of the International Society of Sculptors,
Painters and Gravers, was one of the most popular
etchers of his generation, whose allegories apparently
influenced Annan's treatment of Cat. 13 and Cat. 15.
The subject is reversed from Cat. 31. H. Snowden-Ward
wrote:

When young portraitists submit their work and ask for
suggestions, good guidance is often difficult. . . . Let them
study a portrait such as this and compare it with the
roundly-lighted, carefully-retouched portraits of the ordi-
nary professional. Here we have a harsh lighting, because
we have a strong face; a lack of sharpness, because we want
to show essentials, not incidentals; an almost complete loss
of detail in one half of the face, because we want to empha-
size the strength of the features. Retouching has not been
allowed to remove the texture and the character-lines; the
strong high-lighting and "short" exposure give depth to
the thoughtful eyes and define the powerful brow. (*Photo-
grams of the Year 1909*, p. 78)

31 » *The Etching Printer*. 1902. Gelatine silver.
274 × 358 mm. (10¾ × 13¹⁵⁄₁₆ in.) Inscribed

on verso by J. C. A. with instructions to framer
and titled as above. 33.43.244.
Exhibited: (see Cat. 30).

32 » *Ex Libris*. 1904 (A. S.) Platinum on tissue,
with various paper labels on verso including
those of T. & R. Annan; Amsterdam Salon;
H. Gonkel, Jr., *Vergulder en Encadreur*,
Amsterdam. Tissue, 391 × 279; image, 337 ×
253 mm. (15⅜ × 11; 13¼ × 10 in.) Signed in
pencil on tissue below subject "J. Craig Annan."
33.43.245.
Exhibited: Dresden (1909), no. 4; Buffalo (1910), no.
62.

Reproduced: *Camera Work*, No. 26 (April, 1909),
pl. I, with a different range of tones, printed by T. & R.
Annan, Glasgow; Holme (Biblio. 1292), pl. 6.

33 » *Mrs. C. of Philadelphia* (attributed to J. Craig
Annan). 1906 or before. Gelatine silver. 477 ×
279 mm. (18¹³⁄₁₆ × 11 in.) 49.55.305.
Exhibited: Philadelphia (1906), no. 9, titled *Portrait of
Mrs. C.*

Reproduced: *Camera Work*, No. 19 (July, 1907),
pl. III.

The print is among the few direct enlargements
collected by Stieglitz. When large scale prints were
desired, the customary procedure was to print in
platinum or one of the pigment processes from an
enlarged copy negative. The flat tonal scale of the
print, characteristic of direct enlargements of the time,
was generally found unacceptable.

36

35

37

38

34 » *Stonyhurst.* 1908 or before. Hand printed mezzogravure on tissue. 270 × 241 mm. (10⅜ × 9½ in.) Signed in pencil on margin "J. Craig Annan," and titled adjacent. 33.43.246.
Exhibited: Dresden (1909), no. 3; Buffalo (1910), no. 59, erroneously dated 1909.
Reproduced: Holme (Biblio. 1288), pl. 6.
The drama of dark shadows and stormy clouds has been increased by manipulations on the printing plate, thus exemplifying the anti-naturalistic style that diverted Annan occasionally. Stieglitz scribbled 1902 on verso but style favors 1908.

35 » *The Cooperage.* 1909 (A. S.) Hand printed photogravure on tissue. 201 × 208 mm. (7¹⁵⁄₁₆ × 8³⁄₁₆ in.) Signed and titled in pencil on margin. 49.55.182.

36 » *A Ruined Castle.* 1909 or before. Hand printed photogravure on tissue. 229 × 322 mm. (9 × 12¹¹⁄₁₆ in.) Signed on margin in pencil "J. Craig Annan" and titled as above. 49.55.299.
Exhibited: London (1909), no. 68, titled as above.
Reproduced: *Camera Work,* No. 32 (October, 1910), pl. III, titled *Harlech Castle.*
Harlech Castle was also photographed by Davison, a gravure of which was collected by Stieglitz (Cat. 155) and published in *Camera Work,* No. 26 (April, 1909).

37 » *The White House.* 1910 or before. Hand printed photogravure on tissue. 254 × 240 mm. (10 × 9⁷⁄₁₆ in.) Signed and dedicated on margin in pencil: "To Alfred Stieglitz with kindest regards/from J. Craig Annan—A picture of the Oxon House of our mutual friend Geo. Davison/Ronald Davison in foreground./J. Craig Annan." 49.55.300.
Exhibited: London (1909), per review; Buffalo (1910), no. 60.
Reproduced: *Camera Work,* No. 32 (October, 1910), pl. V, reduced in size and showing different plate flaws than the above; *The Amateur Photographer,* 50 (July–December, 1909), p. 341, titled as above.

Spanish Series

Annan retains his early love of subject in motion in many prints, but in others he reverts to posed portraiture of local types, showing concern for costume, coiffure and body ornament. The most distinctive feature of the following series is the willingness to violate the integrity of the full negative. Many appear to have been trimmed to refine the composition after exposure. Post-visualization of the final print was popular in France and Germany where manipulated printing processes were popular.

Annan's visual concerns were for light, shadow and motion more than the picturesque relics of Spain. The pride Annan took in his gravure is reflected in the fact that he signed almost all and dedicated many personally to Stieglitz, as though to suggest their specialty despite their multiplicity. (See Cat. 47.)

38 » *A Blind Musician—Granada.* 1914. Hand printed photogravure on tissue. 202 × 120 mm. (7¹⁵⁄₁₆ × 4¾ in.) Titled, dedicated and signed

39

41

42

43

on margin in pencil "To A. Stieglitz/J. Craig Annan/A Blind Musician—Granada." 49.55.260.

Reproduced: *Camera Work*, No. 45 (dated January, published in June, 1914), pl. I, showing abrasions on plate.

39 » *Bridge of St. Martin, Toledo.* 1914. Hand printed photogravure on tissue. 128 × 181 mm. (5¹⁄₁₆ × 7⅛ in.) Signed on mount in pencil "J. Craig Annan" and titled as above. 49.55.270.

Reproduced: *Camera Work*, No. 45 (dated January, published in June, 1914), pl. V.

40 » *A Burgos Bullock Wagon.* 1914. Hand printed photogravure on tissue. 143 × 171 mm. (5⅝ × 6¾ in.) Signed, titled as above, and dedicated on margin in pencil "To Alfred Stieglitz from J. Craig Annan." 49.55.263.

Plate 3.

41 » *A Carpenter's Shop—Toledo.* 1914. Hand printed photogravure on tissue. 145 × 179 mm. (5¾ × 7¹⁄₁₆ in.) Signed, titled as above, and dedicated on margin "To Alfred Stieglitz/ J. Craig Annan." 49.55.265.

Reproduced: *Camera Work*, No. 45 (dated January, published in June, 1914), pl. III.

42 » *A Gateway—Segovia.* 1914. Hand printed photogravure on tissue. 145 × 151 mm. (5¾ × 5¹⁵⁄₁₆ in.) Signed on mount in pencil "J. Craig Annan" and titled as above. 49.55.266.

Reproduced: *Camera Work*, No. 45 (dated January, published in June, 1914), pl. VIII.

43 » *A Gitana, Granada.* 1914. Hand printed photogravure on tissue. 195 × 137 mm. (7¹¹⁄₁₆ × 5⅜ in.) Dedicated and signed on mount in pencil "To A. Stieglitz from J. Craig Annan." 49.55.258.

Reproduced: *Camera Work*, No. 45 (dated January, published in June, 1914), pl. II, titled as above where it is also noted that Annan himself printed the published editions. Comparison indicates that the same plate was used to print both editions.

The posed and formal character of this photograph contrasts with the concern for instantaneous effects that first attracted Stieglitz to Annan's photographs in the 1890s.

44 » *Old Church—Burgos.* 1914. Hand printed photogravure on tissue. 181 × 147 mm. (7⅛ × 5¹³⁄₁₆ in.) Signed on mount in pencil "J. Craig Annan" and titled as above. 49.55.267.

Reproduced: *Camera Work*, No. 45 (dated January, published in June, 1914), pl. VI.

45 » *Group on a Hill Road, Granada.* 1914. Hand printed photogravure on tissue. 113 × 180 mm. (4⁷⁄₁₆ × 7⅛ in.) Signed, titled as above, and dedicated on mount in pencil "To Alfred Stieglitz/J. Craig Annan." 49.55.273.

46 » *Old Walls—Toledo.* 1914. Hand printed photogravure. 185 × 145 mm. (7⁵⁄₁₆ × 5¾ in.)

44

45

46

47

48

49

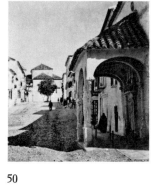

50

51

Signed on margin in pencil "J. Craig Annan." 49.55.269.

47 » *A Square, Ronda.* 1912/13. Hand printed photogravure on tissue. 136 × 188 mm. (5⅜ ×7⁷⁄₁₆ in.) Signed and titled in pencil on margin "J. Craig Annan." 33.43.372.
Reproduced: *Camera Work,* No. 45 (January, 1914), pl. XVII, where it is noted that the series was made on a trip to Spain the year before with his friend William Strang (Cat. 30). Stieglitz described the series in the terse, fragmented style that he had adopted from the creative writers in his circle: "Annan has never done any finer work. His work is always a delight. It is so straightforward. As an artist he continues to grow. The photogravures are by himself. They too demonstrate a decided growth in this line of work in which Annan has for years been a master" (p. 44).

48 » *Toledo.* 1914. Hand printed photogravure on

tissue. 199 × 134 mm. (7⅞ × 5⁵⁄₁₆ in.) Signed on margin in pencil "J. Craig Annan." 49.55.268.
Reproduced: *The Amateur Photographer,* 62 (July–December, 1915), p. 274.

49 » *Water Carrier—Toledo.* 1914. Hand printed photogravure on tissue. 145 × 173 mm. (5¾ × 6¹³⁄₁₆ in.) Signed on margin in pencil "J. Craig Annan." 49.55.272.

50 » *A Wayside Shrine, Ronda.* 1914. Hand printed photogravure. 179 × 153 mm. (7¹⁄₁₆ × 6¹⁄₁₆ in.) Signed on margin in pencil "J. Craig Annan." 49.55.271.

51 » *A Young Gitana—Granada.* 1914. Hand printed photogravure on tissue. 203 × 132 mm. (8 × 5³⁄₁₆ in.) Signed and dedicated on margin in pencil "J. Craig Annan/to Alfred Stieglitz with fraternal greetings." 49.55.259.

52

53

55

54

Reproduced: *American Amateur Photographer*, 61 (January–July, 1915), p. 501.

Egyptian Series (About 1924)

52 » *In Alexandria.* About 1924. Hand printed photogravure on tissue. Plate, 157 × 205 mm. (6³⁄₁₆ × 8¹⁄₁₆ in.) Signed in pencil on margin "J. Craig Annan," with title adjacent. 33.43.247.

The lack of exhibition record of North African subjects prior to 1910 suggests that they were made after then, most likely not long before 1925 when views of that region were exhibited in Glasgow (Scottish International Salon of Photography). A note on Annan's letterhead to Stieglitz dated 17 December 1924 inserted in Cat. 55 indicates the date this group was presented to him, pointing toward their being recent work.

53 » *Cairo.* About 1924. Handprinted gravure on tissue. 148 × 198 mm. (5¹³⁄₁₆ × 7¹³⁄₁₆ in.) Signed in pencil on margin "J. Craig Annan" and titled adjacent as above. 33.43.251.

54 » *In Cairo.* About 1924. Handprinted gravure on tissue. 194 × 150 mm. (7⅝ × 5⁵⁄₁₆ in.) Signed in pencil on mount "J. Craig Annan" and titled adjacent as above. 33.43.252.

55 » *On the Nile.* About 1924. Handprinted gravure on tissue. Plate: 152 × 193 mm. (6 × 7⅝ in.) Signed in pencil on the margin "J. Craig Annan" and titled adjacent as above. 33.43.250.

56 » [*Pyramids at Giza*]. About 1924. Hand printed gravure on tissue. 153 × 204 mm. (6¹⁄₁₆ × 8¹⁄₁₆ in.) Signed in pencil on margin "J. Craig Annan." 33.43.248.

57 » [*Stone Dray, Egypt*]. About 1924. Hand printed gravure on tissue. 102 × 205 mm. (4 × 8¹⁄₁₆ in.) Signed in pencil on margin "J. Craig Annan." 33.43.249.

EXHIBITIONS

* *Glasgow (Annan Gallery) 1892* » London 1893–1909. » *New York (Joint) 1894* » Paris 1894–1898 » Brussels 1895 » *Glasgow 1897* » Munich 1898 » Berlin 1899 » Hamburg 1899–1900 » Philadelphia 1899–1900 » Glasgow 1901 » Leeds 1902 » Paris 1902 » Turin 1902 » Brussels 1903 » Hamburg 1903 » Wiesbaden 1903 » Bradford 1904 » Dresden 1904 » *Glasgow (Scottish National Salon) 1905* » Vienna (C-K) 1905 » Vienna (PC) 1905 » London 1906 » New York (PSG) 1906 » Paris 1906 » *London (NEAG) 1907* » London 1908–1909 » Dresden 1909 » Buffalo 1910 » *London (Secession) 1911* » *Liverpool 1912* » *Glasgow 1926.*

COLLECTIONS

RPS.

56

57

BIBLIOGRAPHY

Manuscript

33. Stieglitz Archives, Collection of American Literature, Beinecke Rare Book and Manuscript Library, Yale University, New Haven, Conn.: 56 unpublished letters from J. Craig Annan to Alfred Stieglitz and 2 from Alfred Stieglitz to J. Craig Annan between 1890 and 1924.

By Annan

34. Annan, J. Craig. "Picture-Making with the Hand-Camera." *The Amateur Photographer*, 23 (27 March 1896), pp. 275–277.
35. ———. "Painters Who Have Influenced Me." *Anthony's Photographic Bulletin*, 30 (November, 1899), pp. 345, 348.
36. ———. "The Arts of Engraving." *The Amateur Photographer*, 31 (9 February 1900), pp. 105–106.
37. "Extracts from Mr. Craig Annan's Address." *Camera Notes*, 3 (April, 1900), pp. 243–246.
38. ———. "Photography as a Means of Artistic Expression." *Camera Work*, No. 32 (October, 1910), pp. 21–24.
See Biblio. 448, 1127, 1291.

About Annan

39. [Ward, H. Snowdon]. 'J. Craig Annan,' in Biblio. 1316 (review), pp. 97–98.
40. "M" [F. Matthies-Masuren]. "J. Craig Annan—

Glasgow." *Photographisches Centralblatt*, 5 (February, 1899), pp. 81–85.
41. Cameron, D. Y. "An Artist's Notes on Mr. J. Craig Annan's Pictures Now Being Exhibited at the Royal Photographic Society." *The Amateur Photographer*, 31 (16 February 1900), pp. 123–124.
42. "The First 'One-Man' Show at the 'Royal.'" *The Photogram*, 7 (March, 1900), pp. 90–91.
43. Pen Wyper [unidentified pseud.]. "Glasgow International Exhibition, 1901. Progress of the Photographic Section. Interview with J. Craig Annan." *The Amateur Photographer*, 32 (31 August 1900), p. 163.
44. Guest, Antony. "Two Photographs by Mr. Craig Annan." *The Amateur Photographer*, 37 (25 June 1903), pp. 514–516.
45. Hinton, A. Horsley. "Photographic Technique of James Craig Annan." *Magazine of Art*, 27 (July, 1903), pp. 461–464.
46. Keiley, Joseph T. "J. Craig Annan." *Camera Work*, No. 8 (October, 1904), pp. 17–18.
47. Lambert, F. C. "The Pictorial Work of J. Craig Annan." *The Practical Photographer*, 13 (October, 1904), pp. 1–5.
48. "A Craig Annan Show." *The Amateur Photographer*, 49 (11 May 1909), p. 441.
49. "Our Illustrations." *Camera Work*, No. 32 (October, 1910), p. 47.
50. Touchstone [unidentified pseud.]. "Photographers I Have Met—J. Craig Annan." *The Amateur Photographer*, 53 (10 January 1911), p. 34.
51. Guest, Antony. "The Work of J. Craig Annan." *The Amateur Photographer*, 57 (17 February 1913), pp. 149–150.
52. Johnston, J. Dudley. "Obituary." *Photographic Journal*, 86 (July, 1946), p. 174.
53. *Glasgow Portraits by J. Craig Annan, Photographer*. Scottish Arts Council, exhibition catalog, 1968.
54. Harker, Margaret. "Annans of Glasgow." *British Journal of Photography*, 120 (19 October 1974), pp. 966–969.
55. Beaton, Cecil and Gail Buckland. "James Craig Annan." *The Magic Image*. Boston, 1975, p. 88.
55A. Mozley, Anita V. "Thomas Annan of Glasgow." *Image*, 20 (June, 1977), pp. 1–12.

MALCOLM ARBUTHNOT (English)

CHRONOLOGY

1874: Born and raised in East Anglia.

About 1895: Takes up amateur photography.

1900–10: Exhibits regularly at London Photographic Salon.

1907: Does commercial photography for *The Graphic* and *The London Magazine.* Marries a Kodak heiress. Friends include Martin Harvey, Alvin Langdon Coburn, George Davison, E.O. Hoppé and William Nicholson. Photographs urban subjects as well as landscapes. » Elected to The Linked Ring. Executes abstract photographs, 1908 or before, with such titles as *A Study in Curves and Angles.*

1909: Stieglitz plans an exhibition titled "New British School," intending to include Arbuthnot, Walter Bennington, E. Warner, and others.

Before 1910: Visits France.

1910: Seven photographs exhibited in Buffalo.

1911: Member of the London Secession; active in movement for international society of artistic photographers (Biblio. 1422). His painting style called by critics "decorative realism."

1912: Appointed manager of the Liverpool Branch of the Kodak Company.

1913: Meets Wyndham Lewis and signs the Vorticist manifesto *Blast!* Re-stages Roger Fry's Second Post-Impressionist Exhibition at the Sandon Studios in Liverpool. Lectures with Fry and the critic Frank Rutter on modern art.

1914: Opens a portrait studio at 43–44 New Bond Street, which he operates until 1926. Leisure activities include yachting and motor touring.

About 1918–20: Photographs for the *Illustrated London News.* Makes a film titled "Arbuthnot—London's Leading Photographer," which has a ten-month run in the London cinemas.

Early 1920s: Becomes a pupil of William Nicholson.

1930: Moves to La Houle on the Isle of Jersey. Studies sculpture under John Duncan Fergusson and takes

58

up painting and sculpture full-time. Until the 1960s exhibits frequently in England, Jersey, and France.

1942: Elected a Fellow of the Royal Institute of Painters in Water-Colours.

By 1945: Elected a Fellow of the Royal Scottish Academy.

1968: Dies.

PHOTOGRAPHS

58 » *Lulworth Cove.* 1909 (A. S.) Glycerine developed platinum (?). 285 × 321 mm. (11¼ × 12⅝ in.) Signed in ink "Arbuthnot." 33.43.347.
Exhibited: London Secession (1911), no. 46, per Biblio. 1422.
Reproduced: *Photograms of the Year, 1911,* p. 46; *Academy Notes* (Biblio. 1399a.), p. 7.

In a review of the London Secession, H. Snowdon Ward compares this print to Cochrane's *Morning* cataloged there as no. 46:

Compare the light of the window and the patch on the wall behind the woman with the great white area of chalk cliffs. . . . It is worth [noting] that though both pictures have a strong sense of light, neither of the effects is obtained by use of white paper. Note, too, how a very small spot of emphasis, the man's figure introduced near the middle of the foot of the Arbuthnot composition, gives scale to the whole. The sails and the semaphore station do this to some extent, but the man is the important note. He throws back the great contorted cliff which would otherwise

be flat against the glass of the frame, his blackness gives the tone-key for the grass and the limestone, and his position emphasises and completes the "S" line from the top left-hand corner of the composition down to the centre foreground. The only weak point in the picture is the shadow in the right foreground which is necessary to the balance of the composition, but which is not fully articulated and does not completely explain itself. Such an essay is the high-water mark of ambition in a certain direction. Eminently worth doing by one who could handle it so masterly as Arbuthnot, and well worth exhibiting and reproducing, it is not a class of thing to be multiplied indefinitely, or imitated by earnest disciples. (Biblio. 1422, p. 71)

EXHIBITIONS

London 1903 » *London (RPS) 1903* » London 1906 » London 1908–1909 » New York (NAC) 1909 » Buffalo 1910 » *London (Secession) 1911* » *London (RPS) 1914.*

BIBLIOGRAPHY

Manuscript

56. Stieglitz Archives, Collection of American Literature, Beinecke Rare Book and Manuscript Library, Yale University, New Haven, Conn.: 11 unpublished letters from Malcolm Arbuthnot to Alfred Stieglitz between 1910 and 1911.

By Arbuthnot

57. Arbuthnot, Malcolm. "The Gum-Bichromate Process." *The Amateur Photographer,* 43 (6 and 13 March 1906), pp. 188–190, 211–213.

58. ———. "The Evolution of an Exhibition Picture." *The Amateur Photographer,* 47 (16 June 1908), p. 606.

59. ———. "A Plea for Simplification and Study in Pictorial Work." *The Amateur Photographer,* 49 (12 January 1909), pp. 34–35.

60. ———. "The Gum-Platinum Process." *The Amateur Photographer,* 49 (2 March 1909), pp. 197–198.

61. ———. "A New Gelatine Pigment-Process for Pictorial Workers." *Photo Era,* 26 (March, 1911), pp. 127–131.

See Biblio. 388, 1127.

About Arbuthnot

62. Tilney, F. C. "Observations on Some Pictures of the Year." *Photograms of the Year, 1914,* p. 13.

63. Portrait Lens [unidentified pseud.]. "Some Professional Picture Makers and Their Work: Malcolm Arbuthnot." *The Amateur Photographer,* 63 (13 June 1916), p. 476.

64. Waters, Grant. *Dictionary of British Artists, 1900–1950.*

65. "The Late Malcolm Arbuthnot." *Magnet Magazine* (19 December 1973), pp. 5, 22.

66. Beaton, Cecil and Gail Buckland. "Malcolm Arbuthnot." *The Magic Image.* Boston, 1975, p. 115.

67. Cork, Richard. *Vorticism and Abstract Art in the First Machine Age: Origins and Development.* Vol. 1. Berkeley, 1976, pp. 152–155.

68. Grabowski Gallery. *Malcolm Arbuthnot—Watercolors.* London (October–December), 1976.

ZAIDA BEN-YUSUF (American)

Fig. 3 » *Zaida Ben-Yusuf.* By F. Holland Day, 1900 or before. Cat. 165.

59

important commission: from *The Century,* a portrait of a "Celebrated Personage."

1898: Photograph published in *Camera Notes* (April, p. 93).

1899: Hartmann writes of her taste for Ibsen performances, her pleasure in reading "decadent literature and her personal daring, style and chic." "There is no affectation in her art . . . the effects are all obtained legitimately" (Biblio. 75, p. 452).

About 1903: Travels in Japan (Biblio. 70–72).

About 1904: Travels in Europe, photographing Capri.

1905: *American Art News* begins a weekly series of photographs of famous American artists; the first 7, out of a total of 31, are by Ben-Yusuf. Her photographs appear from October 14–November 25 (v. 4, nos. 1–7).

1915: Back in New York. Writes to Stieglitz from 40 West 39th Street, thanking him for selling her copies of *Camera Work* for her (Ben-Yusuf to A. S., 28 December 1908, YCAL).

CHRONOLOGY

About 1896: Travels in Europe, where she takes no pictures, but meets George Davison in Paris and shows him her earlier prints. He encourages her to continue (*The Amateur Photographer,* March 1899, p. 120).

1897: Opens a studio at 124 Fifth Avenue in New York City and begins to photograph seriously. » First

PHOTOGRAPHS

59 » *The Book.* About 1898. Platinum. 239 × 187 mm. (9$\frac{7}{16}$ × 7$\frac{3}{8}$ in.) Signed in pencil on verso "Zaida Ben-Yusuf" and titled as above in a slightly different script. 49.55.219.

Exhibited: New York (TCC, 1898) no. 190, as *A Study;* reviewed, *Camera Notes,* 2 (April, 1899), pp. 168–172.

Reproduced: *Photographishe Rundschau,* 14 (April, 1900), p. 91, titled as above.

EXHIBITIONS

London 1897–1899 » *New York (TCC) 1898* » *Vienna (C-K) 1898* » New York (Am. In.) 1899 » Philadelphia 1899 » Newark, Ohio 1900 » London (NSAP) 1900 » Paris (NSAP) 1901 » Glasgow 1901 » Philadelphia 1901 » London 1902.

BIBLIOGRAPHY

Manuscript

69. Stieglitz Archives, Collection of American Literature, Beinecke Rare Book and Manuscript Library, Yale University, New Haven, Conn.: 3 unpublished letters from Zaida Ben-Yusuf to Alfred Stieglitz and 1 from Alfred Stieglitz to Zaida Ben-Yusuf between 1897 and 1915.

By Ben-Yusuf

70. Ben-Yusuf, Zaida. "Japan Through My Camera." *Photo Era,* 12 (May, 1904), pp. 77–79.

71. ———. "Period of Daikan." *Architectural Record,* 19 (February, 1906), pp. 145–150.

72. ———. "Honorable Flowers of Japan." *Century,* 73 (March, 1907), pp. 697–705.

About Ben-Yusuf

73. Hines, Richard, Jr. "Women in Photography." *Wilson's Photographic Magazine,* 36 (March, 1899), pp. 137–141.

74. Murray, William. "Miss Zaida Ben-Yusuf's Exhibition." *Camera Notes,* 2 (April, 1899), pp. 168–172.

75. Hartmann, Sadakichi. "A Purist." *Photographic Times,* 31 (October, 1899), pp. 449–455.

76. "An Artist-Photographer." *Current Literature,* 34 (January, 1903), p. 21.

77. Allan, Sidney [Sadakichi Hartmann]. "A Few American Portraits." *Wilson's Photographic Magazine,* 49 (October, 1912), pp. 457–459.

ALICE BOUGHTON (American)

Fig. 4 » *Alice Boughton* (as Queen Victoria), about 1925. Courtesy of The Cosmopolitan Club, New York.

CHRONOLOGY

1866: Born Alice M. Boughton in Brooklyn. Her father, William H. Boughton, was a New York lawyer.

Before 1902: Studies painting in Paris and Rome; Assistant in studio of Käsebier. » Wins honorable mention at the Turin International Decorative and Fine Arts Exhibition, October–December, 1902.

1904: Listed as an Associate of the Photo-Secession in *Camera Work.* » Seven Boughton prints reproduced in *The Lamp* (28 July, pp. 492–498).

1905: Seven Boughton prints reproduced in a photo-essay, "The Child's Christmas," in *American Illustrated Magazine* (December, pp. 169–175).

1906: Elected a Fellow of the Photo-Secession. » Working hard at painting and photography during summer, photographs nude figures on the sand dunes (Boughton to A. S., 8 November 1906, YCAL).

1907: Joint exhibition with William B. Dyer and C. Yarnall Abbott at Photo-Secession Galleries, February 19–March 5, 23 prints each (Biblio. 1388).

1909: Six gravures published in *Camera Work,* No. 26 (April). » Photo-essay by Boughton, *Healing Miracles of Jesus the Christ,* published as set of enlargements and exhibited at Doll and Richards, Boston.

1924: Photographs reproduced in Paul Rosenfeld's *Port of New York: Essays on Fourteen American Moderns* (Biblio. 1147).

1931: Closes her studio, discarding thousands of prints. » Moves to Brookhaven, Long Island.

1943: Dies at Bay Shore, Long Island, of pneumonia at 77 on June 21.

PHOTOGRAPHS

60 » *The Baby.* 1908 or before. Gelatine silver. 239 × 190 mm. (9$\frac{7}{16}$ × 7$\frac{1}{2}$ in.) Signed in ink "Alice Boughton." 33.43.235.
Exhibited: New York (PSG, 1908), no. 1.

61 » *Portrait.* 1902 (A. S.) Gelatine silver. 370 × 278 mm. (14$\frac{9}{16}$ × 10$\frac{15}{16}$ in.) 33.43.236.
Exhibited: New York (PSG, 1907), no. 6, titled as above.

62 » *Children—Nude.* 1902 (A. S.) Platinum on tissue, mounted on smaller white paper which in turn is mounted on a sheet of tan paper with a narrow border. 202 × 125 mm. (7$\frac{15}{16}$ × 4$\frac{15}{16}$ in.) Signed in pencil "Alice Boughton." 33.43.237.

60

61

62

Exhibited: New York (PSG, 1905), no. 6, titled *Children* and visible in installation photograph published in *Camera Work,* No. 14 (April, 1906), p. 43; New York (PSG, Boughton, Dyer, Abbott, Joint, 1907), no. 25, titled *Children—Nude;* Philadelphia (1906), no. 17; New York (NAC, 1909), no. 102.

63 » *Maxime Gorky.* 1907. Gelatine silver. 321 × 226 mm. (12⅝ × 8¹⁵⁄₁₆ in.) 33.43.238.
Plate 25.
Exhibited: New York (PSG, Boughton, Dyer, Abbott, Joint, 1907), no. 26; New York (NAC, 1909), no. 89; Buffalo (1910), no. 240, dated as above; Newark, N.J. (Public Library), 1911, no. 29.
 Reproduced: *Wilson's Photographic Magazine,* 51 (April, 1914), p. 152; *Vanity Fair* (June, 1914), p. 41; Boughton (Biblio. 83), 107.
 Boughton recollected the day

Gorky was brought to my studio by a friend to be photographed. He was a large, loose-jointed man, so big that he seemed to come through the doorway in sections. . . . He was distinctly bored. He sat down heavily and glared at me. There seemed to be no means of communication, and I tried several ways of getting at him and lifting the gloom which seemed to have permanently settled down. I was in despair. (Biblio. 82, p. 79)

Pale and suffering from improper processing, the print is among the few in which monotone was accidental rather than intentional.

64 » *Danish Girl.* 1906 or before. Platinum on tissue, mounted on tan Japanese paper. 242 × 193 mm. (9⁹⁄₁₆ × 7⅝ in.) Signed in pencil "Alice Boughton." 33.43.239.
Exhibited: Philadelphia (1906), no. 18.
 Reproduced: *Camera Work,* No. 26 (April, 1909), pl. I.

65 » *Sand and Wild Roses.* 1906 or before. Platinum on tissue. 329 × 244 mm. (12¹⁵⁄₁₆ × 9⅝ in.) Signed in pencil "Alice Boughton." 33.43.240.
Exhibited: New York (PSG, 1906), no. 5; New York (PSG, Boughton, Dyer, Abbott, Joint, 1907), no. 14.
 Reproduced: *Camera Work,* No. 26 (April, 1909), pl. III.

66 » *[Summer].* About 1907–1910. Platinum on tissue. 166 × 206 mm. (6⁹⁄₁₆ × 8⅛ in.) Signed in pencil on margin "Alice Boughton." 33.43.241.
Exhibited: Buffalo (1910), no. 245, titled as above.

EXHIBITIONS

Philadelphia 1901 » *Chicago 1901* » New York (NAC) 1902 » Turin 1902 » Cincinnati 1903 » Chicago 1903 » Cleveland 1903 » Denver 1903 » Minneapolis 1903 » Reading, Pa. 1903 » Toronto 1903 » Hague 1904 » London 1904 » Paris 1904 » *London 1905* » Vienna (C-K) 1905 » Vienna (PC) 1905 » New York (PSG) 1905 » New York (PSG) 1906 » Philadelphia 1906 »

64

65

66

London (*NEAG*) *1907* » New York (PSG) Members' and Solo 1907 » New York (NAC) 1908 » New York (PSG) 1908 » Buffalo 1910 » *New York (NAC) 1909* » Newark (Public Library) 1911 » *Philadelphia (Wanamaker) 1915.*

BIBLIOGRAPHY

Manuscript

78. Stieglitz Archives, Collection of American Literature, Beinecke Rare Book and Manuscript Library, Yale University, New Haven, Conn.: 10 unpublished letters from Alice Boughton to Alfred Stieglitz between 1903 and 1931.

By Boughton

79. Boughton, Alice. "Season's Pictures." *American Magazine,* 61 (January, 1906), pp. 325–328.

80. ———. "Pictures of the Stage." *The Scrip, Notes on Art,* 1 (April, 1906), pp. 205–208.

81. ——— "Photography, A Medium of Expression." *Camera Work,* No. 25 (April, 1909), pp. 33–36.

82. ———. "Healing Miracles of Jesus the Christ—Studies in Artistic Photography." *Good Housekeeping,* 49 (December, 1909), pp. 611–618.

83. ———. *Photographing the Famous.* With foreword by L. Ford. New York, 1928.

About Boughton

84. "Alice Boughton." *The Lamp,* 28 (July, 1904), pp. 492–498.

85. Wilcox, Beatrice C. "Alice Boughton, Photographer." *Wilson's Photographic Magazine,* 51 (April, 1914), pp. 151–155.

86. "Photograph Prize Winners." *American Art News,* 14 (27 November 1915), p. 9.

87. "Alice Boughton, Photographer, 77." *New York Times,* 23 June 1943, p. 21.

ANNE W. BRIGMAN (American)

Fig. 5 » *Anne W. Brigman*. By Francis Bruguière, about 1905. Courtesy of The Oakland Museum, Oakland, California.

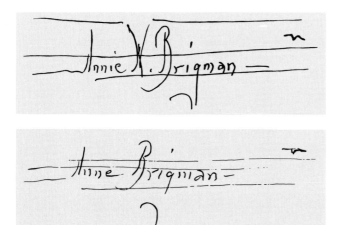

CHRONOLOGY

1869: Born in Honolulu, Hawaii, December 3.
About 1886: Family moves to Los Gatos, California.

About 1894 Marries Martin Brigman, a sea captain. Photographs him, and travels with him on his trips in the Pacific.

1903: Exhibits 1 print in the third San Francisco Photographic Salon, Mark Hopkins Institute, and sees an exhibit of Photo-Secession work there. » Photographs reproduced in *American Amateur Photographer* (February). » Becomes an Associate of the Photo-Secession. » Writes to Stieglitz from Oakland of her pride in the Photo-Secession display in the San Francisco Salon. (Brigman to Stieglitz, 5 November, YCAL).

1904: Sends seven prints to Stieglitz which had been shown in the Bay Area, for an exhibition in Holland (Brigman to Stieglitz, 23 March, YCAL).

1905: Expresses admiration for Elbert Hubbard and his Roycrofters.

1906: Exhibits in the opening show of the Little Galleries of the Photo-Secession, November 24, 1905–January 5, 1906 » Elected a Fellow of the Photo-Secession. » Exhibits three prints at the Members Exhibition at the Photo-Secession Galleries.

1907: Influenced by Eugene, uses pencil and graver on plates. Writes Stieglitz that she hopes to be known for her allegorical photographs (Brigman to Stieglitz, 23 March 1907, YCAL). Continues to make copper plate ink prints and etchings and linoleum-prints for illustrations.

1908: Appears in the role of Sybil in "Will o' the Wisp," by Charles Keeler at the Berkeley Hillside Club.

1909: Five gravures published in *Camera Work,* No. 25 (January). » Elected to The Linked Ring. » Exhibits six prints in the "International Group" selected by Kuehn for the Dresden Exposition (*Camera Work,* No. 28, October, p. 49). » Stieglitz announces his intention to exhibit Brigman in a solo show at the Photo-Secession Galleries during the winter of 1909, but the exhibition does not transpire.

1910: At the age of 41 Brigman separates from her husband and goes to New York to see Stieglitz and 291 and the members of the Photo-Secession. Stieglitz and Brigman outraged that *The Amateur Photographer* reproduces without permission gravures from *Camera Work* (Biblio. 931, p. 14). » In a class of eight studying with Clarence White at Fire Island,

Maine, during July (Brigman to A. S., 9 July 1910, YCAL). » Stieglitz again announces his intention to exhibit Brigman at the Photo-Secession Galleries during 1910–1911 season but the show does not transpire.

1911: First successful platinum prints.

1912: Five gravures published in *Camera Work,* No. 38 (April).

1913: Dryads reproduced in *Camera Work,* No. 44 (October). » Wins $100, first prize in John Wanamaker exhibition, Philadelphia, with *Finis* entered in the competition for her by Stieglitz (Brigman to Stieglitz, 21 March, YCAL).

1914: Statement by Brigman on "What 291 Means to Me" published in *Camera Work,* No. 47 (July), one of only four photographers to respond to Stieglitz's question. Frank Crowninshield of *Vanity Fair* is enthused about her photographs.

1915: With Francis Bruguière organizes Photo-Secession section of San Francisco Exposition.

1918: Correspondence with Stieglitz ends abruptly, but resumes in 1930.

1930: Moves to Long Beach where her two sisters live.

1932: Begins to photograph sand erosions, tidal effects of the beach, and tidal inlets (Biblio. 91).

About 1937: In the late '30s turns from photography to poetry. Takes classes in creative writing. May be troubled with failing eyesight.

1939–40: Visits relatives in the Bay Area. Takes pictures of the family and the Treasure Island Fair, but not of a 1940 trip to the Sierras (Biblio. 98, p. 10).

1950: Work on a book to be called *Child of Hawaii* is interrupted by her death at 81 at her sister's home in Eagle Rock, California.

PHOTOGRAPHS

67 » *The Brook.* 1905. Gelatine silver. 175 × 215 mm. (6⅞ × 8½ in.) Signed in ink "Annie W. Brigman—05." 33.43.112.
Exhibited: New York (PSG 1906), no. 9; London (1908), no. 52; Dresden (1909), no. 16; New York (NAC, 1909), no. 95.
 Reproduced: *Camera Work,* No. 25 (January, 1909),

67

69

pl. III, titled as above and cropped differently, with the following statement: "Brigman prints made from the original negatives and comparison shows that the gravures result in greater resolution and clarity which was not the model established on Brigman's gelatine silver prints, which are often very dark."
 Collections: IMP/GEH, variant in vertical format. Printed from the same negative as Cat. 68.

68 » *The Brook.* 1905. Gelatine silver. 174 × 227 mm. (6⅞ × 8¹⁵⁄₁₆ in.) Signed in ink "Anne Brigman." 33.43.117.
Not illustrated.
Printed from the same negative as Cat. 67, this print is lighter with a somewhat different effect; the water becomes animated, no less effective because of lost detail.

69 » *The Dryad.* 1905. Gelatine silver. 240 × 151 mm. (9⁷⁄₁₆ × 5¹⁵⁄₁₆ in.) Signed "Annie W. Brigman—05." 33.43.122.
Exhibited: New York (PSG, 1905), no. 9; New York (PSG, 1908), no. 3; New York (NAC, 1909), no. 93.
 Reproduced: *International Studio,* 28 (June, 1906), p. cv (105); *Camera Craft,* 12 (January, 1906), p. 15; *Vanity Fair* (June, 1914), p. 26, titled *A Modern Hamadryad, the Youthful Spirit of Pine; Songs of a Pagan* (Biblio. 92), p. 41.

70 » *Dryads.* About 1905. Gelatine silver. 159 × 205 mm. (6¼ × 8¹⁄₁₆ in.) Signed in ink "Annie W. Brigman." 33.43.120.

70

72

74

75

Exhibited: New York (PSG, 1909), no. 9.

Reproduced: *Camera Work,* No. 44 (October, 1913), pl. III, titled as above with a different scale of tones.

71 » *Incantation.* 1905. Gelatine silver, 272 × 172 mm. (10¾ × 6¹³⁄₁₆ in.) Signed in ink "Anne Brigman." 33.43.101.

Not illustrated.

Exhibited: New York (PSG, 1905), no. 7; Philadelphia (1906), no. 19. New York (NAC, 1909), no. 94.

Printed from the same negative as Cat. 72 and Cat. 73.

72 » *Incantation.* 1905. Gelatine silver. 273 × 170 mm. (10¾ × 6¹¹⁄₁₆ in.) Signed in ink "Anne Brigman ©." 33.43.130.

Printed from the same negative as Cat. 71, but cropped differently through rock formation opposite figure, with greater clarity in the valley.

73 » *Incantation.* 1905. Gelatine silver. 270 × 165 mm. (10⅝ × 6½ in.) Signed in pencil "Annie W. Brigman—05." 33.43.121.

Plate 77.

Printed from the same negative as Cats. 71 and 72, but reversed from Cat. 71.

74 » *Thaw.* 1906. Gelatine silver. 271 × 167 mm. (10¹¹⁄₁₆ × 6⁹⁄₁₆ in.) Signed and dated in ink "Anne Brigman—06." 33.43.124.

Exhibited: New York (PSG, 1907), no. 13; New York (NAC, 1908), no. 104.

Reproduced: *Camera Craft,* 15 (March, 1908), p. 86, titled *The First Snow.*

75 » *The Pool.* About 1906. Gelatine silver, brown. 243 × 130 mm. (9⁹⁄₁₆ × 5⅛ in.) Signed in ink "Anne W. Brigman." 33.43.105.

Exhibited: New York (PSG, 1908), no. 2.

Reproduced: *Camera Work,* No. 38 (April, 1912), pl. V, where there is greater detail in sky befitting a gravure that, according to p. 22, was made from the original negative.

Printed from the same negative as Cats. 76 and 77, this print has no clouds. The three impressions are successively softer in focus, this being the most direct print among the three examples. The soft focus was apparently created at the time of enlargement and the clouds were added manually to the negative.

76 » *The Pool.* About 1906. Gelatine silver. 272 × 150 mm. (10¾ × 5⅞ in.) Signed in ink "Anne Brigman ©." 33.43.416.

Not illustrated.

Printed from the same negative as Cat. 75.

77 » *The Pool.* About 1906. Gelatine silver. 272 × 152 mm. (10¾ × 6 in.) Signed in ink "Anne Brigman." 33.43.110.

Not illustrated.

Printed from the same negative as Cat. 75.

78 » *Landscape.* About 1906. Gelatine silver. 134 × 237 mm. (5⁵⁄₁₆ × 9⁵⁄₁₆ in.) Signed in ink "Annie W. Brigman." 33.43.106.

79 » *The Source.* 1906 or before. Gelatine silver. 239 × 140 mm. (9⁷⁄₁₆ × 5½ in.) Signed in ink "Annie W. Brigman." 33.43.97.

78

79

80

82

Exhibited: New York (PSG, 1906), no. 8; New York (NAC, 1909), no. 90.

Reproduced: *Camera Work*, No. 25 (January, 1909), pl. IV, titled as above.

80 » *The Cleft in the Rock*. 1907. Gelatine silver. 192 × 112 mm. (7⁹⁄₁₆ × 4⁷⁄₁₆ in.) Signed in ink "Annie W. Brigman." 33.43.131.

Exhibited: Buffalo (1910), no. 234.

Reproduced: *Camera Work*, No. 38 (April, 1912), pl. I, cropped at edges and with greater detail in the rocks and figure; an exemplary instance of how a gravure made from the original negative changed the photographer's intent as rendered in silver and platinum.

A rich, brown-toned print, darker than Cat. 81, it has less detail in the rocks that suggests an evening effect.

81 » *The Cleft in the Rock*. 1907. Gelatine silver. 266 × 165 mm. (10½ × 6½ in.) Signed and dated in ink "Anne Brigman—07." 33.43.127.

Not illustrated.

Nearly twice the size of Cat. 80, this print has a softer focus and more atmospheric quality suggestive of a foggy day rather than night.

82 » *The Moon-Cave*. About 1907. Gelatine silver. 154 × 110 mm. (6¹⁄₁₆ × 4⁵⁄₁₆ in.) 33.43.415.

Exhibited: Buffalo (1910), no. 235.

83 » *Soul of The Blasted Pine*. 1907. Bromoil. 190 × 243 mm. (7½ × 9½ in.) 33.43.111.

Exhibited: New York (PSG, 1907), no. 14; New York (NAC, 1908), no. 105; New York (NAC, 1909), no. 92;

Buffalo (1910), no. 224, where a bromoil print was exhibited.

Reproduced: *Camera Work*, No. 25 (January, 1909), pl. I, titled as above; *Academy Notes* (Biblio. 1399a), p. 5; *American Annual of Photography and Photographic Times*, 51 (January–June, 1910), p. 237; *Vanity Fair* (June, 1914), p. 28, as *Daphne; Songs of a Pagan* (Biblio. 92), p. 53.

84 » *The Dying Cedar*. 1907 or before. Gelatine silver. 272 × 169 mm. (10¾ × 6¹¹⁄₁₆ in.) Signed in ink "Anne Brigman." 33.43.109.

Exhibited: New York (PSG, 1907), no. 11; New York (NAC, 1909), no. 103.

Reproduced: *Camera Work*, No. 25 (January, 1909), pl. II, titled as above but cropped differently; *Songs of a Pagan* (Biblio. 92), p. 49.

85 » *The Spider's Web*. 1908. Gelatine silver. 250 × 172 mm. (9⅞ × 6¹³⁄₁₆ in.) Signed in ink "Annie W. Brigman—08." 33.43.123.

Plate 78.

Reproduced: *Vanity Fair* (June, 1914), p. 29, titled *Clotho.*

86 » *The Echo*. 1908. Gelatine silver. 269 × 132 mm. (10⅝ × 5³⁄₁₆ in.) Signed and dated in ink "Annie W. Brigman—08." 33.43.98.

Exhibited: New York (NAC, 1909), no. 98.

Brigman wrote Stieglitz not to change the titles of her prints. This is possibly the image he called *The Cave* and exhibited at New York (PSG, 1906), no. 10 that she wanted called *The Echo*. [Brigman to Stieglitz, 3 March 1907, YCAL.]

83

84

86

87

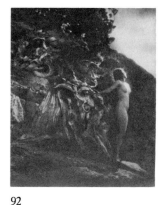

88

90

91

92

87 » [*The Lone Pine*]. About 1908. Gelatine silver. 170 × 268 mm. (6¹¹⁄₁₆ × 10⁹⁄₁₆ in.) Signed in ink "Anne Brigman." 33.43.108.

88 » *Dawn*. 1909 or before. Gelatine silver, brown, mounted on a single layer of brown paper. 125 × 261 mm. (4¹⁵⁄₁₆ × 10⁵⁄₁₆ in.) 33.43.113.

Reproduced: *Photograms of the Year 1909*, p. 143; *Camera Work,* No. 38 (April, 1912), pl. II, titled as above, but with different proportions, where it is also noted the gravures are "direct enlargements from the original 3¼ × 4½ inch film negatives" (p. 22).

This photograph is printed more darkly through the foreground with more resonant atmosphere in the background than Cat. 89, printed from the same negative.

H. Snowden Ward wrote of this print in 1909:

Miss Brigman's *Dawn* (143) is a use of the nude that may well be carried further. . . . In using practically a silhouette shape. . . . the whole thing is as impersonal

as it would have been if a bronze statue had been used instead of the human model. The figure, in its outline and the poise of the hand, has its own interest, while it gives a sense of mystery and poetry to a scene that would otherwise be quite uninteresting. The way in which the line of the figure blends into the light-tipped line of the first plane, helps the idea that here is the genius of the mountain welcoming the dawn, an idea intensified by the heroic scale of the figure in comparison with the landscape setting. (Biblio. 1130, p. 93)

89 » *Dawn*. 1909 or before. Gelatine silver. Mounted on two layers of gray paper. 134 × 261 mm. (5⁵⁄₁₆ × 10⁵⁄₁₆ in.) Signed and dated in ink "Anne W. Brigman—09." 33.43.100.
Not illustrated.
Traces of sulphiding at edges. Printed from the same negative as Cat. 88, dated 1908, cropped differently.

90 » *Finis*. 1910 or before. Gelatine silver. 120 × 223 mm. (4¹¹⁄₁₆ × 8⅞ in.) 33.43.126.
Exhibited: Buffalo (1910), no. 226; Philadelphia

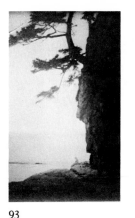

93

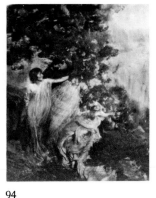

94

95

96

(Wanamaker, 1913), where it was awarded First Prize
of one hundred dollars.

Reproduced: *Academy Notes* (Biblio. 1399a), p. 13;
Photograms of the Year 1911, p. 154; *Camera Work,*
No. 38 (April, 1912), pl. III, cropped differently; *Vanity
Fair* (June, 1914), titled *Clytie.*

91 » *Grief.* 1910. Gelatine silver. 228 × 149 mm.
(9 × 5⅞ in.) Signed and dated in ink
"Annie W. Brigman—10." 33.43.99.

92 » *Light.* 1910. Platinum. 242 × 191 mm.
(9⁹⁄₁₆ × 7½ in.) Signed and dated in pencil
"Anne W. Brigman—10." 33.43.104.

93 » *The Mood.* 1910. Platinum. 234 × 135 mm.
(9¼ × 5⁵⁄₁₆ in.) Signed in ink "Annie W.
Brigman—10." 33.43.114.

94 » *The Enchanted Tree.* 1911. Platinum. 238 ×
188 mm. (9⅜ × 7⁷⁄₁₆ in.) Signed and dated in
ink "Annie Brigman—11." 33.43.116.

95 » *The Storm Tree.* 1911. Platinum. 193 × 243
mm. (7⅝ × 9⁹⁄₁₆ in.) Signed and dated in
ink "Annie W. Brigman—11." 33.43.118.
Reproduced: *Vanity Fair* (June, 1914), p. 28, titled
The Nymph Orythyia.

96 » *The Ancient Pine.* 1912. Platinum (?)
240 × 162 mm. (9⁷⁄₁₆ × 6⅜ in.) Signed in ink
"Anne Brigman—12." 33.43.107.
Reproduced: *American Amateur Photographer,* 29
(1917), p. 83.

97 » *Ballet de Mer.* 1913. Platinum. 243 × 191 mm.
(9⁹⁄₁₆ × 7½ in.) Signed and dated in pencil
"Anne W. Brigman—13." 33.43.102.
Reproduced: *Songs of A Pagan* (Biblio. 92), p. 61,
from a print with a very different tonal scale.

Compare to Cat. 98 which is practically identical
in tone and scale.

98 » *Ballet de Mer.* 1913. Platinum. 238 × 190 mm.
(9⅜ × 7½ in.) Signed and dated in ink on
print and in pencil on mount "Anne Brigman—
13." 33.43.125.
Not illustrated.
Compare to Cat. 97 (here cropped into subject at
bottom).

99 » *The West Wind.* 1914. Gelatine silver. 239 ×
190 mm. (9⁷⁄₁₆ × 7½ in.) Signed and dated in
ink "Anne W. Brigman—14." 33.43.103.

100 » *Pan.* 1914. Platinum. 240 × 189 mm. (9⁷⁄₁₆ ×
7⁷⁄₁₆ in.) Signed and dated in ink "Anne
Brigman—14." 33.43.119.

101 » *Pan.* About 1914. Gelatine silver. 209 ×
157 mm. (8¼ × 6³⁄₁₆ in.) Signed in ink
"Anne W. Brigman." 33.43.115.

102 » *Wind Harp.* About 1915. Platinum. 242 ×
183 mm. (9⁹⁄₁₆ × 7³⁄₁₆ in.) Signed in ink
"Anne Brigman ©." 33.43.128.
Reproduced: *Songs of a Pagan* (Biblio. 92), p. 25.

103 » *The Heart of the Storm.* About 1915.

97 99 100

Gelatine silver. 242 × 192 mm. (9⁹⁄₁₆ × 7⁹⁄₁₆ in.) Signed in ink "Anne Brigman ©." 33.43.129.

Plate 79.

Inscribed on the old mount in an unidentified hand is a quotation from Edward Carpenter's *The Central Calm,* "Like one in the calm that is the center of/a cyclone—guarded by the very tornado/around—."

104 » *Charybdis.* 1942. Gelatine silver. 231 × 195 mm. (9⅛ × 7¹¹⁄₁₆ in.) Signed and dated in pencil "Anne Brigman 1942." 49.55.325.

The image was intended to illustrate the poem "Whirlpools" in Brigman's *Wild Flute Songs* (unpublished). This was the last photograph collected by Stieglitz. He probably received it as a gift, and considering this is typical of the unimaginative state into which pictorialism had fallen since the Photo-Secession day, it is surprising the work was embraced.

EXHIBITIONS

San Francisco 1902–1903 » *Chicago 1902* » Hamburg 1903 » Hague 1904 » Paris 1904 » Pittsburgh 1904 » Washington 1904 » *London 1905* » New York (PSG) 1905 » *Birmingham, England 1906* » New York (PSG) 1906 » *Philadelphia 1906* » *London (NEAG) 1907* » *New York (PSGG) 1907* » New York (NAC) 1908 » New York (PSG) 1908 » New York (NAC) 1909 » Dresden 1909 » Buffalo 1910 » London (Seces-

sion) 1911 » *San Francisco 1915* » *San Francisco (Palace of F.A.) 1922* » *New York (TCC) 1937*

COLLECTIONS

IMP/GEH; RPS; The Oakland Museum.

BIBLIOGRAPHY

Manuscript

88. Anne Brigman Archives. Oakland Museum, Oakland, California.

89. Stieglitz Archives, Collection of American Literature, Beinecke Rare Book and Manuscript Library, Yale University, New Haven, Conn.: 80 unpublished letters from Anne W. Brigman to Alfred Stieglitz and 26 from Alfred Stieglitz to Anne W. Brigman between 1903 and 1944.

By Brigman

90. Brigman, Anne. "What 291 Means to Me." *Camera Work,* No. 47 (July, 1914), pp. 17–20.

91. ———. "Awareness." *Design,* 38 (June, 1936), pp. 17–19.

92. ———. *Songs of a Pagan.* Caldwell, Idaho, 1949.

About Brigman

93. Hamilton, E. J. "Symbolic Nature: Studies from

101 102

104

the Camera of Anne W. Brigman." *The Craftsman,* 12 (September, 1907), pp. 660–666.

94. Laurvik, J. Nilsen. "Mrs. Annie Brigman—A Comment." *Camera Work,* No. 25 (January, 1909), p. 47.

95. "Note on Two Pictures by Mrs. Anne W. Brigman in this Issue." *The Amateur Photographer,* 51 (8 March 1910), p. 236.

96. Bruce, Arther Loring. "A New Classical Note in Photography: With a Series of Recent Camera Studies, Made in California, by Annie Brigman." *Vanity Fair,* 2 (June, 1914), pp. 26–29.

97. "An April Exhibit of California Studies." *Bulletin of the Brooklyn Institute of Arts and Sciences,* 36 (2 April 1932), p. 295.

98. Heyman, Therese Thau. *Anne Brigman: Pictorial Photographer/Pagan/Member of the Photo-Secession.* Oakland Museum, Oakland, California, exhibition catalog, 1974.

JOHN G. BULLOCK (American)

Fig. 6 » *John G. Bullock.* By Robert Redfield, about 1915.
Courtesy of Sotheby Parke-Bernet, Inc., N.Y.

Jno G. Bullock

CHRONOLOGY

1854: Born on September 27, in Wilmington, Delaware, son of William R. Bullock, M.D., and Elizabeth Ann Emlen Bullock.

1874: Graduates with B.A. degree from Haverford College, Haverford, Pennsylvania.

1879: Graduating from Philadelphia College of Pharmacy with Ph.D. degree, Bullock enters firm of Bullock and Crenshaw, a drug and chemical business, where he remains until 1907.

1882: Takes up amateur photography; active in the Photographic Society of Philadelphia, he subsequently becomes its president. Lives in Germantown, Pennsylvania.

1893: Stieglitz writes of Bullock's work exhibited at Philadelphia: "John G. Bullock, a mainstay of the Philadelphia Society, has shown to better advantage in previous exhibitions. Some of his pictures have the fault . . . [of being] too heavy in the shadows. This is a very serious fault in any picture. Shadows are transparent in nature and must be transparent in the reproduction" (Biblio. 879, pp. 252–3).

1900: Three landscape photographs included in F. Holland Day's New School of American Photography show. Described in the Newark, Ohio (1900) catalog as "a leading spirit in the Philadelphia Salon and among the earliest successful American workers in artistic photography" (Biblio. 1333).

1902: Becomes a founder of the Photo-Secession, a Fellow, and a member of the Council.

1905: Exhibits in first Members Exhibition, Photo-Secession Galleries.

1907: Represented in Members Exhibition, Photo-Secession Galleries.

1915: Photographic illustrations for Charles F. Jenkins' *Guide to Historic Germantown* (Third Edition).

1923: Becomes active in the study of the history and genealogy of Chester County, serving as curator of the Historical Society of Chester County. In later years lives in West Chester, Pa.

1939: Dies on December 14.

PHOTOGRAPHS

105 » *The White Wall.* 1901. Glycerine developed platinum (A. S.) 193 × 132 mm. (7⅝ × 5³⁄₁₆ in.) Signed and titled as above on verso in pencil "John G. Bullock." 33.43.344.
Plate 22.
Exhibited: Brussels (1903), no. 91; Bradford (1904), no. 168; Vienna (P–C, 1905), no. 2; New York (PSG, 1906), no. 11; Buffalo (1910), no. 238, titled and dated as above.

Reproduced: *Camera Notes,* 5 (April, 1902), p. 275, titled as above.

EXHIBITIONS

Vienna 1891 » *Philadelphia (Joint), 1893* » Paris 1894 » *New York (Joint) 1894* » London (RPS) 1895 » Paris 1895 » Philadelphia 1898–1900 » London 1899 » Chicago 1900 » London (NSAP) 1900 » Newark 1900 » Paris (NSAP) 1900 » Glasgow 1901 » London 1901 » London 1902 » New York (NAC) 1902 » Turin 1902 » Brussels 1903 » Hamburg 1903 » San Francisco 1903 » Bradford 1904 » Hague 1904 » London 1904 » Pittsburgh 1904 » Washington 1904 » New York (PSG) 1905 » Vienna (PC) 1905 » New York (PSG) 1906 » New York (PSG) 1907 » Buffalo 1910.

COLLECTIONS

MOMA.

BIBLIOGRAPHY

Manuscript

99. Stieglitz Archives, Collection of American Literature, Beinecke Rare Book and Manuscript Library, Yale University, New Haven, Conn.: 14 unpublished letters from John G. Bullock to Alfred Stieglitz and 1 from Alfred Stieglitz to John G. Bullock between 1901 and 1916.

By Bullock

100. Bullock, John G. with Robert Redfield and Edmund Stirling. "The Salon Committee of 1900 Makes a Statement." *Camera Notes,* 5 (April, 1902), pp. 300–302.

101. Jenkins, Charles F. *Guide to Historic Germantown.* Philadelphia, 1915, third edition. Illustrated by Bullock.

About Bullock

102. Moore, Clarence B. "Leading Amateurs in Photography." *Cosmopolitan,* 12 (February, 1892), pp. 421–433.

103. "The Bullock, Redfield and Stirling Prints." *Camera Notes,* 5 (January, 1902), p. 227.

WILL CADBY (English)

Fig. 7 » *Will Cadby*. By Reginald Craigie, 1907. Reproduced from *Photograms of the Year, 1907*, p. 111.

Will Cadby

CHRONOLOGY

1891: Begins taking pictures.

1893: Exhibits for the first time at the Photographic Society, The London Photographic Salon, the Leytonstone Camera Club, and the Bristol International. Wins a bronze medal at Bristol for *Reflections*.

1894: Elected to membership in The Linked Ring. Both he and his wife, Carine, exhibit in The London Salon. Cadby wins silver medals for *Oh Ye Tears* and *Reflections* at the Newcastle International. » Stieglitz writes in review of 1894 New York Joint Exhibition, "This beautiful work was entirely killed by the outrageous framing and the dark red wall upon which the pictures were hung . . ." (Biblio. 882, p. 214).

1896: Begins series of white on white photographs (model in white in white room) that he calls camera sketches, which ultimately lead to his snowy Swiss landscapes (Biblio. 120–121).

1897: Organizes an exhibition of photographs by prominent British workers for the Birmingham Photographic Society. Takes first of what were to be yearly trips to Switzerland.

1901: London critics see the influence of the American school of portraits, a turn away from snowy landscapes.

1902: Writes a review of the London Salon for *Camera Work* (Biblio. 108). Publication of *Dogs and Doggerel*, the first of several children's books by Carine with photographs by Will. The Cadbys move from London to Kent.

1904: Two gravures published in *Camera Work*, No. 6 (April); visits Eugene in Munich (August).

1912: Carine and Will begin writing a column, "London Letter," for *Photo-Era* (Biblio. 119).

1932: The Cadbys are still writing their "London Letter" when *Photo-Era* ceases publication.

PHOTOGRAPHS

106 » *April.* 1902 or before. Platinum, mounted on gray paper with a narrow border upon a larger sheet of another gray. 130 × 89 mm. (5⅛ × 3½ in.) Signed and titled in pencil on mount. 33.43.349.

Exhibited: London (1902), no. 84.

The description of the image as "tender and silvery" in a review of the London Salon (1902) perfectly reflects the subtle iridescence, matched in few other prints of the period, and is expressive of the light and

clear atmosphere of spring (*Photograms of the Year 1902*, p. 129). The date 1904 is inscribed by Stieglitz on verso, suggesting when he acquired the print.

EXHIBITIONS

London (RPS) 1893–1894 » London 1893, 1894–1904 » *New York (Joint) 1894* » *Bristol 1894* » *Leystone 1894* » Brussels 1895 » London (RPS) 1895–1896 » Paris 1895–1896 » London (RPS) 1898 » Paris 1898 » Berlin 1899 » Philadelphia 1899 » Leeds 1902 » Paris 1902 » Turin 1902 » Vienna (C-K) 1905 » London 1906 » Paris 1906 » London 1908–1910 » Dresden 1909.

COLLECTIONS

RPS.

BIBLIOGRAPHY

Manuscript

104. Stieglitz Archives, Collection of American Literature, Beinecke Rare Book and Manuscript Library, Yale University, New Haven, Conn.: 11 unpublished letters from Will A. Cadby to Alfred Stieglitz between 1900 and 1904.

By Cadby

105. Cadby, Will. "Photographic Indigestion." *The Amateur Photographer*, 32 (5 October 1900), pp. 264–266.

106. ———. "A Struggle Round the Academy." *The Amateur Photographer*, 33 (31 May 1901), pp. 430–431.

107. ———. "Diffusion and Simplification." *Camera Notes*, 6 (July, 1902), pp. 17–21.

108. ———. "A Chat on the London Photographic Salon." *Camera Work*, No. 1 (January, 1903), pp. 22–26.

109. ———. "Hands in Portraiture." *The Amateur Photographer*, 38 (20 August 1903), pp. 151–152.

106

110. ———. "An Impression of the London Photographic Salon." *Camera Work*, No. 5 (January, 1904), pp. 43–46.

111. ———. "Still Life Subjects." *The Amateur Photographer*, 39 (28 January 1904), pp. 70–71.

112. ———. "The Influence of Japanese Art on Photography." *The Amateur Photographer*, 39 (18 February 1904), pp. 130–133.

113. ———. "Some Thoughts on a Wood." *Camera Work*, No. 6 (April, 1904), pp. 26–27.

114. ———. "Whistler, and the Gentle Art of—Photography." *The Amateur Photographer*, 39 (2 June 1904), pp. 436–437.

115. ———. "Light Tones in Portraiture." *Photographic Times*, 39 (April, 1907), pp. 171–173.

116. ———. "Moods." *The Amateur Photographer*, 45 (11 June 1907), pp. 516–517.

117. ———. "Line and Tone." *Photographic Times*, 40 (July, 1908), pp. 211–212.

118. ———. "Snow-Landscapes." *Photo–Era*, 28 (February, 1912), pp. 64–67.

119. Cadby, Carine and Will Cadby. "London Letter." *Photo–Era*, one letter per issue from 27 (February, 1912), through 67 (March, 1932).

120. ———. *Switzerland in Summer—The Bernese Oberland*. London, 1922.

121. ———. *Switzerland in Winter*. London, 1924. *See Biblio. 282, 638, 1127.*

About Cadby

122. Lambert, F. C. "The Pictorial Work of Will A. Cadby." *Practical Photographer*, 3 (January, 1903), pp. 1–4.

123. Anderson, J. "A Lesson from Japan." *Photo–Era*, 16 (November, 1904), pp. 334–366.

124. "The Future of Pictorial Photography in Great Britain." *The Amateur Photographer*, 50 (14 December 1909), pp. 574–577.

125. "Photographers I Have Met—Will Cadby." *The Amateur Photographer*, 52 (19 July 1910), p. 66.

126. Blake, A. H. "The Cadbys: An Appreciation." *Photo–Era*, 25 (November, 1910), pp. 219–226.

EUSTACE G. CALLAND (English)

E.G.C.

107

CHRONOLOGY

1891–1894: Exhibits in London, Paris and West Surrey, establishing himself among the most active of the first generation of artistic photographers.

Before 1897: Becomes a student of Davison, on whom he has a stylistic influence according to one writer: "Davison appears to have adopted the style of his own pupil, Mr. Calland. Two street views of Davison's recall the treatment of Calland's *Brompton Road* and *The Mall*." "The Royal Photographic Society Exhibition," *British Journal of Photography,* 44 (October, 1897), pp. 630–634.

1899: The Mall reproduced in *Camera Notes* (January).

1911: Represented in the London Secession exhibition (Biblio. 1422).

PHOTOGRAPHS

107 » *St. George's, Hanover Square [London].* 1904 or before. Platinum (?). 217 × 157 mm. (8⁹⁄₁₆ × 6³⁄₁₆ in.) Initials "EGC" in pencil on tab at bottom. 33.43.348.
Exhibited: London (1904), no. 42.
Reproduced: Holme (Biblio. 1288), G. B. pl. V, titled as above. *Camera Notes,* 3 (January, 1900), opp. p. 148.

Calland paid direct hommage to Whistler in trimming the print to the subject and leaving a tab (5 × 10 mm.) around his initial. The subject is printed pale, with delicate atmosphere that has a distantly Whistlerian feel. Transcribed from the old mount: "Bought from London Salon 1904/$15." Stieglitz had departed for New York before the opening of the 1904 Salon and claims not to have seen the London Salon firsthand before 1907, leaving unresolved the question of where and when in 1904 the print was purchased.

EXHIBITIONS

London (RPS) 1891 » London [1893]–1899 » *West Surrey 1893* » Paris 1894 » Brussels 1895 » Paris 1896 » London (RPS) 1898 » Philadelphia 1899 » Glasgow 1901 » Turin 1902 » London 1903–1904 » Vienna (C-K) 1905 » *Paris 1905* » London 1906–[1908] » Paris 1906 » London 1908–1909 » *London (Secession) 1911* » *London (Ehrich Galleries) 1914.*

BIBLIOGRAPHY

By Calland

127. Calland, Eustace. "The Natural in Photography." *The Amateur Photographer,* 10 (6 December 1889), p. 377.

128. ———. [Photography as Art.] *The Amateur Photographer,* 23 (22 March 1896), p. 442.

129. ———. "Is Switzerland Pictorially Possible?" *The Amateur Photographer,* 24 (11 September 1896), pp. 208–209.

130. ———. "Frames." *The Amateur Photographer,* 24 (30 October 1896), pp. 347–348.

131. Robinson, V. J. *Ancient Furniture and Other Works of Art—A Collection Formed by Vincent J. Robinson—of Parnham House.* Illustrated by Eustace Calland. London, 1902.

See Biblio. 1127.

Further references to Calland can be found in exhibition reviews Biblio. 1301a, 1301b, 1313a, 1313b, 1416, 1418, etc.

JULIA MARGARET CAMERON (English)

Fig. 8 » *Julia Margaret Cameron*, 1868. Courtesy of Paul Walter, New York.

CHRONOLOGY

1815: Born on June 11 at Garden Reach, Calcutta, the fourth child of James and Adeline de l'Etang Pattle.

1818–?: Raised in Paris by her maternal grandmother, Mme. de Grincourt, and educated in Paris and England.

1838: Marries Charles Hay Cameron (1795–1880) in Calcutta from whom issue six children—Julia Hay, Eugene Hay, Ewen Wrottesley Hay, Hardinge Hay, Charles Hay, and Henry Herschel Hay.

1848: Returns to England.

1863: Acquires by gift a wooden camera that takes 9 × 11 inch plates; first successful photograph dated January, 1864.

1864: Becomes a member of the Photographic Societies of London and Scotland.

1864–68: Participates in the annual exhibitions of the Photographic Society of London, often exhibiting technically imperfect prints.

1865: Exhibits at Colnaghi's, London (November–January, 1866). Participates in the annual exhibitions of the Photographic Societies of Scotland and Berlin where she is awarded a bronze medal. Represented at the International Exhibition of Dublin and awarded an Honorable Mention.

1866: Purchases special long focal length lens. Awarded a gold medal, Photographic Society of Berlin; silver medal, Hartley Institution, Southampton.

1867–70: Most active years as a portrait photographer.

1871: Represented at the International Exhibition, London.

1874: At the request of Alfred Tennyson, makes photographic illustrations for Tennyson's *Idylls of the King,* published in December. Writes "Annals of My Glass House," a short account of her photographic career, not published until 1889.

1875: Leaves England in October for Ceylon to join her husband at his tea estates in Ceylon. Continues to photograph native types.

1878: Returns to England for a month's visit in May.

1879: Dies on January 26 in the Dikoya Valley, Ceylon.

1889: Exhibit at the Camera Gallery, London (April), reviewed *in passing* by Emerson who quotes an unnamed critic making comparisons to Claude Monet (Biblio. 134, p. 123).

1908: Keiley discovers cache of Cameron prints in London and writes enthusiastically to Stieglitz about them (16 July).

1912: Autotype Co. of London informs Stieglitz they can make carbon prints from Cameron negatives in their possession.

1913: Five gravures published in *Camera Work,* No. 41 (January).

108

109

110

111

1914: Represented in an exhibition of *The Old Masters of Photography,* arranged by Alvin Langdon Coburn and held in December at the Ehrich Galleries, New York.

PHOTOGRAPHS

108 » *Ellen Terry, at the age of sixteen.* 1863. Carbon. 240 mm. diam. (9⁷⁄₁₆ in.) 49.55.323. Reproduced: *Camera Work,* No. 41 (January, 1913), pl. V, titled as above, and with a similar scale of tones and pattern of grain (compare Cat. 113), likewise described to have been made from the original negative.

Dame Alice Ellen Terry (1847–1928) was a popular actress, known to Cameron through her sister Sarah Prinsep who was matchmaker of Terry's brief and unhappy marriage to G. F. Watts the year after the date of this portrait. A variant pose is reproduced in Biblio. 139, pl. 26.

109 » *Robert Browning.* Print about 1902 from negative of 1865. Carbon print copied from another print. 213 × 221 mm. (8⅜ × 8¹¹⁄₁₆ in.) 33.43.353. Exhibited: *London (1906), Little Gallery of the Offices of the Royal Photographic Society's *Journal,* per review.

Collections: AIC, Stieglitz Collection, two gelatine silver prints, one of which is the reverse of this print.

This and other related carbon prints collected by Stieglitz were presumably made by the Autotype Fine

Art Co., London, to whom Stieglitz wrote (4 September 1912, YCAL) advising that they were in possession of a dozen Cameron negatives. Close inspection of these prints proves false the tantalizing suggestion of the handful of survivals of original Cameron glass negatives. The carbon prints by Cameron collected by Stieglitz are from various forms of copy negative prints. The original mount of a print is clearly visible on which are old inscriptions, including a caption in Cameron's hand.

110 » *Alfred, Lord Tennyson (1809–1892).* Print about 1905 from copy negative after original of about 1866. Carbon. 344 × 256 mm. (13⁹⁄₁₆ × 10¹⁄₁₆ in.) 49.55.320. This rich carbon copy could easily be confused with carbon prints produced in Cameron's lifetime, but that it is copied from a damaged original is evident at the bottom corners.

111 » *Alfred, Lord Tennyson (1809–1892).* Print about 1905 from copy negative after original of about 1867. Carbon. 358 × 262 mm. (14⅛ × 10⁵⁄₁₆ in.) 49.55.319. Exhibited: London (1898), exhibited one of Cameron's several Tennyson portraits.

Collections: AIC, Stieglitz Collection.

This apparently is a carbon print from a copy negative made from a carbon or other print, but not from the early editions published in carbon by The Autotype Co., London.

112 » *George Frederick Watts (1817–1904).* Print about 1905 from copy negative after original

112

113 114

of about 1866. Carbon. 255 × 202 mm. (10⅟₁₆ × 7¹⁵⁄₁₆ in.) 49.55.321.

Exhibited: *London (Little Gallery of the Offices of the British Journal of Photography) 1906.

The light struck area at the right edge indicates this image was copied posthumously from a print.

113 » *Thomas Carlyle (1795–1881).* 1867. Carbon. 350 × 281 mm. (13¾₁₆ × 11⅟₁₆) 49.55.324.

Reproduced: *Camera Work,* No. 41 (January, 1913), pl. II, where the gravure has more detail in shadows of the eyes and is several degrees lighter in tone on the wall, thus rendering a very different interpretation from the carbon print.

Collection: AIC, Stieglitz Collection.

It was stated in the cited *Camera Work* (p. 42) that

the gravure plates of the five Camerons were made by the Autotype Fine Arts Company, directly from the original collodion negatives which average about ten by twelve inches in size. The makers of the gravures [plates] are the owners of the original negatives. The printing of the edition was done by the Manhattan Photogravure Company, New York.

The carbon print shows traces of collodion streaking not present in the gravure which, while printed with more detail, is, like the carbon print, at least two generations removed from Cameron's original. Both states appear to have been made from copies of some sort, and both are reversed from the earliest dated Cameron original in the National Portrait Gallery (Biblio. 143, pl. 2, p. 25 and p. 117).

114 » *Lord Justice James.* Print about 1905 from negative of about 1870. Carbon. 333 × 266 mm. (13⅛ × 10½ in.) 49.55.322.

Perhaps one generation closer to the original Cameron than other Cameron prints collected by Stieglitz, this rich print was made from process positives dating from the time of the original carbon editions produced by The Autotype Co., London.

EXHIBITIONS

London (Photographic Society) 1864–1868 » *Berlin 1865.* » *Dublin 1865* » *Edinburgh (Photographic Society of Scotland) 1865* » *London (Colnaghi's) 1865* » *London (French Gallery) 1866* » *Berlin 1866* » *Paris 1867* » *London (German Gallery) 1868* » *London (Photographic Society) 1870* » *London 1871* » *Vienna 1872* » London (Photographic Society) 1873 » *London (Camera Gallery) 1889* » *Paris 1894* » Brussels 1895 » Hamburg 1899 » *London (Serendipity Gallery) 1904* » Vienna (PC) 1905 » *London (Little Gallery of B.J.P.) 1906* » New York (NAC) 1909 » *New York (Ehrich Galleries) 1914.*

COLLECTIONS

IMP/GEH; MMA.

BIBLIOGRAPHY

By Cameron

132. Cameron, Julia Margaret. "Annals of My Glass House." *Photographic Journal,* 67 (January, 1927), pp. 296–301. (First published in catalog of the Cameron and Smith exhibition at 106 New Bond St., London, 1889.)

About Cameron

133. A Lady Amateur [unidentified pseud.]. "A Reminiscence of Mrs. Cameron." *The Photographic News,* 30 (1 January, 1886), pp. 2–4.

134. Emerson, Peter Henry. "English Letter." [review of Cameron exhibition]. *American Amateur Photographer,* 1 (September, 1889), pp. 121–123.

135. ———. "Mrs. Julia Margaret Cameron." *Sun Artists,* 5 (October, 1890), pp. 33–42.

136. O'Connor, V. C. Scott. "Mrs. Julia Margaret Cameron, Her Friends and Her Photographs." *Century Magazine,* 33 (November, 1897), p. 3.

137. Evans, Frederick H. "Exhibition of Photographs by Julia Margaret Cameron." *The Amateur Photographer,* 40 (21 July, 1904), pp. 43–44.

138. Coburn, Alvin Langdon. "The Old Masters of Photography." *Century Magazine,* 90 (October, 1915), pp. 911–916.

139. *Victorian Photographs of Famous Men and Fair Women.* Introduction by Virginia Woolf and Roger Fry. London, 1926. Revised edition, Boston, 1973.

140. Gernsheim, Helmut. *Julia Margaret Cameron: Her Life and Photographic Work.* 1948. rpt. Millerton, N.Y., 1975.

141. Hill, Brian. *Julia Margaret Cameron: A Victorian Family Portrait.* New York, 1973.

142. Mozely, Anita Ventura. *Mrs. Cameron's Photographs from the Life.* Stanford University Museum of Art, Stanford, California. Exhibition catalog, 1974.

143. Ford, Colin. *The Cameron Collection: An Album of Photographs by Julia Margaret Cameron Presented to Sir John Herschel.* London and New York, 1975.

144. Gibbs-Smith. Charles Harvard. "Mrs. Julia Margaret Cameron, Victorian Photographer. *One Hundred Years of Photographic History: Essays in Honor of Beaumont Newhall.* Albuquerque, 1975, pp. 69–76.

145. Ovenden, Graham, ed. *A Victorian Album: Julia Margaret Cameron and Her Circle.* Introduction by Lord David Cecil. New York, 1975.

SIDNEY CARTER (Canadian)

115

Fig. 9 » *Sidney Carter.* Self-portrait, 1907. Reproduced from *Photograms of the Year, 1907,* p. 81.

CHRONOLOGY

1897: Listed as a clerk in the *Toronto* (Canada) *Business Directory.*

1904: Elected an Associate of the Photo-Secession.

1905: Helps establish the Studio Club of Toronto.

1906: Exhibits in the Photo-Secessionist exhibition at the Pennsylvania Academy of the Fine Arts, Philadelphia. » Ends career as bank clerk and

enters partnership with Mortimer-Lamb in Montreal portrait studio (Carter to Stieglitz, 8 January 1907, YCAL). » His work "influences and in large measure [is] inspired by the leaders of the American School—in particular Steichen." (H. Mortimer-Lamb, "Pictorial Photography in Canada," *Photograms of the Year 1906,* p. 10)

1907: Works in Montreal as a portrait photographer. Organizes Canadian section for the RPS Salon.

1908: Photo Club of Canada holds a major exhibition (Toronto?), organized in large part by Carter.

1909: Listed as "artist" in the *Toronto Business Directory.*

1910: Exhibits two photographs in the open section of Buffalo (1910) exhibition.

1915: Photograms of the Year notes that Sidney Carter of Montreal has "done little photography of late."

1918: Resumes work as a portrait photographer in Montreal.

1922: Still doing portrait photography, but has begun to collect antiques and art objects.

1933: Proprietor of art gallery in Montreal exhibiting painters of his generation.

PHOTOGRAPHS

115 » *Rudyard Kipling.* 1907 (A. S.) Gray pigment gum-bichromate or oil paint. 260 × 197 mm. (10¼ × 7¾ in.) 33.43.333.

Exhibited: New York (PSG, 1908), no. 7; New York (NAC, 1909), no. 100; London (1908), no. 100, titled simply *Kipling;* Buffalo (1910), no. 509, dated 1908 (print?).

Kipling (1865–1936), a Britisher writer noted for his children's books, was presumably portrayed when he visited Toronto in 1907.

EXHIBITIONS

London (RPS) 1901 » Philadelphia 1901 » *Chicago 1903* » Toronto 1903 » Pittsburgh 1904 » Vienna (PC) 1905 » New York (PSG) 1905 » London 1906 » New York (PSG) 1906 » Philadelphia 1906 » New York (PSG) 1907 » New York (PSG) 1908 » London 1908 » New York (NAC) 1909 » Buffalo 1910 » New York 1912.

BIBLIOGRAPHY

Manuscript

146. Stieglitz Archives, Collection of American Literature, Beinecke Rare Book and Manuscript Library, Yale University, New Haven, Conn.: 15 unpublished letters from Sidney R. Carter to Alfred Stieglitz between 1906 and 1907.

By Carter

147. Carter, Sidney. "Pictorial Work in Canada." *Photograms of the Year 1907*, pp. 78–90.
148. ———. "Pictorial Photography in Canada." *Photograms of the Year 1908*, pp. 77–80.

About Carter

149. Lamb, Mortimer H. "Pictorial Photography in Canada." *Photograms of the Year 1905*, pp. 81–85.
150. ———. "Pictorial Photography in Canada." *Photograms of the Year 1918*, pp. 25–27.
151. "Who's Who." *Amateur Photographer and Photography*, 53 (1922), pp. 83–84.

ROSE CLARK & ELIZABETH FLINT WADE (American)

Fig. 10 » *Elizabeth Flint Wade,* about 1895. Courtesy of Buffalo and Erie County Historical Society, Buffalo, New York.

CHRONOLOGY

1852: Harriett Candace Clark (Rose Clark) born in La Porte, Indiana.

1890s: Clark is commissioned by Mrs. Mabel Dodge, a former student, to restore her Villa Curonia in Florence, Italy. Clark resides there for several years.

1894: Wade begins her career as a writer on technical matters in photography for the *American Amateur Photographer* where Stieglitz had recently become an editor. Gains a reputation in literary circles for her poetry.

1899: Rose Clark exhibits solo at The Camera Club, New York.

1900: Clark & Wade jointly exhibit at the Camera Club (October 9–20), and show nine prints at the Chicago Photographic Salon, which suggests the beginning of their collaboration in which Clark apparently made the artistic decisions while Wade printed the negatives, according to Clark's correspondence with Stieglitz. Her letter of 3 November 1900 reads, "Mrs. Wade is very dilatory—and in order to get the photographs you ask for by the 20th of November I shall have to prod her daily." (Clark to Stieglitz, 3 November 1900, YCAL). Wade writes practical book on photography, published by Harper's.

1901: Wade (November) begins regular column for *Photo-Era* until 1912.

1902: Exhibiting jointly, Clark and Wade are awarded gold medal at Turin exhibition, the American section of which is selected by Stieglitz.

1904: Reviewing the Pittsburgh exhibition, Sidney Allan (Sadakichi Hartmann) writes, "The most successful portrait work (next to Steichen's, of course) is furnished by Rose Clark. She must be a close student of painting, all her work, without losing its individuality, is reminiscent of good examples of pictorial art." (Biblio. 1366a)

1906–07: Wade serves as president of the Scribbler's Club, Buffalo.

1915: Wade dies in Norwalk, Conn., having moved there from Buffalo the previous year.

1942: Clark dies in Buffalo on November 28, her photographs passed unnoticed in the obituary which focuses on her career as a painter.

PHOTOGRAPHS

116 » *Out of the Past.* 1898 (A. S.) Platinum. 191 × 118 mm. (7½ × 4⅝ in.) 33.43.263. *Plate 27.*
Exhibited: Glasgow (1901), no. 399; Leeds (1902), no. 617; New York (NAC 1902), no. 19; Buffalo (1910), no. 247; all titled as above.

Reproduced: *The Century Magazine* (Biblio. 1095), 1902, opp. p. 816, titled as above; *Academy Notes* (Biblio. 1399a), p. 25.

Miss Clark was the artistic director and Mrs. Wade

117 118

the master printer. The division of labor caused some disagreement between the two, as Clark reported to Stieglitz.

117 » *Annetje.* 1898 (A. S.) Platinum. 153 × 117 mm. (6⅙ × 4⅝ in.) 33.43.264.
Exhibited: Chicago (1900), no. 26; Glasgow (1901), no. 112; New York (NAC, 1902), no. 18; Buffalo (1910), no. 245, dated 1899.

Reproduced: *Photo-Beacon,* 12 (June, 1900), p. 177, titled as above; *Photo-Era,* 14 (June, 1905), p. 202, copyright by Clark and Wade.

Stieglitz ascribed the print to Clark alone, in a note on the verso, but the *Photo-Era* copyright lists both names.

118 » *Portrait.* 1899 (A. S.) Platinum. 201 × 127 mm. (7⁵⁄₁₆ × 5¹⁄₁₆ in.) Signed in ink on verso "Rose Clark/E. F. Wade" 33.43.262.
Reproduced: *Photographic Times,* 47 (January, 1915), p. 9.

EXHIBITIONS

Clark and Wade exhibited as collaborators except where noted to the contrary.

New York (TCC) 1899 (Rose Clark solo) » Chicago 1900 » *New York (TCC) 1900, (Clark and Wade)* » Newark, Ohio 1900 (Rose Clark solo) » Philadelphia 1900 » Glasgow 1901 » Leeds 1902 » New York (NAC) 1902 » Hague 1904 » Paris 1904 » Pittsburgh 1904 (Rose Clark solo) »

Washington 1904 (Rose Clark solo) » *St. Louis 1904* » Vienna (PC) 1905 » Buffalo 1910 (Rose Clark solo) » *Syracuse 1915 (Rose Clark solo).*

BIBLIOGRAPHY

Manuscript

152. Stieglitz Archives, Collection of American Literature, Beinecke Rare Book and Manuscript Library, Yale University, New Haven, Conn.: 7 unpublished letters from Rose Clark to Alfred Stieglitz between 1900 and 1902.

153. Stieglitz Archives, Collection of American Literature, Beinecke Rare Book and Manuscript Library, Yale University, New Haven, Conn.: 1 unpublished letter from Elizabeth Flint Wade to Alfred Stieglitz, n.d. [about 1908].

By Wade

154. Wade, Elizabeth Flint. "Artistic Pictures. Suggestions How to Make Them." *American Amateur Photographer,* 5 (October, 1893), pp. 441–447.

155. ———. "Photography—Its Marvels." *St. Nicholas,* 20 (September, 1898), pp. 952–959.

156. ———. "The Round Robin Guild." *Photo-Era,* monthly column from 7 (November, 1901) to 31 (September, 1912).

157. ———. "The Nation's Landmarks." *Photo-Era,* 11 (July, 1903), pp. 243–245.

158. ———. "Coloring Lantern Slides." *Photo-Era,* 16 (March, 1906), pp. 151–154.

About Clark and Wade

159. Caffin, Charles H. "Exhibition of Prints by Miss Rose Clark and Mrs. Elizabeth Flint Wade, October 9–20, 1900." *Camera Notes,* 4 (January, 1901), p. 186.

160. Hitchcock, Lucius W. "Pictorial Photography." *Photo-Beacon,* 14 (July, 1902), pp. 199–201.

161. "Words from the Watch-Tower." [Note on E. F. Wade.] *American Amateur Photographer,* 16 (January, 1904), p. 15.

162. "Miss Rose Clark, Artist is Dead at Age 90," *Buffalo Evening News,* 30 November 1942. Scrapbooks Beinecke Rare Book and Manuscript Library, Yale University, New Haven, Conn.

ALVIN LANGDON COBURN (American, lived in England)

Fig. 11 » *Alvin Langdon Coburn*. By Elizabeth Buehrmann, about 1905. 62.579.65. Gift of Elizabeth Buehrmann.

CHRONOLOGY

1882: Born in Boston on June 11.

1890: Begins photography at age eight.

1898: Meets F. Holland Day, who influences him to become a full-time photographer.

1899: Sails to London with his mother and Day.

1900: Helps Day organize New American School exhibition. Meets Steichen, Evans, Eugene, Puyo, Demachy, and Keiley.

1901: Returns to U.S.

1902: Travels to California photographing Missions and landscape. Opens studio on Fifth Avenue, New York, to show own work. First correspondence with Stieglitz.

1903: Elected to The Linked Ring. Associate of the Photo-Secession. First one-man show, at The Camera Club of New York. Works in Käsebier's studio. Studies at Arthur Dow's Summer School at Ipswich, Mass. » One gravure published in *Camera Work,* No. 3 (July). First does gum over platinum.

1904: Returns to London with commission from *The Metropolitan Magazine* to photograph England's leading artists and writers. Photographs George Bernard Shaw in August, then G. K. Chesterton, George Meredith and H. G. Wells, among others. Visits Annan in Edinburgh and makes studies of motifs photographed by Hill and Adamson. » Six gravures published in *Camera Work,* No. 6 (April). » Hartmann writes in review of the Pittsburgh (1904) Exhibition, "A very promising talent has entered the ranks of the Secessionists in the personality of Alvin Langdon Coburn." (Biblio. 1366a, n.p.)

1906: Closes New York Studio. Travels to Spain and Morocco. Decorates and hangs 1906 Linked Ring Salon. Begins attending London County Council School of Photo-Engraving. Five gravures published in *Camera Work,* No. 15 (July). Makes bromide enlargements. Solo show at Royal Photographic Society. Photographs reproduced in *The Metropolitan Magazine, The Pall Mall Magazine.*

1906–07: Travels to Paris, Rome and Venice to make illustrations for the collected works of Henry James, whose portrait Coburn makes. Sees Steichen's color work in Paris and learns the process from him. Has "the colour fever badly." (Coburn to Stieglitz, 5 October, YCAL).

1907: With de Meyer organizes international exhibition at the New English Art Galleries (Biblio. 1419, 1420). Visits U.S. Described by Hartmann as the most progressive member of the Photo-Secession. Solo exhibition at Photo-Secession Galleries (March 11–April 10).

1908: Show at Goupil Galleries. "Printing almost

entirely in grey now . . . think it a reaction from the autochromes. . . ." (Coburn to Stieglitz, 5 February, YCAL). Twelve gravures published in *Camera Work*, No. 21 (January).

1909: Late January, Stieglitz announces solo show of color and black and white photographs by Coburn at the Photo-Secession Galleries. Buys home in London's Hammersmith district where he establishes permanent residence. Visits Charles Lang Freer in Detroit. One gravure published in *Camera Work*, No. 28 (October). Makes photogravure plates for *London*.

1910: Exhibits twenty-six photographs at the Albright Art Gallery after arriving in the United States from England just after the opening. Sees exhibition in Buffalo, making a series of installation views, then travels west via Pittsburgh.

1911: Travels west by train to California, visiting Yosemite and Arizona where he photographs the Grand Canyon. Included in the London Secession exhibition (Biblio. 1422).

1912: In New York where he makes extensive series of photographs of the city published in *New York* (Biblio. 180). Marries Edith Clement of Boston. Returns to Great Britain, and after twenty-three trans-Atlantic crossings, never returns to the United States.

1913: Publishes book, *Men of Mark* (Biblio. 181).

1915: Organizes exhibition *The Old Masters of Photography,* shown at the Royal Photographic Society and the Albright Art Gallery; historical prints from his own collection.

1916: Photographs Ezra Pound and is introduced to Vorticism. Produces non-objective Vortographs. Retires with wife to North Wales, to a life of freemasonry, astrology, mysticism, and also "goat-raising, pianola playing, leek-eating and oil-painting" ("Who's Who," *Amateur Photographer and Photography,* LIII, 1922, p. 472).

1917: Show of Vortographs and paintings at the Goupil Galleries, New York. Stieglitz rejects manipulated photography at Wanamaker (Biblio. 1409) exhibition, thus signaling his unhappiness with such work as Coburn's.

1922: Publishes *More Men of Mark* (Biblio. 182).

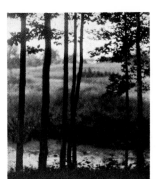

119

120

Becomes deeply involved with mysticism and the occult.

1924: Solo exhibition at Royal Photographic Society.

1930: Donates his personal collection of photographs by contemporary and historical masters to the Royal Photographic Society.

1931: Last letter to Stieglitz. Making almost no photographs.

1932: Becomes a naturalized British subject. Spends many winters in Madeira.

1966: Dies.

PHOTOGRAPHS

119 » *Landscape.* 1902 (A. S.) Platinum. 240 × 188 mm. (9⁷⁄₁₆ × 7⁷⁄₁₆ in.) Blindstamp monogram. 33.43.190.

120 » *Winter Shadows.* 1902 (A. S.) Platinum. 179 × 232 mm. (7¹⁄₁₆ × 9⅛ in.) Blindstamp monogram. 33.43.189.

Reproduced: *Photo-Miniature,* 36 (March, 1902), frontispiece; *Camera Work,* No. 3 (July, 1903), pl. IV, with abrasions that have been retouched, titled as above; *Photographic Art Journal* (15 August 1902).

Camera Work notes that the print reproduced was from an enlarged negative, adding that "It had been our intention to bring out other examples of the work of this young Boston photographer, but circumstances have compelled us to defer this intention," (p. 52). The intent transpired with issue No. 6 (April, 1904).

121 122

121 » [*The Pier*]. 1903 (A. S.) Blue pigment gum
 bichromate over platinum. 166 × 105 mm.
 (6⁷⁄₁₆ × 4⅛ in.) 33.43.192.
Exhibited: Bradford (1904), no. 181, a related or
identical work, suggesting the above title.

Along with Cat. 124, this print represents one of
Coburn's first experiments with gum-over-platinum, a
process which he helped to pioneer. It is unclear
whether he or Steichen first used the process, but it ap-
pears that Coburn arrived simultaneously, or before
Steichen, whose earliest dated gum-over-platinum is
Melpomène (Cat. 483) of Landon Rives, Coburn's good
friend, dated erroneously 1903 by Stieglitz. Landon
Rives, however, did not enter the Stieglitz circle until
1904 through Coburn, who introduced her to photog-
raphy. In all probability, Coburn also introduced
Steichen to her, after which time Cat. 483 was made.
Coburn's correspondence with Stieglitz speaks of this
process as a novelty, suggesting his role as its major
American exponent. Coburn perhaps learned of gum-
platinum printing in Paris where in 1902 a description
of the process was published (Biblio. 1093).

122 » *The Bridge—Ipswich* [*Massachusetts*]. 1903.
 Blue-gray pigment gum-bichromate over
 platinum, mounted on heavy gray paper upon
 another sheet of gray to harmonize with the
 pigment. 234 × 190 mm. (9¼ × 7½ in.)
 49.55.181.
Exhibited: London (1904), no. 39; Washington (1904),
no. 30; Pittsburgh (1904); Portland, Oregon (1905),
no. 4; New York (PSG, 1905), no. 12; Cincinnati

(1906), no. 4, where it is also reproduced; Buffalo
(1910), no. 273, dated as above.
 Reproduced: *Camera Work,* No. 6 (April, 1904),
pl. V; Holme (Biblio. 1288). U.S., pl. 2.

123 » *Alfred Stieglitz*. 1903 (A. S.) Platinum,
 mounted on tan paper, with a thin border
 upon a larger sheet of gray. 240 × 187 mm.
 (9⁷⁄₁₆ × 7⅜ in.) Blind stamp monogram.
 33.43.194.
Exhibited: Hamburg (1903), no. 86; Pittsburgh (1904),
no. 48; The Hague (1904), no. 22; New York (PSG,
1906), no. 14. (The specific portrait is not identified.)

This print was made just prior to Coburn's depar-
ture for England for his second sojourn that resulted in
his fame as portraitist of celebrities in 1906.

124 » *The Bridge—London*. 1903 or before. Blue
pigment gum-bichromate over platinum. 275 × 215
mm. (10¹³⁄₁₆ × 8½ in.) 33.43.191.
Exhibited: Portland, Oregon (1903), no. 3; New York
(PSG, 1905), no. 13; Philadelphia (1906), no. 28;
*New York (PSG, 1907), no. 25; Dresden (1909), no.
33; Buffalo (1910), no. 272, titled *London Bridge* and
erroneously dated 1904.
 Reproduced: *Camera Work,* No. 15 (July, 1906),
pl. V, where it is noted the gravures are made from the
original 10 × 12 inch negatives and reduced. *London*
(Biblio. 179), pl. III.
 Collections: IMP/GEH (platinum print, where it
is identified as Old Waterloo Bridge, London).

Stieglitz erroneously dated the print 1905 through
an inscription that probably reflects the date he received
it for the PSG exhibition. The cover of *Camera Work*
(1903, before the issue number was imprinted) has been
used as the mount, and the gray paper perfectly com-
plements the glue-gray of the print. Coburn used his
new telephoto lens, one of his prize possessions that
was a rarity at this time and about which he wrote to
Stieglitz:

I am finding my Dallmeyer [illegible] lens more useful
every day. It is constructed on the telephoto principle with
a variable focal length of from 8 to 45 inches. Of course it is
not a rapid lens when the bellows is extended about a yard

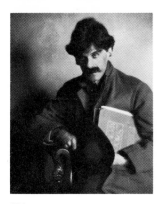

127

123 124 126

but it is much more rapid than the needle hole and you can see your image. The quality is all that could be desired, and I got a thing of the Tower Bridge from the middle of London Bridge, a distance of nearly half a mile, . . . [July, 1904, YCAL].

125 » *Portrait of Gertrude Käsebier.* 1903 or before. Ochre pigment gum-bichromate over platinum, mounted on brown paper with a narrow margin, upon another sheet of brown, upon another larger sheet of the first brown. 269 × 211 mm. (10⅝ × 8¼ in.) Blindstamp monogram "ALC." 49.55.173.
Figure 29.
 Exhibited: San Francisco (1903), no. 43; London (1903), no. 90; Hamburg (1903), no. 82; New York (PSG, 1907), no. 21.
 Coburn showed in London (1903) five portraits of prominent figures in the New York photography world: Stieglitz, Keiley, Abbott, Allen [critic], along with this print. In all likelihood they were all made about the time of the appearance of the first issue of *Camera Work* in late 1902, but before he departed for Europe to photograph celebrities in 1903.

126 » *Weir's Close—Edinburgh.* 1904. Gelatine silver. 278 × 222 mm. (10¹⁵⁄₁₆ × 8¾ in.) 33.43.195.
Exhibited: Vienna (1905), no. 5; Cincinnati (1906), no. 5; Paris (1906), no. 137; Philadelphia (1906), no. 24; *New York (PSG, 1907), no. 41; Dresden (1909), no. 34; Buffalo (1910), no. 262.

Reproduced: *Camera Work,* No. 15 (July, 1906), pl. I, where it is stated to have been made from the original 10 × 12 inch negative. "In the reduction some of the power and quality of the original prints have been necessarily lost. . . ." (p. 44)
 Contrary to what was printed above, the gravure has more detail in the shadows and the distant wall, suggesting how different a gravure was from an expressively made print by the photographer. Writing to Stieglitz of the print, Coburn remarked, "Some prints like *Weir's Close* can't be improved upon." (Coburn to Stieglitz, 2 November 1909, YCAL).

127 » *Amelia Rives, Princess Troubetzkoy.* (After Pierre Troubetzkoy). 1904 (A. S.) Brown pigment gum-bichromate over platinum. 187 × 232 mm. (7⅜ × 9⅛ in.) 33.43.342.
Inscribed on verso in crayon pencil by A. S.: "Negative by Pierre Troubetzkoy/Enlargement & print by Coburn/1904." Coburn visited Castle Hill, the Rives estate at Cobham, Virginia, in 1904 as the guest of Landon Rives (Cat. 128, 129), Amelia's sister who was a photographer. Amelia Rives was married to Pierre Troubetzkoy, and they summered in *Lago Maggiore* on the border of Italy and Switzerland each year, the probable location of this negative.
 The print introduces a question of creative authorship. It was made at a time when the print itself was being valued by Stieglitz, Coburn and others as a unique object in and unto itself. The composition is typically amateur in that no care is given to the out-of-focus foreground resulting from the technical limitation

on rendering equally sharp what is immediately close to the lens and what is distant. Advanced photographers would select a uniform softness of focus minimizing the distortion.

Coburn's print, intentionally dark in the foreground, obscures the selectively out-of-focus foreground that would have offended most serious photographers. In performing this darkroom manipulation, attained by exposing that area longer, Coburn salvaged what might have otherwise been unprintable.

128 » *Study—Miss R. [Landon Rives].* 1904 (A .S.) Brown pigment gum-bichromate over platinum. 240 × 192 mm. (9⁷⁄₁₆ × 7⁹⁄₁₆ in.) 33.43.188.

Exhibited: London (1904), no. 37, titled as above; Dresden (1909), no. 31, titled *Porträt Fräul. R.* Both suggest identical or related works.

Reproduced: *Camera Work,* No. 8 (October, 1904), p. 33, apparently reproduced from this print and described as "a recent work of this young photographer who has just returned from Europe, where his work met with hearty and general appreciation" (p. 43).

Landon Rives was the subject of much conversation between Day, Keiley and Coburn. Keiley wrote Stieglitz a firsthand report of his visit to Castle Hill, the family estate in Virginia (Keiley to Stieglitz, 17 June 1904, YCAL). Coburn visited the Rives estate in May of 1904, when he helped Landon Rives organize a darkroom, which suggests a date for this print. Coburn also made masterful prints from the negatives of Pierre Troubetzkoy, Landon's brother-in-law (Cat. 127).

129 » *Portrait Miss L. R. [Landon Rives].* 1904 or before. Brown pigment gum-bichromate over platinum. 238 × 191 mm. (9⅜ × 7½ in.) 49.55.213.
Not illustrated.

130 » *Portrait of Miss L. R. [Landon Rives].* 1904 or before. Gray-brown pigment gum-bichromate. 213 × 164 mm. (8⅜ × 6⁷⁄₁₆ in.) 49.55.214.
Not illustrated.
See Cats. 128, 129.

131 » *The Rudder, Liverpool.* 1905. Gum bichromate over platinum. 361 × 292 mm. (14¼ × 11½ in.) Signed in ink on insert "Alvin Langdon Coburn./.05." 33.43.199.
Plate 73 and Figure 48, page 467.
Catalog 139 is printed from the same negative in halftone.
Exhibited: *New York (PSG, 1907), no. 35; London (NEAG, 1907), per review; New York (NAC, 1909), no. 131.

Reproduced: *Camera Work,* No. 21 (January, 1908), pl. X, where it is reproduced from this print but from a different printing plate than Cat. 139.

F. H. Evans described in the cited *Camera Work* (p. 32), "*The Rudder* has been very widely praised and deservedly so, for it is a successful study of action and of values in shadows, while the masses and lines are quite imposing." The photograph merits comparison with Steichen's series made at Longchamps (Cat. 491, 492), which dates about the same time. Both suggest the photographer's desire to leave the studio and posed portraiture to contend with the complexity of daily life. Steichen attempts to capture the real animation of people, while Coburn sees the dynamic element of nature as the interaction of still forms and shapes. Coburn and Steichen began using gum-over-platinum about the same time, and *The Rudder* was executed the same year as Steichen's counterpart *The Flat Iron—Evening* (Cats. 477–480) also in 1905.

132 » *The White Bridge—Venice.* 1906. Brown pigment gum-bichromate over platinum. 366 × 290 mm. (14⁷⁄₁₆ × 11⁷⁄₁₆ in.) 33.43.212.
Plate 74.
Exhibited: New York (PSG, 1906), no. 17, incorrectly titled *The Rialto—Venice,* but which certainly is the same as this print since *Camera Work* (below) states that all the original gum platinotypes reproduced there were also exhibited at PSG and no other Venetian bridge is described; New York (NAC) 1908, no. 124; New York (NAC) 1909, no. 108, titled *The White Bridge—Venice.*

Reproduced: *Camera Work,* No. 21 (January, 1908), pl. VII, a halftone reproduced from this print (see Cat. 142).

128

134

135

Collections: YCAL (gravure with the notation by Coburn: "First photogravure made and printed by Alvin Langon Coburn. December MCMV / To Alfred Stieglitz with kindest regards.")

Comparison between this print and the signed halftone (Cat. 142) illustrates how successful such reproductions were early in the century. As would be expected even today in going from an original to a reproduction, the greatest loss (although negligible) is in the shadows. From a distance this print is a persuasive facsimile, but the dot pattern is intrusive upon close inspection.

133 » *Frederick H. Evans.* 1906 or before. Gray-brown pigment gum-bichromate over platinum. 280 × 171 mm. (11 1/16 × 6 3/4 in.) 49.55.212.
Figure 20.
Exhibited: New York (PSG, 1906), no. 15.

134 » *El Toros* [sic]. 1907 print from 1906 negative. Brown pigment gum-bichromate, mounted on gold paper upon a tan, artificially textured sheet of larger size. 117 × 236 mm. (4 5/8 × 9 5/16 in.) Signed and dated on mount in pencil "Alvin Langdon Coburn/ '07." 33.43.200.
Exhibited: New York (PSG, 1907), per *Camera Work* No. 19 (January, 1907), p. 37; Buffalo (1910), no. 260, titled *El Toro,* where it is dated 1906.
Reproduced: *Camera Work,* No. 21 (January, 1908), pl. I, titled as above [grammatically it should read "El Toro"]. The gravure printing plate was made from

this print under Coburn's supervision in London and printed in New York by the Photochrome Engraving Co. (stated on p. 63), as were Cats. 135, 136, 143, 145, 146.
Collections: IMP/GEH (platinum and gum-platinum).

Coburn was in Spain and Morocco in 1906 where the negative of this print and Cat. 135 could have been made. Roman numerals were inscribed by Coburn on the mount and the following twelve prints conform to the order of their appearance in *Camera Work.* They are all attractively mounted as though prepared for a specific exhibition, most likely the Photo-Secession Galleries where Coburn had shows in 1907 and 1908, from which Stieglitz could conveniently have acquired them. The mounts bear the same style of signature, all uniformly dated 1907.

135 » *Road to Algeciras.* 1907 print from 1906 negative. Gray pigment gum-bichromate mounted on gray paper with a narrow border upon a larger sheet of another gray. 196 × 176 mm. (7 3/4 × 6 15/16 in.) Signed and dated on mount in pencil "Alvin Langdon Coburn/ '07." 33.43.201.
Exhibited: *New York (PSG, 1907), no. 32, titled *Ageciras* [sic].
Reproduced: *Camera Work,* No. 21 (January, 1908), pl. II, reproduced from this print.
Collections: IMP/GEH.

The use of plain gum-bichromate in the print is perfectly matched by the subject in that the absence of detail in the bright areas, with rich blacks in the dark areas, enhances the effect of parching southern sun.

136

137

136 » *The Duck Pond.* 1907. Brown pigment gum-
bichromate, mounted on brown paper upon
two layers of the same tan artificially tex-
tured paper. 188 × 143 mm. (7⁷⁄₁₆ × 5⅝ in.)
Signed and dated on mount in pencil "Alvin
Langdon Coburn/'07." 33.43.202.

Exhibited: *New York (PSG, 1907), no. 24.

Reproduced: *The Amateur Photographer* (Febru-
ary, 1906); *Camera Work,* No. 21 (January, 1908),
pl. III (see Cat. 134).

137 » *Notre Dame.* 1907. Halftone proof from a
gum-platinum original, mounted on two
tones of gray paper for presentation. 210 ×
169 mm. (8¼ × 6¹¹⁄₁₆ in.) Signed and dated
on mount in pencil "Alvin Langdon Coburn/
'07." 33.43.207.

Exhibited: New York (PSG, 1907), no. 26; Buffalo
(1910), no. 259, dated 1906.

Reproduced: *Camera Work,* No. 21 (January, 1908),
pl. VIII, of which this is a signed example.

Collections: IMP/GEH (three gum-platinum
prints and three platinum prints).

Roman numeral VIII inscribed on the mount by
Coburn conforms to *Camera Work* (above) plate no.
VIII. The original gum-bichromate from which this
was reproduced apparently was not collected by Stieg-
litz. The negative was probably made during Coburn's
stay in Paris during October of 1906. It is possible that
the halftone reproductions (Cats. 137–142) were ex-
hibited (PSG, 1907) along with gum-platinum originals,
as suggested by the presentation mounting and the
sequence of the Roman numerals in Coburn's hand
conforming to the *Camera Work* presentation.

138 » *The Waterfront [New York].* About 1907.
Halftone reproduction from gum-platinum
original, mounted on two sheets of the same
gray paper. 170 × 167 mm. (6¹¹⁄₁₆ × 6⁹⁄₁₆
in.) Signed on mount in pencil "Alvin Lang-
don Coburn." 33.43.208.

Reproduced: *Camera Work,* No. 21 (January, 1908),
pl. IX, of which this is a signed example, 2 mm. nar-
rower and in a slightly different tone of ink; *New
York* (Biblio. 180), pl. 9

Roman numeral IX inscribed by Coburn conforms
to *Camera Work* plate number.

139 » *The Rudder—Liverpool.* 1907 print from
negative of c. 1905. Halftone reproduction
from gum-platinum original, mounted on a
sheet of gray paper upon a larger sheet of a
slightly different gray. 212 × 168 mm. (8⅜ ×
6⅝ in.) Signed and dated on mount in pencil
"Alvin Langdon Coburn./'07." 33.43.209.

Not illustrated.

Exhibited: See Cat. 131.

Reproduced: *Camera Work,* No. 21 (January,
1908), pl. X.

Collections: IMP/GEH (two gum-platinum
prints).

Roman numeral X inscribed by Coburn conforms
to *Camera Work* plate number.

140 » *Spider Webs.* 1907. Halftone reproduction
from gum-platinum original, mounted on
two sheets of the same gray paper. 245 × 170
mm. (9⅝ × 6¹¹⁄₁₆ in.) Signed and dated on
mount in pencil "Alvin Langdon Coburn/
'07." 33.43.210.

Exhibited: London (1906), no. 126; *New York
(PSG, 1907), no. 37.

Reproduced: *Camera Work,* No. 21 (January,
1908), pl. XI. *La Revue de Photographie,* 4 (Decem-
ber, 1906), opp. p. 376.

Roman numeral XI inscribed by Coburn conforms
to *Camera Work* plate number.

141 » *The Fountain at Trevi.* 1907. Halftone re-
production from gum-platinum original,
mounted on two layers of the same gray paper.
170 × 208 mm. (6¹¹⁄₁₆ × 8³⁄₁₆ in.) Signed and

138

140

141

143

dated on mount in pencil "Alvin Langdon Coburn/'07." 33.43.211.
Exhibited: New York (PSG, 1907), no. 36.
 Reproduced: *Camera Work,* No. 21 (January, 1908), pl. XII, where a different plate with different screen was used; a slightly different tone verifies that two editions of the *Camera Work* halftones were made.
 Collections: IMP/GEH (two gum-platinum prints).
 Roman numeral XII inscribed by Coburn conforms to *Camera Work* plate number.

142 » *The White Bridge—Venice.* 1907. Halftone proof of a gum-bichromate over platinum original. 214 × 172 mm. (8⁷⁄₁₆ × 6¹³⁄₁₆ in.) Signed and dated on mount in pencil "Alvin Langdon Coburn/'07." 33.43.206.
Not illustrated.
Exhibited: See Cat. 132.
 Reproduced: *Camera Work,* No. 21 (January, 1908), pl. VII (halftone), of which this is a signed example. According to the cited *Camera Work,* "the process [halftone] blocks were made by The Photochrome Engraving Co., New York." The signed state and the *Camera Work* state show minute differences in the plates and the ink tone, suggesting that they were printed at different times.
 Collections: YCAL, inscribed, "First Gravure made and printed by Coburn. Dec. 1905."
 The halftone was made from Cat. 132, original gum-platinotype. Mounted as though for exhibition, it bears the same pencil Roman numeral as other original prints that apparently served as a guide for their order of presentation in *Camera Work.* It is possible

that the halftone reproduction was exhibited along with the original gum-platinotype, thus accounting for the presentation mount. The original gold border has been translated to an appealing greenish-gray mezzotint effect in the halftone.

143 » *Alfred Stieglitz, Esq.* 1907. Hand printed photogravure on stiff paper. Diam: 159 mm. (6¼ in.) Signed in pencil "Alvin Langdon Coburn/'07." 33.43.205.
Exhibited: See Cat. 122.
 Reproduced: *Camera Work,* No. 21 (January, 1908), pl. VI, on tissue (see Cat. 134).
 Collections: IMP/GEH (platinum).
 The slightly richer effect of this print over the *Camera Work* gravure suggests a hand pulled proof either at the time the plate was made in London or when the *Camera Work* edition was printed in New York (p. 30). For Coburn's writing on photogravure see Biblio. 170.

144 » *Alfred Stieglitz.* 1907 (A. S.) Gelatine silver, mounted on black paper cut to the shape of the subject. Diam. 212 mm. (8⅜ in.) 33.43.197.
Plate 72.
Exhibited: See Cat. 123.
 Reproduced: *Camera Work,* 21 (January, 1908) plate VI, where it is reproduced from a gum-platinum print rather than a straight platinum as above (p. 30).
 The portrait was presumably made about the time of Coburn's first show at the Little Galleries (March 11–April 10, 1907), for which he had expressly returned from London to New York. Stieglitz identified the image as a platinum print in the collection label,

145 146

indicating how deceptive could be gelatine silver paper manufactured to resemble platinum, which is immediately evident upon microscopic inspection. Distant inspection, however, even provides the basic clues that platinum is not the material: the hair, moustache and jacket lack the subtle shadow detail that gives resiliency to platinum, exemplified in the Moore portrait (Cat. 149), where the delicate scale of tones is retained.

145 » *Rodin*. 1907. Brown pigment gum-bichromate, mounted on gold paper upon two larger sheets of tan, artificially textured paper. 200 × 157 mm. (7⅞ × 6³⁄₁₆ in.) Signed and dated on mount in pencil "Alvin Langdon Coburn/ '07." 33.43.203.
Exhibited: New York (PSG, 1907) no. 2; Buffalo (1910), no. 267.
 Reproduced: *Camera Work*, No. 21 (January, 1908), pl. IV (see Cat. 134); *Men of Mark* (Biblio. 181), pl. IV.
 Collections: IMP/GEH (platinum).

146 » *George Bernard Shaw*. 1907. Brown pigment gum-bichromate. 210 × 162 mm. (8¼ × 6⅜ in.) Signed and dated on mount in pencil "Alvin Langdon Coburn./'07." 33.43.204.
Exhibited: New York (PSG, 1906), no. 13, titled as above; *New York (PSG, 1907), no. 1, titled *G. Bernard Shaw, Esq.;* Buffalo (1910), no. 268, titled *Bernard Shaw.*
 Reproduced: *Camera Work*, No. 21 (January, 1908), pl. V (see Cat. 134); *Men of Mark* (Biblio. 181), pl. I.
 Collections: IMP/GEH.

The sitting took place at Shaw's home, Welwyn, on August 1, 1904, according to Coburn's recollection.

147 » *George Bernard Shaw*. 1907 (A.S.) Autochrome. 163 × 116 mm. (6⅜ × 4⁹⁄₁₆ in.) 55.635.8.
Exhibited: New York (NAC) 1909, no. 216.
 Believed to have been made at the same sitting as Cat. 146.

148 » *George Bernard Shaw*. About 1907. Ochre pigment gum-bichromate over platinum. 265 × 108 mm. (10⁷⁄₁₆ × 4¼ in.) 49.55.211.
Plate 75.
Exhibited: London (1908), no. 140.
 The unorthodox shape of this print is the result of transformations at the time the enlarged negative for the platinum print was made. Coburn wrote of making black and white negatives at the same 1907 sitting when he made autochromes (see Cat. 147).

149 » *George Moore*. 1908. Glazed platinum, mounted on black paper with narrow margin upon a larger sheet of gray. 289 × 227 mm. (11⅜ × 8¹⁵⁄₁₆ in.) Inscribed in pencil "To A.S from A.C./February, 1908." 33.43.193.
Reproduced: *Men of Mark* (Biblio. 181), pl. XVII.
 Collections: IMP/GEH.
 Coburn's amicable dedication followed Stieglitz's enthusiastic support of him in *Camera Work* and a show at the Photo-Secession Galleries (March–April, 1907). The sitting took place in Dublin, Ireland, on January 23, 1908.

150 » *The Tirol*. 1909 (A.S.) Gum-bichromate over platinum. 319 × 400 mm. (12⁹⁄₁₆ × 15¾ in.) 33.43.213.

151 » *[The Bubble]*. 1909 (A.S.) Gelatine silver. 282 × 219 mm. (11⅛ × 8⅝ in.) 33.43.196.
Plate 76.
Collections: IMP/GEH.
 The print is titled as assigned by Stieglitz, but no related title is found in the exhibition lists—surprising in light of its exhibitable subject. The model is Elsie "Toodles" Thomas.

147

149

150

152

152 » *London Bridge.* 1911 print from 1904 negative. Gelatine silver. 271 × 220 mm. (10^{11}/$_{16}$ × 8^{11}/$_{16}$ in.) Signed and dated on mount in pencil "Alvin Langdon Coburn/1904–11." 33.43.198.

Exhibited: New York (PSG, 1907), no. 25, titled as above.

Reproduced: *Camera Work,* No. 15 (July, 1906), pl. II, titled *The Bridge—Sunlight,* where it is stated to have been reduced directly from the original 10 × 12 inch negative, with resulting exaggeration in the gravure of the light-struck area on the upper right that has been minimized by the self-masking effect of the platinum print; Anderson (Biblio. 1294), p. 206, Newhall (Biblio. 198), pl. II.

Collections: IMP/GEH (platinum).

Inscribed by Stieglitz on paper label from the old mount is "Hammersmith Bridge, London," incorrectly identifying what is actually the London Bridge.

EXHIBITIONS

London 1900 » London (NSAP) 1900 » Paris (NSAP) 1901 » Philadelphia 1901 » London 1902–1904 » Paris 1902 » San Francisco 1902–1903 » Brussels 1903 » Cleveland 1903 » Denver 1903 » Hamburg 1903 » Toronto 1903 » Wiesbaden 1903 » Bradford 1904 » Dresden 1904 » Hague 1904 » London (RPS) 1904 » Paris 1904 » Pittsburgh 1904 » Washington 1904 » Vienna (PC) 1904–1905 » New York (PSG) 1905 » Portland 1905 » Cincinnati 1906 » London 1906 » *London (RPS) 1906* » New York (PSG) 1906 » Paris 1906 » Philadelphia 1906 » *London (NEAG) 1907* » *New York (Goupil Galleries) 1907* » New York (PSG) Members' and solo 1907 » New York (PSG) 1908 » New York (NAC) 1908 » London 1908 » Dresden 1909 » New York (NAC) 1909 » Buffalo 1910 » *London (Secession) 1911* » Newark (Public Library) 1911 » New York (Montross) 1912.

COLLECTIONS

IMP/GEH (extensive holdings of prints and negatives); RPS.

BIBLIOGRAPHY

Manuscript

163. Stieglitz Archives, Collection of American Literature, Beinecke Rare Book and Manuscript Library, Yale University, New Haven, Conn.: 153 unpublished letters from Alvin Langdon Coburn to Alfred Stieglitz and 5 unpublished letters from Alfred Stieglitz to Alvin Langdon Coburn between 1902 and 1931.

By Coburn

164. Coburn, Alvin Langdon. "American Photographs in London." *Photo-Era,* 6 (January, 1901), pp. 209–215.

165. ———. "The California Missions." *Photo-Era,* 9 (August, 1902), pp. 51–53.

166. ———. "My Best Picture." *Photographic News,* 51 (1 February 1907), pp. 82–84.

167. ———. "The Buffalo Show." *Camera Work,* No. 33 (January, 1911), pp. 63–65.

168. ———. "The Relation of Time to Art." *Camera Work,* No. 36 (October, 1911), pp. 72–73.

169. ———. "Alvin Langdon Coburn, Artist-Photographer, by Himself." *Pall Mall Magazine,* 51 (June, 1913), pp. 757–763.

170. ———. "Photogravure." *Platinum Print,* 1 (October, 1913), pp. 1–5.

171. ———. "The Future of Pictorial Photography." *Photograms of the Year 1916,* pp. 23–24.

172. ———. [Letters in reply to F. H. Evans]. *British Journal of Photography,* 64 (March 2 and 16, 1917), pp. 115 and 142.

173. ——— and Ezra Pound. *Vortographs and Paintings by Alvin Langdon Coburn.* London, 1917.

174. ———. "Photographic Adventures." *The Photographic Journal,* 102 (May, 1962), pp. 150–158.

175. ———. *Alvin Langdon Coburn, Photographer, An Autobiography.* Edited by Helmut and Alison Gernsheim. London, 1966.

See Biblio. 138, 388, 389, 714, 1295.

Selected Works Illustrated By Coburn

176. James, Henry. *The Novels of Henry James.* 24 vols. London, 1907–1909. Photogravure frontispiece in each volume by A. L. Coburn.

177. Maeterlinck, Maurice. *The Intelligence of the Flowers.* New York, 1907.

178. Wells, H. G. *The Door in the Wall and Other Stories.* New York and London, 1907.

179. Coburn, A. L. *London.* With an Essay by Hilaire Belloc. London, 1909.

180. ———. *New York.* With a foreword by H. G. Wells. London, n.d. [1911].

181. ———. *Men of Mark.* London, 1913.

182. ———. *More Men of Mark.* London, 1922.

About Coburn

183. Cummings, Thomas H. "Some Photographs by Alvin Langdon Coburn." *Photo-Era,* 10 (March, 1903), p. 87.

184. Allan, Sidney [Sadakichi Hartmann]. "A New Departure in Photography." *The Lamp,* 28 (February, 1904), pp. 19–25.

185. Rice, H. L. "The Work of Alvin Langdon Coburn." *The Photographer,* 1 (25 June 1904), pp. 132–133.

186. Caffin, Charles H. "Some Prints by Alvin Langdon Coburn." *Camera Work,* No. 6 (April, 1906), pp. 17–19.

187. Shaw, George Bernard. "Coburn the Camerist." *Metropolitan Magazine,* 24 (May, 1906), pp. 236–241.

188. Shaw, G. Bernard. "Bernard Shaw's Appreciation of Coburn." *Camera Work,* No. 15 (July, 1906), pp. 33–35.

189. Allan, Sidney [Sadakichi Hartmann]. "Alvin Langdon Coburn—Secession Portraiture." *Wilson's Photographic Magazine,* 44 (June, 1907), pp. 251–252.

190. Edgerton, Giles [Mary Fanton Roberts]. "Photography as One of the Fine Arts; The Camera Pictures of Alvin Langdon Coburn as a Vindication of this Statement." *The Craftsman,* 12 (July, 1907), pp. 394–403.

191. "A Bit of Coburn—Our Pictures." *Camera Work,* No. 21 (January, 1908), p. 30.

192. Haviland, Paul B. "The Coburn Show." *Camera Work,* No. 26 (April, 1909), p. 37.

193. Caffin, Charles H. "The De Meyer and Coburn Exhibitions." *Camera Work,* No. 27 (July, 1909), pp. 29–30.

194. Evans, Frederick H. "Mr. Coburn's Experiment." *British Journal of Photography,* 64 (23 February, 9 and 23 March 1917), pp. 102, 126, and 155.

195. Guest, Antony. "A. L. Coburn's Vortographs." *Photo-Era,* 28 (May, 1917), pp. 227–228.

196. Firebaugh, Joseph J. "Coburn: Henry James's Photographer." *American Quarterly,* 7 (Fall, 1955), pp. 215–233.

197. Hall, Norman. "Alvin Langdon Coburn." *Photography,* 16 (October, 1961), pp. 32–41.

198. Newhall, Nancy. *A Portfolio of Sixteen Photographs by Alvin Langdon Coburn.* Rochester, 1962.

ARCHIBALD COCHRANE (English)

CHRONOLOGY

1899: Exhibits at the Royal Photographic Society and in the British section of the Philadelphia Salon.

1901: Gold medal from the Royal Photographic Society for *The Quarry Team*.

1902: Elected a member of The Linked Ring, and begins showing at its annual London Salon.

1904: Shows several French subjects at the Salon, implying a trip to France.

1907: Delivers a talk on the "Pictorial Aim of Photography" before the Edinburgh Photo Society.

1908: Retrospective exhibition at the Photographic Salon, London.

1910: Seven photographs at Albright Art Gallery, Buffalo.

1911: Included in the London Secession exhibition (Biblio. 1422).

1922: Organizes the Scottish Salon and reviews the entries for the *British Journal of Photography*.

PHOTOGRAPHS

153 » *The Viaduct.* Before 1910. Carbon. 455 × 363 mm. (17¹⁵⁄₁₆ × 14¹⁵⁄₁₆ in.) 33.43.339.

Plate 5.

Exhibited: London (1909), this picture reviewed in *British Journal of Photography,* 56 (11 September 1909), p. 721; Buffalo (1910), no. 79.

Reproduced: *The Amateur Photographer,* 50 (November, 1909), p. 438.

Typical of the exceedingly lush effect attainable in carbon transfer printing, this print has rich detail in the shadows and subtle texture in the whitest clouds.

154 » *Grannie's Stocking.* 1905. Carbon. 492 × 348 mm. (19⅜ × 13¹¹⁄₁₆ in.) Inscribed by A. S. on verso in crayon pencil, "Stieglitz Collection/England/1908." 33.43.340.

Exhibited: London (1905), this picture reviewed in *Photograms of the Year 1905,* p. 105.

Reproduced: Bayley (Biblio. 1119), p. 273.

A problem inherent in carbon prints is their tendency to peel from the mount, as happened in this

154

print at the bottom center, a defect for which the only remedy is readhering flake by flake.

EXHIBITIONS

London (RPS) 1898–1899 » Philadelphia 1898 » Berlin 1899 » London 1899–1901 » Glasgow 1901, 1905 » Leeds 1902 » London 1902–1904 » Turin 1902 » Hamburg 1903 » Bradford 1904 » Vienna (C-K) 1905 » London 1905–1907 » Paris 1906 » London 1908–1909 » New York (NAC) 1909 » Dresden 1909 » Buffalo 1910 » *London (Secession) 1911.*

BIBLIOGRAPHY

By Cochrane

199. Cochrane, A. "Preparing Exhibition Work." *Photo–Era,* 4 (April, 1900), pp. 101–104.

200. ———. "Mr. Archibald Cochrane on Landscape Photography." *Photography* (London) 2 (January, 1906), pp. 13–14.

201. ———. "The Scottish Salon." *British Journal of Photography,* 69 (17 February 1922), pp. 91–92.

See Biblio 1127.

About Cochrane

202. Mariller, H. C. "Photographs of Archibald Cochrane of Hur." *The Amateur Photographer,* 35 (6 March 1902), pp. 190–192.

203. "The Future of Pictorial Photography in Great Britain." *The Amateur Photographer,* 50 (14 December 1909), pp. 574–577.

GEORGE DAVISON (English)

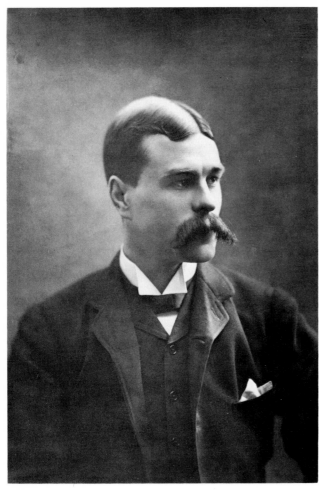

Fig. 12 » *George Davison*, By Friese Greene, about 1890. Courtesy of The Royal Photographic Society, London.

CHRONOLOGY

1854: Born in September, Lowestoft, England.

About 1870–1890: Works in the British Civil Service in London, Exchequer and Audit Department.

1880s: Becomes interested in photography.

1885: Honorary Secretary of the London Camera Club.

1888: President of the Shaftsbury Photographic Social.

1889: One of the founding directors of the Eastman Photographic Materials Company in England. » Exhibits The Old Farmstead (which he later calls The Onion Field) at the Royal Photographic Society. (Davison to Stieglitz, 20 September 1906, YCAL). Praised by Emerson.

1890: Lectures on "impressionistic photography" at the Royal Society of Arts, precipitating a vituperative feud with P. H. Emerson, who felt that Davison had appropriated his theories on naturalistic photography.

1890s: Writes and lectures extensively on "impressionistic photography."

1891: Eighteen photographs exhibited at Vienna, the first selectively organized International exhibition of artistic photography, more than any other exhibitor.

1892: Founder of The Linked Ring, along with H. P. Robinson, Lionel Clark, H. H. Hay Cameron, and Alfred Maskell.

1893: Earliest located correspondence between Davison and Alfred Stieglitz, who wrote upon seeing his work at the Fifth Joint Exhibition in Philadelphia, "it stands in a class by itself." (Biblio. 879).

1894: Retires after nine years as honorary Secretary of the London Camera Club.

1897: Appointed Assistant Manager of the Eastman Photographic Materials Company. Organizes a large exhibition sponsored by the Kodak organization, designed by the Glasgow artist George Walton. Show later travels to the National Academy of design, New York. » Influenced stylistically by his student *Calland*. (q. v.).

1898: Appointed Assistant Managing Director of Kodak Ltd.

1900: Promoted to Managing Director.

1901: Travels around the world in the company of George Eastman.

1900–10: Owns several large homes during this period (see Cat. 37), including one designed by George Walton, and a log cabin houseboat on the Thames, also by Walton.

1904: Corresponds with Stieglitz, Kuehn, Annan and others who abortively attempt to establish an International Society of Pictorial Photographers.

1906: Builds a small country house in Wales.

1907: Six gravures published in *Camera Work,* No. 18 (April).

1908: Writes Stieglitz, "As you know for many years my sympathy has been more with the developments you are helping so strenuously in the United States than with anything that has happened in the other countries." He also announces his imminent retirement from Kodak Ltd. on 31 March 1908 (Davison to Stieglitz, 31 January 1908, YCAL).
» Wintering in North Wales in his mansion "Wernfawr."

1909: One gravure (Harlech Castle) published in *Camera Work,* No. 26 (April); another in No. 28. Leader of the "perfectionist" faction of The Linked Ring, opposed to the secessionist leanings of Annan, Arbuthnot, Coburn, Cochrane, Davison and de Meyer.

1910: Buffalo (1910) catalog states, "Mr. Davison, in the late eighties and nineties, was one of the most conspicuous figures struggling in England on behalf of pictorial photography" (Biblio. 1399).

1911: Member of the London Secession, along with Arbuthnot, Calland, Coburn and Frank H. Read (Biblio. 1422).

1912: Leaves his family. Retires to North Wales, devoting himself to left-wing politics and patronage of the arts. Friends include Evans, Coburn, Annan, Eugene Gossens and Isadora Duncan.

1930: Dies at *Le Chateau des Enfants,* his home in France, in December.

PHOTOGRAPHS

155 » *Harlech Castle.* 1903. Hand printed photogravure. 174 × 245 mm. (6⅞ × 9⅝ in.) Signed in pencil on margin "George Davison." 33.43.352.
Exhibited: New York (NAC) 1909, no. 26; Buffalo (1910), no. 96, dated as above.
Reproduced: *Camera Work,* No. 26 (April, 1909), p. 31, same subject from a different viewpoint.
Also exhibited at Buffalo was Davison's *The Onion Field* of 1889, the talk of that year's exhibition in London, and one of the benchmark pictures in the emer-

155

gence of modern pictorial photography because of its soft focus introduced by the use of the pinhole camera and its large size. Considering the historicizing tone of the Buffalo exhibition and the fact that Davison had written Stieglitz of *The Onion Field*'s historical importance (Davison to Stieglitz, 20 September 1906, YCAL), it is surprising that Stieglitz acquired instead this rather modest and uncharacteristic work. Even more surprising is that Stieglitz acquired but a single work from a person with whom he corresponded prolifically beginning in 1893 and continuing through 1910.

EXHIBITIONS

Vienna 1891 » *Philadelphia (Joint) 1893* » London 1894–1904 » Brussels 1895 » Paris 1895–1898 » London (RPS) 1898 » Glasgow 1901 » Paris 1902 » Paris 1904 » Vienna (C-K) 1905 » London 1906 » Paris 1906 » New York (NAC) 1909 » Dresden 1909 » Buffalo 1910 » *London (Secession) 1911.*

BIBLIOGRAPHY

Manuscript

204. Stieglitz Archives, Collection of American Literature, Beinecke Rare Book and Manuscript Library, Yale University, New Haven, Conn.: 64 letters to Alfred Stieglitz from George Davison and two letters

from Alfred Stieglitz to George Davison between 1895 and 1912.

By Davison

205. Davison, George. "Across the Eastern Counties." *The Amateur Photographer,* Prize Tour Number (June, 1889), pp. 4–7.

206. ———. "Impressionism in Photography." *The Photographic Times,* 21 (January 16, January 23, January 30, February 6, and February 13, 1891), pp. 32, 42, 55, 66 and 79.

207. ———. "The Photographic Salon." [First Linked Ring Exhibition]. *American Amateur Photographer,* 5 (November, 1893), pp. 495–498.

208. ———. "To American Photographers." *American Amateur Photographer,* 6 (January, 1894), pp. 3–7.

209. ———. "Focusing." *American Amateur Photographer,* 6 (December, 1894), pp. 537–542.

210. ———. *"American Amateur Photographer* Special Prize Competition, 1894." *American Amateur Photographer,* 7 (February, 1895), pp. 49–59.

211. ———. "English Notes." *American Amateur Photographer,* 7 (April, 1895) through 8 (March, 1896).

212. ———. "The Recent Paris Exhibition." *American Amateur Photographer,* 7 (June, 1895), pp. 256–259.

213. ———. "Definition and Diffraction Photographs." *American Amateur Photographer,* 7 (October, 1895), pp. 437–442.

214. ———. "The London Exhibitions." *American Amateur Photographer,* 7 (November, 1895), pp. 483–493.

215. ———. "A Question of Facts." *The Amateur Photographer,* 23 (17 and 24 April 1896), pp. 342–343 and 361–362.

216. ———. "Terms and Facts." *The Amateur Photographer,* 23 (8 May 1896), pp. 400–401.

217. ———. "Exhibitions: The Pall Mall and the Salon." *The Amateur Photographer,* 24 (18 September 1896), pp. 236–238.

218. ———. "Pinhole Photography." *Amateur Photography,* 25 (2 April 1897), pp. 271–272.

219. ———. "Faking and Control in Principle and Practice." *Photographic Times,* 30 (30 February 1898), pp. 67–74.

220. "Mr. George Davison on the American Works at the Salon." *Camera Notes,* 3 (January, 1900), pp. 118–121.

221. Davison, George. "La Photographie à L'Étranger: Angleterre." *La Revue de Photographie,* 6 (March, 1908), pp. 119–126.

222. ———. "The Status of Photography in the New Copyright Bill." *British Journal of Photography,* 58 (19 May 1911), pp. 389–390.

See Biblio 1127.

About Davison

223. Robinson, Henry P. "The New Movement in England." *Anthony's Photographic Bulletin,* 25 (1 January 1894), pp. 8–11.

224. "Presentation to Mr. George Davison." *American Amateur Photographer,* 6 (August, 1894), p. 376.

225. Beaton, Cecil and Gail Buckland. "George Davison." *The Magic Image.* Boston, 1975, p. 79.

F. HOLLAND DAY

Fig. 13 » *F. Holland Day.* By Gertrude Käsebier, about 1898. Cat. 344.

CHRONOLOGY

1864: Born Fred Holland Day, on July 8, in Norwood, Massachusetts.

1884: Begins first job as a secretary at Boston branch of New York publishing firm, A. S. Barnes.

1885: Meets poet Louise Imogen Guiney; they begin search for Keatsiana.

1887: Earliest surviving photographs.

1889: Resigns from A. S. Barnes. Travels to England with Guiney in search of Keatsiana.

1890: Travels in Spain.

1891: Obtains Fanny Brawne correspondence. Returns to Boston. Joins Boston Camera Club about this time.

1893: Forms publishing firm of Copeland and Day in partnership with Herbert Copeland.

1894: July 16, unveils Keats Memorial monument, Hampstead Parish, England.

1895: Davison discovers Day as a new talent and alerts Stieglitz.

1896: Becomes third American elected to The Linked Ring. » Begins Friendship with Kahlil Gibran (December).

1897: Guiney buys Five Islands, Maine. Day first visits Maine, where he would spend many summers at Little Good Harbor until 1917.

1898: Summer, begins sacred work. » Exhibits one hundred prints at The Camera Club, New York. Meets Käsebier and White. Prominently illustrated in *Die Kunst in der Photographie* (Biblio. 1260) vol. 2.

1899: Firm of Copeland and Day liquidated. » Begins signing prints instead of blind-stamping them. Member of jury of selection for Philadelphia Photographic Salon, with Käsebier, White, F. B. Johnston, and Henry Troth. » Hangs one-man show of White at Boston Camera Club. » Proposes major salon for Boston Museum of Fine Arts.

1900: February, judges Harvard Camera Club exhibition with Charles Eliot Norton and J. Prince Loud. » April, to England with Coburn where he meets Steichen. » Organizes New School of American Photography exhibition which opens at the galleries of the Royal Photographic Society on October 10 (Biblio. 1402). » *Camera Notes* reports, "Mr. Day has decided to establish himself professionally in London for a year or two " (4 October 1900, p. 120). » Newark catalog describes Day as " a classicist among photographers and a most distinctive worker. He recently opened a studio in London." » Hereafter Käsebier often visits him in Maine until 1915.

1901: February 22, New School of American Photography opens at *Photo-Club de Paris*. » Serves on general committee for Linked Ring photographic salon. » Spring, travels to Europe and North Africa. » Lives with Steichen in Paris while New School exhibition is displaced. » Day's photographic style described as Japonisme. » Meets with

156

157

159

160

Frank Eugene in Narragansett, R.I., during the summer.

1902: December, "Portraits by a Few Leaders in the Newer Photographic Methods," including Annan, Coburn, Demachy, Evans, Käsebier, Watson-Schütze, and White, exhibited at Day's Boston studio. » December 29, declines Stieglitz's second invitation to join Photo-Secession. » Buys Guiney's Maine estate; spends summers there until 1917.

1903: Declines Stieglitz's invitation to reproduce his photographs in *Camera Work* » February, Frederick Evans exhibits work in Day's Boston studio.

1904: Kahlil Gibran exhibits drawings in Day's Boston studio. » Invites White to Maine for first time. » November 11, Harcourt Building studio destroyed by fire.

1905: April, spends eight days with White in Newark, Ohio.

1907: Autochrome, *Autumn Landscape,* reproduced in Holme (Biblio. 1292) pl. 31.

1910: Father dies. » Exhibits in The London Photographic Salon after an absence of ten years. Invited by Stieglitz to exhibit at Buffalo but refuses; to his dismay, Stieglitz exhibits Day prints from his own collection.

1912: Constructs "The Chalet," Little Good Harbor, Maine.

1917: Voluntarily bedridden at his family home in Norwood, Mass., until his death; never returns to Maine.

1922: Mother dies.

1933: Dies on November 2, in Norwood, Massachusetts.

PHOTOGRAPHS

Female Studies

156 » *Julia Marlowe.* 1895 (A. S.) Platinum. 153 × 105 mm. (6 1/16 × 4 1/8 in.) 33.43.146.
Reproduced: *Photographic Times,* 29 (June, 1897), p. 293.

157 » [*Mrs. James Brown Potter or Mrs. Potter Palmer*]. 1896 (A. S.) Platinum, mounted on a layer of tan paper on top of brown. 134 × 108 mm. (5 5/16 × 4 1/4 in.) 33.43.147.
Exhibited: Newark, Ohio (1899), no. 165, titled as above; Philadelphia (1900), no. 33, listed as *Mrs. Potter,* suggesting that the sitter was erroneously identified by Stieglitz. In the exhibition catalog Day is not recorded to have shown a portrait of Mrs. Palmer.
Compare Cat. 158.

158 » [*Mrs. James Brown Potter or Mrs. Potter Palmer*]. 1896 (A. S.) Platinum, mounted on on black and trimmed to narrow border around print. 142 × 119 mm. (5 5/8 × 4 11/16 in.) 33.43.358.
Not illustrated.
Printed from the same negative as Cat. 157.

159 » *Zaïda Ben-Yusuf.* 1898 (A. S.) Platinum. 163 × 109 mm. (6 7/16 × 4 5/16 in.) 33.43.148.
Exhibited: Buffalo (1910), no. 277, titled *Portrait Against the Light* and dated 1899, suggesting a related work.
See Cat. 165.

161

162

163

164

160 » *Portrait.* 1898 (A. S.) Platinum. 157 × 98 mm. (6³⁄₁₆ × 3⅞ in.) 33.43.159.
This print has no true black or white and is mounted on mica-flecked gray paper to accommodate the softness of the image.

161 » *[A Head].* About 1898. Platinum, mounted on green paper upon cream with thread margin upon a large brown leaf. 136 × 111 mm. (5⅜ × 4⅜ in.) 33.43.163.
Exhibited: Newark, Ohio (1899), nos. 168 and 171, titled *A Head,* suggest a related subject.
 Ex-collection of C. Yarnall Abbott according to pencil inscription on verso by Stieglitz.

162 » *[Portrait Study].* About 1898. Platinum. 145 × 118 mm. (5¾ × 4⅝ in.) 33.43.164.
Exhibited: Newark, Ohio (1899), no. 173, titled *Decorative Portrait Study,* suggests a related work.

163 » *Madame Sadi Yaco.* Before 1900. Platinum. 167 × 118 mm. (6⁹⁄₁₆ × 4⅝ in.) 33.43.364.
Exhibited: Glasgow (1901), no. 366.
 Reproduced: *Photo Miniature,* 2 (November, 1900), opp. p. 343.
 A ¹⁄₁₆ inch margin printed in dark gray from the unexposed edge of the negative has been left around the subject apparently for esthetic purposes.

164 » *Portrait.* Before 1900. Platinum. 165 × 106 mm. (6½ × 4³⁄₁₆ in.) 33.43.365.
The print is mounted on black paper on top of green, a happy choice that complements its soft tonal scale that lacks any true black.

165 » *Zaïda Ben-Yusuf.* Before 1900. Platinum, mounted on gray mica-flecked paper on pastel blue-green paper. 165 × 122 mm. (6½ × 4¹³⁄₁₆ in.) 33.43.367.
Figure 3.
 The word "decorative" in *Decorative Portrait Study* was used by Day (Newark, Ohio (1899), no. 173) to suggest a portrait that was a foil for an elaborate design, as is the case with the picture frame of this print and its deliberate placement of the white shape on the top to middle left edge. In the decades preceding the birth of abstract art, photographers thus satisfied their search for pure design.

166 » *[Portrait].* About 1901. Platinum, mounted on white paper upon black upon a larger sheet of tan paper. 155 × 92 mm. (6⅛ × 3⅝ in.) 49.55.223.
A remarkably delicate print with the object of the model's contemplation, a flower held in the right hand, just barely visible.

167 » *[Portrait Study].* 1900/1904. Platinum. 143 × 113 mm. (5⅝ × 4⁷⁄₁₆ in.) Blindstamp monogram "FHD" [F. Holland Day]. 33.43.337.
Ex-collection: C. Yarnall Abbott according to a pencil inscription on verso by Stieglitz.

168 » *Mother and Child.* 1905. Platinum. 244 × 194 mm. (9⅝ × 7⅞ in.) Monogram "FHD / 1905." 33.43.167.
Exhibited: Buffalo (1910), no. 281A, dated 1904; Dresden (1909), no. 44.

166

167

168

169

Collections: Royal Photographic Society, London; Library of Congress.

A conspicuous footnote in the Buffalo catalog refers to Day's exhibit: "It represents with a single exception, Mr. Day's early period [before studio fire of Nov. 11, 1904]. The 'Mother and Child,' however, marks the beginning of his later work, which is not ready for exhibition" (Biblio. 1399) p. 26.

Extremely soft, in light cream tones rather than the light gray of Day's other soft manner prints, the print has a subtle thread margin of white (unexposed) photographic paper reminiscent of the manner in which Whistler trimmed some of his etchings.

Male Studies

169 » *Portrait of a Man with Book* [*Kahlil Gibran*]. 1896 (A. S.) Platinum, mounted on five layers of alternating light and dark gray paper. 160 × 117 mm. (6�5⁄16 × 4⅝ in.) 33.43.165.

Exhibited: Berlin (1899), no. 140, titled *Der Leser;* Buffalo (1910), no. 276, titled as above.

Day met Gibran in 1896 and the portrait studies were begun immediately. This print has deep blacks, especially in the shadows, but still no sense of a real white in the highlights. There is a crease through lower left corner of the subject.

Cats. 170, 171 are printed from the same negative.

170 » *Portrait of a Man with Book* [*Kahlil Gibran*]. 1896 (A. S.) Platinum. 159 × 120 mm. (6¼ × 4¾ in.) 33.43.151.

Not illustrated.

Cats. 169, 171 are printed from the same negative.

The print is mounted on three layers of blue gray

paper, selected to enhance its softness with gray highlights and gray shadows.

171 » *Portrait of a Man with Book* [*Kahlil Gibran*]. 1896 (A. S.) Platinum. 160 × 118 mm. (6�5⁄16 × 4⅝ in.) 33.43.361.

Plate 33.

Highlights are whitest of the three impressions; blacks have lost the velvet quality of Cat. 169.

172 » [*Kahlil Gibran*]. 1896. Platinum. 162 × 120 mm. (6⅜ × 4¾ in.) 33.43.362.

Made at the same sitting as Cat. 169 (in same costume and with same book), the print is creased on lower right and scuffed at the edges.

173 » [*Portrait—Chinaman*]. 1896 (A. S.) Platinum. 170 × 119 mm. (6¾ × 4¹³⁄16 in.) 33.43.155.

Exhibition: The above title was inscribed on verso by Stieglitz. London (1897), no. 157 (*Leung Foo*) and London (NSAP) 1900, no. 302 suggest possible subjects of this print. The same sitter and same room but a different table are in Cat. 174.

174 » [*Portrait—Chinaman*]. 1896. (A. S.) Platinum. 150 × 112 mm. (5¹⁵⁄16 × 4⁷⁄16 in.) 33.43.150.

See Cat. 173.

175 » *The Lacquer Box.* 1899. Platinum. 165 × 117 mm. (6½ × 4⅝ in.) 33.43.363.

Exhibited: Philadelphia (1899) no. 34; Newark, Ohio (1899), no. 169; London, Paris (NSAP, 1900–1901), no. 254.

172 173 174 175

177 178

179

Reproduced: *Photographic Times,* 35 (April, 1903), p. 197.

The mounting of a layer of pastel blue over pastel green paper felicitously enhances this very soft print lacking a true black or white.

Joseph Keiley wrote of this photograph, "The face showed a strange commingling of fine feeling and viciousness" (Biblio. 542). The print is not to be confused with Day's *The White Cap,* absent from the Stieglitz collection, but of a different model.

176 » *The Vigil.* Before 1900. Platinum. 162 × 110 mm. (6⅜ × 4⁵⁄₁₆ in.) 33.43.160.
Plate 30.
Ex-collection: C. Yarnall Abbott according to pencil inscription on verso by A. S.

177 » [*A Street in Algiers*]? About 1900. Platinum. 237 × 181 mm. (9¼ × 7 in.) 49.55.225.
Exhibited: London (1901), no. 4, titled as above,

suggests a related work and is the only Arab subject exhibited there by Day. Coincidentally F. H. Evans also exhibited an Algerian subject.

178 » *Ebony and Ivory.* 1897. Platinum. 183 × 200 mm. (7³⁄₁₆ × 7⅞ in.) 33.43.166.
Exhibited: Newark, Ohio (1899) no. 164; London (NSAP, 1900), no. 293; Paris (NSAP, 1901), no. 249; Glasgow (1901), no. 147; Philadelphia (1898), no. 47; New York (AI, 1898), no. 189; Cincinnati (1906), no. 6, where it is reproduced; Dresden (1909), no. 41.

Reproduced: *Camera Notes,* 2 (July, 1898), p. 19; *American Pictorial Photography* (Biblio. 1279), pl. 8.

Collections: Ruth Lavers White

Day wrote Stieglitz when he sent a print of *Ebony and Ivory,* "I think without exception the print is the most beautiful in tone which ever came from the negative. Its gradation of harmonies are wonderfully fine." (Day to Stieglitz, YCAL, no. 23). We are inclined to think Day was writing about this example. The white statuette is not as brilliant as in some

181

182 184

impressions, which because of the close-toned printing is but faintly distinguished from the background.

The model is Alfred Tanneyhill, an employee of Day's, who, along with his daughter, served as model and assistant in making other photographs according to Biblio. 251, no. 7.

179 » *The Smoker.* 1897. Platinum, mounted on gray paper with a thread margin, upon brown, upon tan, upon darker gray with a thread margin. 156 × 110 mm. (6⅛ × 4⁵⁄₁₆ in.) 33.43.366.
Exhibited: Berlin (1899), no. 138; London (NSAP, 1900), no. 314; Paris (NSAP, 1901), no. 265.

Reproduced: *American Annual of Photography* (1898), p. 198.

In reference to the print Samuel Murray wrote, "Day's aspiration has been to lift us into the realms of the imagination by avoiding the vulgar effects of mere realistic quality" (quoted in full in Biblio. 251, no. 7). The model is Alfred Tanneyhill.

Negro Studies

180 » *An Ethiopian Chief.* About 1896. Platinum, mounted on stiff black card to provide decorative background. 181 × 184 mm. (7⅛ × 7¼ in.) 33.43.157.
Plate 29.
Exhibited: London (NSAP, 1900), no. 335; Paris (NSAP, 1901), no. 269.

Reproduced: *Camera Notes,* 1 (October, 1897), opp. p. 34. *American Annual of Photography* (1898), p. 188, titled *An Ethiopian Chief.*

Collections: AIC, Stieglitz Collection.

Fig. 14 » *Armageddon.* Cats. 185, 192, and 180 were exhibited separately under the titles indicated, but also formed the triptych *Armageddon* when presented in Day's especially designed frame. It was exhibited in London and Paris (NSAP, 1900 and 1901), nos. 275 and 233.

This is the companion to Cats. 185 and 192, and is the middle portion of a triptych that Day exhibited under the title *Armageddon* (Figure 14).

181 » *An Ethiopian Chief [or Menelek].* About 1896. Platinum. 245 × 195 mm. (9⅝ × 7¹¹⁄₁₆ in.) Inscribed on verso in pencil by A. S.: "Stieglitz Collection/Ethiopian Chief/by F. H. Day/Boston/1897." 33.43.158.
Exhibited: Philadelphia (1898) no. 46, titled *Ethiopian Chief;* Philadelphia (1899), no. 96; London (NSAP, 1900) no. 335, titled *Ethiopean Chief;* Paris (1902) no. 155, titled *Le Chef Ethiopien.*

Collections: AIC, Stieglitz Collection.
Collection.

A date of 1896 compatible with Day's other negro studies is favored. *Ethiopian Chief* was apparently the first title applied by Day and later *Menelek* came to be applied.

185

186

187

The untrimmed edges and trace of the mark at bottom right are not typical of Day's finished prints, which suggests that this is possibly a rough proof for reproduction.

182 » *Nubia.* About 1896. Platinum, mounted on a layer of red on top of green paper. 165 × 119 mm. (6½ × 4¹¹⁄₁₆ in.) 33.43.359.
Exhibited: Berlin (1899) no. 143; Newark (1900) no. 17, titled as above.

Cat. 183 is printed from the same negative.

Comparison of the two examples collected by Stieglitz of this print indicates how different they can be without one being inferior. Ranging from resilient white garment, to dark gray skin, to darker gray background, the tone exemplifies the remarkable quality of a perfectly made platinum print, but it is a very literal rendering of the negative.

183 » *Nubia.* About 1896. Platinum. 160 × 124 mm. (6¼ × 4⅞ in.) 33.43.152.
Not illustrated.
Cat. 182 is printed from the same negative where certain important differences are to be noted.

Here the paper texture forms a pattern that is particularly noticeable in the white garment. This print is a less literal rendering of the negative, with great subtlety in the black and the arm just barely distinguishable from the background. The garment reads tan rather than brilliant white as in Cat. 182.

184 » *Negress.* About 1896. Platinum, mounted on

gray paper. 172 × 128 mm. (6¹³⁄₁₆ × 5¹⁄₁₆ in.) 33.43.360.
The model is the daughter of Alfred Tanneyhill according to Biblio. 251, no. 7.

185 » *Kedan.* 1896 (A. S.) Platinum. 114 × 154 mm. (4½ × 6¹⁄₁₆ in.) 33.43.153.
Exhibited: Glasgow (1901), no. 149.

Printed from the same negative as Cat. 186, this photograph is more resilient, but with loss of some detail in the figure's back.

This print goes with Cat. 180 and Cat. 192, being the left third.

186 » *Kedan.* 1896 (A. S.) Platinum. 117 × 157 mm. (4⅝ × 6³⁄₁₆ in.) 33.43.154.
Not illustrated.

Printed from the same negative as Cat. 185, this is a softer print with result that some strength is lost in shapes of the forest background.

Figure Studies

187 » *[Nude].* 1896 (A. S.) Gelatine silver. 108 × 57 mm. (4¼ × 2¼ in.) 33.43.384.
Reproduced: *Camera Notes,* II (July, 1898), p. 3, reproduced from this print.

Printed from the same negative as Cat. 188, the image typifies Day's concern for presentation, with its arched top and the choice of brown-tone against a black-on-brown mount. These materials were typical of the early 1890s before Day himself devised the more elegant, layered paper method exemplified in Cat. 169

189

190

and Cat. 182, which the British came to call the "American Style" mount.

188 » [*Nude*]. 1896 (A. S.) Platinum. 137 × 113 mm. (5⅜ × 4½ in.) 33.43.156.
Not illustrated.
This image, although printed from the same negative as Cat. 187, is a flat snapshot compared to the artfully contrived result of the latter.

189 » [*Boy Piping*]. About 1896. Platinum, mounted on brown paper with thread margin, upon green, upon a larger sheet of brown paper. 118 × 166 mm. (4⅝ × 6½ in.) 33.43.161.

190 » [*Male Nude*]. 1896 (A. S.) Platinum. 160 × 117 mm. (6⁵⁄₁₆ × 4⅝ in.) 33.43.162.
Exhibited: Newark, Ohio (1899), nos. 117–178, titled *Nude Study,* suggest a related subject.

191 » *Evening.* About 1896. Platinum. 118 × 162 mm. (4⅝ × 6⅜ in.) 33.43.149.
Exhibited: Newark, Ohio (1899), no. 179, titled as above.
 Reproduced: *American Amateur Photographer,* 9 (April, 1897), p. 149; *Camera Notes,* 2 (October, 1898), p. 43, titled *Evening;* Caffin (Biblio. 1282), p. 171, titled *The Urn; American Annual of Photography* (1898), p. 191.

192 » [*Untitled*]. About 1897. Platinum, mounted on gray paper. 118 × 158 mm. (4⅝ × 6¼ in.) 33.43.355.

This print goes with Cat. 180 and Cat. 185, being the right third.

193 » *The Honey Gatherer.* About 1898. Platinum, mounted on brown paper on top of gray. Diam. 125 mm. (4¹⁵⁄₁₆ in.) 33.43.357.
Reproduced: *American Annual of Photography* (1898), p. 189; *Camera Notes,* 3 (October, 1899), p. 58, untitled.
 The delicacy and sensuality of the tonal scale notably reinforces the subject.

Sacred Subjects

During the Summer of 1896 a suitable landscape (near Norwood, Massachusetts, or in Maine) was found for *The Entombment,* which was exhibited and reproduced in Vienna (1896). During the Summer of 1898 Day executed related compositions beginning with the Annunciation and ending with the Ascension, a series that comprised some 200 negatives. Other subjects included Baptism, Raising of Lazarus, the Betrayal, the Crucifixion, the Descent from the Cross, the Resurrection, and other incidents connected with the Stations of the Cross. An exhibition was arranged in November of 1898, which Day thus described:

Considerable argument and some protest naturally arose among those to whom the results were shown, and in November [1898], a private view of some thirty prints was arranged in Boston. To this exhibition there came people of all shades of religious belief—Quakers, Jews, Anglicans, and Roman Catholics, Nonconformists, Swedenborgian, priests and clergymen. Among them many were known to hold adverse opinions before seeing the prints, but with the exception of a single individual, these prejudices entirely disappeared. (Biblio. 233, p. 99).

194 » [*The Entombment*]. 1898. Platinum, mounted on a layer of black on top of gray paper. 67 × 166 mm. (2⅝ × 6⁹⁄₁₆ in.) 33.43.356.
Plate 32.
This print is a variant of the predella in the two-part piece, "Beauty is truth, truth beauty." Its center panel is not represented in the Stieglitz collection. See Biblio. 251, No. 32 and p. 53

195 » [*Study for the Crucifixion*]. About 1898.

191

192

193

Platinum. 157 × 55 mm. (6³⁄₁₆ × 2³⁄₁₆ in.)
Inscribed on verso by A. S. "Very rare & very
beautiful print / Given to me by Steichen."
49.55.224.

Plate 31.

The esteem in which Day held this print is suggested
by the elaborate presentation. It is mounted on a sheet
of tan paper with thread margins upon a larger sheet
of green, which in turn is mounted on a sheet of gray
with a narrow margin on a much larger sheet of green
paper. The interplay of colors creates the optical illusion
that the first fillet of tan paper is a thin gilt border.

196 » *The Seven Words.* 1898. Platinum (from re-
 duced copy negative). 79 × 328 mm. (3⅛ ×
 12¹⁵⁄₁₆ in.) 49.55.222.

Plate 28.

Reproduced: *The Photogram,* 8 (March, 1901), frontis-
piece, supplementary fold-out in conjunction with ar-
ticle, "Sacred Art and the Camera" (April, 1901), pp.
91–92; identical except that black background has been
eliminated in the reproduction.

Exhibited: See Cat. 197.

Collections: IMP/GEH (platinum print by Fred-
erick H. Evans, 1912).

The text at top printed from the negative reads:
"Father, forgive them; they know not what they do. To-
day Thou shalt be with me in Paradise. Woman, Behold
thy son; son, thy mother. My God! My God! Why hast
Thou forsaken me? I thirst. Into Thy hands I com-
mend my spirit. It is finished."

197 (I–VII) » *The Seven Words.* I./*Father, for-
 give them; they know not what they do.* II./

To-day thou shalt be with Me in Paradise.
III./*Woman, behold thy son, son, thy mother.*
IV./*My God! my God! why hast Thou for-
saken me?* V./*I thirst.* VI./*Into Thy hands
I commend my spirit.* VII./*It is finished.*
1898. Platinum, seven individual platinum
prints. Each approx: 140 × 115 mm. (5½ ×
4⁹⁄₁₆ in.) 49.55.175 (1–7).

Exhibited: Philadelphia (1899), no. 49, titled *The Seven
Words* with the verses numbered in arabic; London
(NSAP, 1900), no. 273, numbered in roman and with
the verses quoted as above; Paris (NSAP, 1901), no.
231; New York (NAC, 1902), no. 24 (I–VII), incor-
rectly dated 1899.

Reproduced: *American Amateur Photographer,* 30
(27 October 1899); *Photographic Times,* 32 (March,
1900), p. 103; *Bulletin, Photo-Club de Paris* (April,
1901), pp. 135–136.

Collections: AIC, Stieglitz Collection.

See also Cat. 196 which is a reduced copy of the
seven prints, cropped slightly differently, and embel-
lished with an ornamental border. Clattenburg (Biblio.
251, entry no. 19) suggests that Day based the posing
of (I) on Guido Reni's *Crucifixion* in the Church of
San Lorenzo in Lucina, with Day himself as the model.

Record does not yield specific identification of which
versions were exhibited. It can be inferred, however,
that at Philadelphia (1899) the individual large prints
were exhibited numbered in arabic 1–7, while at New
York (1902), the quotation marks and roman numerals
accompanied the reduced copy prints with the texts
printed from the negative that are repeated verbatim
in that catalog with certain variations from the texts
as printed in the Philadelphia catalog.

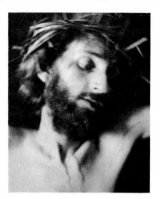

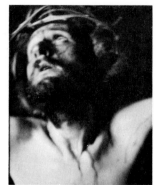

197.I 197.II 197.III 197.IV

Although considered eccentric, Day's work was not found offensive for it hung in the conservative galleries of the Pennsylvania Academy of Fine Arts (Philadelphia, 1899).

EXHIBITIONS

London 1896–1902 » Washington 1896 » New York (AI) 1898 » *New York (TCC) 1898* » Philadelphia 1898–1901 » *Vienna (C-K) 1898* » Berlin 1899 » New York (AI) 1899 » *New York (TCC) Dec. 1899* » Newark 1900 » London (NSAP) 1900; » Paris (NSAP) 1901 » Brussels 1901 » Glasgow 1901 » New York (NAC) 1902 » Paris 1902 » San Francisco 1902 » New York (Clausen Galleries) 1904 » Cincinnati, 1906 » *London (NEAG) 1907* » Dresden 1909 » Buffalo 1910 » London 1910 » London (RPS) 1914.

COLLECTIONS

RPS; The Library of Congress; Norwood Historical Society, Norwood, Massachusetts.

BIBLIOGRAPHY

Manuscript

226. F. Holland Day Archives, Norwood Historical Society, Norwood, Massachusetts: including unpub-

lished correspondence between F. Holland Day and Alfred Stieglitz.

227. Stieglitz Archives, Collection of American Literature, Beinecke Rare Book and Manuscript Library, Yale University, New Haven, Conn.: 48 unpublished letters from F. Holland Day to Alfred Stieglitz and 11 unpublished letters from Alfred Stieglitz to F. Holland Day between 1900 and 1906.

By Day

228. Day, F. Holland. "William Morris." *The Book Buyer,* 12 (November, 1895), pp. 545–549.

229. ———. "Art and the Camera." *Camera Notes,* 1 (October, 1897), pp. 27–28.

230. ———. "Photography Applied to the Figure." *The Amateur Photographer,* 26 (17 December 1897), p. 504.

231. ———. "Art and the Camera." *Camera Notes,* 2 (July, 1898), pp. 3–5.

232. ———. "Photography Applied to the Undraped Figure." *American Annual of Photography and Photographic Times Almanac,* 12 (1898), pp. 186–197.

233. ———. "Sacred Art and the Camera." *The Photogram,* 6 (February and April, 1899), pp. 37–38, 97–99.

234. ———. "Portraiture and the Camera." *American Annual of Photography and Photographic Times Almanac,* 13 (1899), pp. 19–25.

235. ———. "Photography as a Fine Art." *Photo Era,* 4 (March, 1900), p. 91.

236. ———. "Opening Address." *Photographic Journal,* 25 (October, 1900), pp. 74–80.

237. ———. "New School of American Photog-

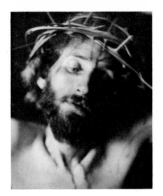

197.V

197.VI

197.VII

raphy."*British Journal of Photography,* 47 (30 November 1900), p. 759.

238. ———. "Pictorial Photography from America." *Camera Notes,* 4 (January, 1901), p. 181.
See Biblio. 1402, 1403.

About Day

239. Humphrey, Marmaduke [Rupert Hughes]. "F. H. Day." *Godey's Magazine,* 136 (January, 1898), pp. 12–21.

240. "Exhibition of F. H. Day's Work." *Camera Notes,* 1 (April, 1898), p. 119.

241. Murray, William. "Mr. Day's Exhibition of Prints." *Camera Notes,* 2 (July, 1898), pp. 21–22.

242. "Sacred Art Modernized: Photograph of the Crucifixion from Living Figures." *Boston Herald,* 17 January 1899, p. 1 (quoted in full in Biblio. 251).

243. "Sacred Art and the Camera." *The Photogram,* 6 (April, 1899), pp. 97–99.

244. "Mr. Holland Day and His Work." *The Amateur Photographer,* 30 (27 October 1899), p. 329.

245. Hazell, Ralph C. "A Visit to Mr. F. Holland Day." *The Amateur Photographer,* 30 (27 October 1899), p. 331.

246. Hartmann, Sadakichi. "A Decorative Photographer, F. H. Day." *Photographic Times,* 31 (March, 1900), pp. 102–106.

247. Taylor, Herbert White. "F. Holland Day: An Estimate." *Photo Era,* 4 (March, 1900), pp. 77–78.

248. Hinton, A. Horsley. "Some Further Considerations of the New American School and Its Critics." *The Amateur Photographer,* 32 (16 November 1900), pp. 385–386.

249. "The New American School and Mr. Holland Day." *The Amateur Photographer,* 33 (15 February 1901), p. 135.

250. Parrish, Stephen Maxfield. "Currents of the Nineties in Boston and London: Fred Holland Day, Louise Imogen Guiney and Their Circle." Ph.D. Dissertation, Harvard University, 1954.

251. Clattenburg, Ellen Fritz. *The Photographic Work of F. Holland Day.* Wellesley College Museum, Wellesley, Massachusetts, exhibition catalog, 1975.

ROBERT DEMACHY (French)

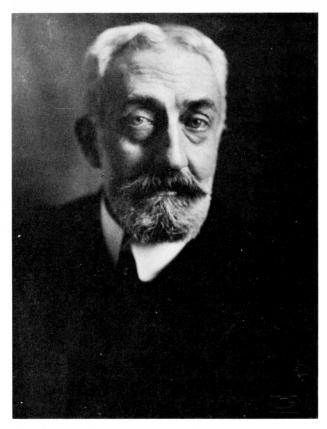

Fig. 15 » *Robert Demachy.* By Elizabeth Buehrmann, about 1910. 62.579.66. Gift of Elizabeth Buehrmann.

CHRONOLOGY

1859: Born Léon Robert Demachy at Saint Germain-en-Laye, near Paris, on July 7, to a prosperous banking family.

1870: Evacuated to Brussels during the Franco-Prussian War.

About 1877: One year as a volunteer in the French Army.

1880: Becomes interested in photography.

1882: Elected member of *Société Française de Photographie.*

1889: Meets and (1893) marries Julia Adelia Delano, an American, and relative of Franklin Delano Roosevelt; Demachy writes and speaks fluent English.

1892: Exhibitor and member of jury, 1st International Exhibition of Photography, Palais de Beaux-Arts, Paris.

1894: Begins to employ the gum-bichromate process recently reintroduced by A. Rouillé-Ladevèze at the 1894 Paris Salon. Demachy's frequent writing helps popularize gum printing (Biblio. 254, 270). » Helps to organize the first Paris Salon that was founded on artistic principles by the *Photo-Club de Paris* (*Gâlerie Durand-Ruel*), formed with the help of Puyo, Le Bègue and Maurice Bucquet.

1894 to about 1902: Serves on the editorial committee of *La Revue de Photographie,* published by *Photo-Club de Paris.*

1895: Exhibits his first experiments with gum bichromate at the second Paris Salon, *Photo-Club de Paris* (*Gâlerie Durand-Ruel*). » Elected to The Linked Ring.

1897: Publishes first book with Alfred Maskell: *Photo-Aquatint, or the Gum Bichromate Process* (Biblio. 254).

1898: Commences a warm and revealing correspondence with Stieglitz, often complaining of the subordinate role of photography in the artistic life of France.

1900: *Coin de rue à Mentone* (Cat. 199) published in *Camera Notes* (January), between pp. 90–91. » Newark, Ohio, Exhibition catalog (Biblio. 1333) describes him as "One of the most distinguished modern photographers, a leader in France and a master of gum printing."

1903: Complains to Stieglitz of Police censorship of his nudes.

1904: Six gravures published in *Camera Work,* No. 5 (January); two in No. 7 (July). » Experiments with Rawlins oil process (Biblio. 272). » Inspired by Steichen and Day to do new work; his work influential on Brigman (Brigman to Stieglitz, 17 February, YCAL).

1905: Elected Honorary member of Royal Photographic Society (at same meeting as Alfred Stieglitz's election). » One gravure published in *Camera Work,* No. 11 (1905). » With Puyo, selects French section of the London Photographic Salon where his own work is amply represented. » Photographs criticized by Kuehn as being decorative and without

freshness (Kuehn to Stieglitz, 6 January, YCAL).
» Awarded Legion of Honor.

1906: Abandons gum-bichromate in favor of oil printing. » Publishes *Procédés d'art en photographie* (Biblio. 273) with Puyo. » Selects Photo-Secession Galleries exhibition French Work (Biblio. 1376) including Puyo, Laguarde, and others. » Six gravures published in *Camera Work,* No. 16 (October). » Presents gift of photographs to Stieglitz.

1910: Illustrates *Three Normandy Inns* by Mrs. Bowman Dodd (Boston). » Described in Buffalo exhibition catalog as "the acknowledged leader of pictorial photography in France, and in conjunction with the Englishman, Mr. Alfred Maskell, adapted the bichromate of the gum-printing process to pictorial expression. This was in the early nineties. Since then the use of the process has been variously adopted by photographers generally. During the last few years his interests have been concentrated upon the 'oil' process."

1911: Introduces modern transfer method for oil printing. » Exhibits oil prints with Society of Amateur Artists, Paris. » Private show in his Paris studio illustrating work with oil process.

1914: Gives up photography at the outbreak of First World War; takes up sketching. » Sells house on *rue François 1er* when his mother dies; moves to 12 *Cité Malesherbes,* Paris, and keeps a weekend home at Hennequeville, near Trouville.

1931: Retrospective exhibition of gum prints with Puyo at *Studio Saint-Jacques,* Paris.

1936: Dies at Hennequeville on December 29. Buried at Père Lachaise Cemetery, Paris, in the family tomb.

PHOTOGRAPHS

198 » *La Communicante.* 1896 (A. S.) Brown pigment gum bichromate. 267 × 181 mm. (10½ × 7⅛ in.) Monogram "RD." 33.43.60.
Exhibited: Paris (1896), no. 225, variant reproduced and titled *Étude,* showing same model in a slightly different posture; Philadelphia (1900), no. 48, *The First Communion,* suggesting a related subject; Berlin (1899), no. 147, reproduced and titled *Studie,* showing the same model but slightly different pose from the Paris print (1896).

Inscribed on the old mount by Stieglitz "La Communicante/by Robert Demachy/Gum Print/1896/ $30/." Various marks on the verso including the old catalog number "1103/$15⁰⁰."

This was among the first gum prints collected by Stieglitz and it caused him to write glowingly of the promise of manipulated printing for the future of creative printmaking (Biblio. 897).

According to Demachy and Maskell (Biblio. 254), the first person to exhibit prints from papers hand coated with gum-bichromate was Rouillé-Ladevèze at the *Exposition d'Art Photographique* of the *Photo-Club de Paris* in 1894. Later that year at the London Salon, several gum prints by Demachy, Puyo and LeBègue were shown. By 1895, in addition to Demachy and Rouillé-Ladevèze, several other Frenchmen were added to the roster of gum printers, including Henry Ballif, Maurice Brémard, Maurice Bucquet, and Claudius Touranchet. Kuehn introduced the process to Vienna in 1896, about the time Stieglitz advocated it in America (Biblio. 897), having perhaps learned of it during his 1894 European trip. There are no Demachy prints in the Stieglitz collection dated before 1896, suggesting the year Stieglitz became enthused with the process.

Maskell and Puyo soon exhibited Artigue prints, a gum-bichromate-carbon process believed also to have been used by Steichen after 1900 (Cat. 456–475). Some saw the manipulated processes as the first direct competition to work by painters, but most of the opponents dismissed them as fakery. Demachy and Maskell pointed out in defense that the alteration of prints and negatives had been practiced for a long time in the form of vignettes, cloud-adding, and portraits posed against backgrounds that are entirely printed by hand (Biblio. 254, p. 50). Demachy and Maskell succinctly stated the theory of gum printing:

As we propose to go little into the theory of the subject, we need only briefly allude, for the information of those to whom it is altogether new, to the underlying principle of all systems of colloid bichromate printing. This principle resides in the fact that if a mixture of a bichromate salt in solution and some colloid substance—such as, for instance, gum, gelatine, or starch—is prepared and applied to the surface intended to hold the impression, such parts as are allowed to be acted upon by light become

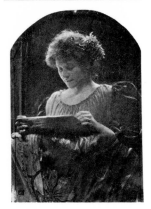

198

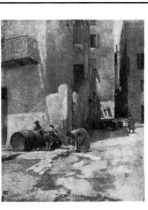

199

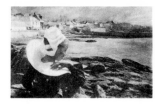

202

203

insoluble in proportion to the amount of light acting upon them and are fixed on the support, the unaltered portions remaining capable of being washed or dissolved away. If we add a colouring matter to the mixture this also will, of course, remain on the support. It follows, therefore, that we may, for example, coat a piece of paper with a mixture say, of gum, bichromate of potash, and red ochre. We may then place this prepared paper under a negative through which, on exposure, the light will act in varying degrees according to the nature of the negative image. The unacted on portions being then dissolved away in water, a positive or counterpart appears, and the free bichromate being removed the colouring matter remains attached to the paper, held there by the insolubilised gum, thus forming an inalterable picture, as permanent as the paper or support on which it lies. (Biblio. 254, pp. 10–11)

199 » *Coin de rue à Mentone.* 1898 print from negative of 1896 or before. Brown pigment gumbichromate. 257 × 202 mm. (10⅛ × 7¹⁵⁄₁₆ in.) Monogram "RD" and date. 33.43.55.
Figure 46, page 453.
Exhibited: Paris (1896), no. 224, titled as above; Philadelphia (1899), no. 112; New York (PSG, 1906), no. 29; Buffalo (1910), no. 149.
 Reproduced: *Camera Notes,* 3 (January, 1898); *Camera Work,* No. 5 (January, 1904), reproduced from this print as *Street in Rouen;* Paris (Biblio. 1269), pl. xvii, titled as above; *Photographic Times,* 32 (November, 1900), p. 497 is a related composition of another site in Mentone.
 The print is identified by Stieglitz on old mount erroneously as *Street in Rouen/1904* which he had in his collection (Cat. 214) but had not identified.

200 » *Panel.* 1898. Orange pigment gum-bichromate. Diam 147 mm. (5¹³⁄₁₆ in.) Monogram "RD" and date. 33.43.56.
Plate 15.
Exhibited: Turin (1902), no. 1321.

201 » [*Dans les coulisses*]. About 1897. Gray pigment gum-bichromate. 367 × 188 mm. (14½ × 7¼ in.) Monogram "RD" in red. 49.55.206.
Plate 14.
Exhibited: London (1900), no. 50; New York (PSG, 1906), no. 14; Buffalo (1910), no. 150, titled *Behind the Scenes,* a fair translation of the above, and dated about 1897, where it is listed as from a private collection, presumably that of A. S., suggesting it was among the works Demachy offered A. S. as a gift after the 1906 PSG show.
 Reproduced: *Camera Work,* No. 7 (July, 1904), pl. I.
 "Some Notes on the Photographic Salon," *American Photography* 32 (1900) observed:

Behind the Scenes, by R. Demachy, is unmistakeably one of the triumphs of this year's Exhibition. It does not, so to speak, shout at one, nor cry aloud for recognition, yet its good points strike one forcibly from the first, and further grow upon one. Two ladies of the *corps de ballet* are seen between pieces of disused stage scenery in the strong light which, it may be supposed, comes from the limelight in the wings; the "drawing" of both figures and the expression, and face, and the poise, of the head of the one facing the spectator, will be to many a revelation as to the powerful suggestion and deeper meaning with which pho-

204

205

206

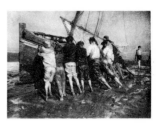

207

tography is capable of infusing its subjects, when capably used, and in the whole management of the figures, drapery, and light and shade, accompanied by the very nature of the subject, it is impossible to resist a comparison between this and the work of Degas.

202 » *En Bretagne.* 1900 (A. S.) Gray pigment gum-bichromate. 140 × 212 mm. (5½ × 8⅜ in.) Monogram "RD" in red. 33.43.253.
Reproduced: *Camera Work,* No. 5 (January, 1904), pl. I, with a different scale of tones; *Camera Kunst* (Biblio. 1285), p. 33, titled as above.

203 » *Une Balleteuse.* 1900 (A. S.) Gray pigment gum-bichromate. 135 × 148 mm. (5�</sub>/16 × 5¹³/₁₆ in.) Monogram "RD." 33.43.58.
Exhibited: Leeds (1902), no. 797, titled *Study for Behind the Scenes,* suggests a related if not identical work; Bradford (1904), no. 16; Buffalo (1910), no. 151, titled *The Balleteuse* and dated about 1905.
 Reproduced: *Camera Work,* No. 16 (October, 1906), pl. V, which differs in such details as the black dot on upper right, and where it was given the title *Behind the Scenes* which is the title generally assigned to Cat. 201; Holme (Biblio. 1288), French School, pl. 4.

204 » *Académie.* 1900. Gray pigment gum-bichromate. × 170 mm. (8¾ × 6¹¹/₁₆ in.) 33.43.57.
Exhibited: New York (PSG, 1906), no. 12, titled *A Model,* suggesting a related or the identical work.
 Reproduced: *Camera Work,* No. 16 (October, 1906), pl. II, reproduced from this print but titled *Study.*

205 » *La Seine.* 1902 print (A. S.), from negative of 1900 or before. Brown pigment gum-bichromate. 130 × 191 mm. (5⅛ × 7½ in.) Monogram "RD." 33.43.53.
Exhibited: Newark (1900), no. 20, titled *Evening on the Seine;* Paris (1904), no. 197, titled as above; Vienna (1905), no. 115; Paris (1906), no. 163; London (1906), no. 22.

206 » *La Vallée de la Touques, No. 2.* 1902. Dark gray pigment gum-bichromate. 173 × 224 mm. (6¹³/₁₆ × 8¹³/₁₆ in.) 33.43.54.
Exhibited: New York (PSG, January, 1906, French Work), no. 4, titled *Tocques Valley;* Philadelphia (1906), no. 31, titled *Valley of the Tocques.*
 Reproduced: *Camera Work,* No. 16 (October, 1906), pl. 1, titled *Tocques Valley.*
 Stieglitz misread Demachy's penciled title inscribed on the verso of the old mount which could reasonably be read as "Tocques."

207 » *L'Effort.* 1904. Gray pigment gum-bichromate or oil print. 156 × 210 mm. (6¹/₁₆ × 8¼ in.) 33.43.332.
Exhibited: London (1904, per review), no. 81; Vienna (1905), no. 116; New York (PSG, 1906), no. 28; Philadelphia (1906), no. 32; Buffalo (1910), no. 148.
 Reproduced: *Photograms of the Year 1904,* p. 1; *Camera Work,* No. 11 (July, 1905), pl. III, a halftone reproduction made from another example; *Academy Notes* (Biblio. 1399a), p. 9.
 Frederick H. Evans's thoughts on the print were reprinted in *Camera Work,* No. 9 (January, 1905):

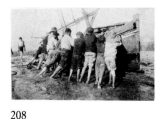

208

209

I think for consummate success his *L'Effort*, No. 81, is the most pronounced example of the exhibition. Of all things in the gallery this is to me the supremely covetable one, though there are a half-dozen other things that run it close. It does not affect me as greatly *photographic;* it is too much miraculously complete and successful to be wholly that; but the posing of the picture and the suggestion of movement is so rarely fine, and the gradations everywhere are of such distinction that the whole affects me as a most searching piece of draughtsmanship might. The color is rich and soft to a marvelous degree, and I would call attention, for this incomparable effort is sure to be seen in America sooner or later (in fact, Mr. Stieglitz purchased the print, together with a few others of the best things shown in this exhibition, for his private collection). . . . (p. 44)

208 » *L'Effort* [*reversed*]. [Undated]. Gelatine silver on postcard stock. Paper, 87 × 140; image, 70 × 108 mm. (3⁷⁄₁₆ × 5½; 2¾ × 4¼ in.) Monogram "RD" in pencil; addressed on verso to A. S. at 1111 Madison Ave., New York. 49.55.210.

Compare Cat. 207, a gum print of the same negative in reverse. This photograph represents a contact print from the original negative and in all probability shows the correct direction of the negative. The gum print was made from a low-contrast enlarged copy negative that suited Demachy's style of gum printing. Such copy negatives have such a thin layer of emulsion that front and back are commonly confused. In this case the reversal could be either accidental or the explicit intent of the artist.

209 » *Honfleur.* 1905 (A. S.) Gray pigment

gum-bichromate. 151 × 214 mm. (5¹⁵⁄₁₆ × 8⁷⁄₁₆ in.) Monogram "RD." 33.43.470.
Reproduced: Holme (Biblio. 1288), pl. 30, titled as above.

210 » *Un Modèle.* About 1905. Gray and black pigment gum-bichromate. 177 × 152 mm. (7 × 6 in.) Titled as above on verso and signed "Demachy." 49.55.208.

Exhibited: New York (PSG, 1906), no. 12, titled *The Model;* Buffalo (1910), no. 152, titled *The Model,* dated as above, and listed as being from a private collection, presumably that of A. S., suggesting it was among those offered to him as a gift after the 1906 show (Demachy to A. S., 10 January 1906, YCAL).

Reproduced: *Camera Work,* No. 16 (October, 1906), pl. II, reproduced from this print, titled *A Model,* where it is stated:

The French collection of gum prints exhibited last winter at the Photo-Secession Galleries created an unusual stir; especially was this the case amongst those interested in the processes of photographic printing methods. Our plates are reproductions of twelve of these prints. Demachy is always of interest, and we only regret that even the best of reproduction processes should give but a very inadequate idea of the exquisite technique of his original prints. It might be added that many of the latter are owned by a New York collector [A. S. ?].

211 » *The Crowd.* 1910. Gray pigment oil print. 158 × 228 mm. (6¼ × 9 in.) Monogram "RD" incised into print; signed and titled as above in English, with address of *13 r. Francois I* inscribed on verso by Demachy. 49.55.205.
Plate 16.

Exhibited: Buffalo (1910), no. 138, titled, dated and listed as being from a private collection, presumably that of A. S.

Reproduced: *Amateur Photographer and Photographic Times,* 51 (January–June, 1910), p. 625; *Academy Notes* (Biblio. 1399a), p. 17; *International Studio* (Biblio. 1399b).

212 » *In the Field* (*Plomarch*). 1910. Oil process (Rawlins?). 196 × 270 mm. (7¾ × 10⅝ in.) 33.43.59.

Exhibited: Buffalo (1910) no. 139, titled and dated as above, and identified as to medium.

210

212

213

214

Collections: IMP/GEH (variant, from a slightly different point of view, with a notation that it was exhibited at Buffalo, 1910).

Microscopic inspection reveals an image constituted somewhat like Steichen's carbon prints (Cat. 456–475); but the surface is sufficiently different to suggest that a slightly different process was used, possibly the Rawlins oil process (Biblio. 272).

213 » *A Breton Landscape.* 1910. Gray pigment oil process. 257 × 369 mm. (10⅛ × 14⁹⁄₁₆ in.) 49.55.207.
Exhibited: Buffalo (1910), no. 135, titled and dated as above.

214 » *Street in Rouen.* 1911 print, from a negative of 1910 or before. Hand printed collotype. Plate, 245 × 178; image, 218 × 163 mm. (9⅝ × 7; 8⁹⁄₁₆ × 6⁷⁄₁₆ in.) Dated 1911 with monogram "RD" in charcoal pencil. 49.55.209.
Exhibited: Buffalo (1910), no. 135, dated 1910.

The Buffalo (1910) catalog identifies the print as an oil print, yet it differs from other oil prints in that the method used required a hard surface and sufficient pressure to leave a shallow plate mark. Microscopic inspection corroborates that this is not a gravure, but rather a result of the collotype process with which Demachy, according to an undated letter to Stieglitz, experimented (leaf 46, YCAL). Collotype works on the principle of lithography and the shallow plate mark is the result of the edge of the glass plate from which this image was printed with oily printer's ink, thus making it literally an "oil" print as described in the Buffalo catalog.

EXHIBITIONS

Paris (Palais des Beaux-Arts) *1892* » Paris 1894–1898. » Brussels 1895 » London 1895–1904 » Hamburg 1896 » London (RPS) 1898 » Hamburg 1898–1899 » Munich 1898 » Berlin 1899 » New York (AI) 1899 » Philadelphia 1899–1900. » Newark 1900 » Brussels 1901 » Glasgow 1901 » *London (RPS) 1901* » *Boston (Day Studio) 1902* » Hamburg 1902–1903 » Leeds 1902 » Paris 1902 » Turin 1902 » Brussels 1903 » Wiesbaden 1903 » Bradford 1904 » *London (RPS) 1904* » *London (Cartwright Hall) 1904* » Paris 1904 » Vienna (PC) 1904–1905 » Vienna (C-K) 1905 » London 1906 » New York (PSG) 1906 » Paris 1906 » Philadelphia 1906 » *London (NEAG) 1907* » *London (RPS) 1907* » *Birmingham 1908* » London 1908–1909 » *Paris (Volnay) 1908* » Dresden 1909 » *Paris 1909* » Buffalo 1910 » Paris 1909–1911.

BIBLIOGRAPHY

Manuscript

252. Stieglitz Archives, Collection of American Literature, Beinecke Rare Book and Manuscript Library, Yale University, New Haven, Conn.: 68 unpublished letters from Robert Demachy to Alfred Stieglitz and two letters from Alfred Stieglitz to Robert Demachy between 1898 and 1910.

By Demachy

253. Demachy, Robert. "Avant-Propos." *Exposition d'Art Photographique* (in Biblio. 1310). *Photo-Club de Paris*, 12–31 (May, 1896), n.p.

254. Demachy, Robert and Alfred Maskell. *Photo-Aquatint or The Gum-Bichromate Process*. London, 1897.

255. Demachy, Robert. "Welche Berechtigung haben die Kunstkniffe der Modernen Schule." *Wiener Photographische Blätter*, 4 (January, 1897), pp. 2–9.

256. ———. "Der photographische Salon des Photoclubs in Paris." *Wiener Photographische Blätter*, 4 (July, 1897), pp. 153–163.

257. ———. "Paris Salon." *Camera Notes*, 1 (October, 1897), p. 39.

258. ——— "Values in Photography." *The Amateur Photographer*, 26 (19 November 1897), p. 415.

259. ———. "Die Hamburger auf der Ausstellung des Pariser Photo-Club." *Photographische Rundchau*, 12 (August, 1898), pp. 225–233.

260. ———. "Artistic Photography in France." *Photograms of the Year*. One article per year from 1898 to 1907, and 1909 to 1912.

261. ———. "The Americans at the Paris Salon." *Camera Notes*, 2 (January, 1899), pp. 107–111.

262. ———. "What Difference Is There between a Good Photograph and an Artistic Photograph?" *Camera Notes*, 3 (October, 1899), pp. 45–48.

263. ———. "Criticism on Photographs." *Camera Notes*, 3 (April, 1900), pp. 193–196.

264. ———. "The American New School of Photography in Paris." *Camera Notes*, 5 (July, 1901), pp. 33–42.

265. ———. "The Training of the Photographer in View of Pictorial Results." *American Annual of Photography and Photographic Times Almanac for 1901*, pp. 92–95.

266. ———. "Cave!" *Camera Notes*, 5 (April, 1902), pp. 243–246.

267. ———. "The Paris Photo-Club Exhibition— A New Method Described." *The Amateur Photographer*, 35 (12 June 1902), p. 467.

268. ———. "Des Points de Contact entre les Procédés Monochromes." *La Revue de Photographie*, 1 (February, 1903), pp. 45–49.

269. ———. "Die kunstlerische Photographie in Frankreich." In Biblio. 1285, pp. 30–47.

270. ———. "The Gum-Print." *Camera Work*, No. 7 (July, 1904), pp. 33–37.

271. ———. "The Salon of the Paris Photo-Club." *British Journal of Photography*, 53 (22 June 1906), pp. 486–487.

272. ———. "My experience with the Rawlins Oil Process." *Camera Work*, No. 16 (October, 1906), pp. 17–23.

273. ——— and C. Puyo. *Les Procédés d'Art en Photographie*. Paris, 1906.

274. ———. "Monsieur Demachy and English Photographic Art." *Camera Work*, No. 18 (April, 1907), pp. 41–45.

275. ———. "On Exhibition Catalogues." *The Amateur Photographer*, 45 (11 June 1907), pp. 518–519.

276. ———. "On the Straight Print." *Camera Work*, No. 19 (July, 1907), pp. 21–24.

277. ———. "An Exhibition of Oil Prints at the Paris Photo-Club." *British Journal of Photography*, 55 (1 May 1908), p. 341.

278. ———. "The Paris Photo-Club at the Volney Art Club." *British Journal of Photography*, 55 (12 June 1908), p. 448.

279. ——— and C. H. Hewitt. *How To Make Oil and Bromoil Prints*. London, 1908.

280. ———. "Mechanism and Pictorial Photography." *The Amateur Photographer*, 51 (March 8 and 15, 1910), pp. 230 and 271.

See Biblio. 527, 854, 1230.

About Demachy

281. Muller, Hugo. "Demachy über die kunstlerische Photographie in Frankreich." *Photographische Rundchau*, 13 (March, 1899), pp. 77–89.

282. Cadby, Will A. "Exhibition of the Works of M. Robert Demachy." *The Amateur Photographer*, 33 (3 May 1901), pp. 350–351.

283. Hinton, A. Horsley. "Some Thoughts Suggested by the Demachy Exhibition and the Exhibitor's Address." *The Amateur Photographer*, 33 (31 May 1901), p. 431.

284. "M. Demachy's Pictures." *The Photographic Art Journal*, 2 (June, 1902), pp. 73–74.

285. Evans, Frederick H. "Notes on Three Examples of the Work of Robert Demachy." *The Amateur*

Photographer, 38 (12 November 1903), pp. 370–372.

286. Keiley, Joseph T. "Robert Demachy." *Camera Work,* No. 5 (January, 1904), pp. 17–18.

287. Lambert, F. C. *The Pictorial Work of Robert Demachy.* London, 1904.

288. Shaw, G. Bernard. "Reply to Demachy." *Camera Work,* No. 18 (April, 1907), pp. 45–46.

289. Evans, Frederick H. "Reply to Demachy." *Camera Work,* No. 18 (April, 1907), pp. 46–48.

290. Jay, Bill. *Robert Demachy, 1859–1936: Photographs and Essays.* London, 1974.

291. Martinez, Roméo. *Robert Demachy.* Paris, 1976.

BARON DE MEYER (German, lived in England and the United States)

Fig. 16 » *Baron de Meyer*. By Sarah C. Sears, 1904 or before. Cat. 435.

CHRONOLOGY

1868: Born Adolf Meyer, the son of Adolphus Meyer and Adele Watson (later adopted name Adolf Meyer-Watson).

1894: Exhibits in London and Paris and listed in catalogs as Adolph Meyer, 8 Parkstrasse, Dresden. Photographs reproduced in *Wiener Photographische Blätter*. Stieglitz writes of photographs exhibited at New York (Joint) 1894 exhibition that his *Por-*

trait Study, Child is "decidedly first class, but was entirely spoiled by the mount and the frame" (Biblio. 882, p. 214).

1896: Moves to England and becomes part of the fashionable set revolving around the Prince of Wales. Listed in London Salon catalog as residing in Dresden and a member of the London Camera Club.

1897: Meets and soon marries Olga Alberta, the illegitimate daughter of the Prince of Wales and Blanche, Duchess of Caraciolla.

1898: Listed in London Salon catalog as Baron A. de Meyer-Watson residing at 1 Cadogan Gardens, London; elected to The Linked Ring.

By 1901: Member of Royal Photographic Society.

1903: Purchases special Pinkerton-Smith lens ground sharply in center and falling off around edges to produce soft focus.

About 1906: Tries gum printing but is not satisfied with results and writes Stieglitz he will continue to use platinum.

1906: Steichen enthused over de Meyer's still-life compositions, which are also collected by Käsebier (YCAL).

1907: Exhibition of *Photographs by Baron de Meyer and George Seeley* (Biblio. 1387), Photo-Secession Galleries (January 25–February 12); boycotts London Salon in pique. » In collaboration with Coburn organizes exhibition of modern photographs at the New English Art Galleries, Bond Street, London, which included Stieglitz, Steichen, White, Käsebier, among the Americans; makes autochromes, of which three still-life examples are reproduced in Holme. (Biblio. 1292.)

1908: Issue No. 24 of *Camera Work* includes 7 photogravures; de Meyer writes Stieglitz he is so taken with autochrome that black and white no longer satisfies him; also writes, "the more I see . . . of those French faked prints the more I shall never want to see anything but straight prints." (De-Meyer to Stieglitz, August, 1908, YCAL). » Joint exhibition with Alvin Langdon Coburn at the *Photo-Club de Paris*. » Resigns from The Linked Ring.

By 1909: Listed as Fellow of the Council of the Photo-Secession, New York.

1909: Photographs in Color and Monochrome by Baron Adolf de Meyer, Photo-Secession Galleries, Febru-

ary 4–22 (Biblio. 1397). » Meets in Munich with Eugene and Kuehn; abandons autochrome and does only black and white until 1920s.

1910: Exhibits with the London Secession. » Listed in Buffalo (1910) catalog as residing in Dresden and London, with note: "Baron de Meyer's affiliations place him in the Austrian-German section, although his sympathies are with the American workers."

1911: Exhibits autochromes, Newark, N.J., Public Library.

1911–12: Photographs by Baron Adolf de Meyer, Photo-Secession Galleries (December 18–January 15), among which was *Three Old Women of the Slums,* a title suggestive of a work out of keeping with De-Meyer's commercial style (Biblio. 304). » Issue No. 40 of *Camera Work* illustrated entirely with fourteen de Meyer photogravures. » Exhibits at the London Secession exhibition (Biblio. 1422).

1914: Publishes book of photographs of Nijinsky and other members of Diaghilev's ballet (Biblio. 293). » Flees to New York because he and Olga are accused of being German spies; close friendship with Stieglitz emerges. » Employed as a photographer for Condé Nast publications, notably *Vogue* magazine.

1916: Under the influence of an astrologer, Adolf changes his name to Gayne and Olga changes hers to Mhahra.

About 1917–18: Returns to Europe after signing of Armistice, settling in Paris.

1923: Leaves *Vogue* and goes to work for *Harper's Bazaar.*

About 1930: Olga (Mhahra) dies.

1934: Career with *Harper's Bazaar* terminated in a reorganization of the magazine.

1940s: During World War II returns to America, settling in Hollywood.

1946: Dies of coronary thrombosis on January 6, with his career as a photographer in eclipse.

PHOTOGRAPHS

215 » *The Shadows on the Wall. "Chrysanthemums."* About 1906. Gelatine silver (?),

mounted on tan paper upon black with narrow borders upon a larger sheet of gray. 347 × 267 mm. (13$\frac{11}{16}$ × 10½ in.) Signed on mount in pencil in stylized block letters "DEMEYER" with ornamental embellishments; inscribed on verso with title as above. 33.43.231.

Exhibited: London (NEAG, 1907), per review; New York (PSG, 1909), no. 16.

In this print de Meyer comes closest to abstraction as it was possible for one grounded in nineteenth century aesthetics. A combination of in-camera manipulations that include closeup point of view and soft focus work, with the external factors of back lighting and the atmospheric background, create great ambiguity around the subject. Typical of *Jugendstil* and continental secessionism, the abstraction is biomorphic rather than geometric, the direction taken by Sheeler and Strand during 1915–1917.

216 » *Water Lilies.* 1912 print (A. S.), from negative around 1906. Platinum. 261 × 352 mm. (10$\frac{5}{16}$ × 13⅞ in.) Signed on mount in pencil in stylized block letters "DEMEYER" with ornamental embellishments. 33.43.234.

Plate 82.

Exhibited: New York (PSG, 1909), no. 17; Buffalo (1910), no. 216; New York (PSG, 1912), per review.

Reproduced: *Amateur Photographer and Photographic Times,* 46 (July–December, 1907), p. 154; *Camera Work,* No. 24 (October, 1908), pl. II, titled *Still Life,* but with marks at the right edge of the gravure not present in this print.

In the cited *Camera Work* (p. 37) de Meyer is reported a resident of Dresden and London, and

no new comer in the field of pictorial photography. Nevertheless, according to his opinion his real serious work may be said to have begun after he had come into touch with and under the direct influence of the leading Photo-Secessionists and their work. For that reason it is not unnatural to hear him frequently classed as belonging to the "American School."

He was classed with the Germans and Austrians at Buffalo (1910).

217 » *Aïda, A Maid of Tangiers.* 1912 print from negative of 1910 or before. Gelatine silver.

215

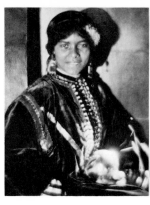

217

340 × 253 mm. (13⅜ × 10 in.) Signed on mount in pencil in stylized block letters "DEMEYER" with ornamental embellishments. 33.43.232.

Exhibited: Buffalo (1910), no. 205, where a platinum print was shown; New York (PSG, 1911), no. 1; Newark, N.J. (Public Library) 1911, no. 52.

Reproduced: *Camera Work,* No. 40 (October, 1912), pl. VII, titled as above, where it is stated that the gravure plates were made from the original negatives, using the two-tone effect of gray and brown.

Stieglitz altered the date on his collection label from 1910 to 1912, which introduces confusion as to whether he acquired this at the time of the Buffalo exhibition (if the 1910 date is correct) or later (if the 1912 date is correct). Since Stieglitz apparently wrote the blue style labels about 1919, he was relying on memory in any event.

218 » *The Silver Cap.* 1912 (A. S.) Gelatine silver. 457 × 276 mm. (18 × 10⅞ in.) Signed on mount in pencil in stylized block letters "DEMEYER" with ornamental embellishments. 33.43.233.
Plate 84.
Exhibited: New York (PSG, 1911), no. 9; this picture was reviewed in *Photographic Times,* 44 (February, 1912), p. 55; Newark, N.J. (Public Library) 1911, no. 54.

Reproduced: *Photograms of the Year 1909,* p. 83; *American Photography,* 6 (March, 1912), p. 133; *Camera Work,* No. 40 (October, 1912), pl. II, titled as above, where it is stated the gravure is made from the

original negative, which partly accounts for the differences between print and gravure.

At first glance, this image could have been confused with a platinum print, as Stieglitz identified it on his collection label, but close inspection reveals it to be in a gelatine silver printing material manufactured to superficially resemble platinum.

219 » *[Dance Study].* About 1912. Gelatine silver. 327 × 435 mm. (12⅞ × 17⅛ in.) 49.55.327.
Plate 83.
De Meyer photographed the dancer Nijinsky in Paris when the ballet *L'Après-midi d'un Faun* (Biblio. 293) was presented there. This work has been dated and titled in consideration of the general relevance to that series, but the connection has not been documented.

220 » *Mrs. Alfred Stieglitz [Emmeline].* 1912. Platinum, mounted uniformly with Cat. 221. 232 × 159 mm. (9⅛ × 6¼ in.) Signed on mount in pencil in stylized block letters "DEMEYER" with ornamental embellishments. 33.43.230.

221 » *Mrs. Alfred Stieglitz [Emmeline].* 1912. Platinum, mounted on cream paper upon gray with a narrow border. 238 × 171 mm. (9⅜ × 6¾ in.) Signed in pencil in stylized block letters "DEMEYER" with ornamental embellishments. 33.43.229.
Same sitting as Cat. 220.

222 » *Mrs. Alfred Stieglitz [Emmeline].* 1912 (A. S.) Platinum. 235 × 159 mm. (9¼ × 6¼ in.) 33.43.228.
De Meyer earned considerable income from his portraits of the fashionable whom he was able to render either in a style of theatrical verve (such as Cat. 218) or in a relatively straightforward manner as here.

EXHIBITIONS

New York (Joint) 1894 » London 1894–1895 » Brussels 1895 » London (RPS) 1895 » Paris

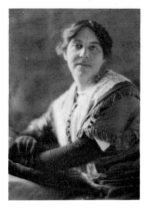

220 221

222

1895–1896 » London 1898–1899 » Berlin 1899 » London (NSAP) 1900 » Paris (NSAP) 1901 » Glasgow 1901 » Turin 1902 » London 1903–1904 » *London (Memorial Hall), 1904* » Bradford 1904 » Vienna (C-K) 1905 » London 1906 » Paris 1906 » *London (NEAG) 1907* » London 1908 » New York (NAC) 1909 » *New York (PSG) 1909 » Dresden 1909 » Buffalo 1910 » *New York (PSG) 1911 » *London (Secession) 1911* » Newark (Public Library) 1911.

BIBLIOGRAPHY

Manuscript

292. Stieglitz Archives, Collection of American Literature, Beinecke Rare Book and Manuscript Library, Yale University, New Haven, Conn.: 50 unpublished letters from Baron Adolf de Meyer to Alfred Stieglitz and 4 unpublished letters from Alfred Stieglitz to Baron Adolf de Meyer between 1901 and 1940.

Illustrated by De Meyer

293. De Meyer, Baron Adolf. *Sur le Prelude à l'Après-Midi d'un Faun.* Paris, 1914. Illustrated with thirty photogravures by Baron de Meyer and illustrations of the costumes of Nijinsky.

About De Meyer

293A. [Ward, H. Snowdon]. "Baron A. Demeyer-Watson," in Biblio. 1316 (review), pp. 107–108.

294. "Meyer, Adolphe von [sic], as Photographer." *Art Journal,* 51 (1899), pp. 270–273.

295. Anderson, A. J. "Some Principles of Flower Photography." *The Amateur Photographer,* 46 (13 August 1907), pp. 152–157.

296. "Camera Pictures by A. L. Coburn and Baron de Meyer." *British Journal of Photography,* 55 (20 March 1908), pp. 218–219.
 See Biblio. 1396A.

297. "Baron de Meyer's Photographs." *American Art News,* 7 (20 February 1909), p. 6.

298. Haviland, Paul B. "The Photo-Secession Gallery." *Camera Work,* No. 26 (April, 1909), p. 37.

299. Caffin, Charles H. "The De Meyer and Coburn Exhibition." *Camera Work,* No. 27 (July, 1909), pp. 29–30.

300. "Baron De Meyer's Photographs." *American Art News,* 10 (23 December 1911), p. 2.

301. Caffin, Charles H. "Exhibition of Prints by Baron Adolf de Meyer." *Camera Work,* No. 27 (January, 1912), pp. 43–45.

302. Haviland, Paul. "De Meyer Photographs." *Camera Work,* No. 37 (January, 1912), p. 47.

303. Schumacher, R. H. "Baron A. de Meyer's Exhibition." *Photographic Times,* 44 (February, 1912), pp. 54–59.

304. "De Meyer Exhibition at Little Gallery of the Photo-Secession." *Wilson's Photographic Magazine,* 49 (February, 1912), pp. 93–94.

305. "The Art of Baron de Meyer." *International Studio,* 46 (April, 1912), sup. pp. 43–44.

306. "Photography Critical, Constructive and Creative: Work of Baron De Meyer." *Craftsman,* 24 (May, 1913), pp. 158–165.

307. Roberts, M. F. "Imagination and the Camera:

Illustrations from Photographs by Baron De Meyer." *Craftsman,* 26 (August, 1914), pp. 517–523.

308. "The Artist's Wonder-Stone: How Baron De Meyer Sees Modern Spain." *Craftsman,* 27 (October, 1914), pp. 46–52.

309. "London Street Types Made Beautiful in Baron de Meyer's Photographs." *Touchstone,* 1 (September, 1917), pp. 438–443.

310. Beaton, Cecil and Gail Buckland. "Baron Gayne de Meyer." *The Magic Image.* Boston, 1975, pp. 106–109.

311. Brandau, Robert. *De Meyer.* New York, 1976.

MARY DEVENS (American)

223

CHRONOLOGY

1898: Five prints by Devens sent to the London Salon by F. Holland Day, who was a strong supporter of her work. » Exhibits gum-bichromate prints, First Philadelphia Photographic Salon, and is among the first Americans to achieve notable success with the gum process.

1900: Exhibits ten prints in Day's New School of American Photography show which opens in London and moves to Paris (1901).

1901: Travels in Europe, Spring through Summer.

1902: Elected to The Linked Ring. » Becomes a Fellow of the Photo-Secession.

1904: Hartmann describes her as the strongest woman photographer of the day (Biblio. 1366b).

1905: Work included in inaugural exhibition at Little Galleries of the Photo-Secession, her last exhibition due to failing eyesight.

EXHIBITIONS

London 1898–1900 » Philadelphia 1898–1900 » Berlin 1899 » London (NSAP) 1900 » Paris (NSAP) 1901 » Glasgow 1901 » Leeds 1902 » London 1902–1903 » New York (NAC) 1902 » San Francisco 1902 » Rochester 1903 » Bradford 1904 » Pittsburgh 1904 » Washington 1904 » Portland 1905 » New York (PSG) 1905 » *London (NEAG) 1907.*

PHOTOGRAPHS

223 » *La Grandmère.* 1900 (A. S.) Gray pigment gum-bichromate over platinum. 161 × 122 mm. (6⅜ × 4¹³⁄₁₆ in.) 33.43.341.
Exhibited: New York (NAC, 1902), no. 34; Pittsburgh (1904), no. 50; Bradford (1904), no. 198; Washington (1904), no. 36.

Devens was among the few Americans to wholeheartedly adopt gum printing after Stieglitz so highly recommended it as an expressive medium in *Camera Notes* (Biblio. 897). The negative was made in Europe where Devens was known to have traveled during 1900–1901 when Day's New School of American Photography was shown in London and Paris.

BIBLIOGRAPHY

Manuscript

312. Stieglitz Archives, Collection of American Literature, Beinecke Rare Book and Manuscript Library, Yale University, New Haven, Conn.: 10 unpublished letters from Mary Devens to Alfred Stieglitz between 1899 and 1904.

About Devens

313. "Old Cambridge Camera Club." *Photo Era,* 2 (March, 1899), p. 261.

314. Bayley, R. Child. "Miss Mary Devens." *Camera Notes,* 4 (January, 1901), p. 172.
See Biblio. 110, 539, 543.

WILLIAM B. DYER (American)

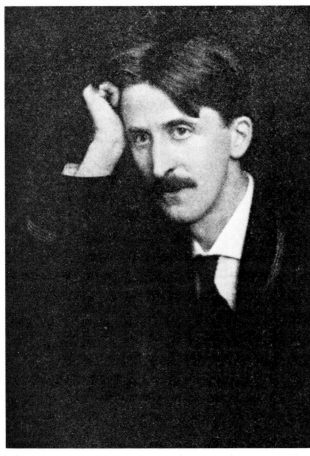

Fig. 17 » *William B. Dyer*. Self-portrait, 1899. Reproduced from *Brush and Pencil,* 5 (October, 1899), p. 20.

CHRONOLOGY

1860: Born on August 7, Racine, Wisconsin, son of Charles and Sarah Dyer.

1895: Becomes an amateur photographer about this time.

1897: Becomes a professional photographer specializing in commercial illustration.

1898–1900: Resides at 99 Dearborn St., Chicago. » Illustrates Riley's *Love Lyrics* and poses himself for some of the pictures (Biblio. 316A).

1900: Newark, Ohio exhibition catalog (Biblio. 1401) describes him as "a professional photographer and a specialist in gum printing and book illustration." Exhibits in Chicago under the pseudonym J. B. Yardwell.

1901: On jury of selection, Chicago Salon.

1902: Elected to The Linked Ring. Visited by Steichen in Chicago. Described by Keiley as "a visionary." (Keiley to Stieglitz, 20 August 1902, YCAL).

1904: White writes to Stieglitz that "Dyer is smothering his depth of feeling with a mad rush of commercialism, otherwise he is one of our strongest workers" (White to Stieglitz, 22 December 1904, YCAL).

1907: Joint exhibition with Alice Boughton and C. Yarnall Abbott at the Photo-Secession Galleries, February 19–March 5 (Biblio. 1388). Two gravures published in *Camera Work,* No. 18 (April, 1907).

1910: Buffalo (1910) catalog lists his residence in Winnetka, Illinois.

1915: Resides in Hood River, Oregon, according to exhibition catalog "American Pictorial Photography" at Syracuse University (May 17–31).

After 1915: Owns fruit orchard. Home burns at unspecified date, presumably destroying collection of prints and negatives; afterwards lives in San Francisco, Pasadena (where his mother resided) and Laguna Beach.

1931: Dies in Laguna Beach, California; interred in Pasadena.

PHOTOGRAPHS

224 » *L'Allegro.* 1902. Gray-green pigment gum-bichromate. 320 × 169 mm. (12⅝ × 6¹¹⁄₁₆ in.) 33.43.338.

Plate 23.

Exhibited: New York (PSG, 1905), no. 19; Cincinnati (1906), no. 10; Philadelphia (1906), no. 37; New York (PSG, 1907), no. 37; Dresden (1909), no. 155; New York (NAC) 1909, no. 109; Buffalo (1910), no. 283, all titled and dated as above.

Reproduced: *Camera Work,* No. 18 (April, 1907), p. 55, titled *L'Allegro,* which is also inscribed on the verso of this print.

Dyer was among the few Americans to whole-heartedly adopt gum printing after Stieglitz so highly recommended it as an expressive medium in *Camera Notes* (Biblio. 897).

EXHIBITIONS

New York (AI) 1899 » Philadelphia 1899–1900 » Chicago 1900 » Newark, Ohio 1900 » London 1901–1903 » Glasgow 1901 » Leeds 1902 » New York (NAC) 1902 » Turin 1902 » Brussels 1903 » Hamburg 1903 » San Francisco 1903 » Wiesbaden 1903 » Bradford 1904 » Denver 1903 » Dresden 1904 » Hague 1904 » London 1904 » Paris 1904 » Pittsburgh 1904 » Washington 1904 » New York (PSG) 1905 » Portland 1905 » Vienna (PC) 1905 » Cincinatti 1906 » Philadelphia 1906 » New York (PSG) 1906 » *London (NEAG) 1907* » *New York (PSG) 1907 » New York (NAC) 1909 » Dresden 1909 » Buffalo 1910 » New York (Montross) 1912 » London (RPS) 1914 » Newark, N.J. (Public Library) 1911.

BIBLIOGRAPHY

By Dyer

315. Dyer, William B. "The Chicago Salon." *Camera Notes,* 4 (July, 1900), pp. 69–72.
316. ———. "What Is Permissible in the Legitimate Artistic Photograph?" *Camera Notes,* 4 (October, 1900), pp. 112–119.

Illustrated by Dyer

316A. Riley, James Whitcomb. *Love-Lyrics with Life Pictures by William B. Dyer.* Indianapolis, n.d. [1905].

About Dyer

317. Clarkson, Ralph. "The Photographs of William B. Dyer." *Brush and Pencil,* 5 (October, 1899), pp. 20–30.
318. Abbott, Henry G. "William B. Dyer." *Photo Era,* 5 (November, 1900), pp. 127–131.
319. Caffin, Charles H. "Other Methods of Individual Expression: Illustrated by the Work of Clarence H. White and William B. Dyer." *Photography as a Fine Art,* 1901, rpt. Hastings-on-Hudson, 1971, pp. 115–139.

RUDOLF EICKEMEYER, JR. (American)

Fig. 18 » *Rudolf Eickemeyer, Jr.* Self-portrait with **Sir Toby Belch,** 1924. Courtesy of Division of Photographic History, Smithsonian Institution National Museum of Science and History.

CHRONOLOGY

1862: Born in Yonkers, New York, son of Mary True and Rudolf Eickemeyer, Sr.

1879–83: Apprenticeship as a machinist.

1884: Buys first camera, a 5 × 8 Platiscope B, while working as a draughtsman in his father's machine business, where the camera is used to record his father's inventions; experiments with photography for amusement.

1890–95: International reputation as a photographer emerges, and he soon stands beside Stieglitz as one of the two most famous American photographers.

1891: Marries Isabelle Hicks of Yonkers.

1893: Stieglitz reviews Philadelphia (Joint) Exhibition, calling Eickemeyer's work "clever little pictures" (Biblio. 879, p. 207).

1894: Stieglitz reviews New York (Joint) Exhibition, calling Eickemeyer's photographs "finest landscape in the exhibition" (Biblio. 882, p. 215). Hinton describes his *A Gray Day in the Meadow* at the Royal Photographic Society exhibition "one of the best and most remarkable things in the room" (Biblio. 467).

1895: His father dies. Works as a professional photographer, with James L. Breese at the Carbon Studio in New York. Elected to The Linked Ring simultaneously with Stieglitz. Replaces his father on the Yonkers School Board.

1900: Has first one-man exhibition at The Camera Club, New York. Illustrates booklet for Kodak. Becomes art manager of the Campbell Art Studio, New York, a stock picture house that published Eickemeyer's photographs. (Cat. 225.) » Hartmann describes Eickemeyer's *Fleur de lis* as "one of the best photographs ever produced in America, and second (only) to Stieglitz's *Winter on Fifth Avenue*" (Biblio. 329, p. 165).

1901: Kodak book, *The Witch of Kodakery,* is dedicated to him. Does Evelyn Nesbit series. Publishes *Down South* (Biblio. 324).

1903: Elected life member in the Daguerre Club. Publishes *Winter* (Biblio. 325).

1904: Illustrates Hamilton Wright Mabie's *Nature and Culture.* » Exhibits in First American Salon

(Biblio. 1404) organized by Curtis Bell, an opponent of Stieglitz.

1905: Buys out Stanford of Davis and Stanford Studios, a firm that is renamed Davis and Eickemeyer, 246 Fifth Avenue.

1911: Commissioned by William Randolph Hearst to take a series of portraits of American ladies who had married into the British peerage. Appointed to the Yonkers Municipal Art Commission.

1916: Wife Isabelle dies.

1918: Marries Florence Brevoort, daughter of James Renwick Brevoort.

1922: Retrospective exhibition at the Anderson Galleries. Appointed one of the original commissioners of the Yonkers Museum of Art and Science, now the Hudson River Museum.

1929–30: Donates all of his photographic plates, cameras, and other equipment to the Department of Photography at the Smithsonian Institution with a grant of fifteen thousand dollars for their preservation and development.

1932: Dies and is buried in Yonkers, New York, his lifelong home.

PHOTOGRAPHS

225 » *A Summer Sea.* 1903 print from negative of 1902 or before. Platinum. 238 × 187 mm. (9⅜ × 7⅜ in.) Stylized 'WE JR/1903" monogram in ink; A. C. Campbell Art Co. Copyright (1902) in negative. 33.43.350.
Plate 26.
Exhibited: London (1902), no. 7; New York (TCC, 1902); London (RPS, 1903) per review; London (1903), no. 13; Brussels (1903), no. 204; Hamburg (1903), no. 156; Washington (1904), no. 49.

Reproduced: *Photograms of the Year 1903,* p. 42, titled *A Summer Morning; American Amateur Photographer* (January, 1903) opp. p. 3; *Photo-Era* (September, 1905), p. 85.

The exhibition record of this print and the evidence of a popular edition suggested in the Campbell copyright attest to the enormous popularity of Eickemeyer at this time. His correspondence with Stieglitz abruptly ends in 1903, the date of this photograph. Eickemeyer was active in the Salon movements that transpired simultaneously in competition with the Photo-Secession (Biblio. 1404).

EXHIBITIONS

Philadelphia 1893 » *Hamburg 1893* » London 1894, 1895 » *New York (Joint) 1894* » Paris 1894–1896 » Brussels 1895 » London (RPS) 1894, 1895 » Hamburg 1896 » London 1897–1903 » London (RPS) 1897–1899 » Hamburg 1899 » New York (AI) 1899 » Glasgow 1901 » Philadelphia 1901 » Brussels 1903 » Hamburg 1903 » London (RPS) 1903 » Pittsburgh 1904 » Washington 1904 » [*New York (FAS) 1904*] » Portland 1905 » Richmond 1905 » Vienna (PC) 1905 » Chicago 1906 » London (RPS) 1907.

COLLECTIONS

Smithsonian Institution, Department of the History of Photography; Hudson River Museum, Yonkers, New York.

BIBLIOGRAPHY

Manuscript

320. Stieglitz Archives, Collection of American Literature, Beinecke Rare Book and Manuscript Library, Yale University, New Haven, Conn.: 18 unpublished letters from Rudolf Eickemeyer, Jr., to Alfred Stieglitz between 1894 and 1903.

By Eickemeyer

321. Eickemeyer, Rudolf, Jr. "Artistic Book Covers for Photographs." *American Annual of Photography and Photographic Times Almanac for 1893,* p. 112.

322. ———. *Letters from the Southwest*. New York, 1894.

323. ———. "How a Picture Was Made." *Camera Notes*, 1 (January, 1898), pp. 63–66.

324. ———. *Down South*. Preface by Joel Chandler Harris. New York, 1900.

325. ———. *Winter*. New York, 1903. Introduction by Sadakichi Hartmann.

326. ———. "My First Photograph." *Photo Era*, 47 (August, 1921), pp. 76–78.

327. ———. "Photography vs. Painting." *Photo Era*, 54 (May, 1925), p. 249.

About Eickemeyer

328. "Rudolph [sic] Eickemeyer, Jr., and His Work." *Photographic Times*, 26 (February, 1895), pp. 71–78.

329. Hartmann, Sadakichi. "Exhibition of Photographs by Rudolph [sic] Eickemeyer, Jr." *Camera Notes*, 3 (April, 1900), pp. 216–217.

330. "Unique Exhibition of Photographs." *Photo Era*, 5 (July, 1900), pp. 7–12.

331. Hartmann, Sadakichi. "Rudolf Eickemeyer's Negro Studies." *The Amateur Photographer*, 32 (28 December 1900), pp. 513–514.

332. ———. "Rudolf Eickemeyers Vordergrundstudien." *Photographische Rundchau*, 15 (August, 1901), pp. 153–154.

333. ———. "A Winter Ramble." *Harper's Monthly Magazine*, 103 (November, 1901), pp. 989–996. Illustrated by R. Eickemeyer.

334. Allan, Sidney [Sadakichi Hartmann]. "The Camera in a Country Lane." *Scribner's Magazine*, 31 (June, 1902), pp. 679–688. Illustrated by R. Eickemeyer.

335. ———. "The Work of Rudolf Eickemeyer, Jr." *Photo-American*, 15 (July, 1904), pp. 195–199.

336. ———. "Rudolf Eickemeyer, Jr.: An Appreciation." *Photo Era*, 15 (September, 1905), pp. 79–82.

337. French, W. A. "Rudolf Eickemeyer, Photographer." *Photo Era*, 51 (September, 1923), pp. 136–138.

338. Madigan, Mary Jean. *Photography of Rudolf Eickemeyer*. Hudson River Museum, Yonkers, New York, exhibition catalog, 1972.

339. Hull, Roger. "Rudolf Eickemeyer, Jr., and the Politics of Photoaphy." *New Mexico Studies in the Fine Arts*, 2 (1977), pp. 20–25.

FRANK EUGENE (American, lived in Germany)

Fig. 19 » *Frank Eugene.* By Heinrich Kuehn, 1910. Cat. 404.

CHRONOLOGY

1865: Born in New York City as Frank Eugene Smith.
About 1885: Begins to photograph for amusement.
Before 1886: Attends the City College of New York.
1886: In Munich. Attends the *Bayrische Akademie der Bildenden Kunste* (Bavarian Academy of Fine Arts).
1895: Reproduction of stage design in *Rip Van Winkle as Played by Joseph Jefferson* (Biblio. 343); career as theatrical portraitist.
1897: Exhibition of Jefferson illustrations, Blakeslee Galleries, 353 Fifth Avenue (March 8–27).
1899: Exhibits at the Camera Club under name Frank Eugene. » Hartmann writes in review of (TCC, 1899): "It is the first time that a truly artistic temperament, a painter of generally recognized accomplishments and ability asserts itself in American photography" (Biblio. 346, p. 561). J. Wells Champney calls work "unphotographic photography" (Biblio. 347, p. 207).
1900: Elected to The Linked Ring. Fourteen prints in London NSAP exhibition. » Issue of *Camera*

Notes devoted to Eugene reproductions inaugurating the short-lived editorial policy of devoting the majority of the illustrations to a single photographer (April). With the June issue devoted to Keiley the policy reverts to fewer illustrations by more photographers. » Described in Newark, Ohio, catalog as "a painter who manipulates both plate and print with the trained hand of an artist" (Biblio. 1333).
1901: Travels to Egypt (January). » Meets with F. Holland Day in Narragansett, R.I., during the summer.
1902: (December) Becomes a Founder of the Photo-Secession, a Fellow, and a member of its governing Council where he is listed as Frank Eugene.
1903: Listed as Associate of the Photo-Secession.
1904: One Gravure published in *Camera Work,* No. 5 (January).
1906: Moves permanently to Germany. Is recognized as a painter and works in a style related to *Jugenstil,* the Austrian counterpart of Art Nouveau. Associates with prominent painters such as Fritz von Uhde (Cat. 276), Hendrik Heyligers (Cat. 283), Willi Geiger (Cat. 281), Franz Roh, and photographs many artists. Designs tapestries that are often seen as backgrounds in his photographs (Cats. 259, 279).
1907: Becomes a lecturer on pictorial photography at Munich's *Lehr-und Versuchs-anstalt für Photographie und Reproduktions-technik* (Teaching and Research Institute for Photography and the Reproductive Processes). At this point, photography rather than painting becomes his primary interest. Experiments with the Lumière autochromes, of which one example is reproduced in Holme (Biblio. 1292), and three are exhibited at the Photo-Secession Galleries. » Hosts Munich "Summit" attended by Steiglitz, Steichen and Kuehn.
1908: Exhibits under name "Frank Eugene Smith" at Munich retrospective.
1909: Two gravures published in *Camera Work,* No. 25 (January). Willi Geiger helps him with etching.
1910: Twenty-seven photographs exhibited under name "Eugene" at Buffalo (Biblio. 1399), nine of which are lent by Stieglitz. Buffalo catalog describes Eugene as first to make successful platinum prints on Japan tissue. » Stieglitz announces his inten-

227 230 232 233

tion to exhibit Eugene at the Photo-Secession Galleries during the 1910–1911 season, but the show does not transpire. » Ten gravures published in *Camera Work,* No. 30 (April), and fourteen in No. 31 (July).

1911: Represented in the London Secession exhibition by special invitation (Biblio. 1422).

1913: Appointed Royal Professor of Pictorial Photography by the Royal Academy of the Graphic Arts of Leipzig. This professorship, created especially for Eugene, is the first chair for pictorial photography at any art academy.

1936: Dies.

PHOTOGRAPHS

Nude Studies

226 » *Adam und Eva.* 1898. Platinum on tissue, mounted on a leaf of wove paper upon a leaf of Japanese tissue that has been mounted on acid board causing discoloration to the other sheets. Image, 169 × 119; paper, 196 × 125 mm. (6¾ × 4¾; 7¹¹⁄₁₆ × 4¹⁵⁄₁₆ in.) Signed "Eugene" in negative but partially effaced. 49.55.250.

Plate 66.
Exhibited: London (NSAP, 1900), no. 79; Dresden (1904), no. 50; Vienna (PC 1904), no. 1; Washington (1904), no. 53; *Munich (1908), no. 78; Buffalo (1910), no. 305, dated as above; *Frankfurt a.M. (1924), no. 23.

 Reproduced: *The Photogram,* 8 (January, 1900), p.

14; *Camera Work,* No. 30 (April, 1910), pl. I, titled *Adam and Eve,* with breaks in the glass plate running through his right shoulder to her big toe, deftly retouched on the upper plate; Biblio. 341, no. 33.

 The vigorous scratches appear to have been added after the plate was first signed to draw attention away from the cracks since they partially obliterate the signature. Prints before the crack are unrecorded in major collections, while the numerous prints made after the cracks attest to Eugene's lack of concern over the matter.

227 » *Song of the Lily.* 1897 (A. S.) Platinum on tissue. Image, 170 × 121; paper, 179 × 152 mm. (6¹¹⁄₁₆ × 4¾; 7 × 4¹⁵⁄₁₆ in.) 33.43.66.
Exhibited: Dresden (1904), no. 52; Cincinnati (1906), no. 15; Richmond (1906), no. 827; *Munich (1908), no. 80.

 Reproduced: *Camera Notes,* 3 (April, 1900), p. 201, titled as above; *British Journal of Photography,* 48 (11 October 1901), p. 648; Caffin Biblio. 1282, p. 201.

228 » *Dido* [*La Cigale, A. S.*]. 1898. Gelatine silver. Image, 253 × 361; paper, 276 × 361 mm. (10 × 14¼; 10⅞ × 14¼ in.) Signed "Eugene" in negative. 33.43.61.

Plate 67.
Exhibited as *Dido:* Philadelphia (1900), no. 67; Dresden (1904), no. 51; *Frankfurt a.M. (1924), no. 6.
Exhibited as *La Cigale:* Glasgow (1902), no. 387; Leeds (1902), no. 498; New York (NAC 1902), no. 55, dated 1898; Denver (1903), no. 176; Minneapolis (1903), no. 18; Rochester (1903), no. 192; Hamburg (1903), no. 163; San Francisco (1903), no. 45a; To-

ronto (1903), no. 5; Washington (1904), no. 57; Pittsburgh (1904), no. 81; Hague (1904), no. 35; Bradford (1904), no. 208; Cincinnati (1906), no. 13; New York (NAC, 1909), no. 107; Buffalo (1910), no. 292, dated as above.

Reproduced: *Camera Notes,* 3 (April, 1900), gravure, between pp. 198–200, titled *La Cigale; Photographische Rundchau,* 15 (December, 1901), p. 243; *Camera Work,* No. 5 (January, 1904), pl. II; *American Pictorial Photography,* Series II (Biblio. 1281), pl. 3.

Collections: AIC, Stieglitz Collection, two prints, making four prints of this subject collected by Stieglitz, a testament to the esteem in which he held the image.

The considerable differences between reproductions indicate the special treatment Eugene gave each print. In exhibitions organized by Stieglitz or those to which the Photo-Secession lent prints, the print was called *La Cigale.* Eugene favored the title *Dido* and exhibited it under this title in exhibitions to which he sent prints directly, as well as listing it as such in Biblio. 341.

229 » *Dido.* 1898. Gelatine silver, printed through a crosshatched screen. Image, 250 × 354; paper, 253 × 354 mm. (9 ⅞ × 13¹⁵⁄₁₆; 10 × 13¹⁵⁄₁₆ in.) 33.43.62.

Not illustrated.

Printed from the same negative as Cat. 228.

230 » *[Studie].* 1899 or before. Platinum. 172 × 63 mm. (6¹³⁄₁₆ × 2½ in.) 49.55.243.

Exhibited: *New York (TCC, 1899), per review.

Reproduced: *Camera Notes,* 3 (April, 1900), p. 189, untitled.

This print might be an experimental study judging by the very bold marking on the plate so as to obliterate all but the figure. The negative has been both scratched and drawn upon by a soft pencil.

231 » *Nude—A Study.* 1898 (A. S.) Platinum. 168 × 116 mm. (6⅝ × 4⁹⁄₁₆ in.) 49.55.247.

Plate 71.

Reproduced: *Camera Work,* No. 31 (July, 1910), pl. XIII, titled as above and of the same model but in a different setting.

The same model in a different pose was titled *Juventas* in Biblio. 341, no. 43.

234

235

Female Studies

232 » *Hortensia.* 1898. Plantinum. 168 × 117 mm. (6⅝ × 4⅝ in.) Signed "Eugene" in negative. 33.43.81.

Exhibited: Wiesbaden (1903), no. 90; Dresden (1904), no. 54; *Munich (1908), no. 66; New York (NAC, 1909), no. 116; Buffalo (1910), no. 302, titled and dated as above; *Frankfurt a.M. (1924), no. 177.

Reproduced: *Camera Work,* 31 (July, 1910), pl. XII, titled as above; Biblio. 341, no. 79.

Collections: AIC, Stieglitz Collection.

233 » *Frl. Emmy Geiger.* 1908 or before. Platinum. 164 × 118 mm. (6⁷⁄₁₆ × 4⅝ in.) Titled on verso by Eugene. 49.55.241.

Exhibited: *Munich (1908), no. 56; New York (PSG, 1908), no. 13, titled *Portrait—Miss G.* *Frankfurt a.M. (1924), no. 131.

Reproduced: Biblio. 341, nos. 73–75, representing variants.

234 » *Frl. Dora Polster.* 1908 or before. Platinum. 167 × 120 mm. (6⁹⁄₁₆ × 4¾ in.) Titled on verso by F. E. S. as above. 33.43.380.

Exhibited: *Munich (1908), no. 68; *Frankfurt a.M. (1924), no. 84, titled *Dora Polster, Malerin.*

235 » *Frau Willi Geiger [Clara].* 1908 or before. Platinum. Image, 119 × 170; paper, 139 × 175 mm. (4¹¹⁄₁₆ × 6¹¹⁄₁₆; 5½ × 6⅞ in.) Signed "Eugene" in negative. 33.43.68.

Exhibited: *Munich (1908), no. 72; Biblio. 341, no. 90, titled *Frau Clara G;* *Frankfurt a.M. (1924), no. 61.

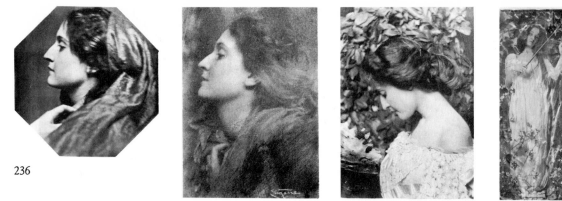

236

238

239

240

236 » *A Profile* [*Miss Convere Jones*]. 1908 or
before. Carbon or oil process. 180 × 179 mm.,
octagon (7⅛ × 7¹⁄₁₆ in.) 33.43.82.
Exhibited: Wiesbaden (1903), no. 79; *Munich (1908),
nos. 39, cover illustration.

Microscopic examination indicates an image struc-
ture very similar to those of Steichen that are assigned
in this catalog as carbon prints. The same model ap-
pears in Cat. 238.

237 » *Lady of Charlotte*. 1900 or before. Platinum.
113 × 83 mm. (4⁷⁄₁₆ × 3¼ in.) Signed "Eu-
gene" in negative. 49.55.244.
Not illustrated.

Exhibited: Newark, Ohio (1900), no. 90; Wies-
baden (1903), no. 91.

Reproduced: *Camera Notes*, 3 (April, 1900), facing
p. 183, titled *Lady of Charlotte; Photographische
Rundchau*, 15 (December, 1901), p. 240, titled as
above; *Camera Work*, No. 25 (January, 1909), pl. II,
titled *Lady of Charlotte*.

Cat. 238 is printed from the same negative; the
platinum has been coated here to show less at the bot-
tom of the negative. The title suggests a play on
Tennyson's *Lady of Shalott*.

238 » *Lady of Charlotte*. About 1899. Platinum.
108 × 78 mm. (4¼ × 3⅛ in.) Signed "Eu-
gene" in negative. 33.43.77.
Exhibited: *New York (TCC, 1899), per review;
Bradford (1904), no. 179; New York (PSG, 1907), no.
31; *Frankfurt a.M. (1924), no. 35.

Reproduced: *Photographic Times*, 31 (December,
1899), p. 555; *Camera Notes*, 3 (April, 1900), p. 182;

Camera Work, 25 (January, 1909), pl. II, titled as
above but with a considerably different tonal range as
might be expected when a gravure is made from the
original negative, as it is stated on p. 48.

Cat. 237 is printed from the same negative.

239 » *A Decorative Panel* [*Fragment*]. 1899 or be-
fore. Platinum. 163 × 116 mm. (6⁷⁄₁₆ × 4⁹⁄₁₆
in.) Signed "Eugene" in negative. 49.55.172.
Exhibited: Inscribed on verso "P.P.S." [Philadelphia
Photographic Salon?] where Eugene was exhibited in
1900, of which this could be no. 69, titled as above.

Reproduced: *Camera Notes*, 3 (April, 1900), p. 191,
triptych titled as above, of which this constitutes the
central portion, the left being Cat. 240; the right por-
tion is not represented in the Stieglitz collection.

240 » *Summer*. 1898 (A. S.) Platinum. Image,
170 × 63; paper, 177 × 63 mm. (6¹¹⁄₁₆ ×
2½; 7 × 2½ in.) Signed "Eugene" on margin
in pencil. 33.43.70.
Reproduced: *Photographic Times*, 31 (December,
1899), p. 560, titled as above; *Camera Notes*, 3 (April,
1900), p. 191, as left side of a triptych titled *A Decora-
tive Panel*.

Stieglitz incorrectly identified this print on his col-
lection label as *Music*, a title which in other sources is
generally given to Cat. 243.

241 » *Joachim's Daughter*. 1899 (A. S.) Platinum
on tissue. 196 × 115 mm. (7⅝ × 2¹⁵⁄₁₆ in.)
33.43.96.
Exhibited: *New York (TCC, 1899), per review; New
York (TCC, 1901); Dresden (1904), no. 53; New York

241 245 244 243

(PSG, 1905), no. 25; Cincinnati (1906), no. 16; Paris (1906), no. 213; London (1908), no. 62.

Reproduced: *Camera Notes,* 5 (October, 1901), opp. p. 139, titled *September;* Biblio. 341, no. 65, titled as above.

Printed from a different negative than Cat. 240, with the models in different costumes against different backgrounds.

242 » *Joachim's Daughter.* 1899 (A. S.) Gelatine silver. 180 × 64 mm. (7 × 2½ in.) 33.43.376.
Not illustrated.

Reproduced: Biblio. 341, no. 65, titled as above. Printed from the same negative as Cat. 241.

243 » *Portrait.* 1899 (A. S.) Platinum on tissue. Image, 168 × 59; paper, 186 × 59 mm. (6⅝ × 2⁵⁄₁₆; 7⁵⁄₁₆ × 2⁵⁄₁₆ in.) 33.43.67.

244 » [*Woman with Muff*]. 1898 (A. S.) Glazed platinum. 176 × 126 mm. (6¹⁵⁄₁₆ × 5 in.) Signed "Eugene" in negative. 33.43.95.

When Eugene marked on the negative, his desire was often purely ornamental, but the marks in this print articulate space and perspective.

245 » *Portrait.* 1901 (A. S.) Platinum, mounted on three layers of Japanese tissue. 172 × 121 mm. (6¹³⁄₁₆ × 4¾ in.) Signed and dated in pencil. 33.43.94.

246 » *Miss Jones* [*Convere Jones*]. 1900 or before. Platinum. 166 × 115 mm. (6⁹⁄₁₆ × 4⁹⁄₁₆ in.) Signed "Eugene" in negative. 33.43.78.

Exhibited: *New York (TCC, 1899), per review; Turin (1902), no. 57; Wiesbaden (1903), no. 79; Denver (1903), no. 1; Washington (1904), no. 59; *Munich (1908), no. 65, titled *Studie M. C. J.;* *Frankfurt a.M. (1924), no. 82.

Reproduced: *Photographic Times,* 31 (December, 1899), p. 556; *Camera Notes,* 3 (April, 1900), p. 210, titled *A Portrait;* Biblio. 341, no. 59.

The model is the same as Cat. 236.

247 » *Frau Ludwig von Holwein.* 1910 or before. Platinum. 120 × 166 mm. (4¾ × 6⁹⁄₁₆ in.) Signed "Eugene" in negative. 33.43.379.

Reproduced: *Camera Work,* No. 31 (July, 1910), pl. X, where it is stated that the "gravures have been reproduced from the original negatives and all but one . . . in the original size . . . engraved and printed by the German firm, F. Bruckmann Verlag, Munich . . . under the personal supervision of Frank Eugene himself" (p. 54).

248 » [*The Diva and Her Most Trusty Friend and Companion*]. N. d. Platinum. 170 × 122 mm. (6¹¹⁄₁₆ × 4¹³⁄₁₆ in.) Signed "Eugene" in negative. 33.43.381.

Biblio. 341, no. 87 is the source for this title.

249 » *Portrait.* N. d. Platinum. 168 × 120 mm. (6⅝ × 4¾ in.) 33.43.378.

250 » [*Magdalaine Königer*]. 1902 (?) Platinum. 168 × 118 mm. (6⅝ × 4⅝ in.) Signed "Eugene" in negative. 33.43.88.

246

247

248

249

250

251

252

253

The backdrop is a painting or tapestry representing Adam plucking the apple.

251 » *Portrait.* N.d. Platinum on tissue. 190 × 132 mm. (7½ × 5³⁄₁₆ in.) Signed "Eugene" in negative. 49.55.171.

The print has a variegated border with mitred diagonals at the corners to give the illusion of a picture frame.

252 » *Portrait.* N. d. Platinum. 146 × 103 mm. 5¾ × 4¹⁄₁₆ in.) 33.43.383.

253 » [*Miss Cushing*]. N. d. Platinum. 148 × 118 mm. (5¹³⁄₁₆ × 4⅝ in.) 33.43.377.

254 » *Studie* [*Mosaik*]. 1908 or before. Platinum, mounted on three layers of colored paper in green, gold and blue. 162 × 115 mm. (6⅜ × 4½ in.) 33.43.75.

Plate 70.
Exhibited: *Munich (1908), no. 6, titled as above; Frankfurt a.M. (1924), no. 173, titled *Mosaik*.

Reproduced: *Camera Work,* No. 30 (April, 1910), pl. VI, titled *Mosaic.*

The pattern of white dots has been achieved by marking with opaquing fluid on the negative, while the black crosshatching has been realized by scratching the plate.

Biblio. 341 lists nos. 100–105: "Fritzi von Derra, Greek, Oriental, and Exotic Dancer," which perhaps describes the model in this print.

255 » [*Dora G.—The Plakat*]. N. d. Platinum. 168 × 120 mm. (6⅝ × 4¾ in.) 33.43.71.

Stieglitz inscribed on mount in pencil "make richer," suggesting that the print was reproduced in an unidentified publication. It is no. 66 in the unidentified exhibition list (Biblio. 341).

256 » *Rebeckah.* 1901. Platinum. 166 × 114 mm.

258

255 256 257

(6⁹⁄₁₆ × 4½ in.) Signed and dated "Eugene/
1901" in negative. 49.55.248.
Exhibited: San Francisco (1902), no. 421, titled *Re-
bekah;* London (RPS 1903), no. 141; Dresden (1904),
no. 49; Portland (1905), no. 20; Paris (1906), no. 212,
titled *Rebecca;* Cincinnati (1906), no. 14; London
(1908), no. 63; *Munich (1908), no. 24, titled *Rebekka
(Studie);* *Frankfurt a.M. (1924), no. 28.
 Reproduced: *Camera Work,* No. 30 (April, 1910),
pl. III, where it is stated that the gravures were printed
from the original negative in Munich under the direct
supervision of Eugene; Biblio. 341, no. 39, titled *Re-
beckah.*

257 » *Taka.* 1908 or before. Platinum. 169 × 114
 mm. (6¹¹⁄₁₆ × 4½ in.) Titled on verso in pen-
 cil by Eugene. 33.43.375.
Exhibited: *Munich (1908), no. 48.

258 » *Menuet.* 1900. Platinum. 178 × 229 mm.
 (7 × 9 in.) Signed "Eugene" in negative.
 33.43.73.
Exhibited: *Munich (1908), no. 82, titled *Studie
(Menuette);* Buffalo (1910), no. 307; *Frankfurt a.M.
(1924), no. 22.
 Reproduced: *Camera Work,* 30 (April, 1910), pl.
IX, titled *Minuet;* Holme (Biblio. 1292), pl. 39, where
it is reproduced as an example of color photography;
Biblio. 341, no. 77.
 The heart motif ornamenting bottom edge appears
as a punctuation in Eugene's family correspondence.
The negative was also printed without the caption. The
idiosyncratic spelling scratched in the negative is not

grammatical in German and should be spelled "Menu-
ette," as it generally was in the exhibition lists.

Children

259 » *Brigitta Wenz.* 1900. Platinum. 120 × 168
 mm. (4¾ × 6⅝ in.) Signed "Eugene" in
 negative. 33.43.69.
Exhibited: *Munich (1908), no. 46; Buffalo (1910), no.
301; Biblio. 341, no. 15.
 Reproduced: *Camera Work,* No. 30 (April, 1910),
pl. X, titled *Brigitta.*
 Collections: AIC, Stieglitz Collection.
 Eugene was also a designer of tapestries, the influ-
ence of which is evident in the decorative backdrop.

260 » *Gabriella Lenbach.* 1908. Platinum. 168 ×
 117 mm. (6⅝ × 4⅝ in.) Signed "Eugene" and
 titled in negative. 33.43.63.
Exhibited: *Munich (1908), no. 42; Buffalo (1910), no.
304, dated as above.

261 » [*Tasse Tee—Master Frank Jefferson*]. 1898.
 Platinum on tissue. 163 × 118 mm. (6⁷⁄₁₆ ×
 4⅝ in.) Signed "Eugene" in negative.
 49.55.174.
Exhibited: *Munich (1908), no. 54; Buffalo (1910), no.
287, titled, dated and printed on the same paper as
above; Frankfurt a.M. (1924), no. 112.
 Reproduced: *Camera Work,* No. 30 (April, 1910),
pl. IV.
 A narrow border of the same width has been left
on three sides; it is wider at bottom where stains from
the sensitizing liquids are seen, which could have been

259

260

261

262

263

264

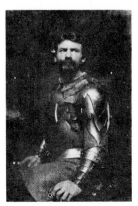

265

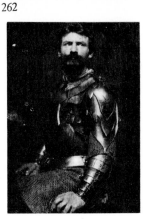

266

trimmed but was deliberately preserved by mounting
the whole sheet on a larger leaf of Japanese paper.

262 » *II. KK. HH. Prinzcessin Rupprecht, Prinz
Luitpold und Prinz Albrecht.* 1908 or before.
Platinum. 169 × 121 mm. (6¹¹⁄₁₆ × 4¾ in.)
Signed "Eugene" in negative. 49.55.245.
Exhibited: *Munich (1908), no. 37, titled as above;
*Frankfurt a.M. (1924), no. 64.
Reproduced: *Camera Work,* No. 30 (April, 1910),
pl. II, titled *Princess Rupprecht and Her Children;*
Biblio. 341, no. 120, titled *Princess H.R.H. Rupprecht
with Prince Luitpold and Albrecht Johan.*
The print typifies the studio portraiture at which
Eugene was so successful. He portrayed the family of
Prince Rupprecht von Bayern on several occasions.

263 » *Master Bliss-Lane.* N. d. Platinum. 167 × 113
mm. (6⁹⁄₁₆ × 4⁷⁄₁₆ in.) Titled on verso in
pencil by Eugene as above. 33.43.382.

Exhibited: Wiesbaden (1903), no. 101; *Frankfurt
a.M. (1924), no. 72.

264 » *Master Keim.* 1897 (A. S.) Platinum. 167 ×
117 mm. (6⁹⁄₁₆ × 4⅝ in.) Signed "Eugene"
in negative; inscribed on verso by A. S.
"Stieglitz Collection/Master Howard K./
1897/." In another hand, "Property of Mrs.
George H. Keim." 33.43.79.
Exhibited: *New York (TCC, 1899), per review; Newark, Ohio (1900), no. 90, identified as having been lent
by Alfred Stieglitz.
Reproduced: *Camera Notes,* 3 (April, 1900), p. 187,
titled as above.

Male Studies

265 » *The Man in Armor.* 1898 (A.S.) Platinum
on tissue. 196 × 132 mm. (7¹¹⁄₁₆ × 5¼ in.)
33.43.65.
Exhibited: New York (NAC 1902), no. 59; San Fran-

267

269

270

272

cisco (1902), no. 415, titled *The Unhelmeted Knight;*
Glasgow (1903), no. 383; Wiesbaden (1903), no. 82;
Cleveland (1903), no. 2; Washington (1904), no. 52;
New York (NAC, 1909), no. 113; Buffalo (1910), no.
296, titled *Self-Portrait;* Frankfurt a.M. (1924), no. 88.

Reproduced: *Photographic Times,* 31 (December,
1899), p. 559; Caffin (Biblio. 1282), p. 107.

In the cited work Caffin notes in his caption, "This
portrait of himself received no manipulation by Mr.
Eugene at any stage." The dark printing of this print
has obscured the signature visible in Cat. 266 (which is
from the same negative) and most of the manipulation,
thus leading Caffin to his erroneous conclusion.

266 » *The Man in Armor [Self-Portrait].* 1898.
Platinum. 173 × 119 mm. (6¹³⁄₁₆ × 4¹¹⁄₁₆ in.)
Signed "Eugene" in negative. 33.43.76.
Not illustrated.

The negative was manipulated to give a wash effect
that is clearly evident in this print but which had been
obscured by the dark printing of Cat. 265.

267 » *The Man in Armor [Helmeted].* 1898.
Platinum on tissue. 197 × 70 mm. (7¾ × 2¾
in.) 33.43.92.
Exhibited: Buffalo (1910), no. 290, dated as above.
Reproduced: *Camera Work,* 30 (April, 1910), pl.
VII.

Compare Cat. 266 where there is a different model
in a different set of armor, but with the same general
composition.

268 » *Our Dragoman in Cairo [A. S.].* 1901.

Wove paper coated with platinum, mounted
on two layers of Japanese tissue. 122 × 68 mm.
(4¹³⁄₁₆ × 2¹¹⁄₁₆ in.) 33.43.90.
Plate 68.
Exhibited: *Frankfurt a.M. (1924), no. 137, titled
Aegyptischer Hirt, suggesting a related, if not identical
composition.

It is unclear whether the entire painterly effect re-
sults from the manipulated negative, as is the case in the
background top, or the coating of the printing paper,
as with the lower edges. Eugene was in Egypt in 1901
when this negative was presumably made.

269 » *Dr. Georg Hirth.* 1910 or before. Platinum.
164 × 116 mm. (6⁷⁄₁₆ × 4⁹⁄₁₆ in.) Signed
"Eugene" faintly in negative on upper right,
with title printed from negative. 33.43.86.
Exhibited: Buffalo (1910), no. 312; *Frankfurt a.M.
(1924), no. 122.
Reproduced: *Camera Work,* 31 (July, 1910), pl.
VIII.

270 » *The Chessplayer [Dr. Emanuel Lasker].*
1898(?) Platinum. 168 × 116 mm. (6⅝ ×
4⁹⁄₁₆ in.) Signed "Eugene" in negative.
33.43.85.
The print is dated 1902 by an unfamiliar hand on the
mount, while the year 1898 is inscribed by Stieglitz
on the verso of Cat. 271, which is from a negative of
the same sitting.

271 » *Dr. Emanuel Lasker and His Brother.* 1907.
Platinum. 155 × 121 mm. (6⅛ × 4¾ in.)

273 274 275 276

Inscribed by A. S. on verso "Stieglitz Collection/1898/The Two Laskers"; inscribed by the photographer "Frank Eugene Smith/152 West 13th St./N. Y. City." 33.43.74.

Plate 69.
Exhibited: Buffalo (1910), no. 301, where it is dated 1907 and titled as above; *Frankfurt a.M. (1924), no. 47.

Reproduced: *Camera Work,* 31 (July, 1910), pl. VII; Biblio. 341, no. 130, titled *Dr. Emanuel and Dr. Berthold Lasker (Ex-Chess Champion).*

272 » *Alfred Stieglitz Esquire. Photographer and Truthseeker.* 1899 (A. S.) Platinum. 165 × 117 mm. (6½ × 4⅝ in.) Signed faintly "Eugene" in negative. 49.55.246.
Exhibited: Newark, Ohio (1900), no. 89; Glasgow (1902), no. 390; Leeds (1902), no. 784; Wiesbaden (1903), no. 143; San Francisco (1903), no. 45; Brussels (1903), no. 212; Vienna (1904), no. 2; Washington (1904), no. 541; *Munich (1908), no. 88; New York (NAC, 1909), no. 117; *Frankfurt a.M. (1924), no. 113, titled as above.

Reproduced: *Photographische Rundchau,* 14 (January, 1900), p. 20; *Camera Work,* No. 25 (January, 1902), pl. II, from a different sitting judging from the change in costume and length of Stieglitz's hair; the light and posing create a more formal effect than the above platinum print.

The sitting probably took place when Eugene was in New York for his exhibition at The Camera Club, which must have coincided with the selection of the photographs for reproduction in *Camera Notes,* 3

(April, 1900), where he was featured with gravures and halftones.

273 » *Alfred Stieglitz.* 1907. Platinum. Image, 172 × 122; paper, 177 × 126 mm. (6¾ × 4¹³⁄₁₆; 6¹⁵⁄₁₆ × 4¹⁵⁄₁₆ in.) 55.635.5.
The negative has been manipulated by scratching and filling primarily the background, but the coat lapel has been enhanced as well. This print and its companions (Cats. 274, 275) were presumably made at the same sitting as that published in *Camera Work,* No. 25 (January, 1909).

274 » *Alfred Stieglitz.* 1907. Platinum. 161 × 116 mm. (6⅜ × 4⁹⁄₁₆ in.) 55.635.6.
The negative has been manipulated as in Cat. 273.

275 » *Alfred Stieglitz.* 1907. Platinum. 165 × 118 mm. (6½ × 4⅝ in.) Signed "Eugene" in negative. 55.635.7.

276 » *Herr. Prof. Fritz von Uhde.* 1908 or before. Platinum. 167 × 117 mm. (6⅝ × 4⅝ in.) 33.43.89.
Exhibited: * Munich (1908), no. 1; *Frankfurt a.M. (1924), no. 110.

Reproduced: *Camera Work,* No. 31 (July, 1910), pl. II.

Von Uhde (1848–1911) was one of Eugene's mentors and one of the most popular painters in Munich.

This is an inky black platinum print where the hand manipulation is subordinated to the printing

279 280 281 282

in comparison to Cat. 278 which is printed from the same negative but in brown-tone platinum.

277 » *Fritz von Uhde.* 1908 or before. Platinum. 171 × 123 mm. (6¾ × 5 in.) Signed "Eugene" in negative. 49.55.242.
Not illustrated.
 Printed from the same negative as Cats. 276 and 278.

278 » *Fritz von Uhde.* 1908 or before. Platinum. 156 × 118 mm. (6³⁄₁₆ × 4⅝ in.) Signed "Eugene" in negative. 33.43.72.
Not illustrated.
 Exhibited: *Munich (1908), no. 1.
 Reproduced: *Camera Work,* No. 31 (July, 1910), pl. II.

279 » *Portrait.* 1902 (A. S.) Platinum. 169 × 121 mm. (6¹¹⁄₁₆ × 4¾ in.) Initial "E" in negative on lower right. 33.43.93.
The model is posed before a tapestry illustrating minarets against a starry sky. The print is typical of studies Eugene exhibited without the name of his sitter, as in London (1899), no. 181, *A Portrait.* By the 1900 London Salon, he had begun identifying his portraits with the initials of the sitter. By the 1908 Munich show, he was listing the sitters with their full names where the sitter was a personality, while other studies were identified with descriptive titles. Two subjects exhibited at Buffalo (1910) were identified as *Portrait,* while the remainder were given either descriptive titles or the names of the sitters.

280 » *Portrait.* 1898 (A. S.) Platinum on tissue. Image, 170 × 120; paper, 189 × 129 mm. (6¹¹⁄₁₆ × 4¾; 7⅞ × 5¹⁄₁₆ in.) Signed "Eugene" in negative. 33.43.91.

281 » *Herr Maler Willi Geiger.* 1907. Platinum. 163 × 120 mm. (6⁷⁄₁₆ × 4¾ in.) Signed "Eugene" in negative, with sitter's name printed from negative at bottom. 49.55.249.
Exhibited: *Munich (1908), no. 67; Buffalo (1910), no. 309, dated 1907.
 Reproduced: *Camera Work,* No. 31 (July, 1910), pl. V.

Groups

282 » *Arthur und Guinevere (illustration zu einem Gedicht Lord Tennyson) [no. 3].* 1899 or before. Platinum. 108 × 82 mm. (4¼ × 3¼ in.) Signed "Eugene" in negative. 33.43.84.
Exhibited: *New York (TCC, 1899), titled *Launcelot and Guinevere;* *Munich (1908) no. 85; Buffalo (1910) no. 306, dated incorrectly 1900.

283 » *Herr Kunstmaler Heyligers mit Frau.* 1908 or before. Platinum. 123 × 168 mm. (4⅞ × 6⅝ in.) Signed "Eugene" faintly in negative on upper right. 33.43.83.
Exhibited: *Munich (1908) no. 34; New York (NAC, 1909), no. 115; *Frankfurt a.M. (1924), no. 11.
 Hendrik Heyligers (b. 1877) was a landscape and marine painter living in Batavia. Biblio. 341, no. 107,

283

284

285

lists *Fisherman's "Luck" Henry Heyligers ans Frau* which suggests a related work.

284 » *Stieglitz, Steichen and Kuehn Admiring the Work of Frank Eugene.* 1907. Platinum. 121 × 168 mm. (4¹³⁄₁₆ × 6⅝ in.) 33.43.87. MMA 1972.633.132 (Purchase, Jacob S. Rogers Fund) is a variant of the same sitting, where Eugene is seen at left next to Stieglitz. Inscribed below by Eugene on 1972.633.132 is: "Stieglitz, Steichen, Smith and Kuehn admiring the work of Frank Eugene." Stieglitz assigned the title *The Tutzing Trio,* preferring it to Eugene's description. The negative was made in the summer of 1907 in Munich when Stieglitz introduced Eugene to the autochrome process.

Views

285 » *Ákra Korinthos.* 1902 (A. S.) Brown-toned platinum. 95 × 115 mm. (3¾ × 4⁹⁄₁₆ in.) 33.43.80.
The print is among the rare examples of Eugene's work outdoors.

286 » *Die Sphinx von Gizeh, Aegypten, Mitternacht [The Sphinx].* 1904 print of 1901 negative (A. S.) Platinum, touched with white pigment. Image, 120× 171; paper, 124 × 174 mm. (4¾ × 6¾; 4⅞ × 6⅞ in.) Signed "Eugene" in negative. 33.43.64.
Exhibitions: Buffalo (1910), no. 300, dated 1902 and titled *The Sphinx;* *Frankfurt a.M. (1924), no. 32.
 Eugene traveled to Egypt in 1901 when the negative was presumably made.

287 » *Emmy and Kitty—Tutzing, Bavaria.* 1907. Autochrome. 165 × 116 mm. (6½ × 4⁹⁄₁₆ in.) Inscribed on mount by A. S., titled as above with comment "first autochrome of Eugene taught by Stieglitz." 55.635.11.

288 » *Stieglitz and Emmy [Tutzing, Bavaria].* 1907. Autochrome. 113 × 160 mm. (4⁷⁄₁₆ × 6⁵⁄₁₆ in.) 55.635.12.

EXHIBITIONS

London 1899–1901 » *New York (TCC) November 1899* » London (NSAP) 1900 » Philadelphia 1900 » *New York (TCC) 1901* » Paris (NSAP) 1901 » Glasgow 1901 » Leeds 1902 » New York (NAC) 1902 » San Francisco 1902–1903 » Turin 1902 » Brussels 1903 » Cleveland 1903 » Denver 1903 » Hamburg 1903 » London (RPS) 1903 » Minneapolis 1903 » Rochester 1903 » Toronto 1903 » Wiesbaden 1903 » Bradford 1904 Dresden 1904 » Hague 1904 » Pittsburgh 1904 » Vienna (PC) 1904, 1905 » Washington 1904 » New York (PSG) 1905 » Portland 1905 » Richmond 1905 » Cincinnati 1906 » Paris 1906 » *London (NEAG) 1907* » New York (PSG) 1907 » *Munich (Kunst-Verein) 1907* » *London 1908* » New York (PSG) 1908 » New York (NAC) 1908 » *Munich 1908 » New York (NAC) 1909 » Dresden 1909 » Buffalo 1910 » London 1910 » London (Secession) 1911 » London (RPS) 1914.

286

287

288

COLLECTIONS

MMA has 133 prints each numbered and described by Eugene on an accompanying list (Biblio. 341), 1972.633, Jacob S. Rogers Fund.

BIBLIOGRAPHY

Manuscript

340. Stieglitz Archives, Collection of American Literature, Beinecke Rare Book and Manuscript Library, Yale University, New Haven, Conn.: 93 unpublished letters from Frank Eugene to Alfred Stieglitz and 2 unpublished letters from Alfred Stieglitz to Frank Eugene between 1900 and 1927.

341. The Metropolitan Museum of Art. *Collection of clippings and other ephemera including typescript list of an unidentified exhibition.* New York.

By Eugene

342. Smith, Frank Eugene. "Extract from a Letter." *Camera Work,* No. 49/50 (June, 1917), p. 36.

Illustrated by Eugene

343. Bell, Cara H., ed. *Rip Van Winkle as Played by Joseph Jefferson* [with one illustration of a stage set by F. Eugene Smith]. New York, 1895.

About Eugene

344. Blakeslee Galleries. *Paintings by Frank Eugene, March 8–27, 1897.* New York, 1897.

345. Hartmann, Sadakichi. "Portrait Painting and Portrait Photography." *Camera Notes,* 3 (July, 1899), pp. 3–21.

346.———. "Frank Eugene: Painter-Photographer." *Photographic Times,* 31 (December, 1899), pp. 555–561.

347. Champney, J. Wells. "Reviews of the Exhibition of Prints by Frank Eugene: By a Painter." *Camera Notes,* 3 (April, 1900), p. 207.

348. Fuguet, Dallett. "Reviews of the Exhibition of Prints by Frank Eugene: By a Photographer." *Camera Notes,* 3 (April, 1900), pp. 208–213.

349. Hartmann, Sadakichi. "Color and Texture in Photography." *Camera Notes,* 4 (July, 1900), pp. 9–12.

350. Dane, Hal. "Some Thoughts on an Exhibition of American Photographic Prints." *The Amateur Photographer,* 32 (26 October 1900), p. 323.

351. *Photographische Arbeiten-Von-Frank Eugene Smith.* Ausstellung, Bayerische Staatsgemaldesammlungen, München, 1908.

352. W. R. "Photographien von Frank Eugene Smith." *Dekoretive Kunst,* 12 (October, 1908), pp. 1–8.

353. [Stieglitz, Alfred]. "Our Illustrations." *Camera Work,* No. 30 (April, 1910), p. 59.

354. Brünner, Max. "Berlin Letter." *Photo Era,* 31 (October, 1913), p. 219.

355. *Kunstgewerbemuseum, Frankfurt a.M., "Austellung von Prof. Frank-Eugene Smith",* Marz–April, 1924. Frankfurt a.M.

356. Beaton, Cecil and Gail Buckland. "Frank Eugene." *The Magic Image.* Boston, 1975, p. 119.

FREDERICK H. EVANS (English)

Fig. 20 » *Frederick H. Evans.* By Alvin Langdon Coburn, 1906 or before. Cat. 133.

CHRONOLOGY

1853: Born on June 26.
1870s: Employed as a bank clerk.
About 1873: Lives with an aunt in Boston for a year.
1880s: Learns photomicrography.
1887: Awarded a medal at the Royal Photographic Society for his photomicrography.

1880s: Becomes proprietor of a bookstore in Queen Street, Cheapside. Friendships commence with G. Bernard Shaw and Aubrey Beardsley.
1892: Influences publisher John Dent to have Beardsley illustrate *Le Morte l'Arthur.*
1894: Photographs Yorkminster, among the earliest cathedral studies.
1897: First solo exhibition, The Architectural Club, Boston.
1898: Retires from bookstore, moves to Epping Forest, and takes up photography full-time.
1900: Elected to The Linked Ring. Marries.
1901: Commences correspondence with Stieglitz.
1903: Six gravures published in *Camera Work,* No. 4 (October). Angered at Steichen and Stieglitz for boycotting The London Salon.
1904: One gravure published in *Camera Work,* No. 8 (October). Kuehn criticizes Evans as making "pale watery prints, without [motive] or pictorial effect, without thoughts. . . ." (Kuehn to Stieglitz, 8 December 1904, YCAL)
1902–05: Decorates and hangs The Linked Ring Salon in a manner very influential on the interior design of the Photo-Secession Galleries, 291 Fifth Avenue.
1906: Exhibits at Photo-Secession Galleries, New York.
1906–07: Spends summers in France on commission from *Country Life* magazine.
1908: Has only one print selected for Photographic Salon, London, and in anger joins the "London Secession" organized by F. J. Mortimer.
1910: Joins the London Salon Club. Stieglitz selects prints for exhibition at the Buffalo Exhibition.
1911: Commissioned by *Country Life* to photograph Westminster Cathedral.
1912–19: Privately publishes platinotype editions of artists' works, including platinum prints of Beardsley drawings.
1943: Dies in London, June 24.

PHOTOGRAPHS

289 » *Lincoln Cathedral: Stairway in S. W. Turret.* 1894/1895. Platinum. Image, 199 × 135; plate, 253 × 154 mm. (7¹³⁄₁₆ × 5⁵⁄₁₆; 9¹⁵⁄₁₆ ×

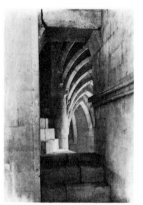
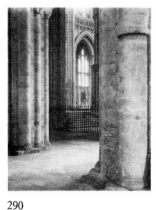

289

290

291

293

6¹⁄₁₆ in.) Signed and titled as above in pencil on margin. 33.43.287.

Exhibited: London (1895), no. 153.

Reproduced: *Photograms of the Year 1895,* p. 37, titled as above.

Collections: IMP/GEH (platinum print, ex-collection of Alvin Langdon Coburn); RPS.

290 » [*Ely Cathedral from Nave to Porch*]. 1899/ 1900. Platinum. 113 × 92 mm. (4⁷⁄₁₆ × 3⅝ in.) 49.55.240.

Exhibited: London (1900), no. 119, titled as above, suggesting a related subject.

Reproduced: *Camera Work,* No. 4 (October, 1903), pl. II, titled *Ely Cathedral Across Nave and Octagon,* a similar composition of approximately the same date.

291 » *York Minster: "In Sure and Certain Hope."* About 1900. Hand-printed photogravure, inscribed "Double proof (superimposed) on Jap. Silk Tissue." 203 × 151 mm. (8 × 5¹⁵⁄₁₆ in.) Signed in pencil on margin "Frederick H. Evans" and noted "No. 1 of 10 signed copies." 49.55.237.

Exhibited: London (1902), no. 27; Leeds (1902), no. 733; Bradford (1904), no. 55, all titled as above.

Reproduced: *Camera Work,* No. 4 (October, 1903), pl. IV, titled as above; No. 8 (October, 1904), titled *In Sure and Certain Hope,* making it among the few images to be reproduced twice in *Camera Work.*

Two gravure copperplates were printed, each with a different tonal scale of highlight and shadow, to realize the effects of both luminescence and detail.

292 » *York Minster, Into the South Transept.* About 1900. Platinum, mounted on a sheet of brown paper with narrow border, upon a natural Japanese paper, upon a larger sheet of gray paper. 209 × 121 mm. (8¼ × 4¾ in.) Inscribed on verso of mount "To Alfred Stieglitz/ from Frederick H. Evans/Xmas '02, "York Minster/Into the South Transept." 33.43.368. *Plate 7.*

Exhibited: London (1901), no. 28, *York Minister* [sic] —*In the South Transept;* New York (PSG, 1906), no. 55, titled *Into South Transept, York.*

Collections: YCAL, titled *York Minster—A Study in Light.*

293 » *George Bernard Shaw.* 1901. Platinum, mounted on a sheet of blue-gray paper upon a sheet of gray upon a larger sheet of the first blue-gray. 226 × 156 mm. (8¹⁵⁄₁₆ × 6⅛ in.) Blindstamp "ꜰʜᴇ" on mount; signed, titled, and dated in pencil on verso. 49.55.239.

Exhibited: London (1901), no. 119.

Reproduced: *Photograms of the Year 1901,* p. 89.

294 » *George Bernard Shaw.* 1902. Platinum. 223 × 112 mm. (8¹³⁄₁₆ × 4⁷⁄₁₆ in.) Blindstamp "ꜰʜᴇ"; signed, titled and dated in pencil on verso. 49.55.238.

295 » *Height and Light in Bourges Cathedral.* 1903. Platinum. 120 × 74 mm. (4¾ × 2¹⁵⁄₁₆ in.) Blindstamp "ꜰʜᴇ" monogram. 33.43.283.

Exhibited: London (1904), no. 68, subtitled "a later version"; Buffalo (1910), no. 116, titled as above.

294 295 296 297

Reproduced: *Camera Work,* No. 4 (October, 1903), plates II and III have been reversed, this being a near variant of pl. II, the title of which (as above) has been interchanged with pl. III; *Magazine of Art* (British ed.), n. s. 2 (June, 1904), p. 373.

The mount consists of nine layers of different brown papers; the first three are nested with thread margins upon a larger sheet in turn nested upon four layers with thread margins, upon a larger sheet. The mounting appears to be a deliberate attempt to echo the layering of architectural elements in the photograph.

It is a masterpiece of platinum printing with subtle detail in both the deep shadows and the brightest areas. Photographs such as this caused Keiley to characterize Evans as a craftsman rather than as an artist. (Keiley to Stieglitz, YCAL.)

296 » [*Late Afternoon Across Octagon and Tran-
 septs: Ely Cathedral*]. 1903. Platinum,
 mounted on two layers of tan paper with
 narrow margins. 247 × 207 mm. (9¾ ×
 8³⁄₁₆ in.) 33.43.284.

Exhibited: London (1904), nos. 50, 129 are related subjects; Buffalo (1910), no. 114, titled as above.

The print is related to the series published in *Camera Work,* No. 4 (October, 1903), esp. pl. 11, titled *Across the Nave and Octagon.* A signed and dated example is in the Library of Congress, but the date could refer to the print rather than the negative. Nevertheless, this print and the following three prints would date past 1900 when Day's "American Style" of mounting was first shown in England.

297 » [*Late Afternoon Across Octagon and Tran-

septs: Ely Cathedral]. 1903. Platinum. 253 × 205 mm. (9¹⁵⁄₁₆ × 8¹⁄₁₆ in.) 49.55.326.

Reproduced: *La Revue de Photographie,* 3 (March, 1905), p. 67.

Printed from the same negative as Cat. 296, in which the lighter printing gives the effect of midday in comparison to the dark effect of this print with deep shadows in vaults suggesting a change in the time of day. The carefully prepared presentation mount of Cat. 296 suggests that it was the preferred version.

298 » [*A Fifteenth Century Doorway, Ely*]. 1903.
 Platinum, mounted on five layers of ochre
 and brown papers, the first four with narrow
 margins upon a larger sheet. 181 × 137 mm.
 (7⅛ × 5⅜ in.) Blindstamp "ғнe" mono-
 gram. 33.43.285.

Exhibited: (See Cat. 296). New York (PSG, 1906), no. 45, titled as above, suggesting the identical or a related work.

299 » *Ely Cathedral, The Octagon.* [1903].
 Gravure on tissue, adhered to a larger sheet
 of heavier paper by the pressure of an etching
 press that has left a platemark. 203 × 138 mm.
 (8 × 5⁷⁄₁₆ in.) Signed in pencil on margin
 "Frederick H. Evans"; blindstamp initial;
 titled in pencil adjacent. 33.43.286.

Exhibited: New York (PSG, 1906), no. 48, titled *Octagon to Nave and Aisle.*

300 » *In Deerleap Woods—A Haunt of George
 Meredith———.* About 1909. Platinum,
 mounted on three layers of different shades

298 299 302

of gray papers. 144 × 111 mm. ($5^{11}/_{16}$ × $4^{3}/_{8}$ in.) Signed, dated, and titled as above in ink on verso with dedication "To Alfred Stieglitz/X'mas/'09/FHE." 49.55.235.
Plate 6.
Exhibited: London (1910), no. 93.
In 1910 H. Snowden Ward wrote of this print:

Frederick H. Evans in his *Deerleap Woods* (135) makes his theme of two bare trunks, both flecked with sunlight, one gracefully yielding, the other straight and uncompromising. It is nothing of a subject. Few men would have attempted it, because few would have seen any beauty in it. Evans both saw and recorded the cool shade, the tranquility, the placid air, and the warm, playful sunlight. Entitling it *A Haunt* of George Meredith a master of poetic thought, he sends the mind and memory wandering through their treasured glimpses of Meredith's imaginings and converting the trees of Deerleap into the true woods of Westermain. (Biblio. 1130, p. 30)

301 » *Across the Transepts of Westminster Abbey.* 1911. Platinum. 239 × 169 mm. ($9^{7}/_{16}$ × $6^{11}/_{16}$ in.) Signed, dated, and titled in ink on verso "Frederick H. Evans." 49.55.236.
Plate 8.
Collections: Library of Congress, also signed and dated 1911.

302 » *The Confession Chapel Westminster Abbey.* 1911. Platinum. 242 × 179 mm. ($9^{9}/_{16}$ × $7^{1}/_{16}$ in.) Signed, dated, and titled in ink on verso "Frederick H. Evans." 49.55.234.

See also Cats. 442–445, printed by him from the negatives of George Bernard Shaw.

EXHIBITIONS

London 1894–1904 » *Boston 1897* » London (RPS) 1897–1899 » Philadelphia 1898–1899 » New York (AI) 1899 » *London (RPS) 1900* » Glasgow 1901 » *Boston (Day Studio) 1903* » Hamburg 1903 » Bradford 1904 » Vienna (C-K) 1905 » London 1906 » New York (PSG) 1906 » Philadelphia 1906 » *New York (PSG) 1907* » London 1908–1910 » Dresden 1909 » New York (NAC) 1909 » Buffalo 1910 » London (RPS) 1914.

COLLECTIONS

IMP/GEH, approximately 129 prints.

BIBLIOGRAPHY

Manuscript

357. Stieglitz Archives, Collection of American Literature, Beinecke Rare Book and Manuscript Library, Yale University, New Haven, Conn.: 82 unpublished letters from Frederick Evans to Alfred Stieglitz and 4 unpublished letters from Alfred Stieglitz to Frederick Evans between 1902 and 1915.

By Evans

358. Evans, Frederick H. "Lincoln Cathedral." *Photographic Journal,* 22 (23 December 1899), pp. 101–105.

359. ——. "Opening Address at Royal Photographic Society Exhibition." *Photographic Journal,* 23 (30 April 1900), pp. 236–241.

360. ——. "Good Drawing in Photography." *Photography,* 12 (10 May 1900), p. 318.

361. ——. "Artistic Photography in Lantern Slides." *The Amateur Photographer,* 37 (19 February 1903), pp. 148–149.

362. ——. "Imitation: Is It Necessary or Worth While?" *The Amateur Photographer,* 37 (11 June 1903), p. 475.

363. ——. "Camera-Work in Cathedral Architecture." *Camera Work,* No. 4 (October, 1903), pp. 17–21.

364. ——. "And What Went Ye Out for To See?" *Photograms of the Year 1903,* pp. 19–25; (on his York Minster Cathedral series).

365. ——. "Odds and Ends." *Camera Work,* No. 5 (January, 1904), pp. 25–30.

366. ——. "The Cult of Vagueness." *The Amateur Photographer,* 39 (4 February 1904), p. 83.

367. ——. "Painters and Photographers." *Photography,* 17 (13 February 1904), p. 125.

368. ——. "Notes on 'An Open Door.'" *The Amateur Photographer,* 39 (31 March 1904), pp. 253–255.

369. ——. "Some Notes on Interior Work." *The Amateur Photographer,* 39 (April 7, 14, 21, 28, May 5, 12, 1904), pp. 272–273, 291, 312–313, 331–332, 351–352, 372–375.

370. ——. "Pros and Cons: What Constitutes an 'Artist'?" *Camera Work,* No. 7 (July, 1904), pp. 21–24.

371. ——. "International Cohesion: A Society of Societies." *The Amateur Photographer,* 40 (25 August 1904), p. 142.

372. ——. "Pros and Cons: Critic Versus Critic." *Camera Work,* No. 8 (October, 1904), pp. 23–26.

373. ——. "The Photographic Salon, London, 1904: As Seen through English Eyes." *Camera Work,* No. 9 (January, 1905), pp. 37–47.

374. ——. "The London Salon for 1905." *Camera Work,* No. 13 (January, 1906), pp. 46–50.

375. ——. "Hand Camera of the Future." *The Amateur Photographer,* 43 (27 February 1906), pp. 171–173.

376. ——. "The London Photographic Salon for 1906." *Camera Work,* No. 17 (January, 1907), pp. 29–33.

377. ——. "Art in Photographs." *The Amateur Photographer,* 49 (19 February 1907), p. 159.

378. ——. "What Is a 'Straight Print'?" *The Amateur Photographer,* 46 (30 July 1907), pp. 111–122.

379. ——. "Personality in Photography—With a Word on Color." *Camera Work,* No. 25 (January, 1909), pp. 37–38.

380. ——. "The New Criticism." *The Amateur Photographer,* 50 (20 July 1909), pp. 89–90.
See Biblio. 137, 194, 285, 289, 708, 1127.

About Evans

381. "The Ideas and Methods of Mr. Frederick H. Evans." *Photography,* 13 (2 January 1902), pp. 1–5.

382. Shaw, G. Bernard. "Evans—An Appreciation." *Camera Work,* No. 4 (October, 1903), pp. 13–16.

383. Lambert, F. C. "The Pictorial Work of Frederick H. Evans." *The Practical Photographer,* No. 5 (1903), pp. 1–5.

384. Hinton, A. Horsley. "Mr. Frederick Evans—A 'Romanticist' in Photography." *Magazine of Art* (London), n.s. 2 (June, 1904), pp. 372–377.

385. Anderson, A. J. "Mr. Evans' Exhibition of Multiple Mounting." *The Amateur Photographer,* 47 (11 February 1908), p. 140.

386. Touchstone [unidentified pseud]. "Photographers I Have Met: Frederick H. Evans." *The Amateur Photographer,* 50 (20 July 1909), p. 71.

387. Strasser, Alex. "Evans, Photographer." *The Saturday Book.* London, 1943. pp. 149–164.

388. Johnston, J. Dudley, Bernard Shaw, Charles Emanuel, Malcolm Arbuthnot, A. L. Coburn, Herbert Felton, J. R. H. Weaver. "In Praise of Frederick H. Evans, Hon. Fellow—A Symposium." *Photographic Journal,* 85A (February, 1945), pp. 31–38.

389. Coburn, A. L. "Frederick H. Evans." *Image, 2* (December, 1953), pp. 58–59.

390. Newhall, Beaumont. *Frederick H. Evans.* Rochester, New York, 1963. Rpt., Millerton, New York, 1973.

HERBERT G. FRENCH (American)

Fig. 21 » *Herbert G. French,* about 1920. Courtesy of The Cincinnati Art Museum, Cincinnati, Ohio.

CHRONOLOGY

1872: Born on January 17 in Covington, Kentucky.

1874: Moves to Chicago.

1885: Moves to Cincinnati; attends University of Cincinnati.

1893: Begins employment with Proctor and Gamble.

1902: Photograph reproduced in *The Photographic Times Bulletin* (February). » Founding member of the Photo-Secession, possibly introduced by Clarence White.

1906: (January 26–February 2) First solo exhibition, Photo-Secession Galleries, of photographs on the theme of Tennyson's *Idylls of the King.*

1909: Five gravures published in *Camera Work,* No. 27.

1910: Declines invitation from Stieglitz to submit work for Buffalo (1910) exhibition, saying, "I shall ask you to show no more of my work at any exhibitions whatsoever for the next few years" (French to A. S., 13 September 1910, YCAL). About this time becomes devoted to collecting etchings and lithographs.

1929: Donates funds for construction of wing to house newly established print department, Cincinnati Art Museum. Appointed trustee of the museum and curator of prints. Becomes a published poet.

1942: Dies on June 25, bequeathing to the Cincinnati Museum his collection of some 800 etchings, engravings and lithographs by artists from the Renaissance to modern times, as well as his photographs.

PHOTOGRAPHS

303 » *Egyptian Princess.* 1907 (A. S.) Gelatine silver, mounted on mica-flecked gray paper, upon blue with a narrow border, upon a larger sheet of the same mica-flecked gray paper. 241 × 188 mm. (9½ × 7⁷⁄₁₆ in.) 33.43.323.

Exhibitions: Cincinnati (1906), no. 21, titled *Egyptian Study,* suggesting a related composition; New York (PSG, 1906), no. 25; Philadelphia (1906), no. 48, titled

303 304

Princess of Egypt; New York (PSG, 1908), no. 16; Dresden (1909), no. 71; New York (NAC, 1909), nos. 119, 122.

Reproduced: *Camera Work,* No. 27 (July, 1909), pl. II, where it is stated that the "original negatives were used by the printer, with consequent sharpening of detail and resolution not present in this softly printed original."

Collections: Cincinnati Museum of Art.

304 » *Winged Victory.* 1907 (A. S.) Gelatine silver, mounted on brown paper upon green with a narrow margin, upon a larger sheet of the first brown paper. 230 × 188 mm. (9⅛ × 7⅜ in.) Stylized "HGF" monogram in pencil and dated. 33.43.324.

Exhibited: New York (PSG, 1907), no. 32, titled *Victory—A Study;* label of Dresden (1909) is affixed but this print is not listed in catalog.

Reproduced: *Camera Work,* No. 27 (July, 1909), pl. I.

Collections: Cincinnati Museum of Art.

EXHIBITIONS

Philadelphia 1900, 1901 » London 1902 » Dresden 1904 » London 1904 » Paris 1904 » Pittsburgh 1904 » Richmond 1905 » Vienna (C-K) 1905 » Vienna (PC) 1905 » New York (PSG) 1905 » Cincinnati 1906 » New York (PSG) Members' and solo 1906 » Philadelphia 1906 » Paris 1906 » New York (PSG) 1907 » New York (PSG) 1908 » Dresden 1909 » New York (NAC) 1909.

COLLECTIONS

The Cincinnati Museum of Art.

BIBLIOGRAPHY

Manuscript

391. Herbert Greer French File, Cincinnati Historical Society, Cincinnati, Ohio.

392. Stieglitz Archives, Collection of American Literature, Beinecke Rare Book and Manuscript Library, Yale University, New Haven, Conn.: 36 unpublished letters from Herbert G. French to Alfred Stieglitz and 1 unpublished letter from Alfred Stieglitz to Herbert G. French between 1904 and 1938.

By French

393. French, Herbert G. "Exhibition of Photographic Art at the Cincinnati Museum." *Camera Work,* No. 14 (April, 1906), pp. 47–48.

394. ———. "The Measure of Greatness." *Camera Work,* No. 27 (July, 1909), p. 45.

395. ———. *Songs of the Shore and Others.* Cincinnati, 1925.

396. ———. "Albrecht Dürer." *Cincinnati Museum Bulletin,* 7 (January, 1936), pp. 9–15.

About French

397. Allan, Sidney [Sadakichi Hartmann]. "Pictorial Criticism, Constructive, not Destructive." *The Photographer,* 1 (30 April 1904), p. 9.

398. Comstock, Helen. "The Herbert Greer French Collection of Prints." *Connoisseur,* 59 (March, 1942), pp. 60–62.

399. Berryman, Florence S. "Important Bequests to Ohio Museums." *Magazine of Art,* 35 (November, 1942), pp. 263–264.

400. Siple, Walter H. "Herbert Greer French." *Cincinnati Museum News Notes,* 1 (November, 1942), pp. 2–3.

ARNOLD GENTHE (American)

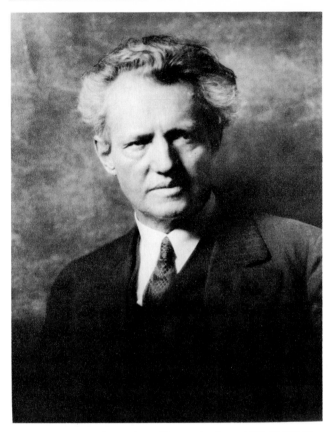

Fig. 22 » *Arnold Genthe.* Self-portrait, about 1920. 54.549.35. Gift of Clarence McK. Lewis.

CHRONOLOGY

1869: Born in Berlin.

1871: Moves to Frankfurt-am-Main.

About 1876: Moves to Corbach.

1886: Father dies. Lives in Hamburg.

1888–90: Studies at the University of Jena; admires art of Adolf Menzel, his mother's cousin.

1891: Studies at the University of Berlin, then returns to Jena.

1894: Receives doctorate from University of Jena; commences studies at the Sorbonne, Paris.

1895: Receives offer to go to the United States from Baron Heinrich von Schroeder to tutor his son, Heinz, and to reside in San Francisco.

1896: Arrives in U.S. Purchases first camera and begins to photograph Chinatown.

1897: Decides to remain in San Francisco; opens Sutter Street portrait studio.

1901: Accepted to Fourth Philadelphia Salon and one print reproduced in *Photographic Times* review of show (February, 1902), p. 80.

1902: Wins first prize for best collection; and portrait class, 2nd and 3rd, Los Angeles Salon. Builds at Carmel-by-the-Sea where he associates with Jack London, Mary Austin, and other writers.

1903: On jury of selection, 3rd San Francisco Photographic Salon. Active in San Francisco Society; member of Bohemian Club. Friendship with painters, writers, opera singers.

1904: Summer, visits Germany for last time to collect family effects.

1906: (April 17–18) San Francisco Fire and Earthquake, photographs the aftermath (Cats. 306, 307).

1907: Experiments with autochrome at Carmel studio.

1908: Visits Japan for 6 months.

1910: Exhibits in Open Section of Buffalo exhibition, after which Stieglitz acquires Genthe photographs for his collection. » Exhibits color portraits at Vickery Gallery, San Francisco.

1911: Moves to New York and soon establishes a portrait studio on the top floor of building at Fifth Avenue and 46th Street. Photographs Morgan Library objects in autochrome.

1911–16: Frequent visitor to White House where T. Roosevelt, Taft and Wilson are photographed.

1917: Anderson Gallery, New York, auctions some 400 Japanese prints collected by Genthe in the late 1890s under the guidance of Ernest Fenellosa.

1918: Becomes U.S. citizen. Is noted for photographing art works as well as portraiture.

1925: Photographs Greta Garbo soon after her arrival from Sweden.

1926: Travels to New Mexico, Guatemala, Mexico and New Orleans. » Begins to photograph dancers including Pavlova, Duncan, Terry, and Duse—a specialty he pursues for the rest of his career.

1936: Writes: "To Alfred Stieglitz of New York, more

310

305

308

309

than to any other man, must be given the credit for the place photography occupies among the graphic arts today. He exercised a far-reaching influence through his own superb work, and perhaps even more through that sumptuous publication, *Camera Work*. . . . His whole life has been devoted to the task of gaining recognition of photography as an art. . . ." (Biblio. 411, p. 264)

1942: Dies on August 9 in New Milford, Connecticut.

PHOTOGRAPHS

305 » *Ostende* [*Belgium*]. [1904]. Gelatin silver, mounted on black paper upon a larger sheet of tan Fabriano paper. 233 × 180 mm. (9³⁄₁₆ × 7⅛ in.) Signed in ink "Arnold Genthe/S. F." 33.43.227.

Genthe traveled in Europe during 1904 when this image was presumably made.

306 » *The First Light—San Francisco.* 1906. Gelatine silver. 226 × 308 mm. (8¹⁵⁄₁₆ × 12⅛ in.) Signed and dated in ink "Arnold Genthe/S. F. 1906." 33.43.225.

Plate 86.

Exhibited: Buffalo (1910), no. 524, titled as above.

Reproduced: *As I Remember* (Biblio. 411), where it is captioned *Steps that Lead to Nowhere* (*After the Fire*), opposite p. 94, a romantic title in comparison to the more sober title given thirty years earlier in the Buffalo (1910) exhibition catalog (Biblio. 1399).

The original negative is in the Palace of the Legion of Honor, San Francisco. Genthe reminisced: "Of another house all that remained were some chimneys and a foreground of steps. Beyond them was devastation with only the lights of the Mission District visible in the distance. It was another scene that had to be taken by moonlight so as to bring out its full significance" (p. 95). The earthquake occurred on April 18.

307 » *After the Earthquake, San Francisco.* 1906. Gelatine silver, mounted on a sheet of gray paper upon a larger sheet of tan paper. 133 × 235 mm. (5¼ × 9¼ in.) Signed in ink "Arnold Genthe/SF 1906." 33.43.223.

Plate 85.

Exhibited: Buffalo (1910), Open Section, no. 518, titled as above.

Reproduced: *International Studio* (Biblio. 1399b), p. xiv; Genthe (Biblio. 411), opp. p. 94.

Collections: IMP/GEH; Library of Congress.

The Open Section of the Buffalo show was introduced to provide geographical and esthetic diversity, a function that served Stieglitz well in bringing Genthe's work to his attention. It is likely that all of Genthe's work was acquired by Stieglitz from the exhibition.

308 » *Inland Sea* [*Japan*]. 1908. Gelatine silver. 339 × 237 mm. (13¼ × 9⁵⁄₁₆ in.) Signed in ink "Arnold Genthe." 33.43.224.

Exhibited: Buffalo (1910), no. 520; New York (Montross, 1912), no. 57.

Reproduced: Genthe (Biblio. 411), opp. p. 236.

Genthe traveled to Japan in 1908 and retained an interest in the studies he made there well after he began to devote full time to studio portraits.

309 » *A Temple Wall* [*Japan*]. 1908. Gelatine silver, mounted on brown paper with a narrow margin upon a larger sheet of tan wove paper. 232 × 186 mm. (9⅛ × 7⁵⁄₁₆ in.) Signed in ink "Arnold Genthe." 33.43.226.

Exhibited: Buffalo (1910), no. 532, titled as above.

Reproduced: Genthe (Biblio. 411), opp. p. 230.

310 » *Braubach on the Rhine*. 1908 (A. S.) Gelatine silver. 268 × 452 mm. (10⁹⁄₁₆ × 17¹³⁄₁₆ in.) 33.43.222.

Exhibited: Buffalo (1910), no. 517, titled *Village on the Rhine,* representing the identical or a related print.

Reproduced: *Academy Notes* (Biblio. 1399a), p. 5.

EXHIBITIONS

London 1901 » Philadelphia 1901 » Chicago 1901 » San Francisco 1902 » *Los Angeles 1902* » *St. Louis 1904* » Buffalo 1910 » *San Francisco (Vickerey Galleries) 1911* » New York 1912 » *Syracuse (College of F.A.) 1915*

COLLECTIONS

IMP/GEH; MOMA; MMA. Genthe negatives are in the Palace of the Legion of Honor, San Francisco.

BIBLIOGRAPHY

Manuscript

401. Stieglitz Archives, Collection of American Literature, Beinecke Rare Book and Manuscript Library, Yale University, New Haven, Conn.: one unpublished letter to Alfred Stieglitz from Arnold Genthe, n.d.

By Genthe

402. Genthe, Arnold. "The Children of Chinatown." *Camera Craft,* 2 (December, 1900), pp. 99–104.

403. ———. "A Critical Review of the Salon Pictures with a Few Words Upon the Tendencies of the Photographers." *Camera Craft,* 2 (February, 1901), pp. 307–320.

404. ———. "Rebellion in Photography." *Overland Monthly,* 38 (August, 1901), pp. 92–95.

405. ———. "Photographic Possibilities in Mexico." *Camera Craft,* 6 (November, 1902), pp. 31–33.

406. ———. "The Third San Francisco Salon." *Camera Craft,* 7 (November, 1903), pp. 207–218.

407. ———. *Pictures of Old Chinatown.* Text by Will Irwin. New York, 1913.

408. ———. *Book of the Dance.* Boston, 1920.

409. ———. *Impressions of Old New Orleans.* New York, 1926.

410. ———. *Isadora Duncan.* Foreword by Max Eastman. New York, 1929.

411. ———. *As I Remember.* New York, 1936.

About Genthe

412. Maurer, Oscar. "The Grand Prize Exhibit: A Criticism of the Work of Arnold Genthe." *Camera Craft,* 2 (February, 1901), pp. 298–299.

413. Allan, Sidney [Sadakichi Hartmann]. "Pictorial Criticism: Constructive, not Destructive—Three Pictures by Arnold Genthe." *The Photographer,* 1 (13 August 1904), p. 248.

414. ———. "Camera Impressionism: Dr. Arnold Genthe." *The Camera,* 14 (December, 1910), pp. 503–509.

415. ———. "A Photographer of Japan: Arnold Genthe." *Photographic Times,* 42 (December, 1910), pp. 458–464.

416. Irwin, Will. "Arnold Genthe." *Wilson's Photographic Magazine,* 50 (July, 1913), pp. 289–294.

417. "How Arnold Genthe Uses Sunlight to Capture Beauty." *Craftsman,* 29 (November, 1915), pp. 168–197.

418. "Arnold Genthe, American—Anderson Galleries." *Art News,* 28 (12 April 1930), p. 10.

419. Borglum, Gutzon. "Dr. Arnold Genthe's Art." *New York Herald Tribune,* 21 January 1939, p. 12.

420. *Arnold Genthe, 1869–1942.* Staten Island Museum, New York, exhibition catalog, 1975.

421. Beaton, Cecil and Gail Buckland. "Arnold Genthe." *The Magic Image.* Boston, 1975, p. 139.

PAUL HAVILAND (American)

Fig. 23 » *Paul B. Haviland.* By W[illiam]. D. H[aviland?]., about 1915. Courtesy of Graphics International Ltd., Washington, D.C.

Paul B. Haviland.

CHRONOLOGY

1880: Born on June 17 to Charles and Madeleine Burty Haviland in Paris, France. His father owned Haviland & Co., china manufacturers in Limoges, and his mother was the daughter of the famous art critic Philippe Burty.

1898: Receives a bachelor of letters degree in Philosophy from The University of Paris.

1899–1901: Attends Harvard University where he is enrolled in the graduate school.

1901–17: Works in New York City as a representative for his father's china firm.

1908: Meets Alfred Stieglitz; becomes active in the Photo-Secession Galleries about the time it comes to be called "291." When rising costs force the Stieglitz group out of their galleries at 291 Fifth Avenue, Haviland guarantees the rent at new accommodations across the hall at 293 Fifth Avenue. His name appears as a member of the Photo-Secession. Begins to photograph seriously about this time.

1909: Becomes a Fellow of the Council of the Photo-Secession and an associate editor of *Camera Work.* He also assumes the responsibilities of Secretary of the Photo-Secession Galleries. One gravure reproduced in *Camera Work,* No. 28 (October).

1910: Assists Stieglitz and Max Weber in hanging Buffalo show (Biblio. 1399).

1910–13: Actively works to acquire exhibits of modern painting and sculpture for 291 with Steichen.

1912: Wins 1st prize in John Wanamaker Exhibition of Photographs. Alfred Stieglitz judge; six gravures reproduced in *Camera Work,* No. 39 (July, 1912). Drops use of "Photo-Secession Galleries" in place of "291" [*Camera Work,* No. 37 (January, 1912), p. 46].

1914: His brother, Frank Burty (Haviland), has one-man show at 291. Two gravures reproduced in *Camera Work,* No. 46 (April, 1914).

1909–14: Actively contributes articles, reviews and translations of French materials to *Camera Work.*

1913: With Marius de Zayas, co-authors *A Study of the Modern Evolution of Plastic Expression* (Biblio. 430).

1915–16: With de Zayas, Stieglitz, Agnes Ernst Meyer, and Francis Picabia, edits the new avant-garde publication *291.*

1916: Returns to France and works in the family business at Limoges.

1917: Marries painter, decorator Suzanne Lalique, daughter of the noted glass designer.

1922–25: With the death of his father in 1922, becomes involved in legal entanglements concerning the ownership of the business. He continues to help run the business through this period. Subsequently purchases a 17th-century priory and becomes a gentleman farmer, specializing in viniculture.

1950: Dies at Yzeures-sur-Creuse, France, on December 21.

311

PHOTOGRAPHS

311 » *Miss G. G.* 1908. Gelatine silver.
242 × 193 mm. (9½ × 7⅝ in.) 33.43.336.
Exhibited: Buffalo (1910), no. 531, titled *Portrait—Gladys,* suggesting the identical or a related work.
Reproduced: *Camera Work,* No. 28 (October, 1909), titled as above, but with different proportions; *Wilson's Photographic Magazine,* 70 (January, 1911), p. 23.
The model is Gladys Granger.

EXHIBITIONS

Buffalo 1910.

BIBLIOGRAPHY

Manuscript

422. Stieglitz Archives, Collection of American Literature, Beinecke Rare Book and Manuscript Library, Yale University, New Haven, Conn.: 40 unpublished letters from Paul Haviland to Alfred Stieglitz and 6 unpublished letters from Alfred Stieglitz to Paul Haviland between 1908 and 1938.

By Haviland

423. Haviland, Paul. "The Home of the Golden Disk." *Camera Work,* No. 25 (January, 1909), pp. 21–22.

424. ———. Occasional monthly column in *Camera Work* entitled "The Photo-Secession Gallery," or "Photo-Secession Notes," or "Notes on the Exhibitions at 291" in Nos. 27, 31, 37, 38, 39, 42/43, and 44, from July 1909 to October 1913.

425. ———. "Quality in Prints." *Camera Work,* No. 30 (April, 1910), pp. 55–56.

426. ———. "Conception and Expression." *Camera Work,* No. 33 (January, 1911), pp. 33–34.

427. ———. "The Accomplishments of Photography and Contributions of the Medium to Art." *Camera Work,* No. 33 (January, 1911), pp. 65–67.

428. ———. "Art as a Commodity." *Camera Work,* No. 34/35 (April–July, 1911), pp. 68–69.

429. ———. "An Open Letter." *Camera Work,* No. 41 (January, 1913), pp. 42–43.

430. ——— and Marius De Zayas. *A Study of the Modern Evolution of Plastic Expression.* New York, 1913.

431. ———. "Marius De Zayas—Material, Relative, and Absolute Caricatures." *Camera Work,* No. 46 (April, 1914), pp. 33–34.

432. ———. "What 291 Means To Me." *Camera Work,* No. 47 (July, 1914), pp. 31–32.

433. ———. [Untitled]. *291,* No. 1 (March, 1915), n.p.

434. ———. "Man, The Machine and Their Product, The Photographic Print." *291,* Nos. 7–8 (September–October, 1915), n.p.

See Biblio. 302, 1132.

HUGO HENNEBERG (Austrian)

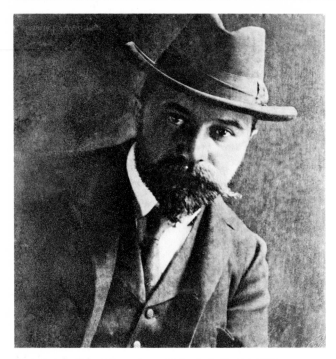

Fig. 24 » *Hugo Henneberg.* By Ludwig David, 1901. Courtesy of *Höhere Graphische Bundes-lehr-und Versuch-sanstalt,* Vienna.

CHRONOLOGY

1863: Born in Vienna, Austria.

1882–87: Studies physics, chemistry, astronomy, and mathematics in Jena and Vienna; completes a dissertation in physics.

1888: Travels to America.

1890: Becomes interested in photography and commences correspondence with Stieglitz. » Travels in Egypt and Greece.

1893: Exhibits photographs for the first time in Salzburg.

1894: Elected to The Linked Ring. » Gravures published in *Wiener Photographische Blätter,* Vol. I, frontispiece (Biblio. 1256). » Develops a friendship with Hans Watzek and later with Heinrich Kuehn.

1895: Exhibits in the London Photographic Salon, and is included in the Photographic Salon portfolio of 1895 (Biblio. 1267). » Is impressed with the gum prints exhibited by Demachy at the Paris Salon.

1896: Work reproduced in *Nach der Nature,* a lavish collection of thirty-two photogravures from the 1896 exhibition (Biblio. 1272). » In association with Watzek and Kuehn, experiments with gum-bichromate. The three make trips together to Germany, Italy, and Holland.

1897: Primarily photographs landscapes. » With Watzek and Kuehn, exhibits under the name and signature of the Trifolium [*Das Kleeblatt*] (Biblio. 1073), signing his prints with a symbolic three-leaf clover.

1898: Exhibits at the Munich "Sezession." » Begins to make paintings and etchings.

1900: Italian Landscape (Cat. 312) reproduced in *Camera Notes* (July), p. 29.

1902: Gravures of his gum prints published in lavish books of the Austrian School (Biblio. 1284, 1286). » Exhibits at the Vienna *Sezession,* open to pictorial photography for the first time.

1904: With Kuehn, supports the new *Wiener Photo-Club,* organized in competition with the *Camera-Klub;* first exhibition in Spring. » Redirects his interest to woodcuts.

1906: Three reproductions after his gum prints published in *Camera Work,* No. 13 (January). » German and Austrian Photographers: Heinrich Kuehn, Hugo Henneberg, Hans Watzek, Theodor and Oskar Hofmeister exhibition at the Photo-Secession Galleries (Biblio. 1381).

1911: Alvin Langdon Coburn writes that Henneberg has "become a painter because he considered photography too difficult" [*Camera Work,* No. 32 (January, 1911), p. 64. Reprinted from *Harper's Weekly*].

1918: Dies in Vienna at the age of 55.

PHOTOGRAPHS

312 » *Italianische Villa im Herbst* [*Italian Villa in Autumn*]. 1898. Blue-green pigment gum-

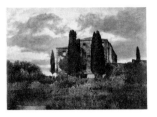

312

313

315

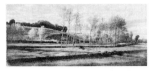

316

bichromate. 540 × 745 mm. (21¼ × 29⁵⁄₁₆ in.) Signed in watercolor "HVGO HENNEBERG—98." 33.43.411.

Exhibited: Munich (1898), no. 90; Hamburg (1898), no. 252; Munich (1898), no. 90, titled as above; Paris (1898), no. 290, titled *Villa italienne en automne;* London (1899), no. 250, titled *An Italian Villa* (see review, *Photograms of the Year 1899,* reprod. p. 97).

Reproduced: *Gummidruck* (Biblio. 1284), p. 13, titled *Italianische Villa im Herbst,* signed and dated 1897; *Camera Notes, 3* (January, 1900), p. 111, untitled.

The strong early exhibition record suggests the importance of this rich, very large print to his colleagues around the world who were interested in manipulated prints.

313 » [*An Italian Villa.*] 1898/1900. Brown pigment gum-bichromate. 558 × 745 mm. (22 × 29⁵⁄₁₆ in.) 33.43. 408.

314 » *Villa Falconieri, Frascati.* 1900. Gray-brown pigment gum-bichromate. 697 × 379 mm. (27⁷⁄₁₆ × 15 in.). Signed and dated in red watercolor with clover monogram "Hugo/Henneberg/1900." 33.43.407.

Plate 9.

Exhibited: New York (PSG, 1906), no. 1; Philadelphia (1906), no. 51; New York (NAC, 1909), no. 44; Buffalo (1910), no. 172.

Reproduced: *Camera Work,* No. 13 (January, 1906), pl. I, reproduced from this print. It is stated (p. 58) that the

originals from which our photogravures were made are mostly gum prints two by three feet, and more, in size, the

reduced picture, as appearing in our pages, necessarily loses some of that power and charm of technique, two factors that are so important in making the Viennese school what it is [*Academy Notes* (Biblio. 1399a)].

315 » *Motiv aus Pommern* [*Pommeranian Motif*]. 1902 print of 1895/1896 negative. Brown pigment gum-bichromate. 777 × 555 mm. (30⁵⁄₁₆ × 21⅞ in.) Signed and dated in watercolor with cloverleaf monogram "Hugo Henneberg/1902." 33.43.412.

Exhibited: London (1896), no. 8, titled *Village in Pomerania;* Paris (1896), no. 307, titled *Village en Pomeranie;* Munich (1898), no. 95, titled *Dorf in Pomern;* Berlin (1899), no. 258, titled *Dorf in Pommern;* New York (PSG, 1906), no. 2; Philadelphia (1906), no. 52, *Pommeranian Motif;* New York (NAC, 1909), no. 46; Buffalo (1910), no. 173, titled *Pomeranian Motif* and dated 1902.

Reproduced: Matthies-Masuren (Biblio. 1284), pl. X, titled *Motiv aus Pommern; Camera Work,* No. 13 (January, 1906), pl. III, reproduced from this print.

316 » *Frühlingslandschaft (Röm).* 1901. Green pigment gum-bichromate. 310 × 680 mm. (12³⁄₁₆ × 26¹¹⁄₁₆ in.) Signed in watercolor "Hugo Henneberg/1901"; signed and titled on verso as above. 33.43.410.

Exhibited: New York (PSG, 1906), no. 3, titled *The Approach of Spring;* Buffalo (1910), no. 171, titled *Spring Landscape* and dated as above.

317 » *Pflünger* [*Ploughing*]. 1903 print of negative from before 1901. Gray pigment gum-bichromate. 658 × 958 mm. (25¹⁵⁄₁₆ × 37¾ in.)

317

318

Signed in watercolor "Hugo Henneberg."
33.43.413.
Exhibited: Berlin (1899), no. 261, titled as above;
Philadelphia (1906), no. 50; New York (NAC, 1909),
no. 45; Buffalo (1910), no. 170, titled *Ploughing.*
 Reproduced: *Photographische Centralblatt, 7*
(1901), adj. to p. 185.

318 » *Platz in Kempten.* 1904. Brown pigment
 gum-bichromate. 528 × 654 mm. (20¹³⁄₁₆ ×
 25¾ in.) Signed and dated in watercolor with
 cloverleaf monogram "Hugo/Henneberg/
 1904." 33.43.409.
Exhibited: Hague (1904), no. 594; Dresden (1904),
no. 77, titled as above; New York (NAC) 1909, no.
47, titled *A Street in Kempten.*
 Reproduced: *Demachy et Puyo* (Biblio. 273), pl.
XXIV.

EXHIBITIONS

Vienna 1891 » London [1893], 1894–1899 »
Paris 1894–1898 » Brussels 1895 » Berlin 1896 »
Hamburg 1896 » Hamburg 1898–1899 » Munich
1898 » Berlin 1899 » Vienna (Museum für Kunst
und Industrie) 1899 » London 1901–1902 »
London (RPS) 1901 » Brussels 1903 » Hamburg
1903 » Dresden 1904 » Hague 1904 » London
1904 » Vienna (PC) 1904 » Vienna (C-K) 1905
» New York (PSG) 1906 » Philadelphia 1906 »
London (NEAG) 1907 » New York (NAC)
1909 » Buffalo 1910.

BIBLIOGRAPHY

Manuscript

435. Stieglitz Archives, Collection of American
Literature, Beinecke Rare Book and Manuscript
Library, Yale University, New Haven, Conn.: 38
unpublished letters from Hugo Henneberg to Alfred
Stieglitz between 1890 and 1909.

By Henneberg

436. Henneberg, Hugo. "Praktische Mitteilungen
für Landschafts-photographen." *Wiener Photo-
graphische Blätter, 2* (May, 1895), pp. 89–95.
437. ———. "Erfahrungen über Negative auf
Bromsilberpapier," *Wiener Photographische Blätter,*
3 (January, 1896), pp. 4–6.
438. ———. "Eine Camera für Landschafts-Auf-
nahem im Formate von 40 × 60 cm." *Wiener
Photographische Blätter,* 3 (February, 1896), pp.
27–29.
439. ———. "Ein Beitrag zur Technik des Gummi-
druckes." *Wiener Photographische Blätter,* 4 (March,
1897), pp. 65–72.
440. ———. "Erfahrungen über den farbigen
Gummidruck im Landschaftsfache Dreifarbendruck."
Wiener Photographische Blätter, 4 (November, 1897),
pp. 229–237.
441. ——— and Frein von Hubl. "Der Combina-
tions-Einfarbendruck." *Wiener Photographische
Blätter,* 5 (March, 1898), pp. 54–59.

About Henneberg

 See Biblio. 998A.
442. M. [F. Matthies-Masuren]. "Hugo Henneberg."
Photographisches Centralblatt, 5 (September, 1899),
pp. 357–360.
443. "Zum Henneberg-Heft." *Photographisches
Centralblatt, 7* (July, 1901), pp. 137–147.
444. Matthies-Masuren, Fritz. "Hugo Henneberg—
Heinrich Kühn—Hans Watzek." *Camera Work,* No.
13 (January, 1906), pp. 23–41.
445. Speer, Hermann. "Die Wiener Schule: Hugo
Henneberg—Heinrich Kühn—Hans Watzek." *Künst-
photographie um 1900.* Museum Folkwang, Essen,
exhibition catalog, 1964, pp. 19–21.
 See Biblio. 1073, 1178, 1183, 1195.

DAVID OCTAVIUS HILL & ROBERT ADAMSON (Scottish)

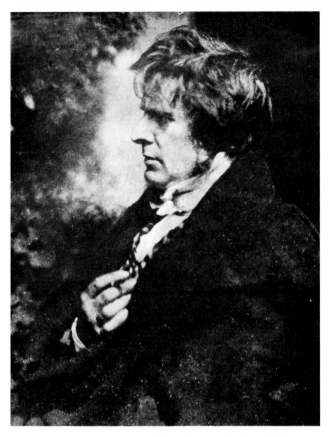

Fig. 25 » *David Octavius Hill*. Self-portrait, about 1850. 46.1.24. McAlpin Fund.

Fig. 26 » *Robert Adamson*. Self-portrait (detail of Adamson family group), 1844–1848. Reproduced from Biblio. 459.

HILL CHRONOLOGY

1802: Born in Perth, Scotland, the eighth son of Thomas Hill, a publisher and bookseller. Educated at Perth Academy.

1821–23: His *Sketches of Scenery in Perthshire, drawn from nature and on stone* (Biblio. 446A)—a book of twenty-five landscapes done in the relatively new medium of lithography—is published by his father. Hill had received his formal artistic training under Andrew Wilson at the School of Design in Edinburgh.

1823–29: Frequently exhibits his landscape paintings and lithographs at the Royal Institution in Edinburgh.

1829: Dissatisfied with the conservatism of the Royal Institution in Edinburgh, founds the Society of Artists, which becomes the Royal Scottish Academy, with a group of fellow artists.

1830: Becomes Secretary of the Royal Scottish Academy, a post he holds until 1869.

1837: Marries Ann Macdonald, an amateur musician. The couple lives at Moray Place in the New Town district of Edinburgh and has a daughter, Charlotte.

1843: Introduced to photography by the pioneer Scottish calotypist, Robert Adamson, with whom he shares a collaboration of four years. Hill's intention is to paint a monumental work in commemoration of the dramatic secession of four-

hundred-and-seventy-four ministers from the Church of Scotland, for which calotypes are used as an aid to rendering the figures. Moves to Adamson's studio at Rock House, Calton Stairs, Edinburgh, and lives there until 1864.

1844–48: Exhibits calotypes at the Royal Scottish Academy, work described as "executed by R. Adamson under the artistic direction of D. O. Hill."

1846: With Adamson, publishes *A Series of Calotype Views of St. Andrews* (Biblio. 446).

1847: Collaboration with Adamson ends when the latter leaves Edinburgh in autumn to return to St. Andrews due to poor health. Hill apparently lacks the technical skills to continue. Adamson dies on January 14, 1848.

1851: A selection of Hill and Adamson's calotypes receive honorable mention at the Crystal Palace exhibition.

1862: Collaborates with A. McGlashan, a wet-plate photographer, to produce "Some Contributions towards the use of Photography" (MMA). Hill and McGlashan exhibit fourteen prints at the Sixth Annual Exhibition of the Photographic Society of Scotland and are awarded a prize for their portrait of Dr. Brown. Marries the sculptress Amelia Paton.

1866: Completes painting *The Signing of the Deed of Demission,* begun in 1843, for which many calotypes are used as models. It is exhibited in Glasgow and Edinburgh, is purchased for £1,500, and is presented as a gift to the Free Church of Scotland.
 » Collaborates with Thomas Annan (father of James Craig Annan) to produce photographic reproductions of the Disruption Painting for the purpose of selling them to members of the Free Church (MMA).

1870: Dies on May 17, and is buried in the Dean Cemetery, Edinburgh.

About 1890: J. Craig Annan begins to re-photograph the Hill-Adamson calotypes and make photogravures of them.

1898: Almost seventy Hill-Adamson photographs are exhibited by The Royal Photographic Society in London's Sydenham Crystal Palace.

1901: Nine prints exhibited at Glasgow (Biblio. 1336), several lent by J. Craig Annan.

1905: Six gravures printed by Annan published in *Camera Work,* No. 11 (July).

1906: Stieglitz organizes exhibition at the Photo-Secession Galleries at 291 (February 21–March 7), drawn from Annan and other sources.

1908: Keiley unearths a collection of calotypes in London and receives one as a gift.

1909: The London Photographic Salon exhibits nearly same selection as at Buffalo (1910) exhibition. Six gravures published in *Camera Work,* No. 28 (October).

1910: Forty of Hill and Adamson's prints are exhibited at the International Exhibition of Pictorial Photography at the Albright Art Gallery, Buffalo, including seven platinum prints by Coburn from original negatives and 28 original calotypes. The catalog states, "the work of the late David Octavius Hill is worthy of the closest attention and study by every serious photographer of today. This worker has been referred to as the pioneer of pictorial portrait photography. . ." (Biblio. 1399). Stieglitz saw in the powerful portrayal of human character a lesson for his own time.

1912: Nine photogravures published in *Camera Work,* No. 37 (January). April, Photo-Secession Gallery exhibition of Hill announced by Stieglitz.

1914: Represented in an exhibition of "The Old Masters of Photography," arranged by Alvin Langdon Coburn and held in December at the Ehrich Galleries, New York.

ADAMSON CHRONOLOGY

1821: Born on April 26 in St. Andrews, son of Alexander Adamson, a Fifeshire farmer.

About 1839: Learns calotype process from his brother, John, who had been privy to early communications from W. H. Talbot, inventor of the process.

1843: Opens his calotype studio at Rock House, Calton Stairs, Edinburgh—the first such studio in Scotland. Begins his collaboration with David Octavius Hill.

1847: Returns to St. Andrews in the autumn due to ill health.

1848: Dies on January 14, at the age of twenty-seven, probably of consumption.

PHOTOGRAPHS

Calotype

The name of Robert Adamson (1821–1848) was not commonly associated with Hill's in the making of the pioneer Scottish calotypes until later in the twentieth century, and Stieglitz identified their works with Hill's name alone. Adamson learned the relatively new calotype process from his brother John, who in turn had been kept informed by Sir David Brewster of important experiments being conducted by W. H. Fox Talbot at Lacock Abbey near Bath, England, between 1835 and 1839. As one of Talbot's Scottish correspondents, Brewster was sent first-hand reports during 1840–1842 which he conveyed to his friend John Adamson, who used them to duplicate Talbot's process before it was made public in all its details. John Adamson taught the process to his brother, Robert, who in 1843 formed a partnership with Hill. The partnership put Hill in the role of artistic director, while Adamson was the technical maestro. This division of labor was, as far as can be determined, a well-set pattern in making the clerical and aristocratic portraits that formed the bulk of the studio output, and likewise of that collected, exhibited, and published by Stieglitz. Adamson had an artistic life of his own, and to him may be ascribed the documentary outdoor views that include the building of the Scott monument, Edinburgh castle views, St. Andrews and New Haven views, and the assembly of scientists at Linlithgow, none of which were collected by Stieglitz. W. H. Fox Talbot designated prints made from his paper negatives as "calotypes" from the Greek meaning "beautiful pictures." He patented the process and hence "calotype" became a trade name that should only be applied to prints made with Talbot's method, the essential elements of which are as follows: a sheet of writing paper is sensitized with silver nitrate and table salt, pinned into the back of the camera, and exposed. The paper is then developed to yield a negative using specified procedures. When dry, the negative is

printed on a sheet of drawing paper sensitized in a roughly similar manner. The paper negative endows the print with a softness that was very much admired by Stieglitz's associates whose own soft-focus pictures required special lenses.

All prints are from negatives of 1844–1848.

319 » *Mrs. Rigby.* Calotype. 209 × 155 mm. (8⅛ × 6⅛ in.) 49.55.313.
Exhibited: Glasgow (1901), no. 43; New York (PSG, 1906), no. 34; Philadelphia (1906), no. 55; London (1909), no. 130; Buffalo (1910), no. 39; Newark, N.J. (Public Library) 1911, no. 87.

Reproduced: Schwarz (Biblio. 454), pl. 15.

Anne Palgrave Rigby (1777–1872), the celebrated wife of a Norfolk doctor, was photographed on several occasions by Hill and Adamson, as were her daughters. MMA 43.10.40 (Gift of McDonald and Tutchings) shows the sitter in the same costume but a different pose.

Carbon Prints (*Arranged in sequence established by Elliot [Biblio. 452]*)

All of the carbon prints collected by Stieglitz are among the forty-eight carbon prints mounted in Elliot (Biblio. 452), which strongly suggests they were single prints made by Jesse Bertram for that edition. Michaelson (Biblio. 459) writes of this project:

Andrew Elliot senior (1830–1922), a nephew of D. O. Hill, took over the bookseller and printer's business in Prince Street in 1898 which had belonged to D. O. Hill's brother, Thomas Hill. . . . He also worked with Miss Jesse Bertram (1882–1954) a photographer of 138 Rose St, to print in 1916 about 300 carbon or pigment prints from Hill's paper negatives, which were sold in boxed sets from A. Elliot's establishment at 17 Prince St.

Carbon prints have very sharply defined edges and tones, and an overall uniformity rare in original calotypes. The opacity of carbon pigment contradicts the translucent image structure of original prints. Moreover, the surface of carbon was prone to crazing, as is evident in several that Stieglitz collected, which constituted fourteen of the seventeen prints exhibited at the Photo-Secession Galleries in 1906.

319 320 321 322

320 » *Hugh Miller [1802–1856].* (Attributed to Robert Adamson.) No later than July 5, 1843. Carbon. 266 × 186 mm. (10½ × 7¹⁵⁄₁₆ in.) 49.55.312.

Reproduced: Elliot (Biblio. 452), pl. III.

 Collections: IMP/GEH; MMA.

 Bruce (Biblio. 461A, p. 29) dates this print as above for unspecified reasons. If correct, the image could represent as much the eye of Adamson as that of Hill since the date would place it at the earliest phase of their collaboration.

 Miller was a stonemason, geologist, and author, who was deeply involved in the Demission of the Free Church.

321 » *William Etty, R.A.* 16 October 1844. Carbon, badly crazed. 201 × 149 mm. (7¹⁵⁄₁₆ × 5⅞ in.) 33.43.217.

Exhibited: New York (PSG, 1906), no. 28; Philadelphia (1906), no. 56.

 Reproduced: Elliot (Biblio. 452), pl. IV; Michaelson (Biblio. 459), p. 159, dated as above.

 Etty (1787–1849) was a popular painter of genre subjects, who painted his self-portrait based on the calotype.

322 » *David Scott, R.A.* Carbon, slightly crazed and peeling in small areas. 199 × 148 mm. (8⅞ × 5¹³⁄₁₆ in.) 33.43.219.

Exhibited: New York (PSG, 1906), no. 25; Philadelphia (1906), no. 57; Buffalo (1910), no. 11.

Reproduced: Elliot (Biblio. 452), pl. VI.

 Scott (1806–1849) was a historical painter and colleague of Hill's at the Royal Scottish Academy.

323 » *Dr. Chalmers.* Carbon. 285 × 206 mm. (11¼ × 8⅛ in.). 49.55.311.

Exhibited: New York (PSG, 1906), no. 24, titled as above, its customary title in Hill's time.

 Reproduced: Elliot (Biblio. 452), pl. XVII.

 Reverend Dr. Thomas Chalmers (1780–1847) served as Chairman of the First General Assembly of the Free Church of Scotland in 1843, an ecclesiastical secession that was the cause of Hill's commencing the partnership with Robert Adamson. The negative was larger than that used for the majority of the Assembly portraits, perhaps to suggest his premier role in that event.

324 » *Dr. [Jabez] Bunting.* Carbon with a light crazing surface. 205 × 151 mm. (8¹⁄₁₆ × 5¹⁵⁄₁₆ in.) 33.43.216.

Exhibited: New York (PSG, 1906), no. 31; Philadelphia (1906), no. 59.

 Reproduced: Elliot (Biblio. 452), pl. XII.

 Collections: IMP/GEH; MMA.

325 » *Lady Ruthven.* Carbon, badly crazed. 202 × 150 mm. (7¹⁵⁄₁₆ × 5¹⁵⁄₁₆ in.) 33.43.220.

Exhibited: New York (PSG, 1906), no. 35; Philadelphia (1906), no. 53; London (1909), no. 132; Newark, N.J. (Public Library), 1911, no. 88; Buffalo (1910), no. 40.

323

324

325

326

Reproduced: *Camera Work,* No. 11 (July, 1905),
pl. III; Holme (Biblio. 1288) opp. p. 12; Elliot (Biblio.
452), p. XX; *Academy Notes* (Biblio. 1399a) p. 12.

Collections: IMP/GEH; MMA.

Lady Ruthven, née Mary Campbell (1789–1885),
married Lord Ruthven in 1813. She was a dilettante and
friend of Sir Walter Scott.

326 » *Mr. Rintoul, Editor of the Spectator.* Carbon.
200 × 153 mm. (7⅞ × 6 in.) Inscribed with
title in pencil, possibly by J. Craig Annan.
49.55.309.

Exhibited: Glasgow (1901), no. 37, lent by J. Craig
Annan.

Reproduced: See Cat. 338, copied from the same
original but printed in gravure; Elliot (Biblio. 452),
pl. XXVI.

Collections: IMP/GEH; MMA.

The carbon and gravure prints differ considerably in
surface appearance, tonal scale, and hue. The gray
printer's ink of the gravure gives a different effect from
the reddish brown pigment of the carbon. Also evident
in this print is the greater vulnerability of carbon versus
gravure, in its surface that is crazed and cracked
through the gelatine layer across the lower right corner.

327 » *Very Rev. Principal Haldane.* Carbon (re-
versed), moderately crazed. 207 × 155 mm.
(8³⁄₁₆ × 6⅛ in.) 33.43.218.

Exhibited: New York (PSG, 1906), no. 30; Philadel-
phia (1906), no. 54; Buffalo (1910), no. 5, titled as above.

Reproduced: *Camera Work,* No. 37 (January, 1912),
pl. I; Schwarz (Biblio. 454), pl. 36, both in reverse of
this print but representing the correct state. A portrait
from the same sitting but a different negative is repro-
duced in Elliot (Biblio. 452) pl. XXVII.

Haldane (1772–1854), a theologian and mathema-
tician who became moderator of the General Assembly
of the Free Church of Scotland in 1827, remained loyal
to the Free Church, while many of his colleagues par-
ticipated in the secession that first brought Hill to
photography.

328 » *Lord Robertson.* Carbon. 189 × 139 mm.
(7⁷⁄₁₆ × 5½ in.) 33.43.221.

Exhibited: New York (PSG, 1906), no. 22; Phila-
delphia (1906), no. 60.

Reproduced: Elliot (Biblio. 452), pl.XXX.

Collections: AIC, Stieglitz Collection; IMP/GEH;
MMA.

Lord Patrick Robertson (1794–1855) was an Edin-
burgh lawyer and amateur poet.

329 » *Mrs. Rigby.* Carbon, surface peeling. 205 ×
151 mm. (8¹⁄₁₆ × 5¹⁵⁄₁₆ in.) 33.43.215.

Exhibited: See Catalog 319.

Reproduced: *Photographische Rundchau* (1900),
p. 40; *Camera Work,* No. 11 (July, 1905), pl. II.;
Academy Notes (Biblio. 1399a), p. 14.

Collections: AIC, Stieglitz Collection, original calo-
type; Elliot (Biblio. 452), pl. XXXIV.

Anne Rigby (1777–1872) sat for Hill on at least four

327 328 329 330

occasions. The second wife of Edward Rigby of Norwich, she was mother of Lady Eastlake and also a favorite sitter of Hill's.

330 » *Doctor Monro.* Carbon. 201 × 147 mm. (7^{15}/$_{16}$ × 5^{13}/$_{16}$ in.) 33.43.214.
Exhibited: New York (PSG, 1906), no. 33; Philadelphia (1906), no. 61; Buffalo (1910), no. 30 (spelled incorrectly, Monroe); Newark, N.J. (Public Library) 1911, no. 86.
 Reproduced: *Camera Work,* No. 11 (July, 1905), pl. II; Holme (Biblio. 1288), opp. p. 4; Schwarz (Biblio. 454), pl. 9; Elliot (Biblio. 452), pl. XXXIX.
 Collections: IMP/GEH; MMA.
 Alexandro Monro (1773–1859) was Professor of Anatomy at the University of Edinburgh; his name often appears as "Munro."

Photogravures (Arranged in sequence established by Stieglitz in Camera Work)

An edition of twenty subjects was printed in gravure on Japanese tissue in 1905 by T. & R. Annan of Glasgow (Biblio. 448, p. 20). Gravure shares with carbon a uniformity of tone not characteristic of calotypes; but the slightly textured surface, the translucent effect of printer's ink on tissue, and the capacity to accurately render the soft resolution make the gravures more faithful renderings of the originals, although lacking in the wall-power of the carbon prints.

An edition of hand-printed photogravures was also made by J. Craig Annan, who had access to the original paper negatives in the possession of Andrew Elliot. The following impressions (except where noted otherwise) are from carefully etched and warmly inked plates, on the same paper with uniform captions. They were proofs pulled apparently before the steel facing, and the same plates were used to print *Camera Work,* No. 37 (January, 1912).

Each plate has a margin of approximately ¼ inch of unetched plate that has been left to print with traces of the wiping, where each title has been uniformly written in pencil.

331 » *Mrs. Anna Brownell Jameson.* 1845. Hand-printed photogravure by J. Craig Annan. 203 × 146 mm. (8 × 5¾ in.) Titled in pencil on margin by J. Craig Annan "Mrs. Anna." 49.55.255.
Exhibited: Hamburg (1899), no. 665; Glasgow (1901), no. 41, lent by J. Craig Annan; Buffalo (1910), no. 9, original calotype.
 Reproduced: *Photographische Rundchau,* 14 (January, 1900), p. 30; *Photograms of the Year 1901,* p. 15; *Camera Work,* No. 11 (July, 1905), pl. VII; Juhl (Biblio. 1285), p. 7.
 Collections: AIC, Stieglitz Collection, original calotype.
 Traces of wiping at the bottom margin where the plate is unbitten indicate that the print was hand inked.
 Mrs. Jameson (1794–1860) writer, critic, and traveler, sat for Hill in the summer of 1845 on her visit to Edinburgh. She was briefly (and stormily) married to Robert Jameson who became Canada's Attorney-General.

331 332 333 335

332 » *The Marquis of Northampton [1790–1851].*
Hand-printed photogravure by J. Craig
Annan. 200 × 149 mm. (7⅞ × 5⅞ in.) Titled
in pencil on margin by Annan. 49.55.257.
Reproduced: *Camera Work*, No. 37 (January, 1912),
pl. II; Schwarz (Biblio. 454), pl. 4; Elliot (Biblio. 452),
in reverse of this print.

Spencer Joshua Alywne, Lord Compton, second
Marquis of Northampton, was educated at Cambridge.
He was a member of Parliament (1812–1820), President
of the Geological Society (1820–1822), and President of
the Royal Society (1838–1849).

333 » *Handyside Ritchie & Wm Henning.* Hand-
printed photogravure by J. Craig Annan.
213 × 159 mm. (8½ × 6½ in.) Titled as
above in pencil on margin by Annan. 49.55.253.
Exhibited: Buffalo (1910), no. 18.

Reproduced: *Photographische Rundchau*, 14 (Jan-
uary, 1900), p. 24; *Camera Work*, No. 37 (January,
1912), pl. III, titled as above; Elliot (Biblio. 452), pl. IX.

William Henning (1771–1851) at right and Alexander
Handyside Ritchie (1804–1870) were sculptors, both
favorite sitters of Hill.

334 » *Handyside Ritchie and Wm Henning.*
Mechanically (?) printed photogravure.
213 × 158 mm. (8⅜ × 6½ in.) 49.55.314.
Not illustrated.
Exhibited: See Cat. 333.

Collections: AIC, Stieglitz Collection, reversed car-
bon print.

Cat. 333 is copied from the same original. The per-
fect wiping at the bottom margin of this print com-
pared to Cat. 333 suggests that it was printed mechan-
ically.

335 » *Sir Francis Grant, P. R. A.* Hand-printed
photogravure by J. Craig Annan. 200 × 147
mm. (8⅞ × 5¹³⁄₁₆ in.) Titled as above in
pencil on margin by Annan. 49.55.251.
Reproduced: *Camera Work*, No. 37 (January, 1912),
pl. IV, where a brief biography is given (p. 48) and it
is stated that Annan made the prints; Schwarz, (Biblio.
454), pl. 44, in reverse.

Grant (1803–1878) was a painter of portraits and
sporting scenes; especially notable was his equestrian
group including the Queen and Lord Melborne, 1840.
He was a member of Royal Academy (1851), its Presi-
dent (1866–1878), and was knighted in 1866. Among
his sitters were Macaulay and Landseer.

336 » *Lady [Ruthven] in Black.* Hand-printed
photogravure by J. Craig Annan. 209 × 157
mm. (8¼ × 6³⁄₁₆ in.) Titled as above in pen-
cil on margin by Annan. 49.55.254.
Exhibited: Glasgow (1901), no. 42, titled, *Portrait of a
Lady*, lent by Andrew Elliot; Dresden (1904), no. 70,
lent by Ernst Juhl, titled as above; Buffalo (1910), no.
29, *Portrait of a Lady*, the only untitled female por-
trait in gravure exhibited.

Reproduced: *Camera Work*, No. 37 (January,
1912), pl. VI; Biblio. 462, p. 205.

Traces of wiping at the uninked bottom margin

336

337

338

where plate is unbitten indicate this print to be hand
inked.

337 » *Mr. Rintoul, Editor of the Spectator.* Hand-
printed photogravure by J. Craig Annan.
201 × 149 mm. (7¹⁵⁄₁₆ × 5⅞ in.) Titled as
above in pencil on margin by Annan. 49.55.252.
Exhibited: New York (PSG, 1906), no. 29, a carbon
incorrectly titled *Mr. Rintone;* Buffalo (1910), no. 14,
likewise incorrectly identified.
 Reproduced: *Camera Work,* No. 37 (January, 1912),
pl. IX; *Photograms of the Year 1901,* p. 17; Juhl,
(Biblio. 1285), p. 5; Elliot (Biblio. 452), pl. XXVI.
 Cat. 330 is copied from the same original but printed
in carbon.
 Robert Stephen Rintoul (1787–1858) was editor of
the liberal *The Dundee Advertiser* (1811–1825). He
became editor of London's *Spectator* until his death.

338 » *Lady in a Flowered Dress [Miss Wilhelmina
Fillans].* Hand-printed photogravure by
J. Craig Annan. 205 × 156 mm. (8¹⁄₁₆ ×
6⅛ in.) Titled in pencil on margin by Annan
as above. 49.55.256.
Miss Fillans aspired to become a sculptor following her
father James's profession.

EXHIBITIONS

Edinburgh (RSA) 1844–1846 » *London (Crystal
Palace) 1851* » *London (New Crystal Palace) 1898*
» *Hamburg 1899–1900* » *Glasgow 1901* » *Dres-*
den 1904 » *Vienna (PC) 1905* » *New York
(PSG) 1906* » *Philadelphia 1906* » *London 1909*
New York (NAC) 1909 » *Buffalo 1910* »
Newark (Public Library) 1911 » *New York (PSG)
1912* » *New York (Ehrich) 1915.*

COLLECTIONS

IMP/GEH; MOMA; RPS; MMA. For other collec-
tions see Biblio. 459.

BIBLIOGRAPHY

By Hill and Adamson

 446. Hill, David Octavius. *Sketches of Scenery in
Perthshire, drawn from nature and on stone.* Edin-
burgh, 1821–23.
 446A. Hill, David Octavius and Robert Adamson. *A
Series of Calotype Views of St. Andrews.* Edinburgh,
1846.

About Hill and Adamson

 447. Lichtwark, Alfred. "Incunabeln der Bildnispho-
tographie." *Photographische Rundchau,* 14 (February,
1900), p. 25.
 448. Annan, J. Craig. "David Octavius Hill, R.S.A.
1802–1870." *Camera Work,* No. 11 (July, 1905), pp.
17–21.
 449. Sharp, Mrs. William. "D. O. Hill, R.S.A."
Camera Work, No. 28 (October, 1909), pp. 17–19.
 450. Inglis, Francis Caird. "D. O. Hill, R.S.A., and

His Work." *Photographic Journal,* 52 (January, 1915), pp. 3–7.

451. Coburn, Alvin Langdon. "The Old Masters of Photography." *Century Magazine,* 90 (October, 1915), pp. 911–916.

452. Elliot, A. *Calotypes by D. O. Hill and R. Adamson.* Edinburgh, 1928. 47 original carbon prints by Jesse Bertram.

453. Strand, Paul. "Review of *David Octavius Hill, Master of Photography* by Heinrich Schwarz." *Saturday Review of Literature,* 8 (12 December 1931), p. 372.

454. Schwarz, Heinrich. *David Octavius Hill, Master of Photography,* translated by Helene E. Fraenkel. New York, 1931.

455. Stieglitz, Alfred. "To the Art Editor." *New York Times,* 28 February 1932, section 8, p. 11. (G. App. 526)

456. Nickel, H. *David Octavius Hill.* Halle, 1960.

457. *David Octavius Hill, Robert Adamson, Inkunabeln der Photographie.* Introduction by Otto and Marlis Steinert. Folkwang Museum, Essen, exhibition catalog, 1963.

458. Dunbar, A. "The Work of David Octavius Hill, R.S.A." *Photographic Journal,* 104 (March, 1964), pp. 53–64.

459. Michaelson, Katherine. *A Centenary Exhibition of the Work of David Octavius Hill and Robert Adamson.* Scottish Arts Council, Edinburgh, exhibition catalog, 1970.

460. Schwarz, Heinrich. "The Calotypes of D. O. Hill and Robert Adamson: Some Contemporary Judgments." *Apollo,* 95 (February, 1972), pp. 123–128.

461. Ford, Colin. *The Hill/Adamson Albums.* Introduction by Roy Strong. London, 1973.

461A. Bruce, David. *Sun Pictures: The Hill and Adamson Calotypes.* Greenwich, Conn., 1973.

462. Ford, Colin and Roy Strong. *An Early Victorian Album, The Photographic Masterpieces (1843–1847) of David Octavius Hill and Robert Adamson.* London, 1974 and New York, 1976.

A. HORSLEY HINTON (English)

Fig. 27 » *A. Horsley Hinton*. By Frederick Hollyer, about 1905. Courtesy of The Royal Photographic Society, London.

CHRONOLOGY

1863: Born in London, England, Alfred Horsley Hinton, son of Alfred and Mary (Witherington) Hinton.

1875: Makes landscape sketches and paintings.

1882: First landscape photographs.

1885: Opens a commercial firm dealing in photographic goods in London.

1887: Editor of *Photographic Art Journal* (London) (Biblio. 1249).

1891: Photographic Art Journal ceases publication. Opens a portrait studio at Guildford and begins writing for *The Amateur Photographer* (Biblio. 1244).

1893: Participates in the first Linked Ring Salon called The Photographic Salon at The Dudley Gallery, London.

1894: Awarded medal at the Royal Photographic Society exhibition for *Harvesting the Reeds*. First book, *A Handbook of Illustration*, published. Lectures at The Dudley Gallery on "The legitimacy of hand-work in Photography" (October 17).

1897: Becomes Editor of *The Amateur Photographer* (London).

1899: Organizes British section of the Philadelphia Photographic Salon. *Day's Decline,* gravure published in *Camera Notes* (July). Keiley devotes over one page analyzing his contribution to the Philadelphia 1899 Salon (Biblio. 542, pp. 155–56).

1900: Writes on the issue of straight versus manipulated prints, *Camera Notes* (Biblio. 474).

1904: Visits America to supervise the installation of a collection of British photographs exhibited at the St. Louis Exposition. While in America, photographs Niagara Falls.

1905: Two gravures published in *Camera Work,* No. 11 (July).

1908: Dies suddenly in his home in Essex on February 24, eulogized in Europe and America.

1910: H. Snowdon Ward lists Hinton in a pantheon of the greatest British photographers along with "D. O. Hill, Mrs. Julia Margaret Cameron, H. P. Robinson, O. G. Rejlander" (Biblio. 1130, p. 25).

PHOTOGRAPHS

339 » *Fleeting Shadows.* 1897 or before. Gelatine silver. 478 × 360 mm. (18¹³⁄₁₆ × 14³⁄₁₆ in.) Signed "A Horsley Hinton" in negative from original print. 33.43.354.
Plate 4.
Exhibited: London (1897), no. 60 (priced at three

guineas); Philadelphia (1899), no. 160; Hamburg (1902), no. 298.

Reproduced: *Camera Notes,* 3 (January, 1900), f.p., halftone opp. p. 138. Stieglitz apologizes for the lack of fidelity in the reproduction, p. 114.

This enlargement was printed from a negative of a print on which various hand manipulations were made.

EXHIBITIONS

London (Photographic Society) 1889–1891 » Vienna 1891 » London 1893, 1894–1904 » *London (RPS) 1894, 1897* » Paris 1894–1898 » Brussels 1895 » London 1897–1899 » Philadelphia 1898–1899 » Glasgow 1901 » Hamburg 1902–1903 » Leeds 1902 » Paris 1902 » Turin 1902 » Bradford 1904 » Dresden 1904 » Paris 1904 » Vienna (C-K) 1905 » Vienna (PC) 1905 » London 1906 » Paris 1906 » Dresden 1909.

BIBLIOGRAPHY

Manuscript

463. Stieglitz Archives, Collection of American Literature, Beinecke Rare Book and Manuscript Library, Yale University, New Haven, Conn.: 113 unpublished letters from Alfred Horsley Hinton to Alfred Stieglitz between 1896 and 1907.

By Hinton

464. Hinton, A. Horsley. "The Office and Future of Our Exhibitions." *The Amateur Photographer,* 15 (16 September 1892), pp. 192–194.

465. ———. "Die Sprache der Photographie." *Wiener Photographische Blätter,* 1 (October, 1894), pp. 205–208.

466. ———. *A Handbook of Illustration.* London, 1894.

467. ———. "The Pall Mall Show, 1894" (RPS). *The Photogram,* 2 (November, 1895), pp. 262–273.

468. ———. "Faking and Control in Principle and Practice." *Photographic Times,* 30 (February, 1898), pp. 67–74.

469. ———. "Englische Landschaftsphotographie," in Biblio. 1260, Vol. II, 1898, pp. 41–48.

470. ———. *Practical Pictorial Photography.* London, 1898.

471. ———. "Both Sides." *Camera Notes,* 2 (January, 1899), pp. 77–80.

472. ———. "Individuality—Some Suggestions for the Pictorial Worker." *Photographic Times,* 31 (January, 1899), pp. 12–19.

473. ———. "Some Motives." *Camera Notes,* 3 (October, 1899), pp. 49–58.

474. ———. "Some Distinctions." *Camera Notes,* 3 (January, 1900), pp. 91–101.

475. ———. "Naturalism in Photography." *Camera Notes,* 4 (October, 1900), pp. 83–91.

476. ———. "The Measure of Pictorial Excellence." *The Amateur Photographer,* 32 (December, 1900), p. 473.

477. ———. "Notes on the Salon, Intended to Help the Less Advanced Photographic Visitor." *The Amateur Photographer,* 34 (September 27, October 11, 1901), pp. 244–245, 285–286.

478. ———. "Influences." *Camera Notes,* 5 (October, 1901), pp. 84–91.

479. ———. "Too Early Satisfied." *Camera Notes,* 5 (January, 1902), pp. 165–169.

480. ———. "Is It Well?" *Camera Work,* No. 4 (October, 1903), pp. 41–44.

481. ———. "Impressionist in Photography." *Magazine of Art,* 28 (December, 1903), pp. 63–68.

482. ———. "A Question of Technique." *Camera Work,* No. 5 (January, 1904), pp. 30–34.

483. ———. "Some Elementary Principles in Pictorial Photography." *The Amateur Photographer,* 39 (January 21, 28, February 11, 18, 1904), pp. 43–44, 63–64, 102–103, 123–124.

484. ———. " 'Quality' and the 'Artist.' " *The Amateur Photographer,* 39 (16 June 1904), pp. 466–468.

485. ———. "Notes on Some of the Principal Pictures at Holland's First International Salon of Art Photography." *The Amateur Photographer,* 40 (7 July 1904), pp. 3–4.

486. ———. "Practical Lessons for the Beginner." *The Amateur Photographer,* series of articles from 40 (28 July 1904), to 47 (14 January 1908).

487. ———. "Accidents." *The Amateur Photographer*, 40 (25 October 1904), pp. 333–335.

488. ———. *To Make Bad Negatives into Good*. London, 1904.

489. ———. "Landscape Photography." *Photo Era* 18 (May, 1907), pp. 227–234.

See Biblio. 45, 248, 283, 348, 1107, 1108, 1231.

About Hinton

490. "Horsley-Hintons Kopier Verfahren." *Photographische Rundchau*, 12 (February, 1898), p. 89.

491. Lambert, F. H. "The Pictorial Work of A. Horsley Hinton." *Practical Photographer*, 2 (May, 1904), pp. 1–7.

492. "A Conversation with A. Horsley Hinton." *The Photographer*, 1 (7 May 1904), pp. 18–20.

493. "Death of Mr. Horsley Hinton." *British Journal of Photography*, 55 (28 February 1908), pp. 160–161.

494. Keighley, Alexander. "Alfred Horsley Hinton." *The Amateur Photographer*, 47 (10 March 1908), p. 219.

495. Maskell, Alfred. "A. Horsley Hinton and the Photographic Salon." *The Amateur Photographer*, 47 (10 March 1908), pp. 220–221.

496. Wright, Percy G. R. "Alfred Horsley Hinton— As I Knew Him." *The Amateur Photographer*, 47 (24 March 1908), pp. 283–284.

497. "A. Horsley Hinton." *Camera Work*, No. 22 (April, 1908), p. 41.

498. "A. Horsley Hinton." *Who's Who, 1908*, British edition, p. 876.

TH. & O. HOFMEISTER (German)

Fig. 28 » *Th.* and *O. Hofmeister*, about 1905. Courtesy of Fritz Kempe, Hamburg.

CHRONOLOGY

1865: Theodor born.

1869: Oskar born.

1895: Reside in Hamburg. Become amateur photographers; Theodor, a wholesale merchant in door handles; Oskar, secretary of the county court house.

1896: Active in the Hamburg Amateur Photographic Society. Exhibit under joint authorship.

1897: About this time, begin to use gum process almost exclusively. Male nudes, peasant types and landscapes their main subjects.

340

1898: Catalog of Hamburg (1896) exhibition (Biblio. 1315) profusely illustrated with halftone reproductions of Hofmeister photographs, including many bled to edge of page, a novel treatment for the times.

1902: By this time doing mainly landscape.

1903: Receive award at Wiesbaden Salon.

1904: By this time Oskar makes exposures, Theodor develops. Six gravures published in *Camera Work,* No. 7 (July), the first German or Austrian work to be published there. Kuehn has great distaste for what he considers to be their garish palette.

1937: Oskar dies.

1943: Theodor dies.

PHOTOGRAPHS

340 » *Einsamer Reiter [Solitary Horseman].* 1903. Blue pigment gum-bichromate. 685 × 980 mm. (27 × 38⅝ in.) Signed in watercolor with monogram and date "T. & O. H./1903/ Hamburg"; inscribed on verso in blue crayon pencil on old backings "Th. & O. Hofmeister— Hamburg/Einsamer Reiter—1903." 33.43.414.

Exhibited: Hamburg (1903), no. 199; Dresden (1904), no. 81 with reproduction; Vienna (P C, 1904), no. 3, as *Einsamer Reiter;* New York (PSG, 1906), no. 18, as *Solitary Horseman;* New York (NAC, 1909), no. 55; Buffalo (1910), no. 195, titled and dated as above.

Reproduced: *Camera Work,* No. 7 (July 1904), p. 5.

A note in the Buffalo (1910) catalog read: "This

print the Hofmeisters considered, in 1904, their most important example, and were only willing to part with it to an American collector [Stieglitz] because they wished to be represented in this country by their best and such it still remains" (Biblio. 1399, p. 24).

"The most unforgettable photograph in the show was perhaps the very large print by Theodor and Oskar Hofmeister called *Solitary Horseman* which astonished everyone by its size as well as its somber decorative qualities." [J. Nilson Laurvik, *Camera Work*, No. 26 (April, 1909), p. 41].

EXHIBITIONS

Hamburg 1896 » Hamburg 1898–1900 » London 1898 » London (RPS) 1898 » Munich 1898 » Paris 1898 » Berlin 1899 » New York (AI) 1899 » Philadelphia 1900 » Glasgow 1901 » Hamburg 1902 » Leeds 1902 » Brussels 1903 » Hamburg 1903 » Wiesbaden 1903 » Dresden 1904 » Vienna (PC) 1904–1905 » New York (PSG) 1906 » Philadelphia 1906 » London 1908 » Dresden 1909 » New York (NAC) 1909 » Buffalo 1910 » London 1910.

BIBLIOGRAPHY

Manuscript

499. Stieglitz Archives, Collection of American Literature, Beinecke Rare Book and Manuscript Library, Yale University, New Haven, Conn.: 4 unpublished letters from Theodor and Oskar Hofmeister to Alfred Stieglitz in 1904.

500. Stieglitz Archives, Collection of American Literature, Beinecke Rare Book and Manuscript Library, Yale University, New Haven, Conn.: 2 unpublished letters from Oskar Hofmeister to Alfred Stieglitz in 1911.

By Th. or O. Hofmeister

501. Hofmeister, Theodor. "Der Gummidruck und seine Verwendbarkeit als künstlerisches Ausdrucksmittel." *Photographische Rundchau,* 12 (April, 1898), pp. 97–102.

502. ———. "Praktische Erfahrungen über die Verwendung von Objektiven in der künstlerischen Photographie." *Photographische Rundchau,* 12 (April, 1898), pp. 113–118.

503. ———. "Der Gummidruck und seine Verwendbarkeit als künstlerisches Ausdrucksmittel." *Photographische Rundchau,* 12 (May, 1898), pp. 130–140.

504. ———. "Vom Figurenbild." *Photographische Rundchau,* 12 (September, 1898), pp. 260–270.

505. ———. "Vom Figurenbild." *Photographische Rundchau,* 12 (December, 1898), pp. 356–363.

506. Hofmeister, Theodor and Oskar. *Das Figurenbild in der Kunstphotographie.* Halle, 1898.
See Biblio. 1284.

About Th. and O. Hofmeister

507. Juhl, Ernst. "Some Notes on the Work of Theodor and Oskar Hofmeister." *The Amateur Photographer,* 34 (20 September 1901), pp. 231–233.

508. Hartmann, Sadakichi. "The Solitary Horseman." *Camera Work,* No. 7 (July, 1904), pp. 17–18.

509. Juhl, Ernst. "Theodor and Oskar Hofmeister of Hamburg." *Camera Work,* 7 (July, 1904), pp. 18–20.

510. Kempe, Fritz. "Th. und O. Hofmeister—Meister des Missverständnisses." *Foto-Prisma* (October, 1963), pp. 543–549.

GERTRUDE KÄSEBIER (American)

Fig. 29 » *Gertrude Käsebier*. By Alvin Langdon Coburn, 1903 or before. Cat. 125.

CHRONOLOGY

1852: Born Gertrude Stanton in Des Moines, Iowa and raised in a mining camp near Leadville, Colorado. Later lives with her grandmother in Pennsylvania and attends college.

1894: On May 18, marries Edward Käsebier, a shellac importer from Wiesbaden, Germany, a tenant at her mother's New York boarding house. Three children issue from the marriage.

About 1888: Enters Pratt Institute, Brooklyn, to study portrait painting.

1892: (January) Awarded $50 prize in *The Monthly Illustrator* photographic competition.

1893: To Europe as chaperone for summer class from Pratt. Becomes involved in photography, and goes to Germany to apprentice with a German chemist to learn the technical side of photography.

1895: European photographs are published in *The Monthly Illustrator* (Biblio. 513).

1897: Works in the Brooklyn photographic studio of Samuel Lifshey for a few months to learn the business side of portrait photography. » Opens portrait studio in New York, near 32nd Street. » Exhibits 150 portrait studies (February) at the Boston Camera Club, and at the Pratt Institute.

1898: Exhibits ten photographs in the first Philadelphia Photographic Salon, glowingly reviewed by Keiley (Biblio. 518). » Reminisces about her career in photography before the Photographic Society of Philadelphia, and is published in *Photographic Times* (Biblio. 514).

1899: On the jury of the Philadelphia Photographic Salon (Biblio. 1329). Her print *The Manger* is sold for $100, the highest price yet paid for a pictorial photograph. Called "beyond dispute the leading portrait photographer in this country" [*Camera Notes*, V. 3, No. 4 (April, 1900), p. 195]. » Keiley marvels, "a year ago [Käsebier's] name was practically unknown in the photographic world. . . . Today that name stands first and unrivalled. . . ." (Biblio. 539, pp. 126–128). » Work reproduced in: Camera Club of New York Portfolio *American Pictorial Photography* (Biblio. 1279).

1900: Becomes a member of the Camera Club of New York. » Buys print of Stieglitz's *Black Forest Studio* at auction for $8.00. First woman to be elected to The Linked Ring. » Called in Newark exhibition catalog as "the foremost professional photographer in the United States" (Biblio. 1333). » Member of Jury of the Philadelphia Photographic Salon (Biblio. 1334). Exhibits ten prints, including *Blessed Art Thou Among Women* (Cat. 345).

1901: Charles H. Caffin's *Photography as a Fine Art* (Biblio. 522, 1282) devotes a chapter to Käsebier's work and career. » Travels in Europe seeing Day and The Linked Ring crowd. » Spends much time with Steichen in Paris.

1902: Visits Clarence White in Newark, Ohio (Cat. 360).

1903: Six gravures published in the premier number of *Camera Work*. Two articles on her, by Charles H. Caffin (Biblio. 523) and by Frances B. Johnston (Biblio. 524).

1905: Six gravures published in *Camera Work*, No. 10 (April).

1906: Joint exhibition at Photo-Secession Galleries with Clarence White (Biblio. 1378).

1908: Has falling-out with Stieglitz which de Meyer attempts to patch up.

1909: Wins a Diploma for the Gold Medal at the International Photographic Exposition, Dresden, in the professional photography class [*Camera Work*, No. 28 (October, 1909), p. 37].

1910: Edward Käsebier dies. » President of the Women's Federation of the Professional Photographers Association of America. » Exhibits 22 prints in the "International Exhibition of Pictorial Photography," Albright Art Gallery, Buffalo. *The Manger* purchased by the Albright Art Gallery.

1911: Critical attack on Käsebier by Keiley in *Camera Work*, No. 33 (Biblio. 561, p. 27). » Represented in the London Secession exhibition by special invitation (Biblio. 1422).

1912: Käsebier sends her resignation from the Photo-Secession to Stieglitz. (Käsebier to Stieglitz, 6 January, YCAL) » July, travels to Newfoundland, where she prepares a photojournal of the region.

1916: Helps to found and becomes a member of Pictorial Photographers of America.

1929: Exhibition at the Brooklyn Institute of Arts and Sciences. » Liquidates her studio.

1934: Dies on October 12, at the age of 82, at the home of her daughter, Hermine W. Turner.

PHOTOGRAPHS

341 » [*First Photograph*]. About 1888. Albumen. 95 × 117 mm. (3¾ × 4⅝ in.) Inscribed in pencil on old mount by A. S.: "Käsebier's first photograph/given to me by Mrs. Käsebier/ 1900/Stieglitz Coll." 33.43.140.

341

342

Not so different from countless better-than-average amateur snapshots, this photograph did not herald the successful career which followed.

342 » [*Cornelia Montgomery*]. About 1896. Platinum. 123 × 113 mm. (4⅞ × 4⁷⁄₁₆ in.) Embossed in blind-stamp script "Gertrude Käsebier" on top. 33.43.134.

Reproduced: *Camera Notes, 3* (July, 1899), p. 9, where it is reproduced uncaptioned from this print. The context is Hartmann's Biblio. 1078.

Dow (Biblio. 516), writing in the *Camera Notes* issue where this print is reproduced, expresses the adulation in which Käsebier was held and which earned her such a reputation: "She looks for some special evidence of personality in her sitter, some line, some silhouette, some expression or movement; she searches for character and for beauty in the sitter" (p. 22). In "Our Illustrations" on the following page, Stieglitz writes: "Mrs. Käsebier is, beyond question, the leading portrait photographer in this country. Her pictures are broad, full of color and harmony, and above all, have the great charm of a keen artistic feeling and temperament. Their strength never betrays a woman."

343 » *"Portrait Miss N."* 1898 (A. S.) Platinum. 200 × 142 mm. (7⅞ × 5⅝ in.) Monogram "GK" on mount. 33.43.137.

Exhibited: Philadelphia (1899), no. 184.

The sitter is Evelyn Nesbitt, the actress and mistress of architect Stanford White, who was killed by her husband, Harry K. Thaw.

349

343 347 350

344 » *Mr. [F. Holland] Day.* About 1898. Plati-
num. 180 × 136 mm. (7⅛ × 5⅜ in.)
49.55.188.
Figure 13.
Exhibited: Philadelphia (1899), no. 186; New York
(TCC, 1900); Chicago (1900), no. 107; Newark, Ohio
(1900), no. 107; London (NSAP, 1900), no. 125; Paris
(NSAP, 1901), no. 81, all representing related if not the
identical photograph.
Reproduced: *Camera Notes,* 3 (July, 1899), p. 35.

345 » *Blessed Art Thou Among Women.* 1899.
Platinum. 230 × 132 mm. (9¹/₁₆ × 5³/₁₆ in.)
Inscribed verso by A. S.: "Stieglitz Collection/
Blessed be Thou Among Women/1897/
Gertrude Kasebier." 33.43.132.
Plate 39.
Exhibited: Philadelphia (1900), no. 107, titled as above;
Newark, Ohio (1900), no. 99; Glasgow (1901), no. 386;
London (NSAP, 1900), no. 126, titled *Thou Art Most
Blessed Among Women;* Paris (NSAP, 1901), no. 82;
New York (NAC) 1902, no. 67; Turin (1902), no. 73;
Leeds (1902), no. 795; Hamburg (1903), no. 241; San
Francisco (1903), no. 13; Pittsburgh (1904), no. 115;
Bradford (1904), no. 195; Dresden (1904), no. 109;
New York (PSG, 1906), no. 3.
Reproduced: *Camera Notes,* 4 (July, 1900), opp. p.
18; *American Pictorial Photography* (ser. II), pl. I;
International Kunst Photographien (II), p. 20; *Camera
Work,* No. 1 (January, 1903), pl. III.
Collections: IMP/GEH; MOMA.
The title is from Luke I.28: "Hail, thou that art

highly favored, the Lord is with thee: blessed art thou
among women."
Stieglitz's dating of the print is contradicted by the
National Arts Club catalog which cites 1899, the pre-
ferred date.
This print is trimmed to exclude the vertical white
line from top to bottom in the *Camera Notes* and
Camera Work gravures, and has a band of atmospheric
gray from edge to edge at the level of the child's waist.
The exhibition and reproduction records attest to
the universal esteem in which this work was held then,
popularity which has not abated since.

346 » *Mother and Child.* 1899 (A. S.) Platinum.
201 × 130 mm. (7¹⁵/₁₆ × 5⅛ in.) Monogram
"GK" on mount. 33.43.141.
Plate 38.
Exhibited: Prints titled as above, but not necessarily of
this negative: Philadelphia (1898), no. 106 or 115; Phil-
adelphia (1899), no. 181; Chicago (1900), no. 56; New-
ark, Ohio (1900), nos. 101–106; New York (TCC,
1900); Paris (NSAP, 1901), no. 88; Wiesbaden (1903),
no. 145; Bradford (1904), no. 219; Portland, Oregon
(1905); New York (PSG, 1906), no. 4.
Reproduced: Caffin (Biblio. 1282, p. 53), where it is
titled *Decorative Panel.*

347 » *Mother and Child.* 1899 (A. S.) Platinum.
183 × 92 mm. (7³/₁₆ × 3⅝ in.) Signed, titled,
and dated in pencil on mount; blindstamp
"Gertrude K[äsebier]"; rubber stamp on
verso, "With Permission of An American

351

352 353

Place/Kindly Return Photo, Keep Clean."
49.55.189.
Exhibited: Philadelphia (1898), no. 106; New York
(PSG, 1906), no. 4, both titled as above.
 Reproduced: *Camera Notes,* 3 (July, 1899), p. 15.

348 » *The Sketch [Beatrice Baxter].* 1899 (A. S.)
 Platinum. 153 × 207 mm. (6¹⁄₁₆ × 8³⁄₁₆ in.)
 33.43.136.
Plate 41.
Exhibited: London (1904), no. 162; Philadelphia
(1906), no. 71; Newark (Public Library) 1911, no.
95.
 Reproduced: *La Revue de Photographie,* 3 (April,
1905), p. 21.

349 » *The Picture Book [Beatrice Baxter].* Plati-
 num, mounted on two layers of paper, tan and
 gray. 1899 (A. S.) 155 × 207 mm. (6¹⁄₁₆ ×
 8³⁄₁₆ in.) Signed in pencil on mount "Gertrude
 Käsebier." 33.43.143.
Exhibited: Buffalo (1910), no. 318.
 Reproduced: *Camera Work,* No. 10 (April, 1905),
pl. II, which shows more of the subject than this print;
Academy Notes (Biblio. 1399a, p. 6), incorrectly cred-
ited to de Meyer. *La Revue de Photographie,* 4 (Oc-
tober, 1906), p. 293.
 Collections: IMP/GEH.
 The sitter and location are same as Cat. 348, said to
be Newport, R.I., and dated by others 1902.

350 » *Portrait.* 1899 (A. S.) Platinum. 163 × 115
 mm. (6⁷⁄₁₆ × 4⁹⁄₁₆ in.) 33.43.139.

Reproduced: *Photographisches Centralblatt,* 5 (Oc-
tober, 1899), p. 398.

351 » *Clarence H. White, Esq.* 1903 print of nega-
 tive of before 1899. Gray pigment gum-
 bichromate. 133 × 212 mm. (5¼ × 8⅜ in.)
 Inscribed on verso by A. S. in brown crayon
 pencil: "Photographed by Gertrude Kasebier/
 Portrait of Clarence White/to be returned to
 Gertrude Kasebier 273 . 5th Ave/City." In-
 scribed in pencil used to cross out address:
 "1903/Gum Print Stieglitz Collection/AS."
 33.43.138.
Exhibited: Newark, Ohio (1899), no. 219; London
(NSAP, 1900), no. 109, titled as above; Paris (NSAP,
1901), no. 68; New York (NAC, 1902), no. 75; all
simply titled *Clarence White.*

352 » *Happy Days.* 1902. Platinum, mounted on
 two layers of gray and tan paper. 198 × 149
 mm. (7¹³⁄₁₆ × 5⅞ in.) Signed in pencil on
 mount "Gertrude Käsebier." 33.43.142.
Exhibited: Pittsburgh (1904), no. 122; Vienna (1905),
no. 13; New York (PSG, 1905); Cincinnati (1906), no.
25; Philadelphia (1906), no. 67.
 Reproduced: *Camera Work,* No. 10 (April, 1905),
pl. XIV, cropped at right edge.
 Collections: IMP/GEH (dated 1902).

353 » *[Girl with the Hat].* [1902]. Platinum. 313 ×
 223 mm. (12⁵⁄₁₆ × 8¹³⁄₁₆ in.) Signed faintly in
 pencil "Gertrude Käsebier" in stylized block
 letters. 49.55.190.

355

357

358

359

Exhibited: New York (NAC, 1902), no. 74, suggesting the above title.

354 » *Alfred Stieglitz.* 1902. Platinum on tissue, touched with pencil near face; mounted on a large sheet of gray paper upon a sheet of brown with narrow border. 337 × 245 mm. (13¼ × 9⅝ in.) Signed in white crayon pencil "Gertrude Käsebier"; titled and dated in brown crayon pencil "Alfred Stieglitz/ MCMII/." 49.55.170.

Plate 42.

Exhibited: Newark, Ohio (1900), no. 113; New York (PSG, 1906), no. 30; London (1906), no. 119; Hamburg (1903), no. 237.

Collections: AIC, Stieglitz Collection, signed and dated 1906.

The tissue appears from its irregularities to have been sensitized by hand, printed to give a black margin at top and a white one at bottom. The photograph exemplifies the painterly qualities attainable with platinum materials.

355 » *Family Group.* 1902 (A. S.) Platinum. 196 × 137 mm. (7¾ × 5⅜ in.) Signed in pencil "Gertrude Käsebier" in compressed block letters making "Käsebier" barely legible. 33.43.370.

Exhibited: New York (NAC, 1902), no. 78, titled as above; New York (Montross, 1912), no. 67, titled *The Family,* representing the identical or related works.

Reproduced: *Wilson's Photographic Magazine,* 46 (May, 1909), p. 214.

A variant is in the collection of the University of Kansas Art Museum.

356 » *The Bat.* 1904 print of 1902 negative. Platinum, with charcoal frame drawn around print. 205 × 150 mm. (8¹⁄₁₆ × 5¹⁵⁄₁₆ in.) Signed and dated in pencil "MDMIV/Gertrude Käsebier" in stylized numerals and letters; inscribed on verso in pencil by A. S.: "White claims that he and Mrs. K. did this together./ That it was his idea. That Mrs. White is the model:/Photographed on Mrs. K's visit to Newark, Ohio/A. S." 33.43.133.

Plate 40.

Exhibited: Leeds (1902), no. 798, exhibited as Käsebier; Hamburg (1903), no. 236, titled as above; Dresden (1904), no. 108; Newark (Public Library), 1911, no. 99.

Reproduced: *Photo-Magazine,* No. 24 (13 June 1909), p. 189, titled *Le Chauve-souris.*

The portrait session took place on Käsebier's visit to Newark, Ohio, of August, 1902.

357 » *Blossom Day.* 1904/1905 (A. S.) Platinum touched with white chalk or other pigment, mounted on four layers of gray paper. 137 × 150 mm. (5⅜ × 5¹⁵⁄₁₆ in.) Signed in pencil on mount "Gertrude Käsebier"; inscribed on verso by A. S. in pencil: "Blossom Day/$15/ by Gertrude Käsebier." 33.43.135.

Exhibited: New York (PSG, 1906), no. 9, titled as above.

358 » *Mrs. Alfred Stieglitz.* About 1905. Platinum,

mounted on two layers of brown paper on top of gray. 193 × 153 mm. (7⅝ × 6¹⁄₁₆ in.) Monogram "GK" (oversize) in tan and black crayon pencil. 33.43.144.

359 » *Mrs. Alfred Stieglitz.* About 1905. Platinum on tissue, horizontal lines of paper visible. 204 × 150 mm. (8¹⁄₁₆ × 5¹⁵⁄₁₆ in.) Signed illegibly in pencil "GK—." 33.43.145.

360 » *Clarence H. White and Family.* 1908 print of 1902 negative. Platinum, mounted on light brown paper with thread margin upon a similarly margined sheet of black, upon a larger sheet of natural Japanese which in turn is mounted on heavy American wove paper. 205 × 156 mm. (8¹⁄₁₆ × 6⅛ in.) Signed faintly in soft pencil "Gertrude Käsebier," and touched with charcoal pencil throughout. 33.43.418.
Plate 43.
Exhibited: New York (PSG, 1906), no. 33; Buffalo (1910), no. 316, dated 1901–1908, lent by Stieglitz; Newark, N.J. (Public Library), 1911, no. 98.

From left to right are Lewis, Maynard, Clarence, and Mrs. White, according to the recollections of Mrs. Clarence H. White (who dated this print 1902) to A. Hyatt Mayor in 1939.

This is one of the most powerful group portraits Stieglitz collected, which expresses familial tenderness in a tightly organized composition, playing light against dark, solid against void, and rectilinear against curvilinear shapes. The negative was presumably made on Käsebier's visit to Newark in August of 1902.

EXHIBITIONS

Boston (CC) 1897 » Philadelphia 1898–1900 » Berlin 1899 » London 1899–1902 » *New York (TCC) 1899* » *Boston (CC) 1900* » Chicago 1900 » Newark 1900 » Glasgow 1901 » London (NSAP) 1900 » Paris (NSAP) 1901 » Hamburg 1902 » Leeds 1902 » New York (NAC) 1902 » Paris 1902 » Turin 1902 » Washington 1902 »

Brussels 1903 » Cleveland 1903 » Denver 1903 » Hamburg 1903 » Minneapolis 1903 » Rochester 1903 » San Francisco 1903 » Toronto 1903 » Wiesbaden 1903 » Bradford 1904 » Dresden 1904 » Hague 1904 » London 1904 » Paris 1904 » Pittsburgh 1904 » Vienna (PC) 1904–1905 » Washington 1904 » New York (PSG) 1905 » Portland 1905 » Richmond 1905 » Vienna (C-K) 1905 » New York (PSG) 1905 » Cincinnati 1906 » London 1906 » London 1906 » Paris 1906 » Philadelphia 1906 » New York (PSG) 1906 » New York (PSG) 1907 » *London (NEAG) 1907* » *Paris (Volnay) 1908* » Dresden (1909) » *New York (NAC) 1909* » London 1909–1910 » Buffalo 1910 » London 1910 » *London (Secession) 1911* » Newark (Public Library) 1911 » New York (Montross) 1912 » London (RPS) 1914 » *Syracuse (University) 1915.*

COLLECTIONS

IMP/GEH; MOMA; RPS.

BIBLIOGRAPHY

Manuscript

511. Stieglitz Archives, Collection of American Literature, Beinecke Rare Book and Manuscript Library, Yale University, New Haven, Conn.: 21 unpublished letters from Gertrude Käsebier to Alfred Stieglitz and 4 unpublished letters from Alfred Stieglitz to Gertrude Käsebier between 1899 and 1914.

512. *Scrapbook of clippings.* Käsebier estate, New York, N.Y.

By Käsebier

513. Käsebier, Gertrude. "An Art Village." *The Monthly Illustrator,* 4 (April, 1895), pp. 9–17.

514. ———. "Studies in Photography." *Photographic Times,* 30 (June, 1898), pp. 269–272.

515. ———. "To Whom It May Concern." *Camera Notes,* 3 (January, 1900), pp. 121–122.

About Käsebier

516. Dow, Arthur W. "Mrs. Gertrude Käsebier's Portrait Photographs—From a Painter's Point of View." *Camera Notes,* 3 (July, 1899), pp. 22–23.

517. Stieglitz, Alfred. "Our Illustrations." *Camera Notes,* 3 (July, 1899) p. 24.

518. Keiley, Joseph T. "Mrs. Käsebier's Prints." *Camera Notes,* 3 (July, 1899), p. 34.

519. Cram, R. A. "Mrs. Käsebier's Work." *Photo Era,* 4 (May, 1900), pp. 131–136.

520. Hartmann, Sadakichi. "Gertrude Käsebier." *Photographic Times,* 32 (May, 1900), pp. 195–199.

521. Watson, Eva Lawrence. "Gertrude Käsebier." *American Amateur Photographer,* 12 (May, 1900), pp. 219–220.

522. Caffin, Charles H. "Gertrude Käsebier and the Artistic Commercial Portrait." *Photography as a Fine Art.* New York, 1901. Rpt. Hastings-on-Hudson, 1971, pp. 51–81.

523. Caffin, Charles H. "Mrs. Käsebier's Work—An Appreciation." *Camera Work,* No. 1 (January, 1903), pp. 17–19.

524. Johnston, Francis Benjamin. "Gertrude Käsebier, Professional Photographer." *Camera Work,* No. 1 (January, 1903), p. 20.

525. Bayley, R. Child. "A Visit to Mrs. Käsebier's Studio." *Wilson's Photographic Magazine,* 40 (February, 1903), pp. 73–74.

526. Keiley, Joseph T. "Mrs. Käsebier." *American Amateur Photographer,* 15 (February, 1903), pp. 78–79.

527. Demachy, Robert. "Mme. Käsebier et son oeuvre." *La Revue de Photographie,* 4 (October, 1906), pp. 289–295.

528. Edgerton, Giles [Pseud. Mary Fanton Roberts]. "Photography as an Emotional Art." *Craftsman,* 12 (April, 1907), pp. 80–93.

529. Keiley, Joseph T. "Mrs. Gertrude Käsebier, Some Account of Her Work, Life and Influence Upon Pictorial Photography in America." *Camera Work,* No. 20 (October, 1907), pp. 27–31.

530. Bunnell, Peter C. "Käsebier, Gertrude Stanton." *Notable American Women: 1607–1950.* Cambridge, Mass., 1971, pp. 308–309.

531. Holm, Ed. "Gertrude Käsebier's Indian Portraits." *The American West,* 10 (July, 1973), pp. 38–41.

532. Tucker, Anne. "Gertrude Käsebier." *The Woman's Eye.* New York, 1973, pp. 13–27.

533. Bunnell, Peter. "Gertrude Käsebier." *Arts in Virginia,* 16 (Fall, 1975), pp. 2–15.

534. Michaels, Barbara L. "Rediscovering Gertrude Käsebier." *Image,* 19 (June, 1976), pp. 20–31.

535. Tighe, Mary Anne. "Gertrude Käsebier Lost and Found." *Art in America,* 65 (March–April, 1977), pp. 94–98.

JOSEPH T. KEILEY (American)

Fig. 30 » *Joseph T. Keiley*. By Gertrude Käsebier, 1900. Reproduced from *Camera Notes*, 3 (April, 1900), p. 195.

CHRONOLOGY

1869: Born on July 26 in Brooklyn, New York, the eldest of five children.

1898: Photographs Sioux Indians; Käsebier photographs same models, suggesting a New York site. » Stieglitz gives glowing review of his work at Philadelphia Salon: "his nine pictures proved him to be an artist of marked individuality. . . . As a

study of artistic tonalities his pictures stood in a class by themselves" [Editor's note, *Camera Notes,* 2 (January, 1899), p. 132]. » Becomes associate editor of *Camera Notes.*

1899: Joins The Camera Club, New York. Commences close friendship with Stieglitz. Sits on Camera Club Prints and Publications Committee. » Collaborates with Stieglitz on a refinement of the glycerine process for the local development of platinum prints. Writes catalog for Stieglitz's Camera Club exhibition (Biblio. 956). » Offers to make large platinum prints for Stieglitz.

1900: Fourth American elected to The Linked Ring. » Issue of *Camera Notes* devoted to Keiley reproductions (July), which ends policy of devoting the majority of the illustrations in an issue to a single photographer. » Writes essay on the importance of exhibitions for the pictorial movement (Biblio. 542).

1901: On Linked Ring general committee for photographic salon. Travels to Cuba, arriving on September 1 (Cat. 385). » Resigns from the Print Committee of the Camera Club. » November, father dies.

1902: Helps Stieglitz hang the National Arts Club exhibition (Biblio. 1342). » With Stieglitz, resigns from *Camera Notes;* becomes associate editor of *Camera Work.* » Wins silver medal, Turin exhibition. » Vacations in Bonnie Crest, Skyland, North Carolina.

1903: One gravure published in *Camera Work,* No. 3 (July).

1904: Advises Stieglitz that there are other Austrians and Germans—besides the Hofmeister brothers, Watzek and Kuehn—whose work he should be familiar with.

1905: On jury for Goerz cover competition with Alphonse Mucha and Stieglitz.

1907: Six gravures published in *Camera Work,* No. 17 (January).

1908: Reads books on symbolist literature. » **Buys** Kodak box camera for 100 exposures on a roll.

1908–09: Travels in Europe. Visits Theodore Roussel, painter; admires Hill and Adamson photographs.

1910: Watson-Schütze refutes Keiley's claim to have

361 362 363

invented the manipulated glycerine-platinum process and declares credit should go to Hinton (Biblio. 556A, 1231).

1911: Active in Mexican Politics (Labor-Socialist Party).

1914: Dies of Bright's disease.

PHOTOGRAPHS

361 » *Zit-Kala-Za.* 1898 (A. S.) Glycerine developed platinum, mounted on light gray paper upon a larger sheet of another gray paper. 188 × 113 mm. (7⁷⁄₁₆ × 4⁷⁄₁₆ in.) 33.43.186.

Titled *An American* when exhibited as a triptych with Cats. 362, 363.

Exhibited: New York (A I , 1898), no. 56, three images in one frame titled *An American* (the pendants beings Cats. 362 and 361); Bradford (1904), no. 206; New York (NAC, 1909), no. 144; Dresden (1909), no. 79; Buffalo (1910), no. 336.

Reproduced: *Camera Notes,* 4 (July, 1900), p. 7, from a print with different local manipulations, titled *An Indian Girl.*

The print is rendered in tones of gray, black and gray, brown, with areas of pure white indicating the selectivity of the printing method.

Keiley illustrated his personal copy of the American Institute exhibition (1898) catalog (Biblio. 537) with small prints of those exhibited and a note specifically describing no. 56, accompanied by small copy prints of the three parts showing three views of the same model.

Keiley's concern about titles is evident in his long note in the catalog: "Each picture was given a title as required by the regulations. These titles were, with several exceptions, either altered or quite ignored in the catalogueing." He went on to criticize the installation of the exhibition. "The pictures were carefully framed then hung so as to kill the framing—and one picture—a landscape could only be seen through a mass of withering pot flowers—for a vegetable and flower show was held at the same time."

362 » *Zit-Kala-Za.* 1898. Glycerine developed platinum. 171 × 113 mm. (6¾ × 4⁷⁄₁₆ in.) Monogram "JTK" in pencil. 33.43.369.

See Cat. 361.

Exhibited: New York (1898), no. 56, three images in one frame titled as above, the pendants being Cats. 361 and 363; Bradford (1904), no. 170, titled *Zitkala-Sa;* Dresden (1904), no. 104, titled *Zitkala-Sa;* Dresden (1909), no. 77, titled as above; Buffalo (1910), no. 338, titled *Zit-kala-Za.*

Reproduced: *Photographic Times,* 32 (February, 1900), p. 78, titled *Indian Girl; Century Magazine,* 64 (October, 1902), p. 815, titled *Sioux Indian Girl.* A close variant is reproduced in *Photographic Times,* 32 (June, 1900), p. 267, titled *Zit-Kala.*

Removed from old mount is paper label with rubber stamp "Loan Collection Photo-Secession/Alfred Stieglitz, Director."

The same model in the same costume and wearing the same jewelry is credited to Käsebier in *Photographic Times,* 32 (May, 1900), p. 199 (Biblio. 520). Keiley and

364 365 366

Käsebier shared Indian models who were visiting New York from the Pine Ridge Agency.

363 » *Zit-Kala-Za.* [see Cat. 361]. 1898. Glycerine developed platinum, mounted on black paper with a thread margin upon gray, upon a larger sheet of another gray. 190 × 114 mm. (7½ × 4½ in.) Monogram "JTK" in black. 49.55.204.
Exhibited: New York (1898), no. 56, three images in one frame titled as above, the pendants being Cat. 361 and 362; Dresden (1909), no. 79; Buffalo (1910), no. 336.
 Reproduced: *Photographic Times,* 32 (June, 1900) p. 266, titled *Zit-Kala; Camera Notes,* 5 (July, 1901), opp. p. 30, titled *Zitkala-Sa; Photograms of the Year 1899,* p. 6, titled *Portrait of a Sioux Girl.*
 The face is toned brown, suggesting the flesh tone of a native American. Evidence of local manipulation is in the background.

364 » *Zit-Kala-Za.* 1898 (A. S.) Glycerine developed platinum, mounted on tan paper upon a large sheet of gray. 178 × 114 mm. (7 × 4½ in.) 33.43.183.
Exhibited: Philadelphia (1900), no. 108; Glasgow (1901), no. 121; Leeds (1902), no. 671; Dresden (1909), no. 77, titled *Zitkala-Sa;* Buffalo (1910), no. 338.

365 » [*Zit-Kala-Za*]. 1898. Glycerine developed platinum, mounted on black paper with a thin margin upon a larger gray sheet. 200 × 148 mm. (7⅞ × 5¹³⁄₁₆ in.) Monogram "JTK" in black. 33.43.171.

Exhibited: Bradford (1904), no. 206; Dresden (1909), no. 79; Buffalo (1910), no. 336, dated as above.

366 » *A Sioux Chief.* 1898. Glycerine developed platinum. 195 × 130 mm. (7⅞ × 5⅛ in.) Stylized "JTK" monogram in red. 33.43.417.
Exhibited: Dresden (1909), no. 76, titled *Indian Chief;* Buffalo (1910), no. 336 and 337, related works dated as above.
 Reproduced: Caffin (Biblio. 1282), titled as above, p. 103.
 Localized tones of pastel gray in the shoulder, gray brown, gray and black give this print a subtle coloristic effect, accented by the red monogram. The print was usually exhibited titled as above or some close variant. The model was Philip Standing Soldier of the Pine Ridge Agency, who was also photographed by Gertrude Käsebier.

367 » *A Sioux Chief.* About 1898. Glycerine developed platinum, mounted on light gray paper with a narrow border upon a larger sheet of another gray. 193 × 141 mm. (7⅝ × 5⁹⁄₁₆ in.) Monogram "JTK" in red. 33.43.174.
Plate 34.
Exhibited: Philadelphia (1899), no. 197, where it is reproduced from a print with slightly different local manipulations; Newark, Ohio (1900), no. 124.
 Reproduced: Variants in *Photographic Times,* 32 (January and June, 1900), pp. 8, 258.
 Rendered in tones of pastel gray, blue gray, brown, and black, the print shows strong evidence of brushwork on right shoulder.

368 369 371

The model was Has-no-Horses of the Pine Ridge Indian Agency, who was also photographed by Gertrude Käsebier.

368 » *Indian Head.* 1898. Glycerine developed platinum, mounted on black paper with thread margins. 198 × 145 mm. (7¹³⁄₁₆ × 5¾ in.) Stylized "JTK" monogram in red. 33.43.187.

Exhibited: Turin (1902), no. 80; San Francisco (1903), no. 28; Washington (1904), no. 82; Pittsburgh (1904), no. 125; The Hague (1904), no. 53; Dresden (1904), no. 105; Paris (1904), no. 363; Vienna (1905), no. 21; New York (PSG, 1905), no. 41; Dresden (1905), no. 75; Buffalo (1910), no. 337, titled *Indian Chief,* and dated as above.

The exhibition record suggests the esteem in which this print was held by Stieglitz.

Articulated in localized tones of pastel gray, blue, gray, brown, and black, the print has a background suggestive of local brush manipulation in development.

369 » *A Winter Landscape.* 1898. Glycerine developed platinum, mounted on gray paper with a thread margin, upon a large sheet of natural Japanese paper. 193 × 124 mm. (7⅝ × 4⅞ in.) Stylized monogram faintly printed in red. 49.55.203.

Exhibited: Buffalo (1910), no. 339, titled and dated as above.

The sky is pastel gray, while the snow is white with a slight brown cast, a rendering that suggests the subtle color in an otherwise monochrome winter landscape.

370 » *A Bacchante.* 1899. Glycerine developed platinum, mounted on green paper upon a larger sheet of chartreuse paper. 245 × 193 mm. (9⅝ × 7⅝ in.) Stylized "JTK" monogram in red. 33.43.185.

Plate 35.

Exhibited: Philadelphia (1899), no. 196; Chicago (1900), no. 64; New York (TCC, 1900); Turin (1902) no. 82; New York (NAC, 1902), no. 90; Leeds (1902), no. 668; San Francisco (1903), no. 29; Brussels (1903), no. 282; Portland (1903), no. 22; Bradford (1904), no. 185; London (1904), no. 139; Washington (1904), no. 81; Pittsburgh (1904), no. 124; New York (PSG 1905), no. 40; Vienna (1905), no. 19; New York (PSG, 1906), no. 37, titled *Study for the Bacchante;* Cincinnati (1906), no. 33; New York (PSG, 1908), no. 19; New York (NAC, 1909), no. 141; Buffalo (1910), no. 340.

The exhibition record suggests the esteem in which Stieglitz held this print.

A considerable amount of local manipulation gives the effect of a figure engulfed in atmosphere. The upper left corner appears to be touched with chalk or other pigment that is not a part of the glycerine developing process.

371 » [*The Averted Head—A Study in Flesh Tones*]. 1899 (A. S.) Glycerine developed platinum, mounted on gold paper with thread margin upon black upon a larger sheet of gray paper. 165 × 105 mm. (6½ × 4⅛ in.) Stylized monogram in red. 33.43.179.

Exhibited: Newark, Ohio (1900), no. 116, titled as above; London (NSAP, 1900), no. 132, titled *Study of*

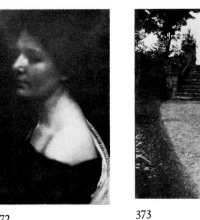

372

375 376

Flesh; Paris (NSAP, 1901), no. 92; Glasgow (1901), no. 363; Turin (1902), no. 79; Dresden (1909), no. 74, titled *Study in Flesh Tones,* suggesting related compositions; New York (PSG, 1906), no. 36; New York (NAC, 1909), no. 147.

Reproduced: Variant in Holme (Biblio. 1288), pl. U.S., 13, titled *A Head Study.*

The background and hair are rich black, while her skin is the color of creamy coffee as though it had been separately toned, which was probably not the case; rather we see a natural glycerine tone that was obscured in the rest of the print by the deep black. The print is a good example of pre-Lumière colorism.

372 » *Female Head [A Study in Flesh Tones].* About 1899. Glycerine developed platinum, mounted on brown paper upon another shade of brown. 180 × 110 mm. (7⅛ × 4⁵⁄₁₆ in.) Stylized monogram in red. 49.55.202.
The print is possibly of the same model as Cat. 371 and is related in style.

373 » *Italian Stairway—Lake George.* 1899 (A. S.) Glycerine developed platinum, mounted on black paper with thread margin upon salmon, upon a large sheet of tan paper. 218 × 164 mm. (8⁹⁄₁₆ × 6⁷⁄₁₆ in.) 33.43.173.
This print, titled as above by Stieglitz, is darker than Cat. 374, giving the appearance of dusk.

374 » *Italian Stairway—Lake George.* 1899 (A. S.) Glycerine developed platinum, mounted on green paper with a thread margin upon char-

treuse, upon a larger pastel green leaf. 227 × 173 mm. (9 × 6¹³⁄₁₆ in.) 33.43.177.
Not illustrated.
Compared to catalog 373, the print is lighter in overall tone with selective dark areas, such as sky at the head of the steps.

375 » *[The Orchard].* 1900 (A. S.) Glycerine developed platinum, mounted on gold paper with a thread margin. 178 × 178 mm. (7 × 7 in.) Stylized "JTK" monogram in red. 33.43.180.
Exhibited: Hamburg (1903), no. 253.

The presence of Keiley's monogram (not inscribed on Cat. 376, a print from the same negative, but very different) introduces the possibility that, of the two, this print is the final version and its companion an experiment towards it. Faint at first glance, the subtle richness in the main branches nevertheless distinguishes it from similar looking albumen prints that have faded accidentally. As such, the print typifies the photographer's response to tonalism in painting (Biblio. 1081).

376 » *[The Orchard].* 1900 print (A. S.), from negative of about 1898. Glycerine developed platinum, mounted on orange paper with a thread margin. 170 × 179 mm. (6¹¹⁄₁₆ × 7¹⁄₁₆ in.) 33.43.176.
The print is deeply contrasting in tones of rich brown that evocatively interpret a summer orchard. Keiley inscribed a note in his copy of The American Institute exhibition (Biblio. 537): "among [the rejected photo-

377

378

379

380

graphs] were some of the best work I had done up to that time—especially landscape work."

377 » *A Pennsylvania Landscape.* 1900 (A. S.) Glycerine developed platinum, mounted on natural American paper with a thread margin upon a larger sheet of natural Japanese paper. 145 × 235 mm. (5¾ × 9¼ in.) Stylized monogram in red. 33.43.181.

The grainy chocolate tone in the sky gives the effect of heavy atmosphere.

378 » *Unloading.* 1901/1902. Platinum. Mounted on tan paper upon a larger sheet of natural Japanese paper. 75 × 91 mm. (3 × 3⁹⁄₁₆ in.) 33.43.172.

Exhibited: Buffalo (1910), no. 344, dated 1901. Dated 1902 by Stieglitz on the verso of the print.

379 » *Reverie: The Last Hour.* 1901. Platinum, mounted on brown paper upon a larger tan leaf. 112 × 187 mm. (4⁷⁄₁₆ × 7⅜ in.) 33.43.170.

Exhibited: New York (NAC, 1901), no. 88; London (1902), no. 18; San Francisco (1903), no. 27; Brussels (1903), no. 283; Washington (1904), no. 83; Pittsburgh (1904), no. 126; The Hague (1904), no. 54; Bradford (1904), no. 192.

Reproduced: *American Amateur Photographer,* 15 (October, 1904), p. 433; *Camera Work,* No. 3 (July, 1903), pl. IX and No. 17 (January, 1907), pl. II.

380 » *Miss de C.* [*Mercedes de Cordoba*]. 1902.

Platinum, mounted on gold paper with thread margin on gray, upon black, upon a larger sheet of gray paper. 86 × 114 mm. (3⅜ × 4½ in.) Stylized "JTK" monogram in red. 33.43.168.

Exhibited: Dresden (1903), no. 256, titled *Portrait Mercedes de C.;* New York (PSG, 1905), no. 38; Buffalo (1910), no. 347, dated as above.

Reproduced: *Camera Work* (January, 1907), pl. IX, where it is stated that Keiley's plates were made using the original negatives.

Compare Cat. 381.

381 » *Miss de C.* [*Mercedes de Cordoba*]. 1902. Platinum, mounted on a leaf of tan paper upon a larger gray sheet. 84 × 111 mm. (3¼ × 4⅜ in.) 33.43.175.

Not illustrated.

Exhibited: See Cat. 380.

382 » *A Side Street, New York.* 1902. Platinum, mounted on tan paper with a thread margin upon a larger gray leaf. 88 × 33.5 mm. (3½ × 1⁵⁄₁₆ in.) 33.43.169.

Plate 36.

Exhibited: Buffalo (1910), no. 350, titled *The Side Street* and dated 1902.

383 » *From a New York Ferryboat.* 1904. Glycerine developed platinum, mounted on gold paper with a thread margin upon a larger sheet of gray paper. 92 × 115 mm. (3⅝ × 4⁹⁄₁₆ in.) 33.43. 178.

384

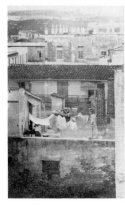

385

Plate 37.
Exhibited: Buffalo (1910), no. 352, dated as above.

384 » *Baracoa Bay [Cuba].* 1904 print of 1901 negative. Platinum, mounted on tan paper upon a larger sheet of gray. 107 × 177 mm. (4¼ in. × 7 in.) 33.43.182.
Exhibited: Buffalo (1910), no. 349, titled and dated as above.

The gray-tan tone of the print suggests that a toning agent other than glycerine, possibly mercury, was used.

385 » *A Bit of Havana.* 1904 print of 1901 negative. Platinum. 187 × 111 mm. (7⅜ × 4⅜ in.) 33.43.184.
Exhibited: Buffalo (1910), no. 348, titled and dated as above.

The print is mounted on a sheet of gray paper with a narrow margin, upon a larger sheet of darker gray, that reinforces the interpretation that the image is at least as much a study of tonal values as of Cuban life.

EXHIBITIONS

New York (AI) 1898 » Philadelphia 1898–1900 » Berlin 1899 » London 1899 » *Newark, Ohio, 1898* » Chicago 1900 » Newark 1900 » **New York (TCC) March 1900* » Glasgow 1901 » London 1901–1902 » London (NSAP) 1900 » Paris (NSAP) 1901 » Leeds (1902) » New York (NAC) 1902 » Turin 1902 » Brussels 1903 » Cleveland 1903 » Denver 1903 » Hamburg 1903

» Minneapolis 1903 » San Francisco 1903 » Toronto 1903 » Wiesbaden 1903 » Bradford 1904 » Dresden 1904 » Hague 1904 » London 1904 » *New York (TCC) 1904* » Paris 1904 » Pittsburgh 1904 » Washington 1904 » New York (PSG) 1905 » Portland 1905 » Richmond 1905 » Vienna (C-K) 1905 » Vienna (PC) 1905 » Paris 1906 » Cincinnati 1906 » New York (PSG) 1906 » Philadelphia 1906 » *London (NEAG) 1907* » New York (PSG) 1907 » London 1908 » Dresden 1909 » New York (PSG) 1908 » Buffalo 1910 » London (RPS) 1914.

BIBLIOGRAPHY

Manuscript

536. Stieglitz Archives, Collection of American Literature, Beinecke Rare Book and Manuscript Library, Yale University, New Haven, Conn.: 180 unpublished letters from Joseph T. Keiley to Alfred Stieglitz and one unpublished letter from Alfred Stieglitz to Joseph T. Keiley between 1899 and 1913.

537. Keiley, Joseph T. *Catalog of Prints. The Photographical Section, American Institute and National Academy of Design.* New York City, 1898 (Biblio. 1319). Extra illustrated with 14 prints by Keiley and inscribed by him with comments on the exhibition. (Private Collection).

538. Eva Watson-Schütze, "A Sketch of Mr. Joseph T. Keiley," seven pages of typescript, Beinecke Rare Book and Manuscript Library, Yale University, New Haven, Conn.

By Keiley

539. Keiley, Joseph T. "The Philadelphia Salon: Its Origin and Influence." *Camera Notes,* 2 (January, 1899), pp. 113–132.

540. ———. "Loan Exhibition." *Camera Notes,* 3 (April, 1900), pp. 214–215.

541. ———. "The American School." *Photograms of the Year 1899,* pp. 7–26.

542. ———. "The Salon: Its Purpose, Character and Lesson." *Camera Notes,* 3 (January, 1900), pp. 135–170.

543. ———. "The 'Camera Notes' Improved Glycerine Process for the Development of Platinum Prints." *Camera Notes,* 3 (April, 1900), pp. 221–226.

544. ———. "A Foreword." *Chicago Photographic Salon of 1900,* Art Institute of Chicago, April 3–18, 1900, exhibition catalog, n.p.

545. ———. "The Pictorial Movement in Photography and the Significance of the Modern Photographic Salon." *Camera Notes,* 4 (July, 1900), pp. 18–23.

546. ———. "The American School." *Photograms of the Year 1900,* pp. 17–33.

547. ———. "The Salon: Its Place, Pictures, Critics and Prospects." *Camera Notes,* 4 (January, 1901), pp. 189–227.

548. ———. "The Element of Chance." *Camera Notes,* 5 (July, 1901), p. 63.

549. ———. "In the Style of the Masters." *Camera Notes,* 6 (July, 1902), pp. 61–62.

550. ———. "The Pursuit of the Pictorial Ideal." *Camera Work,* No. 1 (January, 1903), pp. 54–59.

551. ———. "Concerning the Photo Secession." *Photo Era,* 11 (September, 1903), pp. 314–315.

552. ———. "Landscape—A Reverie." *Camera Work,* No. 4 (October, 1903), pp. 45–46.

553. ———. "Art in Photography." *Camera Work,* No. 12 (October, 1905), p. 62.

554. ———. "The Photo-Secession Exhibition at the Pennsylvania Academy of Fine Arts—Its Place and Significance in the Progress of Pictorial Photography." *Camera Work,* No. 16 (October, 1906), pp. 46–51.

555. ———. "The Element of Vanity in Exhibition Work." *Camera Work,* No. 16 (October, 1906), pp. 52–53.

556. ———. "Ad Infinitum." *Camera Work,* No. 20 (October, 1907), pp. 45–46.

557. ———. "The Dream of Beauty." *Camera Work,* No. 21 (January, 1908), p. 26.

558. ———. "The Members' Exhibition at the Little Galleries—An Impression." *Camera Work,* No. 21 (January, 1908), pp. 46–47.

559. ———. "Impression of the Linked Ring Salon of 1908." *Camera Work,* No. 25 (January, 1909), pp. 29–36.

560. ———. "What Is Beauty?" *Camera Work,* No. 31 (July, 1910), pp. 65–68.

561. ———. "The Buffalo Exhibition." *Camera Work,* No. 33 (January, 1911), pp. 23–29.

See Biblio. 46, 286, 518, 526, 529, 822, 823, 846, 852, 912, 956, 958, 967, 1084, 1086, 1090, 1097.

About Keiley

562. [Stieglitz, Alfred]. [Editor's Note on Keiley's review of the Philadelphia Salon]. *Camera Notes,* 2 (January, 1899), p. 132. (G. App. 212)

563. Abel, Juan C. "Joseph Keiley." *Photographic Times,* 32 (June, 1900), pp. 262–263.

564. Fuguet, Dallett. "Reviews of the Exhibition of Prints by Joseph T. Keiley." *Camera Notes,* 4 (July, 1900), pp. 42–46.

565. Hartmann, Sadakichi. "Through Semi-Japanese Eyes." *Camera Notes,* 4 (July, 1900), pp. 46–47.

566. Smiler, A. [unidentified pseud]. "The Keely Cure; or, How It Came to be Written: A Comedy in Two Acts." *Camera Notes,* 4 (July, 1900), pp. 56–64.

566A. Watson, Eva L. "Apropos of Mr. Keiley." *Photographic Times,* 32 (August, 1900), p. 369.

567. Fuguet, Dallett. "Joseph Turner Keiley." *Camera Work,* No. 44 (October, 1913), pp. 56–57.

568. Kerfoot, J. B. "Joseph Turner Keiley." *Camera Work,* No. 44 (October, 1913), p. 57.

569. Bayley, R. Child. "A Tribute." *Camera Work,* No. 44 (October, 1913), p. 58.

HEINRICH KUEHN (Austrian)

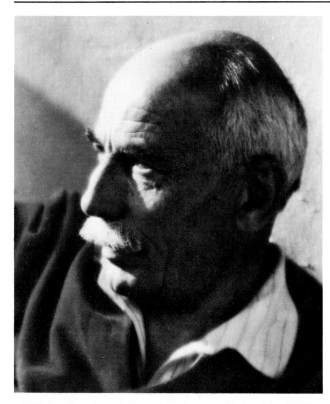

Fig. 31 » *Heinrich Kuehn.* By Adalbert Defner, about 1935. Courtesy of Lotte Schönitzer-Kühn, Birgitz, Austria.

Note: We have adopted the spelling "Kuehn" rather than "Kühn" since the majority of the prints collected by Stieglitz are signed with the spelling "ue." Much of the correspondence to Stieglitz is also signed "Kuehn" although there are instances of "Kühn" to suggest that both spellings were used. *Photographisches Centralblatt* printed the "ue" spelling in captions to reproductions (Biblio. 579), supplying another precedent for our usage. Kuehn's offspring adopted the umlauted spelling and there is evidence to suggest this was also done by Heinrich sometime after 1910 when it was still printed as "ue" in the Buffalo catalog (Biblio. 1399). Stieglitz, who was fluent in German, used the "Kuehn" spelling in *Camera Work* and on the collection labels.

CHRONOLOGY

1866: Born on February 25 in Dresden, Germany.

1883: Begins photographing.

1888: Moves to Innsbruck, Austria, after completing studies in science and medicine.

1894: Mentioned in passing by Stieglitz in review of the Milan United Exhibition (Biblio. 884, p. 134).

1895: Platinum prints exhibited at London Salon and published in *Wiener Photographische Blätter.*

1896: Member of the Vienna Camera-Klub. Associated in the *Trifolium* (Biblio. 1073) with Hugo Henneberg and Hans Watzek; collaborates with them on adopting Demachy's gum bichromate process. » The three travel together to Germany, Italy, and Holland.

1898: Exhibits at the Munich *Sezession.*

1901: Meets Käsebier and Steichen in Munich in September.

1902: Gravures of his gum prints published in lavish book of the Austrian school (Biblio. 1284). » By this time works independent of his colleagues.

1904: Meets with Stieglitz in Igls, Austria. » Spends part of summer at Katwijk-aan-Zee, The Netherlands; begins to make platinum prints changing his style to figures in a landscape setting which is evocative and intimate. At this time is strongly influenced by the Photo-Secessionists, particularly White, Käsebier, and Steichen until about 1908. » Organizes international exhibition at newly formed Photo-Club of Vienna (Biblio. 1367). » Makes effort to organize an international photographic society with Hinton, Stieglitz, and Davison.

1905: Builds house in *Birgitz bei Innsbruck,* designed by Josef Hoffmann, founder of the *Wiener Werkstatte.* On the front gable over the door carved:

"Heil dir Sonne—heil dir Licht" (Bless the sun—
Bless the light). » Writes to Stieglitz, "The
greatest achievement of the photographer is to aim
at a great pictorial effect without adulteration—the
photographer may not paint" (6 January, YCAL).
1907: Experiments with Lumière Autochrome (color)
process (pls. 57, 63, Holme, Biblio. 1292). »
Four gravures published in *Camera Work,* No. 13
(January). » Exhibits twelve prints with the
Trifolium and the Hofmeister brothers at the Little
Galleries. » Exhibits at London Salon. » De-
velops lens for improved photographic portraiture.
» Arranges "Summit" meeting in Igls, Austria,
with Stiglitz, Steichen and Eugene.
1909: Begins making photogravures: adopts a more
independent style, using the "straight" approach in
photography. Stieglitz lends his collection of Kuehn
to National Arts Club Exhibition, New York.
1910: Exhibits eighteen prints at Albright Art Gallery.
1911: Eighteen photographs published in *Camera
Work,* No. 33 (January) in three reproductive proc-
esses: gravure, mezzotint photogravure, and duplex
halftone. (See Cat. 405 for Stieglitz's assessment of
Kuehn.)
1921: Publishes treatise written during the First World
War, *Das Technik der Lichtbildnerei* (Biblio. 576),
in which "straight" photography and previsualiza-
tion are advocated.
1933: Awarded honorary doctorate at University of
Innsbruck.
1944: Dies on September 14 at Birgitz-bei-Innsbruck.

PHOTOGRAPHS

386 » *Ein Sommertag.* 1898. Blue pigment gum-
bichromate. 787 × 526 mm. (31 × 20¹¹⁄₁₆ in.)
Signed and dated in watercolor "Heinrich
Kuehn/98." 33.43.278.
Plate 11.
Exhibited: Vienna (*Museum für Kunst und Indus-
trie*) 1899, per illustration; New York (PSG, 1906),
no. 13, titled *Summer Days;* Philadelphia (1906), no. 85.
Reproduced: *Photographisches Centralblatt,* 5

387

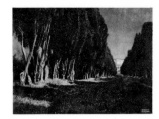
388

(April, 1899), opp. p. 155; F. Matthies-Masuren
(Biblio. 1284), titled *Ein Sommertag,* pl. XV.

387 » *Scirócco.* 1899/1901 (A. S.) Green pigment
gum-bichromate. 561 × 742 mm. (22⅛ ×
29¼ in.) Signed "Heinrich Kuehn" in white
watercolor. 33.43.279.
Exhibited: London (1896), no. 9, *Stormy Weather;*
New York (PSG, 1908), no. 7; Philadelphia (1906),
no. 78, both titled *The Windstorm* (a fair translation of
the above) suggesting identical or related works; New
York (NAC 1909), no. 50, titled *Sirocco,* lent by Stieg-
litz and dated by him in the catalog 1901.
 Reproduced: *Photographisches Centralblatt,* 7
(1901), p. 435, titled *Scirocco* [sic]; *Photographic
Times,* 34 (January, 1902), p. 38; Matthies-Masuren
(Biblio. 1284), pl. IV, dated as above; Biblio. 1289, pl.
[II].

388 » *Moonlight, Villa Frascati.* 1902 (A. S.)
Blue-green pigment gum-bichromate. 541 ×
728 mm. (21⁵⁄₁₆ × 28¹¹⁄₁₆ in.) Signed "Hein-
rich Kuehn" in watercolor. 33.43.276.
Exhibited: Hamburg (1903), no. 268; Dresden (1909),
no. 93, both suggesting related or identical works and
titled *Römische Villa;* Philadelphia (1906), no. 77,
titled *Roman Villa;* New York (NAC, 1909), per re-
view; Buffalo (1910), no. 177, titled and dated as above;
New York (NAC, 1909), no. 52 is incorrectly titled
Moonlight—Villa d'Este, lent by Stieglitz.

389 » *Aus der Römischen Campagna [Roman Cam-*

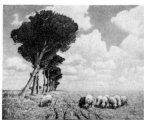

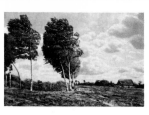

390

389

392

393

pagna]. 1902 (A. S.) Blue-green pigment gum-bichromate. 557 × 703 mm. (21^{15}/$_{16}$ × 27^{11}/$_{16}$ in.) Signed "Heinrich Kuehn" in watercolor. 33.43.275.
Exhibited: London (1902), no. 181, titled *Campagna di Roma;* Dresden (1904), no. 85, titled *Römische Campagna;* New York (PSG, 1906), no. 5; Philadelphia (1906), no. 76, titled *Campagna di Roma;* New York (NAC, 1909), no. 51, titled *Roman Capagna;* Buffalo (1910), no. 179, dated as above.
Reproduced: *Camera Work,* No. 13 (January, 1906), pl. III, variant; Matthies-Masuren (Biblio. 1284), pl. X.; Matthies-Masuren (Biblio. 1124), opp. p. 32; *Academy Notes* (Biblio. 1399a); *The Bookman,* 27 (March, 1908), n.p.

390 » *Landscape—Windy Weather.* 1902. Blue-green pigment gum-bichromate. 475 × 729 mm. (18^{11}/$_{16}$ × 28^{11}/$_{16}$ in.) Signed "Heinrich Kuehn" in ink. 33.43.281.
Exhibited: New York (NAC, 1909), no. 48, titled *Landscape;* Buffalo (1910), no. 175, titled and dated as above.

391 » *Venezianische Brücke [Chioggia, Italy].* 1902/1903 (A. S.) Brown pigment gum-bichromate. 515 × 659 mm. (20^1/$_8$ × 26 in.) Signed "Heinrich Kuehn" in watercolor. 33.43.280.
Plate 10.
Exhibited: Munich (1898), no. 171, titled *Venezianischer Kanal,* suggesting the identical or a related work;

Hague (1904), no. 565; New York (PSG, 1906), no. 15, *Venetian Bridge.* New York (NAC, 1909), titled *Venetian Bridge,* lent by Stieglitz and dated by him in the catalog 1902.
Stieglitz thought this was made in Chioggia, a village on the outskirts of Venice about which he enthusiastically wrote in 1889 (Biblio. 875). Kuehn very likely visited the village upon Stieglitz's advice, as he had Katwyk, another one of Stieglitz's favorite haunts.

392 » *Alfred Stieglitz.* 1904. Gelatine silver. 247 × 192 mm. (9^3/$_4$ × 7^9/$_{16}$ in.) 55.635.3.
Stieglitz identifies this print as having been made in Innsbruck in 1904.

393 » *In der Dune.* 1905. Platinum. 333 × 415 mm. (13^1/$_8$ × 16^3/$_8$ in.) Signed "Heinrich Kuehn" in ink. 33.43.271.
Exhibited: New York (PSG, 1906), no. 11; Philadelphia (1906), no. 81; Dresden (1909), no. 96, titled as above; Buffalo (1910), no. 180, titled *Women on the Dunes* and dated as above.
This is no doubt Katwyk, Holland, a site popular with Stieglitz (Biblio. 886) and others in his circle and from where correspondence to Stieglitz was postmarked.

394 » *Wäsherin in der Düne [Washerwoman on the Dunes].* About 1905. Gray-green pigment gum-bichromate. 554 × 729 mm. (21^3/$_4$ × 28^{11}/$_{16}$ in.) Signed "Heinrich Kuehn" in watercolor. 33.43.277.
Exhibited: New York (PSG, 1906), no. 8; Philadel-

394

395

396

397

phia (1906), pl. VII, titled *Washerwoman on the Dunes;* New York (NAC, 1909), no. 53, titled *Washing—Katwyk* and lent by Stieglitz.

Reproduced: *Camera Work,* No. 13 (January 1906), pl. IV; Matthies-Masuren (Biblio. 1124), opp. p. 16, and (Biblio. 1284), pl. XIX.

Collections: IMP/GEH (oil transfer process).

395 » *Hans and Walter Kühn.* 1906 (A. S.) Platinum. 330 × 435 mm. (13³/₁₆ × 17⅛ in.) Signed "Heinrich Kuehn" in ink. 33.43.274.

Exhibited: New York (PSG, 1906), no. 10, titled as above; Buffalo (1910), no. 181.

The print is possibly one of a group including portraits of children sent by Kuehn to Stieglitz on November 10, 1905 (YCAL). Walter was born on August 1, 1893; Hans on February 2, 1900.

396 » *Wind.* 1907. Platinum. 298 × 218 mm. (11¾ × 8⁹/₁₆ in.) Signed "Heinrich Kuehn" in watercolor. 33.43.269.

Exhibited: Dresden (1909), no. 99, titled as above; Buffalo (1910), no. 183, dated as above.

Reproduced: *Camera Work,* No. 33 (January, 1911), pl. III, titled *Windblown,* with a different configuration of clouds.

397 » *Resignation.* 1908. Unidentified pigment process. 394 × 295 mm. (15½ × 11⅝ in.) Signed "Heinrich Kuehn" in ink; signed and titled on verso "Heinrich Kühn/Resignation." 33.43.270.

Exhibited: Buffalo (1910), no. 185, dated as above, where it is listed as a gum-bichromate print.

Reproduced: *Academy Notes* (Biblio. 1399a), pl. 11.

The pigment is mechanically uniform on a sized paper surface, but without the hard, slightly glossy surface of ozotype. The print is related in medium to Cat. 400.

398 » *Bildnis.* About 1908. Brown pigment gumbichromate. 541 × 502 mm. (21⁵/₁₆ × 19¾ in.) Signed "Heinrich Kuehn" in white ink. 33.43.282.

Exhibited: Dresden (1909), no. 85.

Reproduced: Matthies-Masuren (Biblio. 1284), pl. XVII, titled as above.

Collections: IMP/GEH (oil transfer process).

399 » *Mein Garten.* 1908 (A. S.) Platinum. Paper, 327 × 447 mm. (12⅞ × 17⅝ in.) Signed "Heinrich Kuehn" in watercolor; inscribed on verso with title as above "H. Kühn/Innsbruck," a case of the signing with two spellings of his name on one print. 33.43.272.

Exhibited: Buffalo (1910), no. 187, dated 1909, where a gum-bichromate print was exhibited.

400 » *Teestilleben.* 1908/1909. Unidentified pigment process. 283 × 383 mm. (11⅛ × 15¹/₁₆ in.) Signed in ink "Heinrich Kühn." 33.43.273.
Plate 13.

Exhibited: Dresden (1909), no. 100, titled as above; Buffalo (1910), no. 184, titled *Still Life,* doubtless rep-

398

399

401

403

resenting the *Teestilleben* on Kuehn's list of things sent to Buffalo on June 7, 1900, YCAL.

The print is made in the same unidentified process as Cat. 397.

401 » *Park* [*Innsbruck, Austria*]. 1908/1909. Platinum. 165 × 292 mm. (6½ × 11½ in.) Signed "Heinrich Kuehn" in watercolor. 49.55.199.
This photograph, apparently made after the change in Kuehn's style from plain landscape to figure-in-landscape, is comparable to Cat. 399, dated 1908. Kuehn sent Stieglitz a gum print titled *Park* for Buffalo, but there is no listing under that title in the catalog.

402 » *Der Malschirm* [*The Artist's Umbrella*].
1910 print from earlier negative. Hand-printed photogravure on heavy wove paper (early proof). Plate, 239 × 295; image, 230 × 289 mm. (9⅞₆ × 11⅝; 9₁₆ × 11⅜ in.) Signed in pencil on margin "Heinrich Kühn." 49.55.193.
Plate 12.
Exhibited: Dresden (1909), no. 102–B, titled as above but presumably a gum print since Kuehn did not take up gravure until 1910; Buffalo (1910), no. 191, titled in English as above and noted as a "proof gravure —1910," suggesting this very impression in which the plate bevel has not been wiped, leaving a black border around the perimeter of the plate. Stieglitz presumably acquired this print and the following at the time of the Buffalo exhibition. See Cat. 405.
Reproduced: MacColl (Biblio. 1399b), p. xii.

Collections: AIC, Stieglitz Collection; IMP/GEH (oil transfer process).

403 » *Stilleben* [*Still Life*]. 1910. Hand-printed photogravure on heavy wove paper (early proof). Plate, 173 × 234; image, 167 × 231 mm. (6¹³⁄₁₆ × 9³⁄₁₆; 6⅝ × 9¹⁄₁₆ in.) Signed "Heinrich Kühn" in pencil. 49.55.195.
Exhibited: Buffalo (1910), no. 192, also described as a proof gravure, with fingerprints and ink stains at the margin, in addition to the inked plate mark, and likewise certainly acquired by Stieglitz from the exhibition.

The plate has been deeply etched to give the effect of a mezzotint which required the sacrifice of delicate grays. The plate was apparently much reworked with engraving tools so that the purely photographic qualities have been dramatically altered.

404 » *Frank Eugene*. 1910. Hand-printed photogravure (early proof). Paper, 133 × 176; image, 120 × 171 mm. (5¼ × 6⅞; 4¹¹⁄₁₆ × 6¾ in.) Signed in pencil on margin "H. Kühn." 49.55.200.
Figure 19.
Exhibited: Buffalo (1910), no. 190, titled and dated as above, where it is also described as "first proof gravure."

405 » *Meine Mutter* [*Sophie Kuehn-Conradi*].
About 1910. Hand-printed photogravure. Image, 244 × 198; plate, 245 × 204 mm. (9⅝ × 7¹³⁄₁₆; 9⅝ × 8¹⁄₁₆ in.) 49.55.201.

405

406

407

Exhibited: Dresden (1909), no. 20, titled *Portrait meiner Mutter,* suggesting the possibility it is the *Camera Work* version. Kuehn sent a print of this title to Stieglitz for Buffalo in June of 1910, but it is not listed in the catalog.

Reproduced: Variant in *Camera Work,* No. 33 (January, 1911), pl. I, from a different negative than above, where it is stated:

Kuehn . . . began his career in the eighties. He has been a vital force in the evolution of pictorial photography, not only as an artist but as an indefatigable experimenter in virtually all the photographic processes. Most recently he has turned his attention to the possibilities of photogravure. . . . The plates in the present issue have been in the course of preparation for over two years; the selection was used by Kuehn. The Bruckman [Printing] firm had had great difficulty in retaining the character and spirit of the originals in the reproductions. The reproductions have a two-fold interest. They not only show Kuehn's pictorial scope but show the possibilities of the various photo-mechanical processes used today in reproducing photographs. Plates I–VII are photogravures, intaglio plates printed by hand; numbers VIII–XI are mezzotint photogravures, printed by steam; and numbers XII–XV are duplex halftones (two printings) printed in the usual way. As examples of reproductions by the three different methods they are quite remarkable. [p. 71]

406 » *Lotte Kühn.* [1910]. Hand-printed photogravure on heavy wove paper (early proof). Plate, 320 × 259; image, 261 × 240 mm. (12⅝ × 10³⁄₁₆; 10¼ × 9⁷⁄₁₆ in.) Signed in pencil on margin "Heinrich Kühn." 49.55.196.

This print conforms in printing and appearance to Cat. 402, 403 and, although not listed in the Buffalo catalog, was presumably acquired by Stieglitz for possible inclusion there. The plate is considerably larger than the subject and has been inked to print as a tonal border around the print, larger at top and bottom than the sides. Fingerprints at the edges of the paper further corroborate this being a working proof.

The density of the ink creates a very opaque surface in contrast to the atmospheric delicacy of Cat. 408. Lotte Kühn was born on July 28, 1904.

407 » *Lotte Kühn.* 1910. Carbon on tissue. 266 × 228 mm. (10½ × 9 in.) Signed "Heinrich Kuehn" in pencil. 49.55.197.

Exhibited: Buffalo (1910), no. 189, incorrectly titled *Lotta Kuehn.*

The print is on paper watermarked "[What]man 1906 England," sensitized by hand and stained yellow, perhaps from the bichromated liquids used in the carbon process. The carbon-on-tissue process was listed as among those represented in the Buffalo (1910) catalog, but the only work ascribed to the method was No. 59A, *Portrait,* by J. Craig Annan. Compare to Cat. 409 a gum print related in style and general appearance, but without the uniform surface of the carbon method.

408 » *On the Hillside (Study in Values).* 1910. Hand-painted photogravure (early proof). Plate, 236 × 294; image, 230 × 294 mm. (9⁵⁄₁₆ × 11⁹⁄₁₆; 9⅛ × 11⅜ in.) Signed in pencil on margin "Heinrich Kühn." 49.55.194.

408

409

Exhibited: Buffalo (1910), no. 193, titled and dated as above, and as Cat. 403, is described as a proof gravure, with similar plate printing bevel.

Collections: IMP/GEH (platinum on Japan tissue).

The delicate and very expressive handling of the inking and printing justifies the subtitle added parenthetically in the Buffalo catalog description, which reveals the versatility of the gravure medium. Kuehn sent Stieglitz a print called *Beleuchtungstudie* [Lighting Study] for Buffalo, suggesting a related and possibly identical work.

409 » *Tonwertstudie [Study in Tones]*. 1910. Gray-and-black pigment gum-bichromate. 291 × 230 mm. (11⁷⁄₁₆ × 9¹⁄₁₆ in.) Dated and signed "1910/Heinrich Kühn"; title inscribed on verso "Tonwertstudie/13 Apl. 10." 49.55.198.

Exhibited: Buffalo (1910), no. 188, titled in English as above which is a fair translation of the German inscribed by Kuehn on the verso, and described in the catalog as a multiple gum print; incorrectly dated as 1909.

Collections: IMP/GEH (oil transfer process).

The use of multiple gum in this print is unmistakable with the registration marks of the two printings visible at the edges. It is one of the few prints in the Stieglitz collection where the problem of the precise registration of multiple layers of pigment is evident. Kuehn sent (7 June 1910, YCAL) Stieglitz two prints for Buffalo (1910), titled *Tonwertstudies I* and *Tonwertstudie II,* of which this must represent one.

EXHIBITIONS

Milan 1894 » Brussels 1895 » London 1895–1897 » *Berlin 1896* » Hamburg 1896 » Paris 1897–1898 » Hamburg 1898–1899 » Munich (Secession) 1898 » Berlin 1899 » London 1899 » *Vienna (Museum für Kunst und Industrie) 1899* » Glasgow 1901 » London 1902 » Hamburg 1903 » Wiesbaden 1903 » Dresden 1904 » Hague 1904 » Vienna (PC) 1904 » Vienna (C-K) 1905 » London 1906 » New York (PSG) 1906 » Philadelphia 1906 » *London (NEAG) 1907* » Dresden 1909 » New York (NAC) 1909 » Buffalo 1910 » Newark (Public Library) 1911 » *London (Secession) 1911.*

BIBLIOGRAPHY

Manuscript

570. Stieglitz Archives, Collection of American Literature, Beinecke Rare Book and Manuscript Library, Yale University, New Haven, Conn.: 279 unpublished letters from Heinrich Kuehn to Alfred Stieglitz and 16 unpublished letters from Alfred Stieglitz to Heinrich Kuehn between 1899 and 1931.

By Kuehn

571. Kuehn, Heinrich, "Neue Erfahrungen im Gummidruck." *Wiener Photographische Blätter,* 3 (October, 1896), pp. 181–193.

572. ———. "Zum Gummidruck." *Wiener Photographische Blätter,* 3 (December, 1896), pp. 229–230.

573. ———. "Verbesserungen an der Handcamera." *Photographisches Centralblatt,* 5 (March, 1899), pp. 137–139.

574. ———. "Studie uber Tonwerte." *Die Photographie Kunst in Jahre 1902,* pp. 93–109.

575. ———. "Die Herstellung haltbarer Gummilosungen." *Photographische Rundchau,* 53 (January, 1916), p. 1.

576. ———. *Das Technik der Lichtbildnerei.* Halle, 1921.

577. ———. "Neuorientierrung!" *Photographische*

Rundchau, 61 (June, July, August, 1924), pp. 97–103, 124–126, 144–146.

578. ———. "Klarheit!" *Das Deutsche Lichtbild, 1937,* pp. T11–T18.

See Biblio. 860.

About Kuehn

See Biblio. 998A.

579. M. [F. Matthies-Masuren.]. "Heinrich Kühn." *Photographisches Centralblatt,* 5 (April, 1899), pp. 161–166.

580. Matthies-Masuren, F. "Heinrich Kühn—Zu unsern Bildern." *Photographisches Centralblatt,* 7 (July, 1901), pp. 433–436.

See Biblio. 1284.

581. Matthies-Masuren, Fritz. "Hugo Henneberg—Heinrich Kühn—Hans Watzek." *Camera Work,* No. 13 (January, 1906), pp. 21–41.

See Biblio. 1286.

582. Speer, Hermann. "Zum Gedächtnis des Lichtbildner Dr. h.c. Heinrich Kühn." Photokina, Cologne, exhibition catalog, 1952, pp. 57–58.

583. ———. "Die Wiener Schule: Hugo Henneberg—Heinrich Kühn—Hans Watzek." *Kunstphotographie um 1900.* Museum Folkwang, Essen, exhibition catalog, 1964, pp. 19–21.

584. Vogt, Hubert. "Heinrich Kühn, der Altmeister der Photographie aus Birgitz." *Das Fenster,* 15 (Winter, 1970–1971), pp. 1477–1502.

See Biblio. 1166.

585. Sobieszek, Robert. "Heinrich Kühn." *Image,* 14 (December, 1971), pp. 16–18.

586. Beaton, Cecil and Gail Buckland. "Heinrich Kühn." *The Magic Image.* Boston, 1975, p. 97.

587. Speer, Hermann. *Heinrich Kühn: 1866–1944.* Galerie im Taxispalais, Innsbruck, 1976.

CÉLINE LAGUARDE (French)

[monogram]

CHRONOLOGY

1903: Serves as one of judges and participants in pictorial photography exhibition in Nice, France.

1905: Discussed in special issue of *The Studio* [Clive Holland: "Some Notes Upon the Pictorial School and its Leaders in France" (Biblio. 1288)].

1908: Address listed as Villa des Pins, Aix-en-Provence.

PHOTOGRAPHS

410 » *Un Bibliothécaire.* 1909 or before. Oil, mounted on brown paper upon another sheet of another brown, with a paper label numeral 154 on lower right recto (Buffalo exhibition label?) 222 × 166 mm. (8¾ × 6⁹⁄₁₆ in.) Stylized monogram "CEL" in ink; signed and titled on verso in ink with price 100 francs. 33.43.345.

Plate 21.

Exhibited: Buffalo (1910), no. 154, titled as above.

Laguarde wrote Stieglitz on November 4, 1908 that she had received back all her photographs except an oil portrait of a man smoking. She asked, "Was it sold?" (YCAL).

EXHIBITIONS

Leeds 1902 » Paris 1902 » Brussels 1903 » Hamburg 1903 » London 1903–1904 » Bradford 1904 » Paris 1904 » Vienna (C-K) 1905 » London 1906 » New York (PSG) 1906 » Paris 1906 » Philadelphia 1906 » London 1908 » London (RPS) 1909 » Buffalo 1910.

BIBLIOGRAPHY

Manuscript

588. Stieglitz Archives, Collection of American Literature, Beinecke Rare Book and Manuscript Library, Yale University, New Haven, Conn.: four unpublished letters from Celine Laguarde to Alfred Stieglitz between 1907 and 1908.

About Laguarde

589. Holland, Clive. "Some Notes Upon the Pictorial School and Its Leaders in France." *The Studio*, London, 1905, n.p. See Biblio. 1288.

Further References to Laguarde can be found in the following exhibition reviews: Biblio. 271, 277, 278, 1391, 1417, 1421.

RENÉ LE BÈGUE (French)

411 412

CHRONOLOGY

1894: Helps organize French Photographic Salon in collaboration with Robert Demachy, Constant Puyo, and Maurice Bucquet. Exhibits at first Photographic Salon, London.

1898: Collaborates on *Le Nut et Le Drapé en Plein Air* (Biblio. 591) with his nephew, photographer Paul Bergon (1863–1912).

1899: Listed as residing at 15 Rue Pélétier, Paris. » *Decorative Figure,* a photogravure, reproduced in *Camera Notes* (July) which Stieglitz describes as "although a little restless, has a certain charm" (p. 24).

About 1905: Shares plein-air studio on islet of **Herblay** with photographer Paul Bergon.

1906: Exhibits in Photo-Secession Galleries Exhibition of French Work (January 10–24) selected by Demachy. Two gravures published in *Camera Work,* No. 16 (October). » Stieglitz acquires Le Bègue prints.

PHOTOGRAPHS

411 » *Académie.* 1902 (A. S.) Ochre pigment gum-bichromate, with pencil rules. Paper, 246 × 162; pencil rules, 247 × 154 mm. (9¾ × 6⅜; 9 × 6¹⁄₁₆ in.) Signed in brown crayon pencil "R L Bègue." 33.43.257.

Exhibited: Buffalo (1910), judging from the reproduction in *Academy Notes* (Biblio. 1292), p. 20.

Reproduced: *Camera Work,* No. 16 (October, 1916), pl. II, reproduced from this print but cropped even within the pencil rules.

Whether the pencil rules designating the subject were added by Le Bègue is unclear, although they were

presumably. The *Camera Work* gravure has intruded unnecessarily upon the subject at bottom.

412 » *Académie.* 1902 (A. S.) Blue pigment gum-bichromate. 238 × 139 mm. (9¾ × 6⅜ in.) Signed in ink "R L Bègue." 33.43.256.

Exhibited: New York (PSG, 1906), nos. 40–43; Philadelphia (1906), nos. 85–87, all uniformly titled *Nude Study* and in all likelihood referring to Cats. 410–412.

Reproduced: *Camera Work,* No. 16 (July, 1906), pl. I, reproduced from this print (identical signatures) but the gravure is cropped to her back and into the toe.

The original print has been seriously violated in the printing of the gravure. The loss of actual subject in this print is quite a different matter from the loss of background or foreground as, for example, in Brigman Cat. 80. Le Bègue wrote Stieglitz on **February 11, 1906** (YCAL) that he normally sells his prints for two British pounds each, but will sell the *Blue Académie* to him for one pound.

413 » *Académie.* 1902 (A. S.) Gray-black pigment gum-bichromate. 241 × 180 mm. (9½ × 7⅛ in.) Signed in gray charcoal pencil "R. L. Bègue." 33.43.258.

Plate 18.

Exhibited: New York (PSG, 1906), nos. 40–42, titled uniformly *Nude Study,* an exhibition from which Stieglitz acquired the majority of French works in his collection, with the exception of Demachy; London (RPS, 1905), reviewed in *British Journal of Photography,* 52 (22 September 1905), p. 753: "Two contribu-

414

416

tions by René Le Bègue are exhibited, we presume, as evidences of misplaced energy and ability. They represent [fictional] pages from an artist's sketchbook. One contains three unfinished nudes [Cat. 417] and the other three heads."

414 » *Étude en noir.* About 1902. Black pigment gum-bichromate. 177 × 142 mm. (7 × 5⅝ in.) Signed in black chalk "R. L. Bègue"; inscribed on verso by Le Bègue, *"autorisation de reproduction donnée à M. Stieglitz."* 33.43.255.
Exhibited: London (1897), no. 151; Paris (1898), no. 359, both titled *Femme Nue,* suggesting related works.

The heavy card mounting is typical of the European style of the 1890s, suggesting that the print was sent to Stieglitz sometime prior to the French Work issue of *Camera Work* in 1905, where it was not reproduced. It might possibly have been as early as July, 1899, when Le Bègue's work was reproduced in *Camera Notes.*

415 » [*Étude en orange*]. 1903. Reddish-orange pigment gum-bichromate. 257 × 197 mm. (10 × 7¾ in.) Signed and dated "R. Le Bègue." 49.55.220.
Plate 17.

416 » [*Étude en orange*]. 1904 (A.S.) Orange pigment gum-bichromate. 220 × 143 mm. (8¹¹⁄₁₆ × 5⅝ in.) 33.43.254.

EXHIBITIONS

London 1894–1898 » Paris 1894–1898 » Brussels 1895 » Hamburg 1896 » Hamburg 1898–1899 » Berlin 1899 » Philadelphia 1899 » Glasgow 1901 » Philadelphia 1901 » London 1902 » Paris 1902 » Turin 1902 » Brussels 1903 » Hamburg 1903 » London (RPS) 1903 » London 1904 » Paris 1904 » New York (PSG) 1906 » Philadelphia 1906 » Paris 1906 » *Paris (Volnay) 1908* » *Paris (PC) 1909* » Buffalo 1910.

BIBLIOGRAPHY

Manuscript

590. Stieglitz Archives, Collection of American Literature, Beinecke Rare Book and Manuscript Library, Yale University, New Haven, Conn.: 5 unpublished letters from René Le Bègue to Alfred Stieglitz between 1906 and 1907.

By Le Bègue

591. Le Bègue, René and Paul Bergon. *Le Nut et le Drapé en Plein Air.* Paris, 1898.

About Le Bègue

592. "Nouvelles et Informations." *La Revue de Photographie,* 2 (February, 1904), p. 65.
593. Wallon, E. "René Le Bègue." *Bulletin Société Française de Photographie,* Series 3, vol. 4 (July, 1914), pp. 231–233.
See Biblio. 589.
Further references to Le Bègue can be found in the following exhibition reviews: Biblio. 278, 1301, 1308, 1312, 1336, 1412, 1417.

ELIOT PORTER (American)

Fig. 32 » *Eliot Porter*. By Robert Nugent, about 1960. Courtesy of Eliot Porter.

Eliot Porter [signature]

CHRONOLOGY

1901: Born Eliot Furness Porter in Winnetka, Illinois.

1913: Begins to photograph birds on Great Spruce Head Island, Maine, site of the family summer residence.

1924: Receives Bachelor of Science degree from Harvard Engineering School.

1929: Receives Doctor of Medicine degree from Harvard Medical School.

1930: Purchases Leica camera and begins to photograph after a long hiatus. Photographs a wide variety of subjects with no particular concentration on nature subjects.

1930–38: Pursues his scientific career, researching and instructing in bacteriology and biological chemistry.

1936: Exhibition of thirty-seven photographs at Delphic Studios [Gallery], 724 Fifth Avenue, New York.

About 1936: Meets Alfred Stieglitz and Georgia O'Keeffe at An American Place, New York.

1937: Resumes seriously photographing birds which he had begun as a teenager.

1938: Exhibits twenty-nine photographs at An American Place (December, 1938–January, 1939), reviewed *in passim* in *The New York Times* (January 1); *The New York Sun* (December 31); *Time* (January 14); *The Art News* (January 7). Included are landscape and New England village scenes and three bird studies.

1939: Gives up science for a career in photography, specializing in landscape, birds, and wildlife. Devises method of flash photography from specially constructed blinds, scaffolds, and high ladders so as to capture the birds in their natural habitat. Exhibits at Book Shop of Georgia Lingafelt, Chicago, same work as at An American Place.

1940: Begins serious color photography. Exhibits at Seventh International Salon of Photography at American Museum of Natural History, New York. Solo show at The Art Museum, Santa Fe, N.M., where he settles.

1941: Receives Guggenheim fellowship to photograph "certain species of birds in the United States," a two thousand dollar stipend. Exhibits in *Image of Freedom* show selected by Beaumont Newhall for The Museum of Modern Art, New York.

1942: Exhibits at Katherine Kuh Gallery, Chicago (February 23–March 14), reviewed in *The Chicago Daily News* (February 21, 28); *The Chicago Sun* (February 28); *Chicago Tribune* (March 1, 8); *Chicago Herald-American* (March 8). Exhibits bird photographs at Bronx Zoo, New York (Biblio. 595).

1943: Exhibits at The Museum of Modern Art, New York, *Birds in Color* (April) of which Nancy

419

Newhall writes, "he insisted on attaining three things: a clear and characteristic portrait of the bird, a technically good photograph and an emotionally satisfying picture" (Biblio. 611). Exhibits Photographs of Birds at The Chicago Academy of Natural Sciences, July 28–October 13.

1946: Receives second Guggenheim fellowship.

PHOTOGRAPHS

417 » *Song Sparrow's Nest in Blueberry Bush, 1938.* June, 1938. Gelatine silver. 240 × 193 mm. (9⁷⁄₁₆ × 7⅝ in.) Mounted on verso is the photographer's paper label with address of 3 Sedgwick Road, Cambridge, Massachusetts; date and title inscribed. 49.55.180.

Plate 101.

Porter creates a still life composition of a subject that the title might suggest to be an ornithologist's document. The photograph expresses the pattern and ornament that exist in nature without geometry or architectonic structure, yet in a state of perfect harmony and order.

418 » *Jonathan [Porter].* July, 1938. Gelatine silver. 239 × 179 mm. (9⁷⁄₁₆ × 7¹⁄₁₆ in.) Mounted on verso is the photographer's paper label inscribed in ink with title and date above. 49.55.287.

Plate 102.

Exhibited: New York (An American Place, 1938), no. 24.

Reproduced: *Twice a year* (1946), between pp. 6–7,

where Dorothy Norman writes of it: "The moment I saw Porter's photograph, I felt,—paradoxically—that it was what I had been seeking. To demonstrate precisely through the eye: a communicable tenderness. And in such a way that one must recoil spontaneously from any and all effort on the part of man to maim what is portrayed: himself." The subject is the photographer's eldest son.

Collections: AIC, Stieglitz Collection.

Baby pictures are the standard fare of amateur photographers, but Stieglitz was doubtless attracted to this print because of the strong treatment given to a banal subject.

419 » *Sick Herring Gull.* July, 1937. Gelatine silver. 186 × 217 mm. (7⁵⁄₁₆ × 8⁹⁄₁₆ in.) Mounted on verso is the photographer's paper label with address of 3 Sedgwick Rd., Cambridge, Mass. and inscribed in ink with title and date as above; also an unidentified pencil script "Donated to An American Place by H [illegible] R [illegible]." 49.55.288.

Exhibited: New York (An American Place, 1938), no. 7.

EXHIBITIONS

Exhibitions are listed only to the death of Stieglitz (1946).

New York (An American Place) 1938 » New York (Zoological Society) 1942 » New York (MOMA) 1943.

COLLECTIONS

IMP/GEH; MOMA.

BIBLIOGRAPHY

Manuscript

594. Stieglitz Archives, Collection of American Literature, Beinecke Rare Book and Manuscript Library,

Yale University, New Haven, Conn.: 13 unpublished letters from Eliot F. Porter to Alfred Stieglitz and 3 unpublished letters from Alfred Stieglitz to Eliot F. Porter between 1938 and 1941.

595. "Clippings," Scrapbook of memorabilia including reviews, correspondence, announcements, etc., Porter files, Santa Fe, N.M.

By Porter

596. Porter, Eliot. [Personal Statement] *Exhibition of Photographs by Eliot F. Porter.* Delphic Studios, New York. February 24–March 8, 1936.

597. ———. "Chemistry, Medicine, Law and Photography." *U. S. Camera Magazine,* 8 (February–March, 1940), pp. 26–29.

598. ———. "A Few Words in Appreciation of Alfred Stieglitz." *Stieglitz Memorial Portfolio,* New York, 1947, pp. 35–36.

599. ———. *In the Wilderness Is the Preservation of the World.* San Francisco, 1962.

600. ———. *Forever Wild: The Adirondacks.* New York, 1966.

601. ———. *The Place No One Knew: Glen Canyon on the Colorado.* San Francisco, 1966.

602. ———. *Summer Island.* San Francisco, 1966.

603. ———. *Galapagos: The Flow of Wilderness.* San Francisco, 1968.

604. Powell, John Wesley. *Down the Colorado.* Photographs by Eliot Porter. New York, 1969.

605. ———. *Birds of North America: A Personal Selection.* New York, 1972.

606. Matthiessen, Peter. *The Tree Where Man Was Born.* Photographs by Eliot Porter. New York, 1972.

About Porter

607. Stieglitz, Alfred. "Eliot Porter—Exhibition of Photographs." *An American Place,* New York, exhibition catalog, December 29, 1938 to January 18, 1939, n.p.

608. M.D. [Martha Davidson]. "Several Demuths; Camera Studies by Eliot Porter." *Art News,* 37 (7 January 1939), p. 14.

609. Devree, Howard. "A Reviewer's Notebook." *The New York Times,* Sunday, 1 January 1939, p. 10.

610. Deschin, Jacob. "Photographing Birds in Color." *The New York Times,* 31 May 1942.

611. Newhall, Nancy. "Eliot Porter: Birds in Color." *The Bulletin of The Museum of Modern Art,* 4 (April, 1943), p. 6.

612. "Nesting Birds." *Life* 14 (17 May 1943), n.p.

WILLIAM B. POST (American)

Fig. 33 » *William B. Post.* Reproduced from *The American Amateur Photographer,* 5 (December, 1893), opp. p. 570.

CHRONOLOGY

1857: Born.

By 1889: A member of the Society of Amateur Photographers, New York; has traveled to Europe at least once.

1889: Singled out for praise at 3rd Joint Exhibition.

1892: Introduces Stieglitz to the hand camera (Biblio. 873).

Early 1890s: Travels to California and Bahamas.

1895: Solo show at The Camera Club, New York, where he is on the Exhibition Committee; also included in the annual Member's Exhibition.

1897: Exhibits in members show at The Camera Club, New York.

1898: Begins to collect (Biblio. 619) European and American masterpieces of Pictorial Photography, advised by Alfred Stieglitz. Exhibits in members show at The Camera Club, New York. Becomes member of the New York Stock Exchange.

1899: Exhibits in members show at The Camera Club, New York.

1900: Solo show at The Camera Club, New York [reviewed by Hartmann in *Camera Notes,* 4 (April, 1901), pp. 277–278].

1901: Summer home, "Sans Souci," Freyburg, Maine, becomes his permanent address after a serious illness suspends his photographic activities.

1902: Exhibits in members show at The Camera Club, New York.

1903: Elected a Fellow of the Photo-Secession.

1904: One gravure reproduced in *Camera Work,* No. 6 (April, 1904).

1905: Photographs reproduced in Holme (Biblio. 1288).

1925: Dies in Fryeburg, Maine.

PHOTOGRAPHS

420 » *Village Street.* 1897 (A. S.) Platinum. 188 × 232 mm. (7⁷⁄₁₆ × 9⅛ in.) Signed and titled as above on verso in pencil "W. B. Post." 33.43.346.

Exhibited: Buffalo (1910), no. 553; titled *The Country Street, Winter,* representing the identical or a related photograph; New York (PSG, 1908), no. 24.

This print and *Wintry Weather* [*Camera Work,* No. 6 (April 1904)] typify the winter scenes of which, according to his letter to Stieglitz, he hoped to become the accepted master. Post was irritated with Stieglitz for not using the titles he had assigned (to A. S., 30 October 1908, YCAL). In this particular instance Stieglitz

420

ignored the title inscribed by Post on verso and supplied his own *Fryeburg, Maine, Winter,* descriptive of Post's hometown.

EXHIBITIONS

London 1894 » *New York (TCC) 1895* » Paris 1894–1897 » London (RPS) 1895 » Hamburg 1896 » London (RPS) 1897 » *Vienna 1897* » New York (AI) 1898 » Paris 1898 » *Vienna 1898* » Hamburg 1899 » Philadelphia 1900 » Glasgow 1901 » New York (NAC) 1902 » Brussels 1903 » Chicago 1903 » Cleveland 1903 » Hamburg 1903 » London 1903 » Toronto 1903 » Bradford 1904 » Hague 1904 » Pittsburgh 1904 » Washington 1904 » Portland 1905 » Richmond 1905 » Vienna (PC) 1905 » London 1906 » New York (PSG) 1906 » New York (PSG) 1907 » New York (PSG) 1908 » New York (NAC) 1909 » Buffalo 1910.

BIBLIOGRAPHY

Manuscript

613. Stieglitz Archives, Collection of American Literature, Beinecke Rare Book and Manuscript Library, Yale University, New Haven, Conn.: 29 unpublished letters from William B. Post to Alfred Stieglitz between 1898 and 1921.

By Post

614. Post, William B. "Photography of the Snow." *Photo Era,* 24 (March, 1910), pp. 113–119.
 615. ———. "Picturing the Pond Lily." *Photo Era,* 33 (August, 1914), p. 73.

About Post

616. "Editorial Comment." *American Amateur Photographer,* 5 (March, 1893), p. 119.
 617. Obermeyer, Joseph. "Members' Exhibition of Photographs, New York Camera Club." *American Amateur Photographer,* 7 (May, 1895), pp. 222–223.
 618. "Monthly Competition." *The Amateur Photographer,* 21 (7 June 1895), p. 362.
 619. "The Post Collection of Pictorial Photographs." *Camera Notes,* 2 (January, 1899), p. 96.
 620. Hartmann, Sadakichi. "Exhibition of Prints by William B. Post." *Camera Notes,* 4 (April, 1901), pp. 277–278.

CONSTANT PUYO (French)

Fig. 34 » *E. J. Constant Puyo*, 1926. Archives Photographiques Paris, S.P.A.D.E.M.

421

422

(Biblio. 1302) along with René Le Bègue and Maurice Bucquet.

1896: Publishes *Notes sur la Photographie Artistique* (Biblio. 622), signing himself "C. Puyo," a practice he maintains in other books and articles.

1902: Begins work with Leclerc de Pulligny on anachromatic lenses. Writes preface to Ch. Sollet's *Traité pratique des tirages photographiques*.

1905: Kuehn writes Stieglitz that Puyo "Paints over in pastel—more tasteless, sweeter than any court photographer—his works are recognized only partly as photographs" (To A. S., 20 February, YCAL).

1906: Three gravures published in *Camera Work*, No. 16 (October). Stieglitz purchases Puyo photographs for 375 francs. (January 10–24) exhibits in Photo-Secession Galleries Exhibition of French Work.

1910: Buffalo exhibition catalog describes Puyo as "a co-experimenter with Mr. Demachy in evolving 'gum' and 'oil' processes."

1914: Rejoins the military, World War I.

1924: Publishes *Objectifs de l'Artiste* (Biblio. 635) with Leclerc de Pulligny.

1931: Joint retrospective with Robert Demachy in Paris.

1933: Dies.

CHRONOLOGY

1857: Born.

?: Joins French Army; eventually becomes squadron leader, School of Artillery, La Fères (or La Tère), France.

About 1885–89: Begins to photograph as an amateur.

1894: Joins *Photo Club de Paris* and helps Demachy, his best friend, take over its artistic direction, with whom he forms the first Paris photographic salon

PHOTOGRAPHS

421 » *Été.* 1903 (A. S.) Green pigment Ozotype. 167 × 228 mm. (6⁹⁄₁₆ × 9 in.) Blindstamp "CP" monogram. 33.43.292.

Exhibited: Philadelphia (1900), no. 134; London

425

428

424

427

(1903), no. 36, titled as above; Buffalo (1910), no. 166, dated 1906 and titled *Summer*.

422 » *The Straw Hat.* 1904. Multiple pigment (gray and brown) gum-bichromate. 225 × 170 mm. (8⅞ × 6¹¹⁄₁₆ in.) Monogram in red with all the letters of his name "CPUYO." 49.55.216.
Exhibited: Buffalo (1910), no. 162, dated as above and described as a gum print.
Reproduced: *Camera Work,* No. 16 (October 1906), pl. II, halftone titled as above and reproduced from this print, but with no fidelity to the original hue.

423 » *The Straw Hat.* 1906 print. Halftone proof with margin and registration marks. Image, 215 × 161; paper, 228 × 176 mm. (8⁷⁄₁₆ × 6⁵⁄₁₆; 9 × 6⅞ in.) 49.55.217.
Not illustrated.
Exhibited: See Cat. 421.
Reproduced: *Camera Work,* No. 16 (October, 1906), pl. II, proof for this edition from the same plate, but the *Camera Work* with a more intense green than the proof; in both instances the green tone violates the brown hue of the original. The halftone plate was apparently made from Cat. 422, where line-for-line comparison indicates that marks unique to the gumprint are present in the halftone.

424 » *The Reader.* About 1905. Gray pigment oil print. 245 × 182 mm. (9⅝ × 7³⁄₁₆ in.) 49.55.215.
Exhibited: New York (PSG, 1906), no. 43, titled as above where it was very likely acquired by Stieglitz.

425 » [*The Water's Edge*]. 1906. Green pigment oil (A. S.) 163 × 229 mm. (6⁷⁄₁₆ × 9 in.) 33.43.288.
Exhibited: New York (PSG, 1906), no. 44, titled as above, suggesting the identical or a related work; Buffalo (1910), no. 169, a related subject if not identical to above, providing the title and date.
The heavy gray-green card mount shows no evidence that the American Style mount had been influential on Puyo.

426 » *The White Horse.* 1906. Gray pigment oil (A. S.), mounted on heavy tan card. 165 × 228 mm. (6½ × 9 in.) Signed in pencil on mount "C. Puyo." 33.43.289.
Plate 19.
Exhibited: Buffalo (1910), no. 165, titled and dated as above.

427 » [*Sunset.*] 1906. Green pigment oil (A. S.), mounted on heavy gray card. 227 × 165 mm. (8¹⁵⁄₁₆ × 6½ in.) 33.43.290.
Exhibited: Buffalo (1910), no. 168, titled as above, suggesting the identical or a related work.

428 » *Landscape.* 1906. Gray pigment oil (A. S.), mounted on natural heavy card. 165 × 226 mm. (6½ × 8¹⁵⁄₁₆ in.) 33.43.291.
Exhibited: Buffalo (1916), no. 167, dated as above.

429 » *Nude—Against the Light.* 1906 or before. Gray-brown pigment gum-bichromate. 222 × 154 mm. (8¾ × 6¹⁄₁₆ in.) Monogram in

brown with all the letters of his name "CPUYO." 49.55.218.

Plate 20.

Reproduced: *Camera Work,* No. 16 (October, 1906), pl. III, halftone titled as above and reproduced from this print in gray with no brown. It is stated on p. 54 that all the French prints reproduced were exhibited in the Photo-Secession Galleries (1905), of which this could be no. 45, titled *The Model.*

EXHIBITIONS

Paris 1894–1898 » Brussels 1895 » London 1895–1904. *1905.* 1906–1907 » Hamburg 1898–1899 » London (RPS) 1898 » Philadelphia 1900 » Brussels 1901 » Glasgow 1901 » Hamburg 1902–1903 » Leeds 1902 » Paris 1902 Turin 1902 » Brussels 1903 » Wiesbaden 1903 » Bradford 1904 » Hague 1904 » Paris 1904 » Vienna (C-K) 1905 » London 1906 » *Munich 1906* » New York (PSG) 1906 » Paris 1906 » Philadelphia 1906 » *London (NEAG) 1907* » *Paris (PC) 1908–1909* » Buffalo 1910 » *Paris (PC ?) 1931.*

BIBLIOGRAPHY

Manuscript

621. Stieglitz Archives, Collection of American Literature, Beinecke Rare Book and Manuscript Library, Yale University, New Haven, Conn.: 2 unpublished letters from Charles Puyo to Alfred Stieglitz in 1906.

By Puyo

622. Puyo, C. *Notes sur la Photographie Artistique.* Paris, 1896.

623. ———. "Avant-Propos." *Salon de Photographie. Photo-Club de Paris,* April 13–28, 1897.

624. ———. "Concerning the Use of Artificial Light Combined with Daylight." *Photographic Times,* 31 (January, 1899), pp. 34–41.

625. ———. "A Note upon Artigue Paper." *Photographic Times,* 31 (May, 1899), pp. 237–238.

626. ———. "L'Exposition de M. H. Day et de la 'Nouvelle École Americaine.'" *Bulletin, Photo Club de Paris,* No. 123, (April, 1901), pp. 115–138.

627. ———. "L'Évolution Photographique." *La Revue de Photographie,* 1 (January, 1903), pp. 1–6.

628. ———. "Mounting in the American Style." *Photo Era,* 12 (January, 1904), pp. 5–6.

629. ———. "Le Passé Source d'Inspiration." *La Revue de Photographie,* 2 (January, 1904), pp. 1–8.

630. ———. "Multiple Impression, Chromatic Printing, and Other Expedients in Gum-Bichromate." *The Amateur Photographer,* 40 (11 October 1904), pp. 296–298.

631. ———. "L'Art de la Composition." *La Revue de Photographie,* 3 (January, 1905), pp. 19–24.

632. ——— and Robert Demachy. *Les Procédés d'Art en Photographie.* Paris, 1906.

633. ———. *Le Procédé Rawlins à l'Huile.* Paris, 1907.

634. ———. "Menus Propos sur la Photographie de Plein Air." *La Revue de Photographie,* 6 (January, 1908), pp. 23–30.

635. ——— and Leclerc de Pulligny. *Objectifs de l'Artiste.* Paris, 1924.

636. ———. *Comment Composer un Portrait.* Paris, 1925.

637. ———. *Le Procédé à L'Huile.* Paris, n. d.

About Puyo

638. Cadby, Will. "Notes on Some Examples of the Work of Major C. Puyo." *The Amateur Photographer,* 38 (29 October 1903), pp. 350–351.

639. "Major Puyo on the Properties of Anachromatic Lenses." *British Journal of Photography,* 53 (9 March 1906), pp. 185–186.

640. "M. Puyo's Technique of the Oil Process." *British Journal of Photography,* 54 (30 August 1907), pp. 653–657.

641. Beaton, Cecil and Gail Buckland. "Charles [sic] Puyo." *The Magic Image.* Boston, 1975, p. 125.

FRANK H. READ (British)

Fig. 35 » *Frank H. Read*, 1910. Reproduced from *The Amateur Photographer and Photographic News*, 51 (March 29, 1910), p. 323.

CHRONOLOGY

1900–03: Exhibits at The London Salon jointly as "A. & F. Read" or "Arthur and Frank Read," with address listed as Brentford, Middlesex.

1909: Proposed for The Linked Ring, but not consummated. » Listed in The London Salon catalog as Frank H. Read at The Studio, 61 Richmond Road, Twickenham.

1910: Participates in London Secession, a splinter group of The Linked Ring. Stieglitz selects eight photographs for Buffalo International Exhibition.

430

1911: Participates in the London Secession (Biblio. 1422).

PHOTOGRAPHS

430 » *Summer.* 1910. Gray green pigment oil. 240 × 276 mm. (9⁷⁄₁₆ × 10⅞ in.) Signed in pencil "Frank H. Read/'10." 33.43.331.
Exhibited: Buffalo (1910), no. 127.

EXHIBITIONS

London 1901–1903 (in 1902 and 1903 listed as A. & F. Read) » London (RPS) 1903 (listed as Arthur & Frank Read) » London 1909–1910 (listed as Frank H. Read) » London (RPS) 1909 » Buffalo 1910 » London (Secession) 1911 » London (RPS) 1914 (listed as Frank H. Read).

BIBLIOGRAPHY

Manuscript

642. Stieglitz Archives, Collection of American Literature, Beinecke Rare Book and Manuscript Library, Yale University, New Haven, Conn.: 2 unpublished letters from Frank H. Read to Alfred Stieglitz.

About Read

643. Guest, Anthony. "Three Pictures by Frank H. Read." *The Amateur Photographer,* 50 (9 November 1909), pp. 458–461.

644. "Frank H. Read." *The Amateur Photographer,* 51 (29 March 1910), p. 323.

645. Guest, Anthony. "Mr. Frank H. Read's Pictures at the Camera Club." *The Amateur Photographer,* 55 (1 April 1912), p. 345.

HARRY C. RUBINCAM (American)

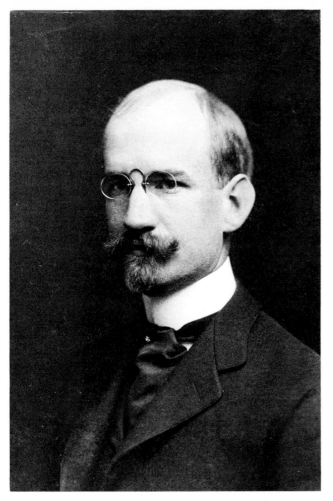

Fig. 36 » *Harry C. Rubincam*, about 1900. Courtesy of Harry C. Rubicam (sic), Jr.

CHRONOLOGY

1871: Born on August 1 in Philadelphia, son of Joseph and Sarah Maria (Bodine) Rubincam. Educated in Philadelphia and Camden, New Jersey, schools.

Mid-1880s: Joins father's fruit importing firm and considers contact with "hucksters" of great importance for a great insight into life. Following failure of business, moves to New York where he is employed in various capacities in the wholesale grocery business, and writes for trade journals.

1894: Marries Kittie Emma Whallon a few years after beginning employment with Equitable Life Assurance Society. Lives in Brooklyn, New York.

About 1897: Moves to Denver as a cure for tuberculosis. Opens an insurance office for the Equitable. Is later employed by the Capitol Life Insurance Company. Becomes interested in photography after helping a friend learn to operate a camera. Receives instruction in the techniques of photography from a retired professional photographer who accompanies him on all his expeditions.

About 1900: Begins activity with the Colorado Camera Club, and is strongly influenced by the artistic point of view of its president, Maj. William Cooke Daniels. Uses a universal focus lens.

1901: Begins writing on photography for *Outdoor Life,* inspired by his new understanding of the artistic potential of photography. Severs relationship with Colorado Camera Club in an esthetic disagreement.

1903: Becomes an associate of the Photo-Secession (Biblio. 649, 650).

1904: Represented at the Exhibition of the Photo-Secession in Pittsburgh (Biblio. 1366). Exhibits *Frightened Boy* at the London Photographic Salon. Dines with Stieglitz when in New York on a visit in December.

1905: Exhibits at the Photo-Secession Galleries (November 24–January 6, 1906).

1906: Exhibits at the Photo-Secession Galleries (November 8–January 1, 1907).

1907: Exhibits two prints at the Photo-Secession Galleries (November 18–December 30); one gravure in *Camera Work,* No. 17 (January, 1907).

1909: Exhibits one print at the exhibition of the National Arts Club, New York.

1914: Establishes his own successful insurance agency, Denver.

About 1917 or 1918: Elected president of the National Petroleum Corporation, a small company drilling for oil in Oklahoma.

1919: National Petroleum Corporation dissolved. Rubincam and family move to a ranch in Douglas County, Colorado.

About 1925: Moves back to Denver. Is employed by the

431 432

Capitol Life Insurance Company as manager of the real estate loan division.
1940: Dies in November.

PHOTOGRAPHS

431 » *Steichen "seeing things."* 1906. Gelatine silver on postcard stock. 98 × 73 mm. (3⅞ × 2⅞ in.) Titled and initialed in ink on verso, addressed to A. S., Caldwell, Lake George, N.Y., postmarked Denver, August, 1906. 33.43.329.

The negative for this print and Cat. 432 were surely made at the time Steichen and his family visited Colorado in June of 1906, when Steichen's negative of Cat. 472 was made.

432 » *Steichen on Horseback.* (Attributed to Harry C. Rubincam). June, 1906. Gelatine silver postcard. 93 × 52 mm. (3¹¹⁄₁₆ × 2¹⁄₁₆ in.) 49.55.233.

The card was addressed by Steichen to "Mrs. Alfred Stieglitz, Caldwell, Lake George, New York" and postmarked August 31, 1906.

EXHIBITIONS

San Francisco 1903 » Hague 1904 » London 1904 » Pittsburgh 1904 » Washington 1904 » New York (PSG) 1905 » New York (PSG) 1906 » New York (PSG) 1907 » Buffalo 1910.

BIBLIOGRAPHY

Manuscript

646. Stieglitz Archives, Collection of American Literature, Beinecke Rare Book and Manuscript Library, Yale University, New Haven, Conn.: 24 unpublished letters from Harry C. Rubincam to Alfred Stieglitz between 1903 and 1911.

647. Typescript Autobiography of Harry C. Rubincam. Joseph T. Keiley Archives. Estate of Joseph T. Keiley.

By Rubincam

648. Rubincam, Harry C. "Darkroom Dissertations." *Outdoor Life,* one article each monthly issue from 8 (August, 1901) through 14 (December, 1904).

649. ———. "Esthetic Activity in Photography." *Camera Work,* No. 3 (July, 1903), pp. 39–40.

650. ———. "A Dissertation on Instruction." *Camera Work,* No. 5 (January, 1904), pp. 41–42.

651. ———. "Straight Photography." *The Photographer,* 1 (28 May 1904), pp. 66–68.

652. ———. "A Condition and a Theory." *The Photographer,* 1 (2 July 1904), pp. 146–147.

653. ———. "The Limitations (?) of Pictorial Photography." *The Photographer,* 1 (23 July 1904), pp. 194–195.

654. ———. "Pictorial Photography and the Questions of Mr. Roland Rood." *The Photographer,* 1 (September, 1904), pp. 290–291.

655. ———. "A Stranger in New York." *The Photographer,* 2 (24 December 1904), pp. 131–132.

656. ———. "Originality in Photography." *American Annual of Photography and Photographic Times Almanac for 1904,* pp. 25–26.

657. ———. [Letter on The First American Photographic Salon]. *The Photographer,* 2 (21 February 1905), pp. 267–269.

658. ———. "Painted Paragraphs." *Camera Craft,* 10 (March, 1905), pp. 153–155.

659. ———. "The Photo-Secession and the First American Salon." *American Amateur Photographer,* 17 (March, 1905), pp. 149–150.

660. ———. "Dark Room Dissertations." *Camera Craft,* 10 (April and May, 1905), pp. 205–209, and 273–277.

About Rubincam

661. Rood, Roland. "The Limitations of Pictorial Photography—Once More! A Few Questions Put to H. C. Rubincam." *The Photographer,* 1 (6 August 1904), p. 229.

MORTON L. SCHAMBERG (American)

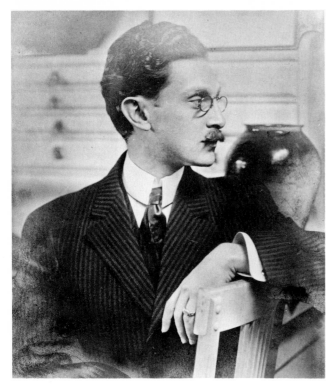

Fig. 37 » *Morton L. Schamberg,* about 1915. Courtesy of Ben Wolf, Philadelphia, Pennsylvania.

1905: Travels to Spain with William Merritt Chase's class (Summer).

1906: Graduated from the Pennsylvania Academy of the Fine Arts.

1906–07: Spends year in Paris.

1907: Begins sharing studio with Charles Sheeler at 1626 Chestnut Street, Philadelphia.

1908: Second trip to Paris (late in the year).

1909: Joined in Italy by Sheeler (January–February).

1910: Takes own studio in Philadelphia; shares house with Sheeler in Doylestown, Bucks County, on weekends. » First solo exhibition of painting at McClees Gallery, Philadelphia.

1912: Begins taking photographs for income, mostly portraits.

1913: Exhibits five paintings in Armory Show.

1915–16: Becomes part of the Arensberg circle of avant-garde artists and writers.

1916: Begins painting abstract machine forms and photographing Philadelphia; shows photographs to Stieglitz after introduction by Sheeler.

1917: Exhibits with Sheeler and Strand at de Zayas's Modern Gallery, New York.

1918: Wins 3rd prize in 13th Annual John Wanamaker Photograph Exhibition for portrait of a little boy (Biblio. 1410).

1918: Dies in flu epidemic on October 13.

1919: First solo exhibition in New York, held at Knoedler's Gallery (posthumous).

CHRONOLOGY

1881: Born on October 15 in Philadelphia.

About 1895–99: Attends Central High School, Philadelphia.

1899: Enrolled at Schol of Fine Arts, University of Pennsylvania.

1902: Travels to Europe with William Merritt Chase's class (Summer).

1903: Graduates from University of Pennsylvania with Bachelor of Architecture degree. » Travels to England with William Merritt Chase's Class (Summer). » Enrolled at Pennsylvania Academy of the Fine Arts (Fall).

PHOTOGRAPHS

433 » *Portrait Study.* 1917. Gelatine silver, mounted on tan wove paper with a subtle ribbed pattern and embossed area for the photograph, typical of commercially manufactured presentation materials. 241 × 177 mm. (9½ × 7in.) Signed and dated "Schamberg/1917." 33.43.351.

Plate 91.

The single source of light is unusual in posed studio portraits. Schamberg supported himself with portrait work, and this print represents an experimental departure from his normal mode (compare MMA 1973.664) toward application to portraits of the single

light source experiments which Scheeler was making in his still-life photographs. The two shared a small house in Doylestown, Pennsylvania, at the time where Sheeler made his counterpart studies (Cats. 446–449).

EXHIBITIONS

Philadelphia (McClees Gallery) 1910 paintings only » New York (Armory) 1913 paintings only » New York (Modern Gallery) 1917 » Philadelphia (Wanamaker) 1918 » New York (Knoedler) 1919 posthumous.

BIBLIOGRAPHY

Manuscript

662. Stieglitz Archives, Collection of American Literature, Beinecke Rare Book and Manuscript Library, Yale University, New Haven, Conn.: 3 unpublished letters from Morton Schamberg to Alfred Stieglitz in 1916.

About Schamberg

663. "Photographic Art at Modern Gallery." *American Art News,* 15 (31 March 1917), p. 3.

664. Fitz, W. G. "A Few Thoughts on the Wanamaker Exhibition." *The Camera,* 22 (April, 1918), pp. 201–207.

665. Pach, Walter. "Schamberg Retrospective." *The Dial,* 66 (17 May 1919), pp. 505–506.

666. Wolf, Ben. *Morton Livingston Schamberg.* Philadelphia, 1963.

667. ———. "Morton Livingston Schamberg." *Art in America,* 52 (February, 1964), pp. 76–78.

668. Coke, Van Deren. "The Cubist Photographs of Paul Strand and Morton Schamberg." *One Hundred Years of Photographic History: Essays in Honor of Beaumont Newhall.* Albuquerque, 1975, pp. 36–39.

669. Scott, Wilford. "Morton L. Schamberg." *Avant-Garde Painting and Sculpture in America, 1910–25.* Delaware Art Museum, Wilmington, Delaware, exhibition catalog, 1975, p. 128.

SARAH C. SEARS (American)

Fig. 38 » *Sarah C. Sears.* Oil on canvas by John Singer Sargent, 1899. Courtesy of Benjamin Sonnenberg, New York. Photo: Peter A. Juley & Son, N.Y.

CHRONOLOGY

1858: Born on May 5 in Cambridge, Massachusetts, daughter of Charles Francis and Elizabeth Carlisle Choate.

About 1876: Studies painting at Cowles Art School and The Museum of Fine Arts School, Boston.

1881: Marries Joshua Montgomery Sears on February 18.

1892–1904: Receives numerous prizes for her watercolors, including Medal at 1893 Chicago Exposition; 1900 Paris Exposition; 1901 Buffalo Exposition; 1904 St. Louis Exposition. Prominent in Boston Society. Collects paintings by Sargent, Cassatt, La Farge, and Degas.

1890s: Begins photographing.

1900: Five prints included in F. H. Day's exhibition, The New School of American Photography, shown in London and in 1901 in Paris. A mutual interest in photography fosters a friendship with Day.

1904: Elected a Fellow of the Photo-Secession. Also elected to The Linked Ring.

1905: J. Montgomery Sears dies on June 2.

1906: With her daughter Helen, travels to Paris where she is friendly with Cassatt, the H. O. Havemayers, and frequents the salons at Gertrude Stein's.

1907: Two gravures reproduced in *Camera Work,* No. 18 (April). Returns to Paris and travels in Europe during 1907–1908, then returns to Boston.

About 1915: Collects primarily watercolors by Marin, Maurer, Demuth (also collected by Stieglitz), and others. Continues her own watercolor painting, and occasionally photographs her family.

1935: Dies on September 25, West Gouldsboro, Maine.

PHOTOGRAPHS

434 » *Portrait of Mrs. J. W. H.* [*Julia Ward Howe*]. 1901 or before. Platinum, mounted on gray paper with a narrow border upon a larger sheet of natural Japanese paper. 237 × 178 mm. ($9^5/_{16}$ × 7 in.) 33.43.267.

Exhibited: Glasgow (1901), no. 142, titled *Portrait of Mrs. H;* London (NSAP 1900), no. 175; Paris (NSAP 1901), no. 119, variant titled as above and reproduced in Steichen's commentary on NSAP (Biblio. 742); Bradford (1904), no. 193; New York (PSG, 1905), no. 62, titled *Portrait, Mrs. Howe.*

Reproduced: *Camera Work,* No. 18 (April, 1907), p. 33, *Mrs. Julia Ward Howe,* plate 1.

Collections: AIC, Stieglitz Collection.

The title assigned in *Camera Work* represents an instance in which the wishes of the photographer were overlooked. Maintaining a policy of not identifying her

434

436

437

sitters in print, Sears on several occasions had this print reproduced as *Mrs. J. W. H.,* while Stieglitz chose to identify her by name. See Biblio. 673.

435 » *A Mexican [Baron Adolph de Meyer].* 1904 or before. Platinum. 242 × 187 mm. (9%16 × 7⅜ in.) 33.43.265.
Figure 16.
 Reproduced: *Photo-Miniature,* 6 (September, 1904), opp. p. 340, titled as above.
 In keeping with the practice established by Day, Coburn, Steichen, and many others in Stieglitz's circle, Sears preferred not to disclose the identities of her sitters when they were publicly exhibited.

436 » *Helen [Sears].* 1902 (A. S.) Platinum, mounted on brown paper upon green, both with narrow borders. 239 × 190 mm. (9⅞16 × 7½ in.) 33.43.266.
Exhibited: Hamburg (1903), pl. 385; Bradford (1904), no. 194; New York (NAC, 1909), no. 162.

437 » *Mary.* 1903 or before. Platinum, mounted on green paper with a narrow border upon a larger sheet of another green. 238 × 173 mm. (9⅜ × 6¹³⁄₁₆ in.) Stylized monogram "scs" in yellow crayon pencil. 33.43.268.
Exhibited: London (1903), no. 7; New York (PSG, 1905), no. 63; Cincinnati (1906), no. 43; Philadelphia (1906), no. 100.
 Reproduced: *Camera Work,* No. 18 (April, 1907), p. II, where it was noted that Sears "strikes a new note in the atmospheric mystery attained in her low-toned picture called *Mary*" (p. 43).

EXHIBITIONS

Vienna (C-K) 1897 » London 1898 » *Vienna (C-K) 1898* » Berlin 1899 » New York (AI) 1899 » Philadelphia 1899 » London 1900 » Glasgow 1901 » London/Paris (NSAP) 1901 » London 1902–1904 » San Francisco 1902 » Hamburg 1903 » Bradford 1904 » Hague 1904 » Pittsburgh 1904 » Vienna (PC) 1904–1905 » Washington 1904 » Portland 1905 » Vienna (C-K) 1905 » New York (PSG) 1905 » Cincinnati 1906 » Philadelphia 1906 » New York (NAC) 1909.

BIBLIOGRAPHY

Manuscript

 670. Stieglitz Archives, Collection of American Literature, Beinecke Rare Book and Manuscript Library, Yale University, New Haven, Conn.: 6 unpublished letters from Sarah C. Sears to Alfred Stieglitz, n.d.

About Sears

 671. Hickman, W. Albert. "A Recent Exhibition." *Photo Era,* 1 (May, 1898), pp. 11–13.
 672. "Recent Exhibitions." *Photo Era,* 2 (March, 1899), pp. 260–261.
 673. Allan, Sidney [Sadakichi Hartmann.] "Pictorial Criticism: Constructive, not Destructive—Portrait of Julia Ward Howe by Sarah C. Sears." *The Photographer,* 1 (11 June 1904), p. 105.
 674. "Sarah C. Sears." *Who's Who,* 5 (1908–1909), p. 1688.

GEORGE H. SEELEY (American)

Fig. 39 » *George H. Seeley.* By Alvin Langdon Coburn, about 1905. Courtesy of Miss Laura Seeley.

George H Seeley.

CHRONOLOGY

1880: Born George Henry Seeley, in Stockbridge, Massachusetts, son of Sara Tubbs and Frederick Bernard Seeley. His older brother Howard becomes a physician; his older sisters, Marian and Lillian, a schoolteacher and a librarian in Stockbridge respectively. His younger sister Laura, a pianist, was his life-companion and favorite model along with Lillian.

About 1885–96: Educated at Williams Academy, Stockbridge. His father is superintendent of the grounds at "Linwood," the estate of Charles H. Butler, a prominent Boston lawyer. "Linwood" is inherited by Miss Helen Butler, who becomes a favorite model of Seeley (Cat. 439). Receives pinhole camera as a gift from his uncle and learns to photograph.

1897–1902: Studies drawing and painting at Massachusetts Normal Art School, but doesn't photograph during this time.

1902: Visits the studio of Day who rekindles his schoolboy's interest in photography and returns to Stockbridge with an eight-by-ten camera.

1902–04: Holds position of Supervisor of Art, Stockbridge Public Schools, and makes his first serious photographs.

1903: F. R. Fraprie awards Seeley's *Early Morning* First Prize in the genre class of the *Photo-Era* competition (December 8). » Many of Seeley's photographs were made during early daylight hours, which he preferred for the quality of light, as Laura Seeley, his primary model, recollects (Biblio. 677).

1904: Private exhibition of thirty photographs at "Linwood," for which a printed announcement is circulated. Six of the works have no titles, while many of the others have lyric titles, of which the following are typical: 1. *Phantasmal Haze* 5. *The Grove's Compass* 9. *Why are you so Homely?* 10. *Sleepy Boats* 12. *Battering for the Soul* 15. *The Mourning Veil* 28. *A Question of Power* 27. *Where Thou Art Anchored* 29. *The Wolf's Skin* » Curtis Bell writes: "I have already taken measures to bring your extraordinary work before the public in such a way that I feel *financial* returns will begin to materialize as soon as the December magazines are out and the Salon is underway. . . . My personal interest in your behalf is great, and I feel you have no more appreciative admirer." (Bell to Seeley, 19 November 1904, Biblio. 676). » Bell attempts to win Seeley's support for the Salon Club and its forthcoming exhibition: "We feel that a *new* standard has been established—a broader and better one than the Photo-Secession. . . . We have been organized to secure fair play for all that is good in Photographic Art regardless of the method or manner of treatment—to protest against a narrow point of view—to molest *no* one but rather to hold out a hand to everyone who is trying to follow an ideal " (Bell to Seeley, ibid.). » Exhibition of fourteen prints in First American Photographic Salon

organized by the Salon Club under the direction of Curtis Bell (Biblio. 1404). Curtis is also President of the American Federation of Photographic Societies » Day writes: "I hear from Curtis Bell your prints are highly appreciated." [N. d. (1904), Biblio. 676 A]. » Stieglitz invites Seeley to become a Fellow of the Photo-Secession: "the Fellowship is an honor not readily conferred, you know." (27 December 1904, YCAL). » Rood writes (Biblio. 684): Seeley "is the one big man who the Salon (FAPS) has brought out. Scarcely more than a boy —not twenty-five—he has already acquired a power of expression which places him in the foremost ranks of American photographers." (Biblio. 676).

1905: Holds position of Stockbridge correspondent for the *Springfield Republican* newspaper, writing articles of general interest including art exhibits, golf tournaments, and interviews with such prominent residents of Stockbridge as Rufus Choate. » Editor of *Photo-Era* writes: "Mr. Seeley's first appearance as an art photographer was through the pages of *Photo-Era*. . . . The next we hear of him, was the acceptance of fourteen prints by the Jury of the American Photographic Salon (Biblio. 676). . . . He is generally considered the photographic art find of the newer generation. . . ." » J. B. Samat writes: *"Un véritable grand artist, c'est un Carrière, avec toute la poesie, le sentiment et la supreme harmonie de notre grand peintre."* (Biblio. 1415, p. 35). » Coburn writes to Seeley after seeing his work at FAPS: "Really must write you of the pleasure your things have given me . . . for previously I had only seen one or two little 4 × 5 prints you had given to Mr. Day. If you come to New York I should very much like to meet you." [Coburn to Seeley, 6 December 1905, Biblio. 676]. » Solo exhibition at Photographic Society of Philadelphia.

1906: Two gravures published in *Camera Work,* No. 15 (July). Exhibits five prints at the inaugural exhibition of the Photo-Secession Galleries. » Stieglitz writes: "Before this reaches you, you will have seen Mr. White who will have given you a pretty good idea of the Secession. . . . I'd like to see your prints as I am much interested in your work & expect quite a little from you." [Stieglitz to Seeley, 4 March 1906, Biblio. 676].

1907: Exhibits jointly with Baron de Meyer at the Photo-Secession Galleries (Biblio. 1387), January 25– February 12. » Six gravures published in *Camera Work,* No. 7 (July), including *The Staghound* (Cat. 439) and *The Burning of Rome* (Cat. 440). » Becomes a Fellow of the Photo-Secession.

1908: Exhibits fifty-one photographs in solo show at the Photo-Secession Galleries (Biblio. 1392). » Steichen writes from Paris on behalf of Stieglitz who is dismayed that Seeley has not complied with a request to send prints to the Dresden Exhibition (Biblio. 676), and encourages him to reconsider his apparent decision not to participate. Stieglitz writes Kuehn of his distress over Seeley's lack of cooperation in sending prints for forthcoming Dresden exhibition (Biblio. 1395). Incident causes breach between Seeley and Stieglitz. (Stieglitz to Kuehn, 1 March 1909, YCAL).

1910: Twenty-three prints exhibited at Buffalo, where new elements are seen in his style. Large in format, all prints are gum-bichromates from enlarged negatives, and several are details of snow and ice scenes sufficiently abstract that one was exhibited upside down (Biblio. 677). Albright Art Gallery purchases *Golden October* for one hundred dollars.

1910–11: Stieglitz announces Seeley exhibition for the 1910–1911 season which never materializes.

1913: Twenty-three prints exhibited (December 6–10) at private studio of Spencer Kellogg, Buffalo, which is deemed of sufficient importance for two reviews to appear in Buffalo newspapers (Biblio. 691–693). De Meyer writes Seeley requesting lantern slides for his forthcoming lecture on Pictorial photography. Kellogg announces intent to show White and Day.

1916: A group of students from the Clarence H. White School of Photography visit Seeley's Stockbridge Studio at "Linwood."

1917: *Country Life in America* reproduces a selection of Seeley photographs (January).

1920: His father dies and family leaves "Linwood," a move which coincides with Seeley's diminished activity in photography.

1920s–30s: Becomes interested in ornithology and painting.

1927: Seeley's mother dies. Laura and George reside together until his death on December 21, 1955.

439

441

PHOTOGRAPHS

438 » *The Pines Whisper.* 1904 (A. S.) Platinum. 220 × 187 mm. (8¹¹⁄₁₆ × 7⅜ in.) 33.43.325.
Plate 81.
Exhibited: Buffalo (1910), no. 359, dated as above and lent by Stieglitz, catalogued as *No Title.* Seeley was among the few photographers in the Stieglitz collection to occasionally exhibit and publish photographs untitled, as in *Camera Work,* No. 15 (July, 1906). Stockbridge ("Linwood") 1904, no. 20; New York (FAPS), per review (Biblio. 1404), where it is reproduced.

Collections: Mrs. Thomas C. Byron, titled in Seeley's hand *The Soughing of the Pines.*

The models are Frederick H. Koch, a friend of Seeley's from art school days in Boston, and Lillian Seeley. Koch wrote a poem of nine four line stanzas called "To G. H. S." dated February 5, 1909, of which Seeley is the subject. The first stanza reads:

A seer went seeking a vision—
A dreamer of luminous dreams—
Far off in the meadows Elysian,
In the hand of murmuring streams.

439 » *The Staghound.* 1904 (A.S.) Brown pigment gum-bichromate over platinum. 188 × 243 mm. (7⁷⁄₁₆ × 9⁹⁄₁₆ in.) Signed in pencil "George H. Seeley." 33.43.328.
Exhibited: Cincinnati (1906), no. 46, titled *Woman with Hound;* Philadelphia (1906), no. 103, titled as above; Montreal (Art Association) 1907, no. 209; Utica

(Public Library), no. 49, titled *Spring, The Staghound;* Dresden (1909) no. 115.

The pedigree Staghound belonged to Miss Helen Butler, mistress of "Linwood." The model is Laura Seeley, who recollects the photograph being made in the very early morning.

440 » *The Burning of Rome.* 1906. Brown pigment gum-bichromate over platinum, mounted on brown paper with a narrow margin on a larger sheet of green, upon a sheet of natural wove paper. 246 × 196 mm. (9¹¹⁄₁₆ × 7¾ in.) Signed in pencil "George H. Seeley/1906." 33.43.326.
Plate 80.
Exhibited: Montreal (Art Association) 1907, no. 212; New York (PSG) 1907, no. 29; New York (PSG) 1908, no. 38; Dresden (1909), no. 111.

Reproduced: *Camera Work,* No. 20 (October, 1907), pl. IV, where it is stated that "the gravures were all made directly from the original negatives" (p. 47), with a consequent increase in the sharpness and detail from the extremely soft effect represented in this print; *The Craftsman,* 13 (October, 1907), p. 300; *The Bookman,* 27 (March, 1908), p. 76.

The models are Lillian and Laura Seeley at "Linwood," the estate of Charles H. Butler. Seeley had a great interest in Greek and Roman literature which inspired the title. The costumes were sewn by Seeley's mother especially for the purpose.

441 » *The White Circle.* 1908 or before. Brown pigment gum-bichromate. 242 × 193 mm. (9⁹⁄₁₆ × 7⅝ in.) Signed in pencil "George H. Seeley." 33.43.327.
Exhibited: New York (PSG, 1907), no. 44, titled *The Circle in Shadow,* suggests a related composition; New York (PSG, 1908), no. 30; Dresden (1909), no. 112.

The model is Laura Seeley.

EXHIBITIONS

*Stockbridge ("Linwood") 1904 » *New York (FAPS) 1904* » *Philadelphia (Photographic So-

ciety) 1905 » *Marseille 1905* » Vienna (C-K) 1905 » Vienna (PC) 1905 » New York (PSG) 1906 » Cincinnati 1906 » Paris 1906 » Philadelphia 1906 » *London (NEAG) 1907* » Montreal (Art Association) 1907 » New York (PSG) 1907 » New York (PSG Members and Solo) 1908 » *(Utica Public Library) 1908* » Dresden 1909 » New York (NAC) 1909 » Buffalo 1910 » Stockbridge, Mass. (The Casino) 1911 » Newark, N.J. (Public Library) 1911 » New York (Montross) 1912 » *Buffalo (Kellogg Studio) 1913 » London (RPS) 1914 » New York (Ehrich Gallery) 1915.

COLLECTIONS

RPS.

BIBLIOGRAPHY

Manuscript

675. Stieglitz Archives, Collection of American Literature, Beinecke Rare Book and Manuscript Library, Yale University, New Haven, Conn.: 46 unpublished letters from George Seeley to Alfred Stieglitz and 7 unpublished letters from Alfred Stieglitz to George Seeley between 1905 and 1911.

676. *Scrapbook*. Articles, letters, reviews, exhibition catalogs and miscellaneous ephemera relevant to the photographs of George H. Seeley, to Pictorial Photography and to the Photo-Secession. Letters from F. R. Fraprie, Curis Bell, F. Holland Day, Coburn, Steichen, Stieglitz, and others. Estate of George Seeley.

677. *Laura Seeley Recollection to Weston Naef.* Stockbridge, Massachusetts, 12 December 1977.

By Seeley

678. Seeley, George H. "Flower Photography." *Western Camera Notes*, 6 (June, 1903), pp. 137–140.

679. ———. "Pictorial Photography." *Western Camera Notes*, 6 (June, 1903), pp. 137–140.

680. ———. "Portaiture." *The Camera*, 8 (1904), pp. 113–118, clipping in Biblio. 676.

681. ———. *Exhibition and Private View of Photographs by George H. Seeley of Stockbridge, Massa-*

chusetts. ["Linwood"]. August 25–27, 1904. (Privately published.)

682. ———. Photographic Society of Philadelphia. *Photographs by George H. Seeley of Stockbridge, Massachusetts*. December, 1905.

683. ———. "Photography: An Estimate." *Photographic Times*, 37 (March, 1905), pp. 99–101.

About Seeley

684. Rood, Roland. "The First American Photographic Salon at New York." *American Amateur Photographer*, 16 (December, 1904), pp. 519–529.

See Biblio.1415 [Marseille International Exhibition], 1905.

685. Edgerton, Giles [Mary Fanton Roberts]. "The Lyric Quality in the Photo-Secession Art of George Seeley." *The Craftsman*, 13 (December, 1907), pp. 298–303.

See Biblio. 1392. (PSG 1908 Exhibition.)

686. Caffin, Charles H. "An Exhibition of Prints by George H. Seeley." *Camera Work*, No. 23 (July, 1908), pp. 8–10.

See Biblio. 1395.

687. Chamberlain, Joseph Edgar. "Esoteric Photography." *The Evening Mail* (New York, 3 February 1908).

688. Hoeber, Arthur. "Photo-Secession Galleries—Notes." *The Globe and Commercial Advertiser*. (New York, n. d., February, 1908?). In Biblio. 676 (Scrapbook).

689. "Art Photographs Shown." *The New York Times* (23 February 1908).

690. Eaton, Walter Prichard. "Geo. H. Seeley's Photographs." *Pittsfield Journal* (31 August 1911). Review of exhibition at The Casino, Stockbridge.

691. Kellogg, Spencer. *Exhibition of Photographs by George H. Seeley.* December 6–10. Buffalo, privately printed, 1913.

692. [Kellogg Exhibition]. "Picture Supplement." *Buffalo Sunday Morning News* (14 December 1913).

693. [Kellogg Exhibition]. "Beautiful Showing of Art Photography of George H. Seeley." *Buffalo Commercial* (date not cited, December 6–10, 1913?). In Biblio. 676.

694. "George Seeley's Pictures." *Photo-Era*, 44 (February, 1920), p. 105.

GEORGE BERNARD SHAW (English)

Fig. 40 » *George Bernard Shaw*. Self-portrait, 1904, printed by Frederick H. Evans. Cat. 445.

CHRONOLOGY

1856: Born in Dublin.

1876: Moves to London with his mother where "I did not throw myself into the struggle for life: I threw my mother into it. . . . I steadily wrote my five pages a day and made a man of myself (at my mother's expense) instead of a slave." (Cited in Hesketh Pearson, *George Bernard Shaw, His Life and Personality,* New York, 1963, pp. 60–61.)

1879–83: First five novels received without acclaim.

About 1880–85: Writes his first photographic criticism. Meets Frederick Evans.

1884: Joins Fabian Society.

1885: Hired to review art exhibitions for the *Pall Mall Gazette* and later observed, "I astonished the cliques by writing a review of a photographic exhibit as if it were the Royal Academy, and criticizing Robinson as if he were Millais" (Biblio. 715).

1888–90: Music critic for the *Star,* under the pseudonym "Corno di Bassetto."

1890–94: Music critic for the *World.*

1892: First Play *Widowers' Houses* produced.

1895–98: Drama critic for the *Saturday Review.*

1898: Marries Charlotte Payne-Townshend. Takes up photography using a Kodak box camera. Of his years as a critic, he writes: "For ten years past . . . I have been dinning into the public head that I am an extraordinarily witty, brilliant, and clever man. That is now part of the public opinion of England . . . I may dodder and dote. I may pot-boil and platitudinize . . . but my reputation shall not suffer; it is built up fast and solid, like Shakespeare's, on an impregnable basis of dogmatic reiteration." (Cited in Dilly Tante, ed. (pseud. of Stanley Kunitz), *Living Authors,* New York, 1932, p. 371.)

1901–02: Reviews photographic exhibitions for *The Amateur Photographer,* where he expresses a distaste for manipulated processes. "If you cannot see at a glance that the old game is up, that the camera has hopelessly beaten the pencil and paint brush as an instrument of artistic representation, then you will never make a true critic" (Biblio. 697, p. 282).

1903: Writes an appreciation for the Evans issue of *Camera Work* (Biblio. 382).

1904: Meets Alvin Langdon Coburn. » One photograph reproduced in *Camera Work,* No. 15 (July).

1906: Writes an appreciation for the catalog of Coburn's one-man exhibition at the Royal Photographic Society (Biblio. 188).

1907: Stieglitz annoyed with Shaw's writing on photographs despite printing of his essay on Evans.

1908: Exhibits prints by F. H. Evans at London's Photographic Salon; makes autochromes after being introduced by Steichen to the process.

1909: Lectures at the Photographic Salon, a speech described by Evans as "a good piece of log rolling" in which Shaw describes his ideal of a photographic exhibition: "D. O. Hill, Mrs. Cameron, old silver prints, early gums, Evans' platinum prints, modern oil prints, and Coburn's photo-gravures," a list which partially describes the current exhibition of the Stieglitz collection (Biblio. 704).

Before 1911: Writes, "In photography the drawing counts for nothing, the thought and judgment count for everything." (Biblio. 710).

1911: Leaves the Fabian Society.

1925: Receives the Nobel Prize for Literature.

442 443 444

1937: Eight photographs reproduced in *The Countryman.*

1950: Dies in Ayot St. Lawrence.

PHOTOGRAPHS

442 » [*Self-Portrait*]. 1904 (A.S.) Gelatine silver printing-out-paper. 138 × 94 mm. (5⁷⁄₁₆ × 3¹¹⁄₁₆ in.) 49.55.184.

Printing-out-paper was favored by beginning photographers because it could be handled in room light, and because no darkroom was required. The high gloss surface and reddish-brown hue of untoned prints were unappealing to most artistic photographers. Shaw apparently was not comfortable as a printer, and F. H. Evans printed and mounted for him (Cats. 445–447).

443 » *George Bernard Shaw by Himself.* (F. H. Evans after George Bernard Shaw.) 1904. Platinum, mounted on four layers of tan and gray papers. 83 × 56 mm. (3¼ × 2³⁄₁₆ in.) Signed and titled as above; dated and noted by F.H.E. "printed & mounted by F. H. Evans." 49.55.185.

Collections: IMP/GEH (platinum print by F. H. Evans).

444 » *George Bernard Shaw by Himself.* (F. H. Evans after George Bernard Shaw.) 1904. Platinum, mounted on four layers of tan and gray papers. 157 × 92 mm. (6³⁄₁₆ × 3⅝ in.) Inscription by Evans identical to Cat. 443. 49.55.186.

445 » *George Bernard Shaw by Himself.* (F. H. Evans after George Bernard Shaw.) 1904. Platinum, mounted on four layers of tan and gray papers. 98 × 110 mm. (4⁵⁄₁₆ × 3⅞ in.) Inscription by Evans identical to Cat. 443. 49.55.187.

Figure 40.

EXHIBITIONS

London 1908 » New York (NAC) 1909.

COLLECTIONS

IMP/GEH.

BIBLIOGRAPHY

Manuscript

695. Stieglitz Archives, Collection of American Literature, Beinecke Rare Book and Manuscript Library, Yale University, New Haven, Conn.: 1 unpublished letter from George Bernard Shaw to Alfred Stieglitz in 1904.

By Shaw

696. Shaw, G. Bernard. "The Art Claims of Photography." *The Amateur Photographer,* 32 (7 September 1900), p. 185.

697. ———. "The Exhibitions." *The Amateur Pho-*

tographer, 34 (October 11, October 18, 1901), pp. 282–284, 303–304.

698. ———. "Wanted: Colour Sensitive Roller Films." *The Amateur Photographer,* 36 (14 August 1902), p. 124.

699. ———. "Some Criticisms of the Exhibitions: The Life Study, the 'Fuzzgraph,' and the 'Underexposed.'" *The Amateur Photographer,* 36 (16 October 1902), pp. 305–307.

See Biblio. 382.

700. ———. "The Unmechanicalness of Photography." *Camera Work,* No. 14 (April, 1906), pp. 18–25.

701. ———. "G. Bernard Shaw on The London Exhibitions." *Camera Work,* No. 14 (April, 1906), pp. 57–62.

See Biblio. 188.

702. ———. "Bernard Shaw Improvises on Photography," *Photography,* 28 (26 October 1909), pp. 332 ff.

703. ———. "Photography in Its Relation to Modern Art." *The Amateur Photographer,* 50 (26 October 1909), pp. 416–417.

704. ———. "A Page from Shaw." *Camera Work,* No. 34/35 (April–July, 1911), p. 22.

705. ———. *Collected Letters.* Edited by Dan H. Lawrence. New York, 1965.

See Biblio. 187, 188, 288, 382, 388.

Illustrated by Shaw

706. Shaw, George Bernard. *Bernard Shaw's Rhyming Picture Guide to Ayot Saint Lawrence.* Luton, 1950. [Shaw's last completed work].

About Shaw

707. "Mr. G. B. Shaw on the Links." *British Journal of Photography,* 56 (22 October 1909), pp. 814–815.

708. Evans, Frederick H. "Mr. Shaw and the Links." *British Journal of Photography,* 56 (29 October 1909), p. 849.

709. Scott, Temple. "The Terrible Truthfulness of Mr. Shaw." *Camera Work,* No. 29 (January, 1910), pp. 17–20.

710. Henderson, Archibald. *George Bernard Shaw: His Life and Work.* Cincinnati, 1911.

711. Henderson, Archibald. "Bernard Shaw on Photography." *Camera Work,* No. 37 (January, 1912), pp. 37–41.

712. Busch, Arthur. "George Bernard Shaw—Photographer." *Popular Photography,* 16 (February, 1945), pp. 19–21.

713. Lowenstein, F. E. *Bernard Shaw through the Camera.* London, 1948.

714. Coburn, Alvin Langdon. "George Bernard Shaw." *Photographic Journal,* 91 (January, 1951), p. 30.

715. Gernsheim, Helmut. "G.B.S. and Photography." *Photographic Journal,* 91 (January, 1951), pp. 31–36.

716. Chappelow, Allan. "An Ideal Model." *Photographic Journal,* 91 (January, 1951), pp. 36–39.

717. Moholy, Lucia. "G.B.S. and Photography." *Photographic Journal,* 91 (June, 1951), p. 205.

718. *Shaw, The Villager and Human Being.* Edited by Allan Chappelow. New York, 1962.

CHARLES SHEELER (American)

Fig. 41 » *Charles Sheeler*, about 1920. Courtesy of Archives of American Art, Smithsonian Institution.

Charles Sheeler [signature]

CHRONOLOGY

1883: Born in Philadelphia on July 16.

1900–03: Attends Philadelphia School of Industrial Art where he works in Applied Design.

1903–06: Attends the Pennsylvania Academy of the Fine Arts where he studies under William Merritt Chase.

1904: Travels to Holland and London with Chase class (summer).

1905: Travels to Spain with Chase class (summer).

1906: Shares a studio in Philadelphia with Morton Livingston Schamberg (fall).

1908: First solo exhibition of paintings in Philadelphia (November). » Travels to Italy with his parents where he joins Schamberg (December).

1909: (January and February) in Paris with Schamberg.

1910–11: Shares a small house in Doylestown, Pa., with Schamberg.

About 1912: Takes up professional photography, specializing in architecture and art works. Makes negatives during 1912–17 that will be used as models for his paintings. On the relationship between painting and photography he reportedly observed, "Photography is nature seen from the eyes outward, painting from the eyes inward . . ." (Biblio. 729, p. 119).

1913: Exhibits six paintings in the Armory Show.

1914: Probable first meeting with Stieglitz. Begins Doylestown House Series (Cat. 446–449).

1915–17: Involved with the Arensberg Circle in New York; begins correspondence with Stieglitz about technical matters of photography.

1915: Begins to photograph barns in Bucks County, Pennsylvania.

1917: Group exhibition at de Zayas's Modern Gallery, 500 Fifth Avenue, New York (March), that also includes prints of Strand and Schamberg. » Solo exhibition of Doylestown house series at de Zayas's Modern Gallery, New York (December); Stieglitz plans issue of *Camera Work* devoted to Sheeler which fails to materialize.

1918: Wins first and fourth prizes in 13th Annual John Wanamaker Photography Exhibition, for *Window with Plant* (Cat. 260), where painter Arthur B. Carles is one of the judges. Photographs the de Zayas collection of African Negro masks. Sells Philadelphia house.

1919: Moves to New York City. Meets Paul Strand. Continues to earn livelihood photographing works of art for such firms as Knoedler and Parish-Watson.

1920–22: Assists at the de Zayas Gallery.

1920: Solo exhibition of drawings and photographs at de Zayas Modern Gallery. Begins to photograph New York buildings.

1921: Makes film *Mannahatta* with Paul Strand.

1922: Meets Edward Weston in New York. Weston writes of Sheeler's work, "the finest architectural photographs I have seen" (*Day-books* I, p. 6).

1923: Marries Katherine Shaffer. » Becomes photographer for Condé Nast publications, working on *Vogue* and *Vanity Fair*. Photographs reproduced in *Broom*, 3 (October, 1923). » Free-lance photography work for several advertising agencies; does little or no painting for a decade. Writes on Stieglitz's photographs (Biblio. 991) in a way that irritates Stieglitz, whose thoughts in reply were expressed by Paul Strand (Biblio. 993).

About 1923–24: Gives up Doylestown house.

1924: Solo exhibition at Whitney Studio Club.

1926: Joint exhibition with Louis Lozowick at J. B. Neumann's Print Room, New York. » Solo exhibition of photographs at Art Center, New York.

1927: Spends six weeks in Detroit photographing the Ford Motor Company's River Rouge Plant. » Moves to South Salem, N.Y.

1929: Fourth and last trip abroad where he does series of photos of Chartres Cathedral. » Exhibits photos at the International Film and Photo Exhibition in Stuttgart, Germany. River Rouge selections reproduced in *Hound and Horn,* no. 18 (Fall, 1929), between pp. 126–127.

1931: Solo exhibition at Julien Levy Gallery, opening on November 2.

About 1931–32: Ceases working for Condé Nast and stops advertising photography.

1932: Moves to Ridgefield, Conn.

1933: Wife Katherine dies.

1935: Joint exhibition with Charles Burchfield at Society of Arts and Crafts, Detroit.

1935–36: Lives in Colonial Williamsburg, Va., to photograph buildings for subsequent paintings.

1937–38: Makes series of cloud studies.

1938: Autobiographical notes used as the basis for Constance Rourke's *Charles Sheeler: Artist in the American Tradition* (Biblio. 729).

1939: Major retrospective of paintings, drawings, and photographs at the Museum of Modern Art, New York.

1939–40: In Colorado, Alabama, and elsewhere. Commissioned to paint six paintings for *Fortune* magazine on the theme of "Power."

1942: Marries for second time and moves to Irvington-on-Hudson, N.Y. Mentioned by Edward Weston in Biblio. 1155. Begins working for The Metropolitan Museum of Art, photographing its collections.

1944: Photographs "Walt Whitman Relics," Houghton Library, Harvard University.

1945: Contract terminated by The Metropolitan Museum of Art (July).

1946: Artist-in-residence at Phillips Academy, Andover, Mass.

1965: Dies on May 7.

[*Note:* Chronology based largely on facts in Biblio. 735.]

PHOTOGRAPHS

446 » [*Bucks County House, Interior Detail*]. 1917. Gelatine silver. 231 × 163 mm. (9⅛ × 6⁷⁄₁₆ in.) 33.43.259.

Plate 89.

Exhibited: See Cat. 447.

Sheeler wrote of the Doylestown series: "These photographs were probably more akin to drawings than to my photographs of painting and sculpture. . . ." [Sheeler to Stieglitz, 22 November 1917, YCAL] Their function as drawing in the sense of being a preliminary study to something larger proved true, for in 1923 Sheeler painted *Interior with Stove* (Coll. Mrs. Edward Steichen).

447 » [*Bucks County House, Interior Detail*]. 1917. Gelatine silver. 228 × 166 mm. (9 × 6⁹⁄₁₆ in.) 33.43.260.

Exhibited: *New York (de Zayas's Modern Gallery, December 3–15, 1917), the Doylestown house series, possibly including this and the two succeeding works; Philadelphia (Wanamaker, 1918), First prize; see also Cat. 446.

Reproduced: W. G. Fitz, "A Few Thoughts on the Wanamaker Exhibition," *The Camera,* 22 (April, 1918), p. 204, titled *Bucks County House, Interior Detail,* presumably the title under which it was exhibited as assigned by Sheeler.

The house in Doylestown, Pennsylvania, was shared with Morton Schamberg (Cat. 433), Sheeler's friend

447 449

from student days at the Pennsylvania Academy of Fine Arts. Schamberg, also a painter/photographer, painted the flower pot that is represented in this print (Coll. Jean Loeb Whitehill).

This and the following studies with their single source of light are quite out of character with Sheeler's earlier photographs of the exteriors of Pennsylvania barns. They paralleled, however, Sheeler's general use of juxaposed patterns of light and dark in his flower paintings of 1917 (Coll. Mrs. Earl Horter) and the interiors dating slightly later (Coll. Mrs. Edwin Litchfield Turnbull).

448 » [*Bucks County House, Interior Detail*].
1917. Gelatine silver. 230 × 163 mm. (9¹⁄₁₆ × 6⁷⁄₁₆ in.) 33.43.261.
Plate 90.
Sheeler used the Doylestown interior stairway photographs as models for paintings on many occasions after 1917, for example that in the Hirschhorn Museum, Washington, of 1925.

449 » [*Bucks County House—Interior Detail*].
1917. Gelatine silver. 210 × 150 mm. (8⁵⁄₁₆ × 5⁵⁄₁₆ in.) 33.43.343.
This print is related to the painting of a stair in the Hirshhorn Museum.

EXHIBITIONS

*New York (Modern Gallery) solo and group 1917 » Philadelphia (Wanamaker) 1917–1918 » *New York (De Zayas Gallery) 1920 » New York*

*(Whitney Studio Galleries) 1924 » New York (Neumann) 1926 » *New York (Art Center) 1926 » Stuttgart (Deutschen Werkbunds) 1929 » *New York (Julien Levy Gallery) 1931 » *New York (MOMA) 1932 » *New York (MOMA) 1939 » Andover, Massachusetts (Addison Gallery) 1946* (For complete exhibition list see Biblio. 735).

COLLECTIONS

IMP/GEH; MOMA.

BIBLIOGRAPHY

Manuscript

719. Stieglitz Archives, Collection of American Literature, Beinecke Rare Book and Manuscript Library, Yale University, New Haven, Conn.: 20 unpublished letters from Charles R. Sheeler to Alfred Stieglitz and 5 unpublished letters from Alfred Stieglitz to Charles R. Sheeler between 1914 and 1922.

720. Miscellaneous Material at the Archives of American Art, Washington, D.C., including George M. Craven, *Charles Sheeler, A Self-Inventory in the Machine Age,* Athens, Ohio, 27 May 1957.

721. Interviews with Bartlett Cowdry, 1958, and Martin Friedman, 1959, Archives of American Art, Washington, D.C.

By Sheeler

See Biblio. 991 (on Stieglitz).

Illustrated by Sheeler

722. Sheeler, Charles. *African Negro Sculpture.* Preface by Marius De Zayas. New York, 1918.

723. Hare, Sussanna and Edith Porada. *The Great King, King of Assyria: Assyrian Reliefs in the Metropolitan Museum of Art Photographed by Charles Sheeler.* New York, 1945.

About Sheeler

724. Fitz, W. G. "A Few Thoughts on the Wanamaker Exhibition." *The Camera,* 22 (April, 1918), pp. 201–207.

725. Parker, Robert Allerton. "The Art of the Camera: An Experimental Movie." *Arts and Decoration,* 15 (October, 1921), pp. 369 and 414–415.

726. Watson, Forbes. "Charles Sheeler." *The Arts,* 3 (May, 1923), pp. 335–344.

727. Parker, Robert Allerton. "The 'Classical' View of Charles Sheeler." *International Studio,* 84 (May, 1926), pp. 68–72.

728. Kootz, Samuel M. "Ford Plant Photos by Sheeler." *Creative Art,* 8 (April, 1931), pp. 264–267.

729. Rourke, Constance. *Charles Sheeler: Artist in the American Tradition.* New York, 1938.

730. *Charles Sheeler, Paintings, Drawings, Photographs.* Introduction by William Carlos Williams. Museum of Modern Art, New York, exhibition catalog, 1939.

731. Chanin, A. L. "Charles Sheeler: Purist Brush and Camera Eye." *Art News,* 54 (Summer, 1955), pp. 40–41, 70–72.

732. Dochterman, Lillian Natalie. "The Stylistic Development of the Work of Charles Sheeler." Ph.D. dissertation, State University of Iowa, 1963.

733. ———. *The Quest of Charles Sheeler.* Iowa City, 1963.

734. Friedman, Martin, Bartlett Hayes, and Charles Millard. *Charles Sheeler.* National Collection of Fine Arts, Washington, D.C., exhibition catalog, 1968.

735. Millard, Charles W. "Charles Sheeler: American Photographer." *Contemporary Photographer,* 6 (1968), p. 41.

736. Beaton, Cecil and Gail Buckland. "Charles Sheeler." *The Magic Image.* Boston, 1975, p. 172.

737. Friedman, Martin. *Charles Sheeler.* New York, 1975.

For further references consult Biblio. 781, 783.

EDWARD STEICHEN (American)

Fig. 42 » *Edward Steichen.* Self-portrait, 1898. Cat. 450.

CHRONOLOGY

1879: Born Eduard Jean Steichen on March 27, son of Jean-Pierre and Marie Kemp Steichen in Luxembourg.

1881: Family settles in Hancock, Michigan.

1889: Family moves to Milwaukee, Wisconsin.

1894–98: Works through a four-year apprenticeship with the American Fine Art Company, a lithography firm where he begins to photograph at work to aid in advertising design.

1895: Purchases his first camera, a Kodak 50-exposure box-type.

About 1897: Helps organize and becomes the first president of the Milwaukee Art Students' League.

1899: Enters two photographs in the Second Philadelphia Photographic Salon.

1900: Enters photographs in the Chicago Photographic Salon and the Third Philadelphia Salon; receives a letter of encouragement from Clarence White, who also writes to Stieglitz about him. In New York he visits Stieglitz, who buys three of his photographs, paying five dollars each. Steichen leaves New York on S.S. Champagne, on his way to Europe. Arrives at Le Havre on May 18, and bicycles to Paris. » Described in the Newark, Ohio exhibition catalog (Biblio. 1326) as "A brilliant young American art student now in Paris."

1901: Lives in Paris. Begins to exhibit regularly; included in Day's New School of American Photography exhibition in London and Paris (Biblio. 1402, 1403). Declines invitation to join The Linked Ring. » Meets Rodin. Concentrates on portraits of artists and writers. Meets and impresses Demachy. Day lives with Steichen beginning of January.

1902: Mid-summer returns to New York and takes quarters at 291 Fifth Avenue, New York City. Works in multiple printing processes including platinum, gum bichromate, gelatine silver, carbon and combinations thereof. » Writes: "I believe

that art is cosmopolitan and that one should touch it at all points. I hate specialism. That is the ruin of art . . . I am no specialist. I believe in working in every branch of art" (Biblio. 775, p. 51). » (December) becomes a Founder of the Photo-Secession, a Fellow and a member of its Governing Council.

1903: Marries Clara E. Smith on October 3. Honeymoon at Lake George, then to Ohio to stay with White. Photographs J. P. Morgan and Eleonora Duse in the same day. » *Camera Work* No. 2 is devoted to his photographs where twelve are published. Between 1903 and 1917 seventy-one photographs will be published in *Camera Work,* more than any other photographer collected by Stieglitz.

1904: Continues to receive numerous awards. Begins to experiment with color photography. One reproduction in *Camera Work,* No. 7 (July).

1905: Anticipating his return to France, turns over the use of his apartment at 291 Fifth Avenue for the Little Galleries of the Photo-Secession. One reproduction in *Camera Work,* No. 9 (January); two in No. 11 (July).

1906: Returns to France. Is shown at Photo-Secession Galleries and has a special number of *Camera Work* devoted to his photographs. Obtains Rodin drawings for exhibition at the Photo-Secession Galleries. » Ten reproductions in No. 14 (April) and sixteen in the *Special Supplement* (April); two in No. 15 (July), also published in de luxe edition (Biblio. 764). » Spends much time with de Meyer in Paris.

1907: Experiments with Lumière Autochrome plates; ten autochromes exhibited at Photo-Secession Galleries. One reproduction in *Camera Work* No. 19 (July). In Paris introduces Stieglitz to the art of Cézanne (Biblio. 873).

1908: Helps found the New Society of American Painters in Paris. Procures Matisse exhibition for the Photo-Secession Galleries. Photographs Theodore Roosevelt (Cat. 474) and William Howard Taft (Cat. 475) for *Everybody's Magazine.* (March) exhibition of forty-seven photographs and fifteen autochromes at Photo-Secession Galleries. Three gravures in *Camera Work* No. 22 (April). » Quoted to have said, "I shall use the camera as long as I live,

for it can say things that cannot be said with any other medium" (Biblio. 775, p. 45).

1909: Exhibits a series of photographs of Rodin's *Balzac* at Photo-Secession Galleries, April 21–May 7.

1910: Arranges Cézanne watercolors show for Photo-Secession Galleries. » Thirty-one of his prints shown at the Albright Art Gallery at the International Exhibition of Pictorial Photography. The Buffalo exhibition catalog states, "In the struggle for the recognition of photography, Mr. Steichen's work has been one of the most powerful factors, and his influence on some workers, both in America and Europe, has been marked. His use of the 'gum bichromate' process is peculiarly his own" (Biblio. 1399, p. 30). » Exhibits color photographs at Photo-Secession Galleries (January–February).

1911: Writes Stieglitz of his admiration for de Meyer. » Does fashion photography for *Art et Decoration* (January–June, 1911), commencing an application that engages Steichen for much of his career as a photographer. » Four gravures in *Camera Work,* Nos. 34–35 (April–July). Advises Stieglitz to close 291.

1913: Double number of *Camera Work* is devoted to Steichen. Seventeen reproductions in *Camera Work,* Nos. 42–43 (April–July); one in No. 44 (October).

1914–17: In New York, continues to exhibit and assist Stieglitz with the Photo-Secession Galleries, *Camera Work,* and the new publication *291.*

1917: Returns to France as a Lieutenant in the U.S. Army. Attends Rodin's funeral. » Helps to establish a department of aviation photography for the U.S. Army.

1919: Leaves service with rank of Lt. Colonel.

1920: Gives up painting; devotes himself solely to photography.

About 1923: Is divorced from Clara.

1923: Does fashion photography for *Vogue* and *Vanity Fair.* Marries Dana Desboro Glover. Gives up home in Voulangis, taking up permanent residence in U.S.

1923–37: Does advertising and portrait photography with great financial and artistic success.

1929: Carl Sandburg's *Steichen the Photographer* (Biblio. 770) is published.

1936: A renowned horticulturist, his delphiniums are exhibited at The Museum of Modern Art.

1938: Closes New York studio on January 1, and retires from commercial photography.

1942–45: Commissioned Lt. Commander in the U.S.N.R., he embarks on several photographic projects. Becomes director of U.S. Naval Photography and is put in charge of all Navy combat photography. Released from active duty in 1946 with rank of Captain.

1946: Death of Alfred Stieglitz.

1947: Appointed Director of the Department of Photography for The Museum of Modern Art.

1973: Dies on March 25 in West Redding, Connecticut, after a long and productive retirement.

PHOTOGRAPHS

The Puzzle of Steichen's Processes

During his Paris years Steichen was attracted to the pigment processes that were in vogue and subsequently did very little platinum printing. Stieglitz reported in *Camera Work* how difficult it was to reproduce Steichen's work because of the complicated accretion of processes: "Some are in gum, some in platinum, some in bromide, and some in a combination of these processes." ["Our Illustrations," *Camera Work*, No. 14 (April, 1906)]. It was also noted that Steichen's detractors accused him of "faking negatives and prints or both." The meaning of the word "faking" takes on special dimension when the Stieglitz collection is studied closely with the question of the specific processes used to make each print. It is evident that Steichen devoted much energy to devising ways of replicating in a second material (such as gelatine-silver or gelatine-carbon) qualities first attained in experimental prints where each was unique (gum-bichromate, for example), as exemplified by Cat. 476. The most accessible way of replicating unique originals was to rephotograph the experimental original and use the copy negative in combination with one or more printing methods such as gelatine-silver enlarging ("bromide") materials that were toned or overlaid with a single printing of pigmented gum-bichromate. The results were highly deceptive facsimiles of the original multiple gum prints few of which have survived (Biblio. 1174, cover illustration). The replications were made within a few years of the original negatives, setting a pattern that Steichen was to follow throughout his career in replicating in one process an original made in another medium. Although Steichen apparently did not identify the specific processes to Stieglitz, he was generally aware of the mixed-media aspect of Steichen's photographs, judging from what he wrote in *Camera Work*. About 1919 when Stieglitz identified photographs in his collection on blue parcel-post style labels, the information came from memory and often contradicted the concensus of modern opinion regarding date and medium.

Steichen recollected in his autobiography (Biblio. 751, p. 56) that the prints in the Stieglitz collection at The Metropolitan Museum of Art represent "the major part of the good prints I made during this period, but also [are] the only surviving record of most of my early work." The scarcity of surviving experimental gum prints that were the models from which Stieglitz collected his prints causes a puzzle for which many parts are missing. The lack of good original documentation necessitates studying the existing prints as circumstantial evidence of earlier models, about which much can be deduced from those that exist.

Platinum

Steichen's first artistically successful photographs were printed on plain platinum papers, a medium he favored before his first Paris sojourn during 1900–1902. Even after he began to use other printing materials for artistic effects, he occasionally returned to platinum. Platinum prints are relatively easy to identify even with the naked eye; under magnification, the character of an image embedded in the paper fibers which show as dark, stringy shapes is unmistakable. A photo-micrograph of Cat. 451 is reproduced to illustrate this quality (Fig. 43). Stieglitz identified on his collection labels many Steichen prints as platinum that do not conform to the expected appearance under magnifications, and these have been grouped as a separate class (Cats. 500–506).

450 » *Self-Portrait.* 1898. Platinum. 198 × 92 mm. (7¹³⁄₁₆ × 3⅝ in.) 33.43.1.
Figure 42.

Related or identical subjects were exhibited: Philadelphia (1899), no. 273, titled *Portrait Study;* Newark,

Ohio (1900), no. 159; Glasgow (1901), no. 365; London (NSAP, 1900), no. 132, titled *Self-Portrait—Composition Study;* London (1900), no. 24, reproduced on p. 115 in review *Photograms of the Year 1900,* titled *Self-Portrait;* Wiesbaden (1903), no. 221; Bradford (1904), no. 186; Buffalo (1910), no. 389, titled *Self-Portrait;* Philadelphia (1899), no. 273, titled *Portrait Study;* Newark (1900), no. 159; London (1901), no. 35; Paris (NSAP, 1901), no. 132, titled *Mon Portrait—Étude de Composition;* Glasgow (1901), no. 365; Brussels (1901), no. 92, titled *Portrait de Lui-même;* Hamburg (1902), no. 230, titled *Selbstbildnis; New York* (NAC, 1902), no. 125, titled *Self-Portrait—Poster Design* and dated 1899.

Reproduced: *Camera Notes,* 4 (January, 1900), p. 147, titled as above; *The Photogram,* 8 (January, 1901), p. 8.

Collections: MOMA, two platinum prints.

The idea of using a portrait as a vehicle for representing abstract elements of design came into vogue between 1896–1898. Steichen creates a brilliant variation on the theme—essentially Whistlerian in its origins— by making this a self-portrait. The early exhibition record identifies at least three self-portraits, of which this was the earliest and most famous.

451 » *Woods Twilight.* 1898 (A. S.) Platinum. 152 × 201 mm. (6 × 7^{15}/$_{16}$ in.) 33.43.14.
Figure 43 (Photomicrograph).
Reproduced: Steichen (Biblio. 751), pl. 9, titled as above.

Collections: AIC, Stieglitz Collection, where it is inscribed in Stieglitz's hand "Steichen's first masterpiece."

Fig. 43 » Fifty times magnification of Cat. 451. (Photo: Steven Weintraub)

451

452

452 » [*Woods Interior*]. [1898]. Platinum. 189 × 161 mm. (7^7/$_{16}$ × 6^3/$_8$ in.) 33.43.8.
Exhibited: Glasgow (1901), no. 152; New York (NAC, 1902), no. 114, dated 1901; Turin (1902), no. 40, all titled *Woods Interior,* suggesting related works.

Reproduced: *Camera Notes,* 4 (January, 1901), p. 145, titled *Landscape;* Caffin (Biblio. 1282), p. 57, titled *The Rivulet,* which is inscribed on the verso of this print in an unidentified hand, suggesting that this print was used to make the halftone. Caffin may have assigned the title without consulting Steichen for no such title can be located in early exhibitions or reproductions.

Between 1898 and 1901 Steichen exhibited many intimate landscape studies, the work which Stieglitz first purchased and for which he was best-known before becoming deeply involved in portraiture in Paris.

453 » *The Pool—Evening.* 1899. Platinum. 207 × 160 mm. (8^3/$_{16}$ × 6^5/$_{16}$ in.) 49.55.232.
Exhibited: Brussels (1901), no. 88; Turin (1902), no. 47, titled *Stagno;* New York (NAC, 1902), no. 119, titled *The Pool* and dated 1899; Denver (1903), no. 140; Pittsburgh (1904), no. 206; Vienna (1904), no. 2.

Reproduced: *Camera Work,* No. 2 (April, 1903), pl. II, titled *The Pool,* where it is stated (p. 54) that the gravures "are made directly from the unmanipulated and untouched negatives." The gravure is lighter and different in subtle details from the platinum print.

Collections: AIC, Stieglitz Collection.

Steichen recollected in his autobiography (Biblio. 751, p. 13) that the negative was made in 1899. When the print was reproduced in *Camera Work,* Stieglitz took the opportunity to state that "much of Mr.

453

454

455

Steichen's work is the straightest kind of straight pho-
tography, but applied with a liberal admixture of brain,
feeling and a wonderful mastery of technique." (p. 54).
The apology was perhaps deemed necessary because of
the manipulated effects in such works as *Lenbach* (Cat.
461) reproduced in the same issue.

454 » *Agnes Ernst [Mrs. Eugene Meyer].* About
1908. Direct platinum. Image, 219 × 273;
paper, 302 × 256 mm. (10¾ × 8⅝; 11⅞ ×
10¹/₁₆ in.) Signed in the negative "STEICHEN."
49.55.226.
Reproduced: (Biblio. 751, pl. 44), the same model in
different costume and presumably at a different sitting,
dated 1910.

Steichen described to Stieglitz the day Eugene Meyer
visited his Paris studio in the Fall of 1908 with Agnes
Ernst, his fiancée. Executed on commission, the por-
trait is an important antecedent of Steichen's portrait
style of the teens where dramatic lighting effects and
eccentric poses became less important in his repertory.
A wedding portrait of the couple was made in 1910.

Agnes Ernst came into Stieglitz's circle in 1908
when she interviewed him for the New York *Morning
Sun* (Biblio. 972). A friendship ensued that brought
her in touch with the most advanced workers in paint-
ing and photography, and inspired a collection of paint-
ings formed by her and her future husband, Eugene
Meyer, many of which were bought from the Photo-
Secession Galleries.

455 » *[Mary Steichen in the Luxembourg Gardens].*
About 1909. Platinum. 166 × 114 mm.

(6⁹/₁₆ × 4½ in.) Signed in pencil "STEICHEN."
49.55.229.
Inscribed on the verso of the paper mount is a note in-
dicating that this print was a gift from Steichen's
daughter Mary Rose, to Stieglitz's daughter, Katherine.
Mary Steichen (now Dr. Mary S. Calderone), the elder
of Steichen's two daughters, was born on July 1, 1904.

Note: Platinum print—see also Cat. 512.

Plain gelatine-carbon (Artigue) prints
Within Steichen's photographs collected by Stieglitz,
one group can be expeditiously isolated because of their
uniform black tone and smooth hard surface which
shows consistently from one print to the next a me-
chanical regularity and absence of the irregularities of
gum prints. Microscopic examination reveals an image
structure that is very distinct from gum-bichromate.
Fig. 44 shows tiny particles of pigment arranged
in a pattern resembling a section through brain coral,
with no visible evidence of the paper fibers, but
with the hill-and-valley pattern typical of a magnified
gelatine surface (Fig. 49). The Artigue carbon method,
popular in Paris during the late 1890s and within
Steichen's easy grasp, was fully described by Maskell
and Demachy (Biblio. 254, Chapter V, "Artigue Pa-
per," pp. 41–47) as a precursor of the gum-bichromate
process. The essential difference between gum-
bichromate and Artigue prints is that the latter is a
transfer process from a plate to which carbon pigment
is supported by gelatine rather than gum-arabic; ge-
nerically it is thus a gelatine-carbon process. Under
magnification (Fig. 44) the peaks and valleys of

the gelatine colloid are clearly evident with the peaks (white) representing the absence of tone, while the valleys absorb pigment and delineate tone. Maskell and Demachy's description of the surface appearance to the naked eye conforms to the appearance of those designated by Steichen as toned (Cats. 485–493) and untoned (Cats. 456–475) carbon prints:

"The paper has a surface of extraordinary fineness and homogeneity—a pigment of some peculiar black mixed with a little gum and possibly some gelatine and fish-glue also. Viewed by reflected light, it is a dead velvety black, and so soft that a moist finger easily removes it. By transmitted light the paper is almost transparent, with a quite light greenish-gray appearance, very regular indeed, with no apparent surface faults. The secret of its quality, in fact, the whole secret of preparing paper for development from the front so that it shall give the most delicate gradations of half-tone, is in the extreme tenuity of coating and the perfection of evenness in which the pigment is held in suspension, allowing of absolute regularity in distribution. At present it is only made in black, and there appears to be some difficulty in using other colours; at any rate, those which have, till now, been put on the market, have not proved to be satisfactory (Biblio. 254, p. 43)."

When Steichen returned to New York in 1902, he spoke in an interview (Biblio. 759) of making his prints in an unidentified process which he described as antiquated and customarily used for commercial purposes, a description that fits the Artigue gelatine-carbon process. The process fits Steichen's description perfectly since it had been in commercial use as a means for reproducing art works since the early 1870s (Swann Carbon Process). France was the center of manufacturing carbon facsimiles of art works, in particular Braun & Cie. of Dornach, France. Gelatine-carbon printing suited Steichen's purpose of making facsimiles of his unique gum originals from copy negatives, a very innovative application considering that the gelatine carbon process was designed to use enlarged copy negatives that Steichen favored at this time. Its application around 1900 was geared to the use of copy negatives and the problems of replicating copies of art works rather than scenes from nature using original negatives, a very different use of the carbon process that was practically non-existent after 1900. It is not surprising that

Stieglitz and many others were deceived into thinking these were gum prints, despite the sceptics who had already accused Steichen of "faking" prints and negatives [*Camera Work*, No. 14 (April, 1906)].

456 » *William Merritt Chase.* 1900. Gelatine-carbon. 183 × 130 mm. (7³⁄₁₆ × 5⅛ in.) Signed and dated in pencil "STEICHEN MDCCCC." 33.43.15.

Exhibited: London (NSAP, 1900), no. 193; Paris (NSAP, 1901), no. 140; Brussels (190), no. 91; Denver (1903), no. 139; San Francisco (1903), no. 8; Toronto (1903), no. 3; London (1904), no. 129; Vienna (PC, 1905), no. 50; Vienna (CK, 1905), no. 31; Richmond (1905), no. 842; New York (PSG, 1905), no. 73; Cincinnati (1906), no. 56; New York (PSG, 1906), no. 66; New York (NAC, 1909), no. 174.

Related standing portraits of Chase by Steichen are reproduced in *Camera Work*, No. 14 (April, 1906), pl. II, and in the Special Steichen Supplement (April, 1906), pl. V.

This print is important for establishing Steichen's intent to replicate his unique gum prints in other materials. The hand-worked area extending from top to bottom at the left edge, and the marks delineating the forearm are here rendered photographically and do not represent actual manipulations to the print, but rather are printed from a copy negative of an original gum print.

If the date inscribed by Steichen indicates when this print was made, it suggests that Steichen began to make carbon prints after gum originals very soon after arriving in Paris. However, it is not inconceivable that this print was made at a later time and given the date of the negative, as was Steichen's style occasionally. In any event this was among the first of Steichen's series of celebrities in arts and letters, soon to be followed by the Watts portrait (Cat. 459).

457 » *Carl Marr.* 1901. Gelatine-carbon. 202 × 155 mm. (7¹⁵⁄₁₆ × 6⅛ in.) Signed in pencil on verso "Eduard J. Steichen/291 5th Ave./ New York." In block letters in Steichen's hand "CARL MARR/STEICHEN 1901." 33.43.10.

Steichen was in Paris in 1901 and did not take the 291 5th Avenue studio until late summer or fall of 1902.

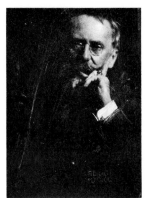

456 457 459

His caption dates from another time, possibly earlier, which would make this among Steichen's earliest surviving carbon prints and suggest that he began to use the process during his first years in Paris. Numerous areas resemble hand work that might be presumed unique to this print, especially the broad line above his hand and the marks at his cuff and collar. These have been replicated photographically from an original gum print the present whereabouts of which is unknown. Marr was a book illustrator.

458 » *Figure with Iris.* 1902. Gelatine-carbon. 340 × 188 mm. (13⅜ × 7⁷⁄₁₆ in.) Signed and dated in ink "STEICHEN MDCCCCII." 33.43.17.

Plate 57
Reproduced: Biblio. 751, pl. 24, titled and dated as above, where it is stated this negative was made in Paris.

Collections: MOMA, an original gum-bichromate print, possibly the original from which this gelatine-carbon print was copied.

459 » *George Frederick Watts.* 1902 (A. S.) Gelatine-carbon. 336 × 261 mm. (13¼ × 10⁵⁄₁₆ in.) Signed in pencil "STEICHEN" and captioned "WATTS" in crayon pencil. 33.43.26.

Figure 44 (Photomicrograph).
Exhibited: Hamburg (1903), no. 409; Wiesbaden (1903), no. 223, variant from another negative; Pittsburgh (1904), no. 205; Washington (1904), no. 123; Bradford (1904), no. 203; The Hague (1904), no. 108; London (1904), no. 121; Vienna (C-K, 1905), not numbered; New York (PSG, 1906), no. 1; New York (PSG,

Fig. 44 » Fifty times magnification of Cat. 459. (Photo: Steven Weintraub)

1908), no. 5; Buffalo (1910), no. 391, dated 1901 and lent by a private collector, presumably Stieglitz.

Reproduced: *Camera Work,* No. 14 (April, 1906), pl. I, where the gravure is reproduced from a print very different from this with prominent local manipulation; Maeterlinck (Biblio. 764), pl. II.

The variant of this subject (with hand to face) exhibited at Wiesbaden (above) and reproduced in the catalog is signed, dated 1902, and titled similarly to this print. Steichen recollected in his autobiography that this print dated from 1901, but the Wiesbaden date and Stieglitz's notation on the verso dating it 1902 suggest the latter as the most favorable year.

460 » *Rodin.* 1902. Gelatine-carbon. 269 × 203 mm. (10⅝ × 8 in.) Signed in pencil "STEICHEN MDCCCCII." 33.43.4.

Plate 60.
Portraits with various titles (per examples below), but not necessarily the same image were exhibited: Ham-

burg (1902), no. 229; New York (NAC, 1902), no. 120, titled *Rodin I,* and no. 121, titled *Rodin II;* Brussels (1903), no. 428; Hamburg (1903), no. 410; San Francisco (1903), no. 5; Wiesbaden (1903), no. 217; Bradford (1904), no. 173; Dresden (1904), no. 164; Hague (1904), no. 112; Paris (1904), no. 665, titled *Portrait de Rodin;* Pittsburgh (1904), nos. 200 and 204; Washington (1904), no. 118; New York (PSG, 1905), no. 67, titled *Rodin—Le Penseur;* Portland, Oregon (1905), no. 18, titled *Rodin—Le Penseur;* Richmond, Indiana (1905), no. 848; Vienna (C-K, 1905), no catalogue number; New York (PSG, 1906), one-man show, no. 3, titled *Rodin—Le Penseur,* no. 4, titled *Rodin—Le Penseur,* and no. 5, titled *Rodin—Le Main de Dieu;* New York (PSG, 1908), no. 11; Dresden (1909), no. 133, titled *Rodin—Le Penseur,* and no. 134, titled *Portrait M. Auguste Rodin;* New York (NAC, 1909), no. 173; Buffalo (1910), no. 401, titled *Auguste Rodin,* no. 392, titled *Rodin,* and no. 394, titled *Rodin.*

Reproduced: *Camera Work,* No. 2 (April, 1903), pl. I, where it is titled as above and stated to have been reproduced from an original in "The private collection of Mr. Alfred Stieglitz."

Transcribed from the original mount: "Bought this print from Steichen in Feb. 1903 for $50.00 (unframed)/The best print of this subject in existence—Unique/." Inscribed on the verso by Stieglitz: "Bought by Alfred Stieglitz on Jan. 17, 1903 for $50.00 directly from Eduard Steichen, 291 Fifth Ave., New York."

This print was thought to have been printed from two negatives similar to its pendant *Rodin—Le Penseur* (also in the Stieglitz Collection, now at The Art Institute of Chicago), where the negative for this print was reversed and printed with a second negative of the sculpture alone.

461 » *Franz von Lenbach.* 1902. Gelatine-carbon. 259 × 230 mm. (10³⁄₁₆ × 9¹⁄₁₆ in.) Signed in watercolor over pencil "STEICHEN MDCCCCII." 33.43.12.
Exhibited: See Cat. 462.
Reproduced: Holme (Biblio. 1288), American pl. XIX.

462 » *Franz von Lenbach.* 1903 print from negative of 1902 or before. Gelatine-carbon. 515 ×

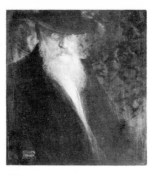

461

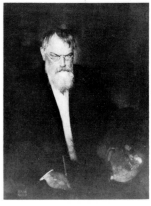

462

371 mm. (20⁵⁄₁₆ × 14⁵⁄₈ in.) Signed in yellow crayon pencil "STEICHEN MDCCCCIII." 33.43.33.
Steichen made at least two negatives of this subject, either of which could have been exhibited: Hamburg (1902), no. 231; New York (NAC, 1902), no. 117; London (1902), no. 162, titled *Dr. Franz Ritter von Lenbach;* Hamburg (1903), no. 429; Brussels (1903), no. X; Wiesbaden (1903), no. 218; The Hague (1904), no. 110; Vienna (1904), no. 5; Richmond (1905), no. 250; New York (PSG, 1906), no. 7; Buffalo (1910), no. 403.

Reproduced: *Camera Work,* No. 2 (April, 1903), pl. VII, titled *Lenbach,* with significant differences from this print. Local manipulation is seen in the lapel and at the right edge; the palette in Lenbach's hand has been obliterated in the gravure, nor is the date evident; *Camera Künst* (Biblio. 1285), p. 103; *Academy Notes* (Biblio. 1399a), p. 1.

It is stated in *Camera Work* (above, p. 54) that the gravure was made from an original gum print in the Stieglitz collection, but it was not reproduced from Cat. 461 or Cat. 462. The print reproduced in *Camera Work* looks very much like a gum print on account of the strong local manipulation. If Stieglitz did once own the gum original, it could have gone back to Steichen from Stieglitz in a manner similar to the way Steichen arranged with Stieglitz to exchange a gelatine silver print for Stieglitz's original gum version of the Morgan portrait Cat. 497. In this case it is possible that Steichen exchanged one or both of the carbon versions of Lenbach for the unique gum print once in the Stieglitz collection. Steichen wrote Stieglitz from Munich where he was visiting with Käsebier and Kuehn when this negative could have been made. (Steichen to Stieglitz, 26 September 1901, YCAL.)

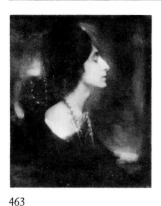

463

464

465

463 » *Mercedes de Cordoba.* 1904. Gelatine-carbon.
315 × 258 mm. (12⁷⁄₁₆ × 10³⁄₁₆ in.) Signed
in crayon pencil "STEICHEN MDCCCIV." 33.43.3.
Exhibited: New York (PSG, 1906), no. 19, titled as
above; Buffalo (1910), no. 395, titled *Miss de Cordoba,*
dated 1904 and lent by a private collector, presumably
Stieglitz.

Reproduced: *Camera Work,* Steichen Supplement
(April, 1906), pl. XIII, halftone titled *Profile;* Maeter-
linck (Biblio. 764), pl. XVIII, printed from the same
plate as *Camera Work.*

Transcribed from the original mount: "Mercedes
de Cordoba/gum, single printing, unique print/
bought from Steichen for $50.00." Carbon prints re-
semble single printings of gum-bichromate which
Stieglitz thought this was. Steichen chose the carbon
process to create replicable prints with the appearance
of unique prints. The model was wife of the painter
Arthur B. Carles.

464 » *Maurice Maeterlinck.* 1904 print of negative
about 1901. Gelatin-carbon. 332 × 265 mm.
(13¹⁄₁₆ × 10⁷⁄₁₆ in.) Signed in pencil
"STEICHEN." 33.43.2.
Exhibited: Paris (1904), no. 664; Pittsburgh (1904),
no. 209; Vienna (C-K, 1905), not numbered; New York
(NAC, 1908), no. 123; Buffalo (1910), no. 393, dated
1902, and lent by a private collector, presumably Stieg-
litz.

Reproduced: *Camera Work,* Special Steichen Sup-
plement (April, 1906), pl. I, halftone, without imper-
fections visible on the carbon print; Maeterlinck
(Biblio. 764), halftone, pl. III, printed from the same
plate as *Camera Work.*

Collections: MOMA, carbon or other pigment
process.

The following inscription was transcribed from the
original mount: "Portrait of Maurice Maeterlinck
(1901)/only print made from negative/Print bought
from Steichen in 1903 for $50.00/Reproduced in Cam-
era Work 'Steichen Special' [sic], bichromate of gum."
The author was presumably Stieglitz writing about
the time his collection labels were prepared in 1919.
The carbon process was intended to approximate gum
printing and the fact Stieglitz was deceived indicates
how successful Steichen was in replicating his unique
originals. The *Camera Work* gravure differs sufficiently
from this print to indicate at least two prints were made,
contrary to what was inscribed on the mount.

Maurice Maeterlinck was a symbolist writer and
frequently contributed to *Camera Work.* He was ad-
mired by many of the Photo-Secessionists, including
Steichen, whose friendship Maeterlinck returned by
authoring a short introduction to the Steichen Supple-
ment, which also appeared in a deluxe version (Biblio.
764).

465 » *The Brass Bowl.* 1904. Gelatine-carbon.
304 × 256 mm. (12 × 10¹⁄₁₆ in.) Signed in
crayon pencil "STEICHEN MDCCCIV." 33.43.6.
Exhibited: Dresden (1904), no. 160, titled *Lady with
Bowl;* New York (PSG, 1906), no. 48, titled *The Brass
Bowl,* representing the identical or a related work.

Reproduced: *Camera Work,* No. 14 (April, 1906),
pl. VII, halftone; Maeterlinck (Biblio. 764), pl. XIX,
printed from the same plate as *Camera Work,* both
apparently reproduced from this print before the sig-
nature and date were added.

466

467

468

469

466 » [*Mother and Child, Sunlight Patches*]. 1905.
Gelatine-carbon. 348 × 275 mm. (13¹¹⁄₁₆ ×
10³⁄₁₆ in.) Signed and dated in yellow-green
crayon pencil "STEICHEN MDCCCCV." 33.43.27.
Exhibited: New York (PSG, 1905), no. 71, *Sunlight
Patches,* suggesting a related if not identical work, as do
the Cincinnati (1906) titles, no. 54 *Mother and Child,*
and no. 60; New York (PSG, 1906), no. 29; Dresden
(1909), no. 161, titled *Mutter und Kind, Sonnenlicht.*
 The models are Mrs. Edward Steichen and her
daughter, Mary, born on July 1, 1904.

467 » *Cyclamen—Mrs. Philip Lydig.* About 1905.
Gelatine-carbon. 315 × 216 mm. (12⁷⁄₁₆ ×
8½ in.) 33.43.9.
Reproduced: *Camera Work,* Nos. 42–43 (April–July,
1913), pl. III, titled as above and reproduced from this
print (as deduced from inscriptions on verso), despite
the considerable differences between the gravure and
this print.
 Inscribed on verso by Stieglitz, "Keep this
composition, make plate size of Rodin portrait in Rodin
number. The light outline around head in this print is
exaggerated [sic] the whole print is a trifle hard."
Presumably these are instructions to the printers of the
Camera Work gravure.
 The *Camera Work* gravure has more detail in the
hat and right background, where there appears to have
been hand retouching on the copper printing plate to
realize Stieglitz's instructions to soften the outline
around the head. Steichen's original composition was
not retained since a 1⅞ inch black band at the bottom
of this print has been eliminated in the gravure.

468 » *Edward Stieglitz.* 1905. Gelatine-carbon.
243 × 195 mm. (9⁹⁄₁₆ × 7¹¹⁄₁₆ in.) Signed in
pencil on the mount "STEICHEN MDCCCCV."
33.43.45.
The model is the father of Alfred Stieglitz, dressed in
the same costume as Cat. 469 that is dated 1906. Both
negatives were made at the same sitting, although in
this print only a fragment of one button in a second
row of buttons on the vest is visible, giving a different
character to what is otherwise unmistakably the same
garment as Cat. 469.

469 » *Edward Stieglitz.* 1906 print from negative
about 1905. Gelatine-carbon. 244 × 191 mm.
(9⅝ × 7½ in.) Signed and dated on mount in
pencil "STEICHEN MDCCCCVI." 49.55.169.
Steichen recollected in his autobiography his relation-
ship with Stieglitz's father, the model in this print:
"The old gentleman, Edward Stieglitz, Sr., and I
developed a particular and close friendship and mutual
affection. I became, in a way, a part of the family."
(Biblio. 751, p. 37)
 In 1950, upon viewing this print, Steichen thought
it was made in 1902, not 1906, despite the date on the
recto. Another print dated 1905 (Cat. 468) suggests that
the later date is more acceptable considering the sitter
wears the same clothes in both.

470 » *Richard Strauss.* 1906 print from 1904
negative. Gelatine-carbon. 467 × 327 mm.
(18⅜ × 12⅞ in.) Signed and dated in yellow
crayon pencil "STEICHEN MDCCCCVI." 49.55.168.
Exhibited: The Hague (1904), no. 113; London (1904),

472

473

470 471

no. 125; Vienna (PC, 1904), no. 8; New York (PSG, 1906), no. 3; Dresden (1909), no. 137; Buffalo (1910), no. 396, dated 1904 and lent by a private collector.

Collections: MOMA (original gum print, possibly the original from which the MMA gelatine-carbon print was made).

Steichen reconciled in this photograph several qualities that had come to characterize his portraits. The single light source that had become almost a trademark is made even more expressive in this print by the overhead light creating sinister shadows over the eyes of Strauss. Steichen's high point of view caused the space of the room to read ambiguously, with the decorative objects becoming highlights.

471 » *Portrait—Otto, A French Photog[rapher].* Gelatine-carbon. 204 × 146 mm. (8¹⁄₁₆ × 5¾ in.) Titled as above by Steichen on verso. 49.55.231.

According to Grace M. Mayer, Steichen assisted in the portrait studio of a Paris photographer known to her only as "Otto," where in 1907 Steichen earned a fee of twenty dollars *per diem,* which was a handsome salary for the time. The subject is possibly Otto Stuck of whom Steichen exhibited a portrait at New York (NAC, 1902), no. 118, dated 1901. Stuck is not listed in the Paris Salon catalogs in Stieglitz's library, but commercial photographers rarely were admitted to the Salons.

472 » *Storm in the Garden of the Gods—Colorado Series.* 1906. Gelatine-carbon. 389 × 465 mm. (15⁵⁄₁₆ × 18⁵⁄₁₆ in.) Signed and dated in

yellow crayon pencil "STEICHEN MDCCCCVI." 33.43.25.

Exhibited: New York (PSG, 1908), no. 13, titled *Storm in the Garden of the Gods—Colorado Series,* New York (PSG, 1908), no. 33; Dresden (1909), no. 163, titled *Stürm in Garten der Götter, Colorado;* Buffalo (1910), no. 407, where the negative is dated 1906 and the print 1909.

Steichen visited the West in the summer of 1906 and was photographed in Colorado by Harry Rubincam (Cats. 431, 432). Steichen had made very few landscape photographs since his Wisconsin years, and the dramatic light and shadow effect in this print is very different from the monotone of the early platinum forest scenes (Cats. 451–453).

473 » *Lady Hamilton [Lady Ian Hamilton].* 1907. Gelatine-carbon. 504 × 396 mm. (19⅞ × 15⅝ in.) Signed in yellow crayon pencil "STEICHEN." 33.43.24.

Exhibited: New York (PSG, 1907), no. 68; and New York (PSG, 1908), no. 10, titled *Lady Ian Hamilton;* London (1908), no. 75; Dresden (1909), no. 142; Buffalo (1910), no. 404, titled as above with the negative dated 1907 and the print dated 1909.

474 » *Theodore Roosevelt.* 1908. Gelatine-carbon. 510 × 382 mm. (20¹⁄₁₆ × 15¹⁄₁₆ in.) Signed, titled (top), and dated in yellow crayon pencil "STEICHEN MDCCCCVIII." 33.43.35.

Exhibited: Dresden (1909), no. 139, titled as above; Buffalo (1910), no. 405, titled *Ex-President Roosevelt* and dated 1909 from a 1907 negative.

474 475

Reproduced: Steffens (Biblio. 749), p. 731; Biblio. 751, pl. 56, a variant of the same sitting.

Steichen was commissioned by *Everybody's Magazine* to make portraits of the major party candidates for the 1908 Presidential elections at a fee of five hundred dollars per portrait. The photographs were reproduced in illustrations of Lincoln Steffens's "Roosevelt—Taft—LaFollette on What the Matter is In America and What to Do About It." (Biblio. 749 where Steichen's first name is spelled "Eduard"). The author perceived that the photograph portrayed Roosevelt as an earnest and passionate man committed to the public interest, energetic, hard-driving, idealistic, but blind to the underlying causes of corruption and America's political and economic problems. "He bent forward in the attitude of attack," related Steffens of his interview (p. 725). Stylistically following the model of his earlier portrait of Morgan (Cat. 497), Stieglitz similarly highlighted the chair arm, but here chose a stronger sidelight on Roosevelt's face. The differing effects of the two photographs can be ascribed as much to differences in appearance and temperament of the two sitters, as to Steichen's interpretation of them since the compositions are almost identical. The only exception is an important detail—the shape of the chair, which in the Roosevelt portrait is conventional, lacking the suggestive implications of Morgan's. Roosevelt was President from 1901–1909.

475 » *President Taft.* 1908 print from 1907 negative. Gelatine-carbon. 506 × 387 mm. (19^{15}⁄$_{16}$ × 15¼ in.) Signed and dated in yellow crayon pencil "STEICHEN MDCCCCVIII." 33.43.34.

Exhibited: Dresden (1909), no. 140, titled as above and dated 1909 from a 1907 negative; Buffalo (1910), no. 406.

Reproduced: Steffens (Biblio. 749), p. 735; *Camera Work,* Nos. 42–43 (April–July, 1913), pl. VIII, where it is incorrectly titled *Henry W. Taft* and where the pattern of highlights is sufficiently different to suggest that another print was used for the reproduction.

Steffens describes Taft as "serene; sure; just; absolutely unselfish and, therefore, fearless. . . . A good fellow [who] does his duty for duty's sake, out of sheer patriotism and self-respect." (p. 732). Taft is pictured during the interview by Steffens as "lying back comfortably in his great chair. . . . The character of the man came out beautifully in the manner of his conversation" (p. 733). Taft succeeded Roosevelt as President and served until 1913.

Multiple pigment prints

Steichen's photographs between 1898 and 1901 were self-conscious tonal studies in black and white. During his first stay in Paris, he developed a serious interest in color, evidently first expressed in the most popular and accessible pigmented process of the day—gum-bichromate (see Biblio. 254). Despite the multiple pigments, it was a process that rendered monotonic effect which was quite distant from the natural color attainable in Autochrome plates that appeared first in 1907 and caused Steichen to lose interest in the pigment process. Before 1907 Steichen made numerous experiments in multiple pigments, of which only one perfect example survives (Cat. 476). He must certainly have made many single pigment gum-bichromate studies, but very few examples are recorded to have survived. Based upon Steichen's autobiographical statement in regard to his Balzac series (Cats. 485–488), it has long been thought that among the Steichen prints collected by Stieglitz were the most numerous examples of Steichen's original work in gum-bichromate to survive in one place. It turns out, however, that the great majority of Stieglitz's collection of Steichen are prints in bastard processes by which fine facsimiles of the original gum-bichromate prints, generated from copy negatives of the original gum prints, were made in gelatine-carbon and gelatine-silver printing materials. It was the use of copy negatives in conjunction with

carbon and silver printing methods that caused the accusation of faking negatives and prints. Steichen's bafflement by these criticisms of his procedure is easy to understand, for they were apparently used to make possible replicating prints that resisted replication due to the considerable handwork in the originals by which they initially became unique.

Fig. 45 is a photo-micrograph of Cat. 476, which is the only true multiple pigment gum-bichromate print by Steichen collected by Stieglitz. Fig. 46 is a photo-micrograph of Cat. 199, a firmly identified multiple pigment gum-bichromate print by Demachy. The paper-fiber strands are visible and the pigment is absorbed into them rather than being deposited in a layer on top of the paper.

476 » *Experiment in Multiple Gum.* 1904. Ter-reverte and black pigment bum-bichromate. 282 × 242 mm. (11⅛ × 9⁹⁄₁₆ in.) Signed and dated in ink on two-layer green paper mount "STEICHEN MDCCCCIV." 33.43.13.
Plate 56 and Figure 45 (Photomicrograph).
This print is perhaps the best example in the Stieglitz Collection of the plain multiple gum process. An inscription describes how the print was made, and microscopic examination (Fig. 45) shows a pattern of pigment and fibre similar to that in plain gum prints by Demachy (Fig. 46), Henneberg, and Kuehn, the most active practitioners of the process.

Steichen described his process on the mount: "Experiment in Multiple Gum/showing color coating on edges/1st printing solid lamp black (contrasty)/2nd printing terre verte (flat)/3rd sepia and black (very

pale)/The three printings developed mechanically/by floating paper on cold water./no local manipulation."

These three steps, required not so much to gain color but to arrive at a sufficient resolution of photographic details, were time-consuming and resulted in a unique original that could be exactly duplicated only by making a photographic copy of the original gum-bichromate print. Attempting replicability of unique originals led Steichen to use multiple processes that could utilize copy negatives (Cat. 456–475). In order to eliminate two of the required steps, a platinum or gelatine-silver image could be used to supply a well-resolved base to which a layer (or layers) of gum were added to achieve a chromatic effect substituting the muddy colors realized in this print.

Except for this particular work, it is not possible to distinguish between the other light-sensitive bases used by Steichen for prints listed here as multiple pigment processes. They can, however, be readily distinguished from gelatine carbon prints by microscopic examination (Fig. 44). A scientific inspection might lead to a conclusion that Steichen frequently preferred to work in gum over a gelatine-silver enlargement rather than gum on platinum from an enlarged negative.

The Flatiron—*gum-over-platinum and gelatine silver prints*

477 » *The Flatiron.* 1905 print from 1904 negative. Brown pigment gum-bichromate over gelatine silver (?) 499 × 389 mm. (19⅝ × 15⁵⁄₁₆ in.) Signed and dated in red crayon pencil "STEICHEN MDCCCCV." 33.43.44.
Exhibited: The date suggests this print could have been

Fig. 45 » Fifty times magnification of Cat. 476. Plate 56. (Photo: Steven Weintraub)

Fig. 46 » Fifty times magnification of Cat. 199. (Photo: Steven Weintraub)

477

478 479

exhibited in New York (PSG, 1905), no. 70, titled *The Flat-Iron;* Cincinnati (1906) no. 58; New York (PSG, 1906), no. 50, titled *The Flatiron,* but its size would have made it very much out of scale with those exhibited at the PSG in 1905, while it would have been in keeping with the general scale of Steichen's 1906 one-man show there.

Reproduced: *Camera Work,* No. 14 (April, 1906), pl. VIII, where the green hue is entirely different from the brown in this print.

The appearance of this print is quite different from its companions (Cats. 479 and 480) which were printed from the same negative but with differing effects. Practically all detail in the building is lost in this print and the visual effect of the evening-turned-dusk is unmistakable. The reduced contrast could be partly due to the apparent use of gelatine-silver printing materials for a direct enlargement of the copy negative, rather than printing from an enlarged negative as is required with platinum.

The smooth, hard surface appears different from the glazed areas of Cats. 479 and 480. The top and bottom edges reveal traces of a neutral gray that results when ambient light strikes silver-bromide enlarging papers. The print lacks the vigor and uniformity of its companions, perhaps the normal result of enlarging at that time.

Evidently Steichen was inspired by Coburn's use of the gum-over-platinum process which he exhibited in 1904 and later in New York (PSG, 1907). Steichen apparently made his first gum-over-platinum prints in 1905, and very quickly saw the possibilities of replicating the unique originals in such processes as is represented by this print.

478 » *The Flatiron* [small state]. 1905 print from 1904 negative. Gelatine-silver touched with black, green and yellow. 240 × 192 mm. (9⁷⁄₁₆ × 7⁹⁄₁₆ in.) Signed and dated in yellow crayon pencil on mount "STEICHEN MDCCCCV." 33.43.37.

Exhibited: The intimate size of this print would have made it compatible with other prints in the first members show in New York (PSG, 1905), no. 70, while Cat. 477 would have been a more appropriate scale for Steichen's 1906 one-man show there.

Reproduced: Camera Work, no. 14 (April, 1906), pl. VIII, printed from a different negative; Biblio. 751, pl. 32, dated 1905.

Transcribed from the old mount is Stieglitz's inscription: "Eduard J. Steichen/The Flatiron Bldg.—New York/Price $50.00."

This print is made from a slightly different point of view, without the taxi in the foreground as represented in Cats 477, 479, 480. Sulfiding at the right edge of the print indicates that this is not a platinum print, which in other respects it closely resembles. There is evidence of hand-applied pigment in the street area. Revealing an intent to create many of the effects of a multiple-gum print using other materials, the print exemplifies what Steichen's critics described as "faking."

479 » *The Flatiron.* 1909 print from 1904 negative. Blue-green pigment gum-bichromate over platinum. 478 × 384 mm. (18¹³⁄₁₆ × 15⅛ in.) 33.43.39.

Exhibited: Dresden (1909), no. 155, titled *The Flat Iron—New York;* Buffalo (1910), no. 412, titled *The*

Flatiron and identified as being from a negative of 1904 printed in 1909.

Reproduced: *Camera Work,* No. 14 (April, 1906), pl. VIII, halftone titled *The Flatiron—Evening,* related to this print by its generally green tone and printed from a different plate (three yellow spots in a vertical row on the turreted building at the right are missing).

The original Buffalo Fine Arts Academy exhibition label from the old mount identifies this as the print exhibited there in 1910, but the Buffalo exhibition catalog does not list it as a loan from a private collector as are many other of Stieglitz's loans to that exhibition, suggesting that Stieglitz acquired it from the exhibition despite the fact that he already owned two prints, acquired about 1905 (Cats. 477, 478).

The traces of pigment at the paper edges and the visual impression of layered color are typical of multiple gum prints, but this print is apparently one generation removed from a unique gum original now lost. The trapezoidal shape below the taxi, an apparent result of handwork, is a shape that is identically repeated in two other versions (Cats. 477, 480). The replication of such a unique mark suggests that this print was made from an enlarged negative (necessary to realize such a large print in platinum) from a second negative copy of the original gum print. The buildings delicately detailed by an image structure absorbed into the paper fibers indicate that platinum was the primary means of creating the print, over which bichromated pigment was added for a subtle color effect.

Stieglitz had already photographed The Flatiron building (designed by George Fuller and completed in 1902) in late 1902 or early 1903, a photograph published in gravure and doubtless known to Steichen. The two photographers treated their subject very differently. Stieglitz isolated it in a snowy landscape, causing the edifice to emerge from light. Although it must have been daylight for the structure to have even been visible, Steichen created the illusion that his negative was made at night through manipulations at the print-making stage. Stieglitz superimposed the primeval shape of the tree over the rectilinear building; Steichen cropped the top edge, thus intruding on the structure's integrity in a slightly different way from Stieglitz. Steichen printed his photograph in a size that allows it to compete with paintings while Stieglitz retained an intimate scale. Their treatment of the same subject reveals two strikingly different artistic temperaments—Steichen expressive and lyrical, Stieglitz cool and concrete. In their public personalities they switched roles.

This is among the few surviving gum-over-platinum prints by Steichen in which Coburn's influence is evident. Steichen's 1905 version is a hand-toned gelatine-silver print similar to Coburn only in effect, while this print utilizes purely photographic procedures without the localized application of pigment and merits comparison with Coburn's *The Rudder* of 1904 (Cat. 131). (On gum-over-platinum printing see Biblio. 60, 1093.)

480 » *The Flatiron.* 1909 print from 1904 negative. Greenish-blue pigment gum-bichromate over gelatine-silver. 478 × 384 mm. (18¹³⁄₁₆ × 15⅛ in.) 33.43.43.
Plate 58 and Figure 47.
Exhibition and reproduction record (see Cat. 479).

The paper label on Cat. 479 identifies it as being the print exhibited at Buffalo, but its general character, nearly identical to this print in tone and the irregular glaze application with small uncoated patches, suggests that the two prints were made at about the same time. It can be speculated that this print was made for the 1909 Dresden exhibition, and Cat. 479 for the Buffalo exhibition. Microscopic examination reveals the image structure of this print as supported on top of the paper surface, with no paper fibers visible. The photomicrograph shows a pebbly surface with highlights on the peaks typical of gelatine-silver materials (Fig. 47). Comparison of Steichen's purported gum-over-platinum print under magnification to a firmly identified print

Fig. 47 » Fifty times magnification of Cat. 480. Plate 58. (Photo: Steven Weintraub)

in that process, namely Coburn's *The Rudder* (Cat. 131), shows Steichen's image structure embedded in a gelatinous colloid that conceals the paper fibers, while Coburn's shows the telltale image structure embedded in the paper fibers.

Other multiple pigment prints

481 » *Moonlight-Winter.* 1902. Platinum toned with yellow and blue-green. 345 × 424 mm. (13⅜ × 16⅞ in.) Signed and dated in green crayon pencil "STEICHEN MDCCCCII." 33.43.30.
Exhibited: London (NSAP) 1900, no. 200, titled *Winter Motive;* Paris (NSAP) 1901, nos. 152, 153, *Motif d'Hiver-Bois de Boulogne;* New York (PSG) 1902, no. 115, *Winter Effect;* Glasgow (1901) no. 144, *Landscape-Winter;* Vienna (CK) 1905, not numbered but titled *Winter-mondnacht,* suggesting related works.

Stieglitz incorrectly dated the print 1903 and identified it as a "platinum-gum" print, which it is not. The color was added similarly as in Cat. 482, where the green tone was identified by Steichen as "ferroprussiate" (cyanotype).

482 » *The Pond—Moonrise.* 1903. Platinum toned with yellow and blue-green. 397 × 482 mm. (15⅝ × 19 in.) Signed in yellow crayon pencil "STEICHEN." 33.43.40.
Plate 63.
Related or identical works are suggested by the following exhibited titles: Glasgow (1901), no. 123; London (1904), no. 118, titled *Moonlight—Winter;* Pittsburgh (1904), no. 202, *Moonrise;* Washington (1904), no. 120, *Moonrise;* New York (PSG, 1905), no. 69, *The Pond Moonlight;* Richmond (1905), no. 849, *Moonrise;* New York (PSG, 1906), no. 69, *The Pond—Moonrise.*

Reproduced: *Camera Work,* No. 14 (April, 1906), pl. IV, a reverse of this print in gravure and dated 1903; Maeterlinck (Biblio. 764), pl. XXIV; (Biblio. 751, pl. 41), titled *Moonrise—Mamaroneck* and identified as a "platinum and ferroprussiate print."

Collections: MOMA, an original multiple gum print lacking the hard surface of the MMA print, printed in the same direction.

Stieglitz's identification of this print on his collection label as "Landscape Moonlight by Steichen/1904/ Stained platinum-gum" represents a rare instance in which he catalogued an esoteric process. Steichen identified this as a ferroprussiate print (cyanotype, commonly called "blueprint," Biblio. 751, p. 6), suggesting the localized blue tone was the result of a single printing in that process. The basic image, however, appears to be platinum enhanced by yellow and green pigments that cannot otherwise be more specifically identified by visual inspection.

Steichen appears to have been motivated by a desire to create a new hybrid process yielding brighter color than is customary with his gum prints. Like gum prints, this image represents a unique effect that would vary slightly with each succeeding print which would require separate handling for each of the following steps: 1) printing in platinum; 2) printing in one or more tones of gum (for green); 3) ferroprussiate toning. It was to eliminate one or more of these steps that Steichen resorted to the use of copy negatives, prints from which could be locally toned by hand to approximate the original effect.

483 » *Melpomène [Landon Rives].* 1904/1905. Ochre pigment gum-bichromate over platinum [or gelatine silver]. 476 × 325 mm. (18¾ × 12¾ in.) Signed and dated in yellow crayon pencil "STEICHEN MDCCCCIII"; titled in orange crayon pencil "MELPOMENE" and touched with yellow watercolor or other pigment. 33.43.31.
Plate 54.
Exhibited: London (1904), no. 115; Vienna (1905), no. 45.

On his collection label written about 1919 Stieglitz dated this print 1905, adding "Steichen's date wrong." Steichen's date inscribed on the print could be read as 1903 or 1904, but Landon Rives (Cat. 128) did not come into the Stieglitz circle through Coburn until 1904 which makes 1903 an implausible date. The model's relationship to Coburn and the specific process of this print suggest that Coburn influenced Steichen's style and process more than has been credited.

484 » *La Cigale.* 1907 print (A. S.) from 1901 negative. Green and yellow pigment gum-bichromate over platinum. 265 × 290 mm.

481

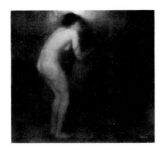

484

(10⁷⁄₁₆ × 11⁷⁄₁₆ in.) Signed in pencil "STEICHEN." 33.43.22.

Exhibited: New York (PSG, 1906), no. 39; Dresden (1909), no. 162; Buffalo (1910), no. 416, where the negative is dated 1901 and the print exhibited 1909.

Reproduced: *Camera Work,* Supplement (April, 1906), pl. VI, titled as above but in reverse of this print.

Collections: MOMA

Microscopic examination shows an image structure almost identical to that of Cat. 478, which places this print among the few original multiple gum-bichromates by Steichen in the Stieglitz collection. The two studies in the MOMA collection are printed with the negative in the same direction as the *Camera Work* state, suggesting this print is the exception.

Camera Work, No. 14 carried the following statement regarding the reproductions:

The plates in this number, together with those published in the *Special Supplement,* constitute a landmark in the achievements of the camera and in their relation all that has thus far been accomplished in photography give promise that either Mr. Steichen himself or some one at present unknown will in the future accomplish such achievements that even the most doubting Thomas will be convinced. Perhaps what we believe in to-day, the world will acknowledge to-morrow. The photogravures were all made from the original negatives and under Mr. Steichen's personal direction. We flatter ourselves that some of the gravure plates are above our own average of reproduction and give a fair idea of Mr. Steichen's spirit, although it is impossible to reproduce the full quality of his originals, some of which are in gum, some in bromide and some in a combination of these processes. . . . (p. 50)

Toned gelatine-carbon (*Artique*) prints

The majority of Steichen's gelatine-carbon prints in the Stieglitz collection are plain black-and-white. A small number show the presence of a general background tone—green in the case of the Balzac series (Cats. 485–488), yellow in the case of the Paris Grand Prix pair (Cats. 491, 492), and a Venetian view (Cat. 493). The color(s), or surviving traces of color (not visible under magnification) in those that have faded, possess a more definite hue than the multiple pigment prints, suggesting the result of a single tone added to the print, perhaps in a separate step.

Steichen's series on Rodin's Balzac

Steichen recollected in his autobiography the circumstances of his making the negatives and prints, and of Stieglitz's acquisitions:

Late in the summer of 1908, I received word from Rodin that he had moved his Balzac out into the open air so that I could photograph it. He suggested photographing it by moonlight. I immediately went out to Meudon [from Paris] to see it and found that by daylight the white plaster cast had a harsh, chalky effect. I agreed with Rodin that under the moonlight was the proper way to photograph it, I had no guide to refer, and I had to guess at the exposure.

I spent the whole night photographing the Balzac. I gave varying exposures from fifteen minutes to an hour, and secured a number of interesting negatives.

In the morning, at breakfast, when I lifted the napkin from my plate, I found two one-thousand franc notes. This was four hundred dollars, a fabulous present for a night's work! It was typical of the generosity of Auguste Rodin. Instead of showing Rodin proofs, I immediately made enlarged negatives and commenced printing.

It wasn't until a week or two later, when I had fine pigment prints, that I turned up to show them to Rodin. The prints seemed to give him more pleasure than anything I had ever done. He said, "you will make the world understand my Balzac through these pictures. They are like Christ walking on the desert." . . . [ca. 1909]

When Stieglitz saw a set of the Balzac prints later, he seemed more impressed than with any other prints I had ever shown him. He purchased them at once and later presented them to the Metropolitan Museum of Art. . . . During World War I, we had to leave my negatives behind, uncared for, in our home in Voulangis when we left.

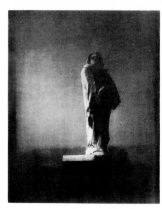

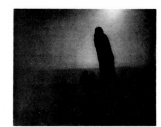

487

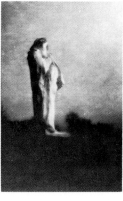

485

488

During the four years of the war, humidity and bacterial action destroyed the emulsions. The plates were ruined. (Biblio. 751, p. 52).

The rarity of Steichen's photographs pre-dating 1917 is partly due to the loss of his early negatives. He does not mention the loss of prints he stored at Voulangis, but many of the unique experiments that formed the models for replicated facsimiles in platinum, gelatine-carbon, and gelatine silver, were undoubtedly lost at the same time. It provides the only plausible reason why so few of Steichen's plain gum prints (not printed over platinum or gelatine) have survived.

485 » *Balzac, The Open Sky, 11 P.M.* 1909 print from 1908 negative. Gray-green gelatine-carbon. 487 × 385 mm. (19⅜₁₆ × 15³⁄₁₆ in.) Signed and dated in black ink "STEICHEN MDCCCCIX." 33.43.46.
Exhibited: New York (PSG, 1909), no. 3; Buffalo (1910), no. 416, titled as above and identified as a loan from a private collection, presumably that of Stieglitz.
 Reproduced: Biblio. 751, pl. 53.

486 » *Balzac, Towards the Light, Midnight.* 1908. Gray-green gelatine-carbon. 365 × 482 mm. (14⅜ × 19 in.) Signed in dull yellow crayon pencil "STEICHEN MDCCCCVIII." 33.43.38.
Plate 61.
Exhibited: New York (1909), no. 1; Dresden (1909), no. 160, titled *Rodins Balzac, Mondlicht;* Buffalo (1910), no. 417.
 Reproduced: *Camera Work,* Nos. 34–35 (April–July, 1911), pl. III, titled as above, where more of the

subject is printed than in this print, and with important differences in the top right and middle of the subject.

A parcel-post style paper label from the old mount inscribed by Stieglitz reads "Stieglitz Collection—/ Balzac by Steichen—1909/ (Gum Print)/Exhibitions: 291—1909/Albright—1910." Steichen sent the Balzac prints to Stieglitz in early spring of 1909 with a letter saying, "photographs do not go in duty free as they are not [considered] works of art so I sailed them under the highfalutin title of gum-bichromate prints and hope to goodness the [illegible] don't recognize them as photographs." (Steichen to Stieglitz, April?, 1909, YCAL). Steichen's identification of these prints as gum-bichromates can be accounted for by the fact that Artigue prints are a subcategory of bichromated prints in general where the gum arabic is replaced by gelatine. It also accounts for why Stieglitz misidentified them on his collection label. Such nuances did not go unnoticed by Steichen's critics who continued to brand him as a "faker."

487 » *Balzac, The Silhouette, 4 A.M.* About 1909 print from 1908 negative. Gray-green gelatine-carbon. 379 × 460 mm. (14¹⁵⁄₁₆ × 18⅛ in.) Signed in yellow crayon pencil "STEICHEN." 33.43.36.
Exhibited: New York (PSG, 1909), no. 2; Buffalo (1910), no. 415, titled as above and credited as a loan from a private collector, presumably Stieglitz.
 Reproduced: *Camera Work,* Nos. 34–35 (April–July, 1911), pl. IV, where it is stated that the gravure was made directly from the original negative with the

consequent differences in the range of tones, notably more detail in the middle ground; Biblio. 751, pl. 52.

488 » *Balzac [after Rodin]*. 1908. Gray-green gelatine-carbon 282 × 206 mm. (11⅛ ×8⅛ in.) Signed in yellow crayon pencil "STEICHEN." 33.43.5.
Exhibited: New York (PSG, 1909), no. 6.
Collections: MOMA (gelatine silver) signed and dated 1909.

Other toned gelatine-carbon prints

489 » *The Big White Cloud, Lake George.* 1903. Gray-green gelatine-carbon. 393 × 483 mm. (15½ × 19 in.) Signed in yellow crayon pencil "STEICHEN MDCCCCIII." 33.43.47.
Plate 64.
Related or identical subjects were exhibited: New York (PSG, 1906), no. 49, *Across the Lake—Evening;* Philadelphia (1906), no. 109, *The Big Cloud—Lake George;* New York (NAC, 1909), no. 176, titled *Big White Cloud;* Dresden (1909), per collection label; Buffalo (1910), no. 399, titled and dated as above, identified as a loan from a private collector, presumbaly Stieglitz, and as a 1909 print from a 1904 negative, a statement contradicted by the date 1903 on the recto of this print.
Reproduced: *Camera Work,* Supplement (April, 1906), pl. XI, titled *The Big White Cloud,* where the cloud formation is reversed but printed from the same negative.
Collections: MOMA.
Inscription on the collection label by Stieglitz states the title as above and that the print was exhibited at Buffalo and Dresden. The Dresden catalog, however, does not list this work, although there is *Mondaufgang —Der Teich.*
It was about this time that Steichen began to drift away from landscape subjects, among the last of which Stieglitz collected was *Garden of the Gods,* 1906, Cat. 472. Steichen recollected that after his experience of photographing J. P. Morgan, "I found that capturing the mood and expression of the moment in portraits was more important than photographing the twigs, the leaves, and the branches of trees" (Biblio. 751, p. 39).

490 » *The Black Vase.* About 1905 print from negative of about 1901. Ochre gelatine-carbon. 204 × 154 mm. (8¹/₁₆ × 6¹/₁₆ in.) Signed on mount in yellow crayon pencil "STEICHEN MDCCCCI" with another signature faintly printed from the copy negative. 33.43.20.
Exhibited: Hamburg (1902), No. 234; Rochester (1903), no. 190, titled *The Black Vase.*
Collections: MOMA (gum-bichromate).
The date of 1901 is perplexing because Steichen's earliest carbon prints apart from this print date from 1904, suggesting that the date was incorrectly added at a later time. The barely legible signature and date from the original print can be seen on this print, demonstrating that a copy negative was used. Such a gum original would have been typical of Steichen's early Paris work, and it can be speculated that Steichen in this instance dated the new print with the year of the negative (1901) rather than the year it was made, as he customarily did. In size and effect, this print is similar to Steichen's small Flatiron (Cat. 480) of 1904, suggesting a plausible date for the print which could have been made between 1904 and 1909, the period from which date the bulk of Steichen's surviving carbon prints. The model is Beatrice Baxter, who was also a model of Käsebier.

491 » *Steeplechase Day, Paris—The Grandstand.* 1907. Gelatine-carbon with selectively applied yellow tone (extremely faded). 272 × 352 mm. (10¾ × 13⅞ in.) 33.43.49.
Plate 65.
Exhibited: New York (PSG, 1908), no. 20; London (1908), no. 89.
Reproduced: *Camera Work,* Nos. 42–43 (April–July, 1913), pl. XII, titled as above and with a signature identical in every stroke to this print; Biblio 751, pl. 45.
See Cat. 494.
Steichen recollected the following about his series of negatives made at the Longchamps race track, Paris:

One day in the summer of 1907, I borrowed from a friend a German hand camera called the Goerzanschutz Klapp Camera. Armed with this camera, I made my first attempt at serious documentary reportage. I went to the Longchamps Races and found an extravagantly dressed society audience, obviously more interested in displaying and viewing the latest fashions than in following the horse races. (Biblio. 751, p. 55).

492 » *After the Grand Prix—Paris.* About 1911 print from negative of 1907. Gelatine-carbon with selectively applied yellow tone (extremely faded). 271 × 295 mm. (10^{11}⁄$_{16}$ × 11⅝ in.) 33.43.51.

Exhibited: New York (PSG, 1908), no. 15; Buffalo (1910), no. 414, titled as above and dated 1907.

Reproduced: *Camera Work,* Nos. 42–43 (April–July, 1913), pl. XI, titled *Steeplechase Day, Paris—After the Races* and printed in duogravure, the second printing to render the localized yellow tone that is badly faded in this print. The signature in the gravure and this print are identical in every stroke, leaving no doubt that this was the print from which the reproduction was made; Biblio. 751, pl. 46.

See Cat. 491.

It was stated in the cited *Camera Work* that "plates XI–XIV are duogravures made from four Steichen original 'Gum' prints." The identical signatures and traces of the original tone establish that this and the following prints were used for the reproductions. Were it not for the visual evidence, however, the connection would appear most implausible since the extreme fading of the selectively toned areas makes the originals look very different from the *Camera Work* reproductions. Magnification indicates these are gelatine-carbon prints with an image structure identical to Fig. 44.

The record is contradictory on the date of these prints. Steichen recollected in his autobiography (Biblio. 751, pls. 45, 46) that these two negatives were made in 1905, but Steichen was in New York that year. The Buffalo (1910) catalog dates it 1907, the favored date for the negative since Steichen was known to have been in Paris then. Stieglitz placed the date 1911 on his collection label, suggesting a plausible date for the prints.

493 » *Late Afternoon—Venice.* 1907. Gelatine-carbon with selectively applied yellow tone (faded). 281 × 335 mm. (11^{1}⁄$_{16}$ × 13^{3}⁄$_{16}$ in.) Signed in pencil "STEICHEN." 33.43.50.

Exhibited: *New York (PSG, 1908), no. 18, titled *Venice;* New York (PSG, 1908), no. 34, titled *Reflections, Venice.*

Reproduced: *Camera Work,* Nos. 42–43 (April–July, 1913), pl. XIV, and No. 44 (dated October 1913), pl. I.

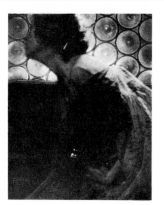

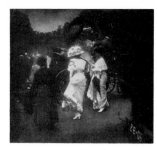

492

490

The print is very similar in treatment to Cats. 491 and 492 in the application of a yellow tone that has faded, but less so than in the other two. It therefore gives a better idea of how the tone originally looked. Like the two prints above, the signature is identical in every stroke to that reproduced in *Camera Work,* proving that this was the print used to make the gravure.

In the mid-1890s Stieglitz had photographed the architecture of Venice from the canal where a genre element in the line of drying clothes is combined with formal frontality, while Steichen focused on the play of light on the water in the manner of impressionist painters.

Gelatine-silver prints

Under magnification the gelatine-silver print is readily identified by the finely graduated range of tones and the absence of visible paper fibres to which the image is adhered (Fig. 49).

494 » *Bartholomé.* 1901 (A. S.) Gelatine-silver. 268 × 202 mm. (10^{9}⁄$_{16}$ × 7^{15}⁄$_{16}$ in.) Inscribed on verso by Steichen is a list of photographs apparently intended for reproduction in *The Craftsman* (Biblio. 1104) and *World's Work:* "Craftsman—Round Mirror, Self-Portrait, and Rodin/World's Work—Self-Portrait, and Nude." 33.43.16.

Exhibited: London (1902), no. 176; San Francisco (1903), no. 3; Wiesbaden (1903), no. 220; *New York (PSG, 1906), no. 9.

Reproduced: *Camera Work,* No. 2 (April, 1903), pl. V, where it is indicated (p. 54) that this gravure

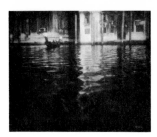

493

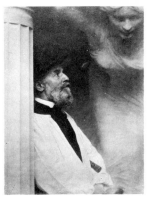

494

495

496

was made from the original negative; the gravure has been retouched to remove flaws on the negative that are evident in this print; Maeterlinck (Biblio. 764), pl. IX, printed from the same gravure plate as *Camera Work;* Allan (Biblio. 1104), after p. 30, titled *Composition in Portraiture.*

Albert Bartholomé (1848–1928) was a prominent French sculptor.

495 » *Self-Portrait.* 1902. Gelatine-silver (Velox). 120 × 92 mm. (4¾ × 3⁷⁄₁₆ in.) Signed and dated on the mount "STEICHEN MDCCCCII." 33.43.18.
Figure 49 (Photomicrograph).
Exhibited: See Cat. 452 for all self-portraits.

Reproduced: *Camera Work,* No. 2 (April, 1903), [p. 65], advertisement for Eastman Kodak Co. captioned: "Reproduced from Manipulated Velox print. Negative by Edward J. Steichen with no. 4 cartridge Kodak. Eastman Transparent Film."

Fig. 49 » Fifty times magnification of Cat. 495. (Photo: Steven Weintraub)

Collections: AIC, Stieglitz Collection.

The image provides a perfect example of how a gelatine silver print can be made to resemble a carbon print to the naked eye, but the continuous tonal character of gelatine silver is striking in comparison to the halftone quality of the gelatine-carbon process (Fig. 49).

496 » *Sadakichi Hartmann.* 1903. Plain gum-bichromate or unidentified oil pigment process. 246 × 305 mm. (9¾ × 12 in.) Signed in light orange crayon pencil "STEICHEN MDCCCCIII." 33.43.52.
Exhibited: New York (NAC, 1902), no. 116, titled *The Critic,* suggesting a related subject; San Francisco (1902), no. 7; Hamburg (1903), no. 411; Washington (1904), no. 125; Pittsburgh (1904), no. 207; Bradford (1904), no. 188; Vienna (PC, 1904), no. 6.

Reproduced: *Camera Work,* No. 7 (July, 1904), plate I, reproduced from another print with more of the subject at the left edge of the paper and of the oriental carving shown but without the paper texture evident in this print.

It was noted in the cited *Camera Work* (p. 41) that "the name of Sadakichi Hartmann, art-critic and familiar contributor to our pages, must be well known to our readers, and Mr. Steichen's portrait of him is peculiarly characteristic." Hartmann, a German-Japanese-American, was a frequent writer on members of the Stieglitz circle (see Biblio. 1078, 1081, 1103, etc.).

On his collection label, Stieglitz inadvertently dated the print 1904 despite the date 1903 inscribed on the print by Steichen.

497 » *J. Pierpont Morgan, Esq.* 1904 print from 1903 negative. Platinum (A. S.) or gelatine silver. 516 × 411 mm. (20⅝₁₆ × 16¾₁₆ in.) Signed and dated in pencil on arm of chair "STEICHEN MDCCCCIV." 49.55.167.

Plate 62.

Exhibited: Hamburg (1903), no. 413; Washington (1904), no. 117; Pittsburgh (1904), no. 117; Paris (1904), no. 663; Philadelphia (1906), no. 115; New York (NAC, 1908), no. 121; Buffalo (1910), no. 418, dated as a 1910 print from a 1903 negative.

Reproduced: *Camera Work*, Steichen Supplement (April, 1906), pl. II, titled as above and possibly reproduced from this print; Maeterlinck (Biblio. 764), pl. V, with copyright imprint of 1904 on margin of print; *Academy Notes* (Biblio. 1399a), p. 1.

Collections: Morgan Library, New York, three examples.

Inscribed on the collection label by A. S. is the note: "Print exhibited at Albright Exhibition/1910 and presented to me by Steichen/[in] exchange for an older print which had/faded (bromide print) and was destroyed/Value $1000.00 (Jan. 1, 1912)."

Stieglitz was under the impression that Steichen gave him a platinum print in exchange for the faded bromide, but the hard, glossy surface is not typical of platinum, while the light-struck areas at the left and right edges are typical of gelatine-silver enlarging materials, as are the opaque glossy blacks.

If this print was in fact exhibited in Buffalo and if the date in the catalog is correct, then the print was made in 1910 and is a documented instance of Steichen post-dating prints to the date of the negative. The date 1904 which should have been 1903 could be explained by a lapse in Steichen's memory.

This print remains one of the masterpieces of twentieth-century portraiture regardless of the exact date of its process. Fedor Encke was commissioned by Morgan to paint his portrait, and Encke, after consulting with Stieglitz, commissioned Steichen to photograph Morgan in the pose he had begun. When Steichen photographed Morgan on January 8, 1903, the first negative was taken in Encke's pose, followed by a second negative with the head and hands in a slightly different position. At the end of the sitting, Morgan gave Steichen a gratuity of five hundred

dollars, remarking to him, "I like you, young man. I think we'll get along first-rate together" (Biblio. 751, p. 39).

Steichen recollected how heavily he retouched Morgan's prominent nose in Encke's negative but only slight retouchings on his own negative. When the proofs were returned to Morgan, a dozen were ordered from the negative with Encke's pose. Steichen's pose (this print) displeased Morgan who tore the print into shreds exclaiming, "Terrible." Steichen was offended by this and remembered, "This act of tearing up something that did not belong to him riled my blood. I was not angry because he did not like the picture but because he tore it up. That stung very deep."

Morgan later changed his mind about Steichen's pose after his Librarian, Belle Greene da Costa, had seen it at the Photo-Secession Galleries. Steichen relates how Morgan tried to buy it from Stieglitz, offering five-thousand dollars. Stieglitz refused to sell and Morgan approached Steichen through Greene to make more prints, but Steichen was still smarting from Morgan's original offence. "For about two years, cablegrams and letters kept arriving, but I ignored them. This was my rather childish way of getting even with Morgan for tearing up that first proof. About three years later, I did make a group of prints for him" (Biblio. 751, pp. 48–49). It was about this time that the print Steichen exchanged with Stieglitz was made, and while Stieglitz stated the print was destroyed, it is very possible that Steichen, in remorse, actually gave Morgan Stieglitz's original print. (Another version of the same story is told by Stieglitz in Biblio. 926.)

The Peruvian-American painter Carlos Bac-Flor (1869–1941) used Steichen's photographs as models for his portrait of Morgan now in The Metropolitan Museum of Art (39.119, see Biblio. 776).

498 » *The Photographer's Best Model—Bernard Shaw.* 1907 (A. S.) Platinum (A. S.) or gelatine-silver. 493 × 385 mm. (19⁷₁₆ × 15¾₁₆ in.) Signed and dated in yellow crayon pencil "STEICHEN MDCCCCVII." 49.55.166.

Portraits titled *George Bernard Shaw* but not necessarily this image were exhibited: *New York (PSG, 1908), no. 6; Dresden (1909), no. 136; Buffalo (1910), no. 402,

498

499

identified as a platinum-gum print of 1909 from a negative of 1907.

Reproduced: *Camera Work*, No. 42/43 (April–July, 1913), pl. X, titled as above, where it is stated the print is reproduced "directly from the original Steichen negative;" but there is evidence of manipulation in the gravure along the left edge and without the hand manipulation at the bottom of this print.

Collections: MOMA, modern gelatine-silver facsimile of MMA example.

Stieglitz did not always agree with Shaw's writing on photography, but was apparently friendly with him judging from the fact that Shaw's calling card was originally affixed to the old mount. On the card Shaw wrote: "Sorry to miss you. We leave tomorrow. Winter Palace Hotel [New York], Dec. 30, 1933." It was written the year Stieglitz gave the first installment of his collection to the Museum. The negative was presumably made during the summer of 1907 when Steichen was in London demonstrating the new autochrome process and made autochromes of Shaw (MOMA collection).

The smooth, hard surface and the sulphiding at the bottom of this print are typical of gelatine silver materials. Inscribed by Stieglitz on the collection label from the old mount: "Best print of this plate.—value $250.00."

499 » *Edmond Joseph Charles Meunier.* 1907 print from a negative of 1900–1904? Gelatine-silver. 357 × 259 mm. (14¹⁄₁₆ × 10³⁄₁₆ in.) Signed on mount in pencil "STEICHEN MDCCCCVII." 33.43.11.

The model (identified by Stieglitz) was a French sculptor, photographed with his work. The image was apparently a part of Steichen's series on artists and writers photographed during 1900–1904. The subject suggests a date earlier than 1907 for the negative.

Ambiguous Processes

The following prints (except Cat. 514) show an image structure similar to Cat. 495 (Fig. 49) under magnification. Paper fibers are not visible as is expected of platinum, and the image is constituted in a gelatinous colloid. Stieglitz identified most of these as "platinum" or "gum-platinum" on his collection labels. In deference to Stieglitz's expertise in platinum printing (Biblio. 878, 1231), his identifications have been provisionally retained despite the fact that the prints do not resemble other platinum or gum-platinum prints in the Stieglitz collection. (See Cat. 508 for a firmly identified gelatine-silver print that Stieglitz labeled as platinum.) The surface of the following group of prints is glazed, but without the imperfections of hand-coated surfaces as in Cat. 479. The large size of many of these smooth, slightly glossy-surfaced prints is also unusual for platinum which, incapable of direct enlargement, required a negative the same size as the desired print. Also generally lacking in this group of prints is the wide scale of tones (except Cats. 512 and 513) typical of platinum, but instead there is a significant compression of the tonal range, as in Cats. 452, 501, and 505.

Stieglitz's seeming assurance that these prints were platinum cannot be disregarded. It should be noted that about this time photo-chemical manufacturers introduced silver printing materials designed to imitate the general appearance of platinum, glazed-platinum and other pigment processes. Among the most widely advertised of these was Kodak's Velox paper for which Stieglitz was commissioned to make a series of advertisements illustrated with original prints tipped into photography publications, of which Cat. 495 is a typical example. In 1905 the Eastman Kodak Company published the results of its *Souvenir Kodak Competition* with prints by Stieglitz, Steichen, and Anne Brigman, and many others not represented in the Stieglitz collection. The preface stated: "All of the pictures are from Kodak or Brownie film negatives—

many are machine developed. The actual photographic prints tell in part of the range of effects that may be obtained on Kodak papers." Evidently Kodak was attempting to pursuade photographers that their manufactured materials could compete with the effects obtained in platinum, gum-bichromate and other processes that resulted from the photographer creating his own materials with stock chemicals and uncoated papers. The extent to which Steichen used the materials from Kodak that he endorsed is as yet undetermined.

500 » *The Little Round Mirror.* 1902 print from 1901 negative. Gray-green pigment gum-bichromate over platinum or gelatine-silver. 483 × 332 mm. (19 × 13¹⁄₁₆ in.) Signed and dated in ink "STEICHEN MDCCCII"; inscribed on verso by Steichen "Terre verte & Black," pigments also used by Steichen in making Cat. 476. 33.43.32.

Plate 55.
Exhibited: Hamburg (1903), no. 418; Washington (1904), no. 121, Pittsburgh (1904), no. 203; London (1904), no. 113; Dresden (1904), no. 165, reproduced; The Hague (1904), no. 101; Vienna (CK, 1905), not numbered; Portland, Oregon (1905), no. 17 (Lent by Mr. Marshall R. Kernochan); Richmond (1905), no. 844; Cincinnati (1906), no. 53; *New York (PSG, 1906), no. 38; Philadelphia (1906), no. 111; Dresden (1909), no. 150; New York (NAC, 1909), no. 177, dated 1901; Buffalo (1910), no. 411, identified as a platinum gum print of 1909 from a negative of 1901.

Reproduced: *Camera Work,* No. 14 (April, 1906), pl. V, titled as above, where the signature and date are identical suggesting that this print was used for the reproduction; Maeterlinck (Biblio. 764), pl. XIV; *Camera-Kunst* (Biblio. 1285), p. 45; Anderson (Biblio. 1294), p. 248.

Collection: André Jammes, Paris, signed and dated 1902.

A paper label from the old mount reads: "Eduard J. Steichen/Little Round Mirror/Platinum/X'mas present to Emmy & myself—1905/print 1905," inscribed by Stieglitz. Despite Stieglitz's identification of this print as a straight platinum, visual inspection and Steichen's notation on verso suggest that a pigment

was applied. The smooth, hard surface, atypical of platinum, resembles other prints collected by Stieglitz that have been identified as pigmented gum-bichromate over gelatine-silver.

501 » *Clarence H. White.* 1903. Platinum (A. S.) or gelatine-silver. 329 × 250 mm. (12¹⁵⁄₁₆ × 9⁷⁄₈ in.) Signed and dated in crayon pencil "STEICHEN MDCCCIII." 33.43.7.

Figure 53.
Exhibited: Vienna (1904), no. 4; *New York (PSG, 1906), no. 13; Dresden (1909), no. 144.

Reproduced: *Camera Work,* No. 9 (January, 1905), pl. VI, where it is stated that the gravures were made from the original negatives and with a consequent increase in detail and resolution from this print; Holme (Biblio. 1288), US, pl. XXIV.

The hard, smooth surface is not typical of other platinum prints that Stieglitz collected. On his honeymoon trip in the Fall of 1903, Steichen visited White in Newark, Ohio, where this negative was very likely made.

502 » *In Memoriam.* 1904 print of 1902 or earlier negative. Gum-over-platinum (A. S.) or gum-over-gelatine-silver. 498 × 403 mm. (19⁵⁄₈ × 15⁷⁄₈ in.) Signed and dated in orange crayon pencil "STEICHEN MDCCCIV." 33.43.48.

Exhibited: New York (PSG, 1905), no. 77; *New York (PSG, 1906), no. 37; Philadelphia (1906), no. 110; New York (NAC, 1908), no. 122; New York (NAC, 1909), no. 122; Buffalo (1910), no. 409, where the negative was incorrectly dated 1903 and the print 1909.

Reproduced: *Camera Work,* Steichen Supplement (April, 1906), pl. VII, with more detail in area of floor and bed than in this print.

Collections: André Jammes, Paris, dated 1902.

The gelatine support is evident at the top and bottom where there are traces of a light-green toning agent applied to the entire surface, without the grainy effect of gum-bichromate pigment. The tonal scale, highly compressed in comparison to the *Camera Work* gravure, could have resulted from the direct enlargement on gelatine-silver materials of a negative that was low in contrast.

505

502

503

504

Stylistically this print has more in common with the *Little Round Mirror* (Cat. 500) than with the nudes of 1901–1902 (Cats. 458 and 484).

503 » *Chestnut Blossoms.* 1905 print from 1904 negative. Gray pigment gum-bichromate over platinum or gelatine-silver. 497 × 400 mm. (19⁹⁄₁₆ × 15¾ in.) Signed and dated in orange crayon pencil "STEICHEN MDCCCCV." 33.43.42.
Exhibited: *New York (PSG, 1906), no. 51, titled *The Big Chestnut Trees;* New York (NAC, 1908), no. 120), titled *Chestnut Blossoms,* both suggesting related if not identical compositions.
Reproduced: Biblio. 751, pl. 39, dated 1904.
Collections: MOMA (gelatine silver or glazed platinum).

504 » *Trinity Church, New York.* 1907 print (A. S.) from negative of 1904. Glazed platinum (A. S.) or gelatine-silver. 482 × 375 mm. (18¹⁵⁄₁₆ × 14¾ in.) Signed in pencil "STEICHEN." 33.43.41.
Exhibited: Dresden (1909), no. 154, titled *Trinitykirche, New York.*
Reproduced: (Biblio. 751), pl. 33, dated 1904 in caption and reproduced from a print in the collection of the Museum of Modern Art, New York, signed and dated 1905.
The hard, glossy surface and suppression of details in the building shadow are atypical of platinum, which would have required an enlarged negative for a print this size. Rather, such qualities characterize the gelatine-

silver. The ghostly image most clearly evident in the shadow across street and at the roof-peak of nave is apparently in the original negative, as the effect is identically replicated in the MOMA and MMA versions. Conceivably, it resulted from the camera being moved slightly during exposure which took place at 11:07 A.M. according to the clock on the church.
Clara E. Smith and Steichen were married in this church on October 3, 1903. Rarely publishing or exhibiting photographs made in the streets of New York, Steichen was at this point in his career much more active as a studio photographer. Despite the great size, the print is essentially a snapshot, in which the people caught in motion are as much the subject as the church.

505 » *Mr. and Mrs. Steichen.* 1908 print from 1903 negative. Gray pigment gum-bichromate over platinum or gelatine-silver. 292 × 336 mm. (11½ × 13¼ in.) Signed in yellow crayon pencil "STEICHEN MDCCCCVIII." 33.43.21.
Exhibited: New York (PSG, 1906), no. 28, titled as above; Buffalo (1910), no. 400, identified as a 1909 print from 1903 negative.
Reproduced: *Camera Work, Special Supplement* (April, 1906), pl. IV, titled *Portraits—Evening,* where it is stated that the original negatives were used for making the gravure plates resulting in more detail in his jacket and behind her right shoulder. It was added, "We flatter ourselves that some of the gravure plates are even above our own average of reproduction and give a fair idea of Mr. Steichen's spirit, although it is impossible to reproduce the full quality of his originals."

506

507

508

The cited *Camera Work* (p. 50) states that "some of Steichen's originals are in gum, some in bromide, and some in a combination of these processes. . . ." The problem of identifying Steichen's materials is typified by this print that bears such a close relationship to what was described in *Camera Work*. The glossy, hard surface is more typical of gelatine-silver over which it appears bichromated pigment has been added. Stieglitz, however, identified the print on his collection label as "Platinum-gum," which is contradicted by microscopic examination that yields no visible evidence of platinum absorbed into paper fibers (Fig. 49), but rather an image constituted in a layer on top of the paper, typical of gelatine-silver.

Steichen and Clara spent their honeymoon at the Stieglitz family house, Lake George, and then visited the Clarence White family in Newark, Ohio (see Cat. 501).

506 » *Edward Gordon Craig.* 1909. Gelatine-silver. 484 × 359 mm. (19¹/₁₆ × 14⅛ in.) 49.55.227.
Reproduced: Anderson (Biblio. 1294), opposite p. 827, titled *Self-Portrait;* Isadora Duncan, *My Life,* New York, 1927, opposite p. 188, titled *Edward Gordon Craig,* with the date 1909 visible.

Stieglitz did not identify the subject on a collection label. The model bears a close resemblance to Steichen (Cat. 450, 495), and the early reproduction of the print as *Self-Portrait* gives credibility to the possibility. However, the reproduction in Duncan's autobiography as the portrait of Craig, her lover and companion of many years, lends greater credibility to this being his portrait.

507 » *Anatole France.* 1909. Gray pigment gumbichromate over gelatine-silver. 389 × 295 mm. (15 × 11¼ in.) Signed in yellow crayon "STEICHEN MDCCCCIX." 49.55.165.
Exhibited: Dresden (1909), no. 135.

Reproduced: *Camera Work,* No. 42/43 (April–July, 1913), pl. V, where it is stated that the original negatives were used to make the gravure plates (p. 68), a rare instance where a gravure from the negative retains the same density in the shadows of an original print. In fact, it appears that the gravure was reproduced from this print, not the negative, since an eccentric border unique to this print (1 inch at top, ¾ inch at right) is repeated exactly in *Camera Work.*

Resembling Cat. 506 under magnification, the print retains traces of sulphiding at the edges, a type of deterioration from which platinum prints do not suffer. It can thus be inferred that gelatine-silver was used for other Steichen prints collected by Stieglitz and that he inadvertently identified some as platinum.

Stieglitz family portraits.

508 » *Mrs. Stieglitz and Daughter.* 1903 (E. S.) or 1904 (A. S.) Platinum (A. S.) or gelatine silver. 495 × 386 mm. (19½ × 15 ³/₁₆ in.) Signed and dated in yellow crayon pencil "STEICHEN MDCCCCIII." 33.43.28.
On the collection label Stieglitz recorded that the sitting took place in 1904 despite the date 1903 inscribed legibly on the print by Steichen.

509 » *Alfred Stieglitz and His Daughter Katherine.* 1905 print from 1904 negative. Gray pigment

510

511

512

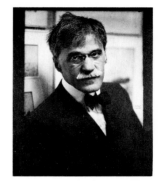

513

gum-bichromate over glazed platinum or gelatine-silver. 455 × 400 mm. (17¹⁵⁄₁₆ × 15¾ in.) Signed and dated in ink "STEICHEN MDCCCCV." 33.43.23.

Plate 59.

Exhibited: *New York (PSG, 1906), no. 26.

The print, dated 1904 by Stieglitz, was presumably made at the same sitting as Cat. 517, with Katherine wearing the same hat. The Stieglitz family portraits show Steichen's working method in a portrait sitting. Walls with picture frames were preferred as backdrops, and the placement of the frames in the compositions become important design elements echoing the theme of Cat. 450. The sitters define themselves through costume. Stieglitz wears his overcoat and Katherine tries her hat on and off. The single light source is less harsh here than in other instances, and was evidently Steichen's trademark as a portraitist at this time.

The grainy surface pattern evident to close naked-eye inspection is similar to Coburn's use of gum-over-

Fig. 48 » Thirty times magnification of Cat. 131. Plate 73. (Photo: Steven Weintraub)

platinum (Cat. 131, Fig. 48) for a monochrome effect, but the hard, glossy surface is atypical of platinum and suggests gum-bichromate over gelatine-silver print.

510 » *Mrs. Stieglitz and Daughter.* 1908 print from 1904 negative. Gelatine-silver. 185 × 136 mm. (7⁵⁄₁₆ × 5⅜ in.) Signed on mount in yellow crayon pencil "STEICHEN MDCCCCVIII." 33.43.19.

511 » *Alfred Stieglitz and his Daughter Katherine.* 1905. Platinum (A. S.) or gelatine silver. 289 × 237 mm. (11⅜ × 9⁵⁄₁₆ in.) 49.55.230.
Collection: AIC, Stieglitz Collection (gelatine-silver on textured paper).

512 » *Alfred Stieglitz and his Daughter Katherine.* 1905 print from 1904 negative. Platinum. 246 × 234 mm. (9¹¹⁄₁₆ × 9¼ in.) Signed in yellow crayon pencil "STEICHEN MDCCCCV." 49.55.228.
Collections: AIC, Stieglitz collection.

Different in overall effect from Cat. 509, this platinum print shows that even the harsh single light source has softened texture and detail. The whitest areas of the hat are gently modeled and the dark garments have a subtle detail not evident in other prints.

The series of Stieglitz and his daughter explore human relationships. The affection of intertwined arms (Cat. 509) is contrasted to the alienation and distance suggested in this print.

513 » *Alfred Stieglitz at "291."* 1915. Gray pigment gum-bichromate over platinum or gelatine-

517A

515

516

517

silver. 288 × 242 mm. (11⅜ × 9⁹⁄₁₆ in.)
Signed and dated in pencil "STEICHEN
MDCCCCXV." 33.43.29.
Collection: AIC, Stieglitz Collection.

On his collection label, Stieglitz identified this print
as "platinum-gum" despite the smooth, hard surface
atypical of platinum. This was one of the last portraits
of Stieglitz made at the Photo-Secession Galleries by
one of its founding members. The galleries had by this
time been renamed "291" after the street address on
Fifth Avenue, and would cease functioning within
two years of this sitting.

Autochromes

514 » *Alfred Stieglitz.* 1907. Autochrome. 229 ×
157 mm. (9 × 6⅛ in.) 55.635.10.
Dustjacket and frontispiece.
The plate is flawed by pockmarks apparently resulting
from mold growths.

515 » *Rodin—The Eve.* 1907. Autochrome. 98×
159 mm. (6¼ × 3⅞ in.) Signed and dated in
ink on mount "STEICHEN MDCCCCVII." 55.635.9.
Exhibited: *New York (PSG, 1908), no. 48; New
York (NAC, 1908), no. 250.

Steichen recollected to A. Hyatt Mayor that a bed-
sheet removed from the sculpture was draped around
Rodin for this pose.

516 » *Miss Katherine Stieglitz.* (Attributed to
Steichen) 1907. Autochrome. 163 × 113 mm.
(6½ × 4⁷⁄₁₆ in.) 55.635.13.
Exhibited: New York (PSG, 1907), no. 11.

In 1959 Steichen did not recollect having made this
plate, but it is presently attributed to him on the basis
of style and the 1907 exhibition.

517 » *Clarence H. White.* About 1907. Auto-
chrome. 142 × 112 mm. (5⁹⁄₁₆ × 4½ in.)
55.635.19.
In 1959 Steichen identified the print as his work.
Stieglitz exhibited two autochrome portraits of White
(with whom he was collaborating at the time) at PSG
1907 members' show, but Steichen is not recorded to
have exhibited an autochrome of White. The question
thus remains as to whether Steichen's memory was
correct half a century after the event.

517A » *Mrs. Gertrude Käsebier.* About 1907. Auto
chrome. 118 × 155 mm. (4¾ × 6⅛ in.)
55.635.15.
The glass is shattered and the image survives only in
a color transparency (Ektachrome) made to the same
size as the original.

EXHIBITIONS

Philadelphia 1899–1900 » Chicago 1900 » London
1900–1902 » Newark 1900 » Brussels 1901 »
Glasgow 1901 » London (NSAP) 1900 » Paris
(NSAP) 1901 » Hamburg 1902–1903 » Leeds
1902 » New York (NAC) 1902 » *Paris* (Champs
de Mars) *1902* » *Paris* (Maison des artistes) *1902*
» Turin 1902 » Brussels 1903 » Cleveland 1903

» Denver 1903 » Minneapolis 1903 » Rochester 1903 » San Francisco 1903 » Toronto 1903 » Wiesbaden 1903 » Bradford 1904 » Dresden 1904 » Hague 1904 » London 1904 » Paris 1904 » Pittsburgh 1904 » Washington 1904 » Portland 1905 » Richmond 1905 » Vienna (C-K) 1905 » Vienna (PC) 1905 » New York (PSG) 1905 » Cincinnati 1906 » New York (PSG) Members' and Solo 1906 » Paris 1906 » *London (NEAC) 1907* » New York (PSG) 1907 » New York (PSG) Members' and Solo 1908 » New York (NAC) 1908 » London 1908 » Dresden 1909 » *New York (PSG) 1909 » New York (NAC) 1909 » Buffalo 1910 » New York (Montross) 1912.

COLLECTIONS

MOMA, The Edward Steichen Archive; IMP/GEH; RPS.

BIBLIOGRAPHY

Manuscript

738. Stieglitz Archives, Collection of American Literature, Beinecke Rare Book and Manuscript Library, Yale University, New Haven, Conn.: 147 unpublished letters from Edward Steichen to Alfred Stieglitz and 5 unpublished letters from Alfred Stieglitz to Eduard Steichen between 1900 and 1932.

739. The Edward Steichen Archive. The Museum of Modern Art, New York, New York.

740. Steichen, Edward. Interview with Paul Cummings, 1970. Archives of American Art, Washington, D.C.

By Steichen

741. Steichen, Eduard J. "British Photography from an American Point of View." *Camera Notes,* 4 (January, 1901), pp. 175–181.

742. ———. "The American School." *The Photogram,* 7 (January, 1901), pp. 3–9. Reprinted, *Camera Notes,* 6 (July, 1902), pp. 22–24.

743. ———. "Ye Fakers." *Camera Work,* No. 1 (January, 1903), p. 48.

744. ———. "Concerning Portraiture." *Bausch and Lomb Lens Souvenir.* Rochester, N.Y., 1903. Scrapbooks, Stieglitz Archives, Beinecke Rare Book and Manuscript Library, Yale University, New Haven, Conn.

745. ———. "Grensen." *Camera Kunst.* (Biblio. 1285), 1903, pp. 12–15.

746. ———. "Les Harmonies de Couleurs et la Plaque Autochrome." *La Revue de Photographie,* 6 (January, 1908), pp. 7–13.

747. ———. "Color Photography." *Camera Work,* No. 22 (April, 1908), pp. 13–24.

748. ———. "Painting and Photography." *Camera Work,* No. 23 (July, 1908), pp. 3–5.

749. Steffens, Lincoln. "Roosevelt—Taft—LaFollette on What the Matter is in America and What to Do About It." *Everybody's Magazine,* 18 (June, 1908), pp. 723–736 ff. (illustrated by Steichen).

750. ———. "291." *Camera Work,* No. 47 (July, 1914), pp. 65–66.

751. ———. *A Life in Photography.* Chronology by Grace M. Mayer. The Museum of Modern Art and Doubleday & Co., Inc., N.Y., 1963.
See Biblio. 831, 1029, 1153.

About Steichen

752. "Edward J. Steichen's Success in Paris." *Camera Notes,* 5 (July, 1901), p. 57.

753. Juhl, Ernst. "Eduard Steichen." *Photographische Rundchau,* 16 (January, 1902), pp. 127–129.

754. "Mr. Steichen's Pictures." *Photographic Art Journal,* 2 (15 April 1902), pp. 25–29.

755. "Mahlstick" [unidentified pseud.]. "Eduard J. Steichen." *The Photographic Art Journal,* 2 (May, 1902), pp. 52–53.

756. Yeo, H. Vivian. "The American School and Mr. Steichen's Pictures." *The Amateur Photographer,* 35 (1 May 1902), pp. 346–347.

757. Allan, Sidney [Sadakichi Hartmann]. "Eduard J. Steichen, Painter, Photographer." *Camera Notes,* 6 (July, 1902), pp. 15–16.

758. Stieglitz, Alfred. "The 'Champs de Mars' Salon and Photography." *Camera Notes,* 6 (July, 1902), p. 50 (G. App. 295).

759. "Eduard J. Steichen." *Photographic Times-Bulletin,* 34 (October, 1902), p. 474.

760. Caffin, Charles H. "Eduard J. Steichen—An Appreciation." *Camera Work,* No. 2 (April, 1903), pp. 21–24.

761. Allan, Sidney [Sadakichi Hartmann]. "A Visit to Steichen's Studio." *Camera Work,* No. 2 (April, 1903), pp. 25–28.

762. Fitzgerald, Charles. "Eduard Steichen: Painter and Photographer." *Camera Work,* No. 10 (April, 1905), pp. 42–43.

763. "Mr. Steichen's Photographs." *New York Evening Post,* 21 March 1906, p. 5.

764. [Maeterlinck, Maurice]. *Steichen.* New York, 1906. Edition deluxe of the *Camera Work Steichen Supplement,* issued simultaneously with No. 14 (April, 1906), described in that issue [p. 56], "Edition De Luxe —Sixty-five (65) signed and numbered copies, of which but forty copies will be for sale, will contain thirty specially selected proofs of Mr. Steichen's work mounted on special paper about 13 × 19 inches. The book will be bound in a specially designed stiff board cover. Price, thirty dollars." (MMA, 49.55.329, Stieglitz Collection).

765. Caffin, Charles H. "Progress in Photography, with a Special Reference to the Work of Eduard J. Steichen." *The Century Magazine,* 75 (February, 1908), pp. 483–498.
 See Biblio. 1289 B.

766. Caffin, Charles H. "Prints by Eduard J. Steichen—Of Rodin's 'Balzac.'" *Camera Work,* No. 28 (October, 1909), pp. 23–25.
 See Biblio. 1291 B.

767. Caffin, Charles H. "The Art of Eduard J. Steichen." *Camera Work,* No. 30 (April, 1910), pp. 33–36.

768. Various Criticisms of the Steichen Exhibition. Reprinted from other sources in *Camera Work,* No. 30 (April, 1910), pp. 36–40.

769. Gallatin, A. E. "The Paintings of Eduard J. Steichen." *International Studio,* 40 (April, 1910), sup. xl—xliii.

770. Sandburg, Carl. *Steichen the Photographer.* New York [1929].

771. Strand, Paul. "Steichen and Commercial Art." *The New Republic,* 62 (19 February 1930), p. 21, in answer to Paul Rosenfeld's article, "Carl Sandburg and Photography," *The New Republic,* 62 (22 January 1930), pp. 251–253.

772. [Dorothy Norman, ed.]. "Alfred Stieglitz: Ten Stories—Museums and Photography—Steichen's *Morgan* and the Metropolitan." *Twice A Year,* Nos. 5–7 (1940–1941), pp. 150–151.

773. Geldzahler, Henry. "Edward Steichen: The Influence of a Camera." *Art News,* 60 (May, 1961), pp. 27–28, 52–53.

774. Kramer, Hilton. "The Young Steichen: Painter with a Camera." *New York Times,* 16 June 1974, p. 4D.

775. Homer, William Innes. "Eduard Steichen as Painter and Photographer, 1897–1908." *The American Art Journal,* 6 (November, 1974), pp. 45–55.

776. Bunnell, Peter C. *Copies as Originals* [discusses Steichen's *Morgan* and Carlos Baca-Flor's portrait of Morgan]. The Art Museum, Princeton University, exhibition catalog, 1974.

PAUL STRAND (American)

Fig. 50 » *Paul Strand*. By Alfred Stieglitz, about 1915. ©
1971 Aperture, Inc.

CHRONOLOGY

1890: Born in New York City, the only son of Matilda
and Jacob Strand, of Bohemian Jewish descent
(name changed from Stransky shortly before Paul's
birth).

1904–09: Attends Ethical Culture School in New York.
Studies art appreciation with Charles H. Caffin, pho-
tography with Lewis W. Hine in after-school club
and class. Hine takes club to Stieglitz's Photo-Seces-
sion Gallery in 1907 to see work of the Photo-
Secession members. The same year a loan collection
of photographs by members of the Photo-Secession

is included in the Annual Exhibit of the Ethical
Culture School. » Strand joins Camera Club of
New York after graduation.

1910–11: Works in father's enamelware business until
sold. Takes savings and spends April and May of
1911 in Europe. In Versailles makes photograph,
Temple of Love, exhibited at Camera Club and in
London Salon.

1912: Attempts to support himself by photographing
college buildings as souvenirs for graduating seniors.
Photographs are printed on platinum paper and
hand-colored. Enterprise is moderately successful
for several years.

1915: Cross-country trip in April and May to increase
business. Photographs for himself in New Orleans,
Colorado, Texas and California. Stieglitz, to whom
Strand has been showing work for several years,
advises him to abandon soft-focus. Taking advice,
Strand makes cityscapes with sharper focus and
more geometric composition. » Exhibits with
pictorialist photographers at The Print Gallery.

1916: Makes abstract compositions and still lifes at
Twin Lakes, Connecticut, during the summer. In
city makes "candid" portraits, using false lens, then
prism on lens. » Solo exhibition at 291 Gallery
(March 13–April 3). » Six gravures published in
Camera Work, 48 (October). Stieglitz writes of
Strand: "He is a young man I have been watching
for years . . . without doubt the only important
photographer developed in this country since Co-
burn. . . . His prints are more subtle. . . . He has
actually added some original vision to photography."
(Stieglitz to R. C. Bayley, 17 April 1916, YCAL).

1917: Wall Street awarded first prize at Wanamaker
Exhibition, Philadelphia. Judges include Stieglitz
and Steichen (Biblio. 1409). Eleven gravures pub-
lished in the last issue of *Camera Work,* 49/50 with
Strand piece on "Photography," printed also in
Seven Arts (August) (Biblio. 783). Exhibits with
Sheeler and Schamberg at de Zayas's Modern Gal-
lery, New York (March 26–April).

1918: Receives second and fifth prize, Wanamaker Ex-
hibition (Biblio. 1410). Charles Sheeler awarded
first prize for *Bucks County House.* Serves as X-ray
technician with Army Medical Corps. Released July
of 1919.

1920–21: Receives first prize for group of five photographs, Wanamaker Exhibition. » To Nova Scotia, photographs at Port Lorne, including close-up of rocks. » Collaborates with Charles Sheeler on a short, *Mannahatta* (released in New York as *New York The Magnificent*). » Considers making medical films. Continues photographing city subjects.

1922: Buys Akeley camera and sets up as free-lance motion picture cameraman. For next seven years makes films of sporting events, works on feature films and special documentary assignments. » Photographs machinery and cityscape. Exhibits at Camera Club of New York. Edward Weston comments that Strand is too much under the influence of Stieglitz (Biblio. 1155). » Marries Rebecca Salsbury.

1923: Delivers lecture at Clarence White School of Photography, subsequently published in *British Journal of Photography* (Biblio. 789).

1925: Exhibits with *Seven Americans* at Anderson Galleries (March 9–28). First trip to Georgetown Island, Maine, summer home of sculptor friend, Gaston Lachaise.

1926: Photographs in Colorado and New Mexico during summer.

1927–28: Returns to Georgetown Island. Makes closeups of rocks, tree roots, grasses, plants (Cats. 524, 525).

1929: One-man exhibition at The Intimate Gallery, New York (March 19–April 7). To Gaspé in summer; makes landscapes.

1930–32: Summers in New Mexico. Meets and influences Ansel Adams. Continues landscape photography. » Exhibits with Rebecca Strand at An American Place Gallery, New York (April, 1932). » Becomes advisor to Group Theatre. Interest in radical politics begins.

1932–34: Exhibits at the Bellas Artes, Mexico City. » Makes still photographs in Mexico, using lens prism. » Is appointed Chief of Photography and Cinemaphotography, Department of Fine Arts, Secretariat of Education of Mexico. Photographs and supervises production of documentary film, *Redes* (released in United States as *The Wave*). Separates from Rebecca Strand.

1935: Visits Soviet Union; meets Eisenstein and Dovchenko. Returns to United States; works with Ralph Steiner and Leo Hurwitz on Pare Lorentz film, *The Plough that Broke the Plains* for Resettlement Administration.

1936: Photographs in Gaspé in summer. » Marries Virginia Stevens.

1937–42: President of Frontier Film, New York. Produces *Heart of Spain, Native Land,* among other documentaries. » First portfolio: twenty hand gravures of Mexican photographs issued in 1942 by Virginia Stevens.

1943–44: Does camera work on films for government agencies. Works on large photographic montage for re-election of Franklin Delano Roosevelt. » Returns to still photography; works in Vermont.

1945–47: One-man exhibition at The Museum of Modern Art, New York (April 25–June 10) (Biblio. 808). Makes still photographs in New England for forthcoming publication, *Time in New England,* with text selections by Nancy Newhall (Biblio. 793). » Delivers talk at Alfred Stieglitz Memorial Exhibition, Museum of Modern Art.

1976: Dies.

PHOTOGRAPHS

A Note on Strand Titles

Strand apparently did not assign titles for most of his photographs when they were made. If he did, titles were not marked on the prints or mounts, nor were they reproduced at the time with descriptive titles. The 1917 *Camera Work* gravures were in many instances called *Photograph* or *Photograph, New York,* titles which we have retained in this catalog to preserve the spirit of the time during which they were collected by Stieglitz. It is unclear why Strand did not call his works *Untitled* or *No Title,* as Seeley had done , for example.

518 » *From the El.* 1915. Platinum from enlarged negative. Image, 326 × 252; paper, 335 × 259 mm. (12⅞ × 9¹⁵⁄₁₆; 13³⁄₁₆ × 10³⁄₁₆ in.) Signed, dated and titled as above on verso in blue crayon pencil "Paul Strand—1917." 49.55.221.

Plate 95.

518

Strand expresses in this print a visual compromise of the two major stylistic directions he was taking between 1915 and 1917. One important set of subjects were figures in the streets, while another consisted of relatively commonplace objects viewed from unexpected points. Here the abstraction results from an interaction between the geometry of the architecture and the pattern of light, all of which become an ornamental framework for the woman walking her dog whose position apparently governed the moment of exposure and thus assumed an important role in the composition. This is among the earliest dated surviving prints where the abstract tendency is evident.

519 » [*New York*]. 1917. Platinum from enlarged negative. 340 × 243 mm. (13⅜ × 9⁹⁄₁₆ in.) Signed and dated on mount and on verso of print "Paul Strand—1917." 33.43.335.
Exhibited: Philadelphia (Wanamaker, 1917), no. 961.

This represents a type of experiment by Strand that depended largely on the manipulation of the camera rather than of the negative or the print. Unorthodox perspective is realized in this print by deliberately not adjusting the front and back of the camera, as in the case of Adams (Cat. 2). Strand's street portraits required a dummy lens (Cat. 520), while the abstractions depended upon selecting an unexpected point of view.

Street Portraits

Strand had a camera specially fitted first with a dummy lens, then with a lens prism, that permitted him to appear to point it in one direction, while actually taking the photograph at a ninety-degree angle. The tight composition suggests that Strand was able to compose his subject through the viewfinder, or else later manipulated the composition in the darkroom, a practice that was becoming more acceptable [compare for example the odd cropping of Annan (Cat. 12)]. Such photographs reveal the profound social conscience that characterized much of Strand's later work (Biblio. 794–797).

520 » *Photograph—New York* [*Blind Woman*]. 1916. Platinum. 337 × 256 mm. (13¼ × 10¹⁄₁₆ in.) Signed and dated in pencil on margin and on the verso "Paul Strand—1916." 33.43.334.
Plate 92.
Exhibited: New York ("291," 1916).
Reproduced: *Camera Work,* Nos. 49–50 (April, 1914), pl. 3, titled as above and reproduced from another print, but both from a negative with retouching at lower left of the sign "Blind."
Stieglitz observed on the *Camera Work* gravures:

The eleven photogravures in this number represent the real Strand. The man who has actually done something from within. The photographer who has added something to what has gone before. The work is brutally direct. Devoid of all flim-flam; devoid of trickery and of any 'ism;' devoid of any attempt to mystify an ignorant public, including the photographers themselves. These photographs are the direct expression of today. We have reproduced them in all their brutality. We have cut out the use of the Japan tissue for these reproductions, not because of economy, but because the tissue proofs we made of them introduced a factor which destroyed the directness of Mr. Strand's expressions. In their presentation we have intentionally emphasized the spirit of their brutal directness.
The eleven pictures represent the essence of Strand.
The original prints are 11 × 14. [P. 36].

In 1970 Strand authorized the title *Blind Woman* (Biblio. 814, pl. 15), used parenthetically above, while the original mount carried Strand's address (314 W. 83 St.) and the title *Blind*. It is thus unclear whether Strand or Stieglitz assigned the austere *Camera Work* title, *Photograph—New York*.

521 » [*Photograph, New York*]. 1916. Platinum from enlarged negative. 262 × 307 mm.

(10⅝₁₆ × 12⅛ in.) Signed and dated on mount in pencil "Paul Strand 1916." 49.55.316.
Plate 93.
Exhibited: New York ("291," 1916).

The absence of this print from both *Camera Work* and subsequent anthologies of Strand's work is surprising since it is perhaps the single most important early work to anticipate Strand's concern for human relationships, a key theme in Strand's mature work. The above title follows the example set in *Camera Work* for similar subjects.

Abstractions

Strand was simultaneously holding two rather different artistic ideas during 1915–1916: a social consciousness expressed in his street portraits, and a concern for pattern and design in nature. The abstractions were apparently fewer in number than the street portraits, judging from the fact that only two abstractions were published in *Camera Work,* with two or three other studies of light and shadow typical of a pictorialism practiced by a few advanced photographers in Europe and America, but quite distant from the deliberate non-objectivity of Cat. 522.

522 » *Photograph.* 1916. Platinum from enlarged negative. 338 × 250 mm., including 2 mm. border all around. (13⅝₁₆ × 9⅞ in.) Signed and dated on verso in pencil "Paul Strand/ 1916." 49.55.317.
Plate 96.
Exhibited: New York ("291," 1916).
　　Literature: Homer (Biblio. 813).
　　Reproduced: *Camera Work,* Nos. 49–50 (June, 1917), pl. XI, titled as above, where the reduced gravure has more contrast, a deliberate effect to emphasize "the spirit of their brutal harshness" according to the notes.

The stylistic contradiction between the directness and high contrast of Cat. 520 compared to the cool aloofness of this composition summarizes the battle between two viewpoints that raged within Strand.

The composition reflects the influence of the non-objective directions of Picasso, Matisse, O'Keeffe and Hartley, whose paintings or drawings Strand saw on exhibition at 291. The date of this negative is of considerable interest since it originated within a year or two after the first abstract paintings were made in America. Strand recollected (Biblio. 813) that the negative was made in 1915, but there is no surviving print dated earlier than this one, which presumably was made shortly after the negative was taken at a cottage rented by Strand's parents in Connecticut for the summer of 1915. Among Americans, only Hartley and Dove had made pictures by 1915 that were abstract to the same degree. Strand was not destined to sustain a long series of abstract photographs and soon turned to lyrical realism that characterized the majority of his mature work. It is uncertain whether the *Camera Work* title adopted here was assigned by Stieglitz or Strand. The case for its being Strand's choice rests mainly with the degree to which it is out of keeping with titles customarily used in *Camera Work.* However, if disengaged titles reflect Strand's idea, he changed his mind by 1971 when it was called *Abstraction* (Biblio. 814). Determining the original title assigned by Strand is important for deciding whether this image is a still-life study two steps removed from Cats. 215 (de Meyer) and 451 (Steichen), reflecting a serious confrontation with abstract art, or some less resolved artistic posture between both stylistic extremes.

523 » *[Untitled].* 1917. Platinum from enlarged negative. Image, 321 × 252; paper, 329 × 261 mm. (12⅝ × 9¹⁵₁₆; 13 × 10¼ in.) Signed in pencil on mount "Paul Strand 1917—." 49.55.318.
Plate 94.
The conscious decision by Strand not to pursue absolute non-objectivity is evident when the possible alternative compositions within this photograph are considered. Had the camera been moved even slightly, certain visual cues essential to identifying the subject would have gone unrecorded—the fragment of the head lamp and the hub of the wheel. Strand could have, but did not conceal the subject, as he had in Cat. 522, and avoided complete abstraction later in his career. A similar stylistic path was followed by Marin, Dove and O'Keeffe, the most prominent artists in Stieglitz's circle, all of whom flirted with non-objective painting, but who were to see the bulk of their mature work essentially grounded in nature.

Later Photographs

524 » *Garden Iris—Georgetown, Maine.* 1928.
Gelatine-silver. 243 × 193 mm. (9⁹⁄₁₆ × 7⅞
in.) 55.635.1 (a).
Plate 97.
Exhibited: New York (The Intimate Gallery, 1929),
no. [29]; Philadelphia (Museum of Art, 1944), per
label on verso.

525 » [*Wild Iris—Center Lovell, Maine*]. 1927.
Gelatine-silver. 234 × 192 mm. (9⁹⁄₁₆ × 7¹⁵⁄₁₆
in.) 55.635.1 (b).
Exhibited: New York (The Intimate Gallery, 1929),
no. 11.

When Stieglitz acquired this print, it was dry
mounted back-to-back with Cat. 524, an apparent de-
vice to assure the perfect flatness of the recto, which was
among Strand's most widely exhibited images. Horti-
culturalists have identified the subject as Wild Iris in
comparison to the garden variety of Cat. 524. Damage
to the emulsion at top edge suggests that this print was
considered by Strand as a reject and hence suitable for
use as backing for the exhibition print.

526 » *Alfred Stieglitz.* 1939. Gelatine-silver. 241 ×
192 mm. (9½ × 7⁹⁄₁₆ in.) 55.635.2.
The print was apparently used for publicity or other
functional purpose and was not treated with the
same care as the majority of the prints Stieglitz col-
lected.

EXHIBITIONS

Exhibitions are listed only to the death of Stieglitz
(1946).

*New York (PSG) 1916 » *New York (Modern
Gallery) 1917* » Philadelphia (Wanamaker) 1918
» *New York (TCC) 1922* » *New York (Ander-
son Galleries) 1925* » *New York (Intimate Gallery)
1929* » *New York (An American Place) 1932* »
*New York (MOMA) 1945, Biblio. 808.

525 526

COLLECTIONS

MOMA; Center for Creative Photography, Tucson,
Arizona.

BIBLIOGRAPHY

Manuscript

777. Katz, Robert. "Talks Between Paul Strand and
Robert Katz." Transcript of an interview, 1962. The
Museum of Modern Art, Department of Photography.

778. Stieglitz Archives, Collection of American Lit-
erature, Beinecke Rare Book and Manuscript Library,
Yale University, New Haven, Conn.: unpublished let-
ters from Paul Strand to Alfred Stieglitz and 129 un-
published letters from Alfred Stieglitz to Paul Strand
between 1916 and 1932.

779. Paul Strand Archives. Center for Creative Pho-
tography, University of Arizona, Tucson, Arizona, in-
cluding correspondence with Stieglitz.

780. Strand, Paul. Interview. 1971. Archives of
American Art, Washington, D.C.

781. Strand, Paul. "Photography and the Other
Arts." Typescript from paper delivered at The Museum
of Modern Art, 1944. The Museum of Modern Art,
Department of Photography.

782. Strand, Paul. "What Was 291?" Typescript
dated October, 1917. Alfred Stieglitz Archives, Beinecke
Library, Yale University.

By Strand

783. Strand, Paul. "Photography." *Camera Work,* No. 49/50 (June, 1917), pp. 3–4.

784. ———. "The Independents in Theory and Practice." *The Freeman,* 3 (6 April 1921), p. 90.

785. ———. "American Watercolors at the Brooklyn Museum." *The Arts,* 2 (December, 1921), pp. 148–152.

786. ———. "John Marin." *Art Review,* 1 (January, 1922), pp. 22–23.

787. ———. "Photography and the New God." *Broom,* 3 (November, 1922), pp. 252–258.

788. ———. "The New Art of Colour." *The Freeman,* 7 (18 April 1923), p. 137.

789. ———. "The Art Motif in Photography." *British Journal of Photography,* 70 (5 October 1923), pp. 613–615.

790. ———. "Georgia O'Keeffe." *Playboy,* 9 (July, 1924), pp. 16–20.

791. ———. "Photography To Me." *Minicam Photography,* 8 (May, 1945), pp. 42–47.

792. ———. "Painting and Photography." *The Photographic Journal,* 103 (July, 1963), p. 216.
See Biblio. 453, 771, 985, 1026, 1036.

Illustrated by Strand

793. ——— and Nancy Newhall. *Time in New England.* New York, 1950.

794. ———. *La France de Profile,* with text by Claude Roy. 1952.

795. ———. *Un Paese,* with text by Cesare Zavattini. Milano, 1954.

796. ———. *Tir-Á Mhurain, Outer Hebrides,* with text by Basil Davidson. London, 1962.

797. ———. *Living Egypt,* with text by James Aldridge. London, 1966.

About Strand

798. Stieglitz, Alfred. "Photographs by Paul Strand." *Camera Work,* No. 48 (October, 1916), pp. 11–12 (G. App. 482).

799. Caffin, Charles H. "Paul Strand in 'Straight' Photos." *Camera Work,* No. 48 (October, 1916), pp. 57–58.

800. Cortissoz, Royal. "[Paul Strand]." *Camera Work,* No. 48 (October, 1916), p. 58.

801. "Our Illustrations." *Camera Work,* No. 49/50 (June, 1917), p. 36.

802. Parker, Robert Allerton. "The Art of the Camera: An Experimental Movie." *Arts and Decoration,* 15 (October, 1921), pp. 414–415.

803. McBride, Henry. "The Paul Strand Photographs." *New York Sun,* 23 March 1929, p. 34.

804. Clurman, Harold. "Photographs by Paul Strand." *Creative Art,* 5 (October, 1929), pp. 735–738.

805. Panter, Peter. "New Light." *The German Annual of Photography, 1930,* pp. 2–5.

806. McBride, Henry. "Attractions in the Galleries." *New York Sun,* 16 April 1932, p. 10.

807. McCausland, Elizabeth. "Paul Strand's Photographs Show Medium's Possibilities." *Springfield Sunday Union and Republican,* 17 April 1932. p. 6E.

808. Newhall, Nancy. *Paul Strand: Photographs 1915–1945.* Museum of Modern Art, New York, exhibition catalog, 1945.

809. Jones, Harold. "The Work of Photographers Edward Weston and Paul Strand: With an Emphasis on Their Work in New Mexico." Master's thesis, University of New Mexico, 1970.

810. *Paul Strand—A Retrospective Monograph, The Years 1915–1968.* 2 vols. Philadelphia Museum of Art et al., N. P., 1970.

811. Keller, Ulrich. "An Art Historical View of Paul Strand." *Image,* 17 (December, 1974), pp. 1–11.

812. Coke, Van Deren. "The Cubist Photographs of Paul Strand and Morton Schamberg." *One Hundred Years of Photographic History: Essays in Honor of Beaumont Newhall.* Albuquerque, 1975, pp. 36–39.

813. Homer, William I. "Stieglitz, 291, and Paul Strand's Early Photography." *Image,* 19 (June, 1976), pp. 10–19.

814. *Paul Strand: Sixty Years of Photographs.* Profile by Calvin Tomkins. Millerton, New York, 1976.
For further Strand references see Biblio. 814.

EVA WATSON-SCHÜTZE (American)

Fig. 51 » *Eva Watson-Schütze*. By Thomas Eakins, about 1885. Courtesy of The Philadelphia Museum of Art: Given by Seymour Adelman.

527

CHRONOLOGY

1867: Born in Jersey City, New Jersey.

1883: Student at Pennsylvania Academy of the Fine Arts; works with Thomas Eakins, a painter and a photographer.

1899: (November) elected to the Photographic Society of Philadelphia; exhibits under the name Eva Lawrence Watson. » Keiley praises her work as showing "delicate taste and artistic originality" (Biblio. 542).

1900: On jury of selection for Philadelphia Photographic Salon (Biblio. 1334) along with Stieglitz, Käsebier, Eugene, White. » Described in Newark, Ohio catalog (Biblio. 1333) as "a professional photographer whose work is based upon an art training. » Photographs reproduced in *Camera Notes,* 4 (October, 1900), pp. 77–82.

1900–1901: Represented in Day's New School of American Photography exhibition (Biblio. 1402, 1403).

1901: Marries Martin Schütze, M.D., and moves to Chicago. » Elected member of The Linked Ring.

1902: Among the founding members of the Photo-Secession, a Fellow, and a member of its governing Council. » Honorable mention and award of merit at the Turin exhibition, the American section of which is organized by Stieglitz.

1904: S. Allan (Sadakichi Hartmann) writes in review of the Pittsburgh Exhibition: "Eva Watson-Schütze does good work; but it lacks the freedom and straightforwardness of expression—her portraits look too affected to be ranked on the same level as Rose *Clark*" (Biblio. 1366a).

1935: Dies.

PHOTOGRAPHS

527 » *The Storm.* 1902 or before. Glycerine developed platinum. 204 × 153 mm. (8 × 6 in.) Stylized monograms "ews" and "ew" in pencil. 49.55.192.

Exhibited: New York (1902), no. 106, titled as above.
 Reproduced: *Camera Work,* No. 9 (January, 1905), pl. IV, halftone titled as above and according to inscriptions on the verso, reproduced from this print. The

notation "5½ wide" conforms to the size of the *Camera Work* halftone. The differences in the clouds indicate the extent to which changes were introduced by the Warren woodcut block that was printed over the halftone impression. Stieglitz described the Warren Woodcut process in Biblio. 893.

528 » *The Rose.* 1903 or before. Brown pigment gum-bichromate. 337 × 128 mm. (13¼ × 5 in.) Stylized abstract monogram "EWS" in pencil. 49.55.191.
Plate 24.
Exhibited: London (1903), no. 110; Hamburg (1903), no. 378; Washington (1904), no. 103; Pittsburgh (1904), no. 164; Dresden (1904), no. 182.

Reproduced: *Camera Work,* No. 9 (January, 1905), pl. III, halftone reproduced from this print. Stieglitz inscribed on verso in blue crayon pencil that the printer made "4 proofs on buff/2 proofs Warren woodcut." It was also noted that "Mrs. Eva Watson-Schütze [formerly exhibited under the name Eva Watson] makes her debut to our readers. It had been our intention to devote six plates to this talented worker, but, thanks to unexpected troubles in the matter of reproduction, four pictures are all we are able to bring at present." The first two plates were reproduced from the original negatives and the fourth was a halftone reproduced from the original glycerine print, suggesting Watson-Schütze's versatility with the manipulated processes that so enthused Stieglitz in 1898/1899.

EXHIBITIONS

London 1897 » Philadelphia 1898–1900 » London 1899–1904 » *New York (TCC) 1900* » Chicago 1900 » Newark 1900 » *New York (TCC) April 1900* » *Boston (Camera Club) 1900* » Glasgow 1901 » London (NSAP) 1900 » Paris (NSAP) 1901 » Hamburg 1902–1903 » Leeds 1902 » Turin 1902 » Brussels 1903 » Denver 1903 » San Francisco 1903 » Toronto 1903 » Wiesbaden 1903 » Bradford 1904 » Dresden 1904 » Hague 1904 » Paris 1904 » Pittsburgh 1904 » Washington 1904 » Vienna (C-K) 1905 » Vienna (PC) 1905 » New York (PSG) 1905 » Cincinnati 1906 » London 1908 » New York (NAC) 1909 » New York (Montross) 1912.

BIBLIOGRAPHY

Manuscript

815. Stieglitz Archives, Collection of American Literature, Beinecke Rare Book and Manuscript Library, Yale University, New Haven, Conn.: 54 unpublished letters from Eva Watson-Schütze to Alfred Stieglitz between 1900 and 1905.

by Watson-Schütze

816. Watson-Schütze, Eva. "Photography." *American Amateur Photographer,* 13 (January, 1901), pp. 10–17.
817. ———. "Some Fragmentary Notes on the Chicago Salon." *Camera Notes,* 5 (January, 1902), pp. 200–202.
818. ———. "Signatures." *Camera Work,* No. 1 (January, 1903), pp. 35–36.
819. ———. "Salon Juries." *Camera Work,* No. 2 (April, 1903), pp. 46–47.
See Biblio. 521, 538.

About Watson-Schütze

820. Yellott, Osborne I. "The Eva Lawrence Watson Exhibit." *Photo Era,* 4 (February, 1900), pp. 42–44.
821. "Unique Exhibition of Photographs." *Photo Era,* 5 (July, 1900), pp. 7–12.
822. Keiley, Joseph T. "Exhibition of Prints by Eva L. Watson." *Camera Notes,* 4 (October, 1900), pp. 122–123.
823. ———. "Eva Watson-Schütze." *Camera Work,* No. 9 (January, 1905), pp. 23–26.

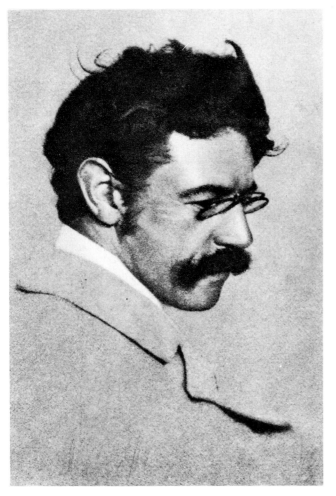

Fig. 52 » *Hans Watzek*. By Heinrich Kuehn, before 1902. Reproduced from Biblio. 1284, pl. VII.

CHRONOLOGY

1848: Born Johann Josef Watzek on December 20.

1865–72: Studies art at the academies of Leipzig and Munich.

1874: Becomes a professor of drawing.

1891: Begins to take a serious interest in photography after viewing the Vienna Exposition. Joins the Vienna *Camera-Klub*.

1892–93: Develops his own version of the pinhole camera with a "monocle" lens, allowing for shorter exposures and a longer focal length.

1894: Becomes closely associated with Hugo Henneberg and later with Heinrich Kuehn; the three later become known as The Trifolium [*Das Kleeblatt*] (Biblio. 1073). Elected to The Linked Ring, and exhibits at The London Photographic Salon. Photographs reproduced in *Wiener Photographische Blätter*.

1895: Impressed by the gum-bichromate work of Robert Demachy.

1896: Travels with Henneberg and Kuehn to Germany, Italy, and Holland, and experiments in gum-bichromate in association with them.

1896–1903: Continues to use the gum-bichromate process, developing new techniques of his own involving new chemical processes based on concentration and saturation, and also in printing techniques. These new methods enable The Trifolium to work on a mammoth scale, creating gum prints measuring up to two-by-three feet in size (Cats. 317, 340). Signs his prints with a symbolic three-leaf clover.

1902: Gravures published in lavish book of the Austrian school (Biblio. 1284).

About 1898–1902: Period of known correspondence with Alfred Stieglitz. The correspondence wholly related to photographic concerns.

1902: Stieglitz receives first Watzek prints.

1903: Dies on May 12 in Vienna, first of Stieglitz's associates to pass; eulogized widely.

1905: Six gravures published in *Camera Work*, No. 13 (January).

1906: Five of Watzek's photographs are reproduced in *Camera Work* and he is included in the exhibition of German and Austrian photographers at Stieglitz's Little Galleries of the Photo-Secession at 291 Fifth Avenue, New York.

PHOTOGRAPHS

529 » *Sheep*. 1901. Brown pigment gum-bichromate. 502 × 636 mm. (19¾ × 25¹⁄₁₆ in.)

529

530

Signed and dated in watercolor "H. Watzek/
MCMI." 33.43.405.
Exhibited: Vienna (PC, 1904), no. 1; New York
(PSG, 1906), no. 17; Philadelphia (1906), no. 122;
New York (NAC, 1909), no. 43, dated 1901 and
lent by Stieglitz; Buffalo (1910), no. 194, titled as
above but dated 1902.
 Reproduced: Matthies-Masuren, *Gummidruck,*
(Biblio. 1284) pl. XXVI; *Camera Work,* No. 13 (January 1906), pl. XII, reproduced from this print;
Academy Notes (Biblio. 1399a), p. 18.

530 » *An der Danau* [*On the Danube*]. 1901 print
 from a negative of 1894 or before. Brown pigment gum-bichromate. 516 × 643 mm.
 (20⁵⁄₁₆ × 25⁵⁄₁₆ in.) Signed in watercolor
 "H. Watzek/MCMI," with a stylized three-
 leaf clover between the name and date.
 33.43.406.
Exhibited: Paris (1898), no. 660, *Au bas de l'Elbe,*
suggesting a related work.
 Reproduced: *Wiener Photographishe Blätter,* Vol.
1, No. 6 (June, 1894), opp. p. 125, titled *An der Danau.*
 Watzek probably made the negative in 1894, and
in 1901 executed the print Stieglitz acquired.

EXHIBITIONS

London 1894–1899 » Paris 1894–1898 » Brussels
1895 » Hamburg 1896 » Hamburg 1898–1899 »
Berlin 1899 » London 1902 » Brussels 1903 »
Hamburg 1903–1904 » Dresden 1904 » Vienna

(PC) 1904 » New York (PSG) 1906 » Philadelphia 1906 » New York (NAC) 1909 » Buffalo 1910.

BIBLIOGRAPHY

Manuscript
 824. Stieglitz Archives, Collection of American Literature, Beinecke Rare Book and Manuscript Library,
Yale University, New Haven, Conn.: one unpublished
letter from Hans Watzek to Alfred Stieglitz, 1902.

By Watzek
 825. Watzek, Hans. "Zur Technik der künstlerischen Photographie." *Wiener Photographische Blätter,*
1 (February, 1894), pp. 21–24.
 826. ———. "Beziehungen zwischen Bildgrösse,
Distanz, Camera-Auszug und Brennweite." *Wiener
Photographische Blätter,* 1 (July, 1894), pp. 149–156.
 827. ———. "Zur Technik der künstlerischen Photographie." *Wiener Photographische Blätter,* 2 (January, 1895), pp. 2–5.
 828. ———. "Über das Künstlerische in der Photographie." *Wiener Photographische Blätter,* 2 (August,
1895), pp. 161–163.
 829. ———. "Aus der Praxis des Gummidruckes."
Wiener Photographische Blätter, 3 (July, 1896), pp.
133–138.

About Watzek
 See Biblio. 1073.
 830. "Hans Watzek—Wien." *Photographisches
Centralblatt,* 5 (January, 1899), pp. 2–7.
 831. Steichen, Eduard. "Hans Watzek—Obituary."
Camera Work, No. 4 (October, 1903), p. 54.
 832. "Hans Watzek." *Die Photographische Kunst
in Jahre 1903,* pp. 124–129.
 833. Matthies-Masuren, F. "Hugo Henneberg—
Heinrich Kuehn—Hans Watzek." *Camera Work,* No.
13 (January, 1906), pp. 21–41.
 834. Speer, Hermann. "Die Wiener Schule: Hugo
Henneberg—Heinrich Kühn—Hans Watzek." *Kunstphotographie um 1900,* Museum Folkwang, Essen,
exhibition catalog, 1964, pp. 19–21.
 See Biblio. 1284.

CLARENCE H. WHITE (American)

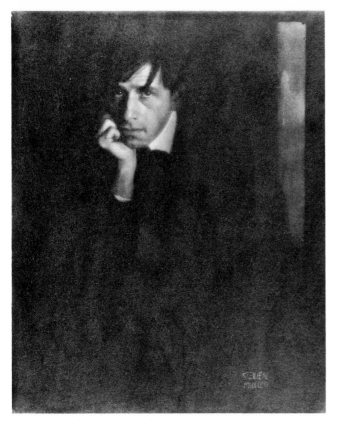

Fig. 53 » *Clarence H. White*. By Edward Steichen, 1903. Cat. 501.

CHRONOLOGY

1871: Born on April 8 in West Carlisle, Ohio.

1887: Family moves to Newark, Ohio.

1890: Graduates from high school where an early interest in art is discouraged by his parents. Goes to work for Fleek and Neal, a wholesale grocery firm.

1893: Marries Jane Felix; takes first photographs. Visits Columbian Exposition, Chicago.

1894: Begins serious work as an amateur photographer; uses a 6½″ × 8½″ Premo view camera with a Taylor-Hobson Rapid View Portrait lens, focal length 13″, aperture f/11. To fit his office schedule often photographs in early morning.

1896/1897: Wins gold medal from the Ohio Photographers' Association.

1898: Camera Club of Newark, Ohio, is founded under White's leadership. Halftone illustrations after his photographs appear in *The Photographic Times,* marking White's introduction to the national photography scene. » Exhibits ten prints at the First Philadelphia Photographic Salon. Wins first prize at first Carnegie Exhibition. » (November) trip east. Meets Stieglitz, F. Holland Day, and Joseph Keiley. » Begins correspondence with Alfred Stieglitz and Gertrude Käsebier.

1899: Solo exhibition at The Camera Club, New York, arranged by Alfred Stieglitz, who also sends his own prints to White for exhibition in Newark, Ohio. » Member of the jury of selection of the Second Philadelphia Photographic Salon (Biblio. 1329); exhibits nine prints. Writes letter of encouragement to Edward Steichen, recommending he see Stieglitz in New York. » Organizes loan exhibition that includes Day, Käsebier, Ben-Yusuf, Keiley, Dyer, and Stieglitz, along with 135 of his own prints at the Newark Camera Club exhibition (Biblio. 1333). » Solo exhibition at Boston Camera Club arranged by F. Holland Day. » Work reproduced in *Camera Notes* (October) for the first time; *Spring* (tryptich) printed with elaborate die-cut mask. » Shows in London's Photographic Salon arranged by The Linked Ring, his first entry in international competition (Biblio. 1324). » (October) travels east, meets Stieglitz and others. » Elected to honorary membership in The Camera Club, New York. » First experiments in gum-bichromate printing.

1900: Shows 33 works in the New School of American Photography exhibition in London, arranged by F. Holland Day (Biblio. 1402). Elected to The Linked Ring at the same time as Käsebier.

1901: (January) establishes The Studio of Clarence H. White with letterhead with intention to mount exhibitions of the work of others from time to time.

1902: Grand Prize Winner at Turin exhibition (Biblio. 1345), the American section of which was organized by Stieglitz. Käsebier visits Ohio in August (see Cat. 360).

1903: Five reproductions in *Camera Work*, No. 3 (July), including Cat. 551. (October) Steichen visits Newark on his honeymoon. (November) White visits New York to see Stieglitz.

1904: Quits his bookkeeper job to make a living as a traveling photographer. Visits with William B. Dyer and Eva-Watson Schütze in Chicago. Meets Annan and Keiley in St. Louis (Biblio. 1416).

1905: Five reproductions published in *Camera Work*, No. 9 (January). Two trips east. Day visits Ohio. First visit to Maine with Day.

1906: Exhibits with Käsebier at Photo-Secession Galleries 27 prints each (Biblio. 1378). » Moves to New York City. His family follows in 1907. Assists Stieglitz in the day-to-day chores of the Photo-Secession Galleries.

1907: (Winter) collaborates with Stieglitz in photographing a series of nude studies called after the models' names "The Cramer-Thompson Series" (Cats. 561–580). Exhibits at the Photo-Secession Galleries portraits and landscape autochromes (November-December. Biblio. 1390). Exhibits an autochrome made in collaboration with Stieglitz. Independently makes a series of outdoor nude studies. » Appointed lecturer in photography at Teachers College, Columbia University.

1908: Appointed instructor in photography at the Brooklyn Institute of Arts and Sciences. *Camera Work*, No. 23 (July) reproduces sixteen photographs (entire issue).

1909: Three reproductions published in *Camera Work*, No. 27 (July).

1910: Founds summer school of photography at Seguinland, Maine. » Shows 33 prints at the Albright Art Gallery, Buffalo (Biblio. 1399), including three made in collaboration with Alfred Stieglitz. Beginning of feud with Stieglitz. One reproduction published in *Camera Work*, No. 32 (October).

1912: Breaks with Stieglitz after ill will that had lingered from the 1910 Buffalo incident. Helps organize Montross Gallery exhibition (Biblio. 1408).

1914: Founds The Clarence H. White School of Photography, New York. Is acclaimed as teacher (Biblio. 858).

1916: Elected first President of the Pictorial Photographers of America, in which Käsebier and Coburn are also active, the membership of which is generally anti-Stieglitz in sentiment.

1921: Resigns from Brooklyn Institute to devote more time to his own photography.

1924: Reconciliation with Stieglitz who is invited to address the White School.

1925: Dies on July 8 in Mexico City where he is photographing with students from the White School, including Julien Levy who later founded an art gallery that exhibited post-Stieglitz generation photographs (Cartier-Bresson, Moholy-Nagy, and Kertèsz). » Stieglitz harshly eulogizes White to Kuehn: "Poor White. Cares and vexation. When I last saw him, he told me he was not able to cope with [life as well as he was] twenty years ago. I reminded him that I warned him to stay in business in Ohio—New York would be too much for him. But the Photo-Secession beckoned. Vanity and ambitions. His photography went to the devil. His pupils—women—half-baked dilettantes—not a single real talent. . . . He listened to flattery and was jealous of Steichen—That was the beginning of his decline as friend and human being and artist . . ." (Stieglitz to Kuehn, 25 August 1925, YCAL).

PHOTOGRAPHS

Portrait Studies

531 » *Portrait Study in Black.* 1896 (A. S.) Platinum. 201 × 97 mm. (7^{15}/$_{16}$ × 3^{13}/$_{16}$ in.) Signed in pencil "Clarence H. White," with graphite retouching above shoulders. 33.43.320.

Exhibited: Newark, Ohio (1899), no. 9, titled and dated as above; Boston (1899), no. 9; Stieglitz indicated on the old mount that this print was exhibited at: Dresden (1909), no. 181, titled *Letitia Felix;* and at Buffalo (1910), no. 447, titled *Letitia Felix* but dated 1897.

Stieglitz inscribed the date 1896 and "very rare" on the old mount. He owned no other print by White dating from 1896, the first year White made negatives

535

531 532 533 534

that yielded work he thought worthy of exhibition (Biblio. 1326). Stieglitz's date makes possible identifying the only Felix portrait from that year exhibited in the first Newark show.

532 » *The Doorway.* 1898. Platinum. 200 × 89 mm. (7⅞ × 3½ in.) Signed and dated in pencil "CH White '98." 33.43.295.
Exhibited: New York (TCC, 1899), titled as above in review; Newark, Ohio (1899), no. 4, *Coming Through the Door;* Denver (1903), no. 12; New York (PSG, 1906), no. 42, *The Doorway.*
 Reproduced: *International Kunst Photographien,* 2 (1902).

533 » *Portrait of Mrs. H.* 1898. Platinum. 207 × 89 mm. (8⅛ × 3½ in.) 33.43.306.
Exhibited: Boston (1899), no. 89; London (NSAP, 1900), no. 250; New York (NAC, 1902), no. 155.
 Reproduced: *Camera Notes,* 3 (July, 1899), p. 9; *Harper's Weekly* (5 November 1899), p. 1088; Caffin (Biblio. 1282), p. 119, incorrectly titled *Mrs. D.; Photographisches Centralblatt,* 6 (1900), p. 381; *Photographic Times,* 32 (January, 1900), p. 20.
 Collections: Library of Congress.
 The portrait bears a striking resemblance, perhaps because of the costume, to Sargent's *Mrs. Stokes* (Acc. no. 38.104) in The Metropolitan Museum of Art. White admitted to Stieglitz a possible influence of some well-known painters (White to A. S., 25 March 1899, YCAL). Dabbling at painting and drawing, White must have had at least a general consciousness of other media.
 The model is Josephine Hamill, according to Mrs.

C. H. White's correspondence with A. Hyatt Mayor (1939).

534 » *On the Old Stair.* 1899. Platinum. 190 × 94 mm. (7½ × 3¹¹⁄₁₆ in.) Signed in pencil "C. H. White" and titled as above on verso. 33.43.294.
Exhibited: Newark, Ohio (1899), no. 71; Philadelphia (1899), no. 341, titled and dated as above; New York (TCC, 1899) per review; London (NSAP, 1900), no. 256; Paris (NSAP, 1901), no. 206.
 Reproduced: *Photographische Rundchau,* 15 (December 1901), p. 238.
 The negative appears to have been retouched to delineate folds in the garment.

535 » *Girl in Black with Statuette.* 1899 or before. Platinum. 112 × 101 mm. (4⁷⁄₁₆ × 4 in.) Signed and dated in pencil on mount "Clarence H. White/'97." 33.43.299.
Exhibited: Newark, Ohio (1899), no. 97, titled as above but dated 1898 (N.B. no. 87 is titled same as *Camera Notes* reprod. below, but not collected by Stieglitz); Boston (1899), no. 87, titled as above but dated 1898; Newark (1900), no. 199, titled *Girl with Statuette;* London (NSAP, 1900), no. 264, titled *Study: Lady with the Venus;* Paris (NSAP, 1901), no. 212, titled *Étude—la femme à la Vénus,* suggesting a related work.
 Reproduced: *Brush and Pencil,* 3 (November, 1898), p. 100, titled *An Arrangement,* a title used by White for several works in early exhibitions; *Camera Notes,* III (January, 1900), p. 123, variant but same statue, same sitter, and titled *Lady with a Venus.*
 F. H. Day, White's early mentor, also used the

537

538 539

device of a female model as a vehicle for an otherwise abstract composition of form and tones suggested by the title *Brush and Pencil,* which would further distinguish it from the close variant *Lady with Venus.*

White customarily dated his works according to when the negative was made, and did so in all his early exhibition catalogs. The question here is whether one should accept 1898 as printed in two catalogs, or 1897 as inscribed on the print. If Stieglitz's print were made much later, White's memory could have failed, causing him to write inadvertently 1897 for 1898 (assuming that he generally inscribed the date of the negative rather than the print). The authoritative accuracy of the dates in the early catalogs written at most a year or two after the works were done cannot be disregarded. By 1902 White had begun to distinguish the dates of the print versus the negative, assigning two dates to Cat. 555.

536 » *Portrait—Letitia Felix.* [1901]. Platinum, touched with crayon pencil, mounted on tan paper with a thread margin upon gray with a narrow margin, upon a larger sheet of natural Japanese paper. 197 × 90 mm. (7¾ × 3⁹⁄₁₆ in.) Name of sitter inscribed in brown crayon pencil. 33.43.300.
Plate 44.
Exhibited: New York (PSG, 1906), no. 53, titled as above, representing a related if not identical subject, as do the following similarly identified portraits; Glasgow (1901), no. 377; New York (NAC, 1902), no. 158, titled *Portrait—Miss L. F.;* Dresden (1909), no. 181; Buffalo (1910), no. 447, titled *Letitia Felix.*

Reproduced: *Photographic Times,* 32 (January, 1900), p. 19, titled *Study.*
The print is retouched in pencil around her shoulders.

537 » · *MISS · LETITIA · A · FELIX · A.D. 1901 ·* 1901. Platinum. 182 × 136 mm. (7⁷⁄₁₆ × 5⅜ in.) Titled inscribed by White as above. 33.43.305.
Exhibited: New York (NAC, 1902), no. 156; New York (PSG, 1906), no. 53; Dresden (1909), no. 181; Buffalo (1910). no. 447.

The sitter wears the same dress as in Cat. 536 which, combined with the similarly inscribed title, suggests that the negatives are of the same sitting.

538 » *Baby Monsarrat.* 1905. Platinum (toned by hand?) 242 × 177 mm. (9⁹⁄₁₆ × 7 in.) Signed in pencil "Clarence H. White," and titled in orange crayon pencil "ʟᴀᴠʀᴀ ᴍᴏɴsᴀʀʀᴀᴛ–––1905;" retouched with graphite pencil in various areas. 33.43.316.
Exhibited: Cincinnati (1906), no. 74; Philadelphia (1906), no. 131; New York (PSG, 1906), no. 93; New York (PSG, 1908), no. 39; Dresden (1909), no. 184, all titled as above.

The distinct sepia hue in the child's garment indicates that White applied the tone either chemically or by hand (its irregularity suggests the latter as the more likely possibility). The choice of this print for two important exhibitions indicates the high esteem in which it was held. Baby pictures were easily dismissed as either excessively commercial or amateur, but this print

exemplifies the genre in the hands of a master photographer. Compare Cat. 102.

Single Figure—Interior

539 » *The Bubble.* 1898. Platinum. 201 × 129 mm. (7¹⁵⁄₁₆ × 5¹⁄₁₆ in.) Signed and dated in pencil; titled in sepia ink on verso by White; without retouching to highlight on table evident in Cat. 540. 33.43.308.
Reproduced: *The Photogram,* 7 (1900), p. 101.
Collections: MOMA.

Inscribed on verso are various marks by White and Stieglitz and a pencil rule indicating the size of reproduction. The pencil rule, along with the ink inscription of title, suggests that this was a print sent to Stieglitz for reproduction.

540 » *The Bubble.* 1898. Platinum (toned with mercury?) 207 × 132 mm. (8³⁄₁₆ × 5³⁄₁₆ in.) Signed in ink "C H White '98," and with monogram "CHW" in red; highlight on table removed by pencil. 33.43.309.
Plate 45.
Exhibited: Philadelphia (1898), no. 250; Newark, Ohio (1899), no. 119; Boston (1899), no. 119, all titled and dated as above; Dresden (1909), no. 178; Buffalo (1910), no. 448, incorrectly dated 1897.

Reproduced: *Photographische Rundchau* 14 (1900), p. 90, titled *The Bubble;* Billman (Biblio. 841), p. 188. White exhibited two works with similar titles, *Blowing the Bubble* and *The Bubble.* The former title would appear to be more appropriate for this photograph, although it has frequently been exhibited, published and reviewed as *The Bubble.*

Keiley wrote of this print in his review of the Philadelphia Photographic Salon (Biblio. 542), "Like most of Mr. White's pictures, it is a well nigh perfect piece of composition whose subject with subtle poetry stimulates and leaves much to the imagination."

The brownish cast in comparison to the steely gray of Cat. 539 suggests the application of a toning agent or perhaps a natural difference between prints made at different times. The pair exemplifies Stieglitz's idea that each photograph is a unique object. The model is Margaret Felix according to Mrs. C. H. White's recollection to A. Hyatt Mayor (1939).

541 » *Lounging.* 1899. Platinum mounted on a commercially manufactured embossed card. 186 × 148 mm. (7⁵⁄₁₆ × 5¹³⁄₁₆ in.) Signed in pencil "Clarence H. White." 33.43.293.
Exhibited: New York (TCC, 1899) per review; Newark, Ohio (1899), no. 101; Newark, Ohio (1900), no. 208; London, Paris (NSAP, 1900–1901), no. 219, titled *La Chaise Longue;* Dresden (1909), no. 182; Buffalo (1910), no. 451.

Reproduced: *The Photogram,* 8 (January 1901), p. 5; *Bulletin du Photo-Club de Paris* (April, 1901), p. 133.

The model has been identified as Letitia Felix in the Penney House, Newark, Ohio. The pale tone of the print must have been a conscious artistic decision since platinum prints do not fade or change in appearance due to the permanence inherent in their particular chemical process. It must be presumed that what we see is nearly identical to its appearance in 1899.

542 » *Evening—Interior.* 1899. Platinum. 196 × 159 mm. (7¾ × 6¼ in.) Signed in pencil "Clarence H. White;" retouched around the entire perimeter in soft graphite. 33.43.317.
Plate 48.
Exhibited: New York (TCC, 1899) per review; Philadelphia (1899), no. 340; Newark (1899), no. 72.

Reproduced: *Photograms of the Year 1899,* p. 21; *Photographic Times,* 32 (January, 1900), p. 18, from another negative showing more of the windows; *Bulletin du Photo-Club de Paris* (April 1901), after p. 122, titled *L'attente; Photographisches Centralblatt,* 6 (1900), p. 382, variant titled *Am Fenster;* Caffin (Biblio. 1282), p. 113.

Among the underlying themes of White's pre-1900 work is a sense of mystery which assumes psychological dimensions in this picture. In French the title *L'attente* (*Expectation*) suggested one possibility among many states of mind ranging from alienation, to pensiveness, to solitude. Each answers differently the implicit question: "who sits in a chair in the middle of a room looking out a window and why?"

Mrs. C. H. White identified the model as Letitia Felix to A. Hyatt Mayor (1939).

543 » *Miss Julia McCune.* 1901. Platinum. 200 × 160 mm. (7⅞ × 6⁵⁄₁₆ in.) Signed

541 543

faintly in pencil "Clarence White" and with
monogram "CHW" in red. 33.43.313.
Portraits of the sitter, none specifically identified, were
exhibited at: Newark, Ohio (1899), no. 24; Wiesbaden
(1903), no. 263; New York (PSG, 1906), nos. 34 and
35; Buffalo (1910), no. 461, titled and dated as above.

The pale printing is in keeping with Cat. 555 where
the pallor is described as deliberate artfulness. Here the
signature with monogram reinforces the intention
behind the effect.

544 » *MW—A.D. 1903—Boy with Camera Work.*
1903. Platinum. 200 × 153 mm. (7¾ × 6 in.)
Signed in pencil "CH White." 33.43.301.
Plate 50.
Exhibited: London (1905), per review, titled *Boy with
Camera Work.*

Reproduced: *Camera Work,* No. 9 (January, 1905),
pl. IV, titled *Boy with Camera Work* and reproduced
"from the original negative," with the resulting
differences from this print.

The model is Maynard White, son of the photog-
rapher.

545 » *The Chiffonier.* 1904. Platinum mounted on
salmon colored paper with narrow margins
upon a larger sheet of brown, upon another
sheet of salmon with thread margins, in a
manner that complements the pale printing.
242 × 193 mm. (9⁹⁄₁₆ × 7⅝ in.) Signed in
pencil on mount "Clarence H. White/'04."
33.43.297.
Exhibited: New York (PSG, 1905), no. 92, titled *The
Old Chest;* Philadelphia (1906), no. 128; Cincinnati

(1906), no. 74; Dresden (1909), no. 194, titled *The
Chiffonier* [chest of drawers]; Buffalo (1910), no. 460,
titled as above.

The print is pale, with printing flaws that read as an
atmospheric haze which presumably is a conscious
artistic decision and not the result of accident.

Mrs. C. H. White recollected to A. Hyatt Mayor
(1939) that Mr. White persuaded an unknown woman
he saw on the streets of Newark, Ohio, to pose for this.

546 » *Portrait—Mrs. C. H. White.* 1905. Platinum.
245 × 195 mm. (9⅝ × 7¹¹⁄₁₆ in.) Signed
faintly in soft pencil "Clarence H. White" and
stamped with monogram "CHW" in red.
33.43.312.
Plate 53.
Works titled as above or near variant were exhibited:
New York (PSG, 1905), no. 95; Cincinnati (1906),
no. 71; New York (PSG, Käsebier joint, 1906), no. 41;
Philadelphia (1906), no. 126; New York (NAC, 1908),
no. 117; Dresden (1909), no. 185; New York (NAC,
1909) no. 199; Buffalo (1910), no. 462, dated 1905/1910.

Reproduced: *Camera Work,* No. 23 (July, 1908),
pl. XII, titled as above, where it is stated that the plates
"were made under the supervision of the photographer
himself, and all of them were done directly from the
original negatives. A White platinotype . . . is full of
subtlety and has a print quality so peculiarly its own,
that even the best of reproductions seldom gives but
an inadequate idea of the actual beauty of the original"
(p. 13). *Academy Notes* (Biblio. 1399a.), p. 10.

J. Nilsen Laurvik, in his review of the 1909 National
Arts Club [*International Studio,* 38 (September 1909)
p. 67], described this print:

The fine seated portrait of Mrs. White . . . was, photo-
graphically speaking, not only the best print in the exhibi-
tion by reason of its masterly handling of the light in the
shadows and its correct rendering of all the values, giving a
sense of space and atmosphere, but in my opinion it was
the best print pictorially. It possesses in a high degree all
the qualities that distinguish a fine portrait. It has reserved
simplicity, combined with dignity, that give to the whole
an air of supreme distinction (Biblio. 1406b).

547 » *Morning—The Bathroom.* 1906. Platinum.
223 × 180 mm. (8¹³⁄₁₆ × 7⅛ in.) 33.43.310.
Exhibited: New York (PSG, 1906), no. 42, titled

545

547

548

551

Morning, identical or related work; Dresden (1909), no. 191; Buffalo (1910), no. 473, titled as above and dated 1906/1910, indicating dates for negative and print. Newark, New Jersey (Public Library, 1911), no. 183.

Reproduced: *Photo-Era,* 30 (January, 1913), p. 6.

Interior environments were important to White's work during 1898–1900 in Newark, Ohio, and remained so after his move to New York in 1906. This and the following picture represent the ways in which apartment life with its more limited range of space influenced the intimacy so important to his earlier work. The bathroom and the bedroom were two spaces that conveyed a sense of the most intimate moment in the day of a city-dweller.

548 » *Mrs. Alfred Stieglitz.* 1906 (A.S.) Waxed platinum mounted on gray paper with narrow margin upon brown paper with a narrower margin. 240 × 147 mm. (9⁷⁄₁₆ × 5¹³⁄₁₆ in.) Monogram "CHW" in pencil on upper left. 33.43.296.

Exhibited: New York (PSG, 1906), no. 76.

Originating from White's first year in New York, this portrait represents the style of commercial portraiture he took up after resigning from Fleek and Neal's in 1904.

549 » *Morning—The Coverlet.* 1906. Platinum. 219 × 168 mm. (8⅝ × 6⅝ in.) Signed in pencil "Clarence White" and with the monogram "CHW" in red. 33.43.311.
Plate 49.
Exhibited: Newark, Ohio (1899), no. 27, titled *Morning,* suggesting a related or identical work;

Buffalo (1910), no. 474, titled *Morning—the Coverlid* and dated 1906/1909.

Mrs. C. H. White recollected to A. Hyatt Mayor (1939) that the model was Marian Reynolds, daughter of Stephen Reynolds of Terre Haute, Indiana, where the negative was said to have been made.

Figure Groups—Interior

550 » *Coming Through the Door.* 1898. Platinum. 202 × 131 mm. (7¹⁵⁄₁₆ × 5³⁄₁₆ in.) 33.43.302.
Plate 47.
Exhibited: Newark (1899), no. 4; Boston (1899), no. 4; New York (TCC, 1899) per review; New York (PSG, 1906), no. 51, titled *The Doorway,* suggesting a related work.

Compare Cat. 532. This is the image most often associated with the above title.

The print is retouched with pencil in large areas of the dress of the far woman and the sleeve of the near one. The models are Letitia and Elizabeth Felix, sisters-in-law of Clarence White.

551 » *The Ring Toss.* 1899. Ochre pigment gum-bichromate, mounted on brown paper with a thread margin, upon a larger sheet of natural wove paper. 180 × 139 mm. (7⅛ × 5½ in.) Signed in ink "C. H. White/'99." 33.43.303.

Exhibited: New York (TCC, 1900) per review; Philadelphia (1900), no. 196; Chicago (1900), no. 153; Glasgow (1901), no. 364; London (1901), no. 58; Turin (1902), no. 43; New York (NAC, 1902), no. 150, incorrectly dated 1900; San Francisco (1903), no. 22; The Hague (1904), no. 130.

Reproduced: *Camera Work*, No. 3 (July, 1903), pl. V, color halftone with more detail in highlights, and a larger area of subject that includes a fourth ring toss pole; *Photography*, 17 (25 June 1904), p. 559.

Collections: Library of Congress, platinum.

The print represents White's shortlived flirtation with the gum-bichromate process that Stieglitz had praised so highly in Biblio. 897. Exhibited along with Stieglitz's now-lost gum prints at the Camera Club in 1899, the print was among the first serious attempts to deal with a process that had been popular on the Continent since 1894, largely through the work of Demachy. White described to Stieglitz how difficult the negative was to print (White to Stieglitz, 29 June 1900, YCAL).

Left to right, the models are: Louise Jones, Helen Jones, and Grace Fulton of Newark, Ohio, according to Mrs. C. H. White's recollections to A. Hyatt Mayor (1939).

552 » *Illustration to "Beneath the Wrinkle."* 1903 (A. S.) Platinum. 220 × 158 mm. (8¹¹⁄₁₆ × 6¼ in.) Signed in pencil (on fireplace) "Clarence H. White;" with graphite or crayon additions in the margin beyond the subject to extend the space. 33.43.321.

Exhibited: Hamburg (1903), no. 479; Washington (1904), no. 147; Dresden (1904), no. 185, reproduced and titled *Illustration;* The Hague (1904), no. 133 *Under the Wrinkle;* Vienna (C-K, 1905), no. 51, titled *Under the Wrinkle: Illustration* (1903) and listed as a loan from the private collection of Stieglitz; New York (PSG, 1906), no. 52, titled *Illustration,* suggesting the identical or a related subject; Dresden (1909), no. 190, titled *Illustration I* and listed as a loan from Stieglitz.

Reproduced: *Camera Work*, No. 9 (January, 1905), pl. II, titled *Illustration to "Beneath the Wrinkle,"* where it is stated that the gravures were made from the original negatives, with the consequent differences from the platinum print; *La Revue de Photographie*, 3 (November, 1905), p. 327.

The print was made in illustration of Clara Morris's "Beneath the Wrinkle" (Biblio. 840). The female models are the photographer's mother and Julia McCune; the male is unidentified. The Little Galleries exhibition

title is preferable to the more elaborate one found in *Camera Work* which is out of keeping with White's simple style of titling.

553 » *The Kiss.* 1904. Waxed platinum. 236 × 152 mm. (9⁵⁄₁₆ × 6 in.) Signed in pencil "Clarence H. White." 33.43.319.
Plate 46.
Exhibited: Vienna (C-K, 1905), no. 53; New York (PSG, 1905), no. 94; Cincinnati (1906), no. 69; Philadelphia (1906), no. 124; New York (NAC, 1908), no. 115; Dresden (1909), no. 192; Buffalo (1910), no. 454, dated 1904/1910.

Reproduced: Holme (Biblio. 1288), pl. U. S. 22.

According to Mrs. C. H. White's recollections to A. Hyatt Mayor (1939), the models are Marian and Jean Reynolds of Terre Haute, Indiana, where the negative was also made.

Figure-in-landscape and related works

554 » *Spring—Triptych.* 1898. Platinum. (l) 177 × 22; (c) 204 × 99; (r) 180 × 25 mm. [(l) 7 × 1¾; (c) 8¹⁄₁₆ × 3¹⁵⁄₁₆; (r) 7⅛ × 1 in.] Signed in pencil on center panel "C. H. White/'98." 33.43.322.
Plate 51.
Exhibited: New York (TCC, 1899), per review; Newark, Ohio (1899), no. 26; London (NSAP, 1900), no. 240, titled *Spring-time;* Paris (NSAP, 1901), no. 192, incorrectly titled *L'été;* Glasgow (1901), no. 115; New York (1902), no. 151; Leeds (1902), no. 502, titled *Spring,* and no. 513, titled *Landscape, Spring;* Dresden (1904), no. 186; Buffalo (1910), no. 450, dated 1898/1910.

Reproduced: Hinton (Biblio. 473), opp. p. 52; *Camera Notes*, 3 (October, 1899), p. 53, where it is printed with a die-cut paper mask to achieve the effect of a framed photograph, with same arrangement of the parts as in this print.

Collections: Library of Congress, with the parts arranged differently.

The left and right are seen reversed in other examples. The most important series of multiple-part photographs made in America before this print were those of Day. Especially notable is his *Seven Words* (Cat. 196), but Day's intent was to expand the narrative

552 555 556 557

aspect, while White's effect was purely visual. White's opening of illusionistic space showed a remarkable insight into principles of visual perception at the time. White apparently did little to follow through with this fertile idea.

555 » [*The Orchard*]. 1902 print from 1898 negative. Platinum. 206 × 159 mm. (8⅛ × 6¼ in.) Signed in pencil "Clarence H. White 98/02." 33.43.304.
Exhibited: New York (PSG, 1906), no. 36; Philadelphia (1906), no. 130; Dresden (1909), no. 189; New York (NAC, 1909), no. 203, all titled as above; Newark, New Jersey (Public Library, 1911), no. 180.

That White intended this print to be a study in close tonal values is obvious in the deliberate date and signature. Permanence of platinum prints eliminates fading as a possible reason for the pale appearance of this print. The case taken in cutting the arched top further minimizes the possibility that this was a faulty print that somehow came into Stieglitz's possession. Made about the time White began to photograph full time, the print could be interpreted as pale for deliberately artful reasons. Lithographs by Whistler, Roussel, and Shannon, as well as the photographs of Arbuthnot (Cat. 58) and Calland (Cat. 107), offer parallel examples of designs that are barely visible on the sheets.

556 » *In the Arbor*. 1905 (A. S.) Platinum. 241 × 190 mm. (9½ × 7½ in.) Signed in pencil "Clarence H. White." 33.43.298.
Exhibited: New York (PSG, 1906), no. 40; London (1908), no. 87.

Reproduced: *Camera Work*, No. 23 (July, 1908), pl. III.
The model is identified as Julia McCune Flory. Upon seeing the print exhibited in London (1908), a reviewer wrote, "The best of all [White's prints] we think is 'The Arbor,' which represents a lady standing under trees in a garden or orchard—it is scarcely an arbor. Her head is in a shadow, and a faint sort of sunlight falls very prettily upon the lower part of her skirt." [*British Journal of Photography* (18 September 1908), p. 726].

557 » *The Arbor*. 1905. Platinum mounted in an unorthodox combination of two layers of gray and tan American papers with narrow margins upon two very thin Japanese papers. 241 × 193 mm. (9½ × 7⅞ in.) Signed and dated in pencil "Clarence H. White." 33.43.307.
Exhibited: London (1908), no. 87, titled as above.

558 » *The Bubble*. 1905 print [from 1898 negative?] Platinum mounted on natural Japanese paper, upon a sheet of brown with narrow border, upon a larger sheet of natural wove paper. 242 × 193 mm. (9⁹⁄₁₆ × 7⅝ in.) Signed and dated in pencil on mount "Clarence H. White/'05." 33.43.318.
Plate 52.
Exhibited: see also Cat. 540. Philadelphia (1899), no. 338; Newark (1899), no. 68, dated 1898; Boston (1899), no. 68; New York (TCC, 1899) per review; Dresden (1909), no. 178; Buffalo (1910), no. 448, incorrectly dated 1897.

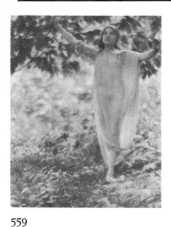
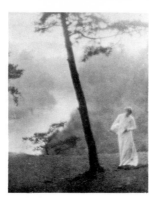
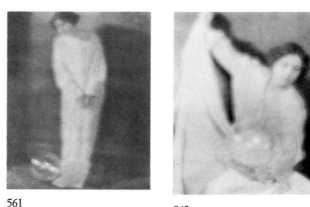

559

560

561

562

According to Mrs. C. H. White's recollection to
A. Hyatt Mayor (1939), the model is Jean Reynolds.

559 » [*A Model*]. About 1907. Platinum.
222 × 172 mm. (8¾ × 6¹³⁄₁₆ in.) Signed
lightly in pencil "Clarence White" and with
monogram "CHW" in red, with pencil
retouchings throughout to tone down high-
lights. 33.43.314.
The subject was a professional model according to Mrs.
C. H. White's recollection to A. Hyatt Mayor (1939).
The print is stylistically related to The Cramer-
Thompson series (Cat. 561–582).

560 » *Morning*. 1908 or before. Platinum adhered
to a commercially manufactured mounting
board. 241 × 191 mm. (9½ × 7½ in.)
Signed lightly in pencil "Clarence H. White."
33.43.315.
Exhibited: New York (1906), no. 42, titled as above.
Reproduced: *Camera Work,* No. 23 (July, 1908),
pl. II, titled as above, where the reproduction is stated
(p. 13) to be made directly from the original negative,
with the consequent difference in tonal range from a
platinum print; Anderson (Biblio. 1294), p. 154;
Holme (Biblio. 1288), pl. 106, titled *Landscape With
Figure*.
The model is Jane Felix, a subject perhaps from one
of the legendary days when White took his model out
at dawn before going to his job at Fleek and Neal's.
In 1899 White had exhibited at Philadelphia,
Newark, Boston and New York, a print titled *Morning*
(1899), but its relationship to the present work is
unclear.

*The Clarence White and
Alfred Stieglitz Collaboration:
The Cramer-Thompson Series*

In 1907 White and Stieglitz combined their talents to
make a series of studies of two models, one Mabel
Cramer and the other known to us only as Miss
Thompson. One purpose of the experiments was to
test lenses. Stieglitz offered suggestions about posing
and, presumably, the placement of the camera, which
was focused by White who also developed the negatives.
The glass ball used was a prop (Cats. 561, 562, 564,
567, 568) belonging to White and the Cramer session(s)
took place in White's studio at 5 West 31st Street. The
model was a friend of Arnold Genthe, who was still a
photographer in San Francisco at the time. (See Biblio.
411).

The experimental aspect of the series extended to
the materials on which the negatives were printed. A
variety of papers were used including platinum,
gelatine-silver, and gum-bichromate-over-platinum
(Cat. 579). Some were straight prints and others were
coaxed to yield every nuance of gray. Some were
retouched in pencil, typical of White's handling (Cat.
571).

White and Stieglitz signed a few of the prints with
a delicate monogram consisting of both their initials.
(Cat. 569). When Stieglitz and White stopped speaking

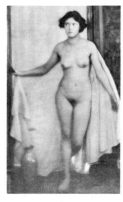

563 564 565 566

to one another in 1912, Stieglitz returned to White eighty-four negatives and seventy-five prints, retaining fourteen for himself. Stieglitz already had in his possession the four reproduced in *Camera Work*, perhaps when the extra two also came into his possession.

One thing I do demand, and I put you on your honor, and this is that my name be not mentioned by you in connection with either the prints or the negatives. As for those I am keeping I shall put them away in storage with the collection of prints I have of your own work and which I bought from you. My name will not be connected with them in any way. I shall see to that. Unfortunately I can not wipe out the past . . .

thus wrote Stieglitz to White (3 May 1912, YCAL).

561 » *Experiment 27.* (Clarence White and Alfred Stieglitz) 1907. Platinum. 239 × 189 mm. (9⁷⁄₁₆ × 7⁷⁄₁₆ in.) 33.43.393.
Reproduced: *Camera Work*, No. 27 (July, 1909), pl. I, where it is stated (p. 47) that the gravures are made from the original negatives with consequent loss of the delicate monotone of the original print.
 This print is identical in tone and scale to Cat. 562 known to have been printed by Stieglitz.

562 » *Experiment 28.* (Clarence White and Alfred Stieglitz) 1907. Platinum. 240 × 185 mm. (9⁷⁄₁₆ × 7¼ in.) Paper label from old mount inscribed by Stieglitz reads: "Mabel Cramer Series./By Stieglitz and White./December—1907./This print made by Stieglitz./A. S." 33.43.394.
Reproduced: *Camera Work*, No. 27 (July, 1909), pl. II,

where it is stated (p. 47) that the gravures are made from the original negatives with consequent loss of the delicate monotone gray of the original print.

563 » *Miss Mabel C.[ramer].* (Clarence White and Alfred Stieglitz) 1907. Platinum. 245 × 193 mm. (9¹¹⁄₁₆ × 7⁹⁄₁₆ in.) 33.43.395.
Reproduced: *Camera Work*, No. 27 (July, 1909), pl. III, where it is stated (p. 47) that the gravures were made from the original negatives, resulting in a grainier image than this print.

564 » [*Miss Mabel Cramer*]. (Clarence White and Alfred Stieglitz) About 1907. Platinum. 239 × 190 mm. (9⁷⁄₁₆ × 7½ in.) 33.43.387.

565 » [*Miss Mabel Cramer*]. (Clarence White and Alfred Stieglitz) About 1907. Waxed platinum. 240 × 192 mm. (9⅜ × 7½ in.) 33.43.392.

566 » [*Miss Mabel Cramer*]. (Clarence White and Alfred Stieglitz) 1907. Gum-bichromate over platinum, mounted on a sheet of white paper with narrow border, upon a larger sheet of gray. 230 × 137 mm. (9¹⁄₁₆ × 5⁷⁄₁₆ in.) 33.43.399.

567 » [*Miss Mabel Cramer*]. (Clarence White and Alfred Stieglitz) 1907. Platinum. 230 × 150 mm. (9¹⁄₁₆ × 5⅞ in.) 33.43.400.

568 » [*Miss Mabel Cramer*]. (Clarence White and Alfred Stieglitz) About 1907. Waxed platinum. 240 × 148 mm. (9⁷⁄₁₆ × 5¹³⁄₁₆ in.) 33.43.388.

567

568

570

569

571

573

574

576

569 » [*Miss Thompson*]. (Clarence White and Alfred Stieglitz) About 1907. Waxed platinum. 233 × 188 mm. (9⅛ × 7⁷⁄₁₆ in.) "CHW" and "AS" worked into a design. 33.43.385.

570 » [*Miss Thompson*]. (Clarence White and Alfred Stieglitz) 1907. Platinum. 177 × 228 mm. (6¹⁵⁄₁₆ × 9 in.) 33.43.403.

571 » [*Nude Against the Light*]. (Clarence White and Alfred Stieglitz) 1907. Toned platinum. 224 × 155 mm. (8¾ × 6⅛ in.) Retouched in soft pencil at the curves of both legs above the knees, similar to retouchings in other White prints, for example Cat. 550. 33.43.397.

Exhibited: Buffalo (1910), no. 471, titled as above, the only print in the Stieglitz collection fitting that description.

A reticulated ochre pattern in the highlights is the result of an unidentified toning agent.

572 » [*Miss Thompson*]. (Clarence White and Alfred Stieglitz), 1907. Waxed platinum. 236 × 190 mm. (9¼ × 7⁷⁄₁₆ in.) Inscribed on verso by White "#5 closeup." 33.43.404.

Plate 87.

573 » *The Torso.* (Clarence White and Alfred Stieglitz) 1907. Waxed platinum. 240 × 188 mm. (9⁷⁄₁₆ × 7⁷⁄₁₆ in.) Signed in soft pencil "Alfred Stieglitz/Clarence H. White." 33.43.391.

Exhibited: London (1908), no. 83; Buffalo (1910), no. 469, both titled and dated as above; Buffalo exhibited under White's name with a footnote of Stieglitz's collaboration.

Reproduced: *Camera Work,* No. 27 (July, 1909), pl. IV, where more of the subject is included and a sketch of the collaboration is given (p. 47).

Collections: IMP/GEH (gum-platinum from enlarged negative).

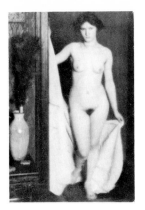 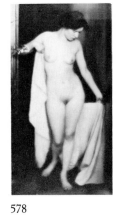 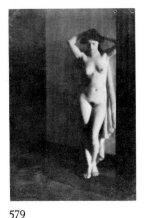

577 578 579 580

The model for this and for Cat. 574 is Miss Thompson.

574 » *The Torso.* (Clarence White and Alfred Stieglitz) 1907. Waxed platinum. 221 × 186 mm. (8¹¹⁄₁₆ × 7⁵⁄₁₆ in.) 33.43.401.
Reproduced: *Camera Work*, No. 27 (July, 1909), pl. IV, titled as above, where it is stated that the gravures were made from the original negatives, with consequent difference in tonal scale.

575 » [*Miss Thompson*]. (Clarence White and Alfred Stieglitz) About 1907. Waxed platinum. 243 × 192 mm. (9⅝ × 7⅝ in.) 33.43.386.
Plate 88.

576 » [*Miss Thompson*]. (Clarence White and Alfred Stieglitz) 1907. Waxed platinum. 242 × 192 mm. (9½ × 7⁹⁄₁₆ in.) 33.43.402.

577 » [*Miss Thompson*]. (Clarence White and Alfred Steiglitz) About 1907. Gelatine-silver. 228 × 149 mm. (8¹⁵⁄₁₆ × 5⅞ in.) 33.43.389.

578 » [*Miss Thompson*]. (Clarence White and Alfred Stieglitz) About 1907. Waxed platinum. 237 × 127 mm. (9⁵⁄₁₆ × 5 in.) 33.43.390.

579 » [*Miss Thompson*]. (Clarence White and Alfred Stieglitz) 1907. Gum-bichromate over platinum. 250 × 162 mm. (9⅞ × 6⅜ in.) 33.43.396.

580 » [*Miss Thompson*]. (Clarence White and Alfred Stieglitz) 1907. Waxed platinum. 237 × 176 mm. (9⅜ × 6¹⁵⁄₁₆ in.) 33.43.398.

EXHIBITIONS

Philadelphia 1898–1900 » London 1899–1901 » *Vienna* (Museum fur Künst und Industrie) *1899* » *Newark 1899 » *New York (TCC) October 1899* » Chicago 1900 » *Pittsburgh (Carnegie) 1900* » Glasgow 1901 » London (NSAP) 1900 » Paris (NSAP) 1901 » Hamburg 1902–1903 » Leeds 1902 » London 1902 » New York (NAC) 1902 » Turin 1902 » Cleveland 1903 » Denver 1903 » Minneapolis 1903 » Rochester 1903 » Toronto 1903 » Wiesbaden 1903 » Bradford 1904 » Dresden 1904 » Hague 1904 » London 1904 » Paris 1904 » Pittsburgh 1904 » Vienna (PC) 1904–1905 » Washington 1904 » Richmond 1905 » Vienna (C-K) 1905 » New York (PSG) 1905 » Cincinnati 1906 » New York (PSG) 1906 » Philadelphia 1906 » Paris 1906 » *London (NEAG) 1907* » New York (PSG) 1907 » New York (PSG) 1908 » London 1908 » Dresden 1909 » New York (NAC) 1909 » Buffalo 1910 » *London (Secession) 1911* » New York 1912 » London (RPS) 1914.

COLLECTIONS

MOMA; RPS; Princeton University Art Museum.

BIBLIOGRAPHY

Manuscript

835. Stieglitz Archives, Collection of American Literature, Beinecke Rare Book and Manuscript Library, Yale University, New Haven, Conn.: 124 unpublished letters from Clarence H. White to Alfred Stieglitz and 6 unpublished letters from Alfred Stieglitz to Clarence H. White between 1898 and 1923.

By White

836. White, Clarence H. "Old Masters in Photography." *Platinum Print,* No. 7 (February, 1915), pp. 4–5.

837. ———. "The Progress of Pictorial Photography." *Pictorial Photographers of America.* New York, 1918, pp. 5–16.

838. ———. "Photography as a Profession for Women." *American Photography,* 4 (July, 1924), pp. 426–432.

Illustrated by White

839. Bacheller, Irving. *Eben Holden.* Boston, 1901. Photographic illustrations by White.

840. Morris, Clara. "Beneath the Wrinkle." *McClure's Magazine,* 22 (February, 1904), pp. 429–434. Photographic illustrations by White.

841. Billman, Ira. *Songs of All Seasons.* Indianapolis, 1904. Photographic illustrations by White.

842. Morris, Gouverneur. "Newport the Maligned." *Everybody's Magazine,* 19 (September, 1908), pp. 311–325. Photographic illustrations by White.

About White

843. Taft, Lorado. "Clarence H. White and the Newark (Ohio) Camera Club." *Brush and Pencil,* 3 (November, 1898), pp. 100–106.

844. Caffin, Charles H. "The Clarence H. White Exhibition." *Photo Era,* 4 (January, 1900), pp. 23–24.

845. Hartmann, Sadakichi. "Clarence F. [sic] White." *Photographic Times,* 32 (January, 1900), pp. 18–23.

846. Keiley, Joseph T. "Exhibition of the Pictures of Clarence H. White of Newark, Ohio." *Camera Notes,* 3 (January, 1900), pp. 123–124.

847. *Exhibition of Photographs by Clarence H. White.* Introduction by Ema Spencer. Camera Club of New York, New York, exhibition catalog, n.d. [1900]. (The catalog was reprinted by the Boston Camera Club for White's exhibit there of the same year).

848. Spencer, Ema. "The White School." *Camera Craft,* 3 (July, 1901), pp. 85–103.

849. Caffin, Charles H. "Other Methods of Individual Expression: Illustrated by the Work of Clarence H. White and William B. Dyer." *Photography as a Fine Art,* 1901, rpt., Hastings-on-Hudson, 1971, pp. 115–139.

850. Caffin, Charles H. "Clarence H. White." *Camera Work,* No. 3 (July, 1903), pp. 15–17.

851. "Exhibition of Pictures by Clarence H. White in Pratt Institute, Brooklyn." *American Amateur Photographer,* 16 (March, 1904), pp. 137–138.

852. Keiley, Joseph T. "Clarence H. White." *Photography,* 17 (June, 1904), pp. 561–566.

853. Beatty, John W. "Clarence H. White—An Appreciation." *Camera Work,* No. 9 (January, 1905), pp. 48–49.

854. Demachy, Robert. "L'Illustration du Libre par les Photographes." *La Revue de Photographie,* 3 (November, 1905), pp. 321–329.

855. Bicknell, George. "The New Art in Photography: The Work of Clarence H. White." *The Craftsman,* 9 (January, 1906), pp. 495–510.

856. "Review of the Exhibition of Clarence H. White at the 'Little Galleries.' " *American Amateur Photographer,* 18 (March, 1906), p. 100.

857. Caffin, Charles H. "Clarence H. White." *Camera Work,* No. 23 (July, 1908), pp. 6–7.

858. Dickson, Edward R. "Clarence H. White—A Teacher of Photography." *Photo-Era,* 30 (January, 1913), pp. 3–6.

859. "Clarence H. White School of Photography." *The Outlook,* 114 (September, 1916), pp. 97–99.

860. Kühn, Heinrich. "Clarence H. White." *Photographische Rundchau,* 62 (June, 1925), pp. 388–389.

860A. "Clarence H. White Memorial Exhibition." *Photo-Miniature,* 17 (May, 1926), pp. 335–336.

861. Marks, Robert W. "Peaceful Warrior," *Coronet,* 4 (October, 1938), pp. 161–171.

862. Marks, Robert W. "The Photography of Clarence H. White." *Gentry,* 9 (Winter, 1953–1954), pp. 134–139.

863. Bunnell, Peter C. "The Significance of the Photography of Clarence Hudson White (1871–1925) in the Development of Expressive Photography." Master's thesis, Ohio University, 1961.

863A. Bunnell, Peter C. "The 1907 Photographic Collaboration of Clarence H. White and Alfred Stieglitz." Unpublished paper delivered before the Symposium on the History of Photography, George Eastman House, November 27, 1964.

864. White, Clarence H., Jr., and Peter C. Bunnell. "The Art of Clarence Hudson White." *Ohio University Review,* 7 (1965), pp. 40–65.

865. Bunnell, Peter C. "Clarence H. White." *Camera,* 51 (November, 1972), pp. 23–40.

866. White, Maynard P., Jr. "Clarence H. White: A Personal Portrait." Ph.D. dissertation, University of Delaware, 1975.

867. *Symbolism of Light: The Photographs of Clarence H. White.* "Clarence H. White: Artist in Life and Photography" by Maynard P. White, Jr., pp. 7–33; "The Artistry of Clarence H. White" by Cathleen A. Branciaroli and William Innes Homer, pp. 34–37. Delaware Art Museum, Wilmington, Delaware, exhibition catalog, April 15–May 22, 1977.

The Bibliography is arranged *chronologically* within each major subdivision, except periodicals in the Stieglitz library, which are listed alphabetically. The major subdivisions are: I. Writings by and about Alfred Stieglitz. II. General books not in the library of Stieglitz and articles including those in periodicals and anthologies in the Stieglitz library. III. The library of Alfred Stieglitz, including exhibition catalogs. IV. Important exhibition catalogs not in the library of Stieglitz, and reviews of exhibitions unknown to us through catalogs. V. Correspondence and unpublished recollections. The research of Sarah Greenough (Biblio. 1059) has been enormously helpful in the study of the published writings of Stieglitz. The appendix to this thesis consists of micro-fiches of the original articles that have been numbered and are herein referred to by the designation *G. App.*

In order to locate in this Bibliography a reference for which the entry number is unknown, it is necessary to know in which of the above four general categories the reference would fall, the date, and the author.

Included in writings by Stieglitz (I, B), are his recollections as recorded by others, mainly Dorothy Norman. These are listed in order of the earliest date recollected in a particular anthology.

I. ALFRED STIEGLITZ, WRITINGS BY AND ABOUT

A. Manuscript sources.

868. Arizona, Tucson. *Center for Creative Photography,* University of Arizona. Correspondence between or concerning Stieglitz is in the Johan Hagemeyer and Paul Strand files.

869. California, Berkeley. *Oral History Collection,* Bancroft Library. Correspondence between or concerning Stieglitz is in the Imogen Cunningham and Johan Hagemeyer files.

870. Connecticut, New Haven. *Collection of American Literature,* Beinecke Rare Book and Manuscript Library, Yale University (YCAL). Alfred Stieglitz Archives. Contains correspondence with photographers in the Stieglitz Collection as specified in the monographic bibliographies and with numerous others with whom Stieglitz corresponded about photography, including the following who are not represented in the Stieglitz Collection: Juan C. Abel, R. Child Bayley, Charles H. Caffin, Peter Henry Emerson, Sadakichi Hartmann, Ernst Juhl, and F. Matthies-Masuren.

871. New York, New York. *Archives,* The Metropolitan Museum of Art. Correspondence between Alfred Stieglitz and General Luigi Palma de Cesnola, Luigi Roversi and others is in the de Cesnola files. *Department of Prints and Photographs* has correspondence from Stieglitz.

872. Washington, D.C. *Archives of American Art.* Correspondence between or concerning Stieglitz is in the files of Paul Burlin, Lloyd Goodrich, Abraham Rattner, Elizabeth Sparhawk-Jones, Judson Walker, and Abraham Walkowitz.

B. Published writings by Stieglitz

873. (1885–1907). Norman, Dorothy, editor. "From the Writings of Alfred Stieglitz." *Twice A Year,* 1 (Fall–Winter, 1938), pp. 77–110. Consists of thirty-eight recollections by Stieglitz transcribed by the editor, in-

cluding the following that are relevant to his collection of photographs: no. 8 on Paris with Steichen in 1907; no. 27 on *Camera Work;* and no. 34 on his autobiography to about 1892.

874. Stieglitz, Alfred. "A Word or Two About Amateur Photography in Germany." *The Amateur Photographer,* 5 (25 February 1887), pp. 96–97. (G. App. 1)

875. ———. "A Day in Chioggia." *The Amateur Photographer,* Prize Tour Number (June 1889), pp. 7–9. (G. App. 37)

876. ———. "The Berlin Exhibition." *American Amateur Photographer,* 1 (November, 1889), pp. 202–204. (G. App. 51)

877. ———. "A Plea for Art Photography in America." *Photographic Mosaics,* 28 (1892), pp. 135–137. (G. App. 82)

878. ———. "The Platinotype Up To Date." *American Amateur Photographer,* 4 (November, 1892), pp. 493–497. (G. App. 95)

879. ———. "The Joint Exhibition at Philadelphia." *American Amateur Photographer,* 5 (May and June, 1893), pp. 201–208, 249–254. (G. App. 103 and 113)

880. (1894–1897). Norman, Dorothy, editor. "Why I got Out of Business." *Twice A Year,* 8–9 (1942), pp. 105–114.

881. Stieglitz, Alfred. "The Joint Exhibition at New York." *American Amateur Photographer,* 6 (April, 1894), pp. 153–156. (G. App. 119)

882. ———. "The Seventh Annual Joint Exhibition." *American Amateur Photographer,* 6 (May, 1894), pp. 209–219. (G. App. 123)

883. ———. [Letter to the Editor: 'Writing From Paris' with itinerary]. *American Amateur Photographer,* 6 (June, 1894), pp. 273–274. (G. App. 132)

884. ———. "Photographic Section of the Milan International United Exhibitions." *American Amateur Photographer,* 6 (August, 1894), pp. 377–378. (G. App. 134)

885. ———. "The Antwerp Exhibition." [Letter to the Editor], *American Amateur Photographer,* 6 (1894), pp. 431–432. (G. App. 136)

886. ———. "Two Artists' Haunts." With Louis H. Schubart. *Photographic Times,* 26 (January, 1895), pp. 9–12. (G. App. 141)

887. ———. "A Plea for a Photographic Art Exhibition." *American Annual of Photography and Photographic Times Almanac for 1895,* pp. 27–28. (G. App. 138)

888. ———. "Pictorial Photography in the United States, 1895." *Photograms of the Year, 1895,* p. 81. (G. App. 145)

889. ———. "The American Photographic Salon." *American Annual of Photography and Photographic Times Almanac for 1896,* pp. 194–196. (G. App. 146)

890. ———. Untitled. *The Amateur Photographer,* 23 (1896), p. 149. [Announcement by Stieglitz that he is no longer editor of the American *American Amateur Photographer*]. (G. App. 150)

891. ———. "Pictorial Photography in the United States: 1896." *Photograms of the Year, 1896,* pp. 43–44. (G. App. 156)

892. ———. "The Hand Camera—Its Present Importance." *American Annual of Photography and Photographic Times Almanac for 1897,* pp. 19–27. (G. App. 158)

893. ———. "Half-Tone Blocks with Wood-Cut Finish." *American Annual of Photography and Photographic Times Almanac for 1897,* pp. 221–223. (G. App. 166)

894. ———. "Our Illustrations." Column in *Camera Notes* 1 (July, 1897)–6 (July, 1902).

895. ———. "The Photographic Year in the United States." *Photograms of the Year, 1897,* pp. 29–30. (G. App. 180)

896. ———. "Some Remarks on Lantern Slides. A Method of Developing: Partial and Local Toning." *Camera Notes,* 1 (October, 1897), pp. 32–39. (G. App. 172)

897. ———. "Notes" [On Gum-bichromate printing]. *Camera Notes,* 2 (October, 1898), pp. 53–54. (G. App. 196)

898. ———. [Untitled Editor's Note on the Philadelphia Salon, Biblio. 1321]. *Camera Notes,* 2 (January, 1899), p. 132. (G. App. 212)

899. ———. "My Favorite Picture." [The Net-Mender]. *Photographic Life,* 1 (1899), pp. 11–12. (G. App. 214)

900. ———. "The Progress of Pictorial Photography in the United States." *American Annual of Photography and Photographic Times Almanac for 1899,* pp. 158–159. (G. App. 205)

901. ———. "Reviews and Exchanges: *Naturalistic Photography* by Dr. P. H. Emerson." *Camera Notes,* 3 (October, 1899), p. 88. (G. App. 222)

902. ———. "Own Work Throughout." *The Amateur Photographer,* 30 (27 October 1899), p. 325. (G. App. 223)

903. ———. "Pictorial Photography." *Scribner's Magazine,* 26 (November, 1899), pp. 528–537. (G. App. 224)

904. ———. "Appreciation." *Camera Notes,* 3 (April, 1900), p. 218.

905. ———. "Why American Pictorial Work is Absent from the Paris Exhibition." *The Amateur Photographer,* 32 (20 July 1900), p. 44. (G. App. 240)

906. ———. "To the Editor of the *American Amateur Photographer.*" *American Amateur Photographer,* 13 (January, 1901), pp. 41–42. (G. App. 251)

907. ———. "American Pictorial Photographs for the International Art Exhibit at Glasgow." *Camera Notes,* 4 (April, 1901), pp. 273–275. (G. App. 257)

908. (1902–1917). "Our Pictures." Regular column by Stieglitz in *Camera Work* (Biblio. 1247), where specific illustrations are discussed. First number issued December, 1902, dated January, 1903.

909. Stieglitz, Alfred. "Irreconcilable Positions—A Letter and the Reply." *Camera Notes,* 5 (January, 1902), pp. 217–218. (G. App. 275)

910. ———. "Extract from Letter from Alfred Stieglitz to F. Dundas Todd." *British Journal of Photography,* 49 (6 June 1902), p. 459. (G. App. 284)

911. ———. "Post-Script—May 10th." *Camera Notes,* 6 (July, 1902), inserted between pp. 50–51. (G. App. 296)

912. ———. "Valedictory." With Joseph Keiley, Dallett Fuguet, John Strauss, and Juan C. Abel. *Camera Notes,* 6 (July, 1902), pp. 3–5. (G. App. 285)

913. ———. "Painters on Photographic Juries." *Camera Notes,* 6 (July, 1902), pp. 27–30. (G. App. 291)

914. ———. "Modern Pictorial Photography." *Century Magazine,* 64 (October, 1902), pp. 822–825. (G. App. 302)

915. ———. *The Photo-Secession,* No. 1 (December, 1902), 4 pp. broadside containing a list of Council, a statement of the object of the Photo-Secession, and informal By-Laws.

916. ———. "The Photo-Secession at the National Arts Club, New York." *Photograms of the Year 1902.* pp. 17–20. (G. App. 314)

917. ———. "The History of Philadelphia." *Camera Notes,* 5 (April, 1902), n.p. (G. App. 282)

918. (1902). Norman, Dorothy, editor. "General Cesnola and the Metropolitan." *Twice A Year,* 5–6 (1940–1941), pp. 147–149.

919. (1902–1908). ———. "The Origins of the Photo-Secession and How it Became *291.*" *Twice A Year,* 8–9 (1942), pp. 114–127.

920. Stieglitz, Alfred. "The Photo-Secession." *Bausch and Lomb Lens Souvenir.* Rochester, N.Y., 1903, p. 3. (G. App. 338)

921. ———. [Letter on the American Success at Turin]. *Photographic Times-Bulletin,* 35 (January, 1903), p. 30. (G. App. 329)

922. ———. "The Photo-Secession—Its Objectives." *Camera Craft,* 8 (August, 1903), pp.81–83. (G. App. 342)

923. ———. [Letter to Editor on Berlin Hospitalization]. *American Amateur Photographer,* 16 (August, 1904), pp. 358–359. (G. App. 366)

924. ———. "Sammler und Vorzugsdrucke." In Biblio. 1285, pp. 55–60. 1977 English translation by Olga Marx in MMA Department of Prints and Photographs Reference Library. (G. App. 350)

925. ———. "Some Impressions of Foreign Exhibitions." *Camera Work,* No. 8 (October, 1904), pp. 34–37. (G. App. 373)

926. (About 1905). Norman, Dorothy, editor. "Steichen's Morgan and the Metropolitan." *Twice A Year,* 5–6 (1940–1941), pp. 150–151.

927. Stieglitz, Alfred. "Simplicity in Composition." In *The Modern Way of Picture Making.* Rochester, 1905. (G. App. 396)

928. ———. "Some of the Reasons." *The Complete Photographer,* Ed. by R. Child Bayley. New York, 1906, pp. 360–362. (G. App. 403)

929. ———. "The New Color Photography. A Bit of History." *Camera Work,* No. 20 (October, 1907), pp. 20–25. (G. App. 411)

930. ———. *Photo-Secessionism and Its Opponents: Five Letters.* New York, 1910. (G. App. 430)

931. ———. *Photo-Secessionism and Its Opponents: Another Letter—The Sixth.* New York, 1910. (G. App. 449)

932. ———. [Letter on the Post Impressionists]. *The Evening Sun,* 18 December 1911, editorial page. (G. App. 465)

933. ———. "The First Great 'Clinic to Revitalize

Art'." *New York American,* 26 (January 1913, p. 5–CE. (G. App. 474)

934. ———. ["What is '291' "]. *Camera Work,* No. 47 (dated July, 1914, published January, 1915), pp. 3–4. (G. App. 478)

935. ———. "A Statement." *Exhibition of Stieglitz Photographs.* Anderson Galleries, New York, 1921, exhibition pamphlet, n.p. (G. App. 488)

936. ———. "Portrait—1918." *Manuscript,* 2 (March, 1922), p. 9. (G. App. 501)

937. ———. "Is Photography a Failure?" *The New York Sun,* 14 March 1922, p. 20. (G. App. 505)

938. (1922–1924). Reyher, Ferdinand, editor. "Stieglitz-Weston Correspondence." *Photo-Notes,* (Spring 1949), pp. 11–15.

939. Stieglitz, Alfred. "How I Came to Photograph Clouds." *Amateur Photographer and Photography,* 56 (19 September 1923), p. 255. (G. App. 510)

940. ———. [Here is the Marin Story]. New York, 1927. (G. App. 522)

941. ———. [Preface]. *Alfred Stieglitz: An Exhibition of Photographs.* An American Place, New York, December 11, 1934–January 17, 1935. Exhibition pamphlet, n.p. (G. App. 534)

942. ———. [Letter on connoisseurship of photographs]. *Twice A Year,* No. 8–9 (1942), pp. 175–178. (G. App. 545)

943. ———. Norman, Dorothy, editor. *A Talk.* (No date, between 1933–1943). Tucson, Center for Creative Photography, 1976.

See Biblio. 455, 607, 758, 798, 1277, 1279, 1280, 1281.

C. Writings about Stieglitz

944. (1885–about 1917). *Scrapbook* of biographical clippings. YCAL.

945. [Review of Stieglitz's photographs]. *The Amateur Photographer,* Home Portraiture Number (7 October 1887), p. 13.

946. "Our Views." [Announcement of first prize to Stieglitz for his Holiday Work]. *The Amateur Photographer,* 6 (25 November 1887), pp. 253–254.

947. [Review of Stieglitz's photographs]. *The Amateur Photographer,* Holiday Work Number (11 July 1888), p. 18.

948. [Review of Stieglitz's photographs of Chioggia]. *The Amateur Photographer,* Prize Tour Number (June, 1889), p. 3.

949. "Special Exhibition of Lantern Slides." *American Amateur Photographer,* 4 (February, 1892), pp. 73–74.

950. "Distinguished Photographers of Today—Alfred Stieglitz." *Photographic Times,* 23 (1 December 1893), pp. 689–690.

951. Woodbury, W. E. "Alfred Stieglitz and His Latest Work." *Photographic Times,* 28 (April, 1896), pp. 161–168.

952. Carrington, James B. "Unusual Uses of Photography. Part 11. Night Photography." *Scribner's Magazine,* 22 (November, 1897), pp. 626–628.

953. Hartmann, Sadakichi. "An Art Critic's Estimate of Alfred Stieglitz." *Photographic Times,* 30 (June, 1898), pp. 257–262.

954. "M." [F. Matthies-Masuren] "Alfred Stieglitz—New York." *Photographisches Centralblatt,* 4 (December, 1898), pp. 428–434.

See Biblio. 1277.

955. "Pictorial Photographers. No. 111. Alfred Stieglitz." *Practical Photographer,* 10 (April, 1899), p. 117.

956. Keiley, Joseph T. [Preface]. *Exhibition of Photographs by Alfred Stieglitz.* New York Camera Club, New York, May 1–15, 1899. Exhibition pamphlet, n.p.

957. DéKay, Charles. "The Photographer as Artist." *New York Times Illustrated Magazine,* 4 June 1899, p. 7.

958. Keiley, Joseph T. "The Stieglitz Exhibition in New York." *The Amateur Photographer,* 29 (6 June 1899), p. 443.

959. Dreiser, Theodore. "A Master of Photography." *Success,* 2 (10 June 1899), p. 471.

960. Hartmann, Sadakichi. "Mr. Stieglitz's Exit." *The Amateur Photographer,* 32 (13 July 1900), pp. 31–32.

See Biblio. 1334.

961. "Editorial Note" [On health of Stieglitz]. *The Amateur Photographer,* 32 (September, 1900), p. 222.

962. Caffin, Charles H. "Photography as a Fine Art: Alfred Stieglitz and His Work." *Everybody's Magazine,* 4 (April, 1901), pp. 359–371 (reprinted in Biblio. 1282).

963. (1902–1917). *Scrapbook* of clippings relevant to *Camera Work.* YCAL.

964. (1902). *Scrapbook* of clippings relevant to the Photo-Secession. YCAL.

965. [Dreiser, Theodore]. "A Remarkable Art, The New Pictorial Photography." *The Great Round World,* 19 (3 May 1902), pp. 430–434.

966. (1904). *Scrapbook* with miscellaneous exhibition catalogs and extensive collection of clippings relevant to the St. Louis Exhibition of 1904. YCAL.

967. Keiley, Joseph. "American Pictorial Photographers. Alfred Stieglitz." *Photography,* 17 (20 February 1904), pp. 147–151.

968. (1905–1908). *Scrapbook* of clippings related to the Photo-Secession Galleries. YCAL.

969. Abel, Juan C. "Editorial: Alfred Stieglitz Expelled from The Camera Club of New York." *Abel's Photographic Weekly,* 1 (8 February 1908), pp. 95–96.

970. "Camera Club Ousts Alfred Stieglitz." *New York Times,* 14 February 1908, p. 1.

971. Strauss, John Francis. "Mr. Stieglitz's 'Expulsion'—A Statement." *Camera Work,* No. 22 (April, 1908), pp. 25–32. (See also Biblio. 1055)

972. Ernst, Agnes. "The New School of the Camera." [Interview with Stieglitz]. *New York Sun,* 26 April 1908. Scrapbooks, Stieglitz Archives, YCAL.

973. (1910). *Scrapbook* of clippings relevant to the International Exhibition of Pictorial Photography, Albright Art Gallery, Buffalo, New York (Biblio. 1399). YCAL.

974. Laurvik, J. Nilsen. "Alfred Stieglitz, Pictorial Photographer." *International Studio,* 44 (August, 1911), sup. xxi–xxvii.

975. Muir, Ward. "Alfred Stieglitz: An Impression." *The Amateur Photographer,* 57 (24 March 1913), pp. 285–286.

976. Swift, Samuel. "Art Photographs and Cubist Painting." [Review of Stieglitz Exhibition]. *Camera Work,* No. 42/43 (April–July, 1913), pp. 46–47.

977. De Zayas, Marius. *"The Steerage*—Stieglitz, Photography and Modern Art." *291,* No. 7–8 (September, 1915), n.p.

978. Traubel, Horace. "Stieglitz." *Conservator,* 27 (December, 1916), p. 137.

979. G. B. [Guido Bruno]. "The Passing of '291.' " *Pearson's Magazine,* 13 (March, 1918), pp. 402–403.

980. Lloyd, David. "Stieglitz, the Pioneer Who Has Developed Photography as an Art." *New York Evening Post,* 12 February 1921, p. 12.

981. McBride, Henry. "Work by a Great Photographer." *New York Herald,* 13 February 1921, section 2, p. 5.

982. Seligmann, Herbert. "A Photographer Challenges." *The Nation,* 112 (16 February 1921), p. 268.

983. Rosenfeld, Paul. "Stieglitz." *The Dial,* 70 (April, 1921), pp. 397–409.

984. Tennant, John A. "The Stieglitz Exhibition." *The Photo-Miniature,* 16 (July, 1921), pp. 135–139.

985. Strand, Paul. "Alfred Stieglitz and a Machine." *Manuscripts,* No. 2 (March, 1922), pp. 6–7.

986. Anderson, Sherwood. "Alfred Stieglitz." *New Republic,* 32 (25 October 1922), pp. 215–217.

987. (1922). Jones, Harold, editor. *Weston to Hagemeyer: New York Notes.* Tucson, Center for Creative Photography, 1977.

988. "Accessions and Notes." [Account of gift of the Alfred Stieglitz Library]. *Bulletin, Metropolitan Museum of Art,* 18 (January, 1923), p. 19.

989. Hind, C. Lewis. "Lesson of Photography." *Photographic Journal,* 63 (February, 1923), pp. 56–63.

990. De Zayas, Marius. "Clouds." *The World,* 1 April 1923, Metropolitan Section, p. 11.

991. Sheeler, Charles. "Recent Photographs by Alfred Stieglitz." *The Arts,* 3 (May, 1923), p. 345.

992. Boughton, Arthur. "Letter to Editor." [Reply to Biblio. 991]. *The Sun and the Globe,* 90 (20 June 1923), p. 22.

993. Strand, Paul. "Letter to Editor." [Rejoinder to Biblio. 992]. *The Sun and the Globe,* 90 (27 June 1923), p. 20.

994. "News and Comments." [Royal Photographic Society Award to Alfred Stieglitz]. *Photo-Miniature,* 16 (January, 1924), p. 594.

995. Coomaraswamy, Ananda. "A Gift from Mr. Alfred Stieglitz." *Museum of Fine Arts Bulletin,* 22 (February, 1924), p. 14.

996. Craven, Thomas. "Art and the Camera." [Review of Stieglitz's exhibition, Anderson Galleries.] *The Nation,* 118 (16 April 1924), pp. 456–457.

997. Seligmann, Herbert. "Alfred Stieglitz and His Work at 291." *The American Mercury,* 2 (May, 1924), pp. 83–84.

998. Search-Light. [Waldo Frank]. "The Prophet." In *Time Exposures,* New York, 1926, pp. 175–179.

999. Ivins, William M., Jr. "Photographs by Alfred

Stieglitz." *Bulletin of the Metropolitan Museum of Art,* 24 (February, 1929), pp. 44–45.

1000. Seligmann, Herbert. "Significance of the Metropolitan Museum's Acceptance of Stieglitz Prints." *New York Sun,* 23 March 1929, p. 34.

1001. Rosenfeld, Paul. "The Photography of Stieglitz." *The Nation,* 134 (23 March 1932), pp. 350–351.

1002. Jewell, Edward Alden. "What Is a Photograph?" [Interview with Stieglitz]. *New York Times,* 24 June 1934, sec. 9, p. 6.

1003. Norman, Dorothy. "Alfred Stieglitz." *Wings,* 9 (December, 1934), pp. 7–9, 26.

1004. Ringel, Fred J. "Master of Photography." *Wings,* 9 (December, 1934), pp. 13–15, 26.

1005. [McCausland, Elizabeth]. "Photographs by Stieglitz Now at an American Place." *Springfield Sunday Union and Republican,* 16 December 1934, section E, p. 6.

1006. Mumford, Lewis. "A Camera and Alfred Stieglitz." *The New Yorker,* 10 (22 December 1934), p. 30.

1007. Frank, Waldo and Lewis Mumford, Dorothy Norman, Paul Rosenfeld, Harold Ruggs, eds. *America and Alfred Stieglitz, A Collective Portrait.* Garden City, N.Y., 1934.

1008. Benson, E. M. "Alfred Stieglitz: The Man and the Book." *American Magazine of Art,* 28 (January, 1935), pp. 36–42.

1009. Stone, Gray. "The Influence of Alfred Stieglitz in Modern Photographic Illustration." *American Photography,* 30 (April, 1936), pp. 199–206.

1010. Haz, Nicholas. "Alfred Stieglitz, Photographer." *American Annual of Photography for 1936,* pp. 7–17.

1011. Flint, Ralph. "What Is '291'?" *Christian Science Monitor,* 17 November 1937, p. 5.

1012. Marks, Robert. "Man with a Cause." *Coronet,* 4 (September, 1938), pp. 161–170.

1013. Johnston, J. Dudley. "Pictorial Photography—Alfred Stieglitz." *The Photographic Journal,* 79 (April, 1939), pp. 200–202.

1014. Mayor, A. Hyatt. "Daguerreotypes and Photographs." *Bulletin of the Metropolitan Museum of Art,* 34 (November, 1939), p. 243.

1015. Marks, Robert W. "Stieglitz—Patriarch of Photography." *Popular Photography,* 6 (April, 1940), pp. 20–21, 76–79.

1016. Zigrosser, Carl. "Alfred Stieglitz." *Twice A Year,* No. 8–9 (1942), p. 137.

1017. McCausland, Elizabeth. "Alfred Stieglitz." *The Complete Photographer,* 9 (1943), pp. 3319–3322.

1018. [Norman, Dorothy, ed.]. "Thoroughly Unprepared." *Twice A Year,* No. 10–11 (1943), pp. 245–264.

1019. Craven, Thomas. "Stieglitz—Old Master of the Camera." *Saturday Evening Post,* 216 (8 January 1944), pp. 14–15, 36, 38.

1020. Norman, Dorothy. "Photography's Patron Saint." *New York Post,* 9 February 1944, p. 41.

1021. Jewell, Edward Alden. "Art and Alfred Stieglitz." *New York Times,* 10 September 1944, Section X, p. 4.

1022. Engelhard, Georgia. "Alfred Stieglitz, Master Photographer." *American Photography,* 39 (April, 1945), pp. 8–12.

1023. "An American Collection." *The Philadelphia Museum Bulletin,* 40 (May, 1945), pp. 68–80.

1024. Newhall, Nancy. "Alfred Stieglitz." *Photo-Notes,* (August, 1946), pp. 3–5.

1025. Rosenfeld, Paul. "Alfred Stieglitz." *The Commonweal,* 44 (2 August 1946), pp. 380–381.

1026. Strand, Paul. "Alfred Stieglitz, 1864–1946." *New Masses,* 60 (6 August 1946), pp. 6–7.

1027. Jewell, Edward Alden. "The Legend That Is Stieglitz." *New York Times,* 18 August 1946, Section X, p. 8.

1028. Beckett, Henry. "Dorothy Norman Sifts Writings of Alfred Stieglitz." *New York Post,* 28 August 1946, p. 50.

1029. Steichen, Edward. "Alfred Stieglitz, 1864–1946." *U.S. Camera,* 9 (September, 1946), p. 13.

1030. Soby, James Thrall. "Alfred Stieglitz." *Saturday Review of Literature,* 39 (28 September 1946), pp. 22–23.

1031. Norman, Dorothy. "Alfred Stieglitz: Six Happenings." *Twice A Year,* No. 14–15 (1946–1947), pp. 188–202.

1032. Larkin, Oliver. "Alfred Stieglitz and '291.'" *Magazine of Art,* 40 (May, 1947), pp. 179–184.

1033. Norman, Dorothy. "Was Stieglitz a Dealer?" *Atlantic Monthly,* 179 (May, 1947), pp. 22–23.

1034. Genauer, Emily. "Monument to Stieglitz Legend." *New York World Telegram,* 14 June 1947, p. 4.

1035. Coates, R. M. "Alfred Stieglitz." *The New Yorker,* 23 (21 June 1947), pp. 43–45.

1036. Strand, Paul. "Stieglitz: An Appraisal." *Popular Photography,* 21 (July, 1947), pp. 62, 88–98.

1037. Brown, Milton Wolf. "Alfred Stieglitz—Artist and Influence." *Photo-Notes* (August–September, 1947), pp. 1, 7–8.

1038. Norman, Dorothy, ed. *Stieglitz Memorial Portfolio, 1864–1946.* New York, 1947.

1039. Beckley, Paul V. "Bulk of Stieglitz Art Collection Going to Metropolitan Museum." *New York Herald Tribune,* 27 June 1949, p. 1.

1040. Rich, Daniel Cotton. "The Stieglitz Collection." *Bulletin, The Art Institute of Chicago,* 43 (15 November 1949), pp. 64–71.

1041. O'Keeffe, Georgia. "Stieglitz: His Pictures Collected Him." *New York Times Magazine,* 11 December 1949, pp. 24, 26, 28–30.

1042. Norman, Dorothy. "Alfred Stieglitz on Photography." *Magazine of Art,* 43 (December, 1950), pp. 298–301.

1043. Bry, Doris. "The Stieglitz Archive at Yale University." *Yale University Gazette,* 25 (April, 1951), pp. 123–130.

1044. Shiffman, Joseph. "The Alienation of the Artist: Alfred Stieglitz." *American Quarterly,* 3 (Fall, 1951), pp. 244–258.

1045. Norman, Dorothy. "Alfred Stieglitz—Seer." *Aperture,* 3 (1955), pp. 3–24.

1046. Bry, Doris. *An Exhibition of Photographs by Alfred Stieglitz.* National Gallery of Art, Washington, D.C., exhibition catalog, 1958.

1047. Norman, Dorothy. *Alfred Stieglitz: Introduction to an American Seer.* New York, 1960.

1048. Newhall, Beaumont. "Stieglitz and '291.'" *Art in America,* 51 (February, 1963), pp. 48–51.

1049. Bry, Doris. *Alfred Stieglitz: Photographer.* Boston, 1965.

1050. Leonard, Neil. "Alfred Stieglitz and Realism." *Art Quarterly,* 29 (1966), pp. 277–286.

1051. Seligmann, Herbert J. *Alfred Stieglitz Talking.* New Haven, 1966.

1052. McKendry, John. "Photographs in the Metropolitan." *Metropolitan Museum of Art Bulletin,* 28 (March, 1969), pp. 333–337.

1053. Bunnell, Peter C. "Alfred Stieglitz and *Camera Work.*" *Camera,* 48 (December, 1969), p. 8.

1054. Hamilton, George Heard. "The Alfred Stieglitz Collection." *Metropolitan Museum Journal,* 3 (1970), pp. 371–392.

1055. Longwell, Dennis. "Alfred Stieglitz vs. The Camera Club of New York." *Image,* 14 (December, 1971), pp. 21–23.

1056. Homer, William Innes. "Stieglitz and 291." *Art in America,* 61 (July–August, 1973), pp. 50–57.

1057. Norman, Dorothy. *Alfred Stieglitz: An American Seer.* New York, 1973. [With extensive quotations from the writing of Stieglitz adapted from Biblio. 873, 880, 918, 919, 926 and unpublished writing].

1058. Homer, William Innes. "Alfred Stieglitz and an American Aesthetic." *Arts,* 49 (September, 1974), pp. 25–28.

1059. Greenough, Sarah E. "The Published Writings of Alfred Stieglitz." Master's Thesis, University of New Mexico, 1976. [With an appendix of photocopies of the articles cited in the MMA Department of Prints and Photographs].

1060. Greenough, Sarah E. "Alfred Stieglitz and the Opponents of the Photo-Secession." *New Mexico Studies in the Fine Arts,* 2 (1977), pp. 13–19.

1060a. O'Keeffe, Georgia. "Alfred Stieglitz." Unpublished typescript intended for 1978 publication. Abiquiu, N.M., 1977.

II. GENERAL BOOKS AND ARTICLES

A. Pictorial Photography and the Photo-Secession

1061. Robinson, Henry Peach. *Pictorial Effect in Photography.* London, 1869.

1062. Vogel, Wilhelm. *The Chemistry of Light and Photography.* Philadelphia, 1875.

1063. Emerson, Peter Henry. "The Ideal Picture Exhibition." *The Amateur Photographer,* 2 (23 October 1885), pp. 461–462.

1064. Black, Alexander. "The Amateur Photographer." *The Century,* 34 (1887), pp. 722–729.

Emerson—see also Biblio. 1213, 1214.

1065. Emerson, Peter Henry. "Our English Letter." Periodic column in Biblio. 1245, Vol. I (1889).

1066. ———. *The Death of Naturalistic Photography.* 1890. Reprinted in Beaumont Newhall, *On Photography,* Watkins Glen, N.Y., 1956, pp. 123–132.

1067. Moore, Clarence B. "Leading Amateurs in Photography." *Cosmopolitan,* 12 (February, 1892), pp. 421–433.

1068. Dillaye, Frederic. *"L'Art photographique."* In Biblio. 1302. *Première Exposition d'Art Photographique.* Photo-Club de Paris, deluxe edition of exhibition catalog, 1894, pp. 3–7.

1069. Lichtwark, Alfred. *Die Bedeutung der Amateurphotographie.* Halle, 1894.

1070. "Camera—Klub in Wien—Mitglieder-Stand am 1 October 1894." *Wiener Photographische Blätter,* 1894, pp. 217–220.

1071. Dillaye, Frederic. "Ce que doit être l'Art Photographique." Preface to *Exposition d'Art Photographique,* Deuxième Année, Photo-Club de Paris, deluxe edition of exhibition catalog, March 22–April 11, 1895, n.p. (Biblio. 1306)

1072. Pennell, Joseph. "Is Photography Among the Fine Arts?" *Contemporary Review,* 72 (1897), pp. 824–836.

1073. Bushbeck, Alfred. "Das Trifolium des Wiener Camera-Klub." In Biblio. 1285, pp. 17–24.

1074. Goerke, Fritz. "Der Photo-Club in Paris." In Biblio. 1285, vol. I (1897), pp. 21–28.

1075. [Johnston, Frances B.]. "Editorial Notes," [Photography as a Profession]. *Photographic Times,* 30 (February, 1898), pp. 83–84.

1076. Caffin, Charles H. "Modern Photographic Art." *New York Evening Post,* 24 October 1898, p. 7.

1077. "Progress in the United States." *Photograms of the Year 1898,* pp. 37–46.

1078. Hartmann, Sadakichi. "Portrait Painting and Portrait Photography." *Camera Notes,* 3 (July, 1899), pp. 3–21.

1079. Dreiser, Theodore. "The Camera Club of New York." *Ainslee's Magazine,* 4 (October, 1899), pp. 324–335.

1080. Schiffner, F. "Zur Geschichte der künstlerischen Photographie in Deutschland und Oesterreich." *Photographisches Centralblatt,* 5 (October, 1899), pp. 381–384.

1081. Hartmann, Sadakichi. "Random Thoughts on Criticism." *Camera Notes,* 3 (January, 1900), pp. 101–108.

1082. ———. "The New York Camera Club." *Photographic Times,* 32 (February, 1900), pp. 59–61.

1083. Fuguet, Dallet. "Truth in Art." *Camera Notes,* 3 (April, 1900), pp. 183–190. [Illustrated with Euguene's photographs].

1084. Keiley, Joseph T. "The Pictorial Movement in Photography and the Significance of the Modern Photographic Salon." *Camera Notes,* 4 (July, 1900), pp. 18–23.

1085. Johnston, F. B. "America's Foremost Women Photographers." *Ladies Home Journal,* 18 (October, 1901), p. 5.

1086. Keiley, Joseph T. "The Linked Ring: Its Position and Origin and What It Stands for in the Photography World." *Camera Notes,* 5 (October, 1901), pp. 111–120.

1087. Yellott, Osborne I. "The Rule or Ruin School of Photography." *Photo-Era,* 7 (November, 1901), pp. 163–166.

1088. "American Photography." *Photograms of the Year 1901,* pp. 71–86.

Caffin (1901)—see Biblio. 1282.

1089. Matthies-Masuren, F. [Preface]. *Erste Internationale Ausstellung für Künstlerische Bildnis-Photographie,* Wiesbaden, exhibition catalog, March 26–May 26, 1902, n.p.

1090. Keiley, Joseph T. "The Decline and Fall of the Philadelphia Photographic Salon." *Camera Notes,* 5 (April, 1902), pp. 279–299.

1091. "Photographers of the New School." *New York Times,* 6 June 1902, p. 8.

1092. Hitchcock, Lucius W. "Pictorial Photography." *Photo-Beacon,* 14 (July, 1902), pp. 199–201.

1093. Sollet, C. "Le Platine-Gomme." *Photo-Gazette,* 12 (1902), pp. 213–214.

1094. Caffin, Charles H. "The New Photography." *Munsey's Magazine,* 27 (August, 1902), pp. 729–737.

1095. Black, Alexander. "The New Photography: The Artist and the Camera: A Debate." *Century Magazine,* 64 (October, 1902), pp. 813–822.

1096. Bayley, R. Child. "Things Photographic in the United States of America. Pictorial Photography." *Photography,* 15 (7 February 1903), p. 124.

1097. Keiley, Joseph T. "Concerning the Photo-Secession." *Photo Era,* 11 (September, 1903), pp. 314–315.

1098. Juhl, Ernst. "Kunst und Kunstphotographie." In Biblio. 1285, pp. 1–12.

1099. Yellott, Osborne I. "Pictorial Photography in the United States." *Photograms of the Year, 1903,* pp. 27–50.

1100. Loescher, Fritz. "Pictorial Photography in Germany." *Photograms of the Year, 1903*, pp. 65–77.

1101. Abbott, C. Yarnall. "Photographic Portraiture: The New American School." *Appleton's Booklovers Magazine*, 3 (February, 1904), pp. 169–173.

1102. Allan, Sidney [Sadakichi Hartmann]. "A New Departure in Photography." *The Lamp*, 28 (February, 1904), pp. 19–25.

1103. Hartmann, Sadakichi. "Aesthetic Activity in Photography." *Brush and Pencil*, 14 (April, 1904), pp. 24–40.

1104. ———. "The Photo-Secession, A New Pictorial Movement." *The Craftsman*, 6 (April, 1904), pp. 30–37.

1105. Steadman, Frank Morris. "Professional Photography of the Future." *The Photographer*, 1 (30 April 1904), pp. 2–3.

1106. Matthies-Masuren, F. [Preface]. *Photographische Ausstellung im Park der Grossen Kunstausstellung zu Dresden*. May–October, 1904, n.p.

1107. Hinton, A. Horsley. "Photography in America —West and East." *The Amateur Photographer*, 39 (19 May 1904), pp. 386–387.

1108. [Hinton, A. Horsley]. "The Work and Attitude of the Photo-Secession of America." *The Amateur Photographer*, 39 (2 June 1904), pp. 426–428.

1109. Willis, Paul. "A Talk with the Photo-Secession." *The Photographer*, 1 (2 July 1904), p. 151.

1110. Rood, Roland. "The Three Factors in American Pictorial Photography." *American Amateur Photographer*, 16 (August, 1904), pp. 346–349.

1111. Juvenal [Sadakichi Hartmann]. "Little Tin Gods on Wheels." *Photo-Beacon*, 16 (September, 1904), pp. 282–286.

1112. Rood, Roland. "Has the Painters' Judgment of Photographs Any Value?" *Camera Work*, No. 11 (July, 1905), pp. 41–44.

1113. Manly, Thomas. "Perfected Gelatine Ozotype." *Camera Work*, No. 11 (July, 1905), pp. 45–51.

1114. Rood, Roland. "The 'Little Galleries' of the Photo-Secession." *American Amateur Photographer*, 16 (December, 1905), pp. 566–569.

1115. Caffin, Charles H. "The Development of Photography in the United States." In *Art in Photography*, Charles Holme, ed. London, 1905, n.p. See Biblio. 1288.

1116. "A Model Exhibition—The Photo Secession Galleries." *Photography*, 20 (15 May 1906), pp. 382–383.

1117. "The Photo-Secession: Its Aims and Work." *International Studio*, 28 (June, 1906), sup. xcix–cx.

1118. Moore, Henry Holt. "The New Photography." *The Outlook*, 83 (23 June 1906), pp. 454–463.

1119. Bayley, R. Child. *The Complete Photographer*. New York, 1906.

1120. Savery, James C. "Photo-Secession." *The Burr McIntosh Monthly*, 12 (April, 1907), pp. 36–43.

1121. Hughes, Rupert. "The Higher Photography." *Appleton's Magazine*, 10 (July, 1907), pp. 102–109.

1122. Oliver, Maude I. G. "The Photo-Secession in America." *International Studio*, 32 (September, 1907), pp. 199–215.

1123. Beck, Otto Walter. *Art Principles in Portrait Photography*. New York, 1907.

1124. Matthies-Masuren, F. *Künstlerische Photographie: Entwicklung und Einfluss in Deutschland*. Introduction by Alfred Lichtwark. Leipzig, 1907.

1125. Hoppé, E. O. "Notes on Some Examples of German Pictorial School." *The Amateur Photographer*, 47 (11 February 1908), pp. 131–135.

1126. Scott, Dixon. "Welding the Links." *The Amateur Photographer*, 50 (13 July 1909), pp. 48–49.

1127. "The Future of Pictorial Photography in Great Britain—A Symposium [including remarks by Annan, Davison, Cadby, Calland, Evans, Arbuthnot, and Cochrane]. *Amateur Photographer and Photographic News*, 50 (14 December 1909), pp. 574–577.

1128. Allan, Sidney. [Sadakichi Hartmann]. *Composition in Portraiture*. New York, 1909.

1129. Hartmann, Sadakichi. *Landscape and Figure Composition*. New York, 1910.

Anderson (1910)—see Biblio. 1294.

1130. Ward, H. Snowdon. "Photograms of the Year." Summaries of international photographic activities published under this title in *Photograms of the Year 1907* and *1908*. Between 1909 and 1911 his writing was published under the serial title "Work of the Year," all of which contain references to photographers in the Stieglitz collection.

1131. ———. "The Collecting of Photographic Pictures." *Photograms of the Year 1910*, pp. 22–26.

1131A. Pollock, Elizabeth. Unpublished research on the International Exhibition of Pictorial Photography, Buffalo, 1910 (Biblio. 1399). New Canaan, 1977.

1132. Haviland, Paul. "The Accomplishments of

Photography and Contributions of the Medium to Art." *Camera Work*, No. 33 (January, 1911), pp. 65–67.

1133. DeZayas, Marius. "Photography and Artistic Photography." *Camera Work*, No. 42/43 (April–July, 1913), pp. 13–14.

1134. Warstat, Wilhelm. *Die Künstlerische Photographie*. Leipzig, 1913.

1135. Anderson, Paul L. "The Development of Pictorial Photography in the United States during the Past Quarter Century." *American Photography*, 8 (June, 1914), pp. 326–334.

1136. Matthies-Masuren, F. "On the Development of Artistic Photography in Europe." *American Photography*, 8 (June, 1914), pp. 335–336.

1137. " '291' The Mecca and the Mystery of Art in a Fifth Avenue Attic." *The New York Sun*, 24 October 1915, p. 6.

1138. Carter, Huntley. "Two Ninety-One." *Egoist*, 3 (1 March 1916), p. 43.

1139. Moore, Henry Holt. "Photography with a Difference." *The Outlook*, 114 (13 September 1916), pp. 97–99.

1140. Anderson, P. L. *Pictorial Photography; Its Principles and Practice*. Philadelphia, 1917.

1141. Muir, Ward. "Photographic Days—Stieglitz and Others in New York." *Amateur Photographer and Photography*, 46 (14 August 1918), pp. 187–188.

1142. Porterfield, W. H. "Pictorial Photography in America." *Photograms of the Year 1917–1918*, pp. 27–28.

1143. Anderson, Paul L. *The Fine Art of Photography*. Philadelphia, 1919.

1144. Carey, Elizabeth Luther. "Recent Pictorial Photography at the Camera Club Exhibition." *New York Times Magazine*, 10 September 1922, p. 10.

1145. Johnston, J. Dudley. "Phases in the Development of Pictorial Photography in Britain and America." *Photographic Journal*, 63 (December, 1923), pp. 568–582.

1146. Gillies, John W. *Principles of Pictorial Photography*. New York, 1923.

1147. Rosenfeld, Paul. *Port of New York. Essays on Fourteen Moderns*. New York, 1924. ("Alfred Stieglitz," pp. 237–280; "Georgia O'Keeffe," pp. 199–210).

1148. Tilney, F. C. "What Pictorialism Is." *Photo-Miniature*, 16 (January, 1924), pp. 565–592.

1149. ———. "Lessons from the Past." *The Principles of Photographic Pictorialism*. London, 1930, pp. 5–23.

1150. Anderson, Paul L. "Some Pictorial History." *American Photography*, 29 (April, 1935), pp. 199–214.

1151. Flint, Ralph. "What Is '291'?" *Christian Science Monitor*, 17 November 1937, magazine section, p. 5.

1152. Moholy, Lucia. *One Hundred Years of Photography*. Harmondsworth, England, 1939.

1153. Steichen, Edward. "The Fighting Photo-Secession." *Vogue*, 97 (June, 1941), pp. 22, 74.

1154. Newhall, Nancy. "What Is Pictorialism?" *Camera Craft*, 48 (November, 1941), pp. 653–663.

1155. Weston, Edward. "Photographic Art." *Encyclopedia Britanica*. (Chicago, 1942). Vol. 27, pp. 796–799. (Stieglitz, Steichen, Strand, Sheeler, Adams, Brett Weston and Edward Weston illustrated.)

1156. Mertle, J. S. *Evolution of Rotogravure*. Private reprint, Oshkosh, 1957, of articles appearing in *Gravure* (November, 1955 to June, 1957. Parts IX–XII deal with Karel Václav Klíč).

1157. Craven, George M. *Group f/64 and its Relation to Straight Photography in America*. Master's thesis. Ohio University, 1958. (Adams, Strand, Sheeler).

1158. Doty, Robert. *Photo-Secession: Photography as a Fine Art*. Rochester, N.Y., 1960.

1159. Gernsheim, Helmut. "Impressionistic Photography," "The Aesthetic Movement," and "The Beginnings of Modern Photography," in *Creative Photography*. London, 1962, pp. 122–130, 135–148, 149–160.

1160. Newhall, Beaumont. "Photography as an Art" and "Straight Photography," in *The History of Photography from 1839 to the Present Day*. New York, rev. ed., 1964, pp. 97–110, 111–134.

1161. Lyons, Nathan. *Photography in the Twentieth Century*. Rochester, 1967.

1162. Scharf, Aaron. "Artistic Photography." *Art and Photography*. London, 1968, pp. 183–188.

1163. Maddox, Jerald C. "Essay on a Tintype." [The Philadelphia Photographic Salon, 1899, Biblio. 1329], *Library of Congress Quarterly*, 26 (January, 1969), pp. 49–54.

1164. Gernsheim, Helmut and Alison. "The Aesthetic Movement," in *The History of Photography from the Camera Obscura to the Beginning of the Modern Era*. New York, 1969, pp. 463–470.

1165. Pollack, Peter. "Photography Comes of Age," "Stieglitz: An American Legend," "Steichen: Painter,

Photographer, Curator," in *The Picture History of Photography*. New York, rev. ed., 1969, pp. 242–257, 258–271, 272–281.

1166. "Pictorialism 1890–1914." *Camera,* 49 (December, 1970), pp. 5–52.

1167. Von Brevern, Marlies. *Künstlerische Photographie*. Berlin, 1971.

1168. "1900–1920: A New Art Form's Fight for Status and Stature," in *Great Photographers,* by the editors of Time–Life Books. New York, 1971, pp. 114–133.

1169. Corn, Wanda M. *The Color of Mood: American Tonalism, 1880–1910*. M. H. De Young Memorial Museum and the California Legion of Honor, San Francisco, exhibition catalog, 1972.

1170. Naef, Weston. *The Painterly Photograph*. The Metropolitan Museum of Art, New York, exhibition catalog, January 8–March 15, 1973.

1171. Maddox, Jerald C. "Photography in the First Decade." *Art in America,* 61 (July–August, 1973), pp. 72–78.

1172. Plagens, Peter. "The Critics: Hartmann, Huneker, De Casseres." *Art in America,* 61 (July–August, 1973), pp. 67–70.

1173. Green, Jonathan, ed. *Camera Work, a Critical Anthology*. Millerton, New York, 1973.

1174. Doty, Robert. *Photography in America*. New York, 1974, pp. 14–18.

1175. Hiley, Michael. "The Photographer as Artist: A Turn of the Century Debate." *The Studio,* 190 (July, 1975), pp. 4–11.

1176. Mann, Margery and Anne Noggle. *Women of Photography: An Historical Survey*. [Essays on Brigman, Cameron, and Käsebier]. San Francisco Museum of Art, San Francisco, California, exhibition catalog, 1975.

1177. Newhall, Nancy. *P. H. Emerson*. [Contains an extensive account of the correspondence between Stieglitz and Emerson.] Millerton, New York, 1975.

1178. Thornton, Gene. *Masters of the Camera: Stieglitz, Steichen and Their Successors*. New York 1976.

1179. Harvith, Susan and John. *Karl Struss: Man With A Camera*. Ann Arbor, 1976.

1180. Maddow, Ben. "Pictorialism in Europe," "Pictorialism in America," in *Faces: A Narrative History of Portrait in Photography*. New York, 1977, pp. 172–185, 186–227.

1181. Harker, Margaret. *The Linked Ring*. Unpublished research. London, 1977.

B. The Painters of '291'

1182. Eddy, Arthur Jerome. *Cubists and Post-Impressionism*. Chicago, 1914.

1183. Wright, Willard Huntington. *Modern Paintings: Its Tendency and Meaning*. New York, 1915.

1184. Weber, Max. *Essays on Art*. New York, 1916.

1185. Cheney, Sheldon. *A Primer of Modern Art*. New York, 1924.

1186. Cortissoz, Royal. *Personalities in Art*. New York, 1925.

1187. Craven, Thomas. *Modern Art*. New York, 1934.

1188. Hartmann, Sadakichi. *A History of American Art*. New York, 1934.

1189. Kuhn, Walt. *The Story of the Armory Show*. New York, 1938.

1190. Mellquist, Jerome. *The Emergence of an American Art*. New York, 1942.

1191. Larkin, Oliver. *Art and Life in America*. New York, 1949.

1192. Baur, John I. H. *Revolution and Tradition in Modern American Art*. Cambridge, Mass., 1951.

1193. Brown, Milton W. *American Painting from the Armory Show to the Depression*. Princeton, 1955.

1194. Soby, James Thrall. *Modern Art and the New Past*. Norman, Oklahoma, 1957.

1195. Brown, Milton W. *The Story of the Armory Show*. Greenwich, Conn., 1963.

1196. Goodrich, Lloyd. *Pioneers of Modern Art in America, The Decade of the Armory Show, 1910–1920*. New York, 1963.

1197. Geldzahler, Henry. *American Painting in the Twentieth Century*. New York, 1965.

1198. Green, Samuel. *American Art: A Historical Survey*. New York, 1966.

1199. Rose, Barbara. *American Art Since 1900*. New York, 1967.

1200. ———. *Readings in American Art Since 1900*. New York, 1968.

1201. Dijkstra, Bram. *Hieroglyphics of a New Speech, Cubism, Stieglitz, and the Early Poetry of William Carlos Williams*. Princeton, 1969.

1202. *Avant-Garde Painting and Sculpture in*

America, 1910–25. Edited by William Innes Homer. Delaware Art Museum, Wilmington, exhibition catalog, 1975.

1203. McBride, Henry. *The Flow of Art.* New York, 1975.

1204. Tashjian, Dickran. *Skyscraper Primitives: Dada and the American Avant-Garde: 1910–25.* Middletown, Conn., 1975.

1205. Homer, William Innes. *Alfred Stieglitz and the American Avant-Garde.* Boston, 1977. [With extensive bibliography on the painters associated with 291].

See Biblio. 430.

III. LIBRARY OF ALFRED STIEGLITZ

A. Handbooks and manuals

1206. Vogel, Dr. H. W. *Die Fortschritte der Photographie Seit dem Jahr 1879.* Berlin, 1883.

1207. Liesegang, Dr. Paul E. *Der Silber-Druck und das Vergrössern photographischer Aufnahmen.* Düsseldorf, 1884.

1208. Eder, Dr. Josef Maria. *Die Moment—Photographie.* Halle, 1886. Illustrated with halftones of primitive quality and several woodburytypes.

1209. Pizzighelli, G. *Handbuch der Photographie für Amateure und Touristen,* vol. 1, *Die Photographischen Apparate und die Photographischen Processe.* Halle, 1886.

1210. Gädlicke, J. and A. Miethe. *Praktische Anleitung zum Photographiren.* Berlin, 1887.

1211. Pizzighelli, G. *Handbuch der Photographie für Amateure und Touristen,* vol. 2, *Die Anwendung der Photographie für Amateure und Touristen.* Halle, 1887.

1212. Lainer, Alexander. *Lehrbuch der Photographischen Chemie und Photochemie.* Halle, 1889.

1213. Emerson, Peter Henry. *Naturalistic Photography for Students of the Arts.* London, 1889.

1214. ———. *Naturalistic Photography for Students of the Arts.* London, 2nd rev. ed., 1890.

See Biblio. 1278.

1215. Wall, E. J. *A Dictionary of Photography for the Amateur and Professional Photographer.* London, 2nd rev. ed., 1890.

1216. Schnauss, Hermann. *Photographischer Zeitvertreib. Eine Zusammenstellung einfacher und leicht ausfuhrbaren Beschäftigunen und Unterhaltungen mit Hilfe der Camera.* Dusseldorf, 1890. Illustrated with a few halftones of primitive quality, including one by Stieglitz.

1217. Vogel, Prof. Dr. H. W. *Handbuch der Photographie:* vol. 1, *Photochemie und Beschreibung der Photographischen Chemicalien.* Berlin, 1890.

1218. Townsend, Charles F. *Chemistry for Photographers.* London, n.d. (about 1890).

1219. Eder, Dr. Josef Maria, ed. *Ausführliches Handbuch der Photographie,* vol. 1–4, 1891–1892, 1897, 1898, 1899. Halle. Illustrated with a few halftones.

1220. Hodges, John A. *The Lantern-Slide Manual.* London, 1892.

1221. Harrison, W. Jerome. *The Chemistry of Photography.* New York, 1892.

1222. Woodbury, Walter E. *Aristotypes and How to Make Them.* New York, 1893.

1223. Black, Alexander. *Photography Indoors and Out: A Book for Amateurs.* Boston, 1894.

1224. Wilson, Edward L. *Cyclopaedic Photography: A Complete Handbook of the Terms, Processes, Formulae, and Appliances Available in Photography.* New York, 1894.

1225. Vogel, Prof. Dr. H. W. *Handbuch der Photographie,* vol. 2, *Das Licht im Dienste der Photographie und Die Neuesten Fortschritte der Photographischen Optik.* Berlin, 1894.

1226. *The "Blue Book" of Amateur Photographers, 1894.* Edited by Walter Sprange. Boston, 1894.

1227. Hübl, Arthur Freiherrn von. *Der Platindruck.* Halle, 1895.

1228. Schmidt, F. *Photographisches Fehlerbuch.* Karlsruhe, 1895. Illustrated with halftone reproductions.

1229. Volkmer, Ottomar. *Die Photo-gravüre.* Halle, 1895.

1230. Maskell, Alfred and Robert Demachy. *Photo-Aquatint or The Gum-Bichromate Process: A Practical Treatise on a New Process of Printing in Pigment Especially Suitable for Pictorial Workers.* London, 1897.

1231. Hinton, A. Horsley. *Platinotype Printing.* London, 1897.

1232. Lambert, F. C. *The Photographer's Note-Book.* London, 1897.

1233. Behrens, Friedrich. *Der Gummidruck.*

Praktische Anleitung vermittelst Aquarellfarben photographische Bilder herzustellen. Berlin, 1898.

1234. Gädicke, J. *Der Gummidruck. Eine Anleitung für Amateure und Fachphotographen*. Berlin, 1898.

1235. Kaiserling, Dr. Carl. *Praktikum der Wissenschaftuchen Photographie*. Berlin, 1898.

1236. Woodbury, Walter E. *The Encyclopaedic Dictionary of Photography*. New York, 1898. Illustrated with one photogravure from a photograph by Stieglitz.

1237. Iles, George. *Flame, Electricity and the Camera: Man's Progress from the First Kindling of Fire to the Wireless Telegraph and the Photography of Color*. New York, 1900.

1238. *A Handbook of Photography in Colors*. Essays by Thomas Bolas, "Historical Development of Heliochromy"; Alexander A. K. Tallent, "Tri-Color Photography"; and Edgar Senior, "Lippmann's Process of Interference Heliochromy." New York, 1900.

1239. Schmidt, Prof. F. *Compendium der Praktischen Photographie*. Wiesbaden, 1903.

1240. Miethe, Prof. Dr. A. *Dreifarbenphotographie nach der Natur nach den am Photochemischen Laboratorium der Technischen Hochschule zu Berlin angewandten Methoden*. Halle, 1904.

1241. Stolze, Dr. F. *Optik für Photographen: Unter besonderer Berücksichtigung des photographischen Fachunterrichtes*. Halle, 1904.

B. Periodicals

1242. *Der Amateur-Photograph*, vols. 1–2; 1887–1888. Düsseldorf. Primarily illustrated with a few primitive halftones.

1243. *The Amateur Photographer*, vols. 1–13, 23–24, 56; 1884–1891, 1896, 1912. London. Early numbers illustrated with a few primitive halftones but later with many more.

1244. *The Amateur Photographer*, Special Numbers, 7 October 1887, "Home Portraiture"; 11 July 1888, "Holiday Work"; June, 1889, "Prize Tour Number"; 1890, "Home Portraiture Number"; 1890, "Photographic Holiday Work." Illustrated with a few woodburytypes, autotypes and numerous halftones.

1245. *American Amateur Photographer*, vols. 1–14; 1889–1902. Brunswick, Maine, and New York. Illustrated with a few halftones in each monthly issue and an occasional photogravure.

1246. *Camera Notes*, vols. 3–4, vol. 6, no. 1; July 1899–April 1901, July 1902. New York. Illustrated with chine collé and other elaborate photogravures, as well as many halftones. Bound by Stieglitz with the seal of the Camera Club. (Stieglitz had several complete sets but inexplicably presented this incomplete one.)

1247. *Camera Work*, Nos. 1–50 including supplements; January, 1903–June, 1917. New York. Illustrated with numerous photogravures and halftones of the finest quality. Two sets, one in a library binding and the other specially bound and boxed by Stieglitz.

1248. *The Photogram*, vols. 1–8; 1894–1901. London. Illustrated with small halftones and occasional photogravures and collotypes.

1249. *The Photographic Art Journal*, vol. 2; 1889. London. Illustrated with two halftones per monthly issue.

1250. *Photographic Art Journal*, vol. 2; March–December, 1902. Leicester, England. Illustrated with many carefully mounted halftones in each monthly issue.

1251. *The Photographic Times and American Photographer*, vols. 19, 25–32; 1889, 1894–1900. New York. Illustrated with numerous photogravures and halftones.

1252. *Photographische Mittheilungen*, vols. 21–24, 26; 1885–1888; July, 1889–February, 1890. Berlin. Illustrated with a few photogravures, autotypes, collotypes, and halftones.

1253. *Photographische Rundchau*, vols. 2–7, 9–15; 1888–1893, 1895–1901. Halle. Illustrated with a few photogravures, collotypes and halftones per issue.

1254. *Photographisches Centralblatt*, vol. 4, no. 23, vols. 5–7; December 1898, 1899–1901. Munich. Illustrated with one photogravure and several halftones per issue.

1255. *The Photo-Miniature*, vols. 1–3; vol. 5, no. 55; vol. 6, no. 62 and 65; vol. 7, no. 82; vol. 15, no. 197; April 1899–November 1901, October 1903, May 1904, August 1904, October 1907, October 1925. New York. Illustrated with halftones.

1256. *Wiener Photographische Blätter*, vols. 1–5; 1894–1898. Vienna. Illustrated with a few photogravures and halftones per issue.

C. Annuals and Yearbooks

1257. *American Annual of Photography and Photographic Times Almanac*, 1887–1904, 1906–1907.

New York. Each annual illustrated with a few photogravures and several halftones.

1258. *British Journal Photographic Alamanac,* 1888, 1890, and 1894. London.

1259. *Jahrbuch für Photographie und Reproductionstechnik,* vols. 1–5, 7–17, 19, 21; 1887–1891, 1893–1903, 1905, 1907. Halle. Illustrated with a few primitive halftones and occasional photogravures or autotypes.

1260. *Die Kunst in der Photographie,* vols. 1–3, 5; 1897–1899, 1903. Berlin. Illustrated with numerous halftones and photogravures.

1261. *Photograms of the Year,* 1895–1914, and 1920. London. Illustrated with numerous halftones.

1262. *Die Photographische Kunst im Jahre,* 1902–1909, 1911. Illustrated with numerous halftones, and a few four color halftones and photogravures.

1263. *The Year-Book of Photography and Photographic News Almanac for 1889.* London.

D. General books and bound collections of plates

1264. Lichtwark, Alfred. *Die Bedeutung der Amateur-Photographie.* Halle, 1894. Illustrated with halftones and a few photogravures.

1265. [*Photo-Club de Paris de luxe volume*]. Photo-Club de Paris. *Première Exposition d'Art Photographique.* Paris, 1894. 30 copies on Imperial Japan numbered 1–30; 470 on White Marais numbered 31–500. (This is no. 169.) Illustrated with photogravures, one each by Eickemeyer, LeBègue, Puyo, Demachy, Henneberg, Stieglitz, Hinton, Annan, Watzek, Calland.

1266. [*Photo-Club de Paris de luxe volume.*] Photo-Club de Paris. *Deuxième Exposition d'Art Photographique.* Paris, 1895. 30 copies with a *"double suite d'épreuves"* on Imperial Japan paper and Rives numbered 1–30; 470 copies on White Marais numbered 31–500. (This is no. 152.) Illustrated with photogravures, one each by Henneberg, Watzek, LeBègue, Puyo, Demachy, Cadby, Eickemeyer, Stieglitz, Annan.

1267. *Pictorial Photographs. A Record of the Photographic Salon of 1895.* Twenty plates reproduced in photogravure by Walter L. Colls. London, 1895. Finely printed gravures of works exhibited in the salon, including one each by Henneberg, LeBègue, Puyo, Watzek, Annan, Hinton, Stieglitz, and two by Demachy.

1268. *Life's Comedy by American Illustrators.* New York, 1896. Halftone reproductions of graphic works by F. W. Read, T. K. Hanna, Jr., C. D. Gibson, and Alice Barber Stephens. Inscribed "Reproduced by the Photochrome Engraving Co. under my direction—AS."

1269. [*Photo-Club de Paris de luxe volume.*] Photo-Club de Paris. *Troisième Exposition d'Art Photographique.* Paris, 1896. 30 copies on Imperial Japan, Blanchet and Kleber, numbered 1–30; 470 copies on Blanchet et Kleber paper numbered 31–500. (This is number 125.) Illustrated with works by Annan, Demachy, Henneberg, Hinton, LeBègue, A. Meyer, Puyo, Stieglitz, Watzek.

1270. *Pictorial Photographs: A Record of the Photographic Salon of 1896.* Eighteen plates reproduced in photogravure by Walter L. Colls. London, 1896. Finely printed gravures, including one each by Hinton, Kuehn, Watzek, Calland, Stieglitz, and Puyo, and two by Demachy.

1271. Adams, W. I. Lincoln. *Sunlight and Shadow: A Book for Photographers, Amateur and Professional.* New York, 1897. Illustrated with numerous large halftones.

1272. Goerke, Fritz, editor. *Nach der Natur. Photogravüren nach original aufnahmen von Amateurphotographen.* Berlin, 1897. Folio of 32 gravures issued in conjunction with the *Internationalen Ausstellung für Amateur-Photographie,* Berlin, 1897, under the auspices of the *Freunden Photographie und freien Photographischen Vereinigung.* The only Americans represented are Emma Farnsworth and Alfred Stieglitz. European members of the Alfred Stieglitz collection include Le Bègue and Henneberg.

1273. *Pictorial Photographs: A Record of the Photographic Salon of 1897.* Seventeen Plates reproduced in photogravure by Walter L. Colls. London, 1897. This is copy number 19. A collection of excellent photogravures including one each by Stieglitz, Demachy, Evans, Hinton, and Kuehn.

1274. Adams, W. I. Lincoln. *In Nature's Image: Chapters on Pictorial Photography.* New York, 1898. Illustrated with numerous large halftones.

1275. Bergon, Paul and René LeBègue. *Le Nu et Le Drapé en Plein Air.* n.d. [1898]. Illustrated with many halftones of varying quality.

1276. *A Record of Art in 1898.* London, 1898. Illustrated with numerous halftones of works by British artists.

1277. Stieglitz, Alfred. *Picturesque Bits of New*

York and Other Studies. New York, 1898. Portfolio of ten photogravures by Stieglitz with an introduction by Walter E. Woodbury.

1278. Emerson, Peter Henry. *Naturalistic Photography for Students of the Arts*. New York, 2nd rev. ed., 1899.

1279. [Stieglitz, Alfred, ed.]. *American Pictorial Photography*. Series I. Published for *Camera Notes* by the Publication Committee of The Camera Club. [About 1899]. Eighteen gravures printed by the Photochrome Engraving Company in edition of 50. Works by Day, Stieglitz, Post, Käsebier, Berg, Eickemeyer, Keiley, Fraser, Murphy, Dumont, Weil, Johnston, Farnsworth, and White.

1280. Stieglitz, Alfred. "Pictorial Photography." *Scribner's Magazine,* 26 (November, 1899), pp. 528–537. Bound and illustrated with halftones of Stieglitz's photographs.

1281. [Stieglitz, Alfred, ed.]. *American Pictorial Photography,* Series II. Published for *Camera Notes* by the Publication Committee of The Camera Club. [About 1900]. Eighteen gravures printed by the Photochrome Engraving Company in edition of 150. 2 copies, no. 1 & no. 2. Works by Käsebier (2), Eugene (4), Eickemeyer (2), and one each by Keiley, White, Dyer, Berg, Watson, Dumont, Champney, Clark & Wade, and Clarkson.

1282. Caffin, Charles H. *Photography as a Fine Art: The Achievements and Possibilities of Photographic Art in America*. New York, 1901. Illustrated with halftones.

1283. Juhl, Ernest, ed. *Internationale Kunst-Photographen,* vol. 2. Halle, n.d. [about 1902]. Collection of sixty halftone reproductions in a folio volume of the work of 32 individuals, including Annan, Day, Eugene, Henneberg, Hinton, Hofmeister Brothers, Käsebier, Kuehn, Watzek, White, Ben-Yusuf, and Sears.

1284. Matthies-Masuren, F., ed. *Gummidrucke von Hugo Henneberg, Wien, Heinrich Kühn, Innsbruck und Hans Watzek, Wien*. Halle, n.d. [1902]. Illustrated with a few halftones and numerous photogravures.

1285. Juhl, Ernst, ed. *Camera-Kunst*. Berlin, 1903. Illustrated with many large halftones.

1286. Juhl, Ernst. *Heliogravuren nach Gummi Drucken*. Hamburg, 1903. Folio volume with text on laid Holland paper with 28 finely printed gravures on different papers including chine collé.

1287. Pichier, Paul. *Reproduktionen nach Gummidrucken*. N.d. [about 1904]. Unique collection with manuscript list of plates, all halftones, except one original gravure signed in pencil by Pichier.

1288. Holme, Charles, ed. *Art in Photography: With Selected Examples of European and American Work*. London, 1905. Illustrated with a few photogravures and numerous halftones.

1289. Matthies-Masuren, F., and W. H. Jdzerda. *Die Bildmassige Photographie*. Halle, n.d. [about 1905]. Illustrated with numerous halftones.

1290. *Die Kunst*. Foreword and introduction by Alfred Lichtwark, and "Künstlerische Photographie: Entwicklung und Einfluss in Deutschland," by F. Matthies-Masuren. Berlin, 1907. Illustrated with several halftones.

1291. Brown, G. Baldwin. *The Glasgow School of Painters*. Glasgow, 1908. Illustrated with 54 reproductions in photogravure by J. Craig Annan. Inscribed "To Alfred Stieglitz with best wishes from J. Craig Annan."

1292. Holme, Charles, ed. *Colour Photography and Other Recent Developments of the Art of the Camera*. London, 1908. Illustrated with numerous black and white, and color halftones.

1293. *Queen Alexandra's Christmas Gift Book: Photographs from My Camera*. London, 1908. Illustrated with photogravures and halftones of the Royal Family and friends.

1294. Anderson, A. J. *The Artistic Side of Photography*. London, 1910. Illustrated with photogravures and halftones.

1295. Coburn, Alvin Langdon. [Untitled Portfolio]. N.d. [about 1912]. Six photogravures signed by Coburn.

1296. Schaefer, Karl. *Die Sammlung W. Clemens*. Cologne Kunstgewebe Museum, 1923.

1297. Anschutz, Ottomar. *Augenblicksbilder*. Posen, n.d. Folio of twelve halftones of animal and military scenes.

E. Exhibition catalogs in the Stieglitz Library and reviews of those exhibitions. (Reviews are not given individual numbers, but rather are included as a subdivision of the entry for the exhibition.)

1298. (Vienna, 1888) Club der Amateur-Photographien Catalog/der Internationalen/Ausstellung von Amateur-Photographien/Wien, 1888. Vienna, 1888.

"The International Photographic Exhibition."

Photographic Times and American Photographer, 18 (21 December 1888), p. 624.

1299. (Berlin, 1889) Photographischen Jubiläums/ Ausstellung/Berlin/1889/Officieller Catalog. Berlin, 1889. See Biblio. 876.

1300. (Vienna, 1891) Club der Amateur-Photographien. Catalog der Internationalen Ausstellung Künstlerischer Photographien. Vienna, 1891.

"Internationale Ausstellung künstlerischer Photographien in Wien 1891." *Photographische Rundchau,* 5 (May, 1891), pp. 165–168.

London (Photographic Salon) 1893, see Biblio. 207 and 1411.

1301. (London, 1894) Photographic Salon. Catalogue of the/Second Annual Exhibition of the/Photographic Salon/1894/Dudley Gallery/Piccadilly, London/From October 1st to November 4th, 1894. London, 1894. (Stieglitz lacked the first catalog.)

a. "The Photographic Salon." *British Journal of Photography,* 41 (5 October 1894), pp. 627–629.

b. Hinton, A. Horsley. "The Pall Mall Show, 1894." *The Photogram,* 1 (November, 1894), pp. 262–273.

c. Wall, A. H. "The Salon and its Suggestions." *The Photogram,* 1 (November, 1894), pp. 274–280.

London (RPS) 1894: See Biblio. 467.

1302. (Paris, 1894) Photo-Club de Paris. Première Exposition/D'Art Photographique/Catalogue/10 au 30 Janvier 1894/Galleries George Petit, 8, Rue de Seze, 8. Paris, 1894. See Biblio. 1265.

a. "Exhibition of Photographic Art Organized by the Photographic Club of Paris." *British Journal of Photography,* 41 (2 February 1894), p. 74.

b. A. B. "Ausstellung in Paris." *Wiener Photographische Blätter,* 1 (March, 1894), pp. 63–64.

1303. (Brussels, 1895) *Cercle Artistique et Litteraire. Salon Photographie.* Bruxelles, November, 1895.

1304. (London, 1895) Photographic Salon. Catalogue of the Third Exhibition at the Dudley Gallery, Piccadilly, London, from the 26th September to the 4th November, 1895. London, 1895.

a. "The Salon, 1895: An Appreciation and a Criticism." *The Amateur Photographer,* 22 (27 September 1895), pp. 203–205.

b. "The Two Great Exhibitions." *Photograms of the Year 1895,* pp. 13–80.

1305. (London, RPS, 1895) Fortieth Annual

Exhibition Catalogue/1895. *The Photographic Journal,* n.s. 20 (September, 1895), supplement #6. London, 1895. See review under Biblio. 1304b.

1306. (Paris, 1895) Photo-Club de Paris. Exposition d'Art Photographique 2ième. Galerie Durand-Ruel, II, rue Le Peletier, Paris. 22 Mars au 11 Avril, 1895. See Biblio. 212, 1266.

"The Paris Salon, 1895." *American Amateur Photographer,* 7 (April, 1895), p. 166.

1307. (Hamburg, 1896) Gesellschaft zur Förderung der Amateur Photographie. Vierte Jahresausstellung der Gesellschaft z. Förderung der Amateur Photographie in der Kuntshalle zu Hamburg. Hamburg, November, 1896.

1308. (London, 1896) Photographic Salon. Catalogue of the Fourth Annual Exhibition at the Dudley Gallery, Piccadilly, London. London, 1896. See Biblio 217 and 1270.

a. "The Photographic Salon." *British Journal of Photography,* 43 (25 September 1896), p. 613.

b. White, Gleeson. "The Great Exhibitions." *Photograms of the Year 1896,* pp. 63–107.

1309. (London, RPS, 1896) Royal Photographic Society. The Photographic Journal/Forty-First Annual Exhibition/1896/September 28–November 12, 1896. London, 1896. See Biblio. 217, 1308b.

1310. (Paris, 1896) Photo-Club de Paris. Photo-Club de Paris/Exposition D'Art/Photographique/Troisème Année 1896/Catalogue/12 au 31, Mai, 1896/Galerie des Champs Élysées. Paris, 1896. See Biblio. 1269.

[Review of Photo-Club Exhibition]. *The Amateur Photographer,* 23 (5 June 1896), p. 477.

1311. (Washington, 1896) Washington Salon. Catalogue of the Washington Salon and Art Photographic Exhibition of 1896. Held at the Assembly Hall of the Cosmos Club. May 26th to 29th, 1896, Washington. See Biblio. 891.

"Notes on the Washington Salon." *American Amateur Photographer,* 8 (July, 1896), pp. 306–308.

1312. (London, 1897) Photographic Salon. Catalogue of the Fifth Exhibition of the Photographic Salon. Dudley Gallery, London, 1897. See also Biblio. 1273.

a. "The Photographic Salon." *British Journal of Photography,* 44 (8 October 1897), pp. 645–646.

b. "The Photographic Salon." *Photograms of the Year 1897,* pp. 93–114.

1313. (London, RPS, 1897) The Photographic

Journal/The Royal Photographic Society/Forty-Second Annual Exhibition Catalogue/1897. London, 1897.

 a. "The Royal Photographic Society's Exhibition." *British Journal of Photography*, 44 (1 October 1897), pp. 630–634.

 b. "The Pall Mall." *Photograms of the Year, 1897*, pp. 55–92.

London (Eastman 1897)—see Biblio. 1413.

1314. (Paris, 1897) Photo-Club de Paris. Salon de Photographie, v. 4. Gallerie de Champ Élysées, Paris. 13 au 28 Avril, 1897. See Biblio. 257.

1315. (Hamburg, 1898) Sechste Internationale Ausstellung von Kunst-Photographien. Hamburg, 1898.

 a. Juhl, Ernst. "Sechste Internationale Ausstellung von Kunstphotographien in der Kunsthalle zu Hamburg." *Photographische Rundchau*, 12 (October and November, 1898), pp. 296–306, 324–333.

 b. Juhl, Ernst. "Moderne Kunstphotographie auf der Ausstellung der Gesellschaft zur Förderung der Amateur-Photographie in der Kunsthalle, Hamburg." *Wiener Photographische Blätter*, 5 (November, 1898), pp. 233–241.

 c. Schiefler, Gustav. "Betrachtungen über die Ausstellung von Kunstphotographien in Hamburg." *Wiener Photographische Blätter*, 5 (November, 1898), pp. 229–233.

1316. (London, 1898) Photographic Salon. Catalogue of the Sixth Exhibition of the Photographic Salon. Dudley Gallery, London, 1898.

 Ward, H. Snowdon. "The Two Great Exhibitions. II—The Photographic Salon." *Photograms of the Year 1898*, pp. 93–112.

1317. (London, RPS, 1898) Catalogue Royal Photographic Society Forty-Third Annual Exhibition. London, 1898. [Supplement to the Photographic Journal, n.s. 23 (September, 1898)].

 Ward, H. Snowdon. "The Two Great Exhibitions. I—Pall Mall." *Photograms of the Year 1898*, pp. 75–92.

1318. (Munich, 1898) "Secession." Offizieller Katalog/der/I, Internationalen Elite-Ausstellung/Künstlerischer Photographien/Münchens. München, 1898. With foreword by F. Matthies-Masuren. [Typescript translation by Olga Marx, 1977 (MMA)].

 "Die 1. Sezessions-Ausstellung von Kunstphotographien in München." *Photographisches Centralblatt*, 5 (January, 1899), pp. 8–15.

1319. (New York, AI, 1898) American Institute. Catalogue of Prints/The Photo-Graphical Section/American Institute/National Academy of Design/New York City/1898. See Biblio. 259 and 261.

 a. "The 1898 American Institute Exhibition of Photographs." *American Amateur Photographer*, 10 (October, 1898), pp. 456–462.

 b. Hartmann, Sadakichi. "A Walk Through the Exhibition of the Photographic Section of the American Institute." *Camera Notes*, 2 (January, 1899), pp. 86–89.

1320. (Paris, 1898) Photo-Club de Paris. Salon de Photographie v. 5. Gallerie de Champs Élysées Paris. 3 au 29 Mai 1898.

1321. (Philadelphia 1898) Philadelphia Photographic Salon/October 24 to November 12, 1898/At the Galleries of the Academy/Broad Street, Above Arch. Philadelphia, 1898. See Biblio. 539.

 a. Caffin, Charles H. "Modern Photographic Art." *The Evening Post*, 24 October 1898, p. 7.

 b. A Valued Correspondent [unidentified pseud]. "The Philadelphia Photographic Salon." *American Amateur Photographer*, 10 (December, 1898), pp. 548–554.

1322. (Berlin, 1899) *Ausstellung fur Künstlerische Photographie*. Berlin, 1899.

 a. Balle, Oskar. "Ausstellung fur künstlerische Photographie, Berlin 1899." *Photographisches Centralblatt*, 5 (March, 1899), pp. 125–129.

 b. Behrens Friedrich. "Die Engländer auf der Berliner Ausstellung fur Künstlerische Photographie." *Photographisches Centralblatt*, 5 (April, 1899), pp. 168–173.

 c. See Biblio. 1260, vol. 3, devoted in its entirety to Berlin 1899 with text by Richard Stettiner.

1323. (Hamburg, 1899) Gesell z. Furderung d. Amat. Hamburg Kunsthalle/7 Internationale Ausstellung/von Künst-Photographien, 1899.

 "M." [Matthies-Masuren, F.] "Zur Hamburger Ausstellung." *Photographisches Centralblatt*, 5 (September, 1899), pp. 360–366.

1324. (London, 1899) Photographic Salon. Catalogue/Of The/Seventh/Annual/Exhibition/Photographic/Salon/Dudley Gallery/Egyptian Hall/Piccadilly, W. London, 1899. See Biblio. 220.

 Carter, A. C. R. "The Photographic Salon." *Photograms of the Year, 1899*, pp. 83–112.

1325. (London, RPS, 1899) Royal Photographic Society/Forty-Fourth Annual/Exhibition 1899. London, 1899. [Supplement to the *Photographic Journal*, n.s. 24 (September, 1899)].

Carter, A. C. R. "The Royal." *Photograms of the Year 1899*, pp. 113–172.

1326. (Newark, 1899) Newark Camera Club. Catalogue/of the/Exhibition of Photographs/Given by the/Newark Camera Club/November 29 and 30 and December 1/1899/At Y.M.C.A. Building/Newark, Ohio. Newark, 1899.

1327. (New York, 1899) The Camera Club. Exhibition of Photographs/by Alfred Stieglitz/at the Camera Club N.Y./3 West Twenty-Ninth Street/May 1st to 15th, 1899. New York, 1899. See Biblio. 956 and 958.

"The Stieglitz Exhibition." *Camera Notes*, 3 (October, 1899) pp. 76–77.

1328. (New York, AI., 1899) American Institute. The American Institute/Photographic Salon/1899/At the Gallery of the Institute/Forty-Fourth St./Nineteen and Twenty-One-West/New York City. New York, 1899.

"American Institute Photographic Salon, 1899." *Photographic Times*, 32 (January, 1900), pp. 26–28.

1329. (Philadelphia, 1899) Penna. Acad. of Fine Arts. The Second/Philadelphia/Photographic/Salon/The Pennsylvania/Academy of the Fine Arts/And the Photographic/Society of Philadelphia/At the Galleries of the Academy/Broad Street/Above Arch/Philadelphia, Pa./U.S.A. From October 22nd to November 19th 1899. Philadelphia, 1899. See Biblio. 542.

Fergusson, E. Lee. "The Second Philadelphia Salon." *Photographic Times*, 32 (January, 1900), pp. 4–6.

(*Vienna, 1899*) *See Biblio. 1414.*

1330. (Chicago, 1900) Chicago Art Institute. Chicago/Photographic Salon/Of 1900/Held Under the Joint Management of the/Chicago Society of Amateur Photographers/and the Art Institute of Chicago/April 3 to 18. Chicago, 1900.

Todd, F. Dundas. "The Chicago Salon." *Photo-Beacon*, 12 (June, 1900), pp. 150–151.

1331. (Hamburg, 1900) Gesell z. Furderung d. Amat. VIII Jahresausstellung/von Kunst-Photogra-/phien von Mitgliedern/Der Gesellschaft zur Forde/rung Der Amateur Photo/graphie Zu Hamburg 1900/

Veranstaltet in Den Raumen Des Kunst/Salons Von Louis Bock und Sohn/Hamburg Voml Bis 30 December/1900. Hamburg, 1900.

Juhl, Ernst. "Die Moderne Kunstphotographie auf der Ausstellung bei Louis Bock und Sohn in Hamburg." *Photographische Rundchau*, 15 (February, 1901), pp. 25–31.

1332. (London, 1900) Photographic Salon. Catalogue/of the Eighth Annual/Exhibition of the/Photographic Salon/Dudley Gallery, Egyptian/Hall, Piccadilly W. London, 1900. See Biblio. 741.

a. Carter, A. C. R. "The Photographic Salon." *Photograms of the Year 1900*, pp. 109–148.

b. "The English Exhibitions and the 'American Invasion.'" *Camera Notes*, 4 (January, 1901), pp. 162–175.

London (New School of American Photography) 1900, see Biblio. 1402.

1333. (Newark, 1900) Newark Camera Club. Exhibit of Photographs by the/Newark Camera Club, Associa-/Tion Building, Newark, Ohio/November 28, 29, 30, December 1/1900. Newark, 1900.

1334. (Philadelphia, 1900) Penna Acad. of Fine Arts. The Third Phila-/delphia Photo-/Graphic Salon/The Pennsylvania Academy/Of the Fine Arts and the/Photographic Society of Philadelphia/At the Galleries of the Academy/Broad Street Above Arch/Philadelphia, Pa. U.S.A. From Octo-/ber 21st to November 18th 1900. Philadelphia, 1900. See Biblio 547 and 906.

Mitchell, Charles L., M.D. "The Third Philadelphia Photographic Salon." *American Amateur Photographer*, 12 (December, 1900), pp. 560–568.

1335. (Brussels, 1901) L'Effort/Cercle d'Art Photographique/Salon 1901 1re Anneé/Du 15 September au 15 Octobre/Cercle Artistique et Litteraire, Bruxelles. Bruxelles, 1901.

"Photographic Salon at Brussels. "*British Journal of Photography*, 48 (27 September 1901), p. 618.

1336. (Glasgow, 1901) Glasgow International Exhibition/1901/Catalogue/Fine Art/Oil Painting/Water Colour/Sculpture/And/Architecture/Art Objects/Black and/White/Photography. Glasgow, 1901. See Biblio. 907.

a. "Glasgow International Exhibition, II." *British Journal of Photography*, 47 (24 May 1901), p. 330.

b. MacKenzie, Allan C. "American Pictorial Photography at Glasgow." *Camera Notes,* 5 (January, 1902), pp. 196–198.

1337. (London, 1901) Photographic Salon. Catalogue/of the Ninth Annual/Exhibition of the/Photographic/Salon/Dudley Gallery, Egyptian/Hall/Piccadilly W. London, 1901. See Biblio. 477 and 697.

Abbott, C. Yarnall. "An American's Impression of the London Exhibitions." *Camera Notes,* 5 (January, 1902), pp. 205–206.

Paris (New School of American Photography) 1901, see Biblio. 1403.

1338. (Philadelphia, 1901) The Fourth Phila/Delphia Photo/Graphic Salon/The Pennsylvania Academy/of the Fine Arts and the/Photographic Society of Philadelphia/At the Galleries of the Academy/Broad Street Above Arch/Philadelphia, Pa. U.S.A. From Nov/Ember 18th to December 14th, 1901. Philadelphia, 1901.

a. Caffin, Charles H. "The Philadelphia Photographic Salon, 1901." *Camera Notes,* 5 (January, 1902), pp. 207–216.

b. Fairman, Charles E. "The Fourth Philadelphia Photographic Salon." *Photographic Times,* 34 (January and February, 1902), pp. 16–24, 65–80.

c. Strauss, John Francis. "Aftermath." *Camera Notes,* 5 (January, 1902), pp. 163–165.

1339. (Hamburg, 1902) Gesell z. Furderung d. Amat. 1X Internationale/Ausstellung 1902/von Künst-/Photographien/Hamburg Kunsthalle. Hamburg, 1902.

1340. (Leeds, 1902) Yorkshire Union of Artists. Catalogue of the Fifteenth Annual/Ex-Hibition of/Pictures/In Connection with the/Yorkshire Union of Artists/Held, By Kind Permission of the/Fine Art Committee in the/City Art Gallery, Leeds/From/Oct. 15th, 1902 to Jan. 3rd, 1903. Leeds, 1902.

"The Leeds Camera Club Exhibition and Conversazione." *British Journal of Photography,* 50 (30 January 1903), pp. 91–92.

1341. (London, 1902) Photographic Salon. Catalogue of the/Tenth Annual Exhibition of the/Photographic Salon/1902/Dudley Gallery, Egyptian Hall/Piccadilly W. London, 1902. See Biblio. 108, 699.

1342. (New York, 1902) Photo-Secession. The National/Arts Club/New York/American/Pictorial/Photography/Arranged by/"The Photo Secession"/March 5 to March 22/1902. New York, 1902. See Biblio. 916.

a. "Exhibition of Pictorial Photography at the National Arts Club." *American Amateur Photographer,* 14 (April, 1902), pp. 171–173.

b. Strauss, John Francis. "The 'Photo-Secession' at the Arts Club." *Camera Notes,* 6 (July, 1902), pp. 33–39.

1343. (Paris, 1902) Photo-Club de Paris. Salon/International/De Photographie/Du Photo-Club/De Paris/Septième Année/1 Mai 1Juin/1902. Paris, 1902. See Biblio. 267.

1344. (San Francisco, 1902) The Second San Francisco/Photographic Salon/The California Camera Club and San Francisco Art Association/Mark Hopkins Institute of Art/January Ninth to Twenty-third/Nineteen Hundred and Two. San Francisco, 1902.

1345. (Turin, 1902) Esposizione/Internationale/Di Fotografie/Artistica/Torino 1902/Catalogo/Ufficiale. Torino, 1902.

Editors. "Photography at Important Art Exhibitions." *Camera Work,* No. 1 (January, 1903), pp. 60–61.

1346. (Brussels, 1903) L'Effort/Cercle D'Art/Photographique/IIIe Salon 1903/Du 20 Juin/Au 5 Juillet/Galleries de la/Société Royale La Grande Hermonie/rue de la Madeleine, 81/à Bruxelles. Bruxelles, 1903.

1347. (Chicago, 1903) Fourth Chicago/Photographic Salon/December 29th, 1903 to January 24th 1904/Held under the joint management of the Chicago Society of/Amateur Photographers and the Art Institute of Chicago. Chicago, 1903.

1348. (Cleveland, 1903) First Annual Salon of the/Cleveland Camera Club/March/Twenty-Third/to/Twenty-Ninth/1903/Fenton & Stair's/Art Gallery/Cleveland, Ohio. Cleveland, 1903. [YCAL]

1349. (Denver, 1903) Catalogue of the Fourth/Photographic Salon of the/Colorado/Camera/Club/March 23rd to 28th, 1903/Club Rooms, Appel Building, Denver. Denver, 1903. [YCAL]

1350. (Hamburg, 1903) Gesell z. Furderung d. Amat. Zehnte Internationale/Jahres-Ausstellung von/Künstphotographien/Hamburg-Kunsthalle/1903. Hamburg, 1903.

a. Warburg, J. C. "The Hamburg Exhibition."

The Amateur Photographer, 38 (3 December 1903), p. 456.

b. Juhl, Ernst. "The Jubilee Exhibition at the Hamburg Art Galleries." *Camera Work*, No. 5 (January, 1904), pp. 46–49.

1351. (London, 1903) Photographic Salon. Catalogue of the/Eleventh Annual Exhibition of the/Photographic Salon/1903/Dudley Gallery, Egyptian Hall/Piccadilly W. London, 1903. See Biblio. 110.

Carter, A. C. R. "The Photographic Salon." *Photograms of the Year, 1903*, pp. 135–153.

1352. (London, RPS, 1903) The Royal Photographic Society of Great Britain/Forty-Eighth Annual Exhibition, 1903/catalogue published in supp. of *The Photographic Journal*, 43 (September, 1903).

Carter, A. C. R. "The Royal." *Photograms of the Year, 1903*, pp. 155–172.

1353. (Minneapolis, 1903) Catalogue/of the/First Minneapolis/Photographic/Salon/at/Art Gallery/Public Library Building/1903. Minneapolis, 1903. [YCAL]

1354. (Portland, 1903) Official/Catalogue/For The/Department/Of The/Fine Arts/The Lewis and Clark/Centennial Exposition/Portland, Oregon, 1903. Portland, 1903.

1355. (Reading, 1903) Lantern Club. Second Photographic/Exhibition/Reading, Penna./Lantern Club/May Fourth to Ninth/MDCCCCIII. Reading, 1903.

1356. (Rochester, 1903) First/Exhibition/Rochester/Camera Club/Mechanics/Institute/March 30th/To/April 11th,/1903. Rochester, New York, 1903. [YCAL]

1357. (San Francisco, 1903) Catalog of/The Third/San Francisco/Photographic/Salon 1903/At the Mark Hopkins/Institute of Art, October Eighth to Twenty-/Fourth Nineteen Hundred and Three. San Francisco, 1903. See Biblio. 406.

1358. (Toronto, 1903) Toronto Camera Club/organized 1887, incorporated 1893/First Salon/(Twelfth Annual Exhibition)/April 21st/to May 2nd Inclusive/1903. Toronto, 1903. [YCAL]

1359. (Wiesbaden, 1903) Erste Internationale/Ausstellung fur/Künstlerische/Bildnis Photographie/Wiesbaden/Im Festsaale/Des Rathauses/26. IV–26. V 1903. Wiesbaden, 1903.

1360. (Bay View, 1904) The "Elect." Catalogue of the/First Exhibit of/The "Elect" a/Photo-Art Club/July and August, 1904. Bay View University, Michigan, 1904.

1361. (Bradford, 1904) Catalogue of the/Works of Art/In the Cartwright/Memorial Hall/1904. Bradford, 1904.

H.E.W. "The Cartwright Exhibition at Bradford." *The Amateur Photographer*, 39 (12 May 1904), pp. 368–369.

1362. (Dresden, 1904) Photographische Ausstellung/Im Park Der Grossen Künstausstellung/Zu Dresden Mai–Oktober 1904/Veranstaltet von Hugo Erfurth Fur die Grosse/Künstausstellung. Dresden, 1904. See Biblio. 925.

1363. (s' Gravenhage, 1904) Eerste/Internationale Salon/Von Kunstfotographie/'s Gravenhage 1904/Geopend von 20 Juni/fot 29 Juli/Gebouw/"Pulchri Studio"/Lange Voorhaut/'s Gravenhage.'s Gravenhage, 1904. See Biblio. 485.

1364. (London, 1904) Catalogue of the/Twelfth Annual Exhibition of the Photographic Salon/1904/Dudley Gallery, Egyptian Hall/Piccadilly W. London, 1904. See Biblio. 373 and 925.

New York (First American Photographic Salon) 1904, see Biblio. 1404.

1365. (Paris, 1904) Photo-Club de Paris. Catalogue Des Oeuvres/Exposées au 1Xe Salon/International De/Photographie du/Photo-Club de Paris/Au Petit Palais/Des Champs Élysées/Du 3 Mai au 5 Juin 1904. Paris, 1904.

1366. (Pittsburgh, 1904) Photo-Secession. A Collection of American Pictorial/Photographs as Arranged by the/Photo-Secession and Exhibited/Under the Auspices of the Cam-/Era Club of Pittsburgh, At the/Art Galleries of the Carnegie/Institute, Pittsburgh, February/1904. Pittsburgh, 1904.

a. Allan, Sidney [Sadakichi Hartmann]. "The Exhibition of the Photo-Secession." *The Photographic Times-Bulletin*, 36 (March, 1904), pp. 97–105.

b. Hartmann, Sadakichi. "The Photo-Secession Exhibition at the Carnegie Art Galleries, Pittsburgh, PA." *Camera Work*, No. 6 (April, 1904), pp. 47–51. *St. Louis (World's Fair) 1904, see Biblio. 1416.*

1367. (Vienna, 1904) Wiener Photo-Club. Katalog der Sechsten/Ausstellung/16 April–15 Mai/1904/Wien I Renngasse 14.

1368. (Washington, 1904) Photo-Secession. Exhibi-

tion of/Photographs/Corcoran Art Gallery/Washington MDCCCCIV. Washington, 1904.

 a. Fairman, Charles H. "The Photo Secession Exhibition in Washington." *Photo Era,* 12 (February, 1904), pp. 17–18.

 b. Moser, James Henry. "A Painter's Impression of the Washington Exhibition." *Camera Work,* No. 6 (April, 1904), pp. 45–46.

London (Photographic Salon) 1905, see Biblio. 1417, 1418.

Marseille (Salon) 1905, see Biblio. 1415.

1369. (New York, 1905) Photo-Secession. Exhibition of Member's Work/November 24, 1905–January 4 1906. New York, 1905.

 "The Photo-Secession Galleries and the Press." *Camera Work,* No. 14 (April, 1906), pp. 33–40.

1370. (Richmond, 1905) Catalogue of the/Ninth Annual Ex-/Hibition of the Art/Association of/Richmond Indiana/1905. Richmond, 1905.

1371. (Rochester, 1905) Souvenir/Kodak/Competition/1905. Rochester, 1905.

1372. (Vienna, 1905) Camera-Klub, Wien. Camera-Klub/Wien/Internationale/Ausstellung/Ausgewahlter/Künstlerischer/Photographien/Vom 15 Februar/Bis Marz 1905. Wien, 1905.

1373. (Chicago, 1906) Sixth Chicago/Photographic Salon/March 1 to 21, 1906/Held under the joint management of the Chicago Camera Club and the Art Institute of Chicago. Chicago, 1906.

1374. (Cincinnati, 1906) Cincinnati Museum/Exhibition of Photographic Art/February 11 to March 5, 1906. Cincinnati, 1906. [YCAL]

1375. (London, 1906) Catalogue of the/Fourteenth Annual Exhibition of the/Photographic Salon/1906/Gallery of the Royal Society of/Painters in Water Colours/5A Pall Mall East S.W. London, 1906.

 Carter, A. C. R. "The Salon." *Photograms of the Year 1906,* pp. 86–92.

 See Biblio. 376.

1376. (New York, 1906) Photo-Secession. Photo-Secession Galleries/Exhibition of French Work/January tenth to twenty-/fourth 1906. New York, 1906.

 Caffin, Charles H. "The Recent Exhibitions—Some Impressions." *Camera Work,* No. 16 (October, 1906), pp. 33–37.

1377. (New York, 1906) Photo-Secession. Photo-Secession Galleries/Exhibition of the Photographs by Herbert G./French, Illustrating portions of Tenny-/son's "Idylls of the King" January the/twenty-sixth to February the second/1906. New York, 1906.

1378. (New York, 1906) Photo-Secession. Photo-Secession Galleries/Exhibition: February the/Fifth to Nineteenth/1906. Gertrude Käse-/bier and Clarence H. White. New York, 1906.

 Rood, Roland. "The Exhibitions of Käsebier, White, Annan, Hill, and Evans at the Photo-Secession." *American Amateur Photographer,* 18 (March, 1906), pp. 99–102.

1379. (New York, 1906) Photo-Secession. Photo-Secession Galleries/First Exhibition of British Photographers/February Twenty-First to March Seventh 1906. New York, 1906. See Biblio. 1376 and 1378.

1380. (New York, 1906) Photo-Secession. Photo-Secession Galleries/Exhibition of Photographs/By Eduard J. Steichen/March Seventeenth to/April Fifth 1906. New York, 1906. See Biblio. 1376.

1381. (New York, 1906) Photo-Secession. Photo-Secession Galleries/Exhibition of Viennese and/German Photographs. April/Seventh to April Twenty-/Eighth 1906. New York, 1906. See Biblio. 1376.

1382. (New York, 1906) Photo-Secession. Photo-Secession Galleries/Exhibition of Members' Work/November Tenth–December Thirtieth, MDCCCVI. New York, 1906.

1383. (Paris, 1906) Photo-Club de Paris. Catalogue/Des Oeuvres Exposées/au Onzième Salon/International de/Photographie Du/Photo-Club de Paris/Au Palais de Glace/Des Champs Élysées/16 Juin au 15 Juillet 1906. Paris, 1906. See Biblio. 271.

1384. (Philadelphia, 1906) An Exhibition/of Photographs/Arranged by the/Photo-Secession/The Pennsylvania Academy/of the Fine Arts 1906. Philadelphia, 1906. [YCAL] See Biblio. 554.

 "The Pennsylvania Academy of Fine Arts." *Camera Work,* No. 15 (July, 1906), pp. 41–42.

London (Photographic Salon) 1907, see Biblio. 1421.

London (New English Art Galleries) 1907, see Biblio. 1419, 1420.

1385. (London, RPS, 1907) The Fifty-Second Annual Exhibition of the/Royal Photographic So-

ciety of/Great Britain,/The New Gallery, Regent Street, London, W./September 19th to October 26th, 1907. London, 1907. Published as sup. to *The Photographic Journal,* 47 (September, 1907).

"The Royal." *Photograms of the Year 1907,* pp. 58–60.

1386. (Montreal, 1907) A Catalog of the Exhibition of Pictorial Photographs. Gallery of the Art Association. 23ʳᵈ November–7ᵗʰ December, 1907. Montreal, 1907. (In Biblio. 676).

1387. (New York, 1907) Photo-Secession. Photo-Secession Galleries/Exhibition: January Twenty-/Fifth to February Twelfth/MDCCCCVII: Baron A. De Meyer/of Germany, and George H./Seeley, of Massachusetts. New York, 1907.

1388. (New York, 1907) Photo-Secession. Photo-Secession Galleries/Exhibition of Photographs by/Alice Boughton, New York;/William B. Dyer, Chicago;/and by C. Yarnall Abbott,/Philadelphia, February Nine/Teenth to March Fifth, MDCCCCVII. New York, 1907.

1389 (New York, 1907) Photo-Secession. Photo-Secession Galleries/Exhibition of Photographs/By Alvin Langdon Coburn/March Eleventh to April/Tenth, MDCCCCVII. New York, 1907.

1390. (New York, 1907) Photo-Secession. Photo-Secession Galleries/Exhibition of Members'/Work November Eighteenth/To December Thirtieth,/MDCCCCVII. New York, 1907.

a. "Photo-Secession Exhibition. Remarkable Work by Steichen, White, Seeley, Coburn and Stieglitz." *The New York Times,* 8 December 1907.

b. Laurvik, J. Nilsen, "The New Color Photography." *Century Magazine,* 75 (January, 1908), pp. 323–330.

1391. (London, 1908) Catalogue of the/Sixteenth Annual Exhibition of the/Photographic Salon/1908/Gallery of the Royal Society of/Painters in Water Colours/5A Pall Mall East S.W. London, 1908. See Biblio. 559.

"The Photographic Salon." *British Journal of Photography,* 55 (18 September 1908), p. 725.
New York (NAC) 1908, see Biblio. 1405.

1392. (New York, 1908) Photo-Secession. Photo-Secession Galleries/Exhibition of Photographs/By

George H. Seeley/February Seventh to/February Twenty-Fifth/MDCCCCVIII. New York, 1908.

1393. (New York, 1908) Photo-Secession. Photo-Secession Galleries/Exhibition of Photographs/By Eduard J. Steichen; March/Twelfth to April Second/MDCCCCVIII. New York, 1908.

1394. (New York, 1908) Photo-Secession. Photo-Secession Galleries/Exhibition of Members' Work/December 8–December 30, 1908. New York, 1908.

1395. (Dresden, 1909) International/Photographische/Ausstellung/Dresden/1909/Mai–Oktober. Dresden 1909. [Section V titled *International Vereinigung von Kunstphotographen* (International Union of Art Photographers), selected by Heinrich Kuehn. It consisted of Annan, Brigman, Coburn, Davison, Day, Demachy, Dyer, Eugene, French, Keiley, Kuehn, de Meyer, Seeley, Spitzler, Steichen, Stieglitz and White. It was apparently the only public manifestation of the International Union].

a. Caffin, Charles H. "Some Impressions from the International Photographic Exposition, Dresden." *Camera Work,* No. 28 (October, 1909), pp. 33–39.

b. Schumann, Paul. "'The International Group' at the Dresden Exhibition." *Camera Work,* No. 28 (October, 1909), pp. 45–48.

c. "The Dresden Exhibition." *Photo-Miniature,* 9 (October, 1909), pp. 238–240.

1396. (London, 1909) Catalogue of the/Seventeenth Annual Exhibition of the/Photographic Salon/1909/Gallery of the Royal Society of/Painters in Water Colours/5A Pall Mall East S.W. London, 1909.

Muir, Ward. "Note on the Salon." *The Amateur Photographer,* 50 (5 October 1909), p. 337.
New York (NAC) 1909, see Biblio. 1406.

1397. (New York, 1909) Photo-Secession. Photo-Secession Galleries/Exhibition of photographs in/Monochrome and colour by Baron/A. De Meyer, of London and Dres-/den: February Fourth to February/Twenty-Second MDCCCCIX. New York, 1909.

1398. (New York, 1909) Photo-Secession. Photo-Secession Galleries/Exhibition of a Series of Photo-/Graphs of Rodin's "Balzac" by/Mr. Eduard J. Steichen, of Paris/and New York: April Twenty-/First to May Seventh, MDCCCCIX. New York, 1909.

1399. (Buffalo, 1910) The Buffalo/Fine Arts

Academy/Albright Art Gallery/Catalogue of the/
International Exhibition/Pictorial Photography/
November 3–December 1/1910. Buffalo, 1910. [YCAL]
See Biblio. 167, 427, 561.

 a. Announcement of International Exhibition of
Pictorial Photography in: *Academy Notes,* V
(October, 1910), pp. 1–6; anthology of writings on
the art of photography relevant to the exhibition in:
Academy Notes, VI (January, 1911), pp. 1–27. Both
articles are generously illustrated with photographs
from the exhibition.

 b. MacColl, William D. "International Exhibi-
tion of Pictorial Photographs at Buffalo." *The
International Studio,* 43 (March, 1911), pp. xi–xv.

 c. Hartmann, Sadakichi. "International Exhibi-
tion of Pictorial Photographs—Albright Art Gallery.
The Most Comprehensive Review of the Exhibi-
tion." *Wilson's Photographic Magazine,* 48
(January, 1911), pp. 2–12.

 d. Lidbury, F. Austin. "Some Impressions of the
Buffalo Exhibition." *American Photography,* 14
(December, 1910), pp. 676–681.

 e. Bertling, Walter E. "The Albright Art
Gallery Exhibition." *Photo Era,* 26 (January, 1911),
pp. 13–18.

 f. Caffin, Charles H. "The Exhibition at
Buffalo." *Camera Work,* No. 33 (January, 1911),
pp. 21–23.

 g. "The Exhibition at the Albright Gallery—
Some Facts, Figures, and Notes." *Camera Work,*
No. 33 (January, 1911), pp. 61–63.
London (Secession) 1911, see Biblio. 1422.
Newark, New Jersey (Free Public Library) 1911,
see Biblio. 1407.
New York (Montross) 1912, see Biblio. 1408.
1400. (London, RPS, 1914) The Fifty-Ninth Annual
Exhibition of the/Royal Photographic Society of/
Great Britain/at the/Gallery of the Royal Society of
British Artists,/Suffolk Street, Haymarket./August
24th till October 3rd, 1914. London, 1914. Published as a
sup. to *The Photographic Journal,* 54 (August, 1914).

 "The Royal Photographic Society's Exhibition."
British Journal of Photography, 61 (28 August
1914), pp. 660–664.
Philadelphia (Wanamaker) 1917, 1918, see Biblio.
1409, 1410.

IV. IMPORTANT EXHIBITION CATALOGS NOT IN THE LIBRARY OF ALFRED STIEGLITZ, AND EXHIBITIONS KNOWN ONLY THROUGH REVIEWS.

A. Exhibition Catalogs

1401. (Paris, 1900) La Photographie d'art de l'Exposi-
tion Universelle. Paris, 1900.
1402. (London, NSAP, 1900) New School of
American Photography, Dudley Gallery, October 10–
November 8, 1900. London, 1900. See Biblio. 164.

 Carter, A. C. R. "The New American School of
Photography." *The Photogram,* 8 (February, 1901),
pp. 33–42.
1403. (Paris, NSAP, 1901) Des Oeuvres de F.
Holland Day et de la Nouvelle École Americaine/
Exposées au Photo-Club de Paris, 44, rue des
Mathurins, du 22 Février au 10 Mars/1901. Paris, 1901.
See Biblio. 264, 626.

 An On-Looker. [Unidentified pseud.] "The
American School." *The Photogram,* 8 (March,
1901), pp. 60–64.
1404. (New York, FAPS, 1904) The First American
Photographic Salon, Clausen Art Galleries, December
5–17, 1904. New York, 1904. See Biblio. 655, 657.

 Zimmerman, Walter. "The Salon." *Photographic
Times,* 36 (December, 1904), pp. 529–538.
1405. (New York, NAC, 1908) The National Arts
Club. Special Exhibition of Contemporary Art. January
4–25, 1908. New York, 1908.
1406. (New York, NAC, 1909) The National Arts
Club. International Exhibition of Pictorial Photog-
raphy. February Second to Twentieth. MCMIX. Fore-
word by Maurice Maeterlinck [extracted from *Camera
Work*]. New York, 1909.

 a. Du Bois, Guy Pène. "Art Notes of the Studios
and Galleries." *New York American.* 9 February
1909.

 b. Laurvik, J. Nilsen. "International Photography
at the National Arts Club, New York." *Camera
Work,* No. 26 (April, 1909), pp. 38–42.
1407. (Newark, Free Public Library, 1911) The
Newark Museum Association. Modern Photography.
Free Public Library of Newark, N.J., April 6–May
4, 1911. Newark, 1911.

 Anderson, Paul. "Beautiful Photographs on View

at Newark Library." *The Sunday Call,* 16 April 1911.

1408. (New York, Montross, 1912) An Exhibition Illustrating/The Progress of the Art of/Photography in America at/The Montross Art Galleries/New York, October Tenth/to Thirty-First MCMXII. New York, 1912.

"Photographs at the Montross Gallery." *Photo-Era,* 29 (December, 1912), p. 317.

1408A. (Philadelphia, 1915) Tenth Annual Exhibition of Photographs. March 1–15, 1915. John Wanamaker, Philadelphia. Philadelphia, 1915.

1408B. (Philadelphia, 1916) Eleventh Annual Exhibition of Photographs. March 1–17, 1916. John Wanamaker, Philadelphia. Philadelphia, 1916.

1409. (Philadelphia, 1917) Twelfth Annual Exhibition of Photographs. March 1–17, 1917. John Wanamaker, Philadelphia. Philadelphia, 1917.

"A Criticism." *The Camera,* 21 (April, 1917), pp. 203–204.

1410. (Philadelphia, 1918) Thirteenth Annual Exhibition of Photographs. March 4th–16th, 1918. John Wanamaker, Philadelphia. Philadelphia, 1918.

Fitz, W. G. "A Few Thoughts on the Wanamaker Exhibition." *The Camera,* 22 (April, 1918), pp. 201–207.

B. Group exhibitions known only through reviews

1411. "The Photographic Salon." *British Journal of Photography,* 40 (13 October 1893), pp. 653–655.

1412. "Exhibition of the Belgian Association." *British Journal of Photography,* 43 (17 April 1896), pp. 249–250.

1413. "The Eastman Exhibition." *British Journal of Photography,* 44 (29 October 1897), pp. 697–698.

1414. E. K. "Die Erste Wanderausstellung Künstlerischer Photographien in Wien." (at K. K. Oestereichischen Museums für Kunst und Industrie in Wien) *Photographisches Centralblatt,* 5 (September, 1899), pp. 369–372.

1415. Samat, J. B. "Le 3ᵐᵉ Salon International d'Art Photographique. . . . Marseille." *Marseille Review Photographique,* 2 (Février, 1905), pp. 26–36.

1416. Hartmann, Sadakichi. "St. Louis World's Fair: Photographer's Impressions." *Photographic Times Bulletin,* 36 (November, 1904), pp. 481–489.

1417. "The Photographic Salon: Second Notice." *British Journal of Photography,* 52 (22 September 1905), pp. 753–754.

1418. "Complete List of American Pictures at the London Salon, 1905." *Camera Work,* No. 13 (January, 1906), pp. 52–53.

1419. "Modern Photographs at the New English Art Galleries." *British Journal of Photography,* 54 (1 February 1907), p. 85. (Installation view by Coburn reproduced in *Photograms of the Year 1907,* p. 116.)

1420. Guest, Antony. "Exhibition of Modern Photography." [Review of New English Art Galleries Exhibition]. *The Amateur Photographer,* 45 (5 February 1907), p. 116.

1421. "The Photographic Salon." *British Journal of Photography,* 54 (27 September 1907), p. 732.

1422. Snowdon-Ward, H. 'The London Secession,' in "The Work of the Year." *Photograms of the Year, 1911,* pp. 26–27, 67–71.

V. CORRESPONDENCE AND UNPUBLISHED RECOLLECTIONS. Edited by Elizabeth Pollock.

1423. Juan C. Abel to Stieglitz, 6 August 1904, YCAL.

1424. Ansel Adams to Stieglitz, 11 October 1936, YCAL.

1425. Ansel Adams to Virginia Adams, November 1936, Adams Files.

1426. Stieglitz to Ansel Adams, 22 October 1936, Adams Files.

1427. ———, 16 December 1936, YCAL.

1428. Ansel Adams to Weston Naef, 23 July 1977.

1429. J. Craig Annan to Stieglitz, 12 August 1903, YCAL.

1430. ———, 5 December 1906, YCAL.

1431. ———, 7 February 1907, YCAL.

1432. ———, 31 October 1907, YCAL.

1433. ———, leaf 79, August 1909, YCAL.

1434. ———, 11 November 1909, YCAL.

1435. John Aspinwall to Stieglitz, 3 May 1901, YCAL.

1436. ———, 16 January 1902, YCAL.

1437. Stieglitz to R. Child Bayley, 29 April 1912, YCAL.

1438. ——, 15 April 1913, YCAL.
1439. ——, 31 October 1913, YCAL.
1440. ——, 11 December 1913, YCAL.
1441. ——, 22 January 1914, YCAL.
1442. ——, 14 December 1914, YCAL.
1443. ——, 17 April 1916, YCAL.
1444. ——, 1 November 1916, YCAL.
1445. ——, 9 October 1919, YCAL.
1446. Walter Benington to Stieglitz, 14 June 1910, YCAL.
1447. ——, 12 July 1910, YCAL.
1448. ——, 6 September 1910, YCAL.
1449. Zaida Ben-Yusuf to Stieglitz, 21 October 1897, YCAL.
1450. Stieglitz to Zaida Ben-Yusuf, 8 December 1915, YCAL.
1451. Anne W. Brigman to Stieglitz, 5 November 1903, YCAL.
1452. ——, 17 February 1904, YCAL.
1453. ——, 14 October 1905, YCAL.
1454. ——, 12 June 1906, YCAL.
1455. ——, 3 March 1907, YCAL.
1456. ——, 24 April 1907, YCAL.
1457. ——, 10 September 1907, YCAL.
1458. ——, 4 January 1909, YCAL.
1459. Stieglitz to Anne W. Brigman, leaf 29–32, about 1918. YCAL.
1460. ——, 1 May 1930, YCAL.
1461. Francis Bruguière to Stieglitz, 5 September 1910, YCAL.
1462. Francis Bruguière and Anne W. Brigman to Stieglitz, 3 February 1915, YCAL.
1463. Buffalo Fine Arts Academy, Albright Art Gallery, Cornelia B. Sage, Director, to Stieglitz, 5 October 1909, YCAL.
1464. Buffalo, Cornelia B. Sage to Stieglitz, 4 November 1909, YCAL.
1465. Charles Caffin to Stieglitz, 23 November 1901, YCAL.
1466. ——, 6 April 1915, YCAL.
1467. Alvin Langdon Coburn to Stieglitz, leaf 6, about July, 1904, YCAL.
1468. ——, 13 February 1906, YCAL.
1469. ——, 28 January 1907, YCAL.
1470. ——, 18 July 1907, YCAL.
1471. ——, 5 October 1907, YCAL.

1472. ——, 20 October 1907, YCAL.
1473. ——, 2 November 1907, YCAL.
1474. ——, 17 September 1909, YCAL.
1475. Stieglitz to Alvin Langdon Coburn, 23 May 1910, YCAL.
1476. ——, 12 December 1911, YCAL.
1477. Imogene Cunningham to Stieglitz, 28 December 1911, YCAL.
1478. ——, 5 February 1914, YCAL.
1479. George Davison to Stieglitz, 13 June 1895, YCAL.
1480. ——, 4 January 1897, YCAL.
1481. ——, 4 November 1897, YCAL.
1482. ——, 20 September 1906, YCAL.
1483. H. G. Mortimer to George Davison (in Davison file), 4 May 1909, YCAL.
1484. Stieglitz to George Davison, 10 April 1909, YCAL.
1485. F. Holland Day to Stieglitz, leaf 10, about 1897, YCAL.
1486. ——, leaf 12, about 1898, YCAL.
1487. ——, leaf 14, about 1898, YCAL.
1488. ——, leaf 22, about 1898, YCAL.
1489. ——, leaf 23, about 1898, YCAL.
1490. ——, leaf 33, n.d., about 1898, YCAL.
1491. ——, leaf 42, about 1899, YCAL.
1492. ——, leafs 43–44, about 1898, YCAL.
1493. ——, 5 May 1899, YCAL.
1494. ——, leaf 54, about 1899, YCAL.
1495. ——, leaf 56, about 1899, YCAL.
1496. ——, leaf 15, February 1900, YCAL.
1497. Stieglitz to F. Holland Day, 31 April 1900, Norwood Historical Society, Norwood, Massachusetts.
1498. ——, 6 October 1902, Norwood Historical Society, Norwood, Massachusetts.
1499. ——, 21 May 1910, Norwood Historical Society, Norwood, Massachusetts.
1500. Robert Demachy to Stieglitz, leaf 7, about 1898, YCAL.
1501. ——, leaf 5, 1898, YCAL.
1502. ——, leaf 3, about 1898, YCAL.
1503. ——, leaf 60, about 1902, YCAL.
1504. ——, 20 June 1902, YCAL.
1505. ——, 6 September 1902, YCAL.
1506. ——, 11 September 1906, YCAL.
1507. ——, leaf 70, about 1906, YCAL.

1508. Adolf deMeyer to Stieglitz, 2 July 1907, YCAL.

1509. ———, 21 July 1908, YCAL.

1510. William B. Dyer to Stieglitz, 26 September 1901, YCAL.

1511. Rudolf Eickemeyer, Jr. to Stieglitz, 28 June 1895, YCAL.

1512. ———, 27 October 1895, YCAL.

1513. ———, 6 February 1898, YCAL.

Frank Eugene. See Frank Eugene Smith.

1514. Frederick H. Evans to Edward Steichen (in Stieglitz Archives), 15 September 1901, YCAL.

1515. Frederick H. Evans to Stieglitz, 24 July 1904, YCAL.

1516. ———, 12 July 1907, YCAL.

1517. ———, 3 January 1910, YCAL.

1518. ———, 12 December 1910, YCAL.

1519. Stieglitz to Frederick H. Evans, 26 December 1910, YCAL.

1520. Herbert G. French to Stieglitz, 8 June 1905, YCAL.

1521. ———, 22 February 1906, YCAL.

1522. Sadakitchi Hartmann to Stieglitz, 2 September 1904, YCAL.

1523. A. Horsley Hinton to Stieglitz, 29 December 1896, YCAL.

1524. ———, 23 November 1899, YCAL.

1525. ———, 21, 27, 30 July 1900, YCAL.

1526. ———, 17 December 1901, YCAL.

1527. ———, 21 January 1902, YCAL.

1528. ———, 29 September 1903, YCAL.

1529. Stieglitz to A. Horsley Hinton, 16 September 1900, YCAL.

1530. ———, 30 October 1903, YCAL.

1531. Gertrude Käsebier to Stieglitz, 27 January 1900, YCAL.

1532. ———, 23 July 1901, YCAL.

1533. ———, 21 August 1901, YCAL.

1534. ———, 17 November 1909, YCAL.

1535. ———, 6 January 1912, YCAL.

1536. Stieglitz to Gertrude Käsebier, 10 December 1910 with Käsebier's response at the bottom of this letter, YCAL.

1537. ———, 4 January 1912, YCAL.

1538. Joseph T. Keiley to Stieglitz, 19 June 1899, YCAL.

1539. ———, 1 September 1899, YCAL.

1540. ———, 9 September 1899, YCAL.

1541. ———, 28 October 1900, YCAL.

1542. ———, 14 September 1901, YCAL.

1543. ———, 20, 21 August 1902, YCAL.

1544. ———, 14 April 1904, YCAL.

1545. ———, 7 July 1904, YCAL.

1546. ———, 24 June 1907, YCAL.

1547. ———, 16 July 1908, YCAL.

1548. ———, 16, 17 July 1908, YCAL.

1549. ———, 12 August 1908, YCAL.

1550. ———, 23 April 1908, YCAL.

1551. Spencer Kellogg to Stieglitz, 24 December 1904, YCAL.

1552. Heinrich Kuehn to Stieglitz, 20 October 1904, YCAL.

1553. ———, 2 December 1904, YCAL.

1554. ———, 6 January 1905, YCAL.

1555. ———, 11 October 1905, YCAL.

1556. ———, 10 November 1905, YCAL.

1557. ———, 31 December 1905, YCAL.

1558. ———, 15 January 1906, YCAL.

1559. ———, 1 March 1906, YCAL.

1560. ———, 13 June 1906, YCAL.

1561. ———, 26 October 1906, YCAL.

1562. ———, 11 January 1907, YCAL.

1563. ———, 2 July 1907, YCAL.

1564. ———, 27 October 1907, YCAL.

1565. Stieglitz to Heinrich Kuehn, 17 November 1906, YCAL.

1566. ———, 10 March 1907, YCAL.

1567. ———, 1 March 1910, YCAL.

1568. ———, 14 January 1912, YCAL.

1569. ———, 22 May 1912, YCAL.

1570. ———, 14 October 1912, YCAL.

1571. ———, 14 December 1923, YCAL.

1572. ———, 20 October 1926, YCAL.

1573. ———, 8 June 1927, YCAL.

1574. ———, 6 August 1928, YCAL.

1575. ———, 27 March 1929, YCAL.

1576. ———, 30 September 1930, YCAL.

1577. Louis A. Lamb to Stieglitz, 16 June 1905, YCAL.

1578. René Le Bègue to Stieglitz, 11 February 1906, YCAL.

1579. David Hunter McAlpin to Weston Naef, 6 December 1977.

1580. Stieglitz to Ward Muir, 30 January 1913, YCAL.

1581. Stieglitz to Eliot Porter, 5 December 1938, Porter Files.

1582. ——, 13 December 1938, Porter Files.

1583. ——, 4 December 1938, Porter Files.

1584. ——, 21 January 1939, Porter Files.

1585. Eliot Porter to Weston Naef, 23 July 1977, MMA.

1586. William B. Post to Stieglitz, 12 December 1898, YCAL.

1587. ——, 20 December 1898, YCAL.

1588. ——, 8 January 1899, YCAL.

1589. ——, 29 December 1902, YCAL.

1590. ——, 7 January 1903, YCAL.

1591. ——, 15 December 1908, YCAL.

1592. Harry C. Rubincam to Stieglitz, leaf 1, about 1902–1903, YCAL.

1593. George H. Seeley to Stieglitz, 18 December 1906, YCAL.

1594. ——, 17 February 1908, YCAL.

1595. ——, 26 March 1909, YCAL.

1596. ——, 17 April 1908, YCAL.

1597. ——, 26 February 1909, YCAL.

1598. Stieglitz to George Seeley, 14 April 1906, YCAL.

1599. ——, 21 November 1910, YCAL.

1600. Charles Sheeler to Stieglitz, 28 October 1916, YCAL.

1601. ——, 5 June 1922, YCAL.

1602. Stieglitz to Thomas W. Smillie, 20 December 1911, YCAL. I am grateful to William I. Homer for drawing this reference to my attention.

1603. Frank Eugene Smith to Stieglitz, 18 September 1907, YCAL.

1604. Stieglitz to Frank Eugene Smith, 8 August 1904, YCAL.

1605. ——, 28 October 1912, YCAL.

1606. Edward Steichen to Stieglitz, 18 May 1900, YCAL.

1607. ——, leaf 12, January, 1901, YCAL.

1608. ——, leaf 15, August, 1901, YCAL.

1609. ——, leaf 17, August, 1901, YCAL.

1610. ——, about March, 1902, YCAL.

1611. ——, leafs 80–81, about 1906, YCAL.

1612. ——, leaf 87, November, 1906, YCAL.

1613. ——, leaf 98, about April, 1901, YCAL.

1614. ——, leafs 111–115, Autumn, 1908, YCAL.

1615. ——, 28 August 1909, YCAL.

1616. ——, leafs 321–325, about 1920, YCAL.

1617. Paul Strand to Stieglitz, leaf 5, July, 1917, YCAL.

1618. ——, 9 August 1919, YCAL.

1619. Stieglitz to Paul Strand, 20 July 1925, YCAL.

1620. Hans Watzek to Stieglitz, 13 January 1902, YCAL.

1621. Clarence H. White to Stieglitz, 6 January 1899, YCAL.

1622. ——, 25 March 1899, YCAL.

1623. ——, 5 May 1899, YCAL.

1624. ——, 21 November 1899, YCAL.

1625. ——, 18 April 1900, YCAL.

1626. ——, 4 January 1901, YCAL.

1627. ——, 17 April 1901, YCAL.

1628. ——, 11 June 1902, YCAL.

1629. ——, 6 July 1906, YCAL.

1630. ——, 14 June 1907, YCAL.

1631. ——, 11 July 1909, YCAL.

1632. —— 15 May 1912, YCAL.

1633. —— 23 October 1923, YCAL.

1634. Stieglitz to Clarence H. White, 23 May 1912, YCAL.

1635. Stieglitz to Peter Henry Emerson, 9 October, 1933, YCAL.

INDEX by David Beams

The above label, printed in a light olive ink, was affixed
to the back of many of the photographs in Stieglitz's collection.
The label was designed by Allen Lewis (1873–1957),
a printmaker noted for his bookplate designs.

The text of this book is set in Linotype Granjon,
modeled on a typeface design of the sixteenth-century publisher,
printer, and type founder, Robert Granjon. This modern
recutting of Granjon was produced in 1924 by George W. Jones.

The book is printed on Warren's Patina.
Composed by American Book–Stratford Press, Inc.,
Brattleboro, Vermont. Printed and bound by
Murray Printing Company, Forge Village, Massachusetts.

Calligraphy by Carole Lowenstein.
Cover and book design by Clint Anglin.
Edited by Yong-Hee Last.